STUDIES IN ANTIQUITY AND CHRISTIANITY

The Roots of Egyptian Christianity
Birger A. Pearson and James E. Goehring, editors

The Formation of Q: Trajectories in Ancient Wisdom Collections
John S. Kloppenborg

Saint Peter of Alexandria: Bishop and Martyr
Tim Vivian

Images of the Feminine in Gnosticism
Karen L. King, editor

STUDIES IN ANTIQUITY AND CHRISTIANITY

The Institute for Antiquity and Christianity
Claremont Graduate School
Claremont, California

STUDIES IN ANTIQUITY & CHRISTIANITY

IMAGES OF THE FEMININE IN GNOSTICISM

Karen L. King, editor

FORTRESS PRESS

PHILADELPHIA

Library of Congress Cataloging-in-Publication Data

Images of the feminine in Gnosticism.

(Studies in antiquity and Christianity)
Papers from a conference held Nov. 19–25, 1985, in Claremont, Calif. and sponsored by the Institute for Antiquity and Christianity, Dept. of Religious Studies at Occidental College, and the Society of Biblical Literature.
Bibliography: p.
Includes index.
1. Gnosticism—Congresses. 2. Women and religion—Congresses. I. King, Karen L. II. Institute for Antiquity and Christianity. III. Occidental College. Dept. of Religious Studies. IV. Society of Biblical Literature. V. Series.
BT1390.I43 1988 299'.932'088042 87–46896
ISBN 0–8006–3103–X

2574B88 Printed in the United States of America 1–3103

Contents

Contributors

Luise Abramowski
Eberhard-Karls Universität
Tübingen, Federal Republic of
Germany

Bernadette J. Brooten
Harvard Divinity School
Cambridge, Massachusetts

Jorunn Jacobsen Buckley
Massachusetts Institute of
Technology
Cambridge, Massachusetts

Ron Cameron
Wesleyan University
Middletown, Connecticut

Elizabeth A. Castelli
The College of Wooster
Wooster, Ohio

Elizabeth A. Clark
Duke University
Durham, North Carolina

Mary Rose D'Angelo
Villanova University
Villanova, Pennsylvania

Paula Fredriksen
University of Pittsburgh
Pittsburgh, Pennsylvania

James E. Goehring
Mary Washington College
Fredericksburg, Virginia

Deirdre J. Good
General Theological Seminary
New York, New York

Charles W. Hedrick
Southwest Missouri State
University
Springfield, Missouri

Karen L. King
Occidental College
Los Angeles, California

Ross S. Kraemer
 Medical College of
 Pennsylvania
 Philadelphia, Pennsylvania

Dennis Ronald MacDonald
 Iliff School of Theology
 Denver, Colorado

Anne McGuire
 Haverford College
 Haverford, Pennsylvania

Marvin W. Meyer
 Chapman College
 Orange, California

Elaine Pagels
 Princeton University
 Princeton, New Jersey

Douglas M. Parrott
 University of California
 Riverside, California

Anne Pasquier
 Université Laval
 Quebec, Quebec

Birger A. Pearson
 University of California
 Santa Barbara, California

Pheme Perkins
 Boston University
 Chestnut Hill, Massachusetts

James M. Robinson
 Institute for Antiquity and
 Christianity
 Claremont Graduate School
 Claremont, California

Kurt Rudolph
 Philipps Universität
 Marburg, Federal Republic of
 Germany

Elisabeth Schüssler Fiorenza
 Harvard Divinity School
 Cambridge, Massachusetts

Madeleine Scopello
 Centre National de la recherche
 scientifique
 Paris, France

John H. Sieber
 Luther College
 Decorah, Iowa

Richard Smith
 Institute for Antiquity and
 Christianity
 Claremont Graduate School
 Claremont, California

John D. Turner
 University of Nebraska
 Lincoln, Nebraska

Michael A. Williams
 University of Washington
 Seattle, Washington

Antoinette Clark Wire
 San Francisco Theological
 Seminary
 San Anselmo, California

Frederik Wisse
 McGill University
 Montreal, Quebec

Editor's Foreword

Religion and gender is an important contemporary topic in the study of religions insofar as religious symbols, including images of gender, shape the symbolic worlds in which individual and collective views of the self and existence are defined. Images of gender both reflect the social practices of men and women and play a role in shaping the gendered character of social reality. In many traditions, gender imagery is used in conceiving deity as well as in discussing humanity and sexuality. In Gnosticism, not only concepts of deity and of humankind's essential nature but also concepts of how the world came into being and the nature of evil and salvation are often formulated in terms of gender. The use of gender imagery in Gnosticism is thus not a peripheral issue. It is also not a simple one. This is largely due to the complexity of the phenomenon of Gnosticism itself and to the lack of social information we have about it.

The essays and responses in this volume attempt to address the many problems inherent in a description of gender imagery in Gnosticism. They were first presented at an international research conference on "Images of the Feminine in Gnosticism." The conference was sponsored by the Institute for Antiquity and Christianity, by the Department of Religious Studies at Occidental College, and by the Society of Biblical Literature. It convened November 19–25, 1985, at the Institute for Antiquity and Christianity in Claremont, California, and at the Society of Biblical Literature annual meeting in Anaheim. Twenty presentations were made, followed by responses. In addition, there was a panel discussion at the annual meeting of the SBL designed to bring the work

of the conference to the attention of a broader audience. The culmination of the conference was a plenary address by the scholar whose work has been most foundational in this area, Elaine Pagels.

The purpose of the conference was to initiate a systematic study of issues of gender in Gnosticism, beginning with a focus upon images of the feminine. The conference succeeded most effectively in setting out a clear picture of the state of present research and in delineating paths for future research.

The many methodological points that were raised centered on two issues: understanding gnostic perspectives on gender and the problem of the relationship between mythology and social description. Other primary subjects included the social description of Gnosticism and substantive topics in literary and comparative historical analysis.

It became clear that certain distinctions are important in order to understand the texts' perspectives on gender. First, it is necessary to acknowledge that there are a variety of perspectives among gnostic texts. Second, it is important to clarify when a gendered image is being used for the sake of its gendered characteristics. Michael Williams lays out these methodological problems and applies his model of analysis to three gnostic texts in order to illustrate the variety of perspectives on gender in Gnosticism. Other participants also illustrate the importance of the second distinction. For example, Anne McGuire demonstrates that the gender of the mythological figures of Norea and the archons in the *Hypostasis of the Archons* is centrally important to the text's theme of confrontation and subversion. On the other hand, I argue that the gender identity of the savior figures in the *Apocryphon of John* is not relevant for the text's concept of salvation. In some cases, gendered imagery is centrally significant because of its gendered character; in other cases, gendered imagery may be present only because it is a part of the tradition or because it is related to the myth or theology as gendered imagery in a different context.

Another way to get at perspectives on gender is to understand the presuppositions or interpretive framework operative behind a text's use of gender imagery. Elaine Pagels, for example, asks: "How do various gnostic exegetical approaches tend to differ from those of orthodox exegetes? And what do these differences have to do with the way gnostic authors interpret sexual imagery" (p. 188)? She argues that Paul is the key to understanding the gnostic interpretation of Genesis and the presentation of Eve in the *Hypostasis of the Archons* and the *Gospel of Philip*. Another method is that of utilizing a feminist hermeneutic aimed

at exposing patriarchal presuppositions at work in presenting gender. Elizabeth Castelli notes, for example, that the medical views described by Richard Smith at work in the Sophia myth presuppose that women are the "other," not only a derivation but a deviation from the male norm. I indicate in my essay that different versions of the *Apocryphon of John* take different emphases in gender perspective. One version presents the first woman as a sexual temptress; the other presents the domination of woman by man as a wicked decree of the world creator.

Another aspect of this problem of understanding the gender perspective of a text concerns the gendered nature of language itself. Deirdre Good raises this issue quite forcefully. It is necessary to determine when images that are gendered by grammar and syntax are relevant to the discussion of gendered imagery in Gnosticism and to what degree. In order to do that, the gendered textures of languages themselves must be analyzed. In turn, this problem generates a related difficulty: What happens to the gender perspective of a text in the process of translation (e.g., from Greek to Coptic or to modern languages)? For example, should we translate the Coptic ειωτ as "father" or as "parent"? In what contexts? Is the term equivalent to the Greek πατήρ (see Good; Sieber)?

Another question is whether or not we need to know the gender of the author in order to understand properly a text's perspective on gender. This issue is raised from a variety of points of view (Williams; Wire; Schüssler Fiorenza; Brooten; Scopello; Parrott). Madeleine Scopello suggests that some of the texts we possess may have been written by women. The consensus of the conference was that this is most certainly the case; the problem remains, however, of determining more specifically which texts were composed by women. The issue is important, since perspectives on gendered imagery, the evaluation of ethical issues of sexual behavior, and attitudes toward ritual practices may be different for women than for men. It was agreed that further work needs to be done on the issues of women's education in antiquity and comparative work on the gender differences that may exist in other literatures.

A primary question that was only touched upon (Sieber; Pagels) regards proper methods to understand the use of metaphorical and mythological language with regard to the issue of gender, that is, What is such language about? Two points are clear, however. It is important to understand the metaphorical nature of certain images of gender and to be careful in relating them to attitudes toward real women and men or to social gender roles.

This point provides a good bridge to the second difficult point of

methodology: the relationship of myth to social description. What is the relationship of gendered images in myth and metaphor to the real lives of women and men? The real problem here is the lack of reliable social and historical information about Gnosticism. Gnostic texts are for the most part apocalyptic and mythological or semiphilosophical treatises. They give us no clear and reliable information about the history, organization, composition, and practices of gnostic groups. What little we know must be carefully culled from texts that were not designed to provide such information or from the Christian opponents of Gnosticism such as Irenaeus, Hippolytus, Epiphanius, and Augustine. One may therefore reasonably question whether or not it is at all possible to construct a history or social history of Gnosticism with the kind of information we have. In her response, Elisabeth Schüssler Fiorenza writes that we "should not either separate social from religious-theological functions or conceive of 'social roles' independently from the social-religious institutions of which they are a part" (p. 328). If, therefore, we cannot establish the social and historical context for gnostic literature and practice, it is essential to be aware of how that may limit our understanding of the images of the feminine in Gnosticism. It also became clear in the course of our conversations that the large amount of feminine imagery in the gnostic texts relative to other similar religious literature of antiquity, especially normative Christian texts, does not necessarily indicate a larger social role for women.

Despite these problems, several authors have attempted (or critiqued attempts) to cull social information from a text or to imagine a plausible historical-social context for an idea or practice (Scopello; Parrott; Cameron; King; Turner; Pagels; D'Angelo; Buckley; Rudolph; Kraemer; MacDonald; Brooten; Wire; Schüssler Fiorenza; Wisse; Goehring). One particular interest was in the gender composition of gnostic groups. How attractive might Gnosticism have been to women? Did ascetic or libertine practices offer an attractive alternative to women in a patriarchal society (Wire; Schüssler Fiorenza; Goehring; Wisse)? Are the images of strong female goddesses, saviors, and heroines an indication that Gnosticism would have been attractive to women (Scopello; Parrott)? Or would other themes have played a role in repelling women from Gnosticism? James Goehring, for example, addresses these questions with regard to libertine cults. He suggests that "there were Phibionite women who were instrumental in the group's development and that they found in the group an avenue to express their release from the societal constraints imposed upon them by their sex" (p. 344). On the

other hand, Frederik Wisse describes the important theme of antifemininity that runs throughout many gnostic texts and suggests that such a theme should make us very cautious about positing important roles for women in gnostic groups.

Another strong interest in social description concerned women's roles in gnostic groups, especially with regard to ritual and cult. Is it plausible that women in some gnostic groups were authors, teachers, and leaders (Scopello; Parrott)? What parts did women play in ritual, especially in the ritual of the bridal chamber (Buckley; Rudolph), rites of initiation (King; Turner; Cameron), or in libertine cults (Goehring)? Can we understand particular actions of women by reference to myth? For example, Dennis MacDonald suggests that the act of women's unveiling (1 Corinthians 11) may be properly understood against a myth of primordial androgyny.

A final set of questions raised concerning social description had to do with the social function of particular practices. For example, did similar behavior, such as asceticism or libertinism, have a different set of social functions for women than for men? What are those functions? Antoinette Clark Wire, for example, argues that women's asceticism had different functions than men's based upon their different social roles. She describes six possible social functions of asceticism for women. Here in particular, the issue of the importance of considering social class in addition to gender was raised as an important issue (Schüssler Fiorenza).

Substantive topics in literary and comparative historical analysis focused on (1) the meaning and connotations of important terms or images, especially by understanding them in their cultural and mythic contexts (Pasquier; Meyer); (2) the nature and roles of important female figures such as Barbelo, Sophia, Norea, Eve, and Sophia-Jesus (Perkins; Robinson; Hedrick; Abramowski; Buckley; Rudolph; McGuire; Pearson); and (3) identifying and understanding imagery borrowed from other literary, intellectual, or mythic contexts of the Greco-Roman world (Scopello; Parrott; Smith; Castelli). These studies are of paramount importance to a discussion of the usages and meaning of imagery of the feminine. Anne Pasquier's study of the term *prounikos* illuminates the range of connotation that a single term can have in expressing gnostic views. Pheme Perkins's study clearly demonstrates the importance of reading images against their proper background. She argues that we misunderstand Sophia in treating her against Jewish wisdom patterns of sin, flaw, and fault that may not be appropriate to her story. When we look to material about Greco-Roman goddesses, a different view of

Sophia's "fall" emerges. Similarly, James Robinson describes an early Christian trajectory that understands the figure of Jesus in terms of Sophia. This trajectory suggests a new vantage point for Christian theology different from the apocalyptic and messianic patterns that may no longer be adequate for us today to understand the Jesus story. Luise Abramowski treats us to a description of the variety of female figures in the gnostic special material (*Sondergut*) of Hippolytus's treatise *Refutation of All Heresies* and allows us to see how very rich and various gnostic treatment of female figures is. Jorunn Buckley shows the way in which a single text, the *Gospel of Philip*, can treat a number of important female figures using them to model for all gnostics, male and female alike, the pattern of salvation as unification. Anne McGuire focuses on the figure of Norea in the *Hypostasis of the Archons*. Using a modified form of reader response criticism, she shows how Norea's confrontation with the world ruler provides a pattern for the subversion of (male) archontic power. Birger Pearson also focuses on the figure of Norea, describing the various roles assigned to her in the gnostic texts and her function as a "saved savior." Madeleine Scopello shows how *Exegesis on the Soul* and *Authoritative Teaching* can be illuminated when compared with Hellenistic novels. She argues that the soul's adventures follow the pattern of female heroines in Jewish and Greco-Roman literature. Similarly, Richard Smith shows how we misread ancient literature if we do not understand the conceptuality that ancient authors and readers presume. In this case, he shows how concepts from biology and medicine can illumine mythological imagery about gender and generation.

Finally, the work here by Elizabeth Clark, Paula Fredriksen, and Elaine Pagels (Part Two) shows the influence of gnostic conceptuality beyond the sphere of Gnosticism proper, especially on Christianity. Elizabeth Clark discusses in detail the charge of "Manicheism" brought against Augustine by Pelagian critics such as Julian of Eclanum. The central issue is Augustine's theory of reproduction. Elaine Pagels takes a different and illuminating direction of inquiry, describing how projections upon the familiar story of creation in Genesis, read by gnostic Christians, their orthodox opponents, and Augustine, relate to specific historical circumstances and perspectives.

So in the end, what meaning may the study of images of the feminine in Gnosticism have? Many of the authors in this volume draw out specifically the implications of their work. Some results are negative. For example, Frederik Wisse points out that the theme of antifemininity, tied to a social setting of encratism, seems to offer little support to the view

that women may have had important roles in Gnosticism. Similarly it seems to me that even when the feminine is highly valued, it is often done so at the expense of real sexuality. It also seems as though gnostic mythology and gender imagery often affirm patriarchy and patriarchal social gender roles. The literature under discussion here was formed in a clearly patriarchal society and reflects that fact thoroughly.

Other authors found in the texts deposits of meaning and resources for human liberation. Pheme Perkins argues that the Sophia stories "had the symbolic [and] mythic resources to image the crisis of roots, generation, and family. . . . The Gnostic holds out a biting critique of the world as it is experienced and a promise that the 'true seed' comes from an entirely different order" (pp. 111–12). Anne McGuire finds a paradigm for the subversion of false powers of domination in the *Hypostasis of the Archons*. The image of a female as a powerful savior figure can be an empowering model for human liberation. Or a renewed understanding of Jesus-Sophia could provide a positive new direction for modern Christian theology (Robinson; Hedrick). In the *Gospel of Philip*, qualities deemed "female" are those envisioned to have the power to heal division and brokenness in all human beings (Buckley).

A direct consequence of the conference was the establishment of a research project titled "Female and Male in Gnosticism." It is functioning conjunctively as a section of the Society of Biblical Literature and a research project of the Institute for Antiquity and Christianity. The purpose of the project is to produce a systematic description of gender in Gnosticism. The project will need to describe and account for (1) the use of gendered language and images in gnostic literature, (2) the meaning of gender in the presentation of deity and certain important mythological figures and themes, and (3) the relation of the use of such language to a social description of Gnosticism. The project will include all the relevant Nag Hammadi texts and other primary gnostic texts, selections from nongnostic Christian texts (especially the heresiologists), and materials from other related traditions such as Mandeism and Manicheism.

Without the support and efforts of the following persons and institutions, the conference and this resulting volume would not have been possible. First, special thanks are due to all the participants for their scholarly contributions and personal support. I want especially to thank Anne McGuire, who served on the convening committee and offered considerable advice and support, and doctoral students Kathleen Corley and Clayton Jefford of the Institute for Antiquity and Christianity, for

their administrative support. My warmest thanks go to Stephanie Dumoski, a student of Occidental College, for her unstinting generosity of time and labor in compiling the bibliography at the end of this volume. Financial support for the conference was provided by the Institute for Antiquity and Christianity and by President Richard Gilman and Dean David Danelski of Occidental College. Their support is greatly appreciated. My thanks are also due Harold W. Rast and John A. Hollar of Fortress Press for their patience and assistance. Finally, I wish to acknowledge and express particular gratitude to James M. Robinson, who conceived the conference, supported the project to fruition, and was a constant guide and adviser at every stage. Many thanks.

KAREN L. KING
Occidental College
Los Angeles, California

Abbreviations

Adv. haer.	Irenaeus, *Adversus haereses*
ANRW	*Aufstieg und Niedergang der römischen Welt*
Ant.	Josephus, *Jewish Antiquities*
Ap. Adam	*Apocalypse of Adam*
1 Ap. Jas.	*First Apocalypse of James*
Ap. John	*Apocryphon of John*
ATR	*Anglican Theological Review*
Auth. Teach.	*Authoritative Teaching*
B.C.E.	Before the Common Era (equivalent to B.C.)
BG	*Berlin Gnostic Codex* 8502 (also called *Codex Berolinensis 8502*)
BS	*Biblische Studien*
BZNW	*Beiheft, Zeitschrift für die neutestamentliche Wissenschaft*
CBQ	*Catholic Biblical Quarterly*
CCL	Corpus Christianorum: Series Latina
C.E.	Common Era (equivalent to A.D.)
CH	*Church History*
CMG	Corpus Medicorum Graecorum
CSCO	Corpus Scriptorum Christianorum Orientalium
CSEL	Corpus Scriptorum Ecclesiasticorum Latinorum
Dial. Sav.	*Dialogue of the Savior*
Ep. Pet. Phil.	*Epistle of Peter to Philip*
ETR	*Etudes Théologiques et Religieuses*
Eugnostos	*Eugnostos the Blessed*
Exeg. Soul	*Exegesis on the Soul*

Ex. Theod.	Clement of Alexandria, *Excerpta ex Theodoto*
FRLANT	Forschungen zur Religion und Literatur des Alten und Neuen Testaments
GCS	Griechische christliche Schriftsteller
Gen. an.	Aristotle, *De generatione animalium*
Gos. Eg.	*Gospel of the Egyptians*
Gos. Phil.	*Gospel of Philip*
Gos. Thom.	*Gospel of Thomas*
Gos. Truth	*Gospel of Truth*
Gyn.	Soranus, *Gynecology*
Haer.	Epiphanius, *Panarion haereses*
Hist. an.	Aristotle, *Historia animalium*
HR	*History of Religions*
HTR	*Harvard Theological Review*
Hyp. Arch.	*Hypostasis of the Archons*
JAAR	*Journal of the American Academy of Religion*
JBL	*Journal of Biblical Literature*
JEH	*Journal of Ecclesiastical History*
JTS	*Journal of Theological Studies*
LCL	Loeb Classical Library
Leg. all.	Philo, *Legum allegoriae*
Melch.	*Melchizedek*
NHC	Nag Hammadi Codex
NHS	Nag Hammadi Studies
NKZ	*Neue kirchliche Zeitschrift*
Norea	*Thought of Norea*
NovT	*Novum Testamentum*
NTS	*New Testament Studies*
Numen	*Numen: International Review for the History of Religions*
OLZ	*Orientalische Literaturzeitung*
Op. mund.	Philo, *Opficio mundi*
Orig. World	*On the Origin of the World*
Paraph. Shem	*Paraphrase of Shem*
PG	J. Migne, *Patrologia graeca*
PGM	K. Preisendanz, ed., *Papyri graecae magicae*
PL	J. Migne, *Patrologia latina*
PW	A. Pauly and G. Wissowa, *Real-Encyclopädie der classischen Altertumswissenschaft*
RAC	*Reallexikon für Antike und Christentum*
RB	*Revue Biblique*

Ref.	Hippolytus, *Refutatio omnium haeresium*
RevScRel	*Revue des Sciences Religieuses*
RGG	*Religion in Geschichte und Gegenwart*
RSR	*Recherches de Science Religieuse*
RSV	Revised Standard Version
Soph. Jes. Chr.	*Sophia of Jesus Christ*
Steles Seth	*Three Steles of Seth*
Teach. Silv.	*Teachings of Silvanus*
Testim. Truth	*Testimony of Truth*
TF	*Theologische Forschung*
ThQ	*Theological Quarterly*
TLZ	*Theologische Literaturzeitung*
Treat. Seth	*Second Treatise of the Great Seth*
Trim. Prot.	*Trimorphic Protennoia*
Tri. Trac.	*Tripartite Tractate*
TSK	*Theologische Studien und Kritiken*
TU	Texte und Untersuchungen
UP	Galen, *De usu partium*
USQR	*Union Seminary Quarterly Review*
Val. Exp.	*A Valentinian Exposition*
VC	*Vigiliae christianae*
Vict.	Hippocrates, *De ratione victus salubris*
WTJ	*Westminster Theological Journal*
ZKG	*Zeitschrift für Kirchengeschichte*
ZKT	*Zeitschrift für katholische Theologie*
ZNW	*Zeitschrift für die neutestamentliche Wissenschaft*
Zost.	*Zostrianos*
ZRGG	*Zeitschrift für Religions- und Geistesgeschichte*

PART ONE

ESSAYS AND RESPONSES

 MICHAEL A. WILLIAMS

Variety in Gnostic Perspectives on Gender

The announced intent of the conference for which the essays in this volume were produced was to "delimit the forms and functions of the most important images of the feminine in the major gnostic groups and to discuss and explore fruitful methodological approaches to interpreting these texts." I take it that the conference itself was an expression of our corporate sense that the progress of scholarship in the analysis of fresh sources such as those from Nag Hammadi and in the digestion of new insights about our sources at large has now carried us to a point beyond which our discussion of the topic of Gnosticism and gender can and ought to become increasingly less generalized, more nuanced. I suspect that we are no longer satisfied with generalizations about "the gnostic myth of the female," "the gnostic pattern" in the use of gender images, and so forth. In what follows, I will offer my own view as to why such dissatisfaction is legitimate and suggest factors that ought to be taken into consideration in interpretations of the significance of gender-related imagery in gnostic sources.

My reflection on theoretical issues relating to the use of gender imagery in religious texts has been heavily informed by the work of a two-year research seminar on "Religion and Gender" conducted in 1981–83 by the faculty of the Comparative Religion Program of the University of Washington and chaired by Caroline W. Bynum.[1] These discussions, encompassing cases from several different religious tradi-

1. See C. W. Bynum, S. Harrell, and P. Richman, eds., *Gender and Religion: On the Complexity of Symbols*. Note esp. Bynum's important introductory essay, "The Complexity of Symbols," 1–20.

tions, demonstrate the prematurity of much generalization in recently produced literature on women and religion or on feminine imagery in religious texts. There is significant diversity among perspectives on gender from one culture or religious tradition to the next, and perspectives on gender can differ from one person to the next even within a single tradition. "Male" and "female" do not have the same associations everywhere or for every person. "Femaleness" does not always imply "passivity," for instance; nor is it the case that "male" and "female" always suggest "opposition" or "polarity."

Some of the contributions were able to compare perspectives of men with those of women, within the same tradition, and the results suggest that there are contrasts involving far more complexity than simply the degree of androcentrism or the amount of female imagery employed. For instance, Bynum has shown that for medieval male writers the "motherhood" of Christ entailed the pairing of the gender images of "mothering" and "fathering" in discussions by these writers of complementary aspects of clerical leadership (affectivity or nurture vs. authority), whereas for female writers, "mothering" was not thought of as one part of a gender pair (with "fathering") but instead was regularly associated with images of "eating" and "suffering."[2] Jack Hawley has compared the writings of male and female poet-saints from the Braj region of North India in their use of the imagery of devotion to Krishna.[3] Hawley has shown that when male poets speak in the voice of the *gopis*, the mythical cowmaids who dance the dance of love with Krishna on moonlit nights, it is not with quite the same tone or concerns that can be found in a female poet who is taking on the *gopi* persona in her poetry but without having to make the imaginative change of sex that is required of male poets.

For our purposes here, one of the most important implications of the research just mentioned is to underscore how essential it is that discussions of images of the feminine in Gnosticism not be separated from an analysis of gnostic perspectives on gender itself. For there are levels of diversity here that must be appreciated before the significance of individual patterns of feminine imagery can be understood. Since the determination of the gender of the author is so problematic for most of our

2. C. W. Bynum, "'. . . And Woman His Humanity': Female Imagery in the Religious Writing of the Later Middle Ages," in *Gender and Religion* (ed. Bynum, Harrell, and Richman), 257–88.
3. J. S. Hawley, "Images of Gender in the Poetry of Krishna," in *Gender and Religion* (ed. Bynum, Harrell, and Richman), 231–56; and in the same volume, see the articles by Richman, Harrell, Wallace, and Toews.

gnostic sources, it may not be possible to identify patterns that distinguish the perspective of female gnostic writers from that of male authors in the way in which Bynum and Hawley have been able to do for their sources. Some of the differences that exist in the gnostic texts may well be due to this factor, but in most cases the nature of the sources will not allow us to test this. Nevertheless I am impressed by the significant diversity in gender perspective that is in evidence among gnostic writers, whatever part the gender of the authors themselves may have played in this. And even where it is likely that two sources have been produced by authors of the same sex, we sometimes encounter what I would want to call qualitative differences in perspective. In order to develop an adequate understanding of gnostic uses of gender-related imagery, we must be sensitive from the start to the diversity in vantage points represented by the writers.

In analyzing the usage of gender-related imagery in gnostic texts, I suggest that we ought to distinguish among at least four different questions that have not always been carefully distinguished in the past: (1) To what extent does a text even use imagery that we would want to call *gendered* imagery? (2) When a gendered image is used, is it used primarily *for the sake of its gendered character*, or is it for some other reason? To rephrase this in the vocabulary of the conference, when are feminine images actually images *of the feminine*? (3) Even where gendered imagery is being used for the sake of its gendered character, what is the nature of the relationship between the roles depicted in the imagery and the perspective of the author on social gender roles? (4) What perspectives on social gender are discernible among gnostic sources?

1. AMOUNT OF GENDER IMAGERY

There is, first of all, variety in the extent to which gnostic texts use gendered imagery at all. I should first comment on what I am counting as "gendered imagery." There are some images over which I assume there would be little or no debate. Examples might include terms such as "bride," "bridegroom," or "mother." In certain instances this would also be true for the term "father"—for example, when it is paired with the word "mother" (e.g., *Orig. World* 104,10f.). However, as Deirdre Good has demonstrated (see her contribution in this volume), the Coptic term (ειωτ) that often does mean "father" can sometimes mean simply

"parent," without reference to specific gender. And many nouns that are simply lexically male (e.g., Nous) or female (e.g., Sophia) are not in themselves "gendered" in the sense in which I am using the term, and they become so only when they are more explicitly gendered in a text, either mythologically (e.g., Sophia referred to as mother) or through some direct attribution (e.g., in a reference such as "male Mind").

The variety in the amount of gendered imagery used in gnostic sources ranges from the virtual absence of it in some texts to a profusion in others. Of all the factors that I will be discussing here, the simple amount of gendered imagery employed is perhaps the one most easily subjected to straightforward measurement. Yet variety in the level of gender imaging has proved susceptible to misinterpretation. For example, past scholarship has sometimes focused too one-sidedly on the relative abundance of female imagery in certain gnostic texts as compared with the amount of female imagery encountered in more "orthodox" Jewish or Christian sources. But it has not been sufficiently recognized that such gnostic texts are frequently manifesting a greater proclivity toward gender imagery at large, both male *and* female imagery. Some authors are simply more inclined than are others to image self, cosmos, or the transcendent in patterns involving gender relationships. Thus, a high visibility of the feminine may in some cases signify a higher level of what we might call "gender consciousness" rather than a special interest in only one gender, the feminine.

But gnostic sources also include representatives from elsewhere along the spectrum, all the way to an almost complete absence of any tendency to image in gender categories. Though we are accustomed to encountering certain gnostic motifs in gendered form, the fact that sometimes the gendering is not present needs to be weighed more carefully. To cite a familiar example, the author of the *Gospel of Truth* (NHC I,3) does not present a Sophia myth that is gendered after the fashion of so many Valentinian examples. We find instead a highly abstract description of Error ($\pi\lambda\acute{\alpha}\nu\eta$) constructing a substitute for Truth (*Gos. Truth* 17,4–20). Here is an instance in which the use of the neuter English pronoun "it"[4] is at least as suitable as "she/her" for translating the text's pronominal references to Error, even though $\pi\lambda\acute{\alpha}\nu\eta$ is lexically a feminine Greek noun. For even though there is admittedly still a

4. This is the translation option chosen by, e.g., G. W. MacRae, *The Nag Hammadi Library in English* (ed. J. M. Robinson), 38.

mythic style in the narrative, nothing about the narrative depends on, or alludes to, the femaleness of Error. We have no reference to Error as mother or consort, for example.

It may well be true, as Hans Jonas long ago suggested,[5] that some more mythological (and more gendered) version of a Sophia myth is presupposed by the author of the *Gospel of Truth*. But my point is that even if this is the case, we should not ignore the degendering that has taken place. At the very least, we should avoid reading the gendering back into the material for the author. On this methodological point I must take issue with, for example, Rose Arthur, who in her recently published study of various feminine motifs in Nag Hammadi texts[6] takes a different tack in the analysis of the *Gospel of Truth*. In her view, the more abstract narrative about Error is a disguised version of the same feminine "motifs and their prejudices" that are found explicitly expressed in other gnostic sources.[7] Even though the *Gospel of Truth* presents the theme of the "deficiency" (ϣⲧⲁ) in more demythologized, abstract form, this is, argues Arthur, a disguised form of the "fault (ϣⲧⲁ) of the woman."[8] But I would argue that we may not have here the cloaking of gender prejudices so much as a lesser degree of gender consciousness. This author is simply not so naturally inclined to image in female/male categories.

2. INTEREST IN THE IMAGERY'S GENDERED CHARACTER

Second, among those texts which do make use of gendered imagery, there is variety in the extent to which such imagery is actually used for the sake of its gendered character. In other words, even a relatively larger amount of gendered imagery may not always indicate higher gender consciousness. One author may give an indication of being intensely conscious of the femaleness of an image, whereas another author's use of the same image may reveal little or no interest in the image qua female.

Let us take a simple modern example of how a gendered image can be used for reasons other than its gendered character: an expression such as

5. Hans Jonas, "*Evangelium Veritatis* and the Valentinian Speculation," in *Studia Patristica* 6 (TU 81; Berlin: Akademie-Verlag, 1962), 96–111.
6. R. H. Arthur, *The Wisdom Goddess: Feminine Motifs in Eight Nag Hammadi Documents*.
7. Arthur, *The Wisdom Goddess*, 181.
8. Arthur, *The Wisdom Goddess*, 177.

"Necessity is the mother of invention" usually has nothing to do either with a theory about the femaleness of necessity or with the subject of motherhood.[9] But it is also possible to cite examples that involve more extended narrative, not just isolated metaphor, and that at the same time are historically far more pertinent to the analysis of our gnostic materials. Wisdom's mythological female gendering in Jewish wisdom literature is well known, but there are examples from this literature that illustrate how the female-gendered imagery used of Wisdom is not always intended as an image *of the feminine*. In Sirach, for example, Wisdom is once compared to both a mother and a wife (Sir. 15:2; cf. 4:11). Yet the point of the extensive Wisdom imagery in Sirach is not a point about motherhood, or the female role, or even gender at all, but rather about wisdom. The female gendering of Wisdom in this case is essentially incidental, providing metaphorical "color" but no profound "message." It is clear that the real message about Wisdom that is intended has to do with the rewards resulting from obedience to the divine instruction found in the Torah (Sir. 6:18–31; 15:1–8; 24:1–34; 51:13–30; etc.).

I would make a similar argument in the case of another Jewish wisdom text, the Wisdom of Solomon, even though the female gendering of Wisdom in this writing is perhaps more prominent than what is found in Sirach. Wisdom is portrayed as a bride who is greatly to be desired, a consort whose companionship brings with it many blessings (Wis. 6:12–20; 8:2; etc.). Wisdom is also praised as being the "mother" of all the good gifts experienced in the life of the person who is guided by divine instruction (Wis. 7:11f.). Yet we would not be accurately capturing the author's point if we were to describe such passages as reflections upon the female character of Wisdom. Instead, the text is a meditation on the rewards of a life lived in intimate communion with divine instruction. Wisdom as consort is a metaphor for that intimate acquaintance with Instruction, and Wisdom as mother is a metaphor for Wisdom as "source" (of good things). It is not Wisdom qua female that is the author's concern but Wisdom as "initiate in the knowledge of God, and an associate in his works" (Wis. 8:4, RSV), Wisdom as mediator of divine instruction, teacher of the willing student.

I would suggest that it is particularly important to ask about how

9. G. Mussies ("Catalogues of Sins and Virtues Personified (NHC II,5)," in *Studies in Gnosticism and Hellenistic Religions: Festschrift for Gilles Quispel* [ed. R. van den Broek and M. J. Vermaseren], 324f.) has pointed out analogous "faded personifications" in ancient sources.

much actual interest an author has in the gendered character of gen-
dered images when one is looking at images that an author has inherited
from an already existing tradition and that were already gendered in
that tradition. Naturally the mere fact that the gendering is inherited as a
given along with the rest of the symbolism does not in itself mean that
the later author has no interest in the gendering. But it does require us to
exercise more caution in such cases, if we are trying to determine what it
is about the imagery that has prompted the later author to use it.

For example, an interpreter interested in "wisdom" could encounter
her already mythologically gendered in Jewish tradition. When Sophia
comes before us in a gnostic text, the thing that we are usually most
certain about is that the author has something to say about "wisdom."
But it is not always clear that a gnostic author is especially, or at all,
interested in Wisdom qua female, even though the author is making use
of some of the inherited imagery in which Sophia had been gendered as
female. The figure of Eve is another significant instance. It is easy to see
how someone interested in the theme of "knowledge" might have con-
sidered the eating of the fruit of the tree of knowledge a step in the right
direction rather than a mistake. And once this fundamental revaluation
of the event is presupposed, it is only natural that favorable attention
instead of censure might be directed toward that person who, according
to the inherited tradition, took the leading role in the eating of the fruit
of gnosis. That this person is female is a given in the tradition but not
necessarily something that was of interest to all gnostic interpreters, any
more than was Adam's maleness.

Before turning to a discussion of a gnostic text that, I believe, illus-
trates my argument, I should add a general remark about the funda-
mental issue of authorial intention. For one might raise questions both
about (1) whether it is possible to reconstruct the original intentions of
an author in the first place and about (2) how much hermeneutical
importance ought to be granted to such original intentions if they can be
recovered. With respect to the first question, I am clearly siding here
with those who still retain optimism about the possibility of our discern-
ing at least something of what a given author's intentions were.[10] For
example, I think that we actually can have reasonable confidence that,
in the cases of Sirach and Wisdom of Solomon, the authors were not
primarily intending to get across to us the femaleness of Wisdom. But
assuming that we can agree in this or that case on an author's original

10. E.g., E. D. Hirsch, *Validity in Interpretation.*

intentions, one might still object that subsequent interpretation of a text need not be strapped to those original intentions. This may be a valid point, but it is also irrelevant to my present argument, if I am correct to begin with, about the accessibility of an author's intentions. (On the other hand, if I am incorrect, and the author's intentions are inaccessible to us, then I suppose that what would be left for us to talk about would be our own intentions.) Thus, I choose to leave aside this second question as far as this study is concerned. I would only urge that in our discussions of the meaning of gender imagery in gnostic sources, we need to be as clear as possible about whose meaning we think we are describing.

Turning now to a specific illustration of the usage of gendered imagery by a gnostic author who shows no clear interest in the gendered character of the imagery, I would point to the *Hypostasis of the Archons* (NHC II,4). The biblical Eve, for example, is obviously of considerable interest to this author, but I would argue that this is because this biblical figure afforded a series of exegetical targets of opportunity and not because the author wants to comment on femaleness or womanhood. Rather than male and female, the categories that are actually of concern to this author are the spiritual versus the psychical and material. The most obvious message conveyed by the text is that spiritual beings who are armed with Truth are immune to assault from psychical cosmic forces. Where might a gnostic author, approaching the text of Genesis 2—3 with this preoccupation, have found opportunities for developing this theme? For the author of the *Hypostasis of the Archons*, at least three things about the biblical Eve seem to have attracted interest: (1) a series of Semitic puns on the name of Eve; (2) the biblical description of Eve as "helper" (LXX: βοηθός); and (3) the leading role played by Eve in the eating of the fruit of the tree of gnosis.

It is well known that underlying the text of *Hyph. Arch.* 89,11–32 is a series of Aramaic puns on the name Ḥawwah ("Eve").[11] The punning had already begun in the Hebrew text of Gen. 3:20, which plays on the similarity between Ḥawwah and the word for "living" (ḥāy). The *Hypostasis of the Archons* bears witness to an expansion on this wordplay, when Adam refers to Eve not only as the one who has given him life but also as the "Physician" and "the one who has given birth" (cf. Aramaic: ḥayyᵃṯā). And still a further extension of the wordplay seems present in the way in which first Eve and then the serpent (Aramaic: ḥewᵃyā') are

11. See, e.g., B. Layton, "The Hypostasis of the Archons, Part II," *HTR* 69 (1976) 55f.

temporary incarnations of the divine "Instructor" (cf. Aramaic: ḥawᵃwyā',
"instruction").

Genesis 2:18–22 describes Eve's creation as the provision of a suitable
"helper" (LXX: βοηθός) for Adam. The *Hypostasis of the Archons* 88,10—
89,17 has taken advantage of this biblical passage to develop the theme
of the provision of divine "help" (βοήθεια, 88,18) to Adam in the form of
the Spirit sent down from above. The appearance of the "spiritual
(πνευματική) woman" to Adam, after she has emerged from his side
(89,11f.), is thus the epiphany of the divine "helper."

Finally, there is the leading role played by the biblical Eve in the
acquisition of knowledge. But neither in this connection nor in the
others that I have just mentioned do we see evidence that the author is
particularly interested in Eve qua female. That the author sees in the
conversation between the serpent and the woman an event of revelation
rather than temptation and sin indicates an interest in making a positive
statement, not about femaleness but about gnosis. Similarly, the point of
the Aramaic pun on Eve/Instruction is not that Instruction is female but
that the biblical character Eve (who is incidentally female) is one symbol
of humankind's reception of Instruction. That gender is really only
incidental in this author's use of these traditions is confirmed by the way
the gender of the divine "Instructor" shifts: "Then the Spiritual One
(fem.: ϯⲡⲛⲉⲩⲙⲁⲧⲓ[ⲕⲏ]) came [into] the serpent, the Instructor (masc.:
ⲡⲣⲉϥⲧⲁⲙⲟ) . . ." (89,31f.); "And the serpent, the Instructor (masc.:
ⲡⲣⲉϥⲧⲁⲙⲟ), said . . ." (90,6); "And the Instructor (fem.: ⲧⲣⲉϥⲧⲁⲙⲟ) was
taken away from the serpent . . ." (90,11).[12] The associations are defined
by the biblical connection of Eve and the serpent with Instruction
(gnosis) and by the wordplays, not by any pattern of gender relation-
ships. Likewise the point of the Spirit/helper motif is not that the Spirit
is female but that divine spiritual assistance is symbolized in the events
surrounding the appearance of the one called "helper." Although the
feminine form πνευματική ("spiritual") is used twice (89,11 and 31), the
author is not consistent in this, and in 90,17 describes the woman and
the man as naked of πνευματικόν, "the spiritual element."

Another prominent female figure in the *Hypostasis of the Archons* is
Norea, the daughter of Eve (91,34—93,13). Birger Pearson has shown

12. I would have to disagree with Layton's decision to translate ⲧⲣⲉϥⲧⲁⲙⲟ in *Hyp.
Arch.* 90,11 as "Female Instructing Principle," unless one were willing to be completely
consistent by translating ⲡⲣⲉϥⲧⲁⲙⲟ in 89,31f. and 90,6 as "Male Instructing Principle."
But this would only add to what in my view is an unjustified emphasis on the gender
of the figures in this passage.

that this Norea is a gnostic version of earlier Jewish traditions about the woman *Na'amah*, where she is found sometimes as the wife and/or twin sister of Seth, or sometimes as Noah's wife who according to some traditions attempted to prevent the building of the ark, or in still other traditions as a Cainite woman who goes about naked and seduces angels.[13] Norea's positive role in the *Hypostasis of the Archons*, where she is the "virgin whom the powers did not defile" and "a help ($\beta o \acute{\eta} \theta \epsilon \iota \alpha$) for many generations of humankind" (92,1–3), is an inversion of her usually negative role in the Jewish haggadic traditions. In the *Hypostasis of the Archons*, her interference with Noah's ark-building symbolizes the theme that true salvation comes, not through the instrumentality of the Jewish God, but through the reception of the spiritual "help."[14] In other words, Norea functions in this text as a symbol of the revaluation of Judaism, not of femaleness.

The two other important female figures in the *Hypostasis of the Archons* are Wisdom and her daughter Life. Both are gendered as female in this text, but once again there is reason to question how much the author is interested in their femaleness as such. For in this text the female gendering of these two figures hardly reaches beyond what was already traditional metaphor in Jewish wisdom literature. Wisdom's femaleness in that literature is well known (e.g., Prov. 7:4), but Life also occasionally appears as the virtual equivalent (i.e., fruit) of Wisdom (e.g., Prov. 3:18; 4:13; Sir. 4:11f.), and thus an implicit female gendering of Life may be said to have been already present in the Jewish wisdom tradition.

In the *Hypostasis of the Archons*, Wisdom seats Life at the right hand of Sabaoth, "to instruct him about the things which exist in the Eighth" (95,31–34). This picture of Wisdom's offspring seated by the throne of Sabaoth is reminiscent of what Jewish wisdom traditions had already said about Wisdom herself (Wis. 9:4: "Give me the wisdom that sits by thy throne"). But there is also here another pun on the similarity between Semitic words for Life and Instruction. It is not really Life qua female that is the author's concern, so much as it is Life as the offspring of heavenly Wisdom, and as Instructor. Frank Fallon has argued persuasively that the story of the enthronement of Sabaoth in the *Hypostasis of the Archons* is intended to give limited legitimation to the revelation of

13. B. A. Pearson, "The Figure of Norea in Gnostic Literature," in *Proceedings of the International Colloquium on Gnosticism, Stockholm, August 20–25, 1973* (ed. Geo. Widengren), 143–52.
14. See Layton, "Hypostasis of the Archons, Part II," 62 n. 99.

the Jewish God: Sabaoth knows some truth, but only indirectly, by way of instruction from Wisdom's child Life.[15] The point being made with the female-gendered image of Life is not a point about femaleness but about Judaism.

I would argue that the femaleness of Wisdom, also, seems to hold no special interest for the author of the *Hypostasis of the Archons*, especially when compared with the way in which Wisdom's femaleness was precisely a point stressed by other gnostic authors. In the *Hypostasis of the Archons*, we have no reference to a "lower Wisdom" who is a "female from a female," nor a description of Wisdom's product as a "weak and female fruit" because it had been produced without her male consort.[16] And in fact, in this text, the eventual product of Wisdom's act is not female but androgynous (94,18).

To summarize: Although the images from the *Hypostasis of the Archons* discussed above are indeed female-gendered images, they are not being used by this gnostic author as images *of the feminine*. (1) What gendering there is in the images is essentially inherited with the tradition rather than having been the original contribution of the author; (2) the text lacks any additional, explicit statement of interest in the gendered aspect of the images; and (3) all of the gendered images have obvious associations with other, nongender categories that we know certainly to have been of primary concern to the author.

3. GENDERED IMAGERY AND PERSPECTIVES ON SOCIAL GENDER

Even where we not only have the use of gendered imagery but also have evidence of far more interest precisely in the gendered character of the imagery, we find more than one possible relationship between the gender roles upon which the point of the imagery depends and the author's own perspective on social gender. For example, there are some instances in which the roles that are depicted in the imagery seem to reflect directly the author's attitude toward social gender roles. But there are also cases where the author's position on social gender roles constitutes an implicit *rejection* of the gender roles in the imagery.

The use of gendered imagery in Justin's *Baruch* (Hippolytus *Ref.* 5.26.1—27.5) illustrates the former possibility. Justin's imagery is tightly

15. F. T. Fallon, *The Enthronement of Sabaoth: Jewish Elements in Gnostic Creation Myths*, 68.
16. E.g., Irenaeus *Adv. haer.* 1.2.4; 1.21.5; *1 Ap. James* 35,5–17.

structured in gender categories, although at two different levels.[17] The first level is governed by the symbol of the marriage of male to female, with the marriage of Elohim to Edem as the primordial instance of this. The union of male and female, Elohim and Edem, generates the created cosmos, including humanity. Adam and Eve embody the *hieros gamos* of Elohim and Edem in two respects: by their union with each other in marriage and through the union of spirit (from Elohim) and soul (from Edem) within each. Justin evidently did not see marriage as something to be abandoned but, on the contrary, as an institution mirroring the positive intent of creation itself. Justin even went so far as to link the social custom of the dowry to Edem's primordial delivering of her power to Elohim, so that the marriage dowry remains a "divine and paternal law" (5.26.10).

However, the second level is structured around the separation of male from female, with Elohim's abandonment of his wife Edem as the mythic paradigm. For Justin, although the union of male and female was the proper symbol for the structure of life *within* the cosmos, the transcendence of the cosmos required the separation from the female. Just as Elohim abandoned Edem when he realized the existence of the transcendent realm of the Good One, so the spirit within each individual (whether man or woman) must abandon the soul and body. Such an ascension was evidently ritually anticipated in some type of baptismal experience (5.27.1–2). But presumably, initiated men and women were neither expected, nor encouraged, nor perhaps even allowed to adopt an ascetic life style which entailed the social separation of male from female. While within the cosmos legitimate existence was defined in terms of faithfulness to the marriage contract, the ideal marital roles in terms of which the actions of Elohim and Edem and Adam and Eve are evaluated are a direct reflection of Justin's own notion of the proper socialization of men and women.

The *Excerpts of Theodotus* offers another example of an author's perspective on social gender found directly reflected in gender roles depicted by the imagery. As I have indicated above, Justin saw in the creation of Eve primarily a symbol suggesting union, her union with

17. See M. A. Williams, "Uses of Gender Imagery in Ancient Gnostic Texts," in *Gender and Religion* (ed. Bynum, Harrell, and Richman), 196–227; and J. J. Buckley, "Transcendence and Sexuality in the *Book of Baruch*," *HR* 24 (1984/85) 328–44. Unfortunately, Buckley's article became available to me only at the stage of final revisions in both the present essay and in my just mentioned article in the Bynum, Harrell, and Richman volume. In spite of some differences in our results, we would seem to be in essential agreement on several points relating to my argument here.

Adam mirroring the union of Edem with Elohim. Completely lacking in *Baruch* is the theme of an original androgyny, which has been ruptured by the appearance of Eve and is destined to be restored. However, the Valentinian gnostic Theodotus, as best we can ascertain his views from the *Excerpts*,[18] found in the creation of Eve primarily a symbol of the fateful separation of female from male, by which Theodotus understood the separation of the human souls here below (the "female") from their angelic doubles (the "male"). This separation was to be overcome by the reunion of the souls with their angels, so that both could once again enter into the pleroma (21.1; 35.1–4).

The image of separation from husband as a symbol of deprivation and need for salvation is used by Theodotus alongside another gender-structured image—namely, the defective condition of children having no legitimate father:

> For while we were children only of the female, as though a product of illicit intercourse, incomplete and infants and senseless and weak and unformed, brought forth like abortions, we were children of the woman. But having received from the Savior, we became children of a man and a bridal chamber. (68)

It is the weakness of the soul, so long as it is an offspring only of the female, which renders it vulnerable to the cosmic powers of Fate (78–79). Invulnerability to Fate comes only through a second birth in which one is begotten by the legitimate male parent (Christ), and then the previously female seed "is changed into a man" and becomes a "male fruit" (79; cf. 21.3).

Of course, Theodotus has applied the image of "female seed" to humans of both sexes. In this sense, there is something female about every person, man or woman. Yet there is nothing to suggest that this application of gender-role imagery to the "vertical" axis of human experience was intended by this gnostic teacher as a renunciation of these gender roles on the "horizontal" or social axis. Marriage, and specifically the production of children in marriage, is defended by Theodotus as "necessary for the salvation of those who believe" (67.2). In contrast to some other gnostic sources, Theodotus has not merely lifted the images of marriage and reproduction, and of distinct male and female roles therein, while renouncing the social institutions from which

18. For a discussion of the problem, see R. P. Casey, ed. and trans., *The Excerpta ex Theodoto of Clement of Alexandria*, 5–16; and F. Sagnard, *Clément d'Alexandrie: Extraits de Théodoto*, 33–49.

the images were borrowed. Thus it would seem that subordination, weakness, dependency, imperfection, and so forth, still belong among the connotations that Theodotus attaches to the social position of women.

But other texts confront us with a quite different relationship between gendered imagery which is employed and the author's perspective on gender roles. The *Exegesis on the Soul* (NHC II,6) employs imagery that depicts social gender roles which are renounced by the author. The fall of the soul into the body is portrayed as a young virgin's foolish desertion of her father's house. The unfortunate maiden becomes sexual prey to the cosmos, and her pitiful plight is described as that of an exploited prostitute receiving the reward that her error deserves. The rescue of the soul is effected by the descent of the soul's heavenly brother/bridegroom and her marriage to him.

The soul is thus identified as female, although in the soul's unredeemed state this femaleness is unnatural, perverted. The perversion is portrayed by means of the social metaphor of the promiscuous prostitute but also by means of an anatomical metaphor: the soul has a womb, but prior to redemption this womb is turned inside out, so that it resembles male genitalia because of its externality. The repentance of the soul is a turning inward once again, a return to "natural" femaleness. In the case of the social metaphor, the soul's repentance is the return to the "natural" role of dependence upon the proper males in her life, her father and her husband.

Thus the *Exegesis on the Soul* has made use of a sharply defined set of gendered images, and it is precisely the gender relationships depicted in the images which convey the text's message. The femaleness of the soul here suggests absolute dependence upon the male Divine, an attitude of proper submission and obedience, the soul's potential for unfaithfulness, and its vulnerability to temptation and entrapment by male cosmic forces. Nevertheless the author can hardly be condoning these imaged roles as the social ideal. They have been borrowed as images, but in fact the theological point of the text undermines the social institution of marriage in favor of encratism (e.g., 132,28–33; 137,5–11). Therefore, at least that portion of the metaphor which has marriage as the vehicle of female dependence and male dominance is in this text only that, metaphor.

Another tractate on the origin, condition, and destiny of the soul, *Authoritative Teaching* (NHC VI,3), also illustrates this lack of correspondence between gender roles in the imagery and the author's per-

spective on social gender. The Divine is once again male in this text, but here the cosmos is female, as opposed to the male gender of the cosmic realm found in the *Exegesis on the Soul*. There is some ambivalence in *Authoritative Teaching* as to the gender of the soul itself, since it is sometimes described as a bride rescued by her heavenly bridegroom, but is elsewhere said to have become, in its bodily condition, a "brother" (Coptic: con) to passions such as lust, jealousy, and hatred (23,12–17). Here again is the motif of the child with no legitimate father, although in the mind of this gnostic author this image conjures up most of all the *legal* issue of inheritance rights rather than the connotations of weakness and formlessness that we saw in the *Excerpts of Theodotus*. By its descent into the body, the soul has become brother to the "sons of the woman" (= Matter). Passions and other characteristics of material existence are like bastards who "have no power to inherit from the male, but will inherit from their mother only" (23,22–27). The soul shares this same disadvantaged state while it is a "brother" to the material passions. On the other hand, "the gentle son (i.e., the soul which has received gnosis) inherits from his father with pleasure" (24,26–28).

A theological point has been made in this text by means of metaphors of socioeconomic disadvantage associated with the status of females. But again, although the image draws its power from what was a reality in the larger social world of the author and readers, we should be cautious about assuming that the gender roles in the imagery reflect the author's own perspective. For it is not really the avoidance of socioeconomic disadvantage—female or otherwise—that is the author's real concern, since this text in fact idealizes poverty and world renunciation (e.g., 27,12–26; 30,26—32,16).

The *Apocryphon of John* (NHC II,1; III,1; IV,1; BG 8502,2) provides a third case. This writing is among those gnostic works in which the events of the unfolding of the divine realm are organized into three basic stages: (1) the description of the first-existing Father; (2) the Father's self-contemplation, which is then mythologically portrayed as a stepping forth of the Father's image, his Thought, who now stands over against the Father as his female consort and whose appearance inaugurates the production of further divine entities; and (3) the completion of the divine realm with the production of a male offspring from the primordial couple. The primordial consort, or Barbelo, as she is called in the *Apocryphon of John* and in several other texts, can be seen to function within this structure as a mediator of masculinity. Her proper task is

completed, we might say, with the successful completion of one genera-
tion by the production of a son for her consort. In other words, it is hard
not to see in the mythic activity of Barbelo a reflection of the social
gender role of ideal wife and mother.[19] With Barbelo, female produc-
tivity is carefully circumscribed by male boundaries. On the other hand,
the action of Sophia in the *Apocryphon of John* is portrayed as an instance
of deviant female socialization, since her activity is initiated both with-
out paternal consent and without the cooperation and consent of her
spouse (NHC II 9,29–33 par.).

Yet this gender role of the female as husband-oriented wife and
producer of a son cannot as such have been a part of the author's own
perspective on social gender, since the *Apocryphon of John* advocates the
renunciation of sexual intercourse (e.g., NHC II 24,25–27 par.).

I have pointed out at least two distinct types of relationship between
gender roles depicted in imagery and a gnostic author's actual per-
spective on social gender roles, and perhaps there are still other types.
But by now the fundamental point should be clear: we cannot always
simply read the author's own perspective off the surface of the text's
imagery. Some gnostic authors did indeed employ images that express
directly their own understanding of the proper social roles for men and
women. But it is also true that social gender roles can sometimes be used
as images for purposes other than the affirmation or advocacy of their
imaged roles themselves, and the employment of the images does not
always even reflect an acceptance of the roles.[20]

4. QUALITATIVELY DIFFERENT PERSPECTIVES

Finally, I focus on the diversity to be found among the perspectives
themselves. For present purposes, we can limit the comparison to three
gnostic sources, all of which I would place in the category of texts in
which the use of gendered imagery directly reflects aspects of the
author's perspective on social gender: the *Gospel of Philip* (NHC II,3), the
Gospel of Thomas (NHC II,2), and Justin's *Baruch*.

In discussing the perspective of the author of the *Gospel of Philip*, I

19. Cf. Clement of Alexandria, *Stromateis* 2.139.5; Stobaeus, *Florilegium* 67, 21.25.
20. The article by L. D. Shinn, "The Goddess: Theological Sign or Religious Symbol,"
Numen 31 (1984) 175–98, presents an argument that is roughly congruent to my point in
this section, by illustrating how differently the gender imagery associated with the
goddess Kālī can function for various worshipers and interpreters.

begin by referring to one particularly suggestive passage from this text. As G. Quispel has pointed out,[21] the *Gospel of Philip* 65,1–26 describes the vulnerability of humans to attack from *incubi* and *succubae*, unclean spirits who roam the cosmos and are attracted sexually to humans. Unlike some gnostic texts, which describe an androgynous gendering of the malevolent cosmic powers, the *Gospel of Philip* 65,1–26 speaks of male unclean spirits and female unclean spirits. The male spirits attack and cohabit with human souls who dwell in female forms, and the female spirits assault souls who dwell in male bodies.

Immunity to assault from these spirits is achieved by means of the "mystery of marriage."[22] The marriage has two axes: a person is paired with a Gnostic of the opposite sex, but at the same time with either "a male or female power" (65,9f.). That is, the Gnostic's angelic double, who in so many Valentinian sources is male, is in this text always of the gender opposite to that of the Gnostic himself or herself. The ritual marriage is called the "undefiled marriage" (e.g., 82,4–8), and I under-stand this to refer to a "spiritual" or "virgin" marriage, in which physical intercourse was forbidden to the gnostic couple.[23] In this ritual pairing of gnostic men and women, the dangerously unbalanced "gender charge" of each partner was neutralized by the opposite charge possessed by the spouse.

The author's interest in social gender identity seems to be almost exclusively confined to the partnership role in spiritual marriages. Out-side the marital pairing, a woman is incomplete in exactly the same way that a man is. Thus the author apparently is operating with no assump-tion of social gender asymmetry. But it is interesting that the gender symmetry presupposed by the author serves to sharpen rather than blunt the significance of sexual differentiation. Physical sexual identity is not reduced to irrelevance but instead is one part of a more inclusive

21. G. Quispel, "Genius and Spirit," in *Essays on Nag Hammadi Texts in Honour of Pahor Labib* (ed. Martin Krause; NHS 6; Leiden: E. J. Brill, 1975) 164f.

22. See, e.g., E. Segelberg, "The Coptic-Gnostic Gospel According to Philip and Its Sacramental System," *Numen* 7 (1960) 189–200; R. M. Grant, "The Mystery of Marriage in the Gospel of Philip," *VC* 15 (1961) 129–40; and J. J. Buckley, "A Cult-Mystery in the *Gospel of Philip,*" *JBL* 99 (1980) 569–81.

23. *Contra*, e.g., Grant, "The Mystery of Marriage in the *Gospel of Philip,*" 135; and Buckley, "A Cult-Mystery in the *Gospel of Philip,*" 572; cf. E. Pagels, "Adam and Eve, Christ and the Church: A Survey of Second Century Controversies Concerning Marriage," in *The New Testament and Gnosis: Essays in Honour of Robert McL. Wilson* (ed. A. H. B. Logan and A. J. M. Wedderburn), 166–70; G. S. Gasparro, "Aspetti encratiti nel 'Vangelo secondo Phillipo,'" in *Gnosticisme et monde hellénistique: Actes du Colloque de Louvain-la-Neuve, 11–14 mars 1980* (ed. J. Ries, Y. Janssens, and J.-M. Sevrin), 394–423; and Williams, "Uses of Gender Imagery."

gender identity which extends into the transcendent realm. Such a text illustrates why we must avoid a generalization such as: "All gnostics understand themselves as 'female.'"[24] For this author, one is either male or female, and one's gender identity determines the gender of the partner one needs both within the cosmos and beyond it.

We can contrast this with what is found in the *Gospel of Thomas*, and in particular in logion 114, the final words of this text:

> Simon Peter said to them, "Let Mary leave us, since women are not worthy of the life." Jesus said, "Behold, I myself will lead her in order to make her male, so that she also might become a living spirit like you males. For every woman who makes herself male will enter the Kingdom of Heaven."

It seems to me that much of the interpretation of this passage has too hastily treated this exchange as sheerly allegorical in intent, as if it were an allusion to the transformation of the "femaleness" (i.e., cosmic identity) of any human, man or woman, into "maleness" (divine or spiritual identity). Such an allegorization of the passage has been supported by noting its general similarity to certain other texts, where indeed the slogan "Female becomes male" is intended in a more abstract sense, applicable to both men and women.[25] To be sure, the *Gospel of Thomas* logion 114 is at least a rejection of the type of chauvinistic attitude that this passage ascribes to Peter, and to that extent it is a defense of a notion of "equal access" to salvation. However, the affirmation that it is possible for women also to become "living spirits" is not necessarily the same as the renunciation of all distinctions in gender roles. Jorunn Buckley has gone so far as to suggest that the passage alludes to an extra initiation ritual that was required of female disciples, to bring them to the intermediary stage of "maleness" that men already occupy by reason of their sex. Then, both men and women-become-males must make the final transition to the status of "living spirits."[26]

Whether or not Buckley is correct in her reconstruction of the rituals involved, I do think she is correct not to allegorize away the social gender distinctions that are expressed in the passage. Methodologically, we cannot achieve a satisfactory interpretation of a passage such as logion 114 by remaining at the level of general similarities. Logion 114

24. E. Schüssler Fiorenza, *In Memory of Her: A Feminist Theological Reconstruction of Christian Origins*, 275.

25. E.g., Heracleon, Frg. 5 (Origen *In Joh.* 6.20f.); Clement of Alexandria *Ex. Theod.* 79. For the most recent example of this approach, see M. W. Meyer, "Making Mary Male: The Categories of 'Male' and 'Female' in the Gospel of Thomas," *NTS* 31 (1985) 554–70.

26. J. J. Buckley, "An Interpretation of Logion 114 in the *Gospel of Thomas*," *NovT* 27 (1985) 245–72.

simply does not say, as it might have (and as other gnostic sources do), that there is something "female" about *every* human which must be transformed into "male." We have to be more alert to the variety in perspective that was possible, and we must therefore be open to the possibility that when a passage speaks of men as males but women as females-who-can-become-males, it may mean just that. The perspective on gender here is not the same as that in the *Gospel of Philip*. We do not have symmetrically opposite "gender charges" which stand in need of ritual union and neutralization. The *Gospel of Thomas* in fact does not understand the ideal socialization of men and women in terms of ritual marriage to one another but rather in terms of the role (for both sexes, presumably) of the itinerant celibate, the *monachos* (logia 16, 49, and 75).[27] And logion 114 suggests that proper socialization involved asymmetrical requirements for men and women.[28]

As a final example, I turn once again to Justin's *Baruch*. For Justin too, sexual identity is not consigned to the category of the irrelevant. Even though one dimension of Justin's symbolism treats the spirit as male (contribution of Elohim) and the soul as female (contribution of Edem), and stresses that this is true for both men and women (Hippolytus *Ref.* 5.26.25), nevertheless the other dimension of the Elohim/Edem symbolism just as emphatically maintains the significance of the maleness of husbands and the femaleness of wives.

Yet the distinction between male and female in *Baruch* involves a perception of social gender that is entirely different from what is found in either the *Gospel of Philip* or the *Gospel of Thomas*. There is nothing corresponding to the asymmetrical requirement of the *Gospel of Thomas* logion 114 for women to "become male." Nor does being a man or a woman mean for Justin that one is an incomplete half, an unbalanced "charge," as in the *Gospel of Philip*. In the social institution of marriage which Justin condones, male and female stand to each other, not as opposite charges that balance each other but as partners in a legal, contractual relationship. Justin has no notion of a primordial androgyny or a need for return to androgyny. He does make use of the motif of the

27. See F.-E. Morard, "Monachos, moine: Histoire du terme grec jusqu'au 4e siècle; Influences bibliques et gnostiques," *Freiburger Zeitschrift für Philosophie und Theologie* 20 (1973) 329–425; and idem, "Encore quelques réflexions sur monachos," *VC* 34 (1980) 395–401.

28. P. Perkins ("Pronouncement Stories in the Gospel of Thomas," *Semeia* 20 [1981] 130) suggests that this saying may represent a community rule that "justifies the inclusion of women in the community—against orthodox slander that these so-called ascetics were really sexual libertines." Even so, the saying would still be calling attention to females as the sex for which special comment is required.

separation of male from female, but Justin thinks about this primarily in *contractual* terms. The ascension from this world, the separation of the male from the female, is a breach of contract. The paradigm for this ascension, the act of Elohim's abandonment of Edem, was "contrary to the contracts (κατά τὰς συνθήκας) which he had made" (*Ref.* 5.26.21). So long as one is alive in this world, the faithfulness to the laws of the marriage contract between man and woman is the appropriate symbolic participation in the creativity of divine union. The breach of contract between male and female is a symbol appropriate only to ascension and participation in divine transcendence.

5. SUMMARY

I have offered only a sampling of the diversity that must be taken into account in an analysis of images of the feminine in Gnosticism. But the examples provided are sufficient to demonstrate the complete inadequacy of applying only one or two unilinear gauges, such as the amount of female imagery or whether the female imagery tends to be "positive" or "negative."[29]

The amount of female imagery in a text is indeed one significant element that does need to be measured, but only in relation to an author's tendency to use gendered images at large, whether male or female. An adequate analysis of "Gnosticism and gender" must take into account instances of the relative absence, and not only instances of the abundance, of gender imagery. But we must also distinguish between the question of how much gendered imagery appears in a text and the

29. To cite only one recent example of the consequences of a failure to attend to the sorts of variety among perspectives on gender that I have been discussing in this study, I mention the article by I. S. Gilhus, "Gnosticism—A Study in Liminal Symbolism," *Numen* 31 (1984) 106–28. Gilhus's otherwise laudable attempt to test categories developed by Victor Turner against evidence from gnostic sources is severely marred, in my view, by a tendency toward sweeping generalizations about "gnostic religion," including generalizations about gender symbolism: "A special problem is the role played by women among the gnostic sects. On the one hand, they were permitted a rather free position in relation to the position offered to women in the Christian religion." This is in fact something that we do not know with certainty for all, or even most, gnostic groups. "On the other hand, there was a strong rejection of femininity in the Nag Hammadi-texts. The female nature and especially female sexuality had a negative symbolic value, and were strongly condemned. This apparent contradiction can easily be solved. In a liminal community—at least ideally—the sex-distinctions are wiped out and transcended. Women are admitted on the condition that their sexual natures are repressed and in this way neutralized" (p. 120). This theoretical analysis may turn out to be helpful in the case of certain gnostic groups, but it cannot be claimed as a valid interpretation of gender symbolism in Gnosticism at large.

question of how much the author is really interested in the gender of the images. An even further distinction must be made between an author's interest in the gendered character of the images and the relation of the gender roles depicted to patterns of socialization that are preferred or advocated. More "positive" or "negative" gender roles appearing in the imagery of a text may or may not directly reflect an author's notion of the proper patterns of socialization for men and women. And finally, we must recognize the qualitative, and not only the quantitative, diversity among gnostic perspectives on gender. Movement from text to text reveals not merely greater or lesser degrees of androcentrism but qualitatively different "textures" in the experience of gender itself.

DEIRDRE J. GOOD

Gender and Generation: Observations on Coptic Terminology, with Particular Attention to Valentinian Texts

The assertion that sexuality is a predicate of divinity is to be observed in the phenomenon of late antiquity called Gnosticism.[1] This is true not only of the patristic accounts of gnostic groups but also of the Coptic texts from the Nag Hammadi library, some of which may be regarded as gnostic.[2] Few scholars, however, have attempted to account for this feature of gnostic texts: those who have studied the Valentinian sacrament of the bridal chamber in the *Gospel of Philip* have understood it to be written in metaphorical rather than literal language.[3] Other scholars have indicated that the discrepancy between patristic accounts of licentious gnostic behavior and the ascetic tone of many of the Nag Hammadi documents might be due to patristic misunderstanding of gnostic mythologies which included accounts of sexual relations between divine entities.[4]

1. Throughout this article, I understand sexuality to be a physical category and gender a grammatical one. Of course, the issue is not as simple as this statement implies. Moreover, current use of the term "gender" tends to equate it with "sex." Nevertheless, for the purposes of this article, I shall adhere to the above definition. For a discussion of some of the issues, see J. P. Stanley, "Gender Marking in American English: Usage and Reference," in *Sexism and Language* (ed. A. P. Nilsen et al.), 43–76.

2. E. Pagels, "What Became of God the Mother? Conflicting Images of God in Early Christianity," in *Signs* 2 (1976), republished in *The Gnostic Gospels*, 48–69; J. P. Mahé, "Le sens des symboles sexuelles dans quelques textes hermétiques et gnostiques," in *Les textes de Nag Hammadi* (ed. J. Ménard), 123–45; and I. S. Gilhus, "Male and Female Symbolism in the Gnostic Apocryphon of John," *Temenos* 19 (1983) 33–43.

3. J. J. Buckley ("A Cult-Mystery in the *Gospel of Philip*," 569–81) provides a good critique of this approach.

4. See most recently G. A. G. Stroumsa, *Another Seed: Studies in Gnostic Mythology*, 173.

Before we examine gnostic ideas about divine sexuality, some obser-
vations about the categories of male and female must be made, since it is
often in the context of gender that sexuality is described. Rather than
account for this phenomenon, the present study will be content to
explore certain gnostic texts wherein divine generative ability is de-
scribed. The language of the *Tripartite Tractate* (NHC I,5) describes
God's creative activity as that of a male engendering and a female giving
birth. Where such language occurs, it is difficult to determine whether
feminine traits have been assimilated by the masculine Father (in which
case the female is lost) or whether the idea of the "Father" has been
altered to include maternal characteristics (in which case, how some
early Christians understood the term "Father" was rather different from
our understanding of the term today). In the present study, the latter
position is favored and its implications explored.

As far as research on gender is concerned, scholars are coming to the
sound observation that many gnostic texts, like the majority of texts in
the Nag Hammadi library, use the terms "male" and "female" to denote
cosmic principles rather than to describe men and women.[5] This is an
important observation. At the present stage of research, there is much
more to be learned about "the female" or "the male" in the Nag Ham-
madi library than there is to be learned about women or men.

1. THE COPTIC LANGUAGE AND
THE FEMININE GENDER

All the extant texts of the Nag Hammadi library are in Coptic. In most
cases, the Coptic texts are translated from Greek originals which we no
longer possess but have to reconstruct. Some Coptic translators preserve
the original Greek words in Coptic, while others translate the original
Greek into what they deem to be a Coptic equivalent. Therefore the first
stage of investigation must be conducted at the level of translation from
Greek into Coptic. I want to give a specific example of the limitations of
the Coptic language that directly affect the reader's understanding of
gender terminology.

My interest is in the Coptic word ⲉⲓⲱⲧ ("father"), a word that trans-
lates the Greek word πατήρ ("father"). Frequently this word is used in

5. E. Schüssler Fiorenza, "Word, Spirit and Power: Women in Early Christian
Communities," in *Women of Spirit: Female Leadership in the Jewish and Christian
Traditions* (ed. R. R. Ruether and E. McLaughlin), 44–51, 50.

the Nag Hammadi library to denote male divinity. There is, for example, an extensive discussion of the nature of the Father in the *Tripartite Tractate*, which I want to examine in a moment. Problems ensue, however, when, as is often the case, androgynous divinity is designated by the Coptic word ⲉⲓⲱⲧ ("father"). In the following example, it will be obvious that Coptic, like English, not only makes the gender of an active subject clear but also favors the masculine gender over the feminine.

> This Ruler, by being andro[gynous], made himself a vast realm . . . and he contemplated creating offspring for himself, and created for himself seven offspring, androgynous, just like their parent (ⲉⲓⲱⲧ).[6]

A Greek verb in the third person singular is personless, whereas a Coptic verb specifies a male or female agent. If the subject is an androgynous creator, then the reader needs to understand that the Coptic translator generally assumes the masculine gender of the agent. This too can be reflected in the English, but it would not have been evident in the original Greek. The English translator of the above passage, Bentley Layton, seems to be aware of the problem, since he translates ⲉⲓⲱⲧ in the last line as "parent." The word in Coptic is "father." His translation is quite accurate, since, in the first line, the ruler is called "male-female." Fortunately, Layton is not alone in regard to accurate translation of the Coptic; Marvin Meyer's recent book, *The Secret Teachings of Jesus*, contains similar examples. He translates the term ⲉⲓⲱⲧ by "parent" at *Ap. John* 8,12; 10,2, 11, 12; 15,2–3 and explains in a footnote, "In Coptic, the pronouns used here are masculine, probably because 'parent' and 'first humanity' are masculine terms."[7] Not all translators have been as sensitive to the peculiarities of the Coptic term "father."

Coptic consistently favors the masculine gender when translating the Greek word for "parents," γονεῖς. At Mark 13:12b, the (Sahidic) Coptic masculine plural ⲉⲓⲟⲧⲉ ("fathers") translates the Greek word for "parents."[8] Thus, in Coptic, "parents" can appear as "fathers." In such cases, the mother has disappeared. One Coptic manuscript in the Pierpont Morgan Library [M595, fol. 129r (col. 1, l.3)] speaks of "their male fathers" and "their female fathers," perhaps indicating the desire of a Coptic author to overcome Coptic linguistic deficiencies and speak of

6. B. Layton, "The Hypostasis of the Archons or the Reality of the Rulers," *HTR* 67 (1974) 351–425; 94,25—95,4.
7. M. Meyer, trans., *The Secret Teachings of Jesus: Four Gnostic Gospels*, 115. S. Laeuchli (*The Language of Faith*, 32–40) discusses gnostic use of the term "father" in a section of his book on gnostic language.
8. H. Quecke, *Das Markus-evangelium Saïdisch*, 153.

male and female parents. Since there is no word for "parents" in Coptic, this author speaks of male and female "fathers."

In the same way, the *Apocryphon of James* (NHC I,2) at 4,26 speaks of the disciples forsaking "our male fathers and our mothers" (ⲛⲛⲉⲛⲉⲓⲁⲧ ⲛⲍⲁⲱⲩⲧ ⲙⲛ ⲛⲉⲛⲙⲉⲉⲩ).[9] Again, this may indicate an awareness on the part of a Coptic translator that the one Coptic word for "father" is used in the plural to translate the Greek plural "parents." This translator writes accordingly "our male fathers." There is no such difficulty with the word "mothers." Why the Coptic translator of Pierpont Morgan M595 speaks of "their female fathers" rather than "their mothers" is unclear, since there is a Coptic word for "mother." The ambiguity of the Coptic term for "father," however, still stands. Perhaps use of the phrase "male fathers" in the Pierpont Morgan manuscript shows that some Coptic translators were aware of the problem.

Mention has been made of the Coptic translation of Mark 13:12 in which the Greek word for "parents" is rendered as "fathers" in Coptic. Similar results come from a comprehensive survey of the thirteen instances in the Coptic New Testament (Sahidic and Bohairic versions) of the word "parents" (Matt. 10:21; Mark 13:12; Luke 2:27; 8:56; 18:29; 21:16; John 9:2; 9:22; Rom. 1:30; 2 Cor. 12:14; Eph. 6:1; 1 Tim. 5:4; 2 Tim. 3:2; Heb. 11:23). In almost every case, the Coptic masculine plural "fathers" rather than the Greek term "parents" is used.[10] As one would expect, the English translations are not always consistent: sometimes "fathers" and sometimes "parents" is given. In one case from the Bohairic version of 1 Tim. 5:4, the English translation reads: "they should honor their forefathers."[11] In another case, the Bohairic version of Matt. 10:21 reads: "sons, rising upon their fathers."[12] The significance of this survey

9. R. Cameron translates "our forefathers and our mothers" in *The Other Gospels*, 58. This translation is corrected in his edition of the *Apocryphon of James* in *Sayings Traditions in the Apocryphon of James* (Philadelphia: Fortress Press, 1984), 72 to "our fathers and mothers." A good translation of this text exists in Meyer, *The Secret Teachings of Jesus*, 5.

10. G. Horsley, *The Coptic Version of the New Testament* (Bohairic, 1898–1905; Sahidic, 1911–1924). For a survey of the Coptic versions of the New Testament, see B. Metzger, *The Early Versions of the New Testament*, 99–141.

11. Horsley (Bohairic, 1905), 574.

12. Horsley (Bohairic, 1898), 74. Cf. Mark 13:12, which translates into Coptic "sons will rise upon fathers and will kill them" (434) on the basis of the Greek "children rising up against their parents." This translation has been discussed earlier. In Mandeism the same ambiguity exists, since the one word *abahata* (pl. of *ab*, "father") can be translated "parents," "ancestors," or "fathers." See E. S. Drower and R. Macuch, *A Mandaic Dictionary*, col. 1a. For examples, see E. S. Drower, *The Canonical Prayerbook of the Mandaeans*, Hymns 65 (p. 52); 71 (p. 59); and 72 (p. 61). I am grateful to J. J. Buckley for these references.

should be obvious, since in most instances we know the Coptic to be translating the Greek word "parents." Thus, all translations using "fathers" or "forefathers" for parents are erroneous. However, the fact is that these erroneous translations appear in the printed English text.

The tendency of the Coptic language to subordinate the feminine to the masculine gender has been demonstrated by the discovery of the Russian Coptologist, A. I. Elanskaja. She has observed that feminine nouns without an article can be resumed by masculine pronouns. If the masculine is assumed to predominate, these cases demonstrate such predominance but do not account for it. Reasons other than the purely linguistic are at work in such cases.[13]

2. THE FATHER IN THE *TRIPARTITE TRACTATE*

The *Tripartite Tractate* describes the process of emanation whereby a single divine being creates other divine beings.[14] Thus the mode of generation merits attention. The unique aspects of this description in the *Tripartite Tractate* can be seen to best advantage by a comparison with the *Enneads* of the philosopher Plotinus.[15] Although probably not a contemporary of the author of the *Tripartite Tractate*, Plotinus (204–270 C.E.) at least moved in a similar intellectual milieu. In contrast to Plotinus, who is also concerned with describing the generative capacity of a single divine entity, the author of the *Tripartite Tractate* uses sexual language to describe the process of emanation. To examine this feature, I would like to begin by outlining the theory of emanation in the *Enneads* of Plotinus.

According to A. H. Armstrong, emanation is the manner in which Plotinus describes the production of the two lower hypostases, Nous and Psyche, from the One. The action itself is a spontaneous and

13. A. I. Elanskaja, "'Kvalitativ vtoroj' v koptskom jazyke," in Akademija nauk SSSR, Institut vostokovedenija, Leningradskoe otdelenie: *Pis'mennya pamjatniki i problemy istorii kul'tury narodov Vostoka* II, Moskva, "Nauka" 1975, 44–47. Translated (but not published) into German by P. Nagel. I am grateful to Professor Nagel for a copy of his translation.

14. *Tractatus Tripartitus I and II* (ed. H. C. Puech et al.); E. Thomassen, *The Tripartite Tractate from Nag Hammadi* (2 vols.; forthcoming); and *Nag Hammadi Codex I* (2 vols.; ed. H. Attridge).

15. *Plotini Opera* (2 vols.; ed. P. Henry and H.-R. Schwyzer). Cf. A. H. Armstrong, "Emanation in Plotinus," *Mind* 46 (1937) 61–66; idem, *The Architecture of the Intelligible Universe in the Philosophy of Plotinus*; H. Dörrie, "Was ist spätantiker Platonismus?" *Theologische Rundschau* 36 (1971) 285–302, also in H. Dörrie, *Platonica Minora*, 508–23; and idem, "Emanation: Ein unphilosophisches Wort im spätantiken Denken," in *Platonica Minora*, 70–88.

necessary efflux of life or power from the One but leaves the source itself undiminished. To describe this process, Plotinus uses either of two metaphors: radiation of light from a luminous source or development and growth from a seed.

In *Ennead* 5.3.12, Plotinus discusses the composition of the Intellectual Principle as "a unity with a variety of activities." He continues:

> The only reasonable explanation of act flowing from it lies in the analogy of light from a sun. The entire intellectual order may be figured as a kind of light with the One in repose at its summit as its King: but this manifestation is not cast out from it—that would cause us to postulate another light before the light—but the one shines eternally, resting upon the Intellectual realm.[16]

Similarly, in a discussion of how the immobility of the Supreme Being issues in the production of another entity, Plotinus asserts:

> It must be a circumradiation—produced from the Supreme but from the Supreme unaltering—and may be compared to the brilliant light encircling the sun and ceaselessly generated from that unchanging substance.[17]

Occasionally, Plotinus does use sexual language to describe the origin of the Intellectual Principle (Nous): the One "knows that it can beget an hypostasis" (*Ennead* 5.1.7). Such language explains not only the intimate connection between the two entities but also the motivation for conduct:

> The offspring must seek and love the begetter; and especially so when begetter and begotten are alone in their sphere; when in addition the Begetter is the highest Good, the offspring, inevitably seeking its good, is attached by a bond of sheer necessity, separated only in being distinct.[18]

Such intimate language Armstrong explains by noting that Plotinus's system is a record of the spiritual life: the final goal of human existence results in identification with the Intellectual Principle, in which state one is regarded as "no longer human" (*Ennead* 5.3.4).

> Plotinus was possibly conscious that the unity produced by self-willing and self-loving was closer and had in it less of the duality he was trying to escape than that produced by self-directed knowledge. The lover and the beloved are united more completely than thought and the object of thought.[19]

16. S. MacKenna, trans., *The Enneads*, 395.
17. Plotinus *Ennead* 5.1.6.
18. Plotinus *Ennead* 5.1.6.
19. Armstrong, *The Architecture*, 26.

Thus, when Plotinus uses intimate language, one can say first that such language is used primarily to express the personal experience of apprehending the One. It does not occur in passages describing the relation between the Supreme Being and what is created—the Intellectual Principle. In the *Tripartite Tractate*, however, it is precisely at this point that intimate language occurs. Second, the passages cited from *Ennead* 5.1 and 3, together with *Ennead* 6.9.9 ("love is inborn with the soul . . . the soul in its nature loves God"), are early descriptions that differ from later passages describing the birth of nature as sheer contemplation (*Ennead* 3.8.3, 4). P. Henry and H.-R. Schwyzer place *Enneads* 5.1 and 6.9 as ninth and tenth in chronological order, with 3.8 as thirtieth. At *Ennead* 3.8, Plotinus may have been combating the Gnostics and deliberately avoided sexual language.[20]

The term most commonly used in classical Greek to describe the production of a subsequent divine being from an original divine entity was "emanation." It is therefore remarkable that none of the above passages actually uses the word ἀπόρροια ("emanation"); where it does occur, the immediate qualification is given that a diminution of the One is not implied:

> Seeking nothing, possessing nothing, lacking nothing, the one is perfect and, in our metaphor, has overflowed, and its exuberance has produced the new.[21]

H. Dörrie concludes that Plotinus avoided using emanation imagery for the simple reason that it implied a lessening of divinity. Rather, he says, Plotinus writes directly and metaphorically of the relations between the first and second hypostases within the context of relating the One to the created world.[22]

The author of the *Tripartite Tractate* uses images familiar from Plotinus but adds sexual terminology in the account of the Father's creative activity:

> All those who came forth from him, that is, the aeons of the aeons, being emanations and offspring of a procreative nature, they too, in their procreative nature, have ⟨given⟩ glory to the Father, as he was the cause of their establishment.[23]

20. Henry and Schwyzer, *Plotini Opera*, 1:xxv. See R. Harder, "Ein neue Schrift Plotins," *Hermes* 71 (1936) 1–10; and D. Roloff, *Plotin: Die Gross-Schrift* III,8;V,8;V,5;II,9.
21. Plotinus *Ennead* 5.2.1.
22. Dörrie, "Emanation," 83.
23. *Tri. Trac.* 68,1–3.

The word translated "emanations" (προβολαί) in the above passage occurs in the *Tripartite Tractate* at 65,35; 68,[1]; 70,25; 73,18; 86,10; 111,32; 115,37; 136,10, and in its verbal form at 116,2. In Valentinianism it is a technical term: Valentinus himself speaks of "the depths bringing forth fruits" by which Hippolytus explains that he means "the entire procession (προβολή) of aeons from the Father."[24] Use of this term in the *Tripartite Tractate* strengthens its Valentinian connections. It is also understood physically: the coming of the companions of the Savior in "the emanation according to the flesh" (προβολή κατά σάρξ, Tri. Trac. 115,37) is described as receiving "their bodily emanation" (ⲛⲉⲩϫⲓ ⲡⲣⲟⲃⲟⲗⲏ ⲛⲥⲱⲙⲁ, Tri. Trac. 116,2).[25]

Elsewhere, the Father is described as "the cause of the generation of the All for their eternal being" (*Tri. Trac.* 55,38–40); and "the one who projects himself thus, as generation, having glory and honor, marvelous and lovely" (*Tri. Trac.* 56,16–19). Familiar metaphors are used to explain this process: "(The Father) is a spring which is not diminished by the water which abundantly flows from it" (*Tri. Trac.* 60,12); he "sowed a thought like a [spermatic] seed" (*Tri. Trac.* 61,9). At one point, these metaphors become a kind of poetic chant:

> The Father brought forth everything,
> Like a little child,
> Like a drop from a spring,
> Like a blossom from a [vine],
> Like a [flower], like a ⟨planting⟩. (*Tri. Trac.* 62,7–13)

The Leitmotif of these images is the generative ability of the divine Father. In a discussion of the existence of the aeons before their generation, the narrative declares that "they only had existence in the manner of a seed, so that it has been discovered that they existed like a fetus" (*Tri. Trac.* 60,30–34). The word ⲃⲉⲕⲉ, translated "fetus" (Attridge) or "embryo" (Thomassen), is extremely rare and its meaning conjectured from the cognate verb ⲃⲟⲕⲓ, which means "to conceive, become pregnant, bear a child." J. Černý gives the root as ⲃⲕ ("to become pregnant").[26]

24. Hippolytus, *Ref.* 6.37.8. ET in *Gnosis: A Selection of Gnostic Texts* (ed. W. Foester; trans. and ed. R. McL. Wilson), 1:243.

25. G. May (*Schöpfung aus dem Nichts: Die Entstehung der Lehre von der Creatio ex Nihilo*, 95–100) discusses this term.

26. J. Černý, *Coptic Etymological Dictionary*, 21. The editors of the *editio princeps* suggest that in order to transform the Sahidic into his variety of sub-Achmimic, the scribe created forms such as this which they entitle "hyper-lycopolitanisms." This change follows certain rules such as "o" to "e." For the dictionary meaning, see W. E. Crum, *A Coptic Dictionary*, 31a.

From instances of the verb's usage in W. E. Crum it appears to be associated exclusively with female conception. (The verb is used in this way in the *Apocalypse of Adam* [NHC V,5] at 79,11.) Such an ability is attributed to the Father by analogy, to be sure. To this point, the language of the *Tripartite Tractate* is metaphorical: the Father's generative capacity includes those of (male) generation and (female) conception. In this regard the *Tripartite Tractate* contrasts with Plotinus but, as E. Thomassen shows, is similar to several Neopythagorean writings in which the monad is thought of as a generative entity.[27] However, with only one exception, the examples he cites are those of (male) spermatic generation rather than conception. Perhaps what we are seeing is the diversity of generative metaphors shared by the *Tripartite Tractate* and Neopythagorean authors, both preferring the use of male generative terminology. If this is the case, then it is striking to find a subsequent passage in the *Tripartite Tractate* describing the ability of the Logos both to generate and to conceive specifically without the use of metaphors.

At *Tri. Trac.* 95,17, the author summarizes his doctrine of the Logos as the one "entrusted with the organization of all that which exists." The passage continues:

> Some things are already in things which are fit for coming into being, but the seeds which are to be he has within himself, because of the promise which belonged to that which he conceived, as something belonging to seeds which are to be. And he produced his offspring, that is, the revelation of that which he conceived. (*Tri. Trac.* 95,22–31)

This same intimate language is used again to describe the subsequent relation of the Logos to the Savior at *Tri. Trac.* 114,11: "He had conceived (flesh) at the revelation of the light, according to the word of the promise, at his revelation from the seminal state." Both these passages show that the Logos and the Savior have the ability to conceive. Both passages are equally reticent about identifying the other agent in conception. But whence does this ability derive? Obviously from none other than the Father. Both Plotinus and the *Tripartite Tractate* agree that creation in no way diminishes the Father: generation is not an occurrence in time but rather an eternal relation. Even to use the term "Father," the author of the *Tripartite Tractate* states, is to imply generation: "Wherever there is a 'Father,' it follows that there is a 'Son'" (51,14–15; one might just as accurately translate 'Parent' or 'Child'). The ema-

27. Thomassen, *The Tripartite Tractate*, 1:275.

nation (ⲡⲣⲟⲃⲟⲗⲏ) of the totalities is understood as a begetting "like a process of extension, as the Father extends himself to those whom he loves, so that those who have come forth from him might become him as well" (*Tri. Trac.* 73,25–28). The author has previously specified that "this did not occur according to a separation from one another, as something cast off from the one who begets them" (*Tri. Trac.* 73,21–23). Four images then follow to explain this important idea: division of this present aeon into segments of time; the flow of water into rivers, lakes, and canals; the root which extends into trees and branches; the human body divided into various members (*Tri. Trac.* 73,29—74,18). In each case—time, water, root, a human body—the essential component is not diminished by division. By means of such images, the author explains how the aeon of Truth can be a unity and a multiplicity at the same time. Plotinus uses the natural images of a spring and a tree to make essentially the same point at *Ennead* 3.8.10. In the *Tripartite Tractate,* such images introduce a way to understand varying degrees of perception on the part of those who wish to comprehend the Father. He "receives honor in the small and the great names according to the power of each to grasp it" (*Tri. Trac.* 74,3–6). In these passages, Logos and the Son engender and give birth. They have inherited such abilities from their divine parent. Modern readers customarily assign these abilities to either sex although the *Tripartite Tractate* does not. It simply describes the creative qualities of the divine parent without regard to sexual distinction. Such observations may have been prompted by the author's interest in soteriology: a lesser capacity to perceive the One does not diminish one's chances of salvation.

If the Father is possessed of a procreative nature, this is inherited by the aeons who are described as "roots and springs and fathers" (*Tri. Trac.* 68,9–10). Here the Coptic masculine plural should be translated "parents." The spiritual Logos too possesses "the power of procreation, because he is something that has come into being from the representation from the Father" (*Tri. Trac.* 105,37—106,2). Thus the Father's generative capacity can be inherited, although it is nowhere so richly described. In actual fact, the author of the *Tripartite Tractate* is propelled into a comprehensive statement of the Father's generative capabilities simply by the document's insistence on the singleness of divinity. This "monadic theology" places the author in close proximity to Christian theologians of the third and fourth centuries such as Origen. What is striking is that it is expressed inclusively. In the apophatic theology (denial of divine attributes that effectively heightens the status of God) which opens the document, the author states the same opinion:

He is of such a kind and form and magnitude that no one else has been with him from the beginning; nor is there a place in which he is, or from which he has come forth, or into which he will go; nor is there a primordial form, which he uses as a model in his work; nor is there any difficulty which accompanies him in what he does; nor is there any material which is at his disposal, from which ⟨he⟩ creates what he creates; nor any substance within him from which he begets what he begets; nor a co-worker with him, working with him on the things at which he works. To say anything of this sort is ignorant. Rather, (one should speak of him) as good, faultless, perfect, complete, being himself the totality. (*Tri. Trac.* 53,21— 54,1)

The elimination of mythological details elsewhere characteristic of Gnosticism (such as the existence of female consorts by which creation is effected) results in the Father encompassing qualities usually ascribed to female spouses. In the following passage, Silence (Sige) and Wisdom (Sophia) are assimilated to the Father.

The Father, in the way we mentioned earlier, in an unbegotten way, is the one in whom he knows himself, who begot him having a thought, which is the thought of him, that is, the perception of him, which is the [. . .] of his constitution forever. That is, however, in the proper sense, ⟨the⟩ silence and the wisdom and the grace, if it is designated properly in this way. (*Tri. Trac.* 56,32—57,7)

The document thus assumes that proper creation can only be effected by the expression of male and female creative abilities. If the Logos creates alone, he becomes weak "like a female nature" (*Tri. Trac.* 78,11). Thus the Father of the *Tripartite Tractate* is a parent in the true sense of the word. He is not a Father in an exclusively male sense. He expresses the capacity to conceive and to procreate. Only the aeons in their totality express the multiplicity of the Father: individual wisdom and power even when they are used in search of God are deprecated (*Tri. Trac.* 126,13–15). Eventually the salvation of the whole, rather than one or other of its parts, will be achieved:

For the end will receive a unitary existence just as the beginning is unitary, where there is no male nor female, nor slave and free, nor circumcision and uncircumcision, neither angel nor man, but Christ is all in all. (*Tri. Trac.* 132,20–28)

3. THE FUNCTION OF SEXUAL LANGUAGE IN THE *TRIPARTITE TRACTATE*

The author of the *Tripartite Tractate* employs sexual language as the means of asserting a connection that exists between the higher beings

and the inhabitants of the cosmos. In this way, the document seeks to demonstrate that human sexual expression is a mirror of divine generative activity. That this correlation is effected within the confines of monism demonstrates the richness of theological expression in this early period of Christian history.

We have already seen how the *Tripartite Tractate* stresses the autonomy of the Father. Accordingly, to him alone belongs the ability to generate. He does this out of a desire to be known (*Tri. Trac.* 55,31–32). Thus the document stresses the will of the Father to initiate self-extension. The reader is thereby reassured throughout the document that whatever is effected is done by divine purpose: the will of the Father results in the free will of the aeons (*Tri. Trac.* 74,21; 75,36–37).[28]

In analyzing a key section in which the generation of the Son is discussed (*Tri. Trac.* 56,1—57,8), Thomassen, under the rubric that in Gnosticism knowing and begetting are convertible terms, concludes on the basis of this passage that "the mental self-reflection of the Father is equivalent to the generation of the Son."[29] The whole section, he maintains, illustrates the movement from the oneness of the Father to the "unity-in-duality of his self-thinking thought," namely, the generation of the son. Thus he quite rightly sees that for the author of the *Tripartite Tractate* the concept of mind is the solution to the metaphysical problem of how the Father can be one and at the same time origin. Thomassen's analysis, however, does not do justice to the complexity of the author's contribution to the issue under discussion. For it is only as a consequence of his generative abilities that the Father's qualities become manifest: "He is the one who projects himself thus, as generation, having glory and honor" and, in a catena of these attributes, the author leads up to the significant conclusion: "The one glorifies himself, who marvels, [who] honors, who also loves; the one who has a Son who subsists in him. . . . Thus, he exists in him forever" (*Tri. Trac.* 56,16–31). In addition then to the rational quality of a self-conceiving mind, the intimate sexual component of the Father's nature is described, and the limitations of noetic perception frequently referred to (*Tri. Trac.* 54,16; 55,21–22; 59,16–17). The intimate nature of the connection between the

28. E. Thomassen, "The Structure of the Transcendent World in the Tripartite Tractate," *VC* 34 (1980) 358–75, esp. 369 and n. 54. G. Quispel ("From Mythos to Logos," in *Gnostic Studies*, 1:52) remarks that Origen's concept of free will is prefigured in the *Tripartite Tractate*.
29. Thomassen, "The Structure," 360.

Son and the Father is sustained in the description of the origin of the ecclesia (church) which has "come forth like kisses from the Son and the Father" (*Tri. Trac.* 58,22–23). This image too makes the noetic tangible: "like kisses because of the multitude of some who kiss one another with a good, insatiable thought, the kiss being a unity although it involves many kisses."

Similarly, the movement from spermatic subsistence in the thought of the Father to the independent existence of the aeons is accomplished descriptively by the use of birth images. Without these images, the aeons' growth and development would be arrested. *Tripartite Tractate* 59,36—62,5 illustrates the two stages of the aeons' coming into being.

At first, the aeons exist in the thought of the Father, "in the hidden depth" (*Tri. Trac.* 60,18). While the depth knew them, they were unable to conceive of the depth where they were, namely, the Father, or anything else. They had no independent existence (*Tri. Trac.* 60,20–22). This state the author characterized as "existence in the manner of a seed" or "like a fetus" (*Tri. Trac.* 60,31–32). In this transitory state of existence they were, as yet, unable to recognize the source of their being. Yet God's purpose in conceiving of them is that "they might exist for themselves too" (*Tri. Trac.* 61,4, 7). It is the promise of the Father that he will complete their coming into being so that they might become conscious—"to know what exists" (*Tri. Trac.* 61,36). The process is subsequently completed by their birth "just as people are begotten in this place: when they are born they are in the light, so that they see those who have begotten them" (*Tri. Trac.* 62,3–6). The Coptic verb ⲘⲒⲤⲈ ("to produce, give birth, or bear") occurs also at *Tri. Trac.* 115,9, 15 in regard to the birth of the Savior. The same verb occurs twice in the *Apocalypse of Adam* (79,11 and 80,4), where it describes a woman giving birth. The noun occurs at *Tri. Trac.* 64,2; 84,7; 95,29; 103,31. Thus, by analogy to human birth, the Father in the *Tripartite Tractate* has given birth. Subsequently, the generative capacity of the Father becomes the primary means of his identification: "therefore his powers and properties are innumerable and inaudible, because of the begetting by which he begets them" (*Tri. Trac.* 67,19–21).

It is with regard to the salvation of the individual, or in this case a group, that the significance of this conception of God can be seen. Gnostic inquiry into the nature of God is never conducted for its own sake but on the premise that comprehending such knowledge constitutes salvation. What does this imply about the procreative ability of the Father? Simply this: The author of the *Tripartite Tractate* relates not a

history of the *Urzeit* from which tenuous links to the present can be extracted; it is not a sketch of the Father's nature which remains essentially removed from the human situation. Rather, what takes place in the Father can take place in the individual: the individual constituted "in the proper sense" (*Tri. Trac.* 56,2; 57,4; 65,38) is born of male and female. This does not take place at a specific point in time but is rather an "eternal begetting" (*Tri. Trac.* 70,21; 73,23) which results in a progressive return to one's divine origins (*Tri. Trac.* 71,19–20; 79,1–2). Because one is born of male and female, one possesses male and female procreative abilities. However, the first person singular cannot simply be substituted for the Father in the *Tripartite Tractate;* rather, the impetus for generation lies in the mutual actualization of will. That this is always a possibility is reflected in the author's deliberate and consistent use of the present tense:

> If this one . . . wishes to grant knowledge so that he might be known, he has the ability to do so. (*Tri. Trac.* 55,27–33)

> He himself, since in the proper sense he begets himself as ineffable one . . . since he conceives of himself, and since he knows himself as he is, (he is) the one who is worthy of his admiration and glory and honor and praise, since he produces himself. (*Tri. Trac.* 56,1–10)

Knowledge that one is continually constituted not on account of remote events in the past but on the basis of present identity with the Father is what the *Tripartite Tractate* seeks to provide. This identity is perceived not only through intellectual knowledge but also through the potential for creation each possesses.

The purpose behind the range of sexual and generative terminology may be seen in what could be called the democratic tendencies of the document. The possibility of transformation by mutual consent is not restricted to a single group or even, given our linguistic research, to a single sex: "whoever he wishes he makes into a Father (Parent)" (*Tri. Trac.* 70,32).

4. THE *TRIPARTITE TRACTATE*, ORIGEN (185–253 C.E.) AND TERTULLIAN (155–?220 C.E.)

Origen's work *On First Principles* shows considerable similarity to the *Tripartite Tractate,* especially in its discussion of the relationship be-

tween the Father and the Son.[30] Origen's work is prefaced by an outline of its contents formulated according to apostolic teaching. In addition, Origen proposes to consider "what has existed before this world or what will exist after it," since "no clear statement about this is set forth in the church teaching." Likewise, what is not clearly set forth in church teaching—"how God himself is to be conceived, whether as corporeal or fashioned in some shape, or as being of a different nature from bodies"—must be made the object of inquiry, and the same must be made with regard to Christ and the Holy Spirit and "every soul and rational nature also." Such points as these he considers to be foundational elements on the basis of which to construct a system.

The relationship of Father to Son is further explained in book 1:

> Whereas the offspring of men or of other animals whom we see around us correspond to the seed of those by whom they were begotten, or of the mothers in whose womb they are formed and nourished, drawing whatever it is from those parents that they take and bring into the light of day when they are born, it is impious and shocking to regard God the father in the begetting of his only begotten son and in the son's subsistence as being similar to any human being or other animal in the act of begetting; but there must needs be some exceptional process, worthy of God, to which we can find no comparison whatever, not merely in things but even in thought and imagination, such that by its aid, human thought could apprehend how the unbegotten God becomes father of the only-begotten son. This is an eternal and everlasting begetting, as brightness is begotten from light. For he does not become Son in an external way through the adoption of the spirit but is son by nature.[31]

Like the *Tripartite Tractate* and Plotinus, Origen stresses that the begetting of the son from the Father does not result in a diminution of divinity. The son's birth from the Father is described as an act of will which is not a separation. In *On First Principles* 2.7, he uses the Fourth Gospel to explain the derivation of son from Father as "brightness from light." He thus insists on the uniqueness of the son's birth by stressing its nontemporal nature. Such images also occur in Tertullian's *Against Praxeas*, a work probably written in 213 c.e. that displays clearly his Stoic background in its emphasis on materialism:

> The word is never separate from the father . . . for God brought forth the word . . . as a root brings forth the ground shoot and a spring the river and

30. Origen, *Vier Bücher von den Prinzipien* (ed. H. Goergemanns and H. Karpp), 94.
31. ET from H. de Lubac, *Origen. On First Principles*, 17–18.

the sun its beam: for those manifestations are also projections (προβολαί) of those substances from which they proceed. . . .

Everything that proceeds from something must of necessity be another beside that from which it proceeds but it is not for that reason separated ⟨from it⟩. . . .

In no respect is (the Spirit) alienated from that origin from which he derives his proper attributes.[32]

In the light of these passages from Origen and Tertullian, the *Tripartite Tractate*, as an example of Valentinian monism, is no less orthodox than the church fathers. The assertions of all three writers with regard to the relationship existing between the Father and the son are reflected in the words of the Nicene Creed: "eternally begotten of the Father before all ages . . . begotten, not made; of one substance with the Father." Such language lies at the heart of the Christian doctrine of the Trinity. If it is given a masculine expression in the creed, it is expressed inclusively in the *Tripartite Tractate*.

5. MALE AND FEMALE IN THE NAG HAMMADI LIBRARY

In regard to questions of gender, I want to discuss several texts in the Nag Hammadi library where the terms "male" and "female" have been misunderstood and/or mistranslated. Previous research has established that in such cases men and women are not necessarily implied. As a matter of fact, the hermeneutical principle that the terms "male" and "female" do not denote men and women but stood rather for abstract principles was recognized long ago by Clement of Alexandria in his explanations of gnostic texts that employed these terms. In a critical commentary on Julius Cassianus, he proposes that in order to explain a text in which the male and female become something that is neither male nor female, one should understand that "by the male impulse is meant wrath and by the female lust."[33]

The recognition that texts referring to male and female do not necessarily say anything about men and women helps the reader to understand the reason for the fact that in several texts humans are all described as female, regardless of their actual gender. The *Exegesis on the Soul* (NHC II,6) begins with the words: "Wise men of old gave the soul a

32. ET from E. Evans, *Tertullian, Adversus Praxean Liber*, 139–40.
33. Clement of Alexandria *Stromateis* 3.13.93,1.

feminine name. Indeed, she is female in her nature as well." All who possess a soul are thus female. In the same way, the *First Apocalypse of James* (NHC V,3) speaks of the ascent of human beings to the divine realm: "The perishable has gone up to the imperishable and the work of femaleness has attained to the work of maleness."[34]

Another group of texts speak of male and female as incomplete in themselves. Together, the perfect human being ($\check{\alpha}\nu\theta\rho\omega\pi\sigma$) is formed. Mary, in the *Gospel of Mary* (BG 8502,1) 9,19–21, consoles the company of assembled disciples concerned at the prospect of being killed by the Gentiles as Jesus was. She says: "Do not weep and do not grieve or be irresolute for his grace will be entirely with you and will protect you. But rather let us praise his greatness, for he has prepared us (and) made us human ($\check{\alpha}\nu\theta\rho\omega\pi\sigma$)." The assembled company of male and female disciples has become truly human, that is, indivisible in the face of threatening circumstances and hence resolute. Levi, in the same document, tells Peter to "put on the perfect $\check{\alpha}\nu\theta\rho\omega\pi\sigma$, engendering him in us and preach the gospel" (*Gos. Mary* 18,16–19). The fact that one man invites another man to "put on the perfect $\check{\alpha}\nu\theta\rho\omega\pi\sigma$" should indicate clearly that men are not always seen as complete in and of themselves in the Nag Hammadi library. Translators who translate the above references to male and female becoming $\check{\alpha}\nu\theta\rho\omega\pi\sigma$ as male and female becoming men[35] have failed to recognize the intent of the passages to describe the transformation of both sexes into what is fully human.

6. CONCLUSION

The foregoing observations, made at the level of the Greek and Coptic texts and their modern translations, should help to inform discussions as

34. *1 Ap. Jas.* 41,15. See the forthcoming edition of this text for the Laval Project by Father A. Veilleux. I am indebted to him for help with this translation.

35. An erroneous translation of these passages from the *Gospel of Mary* can be found in *Nag Hammadi Library* (ed. Robinson) by G. MacRae and R. McL. Wilson. According to their translation, Mary declares, "He has . . . made us into men." The Coptic word translated "men" is not prefaced by the masculine plural article but by the adjectival predicate, i.e., "man." Wilson and MacRae continue to translate "he has . . . made us into men" in the most recent English edition of the text, *Nag Hammadi Codices V,2–5 and VI with Papyrus Berolinensis 8502, 1 and 4* (ed. D. M. Parrott), 461. However, they correctly translate the passage wherein Levi enjoins Peter to "put on the perfect man and separate as he commanded us." The Coptic word translated "man" is ρωмε. It commonly reflects the Greek $\check{\alpha}\nu\theta\rho\omega\pi\sigma$. Therefore one has to understand the term "man" inclusively. A better translation of these passages can be found in *L'Evangile selon Marie* (ed. and trans. A. Pasquier), 45. My attention was drawn to this translation by Father Veilleux.

to how terms such as "father," "female," and "male" are to be understood in Coptic texts.[36] It is still possible, since many of these texts have been published recently, to indicate mistaken interpretations and translations of Coptic and gnostic texts and, in such cases, to rethink conceptions of gender and sexuality. Since these issues relate to ways in which ancient (and modern) Christians expressed (and continue to express) their understanding of God, and since such investigations reveal a richness not readily apparent in the credal language of the early (and contemporary) church, there is much to be gained from critical linguistic studies of simple terms such as "Father."

36. R. Mortley (*Womanhood: The Feminine in Ancient Hellenism, Gnosticism, Christianity and Islam*) has made a beginning but has not taken into account the important distinction between gender and sexuality made at the outset of this essay.

Response to "Gender and Generation" by Deirdre J. Good

First, I want to thank Professor Good for her interesting and thought-provoking essay. As one who has been involved for a long time with the translation of a Nag Hammadi text, I am most appreciative of work such as hers which moves the interpretation of these texts into a deeper level.

Her essay raises for me two interrelated issues to which I wish to make specific responses: the in-depth meaning of male/female terminology, especially the meaning of the term "Father" in the *Tripartite Tractate* (NHC I,5); and the responsibilities of translators in the handling of such terms. With regard to the former, it is important that we who are interested in these texts move on to significant hermeneutical questions. If "male" and "female" represent "cosmic principles," then we must investigate them to discover what those principles are in order to understand the documents. Such studies will at the same time raise for translators some very real problems related both to the determination of the type of translation (formal or dynamic equivalent) that they wish to produce and to the limits that English itself presents as a receptor language.

My response will be made in three sections. Its first part will address the grammatical and lexigraphical concerns raised by Professor Good. The second will speak to her analysis of the use and meaning of "Father" in the *Tripartite Tractate*. The third will try to expand her topic by raising questions from another Nag Hammadi tractate, *Zostrianos*.

1. GRAMMATICAL AND LEXICAL CONCERNS

Professor Good is correct when she asserts that Coptic "favors the masculine gender over the feminine" (p. 25). So also do Greek and Latin,

because they came from androcentric cultures. Her examination of the use of ειωτ provides an instructive case in point. That it was used to translate γονεύς/γονεῖς is clear from the references in W. E. Crum (86b), but not one readily apparent, since the only meaning listed is "father." The examples from Nag Hammadi that she cites in which B. Layton and M. Meyer translate ειωτ as "parent" are likewise instructive, and I would hope that they would also comment on their reasons for doing so. The translator's task is, of course, much more difficult when there is no Greek *Vorlage* extant, but Professor Good's point is well taken and she is correct in saying that most of the rest of us have not been sensitive to this usage.

In addition to the examples she gave for ειωτ, one might also wish to note that μντειωτ is the term used for "family" as well as for "father-hood." As a somewhat parenthetical comment for those interested in the New Testament, we might also wish to debate the propriety of trans-lating πατήρ as "Father" when used by Jesus, since πατήρ is a too formal translation of אבה.

Besides discussing ειωτ, we might also profitably discuss the use of ϣHPE ("son," "child"). Crum (584a) notes that this word translates not only υἱός but also τέκνον, βρέφος, and παῖς (which are not sex specific), and that p, o ϣHPE means "to be a child." I cannot recall instances of ϣHPE translating θυγατήρ, but others may. In any case, we must also learn to be sensitive to ϣHPE as well and not automatically translate the term as "son" but also as "child." Again somewhat parenthetically, I would add that in my own career I have seen a shift in translating οἱ υἱοὶ τοῦ Θεοῦ from "the sons of God" to "the children of God," both in Scrip-ture translations and in liturgical usage. Perhaps that shift will not take as long for noncanonical documents such as these from Nag Hammadi in phrases like "the sons of Seth."

It might also be a good thing to share with one another still other ways in which Coptic as a language prefers the masculine. Professor Good cites the resumption of feminine nouns by masculine pronouns, as demonstrated by A. I. Elanskaja. That observation raises the whole issue of the gender of nouns and pronouns as well. We teach beginning lan-guage students that the grammatical gender of nouns is not necessarily connected to any sexual identification. Masculine nouns do not neces-sarily represent males, feminine nouns do not necessarily represent females. The same is true of the pronouns that refer to those nouns. In Latin, *puella* indeed refers to a young girl but *machina* to a thing, an "it." A translator is responsible for making distinctions such as these so that a

translation does not simply reproduce the original pronouns with equivalent words in the receptor language.

The transformation of Greek neuter nouns into Coptic masculines provides another case in point, together with the concomitant masculine pronouns, as, for example, is often the case with πνεῦμα in the Nag Hammadi texts. In tractates such as *Zostrianos* where Spirit is the major name for the highest deity, that is a very real problem; I at least have struggled with the question of whether one should translate those Coptic masculine pronouns referring to the Spirit as "he" or "it." (Should we also consider "she," as feminists in the Christian tradition have suggested?) Is it not the case also that the vast majority of Coptic nouns are masculine anyway?

Or, to take another example, we might talk about nominal sentence patterns where ⲡⲉ or ⲧⲉ normally agrees in gender with the noun that is the topic of the sentence. But is it always so? I think not, although sometimes what seems to be a lack of agreement may actually be a lack of understanding about the topic of the sentence, such as at 1 Cor. 11:3. A similar example from the *Tripartite Tractate* (82,4–5) might be worth discussing. H. Attridge and E. Pagels translate as follows: "for a cause of his remembering those who have existed from the first was his being remembered." From the English translation we might take "cause" (ⲗⲁⲉⲓϭⲉ, fem.) as the topic and the ⲡⲉ as a case of disagreement; however, since "cause" has the indefinite article, it is almost certainly the comment and the agreement is maintained. Or is ⲗⲁⲉⲓϭⲉ the topic? Whether or not these examples are valid, surely there are other ways in which the masculine is emphasized in Coptic, and we might begin to compile a list of them.

2. THE USE AND MEANING OF "FATHER"
IN THE *TRIPARTITE TRACTATE*

The question of meaning goes far beyond grammatical concerns, and we are indebted to Professor Good for demonstrating that ⲉⲓⲱⲧ in the *Tripartite Tractate* is used to refer to the generative powers (expressed in female as well as male images) of the high deity in that text. The decisive passages in my opinion are 53,21—54,6; 56,31—57,7; and 59,36—60,1. We should also credit Attridge and Pagels with similar comments in their notes to 55,37; 57,5–7; and 59,36ff.[1]

1. H. W. Attridge, ed., *Nag Hammadi Codex I*, 2:234, 237, 246.

To the arguments Professor Good has offered I would add two others in support of her thesis. On p. 33 she notes that the deity is "not a father in an exclusively male sense," and she cites as evidence (on p. 35) feminine images such as depth, seed, and fetus, from the passage *Tri. Trac.* 59,36—62,5. To those images should we not also add "to bring forth" (ⲉⲓⲛⲉ ⲉⲃⲁⲗ) in the sense of "to give birth"? At *Tri. Trac.* 62,3–6 she notes the use of ⲙⲓⲥⲉ in that sense but does not comment on ⲉⲓⲛⲉ ⲉⲃⲁⲗ in the next lines. Crum (79b) does not list "to give birth" as an option but surely it is so. He does note that it translates ἐκφέρω, and ἐκφέρω is definitely so used (see Liddell and Scott, 1.525a with examples from Plato, Hippocrates, and Aristotle). Other instances of ⲉⲓⲛⲉ ⲉⲃⲁⲗ with this birthing meaning occur at 60,9 and 11; 69,2 (+ note); 76,8 (+ note); and also possibly 56,9.

There is also a passage in the text itself which argues that none of the names for the deity are part of his true existence. The passage (*Tri. Trac.* 54,2—55,26) declares that "He" is unknowable and the names are only ways that humans can give him glory and honor. *Tripartite Tractate* 54,2–24 is worth quoting (Attridge and Pagels):

> Not one of the names which are conceived, or spoken, seen or grasped, not one of them applies to him, even though they are exceedingly glorious, magnifying and honored. However, it is possible to utter these names for his glory and honor, in accordance with the capacity of each of those who give him glory. Yet as for him, in his own existence, being and form, it is impossible for mind to conceive him, nor can any speech convey him, nor can any eye see him, nor can any body grasp him, because of his inscrutable greatness and his incomprehensible depth, and his immeasurable height, and his illimitable will.

Presumably these limitations of language apply also to the name "Father" and to the masculine pronouns that are used to refer to "him." Thus the author of the tractate invites us to recognize that terms such as "Father" and "maleness" are to be understood as inadequate metaphors for the deity. That these human metaphors (both masculine and feminine) can be so used is, as Professor Good says on p. 36, based on the identity with the Father felt by the Gnostic.

Although I agree with her about the meaning of "Father" in this tractate, I must confess to having some doubts that changing the translation to "parent" will be of much help. I do not understand her to be arguing for γονεύς as the Greek behind this use of ⲉⲓⲱⲧ, and I assume the Greek to have been πατήρ. We must ask, as she has, what the term "father"

means, but then we must also ask why those ancients chose to use "father" instead of "mother," especially since both male and female images are used of the deity. The clear answer is that they chose "father" because their culture was androcentric, and that raises for the translator a serious issue. What are our responsibilities as translators, especially the initial English translators of most of these documents, toward the milieu of the ancient document? To put it baldly, if the ancient writer was a male chauvinist, should not our translation of his document show that? Except in a few instances it would seem better to me to translate ειωτ as "father" and to provide an interpretation of it in the introduction and notes. Even should we be able to agree to changing "father" to "parent," we still face the question of what to do with all the masculine pronouns that refer back to it.

We should also note that others have also begun to study the use of male/female imagery in this literature. In a recent essay entitled "Dualism Platonic, Gnostic and Christian," A. H. Armstrong has traced its philosophical heritage to the pre-Socratic Pythagoreans.[2] He cites Aristotle *Metaphysics* A 5 986a22–26 as evidence. It reads:

> Others of this same school say that there are ten principles which they list in a series of corresponding pairs: Limit/Unlimited; Odd/Even; One/Many; Right/Left; Male/Female; Rest/Motion; Straight/Crooked; Light/Darkness; Good/Evil; Square/Oblong.

Armstrong labels the "female" side of the tradition the "dark other" and traces its development. In the philosophical tradition he finds that both principles, father and mother, are necessary and of equal honor, at least early in the tradition and in Plotinus. The Gnostics differ in placing a greater importance on some kind of fall or failure in the female that leads to creation. Thus, some of the Nag Hammadi treatises have relatively positive evaluations of the dark other (he names the *Tripartite Tractate* as one), while others such as *Zostrianos* are quite negative.

What Armstrong has shown, then, is that there is a long and ancient tradition that uses male/female imagery in a positive sense and that some Gnostics were not totally negative about the female. Since that is related to what Professor Good has demonstrated, those who have read her essay might also wish to read his. I would take the existence of that long tradition of usage also as an argument for continuing to translate both πατήρ and ειωτ as "father."

2. In *Plotinus Amid Gnostics and Christians* (ed. David T. Runia).

3. ZOSTRIANOS

My response will conclude with a few references to another Nag Hammadi tractate, *Zostrianos*. I have already mentioned the problems relating to the Spirit and its pronouns. A similar one exists over against the Aeon Barbelo who (which) occupies a place between Spirit and the physical world. Barbelo is signified with the feminine definite article and feminine pronouns and is usually designated as the "virgin" or the "male-virgin" Barbelo. In the current version I am treating Barbelo as a female, largely because the pronoun "it" does not seem suited to a mythological being, but also in part because I believe a primary translator ought to produce a fairly formal translation. Later, when others have studied the text in more depth, there will be opportunity for a dynamic equivalent translation. As a beginning of that process, I have argued elsewhere[3] that Barbelo represents the pristine Sophia and that only her weaker copy is the fallen Sophia of the Autogenes Aeon. As for the terms "maleness" and "femaleness" in *Zostrianos*, it is not clear to me yet that they stand for any cosmic principles. At present I am inclined to agree with Armstrong that this author does not think in terms of abstract principles and that femaleness is only a way of naming the lower cosmos which imprisons the spirit. But Professor Good's essay is evidence that it could be otherwise, and I am willing to accept your comments. She has given us all much to think about and to discuss.

3. "The Barbelo Aeon as Sophia in *Zostrianos* and Related Tractates," in *The Rediscovery of Gnosticism* (ed. B. Layton), 2:788–95.

Prouneikos. A Colorful Expression to Designate Wisdom in Gnostic Texts

In their critical edition of book 1 of the *Adversus haereses* by Irenaeus, A. Rousseau and L. Doutreleau[1] note that the term *prouneikos,* as an appellation for Wisdom, is not found anywhere except in the two notices devoted to Gnostics: Barbelo Gnostics and Ophites.[2] Epiphanius also mentions it many times in his notice on Ophites and about the Gnostics sprung from Nicolas.[3] Moreover, at Nag Hammadi, the word is found in the *Apocryphon of John* as well as in the *Second Treatise of the Great Seth*[4]— in a word, in texts that have a doctrinal connection with the so-called gnostic, barbelo gnostic, or ophitic systems, likened to those of the Sethians by some heresiologists. Yet according to Origen and Epiphanius,[5] the Valentinians also used it, as did the Simonians from evidence supplied by Epiphanius.[6] The frequency of this term in the gnostic material indicates that the Gnostics must have been quite familiar with it, that it must have been part of the cultural attainments of their time.

1. A. Rousseau and L. Doutreleau, *Irénée de Lyon, Contre les Hérésies, livre 1* (SC 263), 303; (SC 264), 363 n. 1.

2. Irenaeus *Adv. haer.* 1.29.4; 1.30.3,7 (twice); 9 (twice); 11.12. The word is also found in 4.35.1 (in a passage where "Gnostics" are expressly mentioned), in 5.18.2, and in 5.35.2 (without mentioning any specific sect).

3. Epiphanius *Haer.* 37.3.2; 37.4.2; and 25.3.2.

4. *Ap. John* BG 37,10–11; 51,1–3; III 15,3–4; 23,19–21; *Treat. Seth* 50,25—51,7.

5. Origen *Celsus* 6.35; Epiphanius *Haer.* 31.5.8,9; 31.6.9. In *Celsus* 6.34, however, the quotation about Prouneikos might belong to the ophitic doctrines which Origen has just spoken about; see the expression "circles upon circles" which refers to the diagram of the Ophians. See n. 66, below.

6. Epiphanius *Haer.* 21.2.4,5. Epiphanius also attests to the verb προυνικεύω (*Haer.* 25.4.1; 37.6.2) and the abstract noun προυνικία (*Haer.* 31.5.7). See also Theodoret *Haereticum fabularum compendium* 13.14; Gregory of Nyssa *Contra Eunomium* 1.12.9.

But for us, a lot of research on the work of ancient grammarians and etymologists is necessary before trying to explain it through its gnostic context.

1. ETYMOLOGICAL AND PRIMITIVE MEANINGS
OF THE WORD *PROUNEIKOS*

Etymologicon Magnum 691,19 by T. Gaisford explains that the word means Τοὺς ὑβριστὰς, καὶ τοὺς ἄνδρας τοὺς ἱσταμένους ἐν τῇ ἀγορᾷ καὶ φέροντας τὰ ὤνια καὶ λαμβάνοντας ὑπὲρ τούτων μισθόν, "the impetuous (hotheaded, excessive, etc.), and the people standing at the agora and who would transport articles of trade in return for a salary." Gaisford adds that if the meaning is ὑβριστάς, the word comes from πρό and νεῖκος, πρόνεικος, to which the letter υ is added; if not, from πρό and the Boeotian aorist ἐνείκω (from the verb φέρω): προένεικος, the o and the ε being changed into the ου diphthong: προύνεικος, see Choeroboscus (fourth/fifth century C.E.).[7] The second etymology (aorist of the verb προφέρω) is adopted by Aelius Dionysius (second century C.E.) according to Eustathius,[8] Herodianus (second century C.E.),[9] Alexis (first century C.E.), and Demetrius according to Choeroboscus:[10] ᾿Αλεξίων μέντοι παρὰ τὸ ἐνεικός (sic?) ἐσχημάτισεν· κυρίως γὰρ λέγεται προύνεικους τοὺς μισθοῦ τὰ ἐξ ἀγορᾶς ὤνια κομίζοντας παῖδας· Δημήτριος δέ φησι τοὺς διδόντας τὰ ὤνια πρὶν ἢ λαβεῖν τιμήν, Alexis specifying that they are children (παῖς, young servant or young slave) and that they carry the articles of trade out of the agora; Demetrius, for his part, that they have to deliver the goods before they get any salary.

In short, for the grammarians of the first and second centuries C.E., the literal meaning of the word (κυρίως) is a young peddler or young porter, but Choeroboscus,[11] who reports most of their testimonies, also adopts the first etymology, according to which the word comes from νεῖκος: ἐπὶ γὰρ ἀπαιδεύτων . . . κεῖσθαι τὴν φωνήν, because, he says, the term applies to undisciplined or uneducated people (which is normal when they are children) and it is then, as we have already pointed out, a synonym of ὕβρις. The term therefore means on the one hand a function and on the other a personality.

7. J. A. Cramer, *Anecdota Graeca*, 2:251.5.
8. M. van der Valk, *Eustathii, Commentarii ad Homeri Iliadem pertinentes*, 3:634–35 (983, 48).
9. A. Lentz, *Grammatici Graeci*, pt. 3, 2:445.7 and 574.9–16.
10. I. Bekker, *Anecdota Graeca*, 3:1415; Cramer, *Anecdota Graeca*, 4:189.9, where Philoxenus is mentioned besides Demetrius and Alexis.
11. Bekker, *Anecdota Graeca*, 3:1415.

1.1. A function in comedy

In the second century C.E. again Pollux, and a little bit later Hesychius (fifth century C.E.?), add some useful information. According to the first,[12] ʿφόρτακαςʾ μέντοι ἡ παλαιὰ κωμῳδία τοὺς ἀχθοφοροῦντας ἐκ τοῦ ἐμπόριου καλεῖ. Εἰ δὲ καὶ ʿπρουνίκουςʾ τοὺς μισθωτοὺς οἱ νέοι κωμῳδοδιδάσ-καλοι ὠνόμαζον, "Ancient comedy calls φόρτακες those who carry the supplies from the market whereas the poets of new comedy call προύνι-κοι the paid porters."[13] And according to Hesychius,[14] προύνικοι means οἱ μισθοῦ κομίζοντες τὰ ὤνια ἀπὸ τῆς ἀγορᾶς, οὕς τινες παιδαρίωνας καλοῦσι· δρομεῖς, ταχεῖς, ὀξεῖς, εὐκίνητοι, γοργοί, μισθωτοί,[15] "those who in return for a salary carry the supplies from the market, that some call young boys: runner, quick, hasty, changing, impetuous, wage-earning" (or hireling). According to J. M. Edmonds,[16] this list of qualifications is probably not a citation but rather a series of terms that were given to them in comedies.

This character is mentioned in a mimiamber by the Alexandrian comic poet Herondas (or Herodas, probably third century B.C.E.). In this mime, entitled *The Schoolteacher*,[17] a desperate mother commits her worthless son to the hands of the schoolteacher who will give him a good thrashing. Because that little scamp, who would find it very difficult to indicate the address of the elementary school to anyone and cannot even read the first letter of the alphabet, spends all his time gambling on the playgrounds (παίστριην = κυβευτήριον, σκιραφεῖον), where the peddlers (προύνικοι) and escaped slaves hang out. Unfortunately only fragments remain from the new comedy, and it seems that this mime by Herondas

12. Pollux 7.132, in J. M. Edmonds, *The Fragments of Attic Comedy* (after A. Meineke, T. Bergk, and T. Kock), 1:977 nu. 102 and 3A.405 nu. 333. Cf. Athenaeus, *Deipnosophistae* 14.639d: ἀνδράσι παρ᾽ κείνοισιν or προσκείνοισιν or προυνείκοισιν? (see LCL 6:451.6).

13. Pollux adds: τὸ ὄνομα βυζαντίων ἦν, ὅθεν καὶ βυζαντίους αὐτοὺς ἀπεκάλουν, "the word was Byzantine, whence they used it of the Byzantines themselves." Maybe Byzantine porters are here in question or porters in Byzantine comedy, who might have inspired the poets of new comedy. Or it might be a play on words; see Hesychius in his lexicon, s.v. βύζαντες. πλήθοντες from πίμπλημι, "be full, be loaded (burden)": M. Schmidt, *Hesychii Alexandrini Lexicon*, 1:405.3.

14. Schmidt, *Hesychius*, 3:396.34; and Edmonds, *Fragments of Attic Comedy*, 3A.509.1343.

15. παιδάριον; cf. Clement of Alexandria *Paidagogos* 1.4.11: "It seems that attic writers make use of this word concerning young boys or young girls, according to what Menander says" (one of the most famous poets of the new comedy). See also S. A. Naber, *Photii Patriarchae Lexicon*, 116: προύνεικος · δρομαῖος, γοργός.

16. Edmonds, *Fragments of Attic Comedy*, 3A.509, note ad nu. 1343.

17. A. D. Knox, *Herodas, the Mimes and Fragments* (with notes by W. Headlam), 110 and 114 (mime 3, lines 12 and 65); for the notes, see 125–27.

is the only remaining comedy piece in which we can catch a glimpse of the *prouneikoi*. We can catch only a glimpse, since in the mime they are only secondary characters: we know that they gambled with dice or money (possibly playing heads or tails?) on playgrounds, with schoolboys on the loose (and that the word was known in Egypt).

This could explain why in his lexicon Hesychius,[18] under the word σκείρατες (word unknown in this form), gives the synonyms οἱ προύνικοι καὶ κυβευταί, this last term meaning players (dice): κυβευταί comes from the verb κυβεύω, which, apart from its literal meaning of "throw or cast the dice," can also mean: (*a*) to venture, to risk; (*b*) to fool, to swindle, to make game of someone. As we have said, the entry word that Hesychius wants to define, σκείρατες, is not encountered anywhere else. It could be a deformation of σκίραφες (or σκείραφες), σκιραφευτής, of σκιραφεύειν, to play a game or to make game of someone, σκιραφευτής designating the players. Σκίραφ is the name that we usually find in the comic poets to designate either a game of dice or else a deceit or a stratagem.[19] Another possibility is that the word σκείρατες might come from σκιρτητής (from the verb σκιρτάω or σκιρόω coming from σκαίρω) which in the literal sense means a bounding, lively individual, and, in the figurative sense, "mischievous," "undisciplined," and "turbulent." The character of *prouneikos* resembles the κόβαλος. Indeed κόβαλος, whose original meaning is "porter," represents in comedy a kind of elf or goblin who plays nasty tricks; see Aristophanes *Knights* 635.

Prouneikos or *prounikos* therefore designates a character of the new comedy, in other words the comedy of the Hellenistic period: he is a young character who springs impetuously to carry his goods or his burden out of the market before he can get paid, therefore quite enterprising and combative (he runs to arrive before the others), probably difficult to control, undisciplined, and a gambler, maybe mystifying.

1.2. A personality

As we have seen, according to the testimonies of ancient grammarians the word *prouneikos* would originate from the verb προφέρω. This etymology is acknowledged by scholars today: M. P. Nilsson, P. Chan-

18. Schmidt, *Hesychius*, 4:41 and note. In Hesychius, we also find s.v. οἴσυλος · προϊοῦλος, προύνικος: according to Schmidt (*Hesychius*, 3:191), οἴσυλος might come from οἶσαι, the aorist of the verb φέρω (cf. οἶσις, the fact of carrying) and, instead of προϊοῦλος, we should have to read προοίσυλος from προφέρω. See also Liddell, Scott, and Jones, suppl. 29: βαίο(υ)λος, Lat. *baiulus*, "porter" (Plautus *Poenulus* 5.6.17), which looks like οἴσυλος and προϊοῦλος.

19. Cf. Schmidt, *Hesychius*, 4:41 and note.

traine, A. Meineke, and others;[20] the prefix πρό is admissible and the thematic form is freely taken from the aorist.[21] Προφέρω means: (a) "to proceed forward," "to advance" or "to carry to the outside"; (b) "to carry before" (one's time), that is to say, "to precede," "to take the initiative." The idea of haste or audacity is therefore not absent from the verb προφέρω itself. However, the other etymology (νεῖκος), indicating someone who is excessive and quick-tempered, is not too far from the personality attributed to this passionate character and would complete it well. We can then ask ourselves if what we have here is not a pun on the name of the character, something that the comic poets had a predilection for, often using the name of the character to attest his personality (e.g., in Aristophanes, Lysistrata: the-one-who-can-dissolve-armies; or Dikaiopolis: the-one-who-is-just-to-the-city). That would explain why, in new comedy, the term designating the profession of porter does not come from the present tense of the verb φέρω—the term φορεύς ("porter") and also the word φόρτακες, for example, exist already in ancient comedy—but rather from his aorist, which would thus allow the inclusion and placing into relief of the word νεῖκος to indicate a personality feature inherent to this peddler character. The word prouneikos would then represent a character, untamed or untamable, that audaciously and impetuously hurries to the outside, provoking discord or dissension.

The character obviously evokes a personality or certain personality features. That is why, from the field of comedy, the word came into common use as an adjective. From there also came the abstract noun designating a quality, the προυνικία (as φιλόνικος, φιλονικία or φιλόνεικος, φιλονεικία), as well as the verb προυνικεύω attested solely in Epiphanius.

20. M. P. Nilsson, *Opuscula Selecta*, 3:124–27; P. Chantraine, *Dictionnaire étymologique de la langue grecque*, 943; F. H. Bothe, *Poetarum comicorum Graecorum fragmenta* (post A. Meineke), 753–54 nu. 323–24. For his part, Pollux states that the word might come from the Byzantines (see n. 13, above). Also Bochartus (*Hierozoicon, sive Historia Animalium S. Scripturae* 1:794 = 2:112), who argues for a Chaldean origin: from *phuranik*, which means "swiftness," "eagerness."

21. According to the ancient grammarians, the accent and spelling differ: προΰνεικος, προυνικός, προΰνεικος. The spelling differs also in the gnostic and patristic writings: προνικοc (*Second Treatise of the Great Seth*), προγνικοc(ον), φρογρικον? (*Apocryphon of John*), and one quick look at the critical apparatus of Irenaeus's *Adversus haereses* is enough to notice the uncertainty that prevailed concerning its transcription: *pronichon, prunichum, prunicum, pronicum, prianicum,* etc.; see Rousseau and Doutreleau, *Irénée de Lyon* (SC 264), 362 and 366. See also Chantraine, *Dictionnaire,* 754–55, s.v. νίκη; besides νίκη, we find a semantic doublet νῖκος, sometimes spelled νεῖκος (LXX, NT, pop.). As a second term, we find many compounds of νικος, e.g., φιλό=νικος, φιλο=νικία, and the word can be understood in a positive sense (competitive) but also unfavorably (quarrelsome). This ambiguity led to the frequent written form φιλόνεικος, φιλονεικία, in connection with νεῖκος; but it is a secondary connection because the compounds of νεῖκος ought to end in -νεικής, -νείκεια.

Finally, it exists as a proper noun.[22] Comedy was to the moralists, poets, and philosophers—in short, to writers of all kinds—what Homer was to tragedians. The new comedy in particular was to them an abundant source of themes, types, and verbal expressions, since it concerned itself with the study of characters, in the way that Theophrastus would do it for example, though his psychology is much more profound.

With the exception of the Gnostics, there are very few testimonies outside the field of comedy: those of Diogenes Laertius (third century C.E.?) and of Strato of Sardes (around 130 C.E.), the latter having introduced the word in a context of games and amorous rivalries. For if *prouneikos* came to signify any impetuous and audacious leap toward the outside or toward someone, we will understand that it could have been used in very different contexts.

Diogenes Laertius[23] indeed writes that "Xenocrates was always of a solemn and grave character, so that Plato was continually saying to him: 'Xenocrates, sacrifice to the Graces' . . . and whenever he was about to go to the city," τοὺς θωρυβώδεις πάντας καὶ προνείκους ὑποστέλλειν αὐτοῦ τῇ παρόδῳ, "*all the turbulent and hasty (or quarrelsome) rabble in the City used to make way for him to pass by,*" most likely because of his grim appearance.

As far as Strato of Sardes[24] is concerned, in an epigram named the μοῦσα παιδική, he is talking to a young boy (παιδίον) with gloomy face: ἔστω που προύνεικα φιλήματα, καὶ τὰ πρὸ ἔργων παίγνια, πληκτισμοί, κνίσμα, φίλημα, λόγος, "*that there be ever so few kisses eagerly vying (or "an assault of kisses") with the preliminary games, provocations, bickering, kissing, arguing.*" Lovers' tiffs, provocations, and so forth, the epigram is aimed at a listless and tepid boy, to incite him to play and show a little passion: Strato certainly knew the character of the *prouneikos*. We deduced from this text that the word simply meant πορνεία. Indeed, maybe we could replace it with πορνεία, but without metaphor where would poetry be? Be that as it may, that means that the word can be used in a sexual context.[25] Indeed Hesychius, in his lexicon under the word

22. See F. Bechtel, *Die historischen Personennamen des Griechischen bis zur Kaiserzeit*, 519: G. Thasos, 1G 12.8 nu. 484.
23. Diogenes Laertius *De clarorum philosophorum vitis* 4.6.
24. Strato of Sardes *Anthologia palatina* 12.209.
25. In his lexicon, s.v. σκίταλοι, Hesychius uses the word προυνικία: σκίταλοι · ἀπὸ τῶν ἀφροδισίων καὶ τῆς προυνικίας τῆς νυκτερινῆς θεούς τινας ἐσχημάτισεν, "He forged some gods from voluptuous pleasures and from eagerness in the night-time." The σκίταλοι are some impudent and cunning gods or daemons invented by Aristophanes (in *Knights* 634): "Ἄγε δὴ Σκίταλοι καὶ Φένακες . . ."; see Fr. Dübner, *Scholia Graeca in Aristophanem*, 57: "He forged some impudent and shameless daemons for a laugh." Also

σκίταλοι, uses the word προυνικία, which applies to someone who, very likely, is overzealous for sensual pleasure. The use of the word in this sense has raised an objection that we find in Photius,[26] indicating that it must have deviated from its original meaning: προύνεικον· οὐ τὸν ἀκόλαστον (licentious, lewd) ἀλλὰ, τὸν κομίζοντα τινα ἐξ ἀγορᾶς μισθοῦ. καὶ ἔγκειται τὸ ἐνείκω.

Obviously these testimonies do not allow us to apprehend the character of the *prouneikos* from all aspects. Unfortunately, of the new comedy there remain only fragmented papyri of various lengths (two fragmented works by Menander), as well as some Latin adaptations, sometimes quite literal, it is true. It must have been a conventional or semiconventional character, because in comedy types gradually become fairly rigid: they have the same features every time we see them. In ancient comedy the porters were named *phortakes*, in the Latin comedy that came from the Hellenistic Greek comedy, *baiulus*.[27] Thus we can find them through the different eras, with little change in their personality. Numerous statuettes of the Hellenistic and Roman periods represent characters throwing themselves forward, running, leaping, or dancing (only rarely are they young though).[28] In comedy, the movements have to be quick and lively, in particular for characters like the porters, servants, and slaves (e.g., the *servus currens*). In new comedy, this kind of character is often viewed with a lot of sympathy and his personality is given many different shades. He is most of the time characterized by his astuteness, his taste for stratagems, and he often serves as an instigator in the story. He is always ready to leap up, suddenly turning about when the situation calls for it, struggling, feverishly moving back and forth as he elaborates some new scheme. And if the epithets νεῖκος and ὕβρις were attributed to this young and passionate character, they must not have been meant in the sense of violence or extreme savagery but rather as temerity, boldness, and excessive competition.

In the middle, and especially the new comedy, we notice a growing interest for the study of characters (whereas the old was more interested

in Longus, an erotic poet (G. A. Hirschig, *Erotici scriptores*, 159 nu. 3.13), the verb σκιταλίζω applies to somebody who is eager for sensual pleasure. However, the word σκίταλοι applies to characters from *comedy*, and in Aristophanes it rather means "cunning," "audacious," "shameless."

26. Photius *Lexicon* (ed. Naber), 116. Photius says the word also means "overzealous," "eager," "fiery" (see n. 15, above). In other words, with a function in comedy (here, the fact of peddling or carrying) is always connected a personality.

27. See n. 18, above.

28. See M. Bieber, *The History of the Greek and Roman Theater*, chaps. 7, 8, and 12.

in politics). In Menander, for example, the problems raised are some-
times those of peripatetic ethics.[29] And what we have left of this new
comedy, other than the numerous fragments, are the countless citations
of the Greek authors, particularly of the most philosophical excerpts.
The *Anthology* of Stobaeus abounds in such passages, and some persons
such as Justin and Clement of Alexandria[30] drew from it many of their
arguments: against idolatry, on marriage, on God, and so forth. It is
therefore not surprising that the Gnostics themselves were inspired by
it.[31] The use of a word like *prouneikos* certainly had a pedagogical end: it
must have evoked for their followers what Tartuffe or Scapin means for
us today. And, as we will see, that allowed them to explain, using a
single colored and evocative word, the part played by Wisdom in the
organization of the exterior world.

2. SOPHIA PROUNEIKOS[32] (OR THE SHAKING
OF THE UNSHAKABLE RACE)

In Irenaeus's notices on the Gnostics, the appearance of Sophia Prou-
neikos right away causes a febrile agitation in the lower pleroma. This
takes place in the lower end of the pleroma, since Sophia is often pre-
sented as the last-born aeon.[33]

Irenaeus *Adv. haer.* 1.29: The Holy Spirit that the Gnostics also call
Wisdom and Prounikos "started to do her utmost (or "to struggle") and to
stretch herself out and to look towards the lower regions (*adseverabat et*

29. See T. B. L. Webster, *Studies in Later Greek Comedy*, chap. 4; and A. Blanchard,
Essai sur la composition des comédies de Ménandre, 415 n. 25. Some important fragments
of comedies by Menander were found in Egypt. According to Diogenes Laertius (*De
clarorum philosophorum vitis* 5.36), he was Theophrastus's pupil whose book of *Char-
acters* undoubtedly influenced the psychological descriptions and analyses of character
by Menander and other writers of new comedy. The Latin poet Terence imitated
Menander (he is called a "half Menander" by Caesar).
30. Clement of Alexandria *Stromateis* 2.23.137; 2.23.141; *Protrepticus* 68.4; 75.2.4; 105.2
(without mentioning Menander's name); Justin Martyr *1 Apology* 55; also Paul, 1 Cor.
15:33: "Bad company corrupts good morals," ascribed to Menander by Jerome (*Epistula*
70.2).
31. M. Harl, "Les 'mythes' valentiniens de la création et de l'eschatologie dans le
langage d'Origène: le mot hypothesis," in *Rediscovery* (ed. Layton), 1:417–25; in the
heresiologists' writings, the word *hypothēsis* refers to the plot in a play.
32. Nilsson alone studied the etymological meaning of the word *prouneikos* in rela-
tion to Sophia (see n. 20, above). Many other interpretations or translations have been
put forward—e.g.: N. A. Dahl, "The Arrogant Archon and the Lewd Sophia: Jewish
Traditions in Gnostic Revolt," *Rediscovery* (ed. Layton), 2:706–12; S. Giversen, *Apocry-
phon Johannis*, 194–95; S. Pétrement, *Le Dieu séparé: Les origines du gnosticisme*, 144–46;
and Stroumsa, *Another Seed*, 62–65.
33. Tertullian *Adversus Valentinianos* 9.2.

extendebatur et prospiciebat ad inferiores partes) . . . then she leaped out-
side *(exsiliit),* sprung impetuously *(impetum fecerat).* But she was over-
whelmed with disgust because she had sprung without the Father's
agreement."

Irenaeus *Adv. haer.* 1.30: The Holy Spirit, also called the Mother of the
Living, "was unable to carry and contain the extreme Greatness of the
Light, so they say, she was overfull and bubbling over on the left side
(*superrepletam* and *superebullientem:* Prouneikos is not content with
mere boiling, she is superboiling). Thus the Power, which bubbled over
from the Woman, had a dew of light. Quitting the Father's sphere, she
rushed toward the lower regions, *on his own initiative,* taking away with
her the dew of light. This Power, they call her the Left or Prounikos, or
Wisdom, or Man-Woman. She went down straight into the waters when
they were still, set them in motion, daringly stirring them to the very
depths, and she took on a body from them" (daringly: *petulanter, petu-
lantia* designates a hotheaded personality, provocative, impetuous).[34]

We could perhaps deduce, from these first descriptions, that Irenaeus
knew the character of *prouneikos* and that it was in his best interest to
accentuate the leapings and the contortions in order to ridicule the
gnostic Wisdom.

At Nag Hammadi, in the *Second Treatise of the Great Seth* for example,
the description is more allusive and sober. At 50,27–33, we read that our
sister Sophia is called Pro(u)nikos ετε μπογταογος·ογτε μπεσρ
αιτι νλααγ ντοοτϥ μπιπτηρϥ· μν †μντνοϭ ντε τεκκλнсια μν
πιπληρωμα εαсρ ϣορπ, "that is to say that she had not been sent and
had asked nothing to the Whole, neither to the Greatness of the Church,
nor to the pleroma, when she made the first move" (ρϣορπ: to dash, to
hasten, to precede, to take the initiative).

In the *Apocryphon of John,* however, her part is exposed in detail and
her attitude is, as we will see, more theatrical (BG 36,17—37,1):
αсμεεγε εγμεεγε εβολ ν2нтс αγω 2ραϊ 2м πμεεγε μπεπ̄ν̄ᾱ μν
πϣορπ νсοογν αсρ 2νас εογωn2 μπι[νε] εβολ ν2нтс...(BG 37,7–

34. For my translation, I drew inspiration from Rousseau and Doutreleau, *Irénée de
Lyon* (SC 264), 367. Prouneikos's bustle is linked to the move back and forth of the
Spirit in Gen. 1:2b; in the *Apocryphon of John* also, yet with a different meaning, see n.
47, below. From her left side, the Spirit lets drop a luminous Power, while from the
right side comes forth Christ, who, at once, goes back up to the pleroma: the straight-
ness of the right side is on the pattern of the motion of the fixed stars, it is a rise; the
obliquity of the left side, on the pattern of wandering stars, it is a going down. Con-
versely, in the *Chaldaean Oracles:* from the right side of Hecate overflows the cosmic
soul which will animate the various worlds; from her left side, a Power which remains
inside (see H. Lewy, *Chaldaean Oracles and Theurgy,* 88.

13) ⲉⲥⲛⲁⲕⲁⲧⲁⲛⲉⲅⲉ ⲉ̇ϫⲛ ⲧⲉⲩⲇⲟⲕⲓⲁ ⲙⲡⲉⲡ̅ⲛ̅ⲁ̅ ⲙⲛ ⲡⲥⲟⲟⲩⲛ ⲙⲡⲉⲥ-
ⲥⲩⲙⲫⲱⲛⲟⲥ ⲙⲙⲓⲛ ⲙⲙⲟⲥ ⲉⲥⲧⲱⲕⲉ ⲉⲃⲟⲗ ⲉⲧⲃⲉ ⲡⲉⲡⲣⲟⲩⲛⲓⲕⲟⲛ ⲉⲧⲛ-
ϩⲏⲧⲥ ⲡⲉⲥⲙⲉⲉⲩⲉ ⲙⲡⲉϥϣ ϣⲱⲡⲉ ⲛⲁⲣⲅⲟⲛ, "She (Wisdom, our twin
sister) formed a project of herself and thinking of the Spirit and of the
First Knowledge, she wanted to manifest (its) resemblance (or "manifest
a likeness") *by herself*. . . . It is without the approval of the Spirit and
without knowing who is destined to harmonize with her that she will
slant towards the bottom (or "will start a descent")[35] by throwing to the
outside (or "by spouting to the outside") because of that untamable and
proneness to rivalry (Power) that is in her: her plan could not remain
sterile."

Sophia carries or throws to the outside (ⲧⲱⲕⲉ ⲉⲃⲟⲗ) because there is
in her an impetuous and untamable (ⲡⲣⲟⲩⲛⲓⲕⲟⲛ) Power. ⲧⲱⲕⲉ and
ⲡⲣⲟⲩⲛⲓⲕⲟⲛ are linked in the *Apocryphon of John* (see III 23,20–21; BG
51,2–5). According to Crum, ⲧⲱⲕⲉ ⲉⲃⲟⲗ corresponds to ἐκβάλλω or to
πρόειμι, that is to say, the equivalent of προφέρω (or προφέρω itself), with
perhaps in addition a shade of violence or hastiness. ⲧⲱⲕⲉ ⲉⲃⲟⲗ also
means, according to R. Kasser (in his *Compléments au dictionnaire copte
de Crum*, p. 63): to produce luminous emanations, to strike sparks, in
short, σπινθηρίζω; cf. †ⲕ, σπινθήρ ("spark"). It is possible that the author
has here played upon the different meanings of the word, because what
Prouneikos is about to carry outside the pleroma is her luminous
Power,[36] generative and sovereign, as well as, in Irenaeus's notice on
Ophites, the organization of the lower world starts with the projection to
the outside of a dew of light. And while ⲧⲱⲕⲉ describes a transport
toward the outside, it seems to us that the word ⲡⲣⲟⲩⲛⲓⲕⲟⲛ indicates
the reason of that movement, or explains how Sophia carries it out: by
acting without permission or agreement. It is then as νεῖκος ("dissen-
sion"), or rather as *proneikos* that we must take it here also. In a few
words, it means "somebody who cannot be held back (untamable or
indomitable) because he is eager to spread as a peddler (his Power), thus

35. In the *Apocryphon of John*, κατανεύω is always the origin of a creative deed. In my
opinion, it means here not "to nod (one's head) to agree with someone" (Sophia does
just the opposite) but "slant toward bottom." In other words, she is making the first
move toward a descent which will lead to the creation of the lower world; cf. A. J.
Festugière, *La révélation d'Hermès Trismégiste*, 3.92. According to the Gnostics whom
Plotinus met, the Soul, joined with a certain Wisdom, slanted toward bottom. It has not
gone down itself, but it only has enlightened the darkness. This slant led to the going
down of a lot of individual souls (Plotinus *Ennead* 9.10.19).

36. ⲧⲱⲕ, ⲧⲱⲕⲉ also means "to be powerful" or "to become powerful." In the *Apocry-
phon of John*, this verb is always linked to the outflow of Sophia's Power; see *Ap. John*
III 23,19–21; 24,5–6; 15,22–24 (in the other versions: ⲉⲓⲛⲉ ⲉⲃⲟⲗ: προάγειν, προφέρω).

provoking discord."[37] As we will see later, Sophia is indeed the cause of a rift between the upper world and that which will become the lower world.

2.1. Double function of Prouneikos in the so-called gnostic texts, Ophites or Sethians

a. Projection of her Power outside the upper world

The first function of Prouneikos is described in explicit terms in Irenaeus's notice on the Ophites as well as in the *Apocryphon of John*.

1. In Irenaeus *Adv. haer.* 1.30, the organization of the lower world starts with the boiling and the uncontrollable overflowing of a luminous Power that springs audaciously to the bottom of the immobile waters to set them in motion.[38] This Power draws from these waters or lower elements a body that makes her feel heavy.

Feeling in a sorry plight, she hatches a machination *(machinatam)* in order to keep the upper Light from suffering from the inferior elements the way she has. Thanks to the dew of light that she carries inside her, she rebounds *(resiliit)* and unfolds herself, creating a heaven with part of her body. This heaven separates the upper and lower worlds. Then she delivers herself and expels the remains of the body. These remains are her son, to whom she has left part of her dew of light: it is the Archon.

2. In the *Apocryphon of John*,[39] Sophia elaborates a plan: she wants to manifest a resemblance *by herself*, that is to say, to imitate the Spirit in the work of the creation and organization of the world (the Spirit manifests by itself, without needing a mate). She carries out this plan without the approval of the Spirit and without an agreement with her mate. She

37. It is very difficult to translate the word *prouneikos* or *prouneikon* by a single word. In the heresiologists' writings, it is a proper noun: the proper noun evokes a character that includes several personality features. See also *Ap. John* III 15,2–4: ⲛⲉⲥⲭⲏⲕ ⲉⲃⲟⲗ ⲉⲧⲃⲉ ⲡⲉⲫⲣⲟⲩⲣⲓⲕⲟⲛ ⲉⲧⲛ2ⲏⲧⲥ. *(a)* ⲭⲏⲕ ⲉⲃⲟⲗ: πλήρης, 'be full,' 'overflow,' or 'be loaded" (sometimes: with a child). *(b)* ⲫⲣⲟⲩⲅⲣⲓⲕⲟⲛ, which means "of a watch," is perhaps a mistake. The word is interesting, however: a watchman stands on the frontier and looks outside (maybe an allusion to the watchers in 1 Enoch?). *Ap. John* II 9,35—10,2: ⲉⲧⲃⲉ ⲧ6ⲟⲙ ⲇⲉ ⲛⲁⲧⲭⲣⲟ ⲉⲣⲟⲥ ⲉⲧⲛ2ⲏⲧⲥ: ⲁⲧⲭⲣⲟ = ἀνίκητος from νίκη; see n. 21, above, about the semantic doublet νίκη/νεῖκος. The writer played on words and gave a positive interpretation of the passage: Sophia shares the Power of Adamas which is indomitable (6ⲟⲙ ⲉⲙⲁⲅⲭⲣⲟ ⲉⲣⲟⲥ) or unconquerable (ἀδάμαστος); see *Ap. John* III 13,1–10. Cf. ἀδάματος = ἀδάμαστος = unwedded (women).

38. Before Prouneikos went out of the upper world, the Spirit—also called "the Mother of the Living" (Zoe)—hovered over the lower elements.

39. *Ap. John* BG 36,16—39,1; II 9,25—10,23; III 14,9—16,4. Contrary to Irenaeus's notice, the lower elements do not exist yet.

first gives birth to an abortion, that is to say, a shapeless gloom with no resemblance to the upper world, because it was conceived without a mate.

Faced with this shapeless being, Sophia then uses a stratagem to carry out her plan (to manifest a resemblance): she expels the abortion so that no immortal will be able to see it, then unfolds or unfolds herself in the shape of a luminous cloud that hides the deformity of the abortion and at the same time gives him the Power.[40] The mingling (NOYϨB) of this Power or of the luminous cloud and the abortion produces the first Archon. From an abortion, Sophia creates an Archon. Her plan is a success: it results in the installation of a demiurgic and royal Power in the likeness of the upper world.[41]

In the *Apocryphon of John* as in Irenaeus's notice (*Adv. haer.* 1.30), Prouneikos's undertaking unfolds in a similar motion, despite the doctrinal differences:
• Audacious exit (with disagreement) with the intention of creating and organizing a world by herself (carrying to the outside a luminous Power).
• Intention that materializes itself through the conception of a shapeless body-burden that makes heavy and embarrasses.
• And by the expulsion of this burden which leads:
 • to the deployment of a heaven or luminous cloud that separates.[42]
 • to the appointment of an Archon.

This cosmogony presents itself as a cosmic birth or abortion: ejaculation of light, conception of a body-burden, expulsion.[43] In both cases,

40. See M. Tardieu, *Ecrits gnostiques: Codex de Berlin*, 275: the luminous cloud which surrounds the abortion is the dwelling place of the glory of Yaveh (Exod. 16:10; 19:15, 16; 24:16; 34:5). Also in Sir. 24:4, Sophia's throne is in a cloudy pillar. In the *Apocryphon of John*, Sophia gives her Power to her son; she is giving him a name and a throne: it is an *enthronement* and her plan results in the installation of an Archon. So when *Ap. John* III 23,20–21 says that she gave the Archon her Power (ϨN OYΠPOYNIKON), it seems to us that the word *prounikon* should be translated according to this context—a lust for power—even if, in some texts, her impetuosity is also a sexual one (see in Irenaeus *Adv. haer.* 1.30: Sophia's desire for a partner) and a desire to give birth. The emphasis on a lewd or obscene meaning, however, is rather the work of heresiologists, since the desire to mate is good in the pleroma, according to the Father's will; cf. n. 62, below.
41. Cf. *Orig. World* 100,1–6: "Now when Pistis Sophia desired [to cause] the one who had no spirit to receive the pattern of a likeness [ϵINϵ] and rule over the matter and over all its powers, a ruler [ΑPXⲰN] first appeared" (trans. H.-G. Bethge and O. S. Wintermute, in *Nag Hammadi Library* [ed. Robinson]), 163.
42. In many texts, Sophia herself remains in a middle region between the pleroma and the lower world until she has corrected her deficiency.
43. As regards Sophia, often called "the mother," all the words might be understood in a physiological meaning: φορτοφορέω means "carry a burden" or "be pregnant" (φορτίον, "burden" or "child in the belly"); προφέρω, "create outside" or "give birth";

there is projection outside the upper world of a luminous Power (προφέρω) with the intention of organizing the inferior elements or a shapeless matter (abortion), and this organization is carried out through rejection, expulsion, through separation as well as through dissension (νεῖκος), because of Sophia's impetuosity, of her zeal or even of her excessive fecundation.[44]

3. The son or Archon of Prouneikos. What Sophia engenders is a creation that contains ignorance, presumption, and dissension.[45] In the *Apocryphon of John*, for example, the Archon immediately turns away from his mother, carrying away her Power. Having conceived sons (without her approval), he gives birth to the inferior authorities, angels and powers, then blasphemes by declaring that he is the only God and "of the pure light of the Power which he had drawn from the mother he did not give them. And that is the reason why he is Lord over them because of the glory which was in him from the Power of (the light) of the Mother. And that is the reason why he had called himself God."[46]

Losing control over her creature, Sophia loses part of her luminous Power and fades away. In the *Apocryphon of John*, she is then plunged into a fog and into an abyss of perplexity: we see her springing in a feverish back and forth motion (ἐπιφέρομαι)[47] before daring to turn about, that is to say, repent and ask for help from the upper world.

ⲛⲟⲩϫⲉ ⲉⲃⲟⲗ = ἐκβάλλειν could mean "abort"; ἀργεύομαι (ἀργέω), "be sterile"; etc. In Irenaeus's notice (*Adv. haer.* 1.30), the luminous Power that Prouneikos is carrying downward attracts as a magnet all the lower elements which gather and become as a body that makes her feel heavy. Then, thanks to this same Power, Prouneikos is able to expel this body: all this is reminiscent of Galen's attractive and repulsive faculties (*On the Natural Faculties* 2.3; 3.1–3, e.g.). Also for the physics of receptacle and overflowing which could explain pregnancy in Greek medical science, the idea that restlessness and movement activate the semen, etc., see R. Joly, *Hippocrate* 11, introduction.

44. See Irenaeus *Adv. haer.* 1.29.4: Sophia is moved by goodness or prodigality. In all these texts, she "leapt forth" without any approval or agreement, or manifested "by herself" or "without asking anything" or "rushed towards the lower regions, on his own initiative": this is Sophia's defect.

45. See Irenaeus *Adv. haer.* 1.29.4: "He (the proarchon) stole from his mother a great Power and departed from her into the lower regions. . . . He united with Presumption and begot Wickedness, Jealousy, Envy, Discord and Passion." Irenaeus *Adv. haer.* 1.30.5: "The first of them is Ialdabaoth, who despises his mother inasmuch as he made sons and grandsons without anyone's permission. . . . When they were just made, his sons turned to contention and strife with him about the primacy." (For my translation, I drew inspiration from Foerster, *Gnosis* [trans. and ed. Wilson], 1:88, 89, 105; and Rousseau and Doutreleau, *Irénée de Lyon* [SC 264], 363, 371. For the expression "Son of Prounikos," see Theodoret *Haereticum fabularum compendium* 14.)

46. *Ap. John* BG 42,16—43,4; see Tardieu, *Ecrits gnostiques*, 113, 114; also Irenaeus *Adv. haer.* 1.29.4; 1.30.6. Ialdabaoth also possesses his own Power which is inferior to the mother's.

47. The authors turned the motion of the Spirit over the waters (Gen. 1:2b) into a state of agitation, playing once again on the various meanings of the verb φέρω, here ἐπιφέρομαι which sometimes means an impetuous rush or "rush around."

Because of the Archon, the Power of Prouneikos is stopped in its impulse since he keeps it prisoner: he has cut all the links that existed between this luminous particle and the upper world.

b. Second function of Sophia Prouneikos as a peddler;[48] escaping the Archon and his sons, her Power then continues to spread

Having repented, Sophia wishes to take away the Power that she has given the Archon in dissension (or: insubordination, ϨΝ ΟΥΠΡΟΥ-ΝΙΚΟΝ).[49] A stratagem is then arranged for this purpose: an image of the celestial Man appears in the lower world,[50] which provokes the Archon and his angels to create a man "according to the resemblance." The Archon himself is then urged to insufflate the Power into his creature.

> Sophia contrived also, so as to empty him (Jaldabaoth, the Archon) of his drop of light, so that, being deprived of his Power, he would not be able to rise up against those above. As he breathed into the man the breath of life, they say that he was unwittingly emptied of his Power. But the man thus got *Nous* and *Enthumesis* (thought), and that is what will be saved, they say; and he at once gave thanks to the First Man, forsaking his creators.[51]

It is "the man according to the *resemblance*," the result of Prouneikos's scheme.

This text by Irenaeus had the advantage of summarizing what is presented in more elaborate fashion in the *Apocryphon of John*, for example,[52] with of course some differences. The same story is taken up again by Epiphanius in his notice on the Ophites: he specifies among

48. Irenaeus's notice on Barbelo Gnostics (*Adv. haer.* 1.29), interrupting the story just after the Archon's blasphemy, is of no use anymore. On the other hand, the *Second Treatise of the Great Seth*, just as Irenaeus and Epiphanius's notices on Ophites, lays stress on Prouneikos's taking part. As for the *Apocryphon of John*, this taking part is minimized a little (see n. 52, below). Since, in this part, her function is beneficial—the preparation for salvation is at stake—it might imply that the latter text views her with a not so favorable eye, as the *Second Treatise of the Great Seth*, e.g. As far as Epiphanius is concerned, he seems to explain the word *prouneikos* in reference to the second function of Sophia only; see 2.2 Prouneikos in Epiphanius.

49. *Ap. John* III 23,20–21: ΑϹΡ ϨΝΑϹ ϬΕ ΝϬΙ [ΤΜΑ]ΑΥ ΕΤⲰΚΕ ΝΤΑΥΝΑΜΙϹ ΝΤΑϹ[ΤΑΑϹ Μ]ΠΑΡΧⲰΝ ϨΝ ΟΥΠΡΟΥΝΙΚΟΝ. See also BG 51,2–5: ΠΑΡΧⲰΝ ΝΤΕ ΠΕΠΡΟΥ-ΝΙΚΟϹ, "the Archon of insubordination" or "of dissension" or "who cannot be tamed." One would rather expect here the word προυνικία (not encountered before the fourth century?).

50. *Ap. John* BG 47,14—48,5; Irenaeus *Adv. haer.* 1.30.6.

51. Irenaeus *Adv. haer.* 1.30.6. Also, *Ap. John* BG 51,1—52,1; III 23,19—24,14; II 19,15–33. Without Prouneikos's Power, the creature of the Archons (or of the Archon and his powers) would be inactive and motionless (ΑΤΚΙΜ, ΑΡΓΟΝ).

52. In the *Apocryphon of John*, e.g., the four Lights are coming down from the upper world in order to drain the Archon's Power.

other things that the Power of the Mother is a spark of light ($\sigma\pi\iota\nu\theta\acute{\eta}\rho$) and that it is called the soul from the moment that it is passed into man. We found the same account in the *Apocryphon of John*.[53] From then on, the Power of Prouneikos, the soul, will spread: from Adam it will be passed over to his descendants and will be distributed from body to body. In the *Second Treatise of the Great Seth*, for example, Sophia Prouneikos has gone out "to prepare residences and places": she picks her work companions among the lower elements so that they will build "bodily houses." Living in bodies from then on, the souls (in the *Second Treatise of the Great Seth* they are called *ennoias*) are ready to receive the masculine Aeons saviors, their mates, and those can then go down to live there as well.[54] Also in the *Apocryphon of John*, "Those on whom the Spirit of Life will come down and will be joined to the Power will be saved."[55] In this part, Sophia's role is beneficial, because by allowing the Power to escape the Archon she has prepared salvation.

Irenaeus's notice on the Ophites (*Adv. haer.* 1.30) describes in very precise fashion the efforts displayed by Prouneikos to protect her Power against the Archon's intrigues, so that it can propagate from Adam and Eve, in Seth and Norea and their descendants.[56] She does not stop *spreading it around*, emptying or filling up depending on circumstances (e.g., Eve, so that the Power that inhabits her be not tarnished by the Archons), acting against the plans of the Archon in all and always behind his back, laughing at him when she sees her own stratagems succeed. The insubordinate personality of Prouneikos has turned itself against the Archons. The man who has her Power can disobey them because he is superior to them.[57] Here the activity of Prouneikos stops. Salvation itself can then start for men,[58] while our sister Sophia "who had herself no respite,"[59] awaits her mate's arrival.

This portrait of Prouneikos is that which appears in the Ophite and

53. Epiphanius *Haer.* 37.4.2; 37.6.1–4; *Ap. John* BG 67,10; III 34,12; II 26,15.
54. *Treat. Seth* 50,25—51,17; see L. Painchaud, *Le Deuxième Traité du Grand Seth*, 26–29 and 81–84.
55. *Ap. John* II 25,23-25; see Tardieu, *Ecrits gnostiques*, 149. And similarly, Adam is ready to be united with his celestial mate, the spiritual Eve.
56. Irenaeus *Adv. haer.* 1.30.9 (trans. in Foerster, *Gnosis*, 1:91): "By the providence of Prunicos . . . Seth was conceived, and then Norea; from them they say the rest of the human multitude is descended." In this notice, Prouneikos's function (as a peddler) is emphasized.
57. See *Ap. John* BG 58,8-10.
58. The Savior will fulfill the separation from the Archons that Prouneikos prepared just as the Archon fulfilled the separation from the upper world that she had started; see n. 66, above.
59. Irenaeus *Adv. haer.* 1.30.12; Prov. 7:4.

Barbelo Gnostic notices, and at Nag Hammadi. Epiphanius, however, quotes the term in his chapters on the Nicolaitans and on the Simonians, as well as in a letter attributed to the Valentinians. That is why I think it would be interesting to end by observing the character under this slightly different lighting.

2.2. Prouneikos in Epiphanius

a. The Nicolaitans or the practice of salvation (*Haer.* 25.3.2)

Epiphanius, speaking of the followers of Nicolas, writes that they prepare their salvation by bringing together again the Power of Prouneikos, bringing it out of the bodies through the ejaculation of the sperm and the blood of the menses. He specifies later: "The Power which resides in the periods and in the semen, they say, is a soul, which we collect and eat."[60] As we know, this practice was to be an obstacle to procreation; it was opposed to the command to "increase and multiply" of the Book of Genesis (or at least to its literal interpretation), since the multiplication of bodies would split up and alienate more and more the Power of Prouneikos. In his notice on the Ophites, Epiphanius interprets the word *prouneikos* in reference to the *second* function of Sophia, which is her stratagem to drain the Archon's Power.[61] And, in the same way that Sophia had emptied the Archon by prompting him to insufflate this Power into Adam and his sons in order to protect it, salvation itself consists in bringing the Power out of the bodies, to assemble it and bring it back to the upper world. Now, according to Epiphanius, the Gnostics that he had met would not interpret symbolically but sexually the ritual of the "nuptial chamber" and the assembling. For Epiphanius the word *prouneikos* therefore means "a seduction's attempt, the pursuit of pleasure" (the verb προυνικεύω, according to him, would be used by the Greeks to signify "rape").[62] Because, he adds, in the erotic Greek myths it

60. Epiphanius *Haer.* 25.9.4; see M. Tardieu, "Epiphane contre les gnostiques," *Tel Quel* 88 (1981) 71 and 84 (notes).

61. Epiphanius here plays ironically with the different meanings of the verb κενόω which signifies "to empty" but also "to make sb. impotent" (*Haer.* 37.6.1–4). In his view, Prouneikos is the one who made the Power (or the seed) gush forth out of the Archon but, at the same time, made him impotent (since he is emptied of his Power), which is absurd. Cf., in other texts, the revelation of the image of the Man in the lower waters or the attempt to seduce Barbelo (according to Epiphanius *Haer.* 25.2.4), who appeared to the Archons in beauty in order that they may ejaculate her luminous Power. But that is the preparation for salvation (according to the Father's will).

62. Cf., following Epiphanius, Nicetas (Acominatos) *Chron. in thes. orthod. fidei cathol.* 4.2: "Gnostics honour a certain Prounikos whose Power is in the sperm" and in his view

is said that κάλλος προύνικον, "beauty is seductive or provokes agitation." But to which erotic Greek myths is Epiphanius referring? That of Helen of Troy, taken up again by Simon the Magician, is probably one of them.

b. The Simonians (Haer. 21.2.4ss)

This notice relates the descent of a superior Power, named Ennoia or Prounikos (or Barbelo or Barbero in other heresies). This Power had sprung out of the Father and, anticipating his intentions, had created the powers and the angels by whom the world and man were then created.[63] Epiphanius here specifies that it is Helen who, "in the ancient myths," had caused the Trojan War, for "her beauty appeared" to the powers and angels, "thus provoking their agitation." Seduced, they held her captive out of jealousy, and since they were all quarreling for her possession, fights and a constant state of war prevailed. The powers then started to kill one another. Helen-Prouneikos herself is dragged toward the lower world, locked and decanted from body to body for centuries.

Helen-Prouneikos provokes, through her beauty, *dissension* and war (ἔρις, "dissension," often combined with νεῖκος in the *Iliad*, is the origin of the Trojan War).[64] The word *prouneikos*, however, does not come from Homer, as Epiphanius seems to believe. It is inscribed in the gnostic interpretation of the myth of Helen. Her beauty symbolizes that of the soul over which the lower elements quarrel and which will be split up little by little from body to body.[65]

c. The letter attributed to the
Valentinians (Haer. 31.5—6.10)

In this letter attributed to the Valentinians by many authors (K. Holl,

the word means "rape." Nicetas adds, however, that the Greek word for "rape" is not προυνικεύω but rather πορνεύειν. Thus sometimes the word *prouneikos* must have been taken for πορνικός (and related to ὕβρις, ὑβρίζω). It is evident that the heresiologists made good use of this meaning against their gnostic opponents.

63. Irenaeus *Adv. haer.* 1.23.2; Hippolytus *Philosophumena* 6.19. According to Tertullian's account (*De anima* 34), Ennoia anticipated the Father's purpose.

64. According to a late legend, the apple of discord was the one that Paris gave to Aphrodite which gave rise to Hera and Athena's hate. With the help of Aphrodite, Paris then kidnapped Helen, thus provoking the Trojan War; see Hyginus *Fabellae* 92 and Lucian *Dialogi Marini* 5.

65. This notice agrees with Irenaeus's notices, the *Apocryphon of John*, and the *Second Treatise of the Great Seth* about Prouneikos's function, with some differences: she *leaped forth* from the Father, gave birth to angels and powers "by whom the world and *man* were created," and provoked dissension. However, (a) she knew what her father *willed* and (b) she does not remain in a middle region, as Sophia does, but is decanted from body to body: being more closely linked to the multiplicity of souls, she prostituted herself (cf. *Exegesis on the Soul*).

O. Dibelius, W. Foerster, etc.), the word *prouneikos* designates some superior aeons in the pleroma, not only the last one. The *prounikia* here proceeds directly from the first principle or the Autopator.

While everything until then was at rest and nothing had yet manifested itself, the Ennoia of the Autopator who is in him wished. (Ennoia is the first Thought of the Autopator, also called Sige.) She, indeed, decided to *break* the eternal bonds; she became woman (ἐθήλυνε), then mated with the Autopator and manifested the Immortal Man with his mate, Truth. Here begins the heavenly androgyny. Through this androgyny, Ennoia wished to reveal the natural unity of light; for the union of Man and Truth is due to desire (θελητός), desire that compares itself with the attraction, or to the natural cohesion, of light with light. For that purpose, Ennoia sees to it that from Truth, the *separation* (μερίζω) in masculine and feminine lights be equal, so that the natural cohesion of light can be manifested to those who are separated in perceptible (masculine and feminine) lights in the lower world.

Then Truth reveals (or utters, προφέρω) a προυνικίαν μητρικήν, an eagerness to proliferate, comparable with the mother's desire to give birth. She became woman, or started to act like a woman, to seduce her mate and join with him. For this coming together, a tetrad is born which conceives a dodecad of *prounikoi* aeons, that is to say, aeons who compete in prolific eagerness, are obviously androgynous, and who in turn conceive more aeons until they realize a triacontad, and so on and so forth.

In other words, the manifestation of light can be realized only through separation, through the fragmentation into masculine and feminine lights, the source of a more and more rapid multiplication, bouncing in the way that numbers do. The heavenly androgyny leads to a will to mate, just as in the lower world the sexual impulse will result directly from the separation of Adam and Eve. However, in the upper world desire is the source of a plurality in unity.[66]

66. It is important to add a few notes on the account of Origen, who also ascribes to the Valentinians the word *prouneikos*. According to Celsus (Origen *Celsus* 6.34), Christians "add one thing on top of another, . . . circles upon circles, emanations of an earthly Church and of circumcision, the flowing power of a certain virgin Prunicos, and a living soul, and heaven slain so that it may live, and earth slain *with the sword*, and many people slain so that they may live." Referring to this quotation, Origen explains (in *Celsus* 6.35) that "Prunicus is the name which the Valentinians give to Wisdom, . . . who is, according to them, symbolized by the woman with an issue of blood, who suffered for twelve years," pointing out to us what was the Valentinian exegesis of Luke 8:43–48 (Matt. 9:20–22; Mark 5:25–34). Cf. Irenaeus *Adv. haer.* 1.3.3: "For the one who suffered for twelve years, they say, is that power which extended itself and would have

In conclusion, what did the mythical character of Prouneikos incarnate for the Gnostics? Most likely, the cosmic principle of separation, source of plurality, without which there could be no life. She thereby evokes the νεῖκος of Empedocles or of the Pythagoreans, which we find also in Apollonius Rhodius and certain Gnostics such as Marcion, according to Hippolytus's testimony. She also evokes the dyad of the Pythagoreans, which generates numbers, the source of plurality and division, and which they identify with ἔρις and τόλμα, dissension and boldness. This dissension, the principle of movement, has as its function the fragmentation from the original Whole, and she is the cause of the entire creation.[67] According to Hippolytus, because of her, the souls have to wander and pass from one body to another.[68]

But this dissension (νεῖκος) exists only in her dialectical function. She is opposed to a cosmic principle of attraction, erōs, philia, or philotēs, depending on the texts, that brings back the beings from plurality to unity. In the gnostic texts, this principle is called "harmony" (συμφωνία, συμφώνησις), or θελητός, εὐδοκία, in Coptic oγωϣ, the principle to which Prouneikos is always opposed. In the upper world, the detachment achieved through coupling and generating is made by the intervention of that beneficent harmony; in the lower world, it is dissension itself that provokes it: the lower world is the result of a difference.

Why then Prouneikos and not νεῖκος, the maleficent dissension per-

flowed into the immensity of substance." Irenaeus adds that Sophia was cured after she had touched the garment of the son, after twelve years (she is the twelfth aeon). And "if she had not touched the garment of the son, that is, the Truth of the first Tetrad, . . . she would have been dissolved into the general essence." The power which went forth from the son—and which they maintain is Horos (boundary)—healed her and separated the passion from her or her *enthumesis* ('plan'). Then Origen comments: "Emanations from the earthly Church and circumcision are perhaps derived from the fact that, according to some people, the Church on earth is an emanation of a heavenly Church and of a higher *aeon*, and the circumcision written in the law is a symbol of a circumcision which happens there as a purification" (trans. in Foerster, *Gnosis*, 1:98, 99, 132). To the uncontrollable flow of the woman corresponds a circumcision, and to the overflowing of light from the left side of the Spirit corresponds the flow of blood from Christ's side, which symbolizes the exit of the church. Cf. also M. van Esbroeck, "Col. 2,11: 'Dans la circoncision du Christ,'" in *Gnosticisme et monde hellénistique*, 229–35.

67. Empedocles frg. 16.29.115 (see H. Diels, *Die Fragmente der Vorsokratiker*, 1:314, 324, 356); Aristotle *Metaphysica* 985.24; Apollonius of Rhodes *Argonautica* 1.496ss; Plutarch *De Iside* 75; Clement of Alexandria *Protrepticus* 5; *Theologumena arithmeticae* 89. Cf. G. C. Stead, "The Valentinian Myth of Sophia," *JTS* 20 (1969) 98–100 and n. 1, p. 100.

68. Hippolytus (*Philosophumena* 7.29,3—31,4) identifies Empedocles' daemons with the souls; see J. Frickel, "Unerkannte gnostische Schriften," *Gnosis and Gnosticism*, 126–30; J. Mansfeld, "Bad World and Demiurge: A 'Gnostic' Motif from Parmenides and Empedocles to Lucretius and Philo," in *Studies in Gnosticism and Hellenistic Religions* (ed. R. van den Broek and W. J. Vermaseren), 278–90; also, Hippolytus *Philosophumena* 6.23,25 (Valentinus).

sonified? Because this leaping character of the gnostic texts cannot symbolize innate evil, evil that would come directly from the upper world or would be opposed to it from time immemorial. Prouneikos does not directly bring about the creation of the lower world, and she is only preparing the separation. Νεῖκος is rather the Archon himself, Ialdabaoth, the prolific begetter. The emergence of evil from the upper world is perceived as a slackening of the bonds, caused by a greater and greater estrangement from the luminous source of the Father, that ends up in an uncontrolled overflowing of prodigality or fecundity with the last Aeon. Such a representation of Wisdom relies on the sapiential texts: she is a Spirit πολυμερές, λεπτόν, ἐυκίνητον, ὀξύ (lively, crafty, mobile, etc.). "For Wisdom is more moving than any motion" (Wis. 7:24). She spreads herself with strength from one extremity to the other (Wis. 8:1), like a cloud (Sir. 24:3), and she is often represented as a light that overflows and spills out (Sir. 24:25–33). Finally, in the beginning, Wisdom plays before God and then organizes the world through play (Prov. 8:30–31). Though malicious or impertinent, the laughter of Prouneikos, seeing that the Archons have been defeated by their own creation, the carnal Adam, announces the laughter of Christ when the Archons make the mistake of confusing him with the carnal envelope that they have crucified.[69]

69. Cf. *Treat. Seth* 53,30–33; 56,14–19; *Ap. Peter* 81,29—82,9; Irenaeus *Adv. haer.* 1.24.4; and Epiphanius *Haer.* 24.3.2–5.

[Many thanks to Simon Barry for helping me with the English translation of this essay.— A.P.]

Response to "Prouneikos. A Colorful Expression to Designate Wisdom in Gnostic Texts" by Anne Pasquier

Professor Pasquier is to be commended for a thoughtful and helpful study of that elusive term *prouneikos/prounikos*. I suspect that most students of Gnosticism initially encountered Sophia Prouneikos in such standard translations and interpretations of texts on Gnosis as those of Werner Foerster and Hans Jonas, where Prouneikos is translated as "lewd" or "prurient," or even as Wisdom "the Whore."[1] Some scholars may have pursued Prouneikos further, directly into the lexica, where such lexicographers as Liddell-Scott-Jones offer, in addition to the adjectival meaning "lewd," the entries "one who bears burdens out of (the market)," or "hired porter."[2] Now Professor Pasquier has performed the considerable service of unpacking and examining the lexical data and employing that data to shed new light on the term and the figure of Prouneikos in gnostic contexts.

Building upon ancient etymologies of the term *prouneikos* which suggested that a *prouneikos* was either an impulsive person (from πρό + νεῖκος) or a porter (from πρό + ἐνείκω, a form of φέρω), Professor Pasquier posits that the gnostic figure of Sophia Prouneikos resembles that of an impulsive porter, a peddler of ογοειν ("light"), if you will. In her discussion of the place of the term in the comic poets, Professor Pasquier observes that the verb προφέρω ("bring forward") may include

1. See W. Foerster, *Gnosis* (trans. and ed. R. McL. Wilson), "Index of Gnostic Concepts," s.v. "Prunicos"; H. Jonas, *The Gnostic Religion*, passim, esp. 177; and H. Jonas, *Gnosis und spätantiker Geist*, 1:360 n. 2: προύνικος is "die 'Wollüstige.'"

2. H. G. Liddell and R. Scott, *A Greek-English Lexicon*, s.v. Προύνεικος/προύνικος (p. 1537). Cf. G. W. H. Lampe, ed., *A Patristic Greek Lexicon*, s.v. Προύνικος (pp. 1190–91), also προυνικεύω, προυνικία.

elements of haste or audacity, and, conversely, an impulsive person (cf. νεῖκος, "dissension") shares character traits with an enterprising peddler. If this is the case, she concludes, "the word *prouneikos* would then represent a character, untamed or untamable, that audaciously and impetuously hurries to the outside, provoking discord or dissension" (p. 51).

With this image of *prouneikos*, Professor Pasquier provides a rereading of the mythic accounts of Sophia Prouneikos, and the results are illuminating and refreshing. We may wish to carry such a rereading even farther into a text that is of great significance for the present essay, namely, the *Apocryphon of John*.[3] Sophia audaciously projects a being, a shapeless, formless, different sort of being that yet contains a power of light. Together with the holy Mētropatōr and the completely perfect Pronoia, as well as the Epinoia of light, with whom Sophia is closely linked, she plots a salvific stratagem in order to spread and distribute the entrapped light and ultimately to gather the "seed" into the pleroma. These interests in the bearing of the light also come to clear expression in the Pronoia-hymn which closes the longer version of the *Apocryphon of John* in Nag Hammadi Codices II and IV. The revealer, probably understood to be Christ only in the later redaction of the text, discloses itself as the Pronoia that descended, or projected its self, in a threefold fashion that calls to mind the specific descriptions of Pronoia, Epinoia, and Sophia elsewhere in the text.

This bearing, scattering, and gathering of light is described with some ambivalence in various gnostic texts, and so also in the *Apocryphon of John*. On the one hand, Sophia's initial expulsion of light looms in part as a divine tragedy, and later Sophia tearfully repents of what she had done (see NHC II 13,32—14,13);[4] according to the version of the *Apocryphon of John* in Codex III, as Professor Pasquier notes, Sophia had given the power to her son the first Archon ϩⲛ ⲟⲩⲡⲣⲟⲩⲛⲓⲕⲟⲛ, "in an impetuous manner" (23,21). On the other hand, Sophia is acclaimed for her innocence (she is named ⲧⲛ̄ⲥⲱⲛⲉ, "our sister," who descended ϩⲛ̄ ⲟⲩⲙⲛ̄ⲧⲁⲕⲁⲕⲟⲥ, "in an innocent manner," NHC II 23,20–22); and finally

3. For the Coptic versions of the *Apocryphon of John*, see M. Krause and P. Labib, eds., *Die drei Versionen des Apokryphon des Johannes im koptischen Museum zu Alt-Kairo*; and W. C. Till and H.-M. Schenke, eds., *Die gnostischen Schriften des koptischen Papyrus Berolinensis 8502*.

4. Sophia's deed is alluded to as ⲙⲛ̄ⲧⲁⲧⲥⲱⲧⲙ̄ ("disobedience"), ⲙⲛ̄ⲧⲁⲧϣⲟⲭⲛⲉ ("foolishness"), and ⲧⲡⲁⲣⲁⲃⲁⲥⲓⲥ ⲛ̄ⲧⲙⲁⲁⲩ ("the transgression of the Mother") in the *Letter of Peter to Philip* (NHC VIII 135,10–11; 139,23); see my commentary on these passages in *The Letter of Peter to Philip*, 122–23, 174 (notes). On the fall of Eve and the fall of Sophia in gnostic literature, see G. W. MacRae, "The Jewish Background of the Gnostic Sophia Myth," *NovT* 12 (1970) 86–101.

she, along with the seed of light, realizes glorious fullness. Like other gnostic texts, the *Apocryphon of John* struggles with the question of theodicy and maintains a tension in its depiction of Sophia's deed. This tension seems to account for the odd qualifying statement about Sophia in the *Apocryphon of John* (NHC II 9,26–28): she thought her procreative thought by herself, *together with* (ⲙⲛ̄) the reflection of the Invisible Spirit and Prognosis. In this regard, Professor Pasquier certainly is correct when she insists, "This leaping character of the gnostic texts cannot symbolize innate evil, evil that would come directly from the upper world or would be opposed to it from time immemorial. Prouneikos does not directly bring about the creation of the lower world, and she is only preparing the separation" (p. 66). Rather, Ialdabaoth is the one who has the privileged position of νεῖκος ("dissension").

As attractive as portions of this essay are, Professor Pasquier may wish to reconsider her lack of particular emphasis upon the sexual connotations of *prouneikos*. Although she observes the "amorous rivalries" and "sexual context" in the usage of *prouneikos* in Strato of Sardes and Hesychius, these observations play no substantial role in her interpretation of gnostic texts. She may pass too quickly over the "slightly different" and overtly erotic descriptions of Prouneikos in Epiphanius (on the Nicolaitans, the Simonians, and the letter attributed to the Valentinians). Further, the sexual motifs in the description of the birth of Ialdabaoth from Sophia (or Sophia Prouneikos) in texts such as the *Apocryphon of John* should not be ignored. Sophia conceived, albeit in an irregular, independent fashion, so that her child is expelled as an ἔκτρωμα ("miscarriage, abortion"), or ϩⲟⲩϩⲉ ⲙⲡⲕⲁⲕⲉ ("miscarriage, abortion of darkness"; see BG 8502 46,10–11). This graphic imagery, apparently derived from ancient medical theories regarding human reproduction, may bring to mind Hera's independent production of the lame Hephaistos or the monstrous Typhaon, as recounted in Hesiod's *Theogony* (lines 924–29) and the *Homeric Hymn to Pythian Apollo* (lines 300–62); or Plato's discussion of conception and birth, and the formation of creatures, in his *Timaeus* (90E–91D); or Greek medical reflections upon "hysteria," the supposed drying out of the womb through lack of sexual intercourse and the subsequent deprivation of semen.[5] Whatever

5. See J. E. Goehring, "A Classical Influence on the Gnostic Sophia Myth," *VC* 35 (1981) 16–23; M. W. Meyer, "The *Apocryphon of John* and Greek Mythology," paper presented at the Society of Biblical Literature Annual Meeting, Chicago, Ill., December 1984; and esp. Paula Fredriksen, "Hysteria and the Gnostic Myths of Creation," *VC* 33 (1979) 287–90, and R. Smith's essay "Sex Education in Gnostic Schools" in this present volume.

parallels are especially appropriate to the imagery under discussion, the description of Sophia giving birth is undeniably sexual. Thus, when Sophia projects her power outside the upper world, as Professor Pasquier puts it, she does so through reproductive means.

Within the parameters of these considerations, then, the traditional translation and interpretation of Prouneikos in Foerster and Jonas become all the more understandable. Yet Professor Pasquier has enriched our awareness of some of the subtle and not so subtle features to be noted in the portrayal of Sophia Prouneikos in gnostic texts, and, thanks to her work, it should not be as easy and simple hereafter to refer to Sophia Prouneikos as "Wisdom the Whore."[6]

6. Besides Professor Pasquier's study, which is essentially a word study, more work still needs to focus upon the role of the prostitute, and her dissemination of wisdom, in gnostic and other ancient traditions—e.g., the harlot who aids in the humanization of Enkidu in the *Epic of Gilgamesh*, the figure of Helena-Ennoia in Simonian Gnosticism, and the soul as prostitute in the *Exegesis on the Soul* (NHC II,6) and the *Authoritative Teaching* (NHC VI,3). [For treatment of the latter, see the essay of Madeleine Scopello in this volume.—ED.]

Jewish and Greek Heroines in the Nag Hammadi Library

1. INTRODUCTION

It is a matter of fact that female figures play an important role in the Nag Hammadi texts. As one glances through them, it appears that the number of female figures who dominate the various treatises is very considerable.

The Nag Hammadi library has conserved numerous writings centered on a female personage. Some treatises are already, according to their titles, devoted to a female entity. One recalls to mind *Bronte* (VI,2), *Norea* (IX,2), *Hypsiphrone* (XI,4), *Protennoia* (XIII,1), and the *Gospel of Mary* (BG 8501,1), where Mary, in this literary fiction, is the counterpart of the Lord. Other texts, devoted mainly to cosmogonic or anthropogonic arguments, do not miss the opportunity to provide the reader with brief stories concerning women: for example, the treatise of the *Origin of the World*, with its sections on Pronoia, Psyche, Pistis, and Sophia;[1] the *Hypostasis of the Archons*, which tells of Pistis Sophia's and Orea's adventures;[2] the *Dialogue of the Savior*, with Mariam;[3] and the *Paraphrase of Shem*, with the account of Rebouel.[4]

1.1. The novel

My purpose here is to examine a few texts from the Nag Hammadi library that could be ascribed to the literary genre of the novel. They are

1. *Orig. World* 108, on Pronoia; 111, on Psyche; 112, on Pistis; and 113, on Sophia.
2. *Hyp. Arch.* 87, on Pistis Sophia; and *Hyp. Arch.* 93, on Orea.
3. *Dial. Sav.* 139.
4. *Paraph. Shem* 40.

distinct from other texts in that they tell the reader a short story containing the gnostic history of the Soul from fall to salvation. In doing that, they leave aside the complex philosophical and theological language of many of the treatises of the Nag Hammadi library. Their scope explains the gnostic doctrine in a quite attractive manner, using images and expressions easily understood by the cultivated public as well as by philosophers and academicians.

Among these stories, I have chosen the *Exegesis on the Soul* from Codex II[5] and the *Authoritative Teaching* of Codex VI.[6] Both are women's stories, with a female heroine who is the key figure of the tale. We shall examine how these gnostic heroines are painted by their authors and which roles they play in the stories.

This essay consists of two main sections. First, we shall study the gnostic heroine in the gnostic novel to see the literary influence of neighboring literatures on gnostic authors. Second, we shall ask ourselves whether it is possible to discover, under the literary fiction, some features of the historical and social reality of women in the gnostic communities between the second and the third century.

2. THE HEROINE IN THE GNOSTIC NOVEL

2.1. *Exegesis on the Soul*

Exegesis on the Soul is a short tale (only ten pages of papyrus) based on the gnostic myth of the fall of the Soul into the world and her return to heaven.

Soul, whose nature is feminine—she even had a womb—was virginal and androgynous in form when she was alone with her Father,[7] but when she fell into the world and into a body, she polluted herself with many lovers: "In her body she prostituted herself and gave herself to one and all, considering each one she was about to embrace to be her husband."[8]

Soul's deceptions are many, her lovers—brigands and bandits—treat

5. Cf. M. Scopello, *L'Exégèse de l'Ame: Introduction, traduction, commentaire.* This translation is followed wherever the translation of the *Exegesis on the Soul* differs from W. C. Robinson's English translation in *Nag Hammadi Library* (ed. J. M. Robinson), 180–87.

6. For *Authoritative Teaching*, I follow in general the translation of G. MacRae in *Nag Hammadi Library* (ed. Robinson), 278–83.

7. *Exeg. Soul* 127,23–24.

8. *Exeg. Soul* 128,1–4.

her as a whore, then abandon her.[9] She suffers when she understands that they are taking undue advantage of her, and seeks other lovers. But even these compel her to live with them and make her their slave on their beds, as if they were her masters,[10] for their sexual pleasure.

Ashamed, the Soul remains in slavery, in submission. She lives in a brothel, going from one marketplace to another. She never receives a gift from them, except their polluted seed;[11] her offspring are dumb, blind, sick, and feebleminded.

The Soul remains in this sexual and psychic captivity until the day she perceives her situation and repents.[12] She asks for help from her Father, reminding him about the time when she stood by him still a virgin: "Save me, Father, for behold I will render an account to Thee, for I abandoned my house and fled from my maiden's quarters; restore me to Thyself again."[13]

The Father, seeing the Soul alone, counts her worthy of his mercy[14] and accomplishes two actions to help her. First, he makes her womb turn inward, so that the Soul will regain her proper character: "In fact the womb of the Soul was outside like the male genitalia which are external."[15] This turning inward protects the Soul from further sexual contaminations by her lovers.[16] But this action is not sufficient to lead the Soul to reproduce an unblemished specimen. Soul, in fact, is beginning to rage at herself like a woman in labor, but, since she is a female, she is powerless to beget a child.[17] For this reason, the Father sends her a bridegroom from heaven. This bridegroom is her brother, the firstborn of the house of the Father.[18]

The bridegroom comes down to the bride; she abandons her former prostitution and cleanses herself of the pollution of the adulterers. She is renewed like an unblemished bride; she adorns herself in the bridal chamber after having filled it with perfume. Then she sits there waiting for the true bridegroom.[19] Having renounced prostitution and running about the marketplace, she waits for her man, anxious for his arrival but

9. *Exeg. Soul* 128,4–7.
10. *Exeg. Soul* 128,7–11.
11. *Exeg. Soul* 128,21–26.
12. *Exeg. Soul* 128,26–34.
13. *Exeg. Soul* 128,34—129,2.
14. *Exeg. Soul* 129,2–5.
15. *Exeg. Soul* 131,19–27. [For another interpretation of this sentence, see Richard Smith, "Sex Education in Gnostic Schools" in this present volume.—ED.]
16. *Exeg. Soul* 131,30–31.
17. *Exeg. Soul* 132,2–5.
18. *Exeg. Soul* 132,6–9.
19. *Exeg. Soul* 132,9–15.

at the same time afraid of him because she does not know him. In fact, she no longer remembers anything before the moment she fell from her Father's house. Nevertheless a dream will restore memory of him to her.[20] Then bride and bridegroom are enveloped in passionate love, which is spiritual and eternal, even if it is described with a vivid sensuality proper to carnal intercourse.[21] Good and beautiful sons are the fruit of this marriage.[22] Finally the Soul regenerates herself and returns to her former state, coming back to the place where she had originally been.[23]

2.2. The Authoritative Teaching

The *Authoritative Teaching* of Codex VI is a short tale having some themes in common with the *Exegesis on the Soul*. I believe that this story is not as well told as *Exegesis on the Soul*, because its author does not explain fully the various arguments he gives. His descriptions of the soul, first as whore, then as bride, are often interrupted by quotations of proverbs or sayings typical of a cultivated writer of the Greco-Roman world.

The text opens with a scene where the fiancé nourishes the bride, who has fallen into the bad world:

> Secretly her bridegroom fetched it (the word); he presented it to her mouth to make her eat it like food and he applied the word to her eyes as a medicine to make her see with her mind and perceive her kinsmen and learn about her roots, in order that she might cling to her branch from which she had first come forth, in order that she might receive what is hers and renounce matter.[24]

This is one of the few passages in which the fiancé appears and his role is defined. As in the *Exegesis on the Soul*, no portrait of him is given by the author. But Soul, to the contrary, is fully described by presenting the different stages of her life. We have just seen her sickness where matter, blinding her, is the real disease. We shall see her as a whore,[25] then as a triumphant heroine,[26] as a strong queen,[27] and at last as a beautiful bride.[28]

20. *Exeg. Soul* 132,15–23.
21. *Exeg. Soul* 132,27–35.
22. *Exeg. Soul* 133,31—134,3.
23. *Exeg. Soul* 134,6–11.
24. *Auth. Teach.* 22,23–35.
25. *Auth. Teach.* 24,6–8.
26. *Auth. Teach.* 28,10–30.
27. *Auth. Teach.* 28,15–30.
28. *Auth. Teach.* 35,11–15.

The most interesting passages concern Soul's prostitution and victory; there she is painted with passion and strength. The period the Soul spends in the world is expressed in a more metaphorical way than in the *Exegesis on the Soul*: "When the spiritual soul was cast into the body, she became a brother to lust, hatred, envy and a material soul."[29] As to prostitution, it seems to be the result of a free choice of the soul: ". . . for her debauchery. She left modesty behind, for death and life are set before everyone. Whichever of these two they wish, then they will choose for themselves."[30] Soul has fallen into bestiality, having left knowledge behind.[31] The mythical story reflects reality: "For if a thought of lust enters into a pure man, he has [. . .] being contaminated."[32]

The author describes Soul as a strong heroine. From the medicine she is going to put on her eyes and in her mouth, she will be able to cast away matter. She is painted by the gnostic writer as a triumphant heroine, represented with the symbols of royalty: "and her light may conceal the hostile forces that fight with her and she may make them blind with her light and enclose them in her presence and make them fall down in sleep and she may act boldly with her strength and with her scepter."[33] Her refuge from enemies is a spiritual one, a treasure-house, a storehouse in which her mind is.[34] The devil's pleasures attract the Soul:

All such things the Adversary prepares beautifully and spreads out before the body, wishing to make the mind of Soul incline her toward one of them and draw her, like a hook, pulling her by force in ignorance, deceiving her until she conceives evil and bears fruits of matter and conducts herself in uncleanness, pursuing many desires, and covetousness, while fleshly pleasures draw her in ignorance.[35]

Soul is not a naive creature, according to the gnostic author:

But the Soul, she who tasted these things, realized that sweet passions are transitory, she had learned about evil. . . . She adopted a new way of life; she despises this life because it is transitory and she looks for those foods that will take her into life, and she leaves behind her those deceitful foods.[36]

29. *Auth. Teach.* 23,12–17.
30. *Auth. Teach.* 24,9–14.
31. *Auth. Teach.* 24,21–23.
32. *Auth. Teach.* 25,6–9.
33. *Auth. Teach.* 28,14–22.
34. *Auth. Teach.* 28,23–26.
35. *Auth. Teach.* 31,9–24.
36. *Auth. Teach.* 31,24—32,2.

She is conscious of her power: "She learns about her light and she goes about stripping off this world while her true garments clothe her from within."[37]

If she was a slave, she is now a queen. As the author writes:

> She gave her body to those who had given it to her and they were ashamed while the dealers in bodies sat down and wept because they were not able to find any other merchandise. They endured great sufferings until they had shaped the body of this Soul, wishing to strike down the invisible Soul.[38]

She swindles the dealers in bodies, keeping secret her superior nature from them: "They did not realize that she has an invisible, spiritual body, thinking, 'We are the shepherd who feeds her.' But they did not realize that she is aware of another way which is hidden to them. This, her true shepherd taught her in knowledge."[39] Their fault is ignorance—they do not seek after God.[40] Soul, on the other hand, possesses $\gamma\nu\hat{\omega}\sigma\iota\varsigma$ ("knowledge") because of her *curiositas* concerning God: "but the rational Soul, who also wearied herself in seeking, learned about God . . . to rest in Him who is at rest."[41]

An amorous conclusion was needed for this short tale: "She reclined in the bridal chamber, she ate of the banquet for which she had hungered, she partook of the immortal food. She found what she had sought after."[42]

2.3. Sophia and the soul

These two short texts are not merely novels; they are in fact *gnostic novels*. The two female heroines are described in the image of Sophia, whose myth, as related in its essential lines by Irenaeus of Lyon,[43] is found here under a romanesque adaptation. By leaving her wantonness for *metanoia* ("repentance"), Sophia regains acceptance into her Father's home. This myth, which constitutes one of the key building stones of gnostic speculation, has often been interpreted in complicated ways. The authors of the two Nag Hammadi texts considered above have been able to recount this myth in a simplified manner.

37. *Auth. Teach.* 32,2–6.
38. *Auth. Teach.* 32,17–27.
39. *Auth. Teach.* 32,30—33,3.
40. *Auth. Teach.* 33,4–5.
41. *Auth. Teach.* 35,10–15.
42. *Auth. Teach.* 35,10–15.
43. See Irenaeus's notice on the Valentinians, in *Sancti Irenaei, Episcopi Lugdunensis, Libros quinque adversus haereses* (ed. W. W. Harvey), vol. 1.

In the *Exegesis on the Soul* and *Authoritative Teaching*, the story of the Soul, fallen from the Father's house, recalls the Valentinian story of Sophia, the last aeon, who leaves the pleroma searching for new horizons.[44] Prostitutions and adulteries mark the trip of both Sophia and the Soul into the world.[45] The result of their rebellion is the same: Sophia and the Soul of the *Exegesis on the Soul* give birth to sick, imperfect children: Sophia, because of her strong will to conceive alone, the Soul because of her union with adulterers.[46]

Anguish, fear, and loneliness mark the *metanoia* ("repentance") of both Sophia and Soul.[47] They pray to the father in the same manner.[48] Salvation comes for Sophia as for the Soul by a heavenly bridegroom. Nuptial union restores virginity and androgyny to them.[49]

2.4. The woman as heroine

How do the two Nag Hammadi authors describe their two heroines? These women appear to be described in a colorful style, while their male counterparts receive a more sober description. Actually the gnostic authors quite often give a feeble appearance to male characters, while their imagination has always been lively and vivid when applied to females. The whore, the Soul, is the object of an ardent description. Notwithstanding her questionable past, and even when such a past is mentioned, the female Soul enjoys the solidarity, if not the complicity, of the author.

As to the *Exegesis on the Soul*, the most detailed parts of the treatise concern the earthly adventures of Soul. These can be summarized by

44. Irenaeus *Adv. haer.* 1.2.2: "Praesiliit autem valde ultimus et junior de duodecade ea, quae ab Anthropo et Ecclesia emissa fuerat, Aeon, hoc est Sophia: et passa est passionem sine complexu conjugis Theletis"; cf. *Exeg. Soul* 127,25–28; 132,19–21.

45. Irenaeus *Adv. haer.* 1.1.2: "Derivavit autem in hanc Aeonem, id est Sophiam demutatam, sub occasione quidem dilectionis, temeritatis autem, quoniam non communicaverat Patri perfecto, quemadmodem et Nus. Passionem autem esse exquisitionem Patris." Cf. *Exeg. Soul* 127,28—128,23; 128,30–31 passim.

46. Irenaeus *Adv. haer.* 1.1.3: "Quidam autem ipsorum huiusmodi passionem et reversionem Sophia . . . impossibilem et incomprehensibilem rem eam agressam peperisse substantiam informem qualem naturam habebat foemina parere." Cf. *Exeg. Soul* 128,23–26.

47. Irenaeus *Adv. haer.* 1.1.3: "In quam cum intendisset, primo quidem contristatam propter in consummationem generationis: post deinde timuisse, ne hoc ipsum finem habeat: dehinc expavisse et aporiatam, id est, confusam, quaerentem causam et quemadmodum absconderet id, quod erat natum." Cf. *Exeg. Soul* 128,6–7,29.

48. Irenaeus *Adv. haer.* 1.1.3: "In iis autem passionibus factam, accepisse regressionem, et in Patrem regredi conari; et aliquamdiu ausam, tamen defecisse et supplicem Patris factam." Cf. *Exeg. Soul* 128,31–35; 131,18.

49. Irenaeus *Adv. haer.* 1.1.3: "Per Horon autem dicunt mandatam et confortatam Sophiam et restitutam conjugi." Cf. *Exeg. Soul* 132,7–8.

one word: prostitution. Soul's deceptions are fully related by the author. Her life in the world gives the gnostic writer the possibility of displaying his romanesque taste: thieves, brigands, and bandits are inserted in the novel and intensify its effect. The scenes often consist of places of ill repute, of brothels and bedrooms where Soul is deceived by her lovers. More than that, she is painted as a slave subject to her masters' desires. Filthy gifts, tricks, and a final storm are used to grasp the attention of the reader.[50]

As in most novels, the unlucky adventures of the female heroine are followed by a positive conclusion: heavenly intervention in the image of love. This last section is sensually described by the gnostic author; it consists of relating Soul's search for her predestined partner, her excitement in waiting for him, the lucky union between the betrothed, and finally the fruition of the γάμος ("marriage").

Even the more moderate author of *Authoritative Teaching* reserves his most efficacious images for the female Soul. His descriptions of her, made drunk by wine, are lively, as in the episode when she skillfully deceives the "dealers in bodies" (probably an allusion to slave traders). The final portrait of the wonderful bride in the arms of love is painted in sensual and attractive strokes.

The male Nous (mind), on the other hand, although acting as the savior of the Soul, is not as interesting for the writer or the reader; despite his past of righteousness in the house of the Father, the Savior is not a very exciting hero. We sometimes get the feeling that the fiancé exists merely as a means for Soul to recover her privileged place near to God.

3. WOMEN IN THE HELLENISTIC NOVEL

I now asked myself if the Nag Hammadi heroines have been influenced, from a literary point of view, by female personages in neighboring literatures that may have been known to the Gnostics. It might be interesting to ascertain to what extent the two gnostic authors are indebted to other writers for their ascription of a female personage as well as for the structure of the novel. I do believe that the Greek Hellenistic novel has exerted an influence on the *Exegesis on the Soul* and *Authoritative Teaching*.

Love and adventure are the chief ingredients of Hellenistic novels.

50. *Exeg. Soul* 128,12–20; *Auth. Teach.* 36,16–24.

One can recall heroes' roles in most of the Greek novels.[51] Love in fact is the first cause of romanesque action. Many authors in the Greco-Roman world have built their novels on an identical model: the tragic separation of two lovers and their eventual reunion after many adventures. Thousands of misunderstandings are part of this model: tricks, dangerous journeys, pirates, storms, divine wrath.

Descriptions and accounts of women are numerous. The heroine of the Greek novel is described through the eyes of a man who makes of her an attractive object to please the readers. They follow her through several adventures, observing her often on the point of falling into the hands of dangerous men.[52] The Greek heroine is painted as an object of desire. She is always charming; even under the worst of situations, her beauty emerges from the rags that cover her. The reader pleases himself too in seeing her in the nuptial clothes which she always wears at the end of the story.[53] These nuptial robes are the instruments for seduction: colors, flowers, and precious jewels cover her as an oriental goddess.[54]

Love scenes are appreciated in the Greek novel.[55] Only at the moment of her marriage with the male protagonist of the story does the heroine

51. P. Grimal, *Romans grecs et latins*, xiii, xiv.

52. *Chereas and Callirhoe* 1.11; *Theagenes and Chariclea* 1.12; 2.4.

53. On the beautiful clothes of the bride, see *Daphnis and Chloe* 4.31.3; *Leucippe and Clitophon* 3.7.5; *Chereas and Callirhoe* 3.2; *Anthee and Abrocomes* 1.2; 3.5; and *Ethiopica* 6.6.

54. Cf. *Chereas and Callirhoe* 1.1: "The women of Syracuse were there to accompany the young bride to her fiancé's house; they were singing the hymeneal, the doors of the houses were overflowing with wine and perfume. . . . When the maidens had adorned the bride . . . her parents took her to the bridegroom"; and 8.1: "People threw flowers to the lovers, everybody drank wine, myrrh was poured in front of them."

55. As in the *Exegesis on the Soul*, in the Greek novels the bride is afraid of her fiancé before the marriage. One may quote a passage of the *Metamorphoses* of Apuleus 5.4: "Tunc virginitati suae pro tanta solicitudine metuens et pavet et horrescit et quavis malo plus timet quod ignorat. Iamque aderat ignobilis maritus et torum inscenderat et uxorem sibi Psychen fecerat." The unknown features of the bridegroom are indicated in the expression *ignobilis maritus*. As the soul does not remember her fiancé, a dream will restore his memory to her. This theme that we find in the *Exegesis on the Soul* is typical of the Greek novel. *Chereas and Callirhoe* 5.5: "At nightfall, she had a dream: she saw herself when she was still a virgin, in Syracuse, entering the temple of Aphrodite, then . . . catching a glimpse of Chereas . . ., then she saw the day of her marriage, the whole city full of flowers and garlands, herself accompanied by her parents to her fiancé"; and 6.7; 8.9: "I thank you, Aphrodite, because you have shown me Chereas at Syracuse, when I was still a virgin, I have seen him by your will." *Anthee and Abrocomes* 1.5: "They were crying during the whole night, forming in their mind the image of the cherished person." Love scenes are strongly sexualized in the Greek novel. We can compare the passage of *Exeg. Soul* 132,28–30 ("those who are to have intercourse with one another will become drunk with that intercourse and as if it were a burden they leave behind them the annoyance of physical desire") to *Daphnis and Chloe* 2.38.2: "Daphnis was near Chloe, and at nightfall they could make themselves drunk with their bodies." Cf. also *Ethiopica* 5.4.5.

leave aside her modesty. Her shame disappears as she faces her fiancé.
They love each other passionately. Sensual, vivid images describe their
union. These were probably scenes that were performed before an
audience, accompanied by music.[56]

I wondered what the social reality of the heroine of the Hellenistic
novel could be. She is not an ἑταίρα ("courtesan") but a well-bred girl of a
noble family, fallen into disgrace. Sometimes the heroine is abducted as
a slave and taken aboard a ship on the Mediterranean Sea, where,
because of the highly organized bands of pirates, navigation was
dangerous, at best, during this period. The Greek heroine suffers the
worst humiliations before her release.[57] She is compelled to perform the
menial tasks and is treated as a mere servant. She never loses her proud
character, however—a consequence of her noble stock, her accom-
plished manners, or her aristocratic features—but always recalls that she
is the daughter of a noble family. Her salvation depends on the inter-
vention of a strong, powerful, and noble fiancé. In her attempt to
recover her former condition, her role remains quite passive; her strong-
est desire is to preserve her virginity, even in the most adverse circum-
stances.

The themes treated in the *Exegesis on the Soul*, and partially in
Authoritative Teaching, were mainly those of captivity, prostitution,
robbery, and release. All these themes are peculiar to the Hellenistic
novel. A careful comparison might arise easily among the major novels

56. Union, as in the *Exegesis on the Soul*, is described with great emotion in Greek
novels. The soul in the *Exegesis on the Soul* cries, then laughs, during the scenes of love
with her fiancé. This is a τόπος (set motif) of Greek novels. See *Chereas and Callirhoe*
8.1: "A couch was covered with gold leaves and purple blankets of Tyre. Who would be
able to tell how much that night was filled with tears and kisses! When they were tired
of crying, they embraced themselves tightly." *Anthee and Abrocomes* 1.9: "The two of
them were unable to talk and look at each other. They lied down on the couch, won by
pleasure, afraid of everything, ashamed, breathless. Their bodies were vibrating, their
souls too. After a while, Abrocomes kissed Anthee, she cried, her tears came from her
heart, showing her desire." Cf. 5.13; *Ethiopica* 3.7; *Leucippe and Clitophon* 2.2; *The Novel
of Ninus*, frg. A V; *Daphnis and Chloe* 1.13.6. The bridegroom is the only man whom the
soul will call "master." This is part of the amorous language: *Leucippe and Clitophon*
5.26; *Anthee and Abrocomes* 5.14: "Anthee, after kissing Abrocomes, was crying, saying:
'My bridegroom and Lord, I have found you after having wandered on earth and sea,
after having escaped brigands, after having flown the deceptions of pirates and the
shame of the merchants of bodies . . . but now I am (come) back to you.'"

57. Suffering is necessarily a sort of κάθαρσις ("catharsis"). According to Grimal
(*Romans grecs et latins*, p. xv), "The heroine must be a slave and be deprived of her
family and her royal protection to become herself, to understand herself. Leucippe,
Callirhoe, Chariclea have to go till the worst humiliations to discover themselves."
Greek novels probably hide mystical souvenirs of oriental religions in these initiation
trials. On this subject, see K. Kerenyi, *Die griechisch-orientalische Romanliteratur*, and R.
Merkelbach, *Roman und Mysterium in der Antike*.

of late antiquity: *Leucippe and Clitophon, Chereas and Callirhoe,* and *Daphnis and Chloe.* Similar conclusions would be obtained if the Soul's character were taken into account. The positive attributes of charm and beauty which the authors have given to Soul are in no way different from the characters that Greek writers have assigned to similar feminine figures.

Nevertheless, two features can be observed in gnostic novels that have no correspondence to the Greek texts. First, the heroine of gnostic novels is *unique,* while in the Greek novels the primary role is always given to a *couple,* a man and woman or a bridegroom and bride. This is the striking difference as compared with the gnostic novel, in which, as we said, most of the meaning converges on the female heroine. It is sufficient to give a look at the titles to be assured of this fact: *Chereas and Callirhoe, Daphnis and Chloe,* and so forth.

Second, the Greek heroines' desires are to save their virginity at any cost. They are wise, virtuous girls. The heroines of gnostic novels, to the contrary, have led filthy lives of prostitution; they have been, at a certain time in their lives, professional whores.

Finally, in the gnostic texts the male partners play a secondary role, while in Hellenistic novels, the male is really the savior.

Let us observe schematically the differences between the Greek and gnostic heroines, at the same time not forgetting their shared themes and topics.

Greek Novel	*Gnostic Novel*
female heroine	female heroine
keeps her virginity	loses her virginity
remembers her origin	forgets her origin
salvation comes from a man	salvation comes from herself
passive role	active role
OBJECT OF DESIRE	THINKING WOMAN

In the gnostic novels, there is a tension between prostitution and virginity which is unknown to Hellenistic novels where the heroine is always wise and virgin, not virgin and then whore. The attribution of positive and negative qualities, that is, virginity and prostitution, to the same personage, is not limited to the two Nag Hammadi texts studied above but is, in my opinion, a common feature which links most of the women's stories in the Nag Hammadi library.

It is remarkable that the overwhelming majority of women in the Nag Hammadi library are formed by sinners, more precisely by whores.

Some sinners among them have a consistent historical reality. Let us think about the different Marys of the *Dialogue of the Savior*, the *Gospel of Thomas*, the *Gospel of Mary*, or the *Sophia of Jesus Christ*. Others exist only at a mythical level—for example, Norea, Hypsiphrone, or the heroines of the *Exegesis on the Soul* and *Authoritative Teaching*. These female sinners are eventually all rehabilitated. Some treatises show them when they are already saved; others relate the whole process that leads them from fall to salvation.

Repentance and contrition lead Soul to her former condition, virginity. The union with a heavenly fiancé restores it to her. By spiritual intercourse, the Soul obtains knowledge, a gnosis superior to the male's because it is closer to God. Let us recall the words of the Savior: "Mariam speaks as a woman who knows the All" (*Dial. Sav.* 139,12). The preference of Jesus for Mary, a woman, and her knowledge of secret matters follows along the same lines (*Gospel of Mary* 10,1–6).

4. WOMEN IN JEWISH LITERATURE

I next asked myself whether gnostic authors had taken the idea of charging their heroines with negative and then positive attributes from already existing personages of neighboring literatures.

If we want to find some stories concerning women that approach the *Exegesis on the Soul* or *Authoritative Teaching*, we need to take a look at contemporary Jewish literature where romanesque production, with exhortatory and moral purposes, largely developed.

Jewish literature has preserved several stories and novels about women. These, beyond their historical meaning, symbolize soul-searching for God. Stories of wise women are the object of some biblical writings, for example, the books of Esther, Judith, and Susanna (LXX). The wisdom of these women is equal to their virginity.[58] The beauty of these women is often emphasized; their charm seduces and appeals to man's desire. Their beauty will save them too, being a gift from God, a sign of privilege.[59]

Furthermore, several stories about women charged with a questionable past are recounted in the Hebrew Scriptures (Old Testament) and

58. Cf. Esther (LXX) 2:12, 17; Judith 11:17, 20, 21, 23; 13:16; 15:7; 16:22, 23; Susanna 1:38.

59. Esther (LXX) 2:15; Judith 10:3–4; 10:7–8; 10:14, 19, 23; 12:15, 16, 20; Susanna 1:8; 31:32.

are picked up with great attention in the Apocrypha and the Pseude-pigrapha—for example, Tamar, Rahab, Ruth, and the wife of Uriah. These women are mentioned in the genealogy of Jesus according to Matt. 1:1–6:

> The book of the genealogy of Jesus Christ, the son of David, the son of Abraham. Abraham was the father of Isaac, and Isaac the father of Jacob, and Jacob the father of Judah and his brothers, and Judah the father of Perez and Zerah by *Tamar* and Perez the father of Hezron, and Hezron the father of Ram, and Ram the father of Amminadab, and Amminadab the father of Nahshon, and Nahshon the father of Salmon, and Salmon, the father of Boaz by *Rahab*, and Boaz the father of Obed by *Ruth*, and Obed the father of Jesse, and Jesse the father of King David. And David was the father of Solomon by the wife of Uriah.

Only four women are named in this genealogy. All of them—Tamar, Rahab, Ruth, and the wife of Uriah, Bathsheba—were considered sinners.[60] This fact highly surprised Jerome, who wrote in his *Commentary on Matthew* 1.3: "notandum in genealogia salvatoris nulla sanc-tarum adsumi mulierum, sed eas quas scriptura reprehendit, ut qui propter peccatores venerat, de peccatricibus nascens omnium peccata deleret. Unde et in consequentibus Ruth Moabitis ponitur et Bethsabe uxor Uriae."[61]

Let us quickly summarize these four women's stories to see whether there are points in common with our gnostic texts.

4.1. Tamar

Genesis 38:6–30 informs us about Tamar. Widow of two brothers, she was promised to the third one by Judah, her father-in-law. But Judah did not respect his promise. Tamar, then, planned and seduced her father-in-law. She rid herself of her garment of widowhood, put a veil on her head, made up her face,[62] and sat near the gates of the town of Enaim, waiting for Judah. When he arrived, he thought she was a whore and copulated with her.

The book of *Jubilees* (41:1–28) gives the same account as Genesis,

60. On these women, see H. L. Strack and P. Billerbeck, *Kommentar zum Neuen Testament aus Talmud und Midrasch*, vol. 1: *Das Evangelium nach Matthäus*, 15–30.
61. CCSL, p. 8.
62. Gen. 38:14–16 (LXX); Vulgate: "Quae depositis viduitatis vestibus adsumpsit theristrum et mutato habitu sedit in bivio itineris quod ducit Thamnam eo quod crevisset Sela et non eum accepisset maritum quam cum vidisset Iudas suspicatus est esse meretricem operuerat enim vultum suum ne cognosceretur ingrediensque ad eam ait dimitte me ut coeam tecum nesciebat enim quod nurus sua esset."

introducing just a few variants.[63] The *Testament of Judah* adds some
interesting details: having shed her widow garments, Tamar adorns
herself as a bride (κοσμεθεῖσα κόσμῳ νυμφικῷ) when she sits near the
gates of Enaim. According to the law of Amorites (*T. Judah* 12:1), every
bride had to prostitute herself for seven days before her marriage at the
gates of the town.[64] In the book of *Jubilees*, Judah recounts that, being
drunk, he did not recognize Tamar, his daughter-in-law, and was
seduced by her beauty to copulate with her.

4.2. Rahab

She is a professional whore. Joshua 2 tells us she is the prostitute of
Jericho who helps and hides two young men sent by Joshua to spy about
the country.[65]

The haggadoth give several details about her. She became a whore
when she was ten years old. She was so beautiful that men became
excited at the mere mention of her name.[66] She was also an important
and feared woman because of her high-ranking liaisons.

4.3. Ruth

Ruth, on the other hand, was not a real whore, but the stratagem she
conceives with her mother-in-law to obtain a levirate marriage (from
Boaz) depends on seduction. In Ruth 3:3–5 (LXX), Naomi counsels Ruth
about her manners: "Wash and anoint yourself, and put on your best
clothes and go down to the threshing floor; but if he has not yet finished
eating and drinking, do not make yourself known to him. But when he
lies down, observe the place where he lies, then go and uncover his feet
and lie down; and he will tell you what to do.' And she replied, 'All that
you say, I will do.'"[67]

4.4. Bathsheba

She seduces King David by her beauty and has intercourse with him

63. *Jub.* 4:1–28 in R. H. Charles, *The Apocrypha and Pseudepigrapha of the Old Testament*, 2:71–72.

64. In R. H. Charles, *The Greek Version of the Testaments of the Twelve Patriarchs.*

65. Josh. 2:1.

66. *Megilla* 15a: "The rabbis tell that there are four women in the world of wonderful beauty: Sarah, Rahab, Abigail, Esther. . . . Our rabbis have said: Rahab inspired the desire by her name, Jael by her voice, Abigail by her memory, Mical by her features." *Zebahim* 116b: "She was ten years old when the people of Israel left Egypt and she prostituted herself during the forty years that the people of Israel spent in the desert. When she was fifty years old, she became a proselyte."

67. LXX; Vulgate: "Lava igitur et unguere et induere cultoribus vestimentis."

without responsibility while her husband is absent. 2 Kings 11:2–5, according to LXX, reads: "It was the evening when King David arose from his couch and went onto the roof of his royal palace. He saw from the roof a woman bathing and the woman was very beautiful to look upon. And David sent and enquired about the woman. It was told to him: 'Is not she Bathsheba, the daughter of Eliab, the wife of Urias, the Hittite?' David sent some messengers to her and took her and had intercourse with her. After having purified herself from her impurity, she went back home. The woman conceived and she sent and told David and said, 'I am with child.'"

4.5. Comparison

These four stories of women have some common features. First, all the four women are foreigners: Bathsheba, a Hittite; Tamar, a Canaanite; Ruth, a Moabite; Rahab, a woman from Jericho. By the end, they will all become Hebrew and, moreover, they will be quoted as an example in Judaism. All of them give themselves to prostitution, but in different ways: Rahab because of her profession, the others for a precise reason. For the four women, prostitution and seduction precede the moment of their redemption and are part of a divine project concerning them. All four of them, in fact, will be chosen for uncommon destinies.

The story of Rahab is the most significant: having left behind her prostitution,[68] she becomes the prototype of repentance and conversion. One recalls Philo's allegories of Tamar as μετάνοια ("repentance"). Rahab is saved because she acknowledged that the God of Israel is the True One. Her profession of faith is striking: ὅτι κύριος ὁ θεὸς ὑμῶν, θεὸς ἐν οὐρανῷ ἄνω καὶ ἐπι τῆς γῆς κάτω (Josh. 2:11; "for the Lord our God, God in heaven above and upon the earth below").[69] Rahab becomes, in Jewish tradition, the prototype of the woman saved by her faith. We even find an echo of this idea in Heb. 11:31: "Because of her faith, Rahab, the prostitute who had welcomed the spies with words of peace, did not die with those who were disobedient." The confidence she had in God marked her destiny and made her a chosen woman. Some rabbinical traditions make her the bride of Joshua and the ancestor of eight prophets.[70]

The parallel with the *Exegesis on the Soul* and *Authoritative Teaching*

68. Rabbinical accounts underline her immorality to emphasize her conversion: *Mekilta Yitro* 57a; *Zebahim* 116b.

69. Cf. *Deuteronomy Rabbah* 2,26–27, where Rahab proclaims the unity of God.

70. *Megilla* 14b.

seems to me quite exact: the prostituted soul is saved because she has confidence in God (*Exeg. Soul* 128,34—129,5). Through repentance, she delivered herself from πορνεία ("immorality") and will be again part of the house of the Father.[71]

As for Ruth and Rahab, their stories are similar. The two of them take recourse to the stratagem of seduction to attain the same end: a levirate marriage. Ruth is described as a proselyte (2 Chr. 2:11; Ruth 4:21) and Rahab as a convert to Judaism. These two foreign women are said to be better than the people of Israel and are privileged in the presence of God. Boaz, having understood the reason for Ruth's behavior, speaks of her as a virtuous woman (Ruth 3:11).

Judah at Tamar's trial as a whore says she is a righteous woman: "Tamar is more righteous than I, inasmuch as I did not give her to my son Shelah" (Gen. 38:26). "Judah acknowledged, and said, 'Tamar is more righteous than I am.' . . . And Judah acknowledged that the deed which he had done was evil, for he had lain with his daughter-in-law . . . that he had transgressed and gone astray for he had uncovered the skirt of his son" (*Jub.* 41:20–23).

4.6. Conclusions

Jewish literature has preserved some examples of a literary genre, novel or romanesque tale, centered on a female personage. Real novels concern wise women: for example, Esther, Judith, and Susanna. If we look at the sinners, we have to be more careful in speaking about novels. Among them, Ruth is the only one to whom a real novel is dedicated. As for the others, Tamar, Rahab, and Bathsheba are the objects of tales of longer or shorter length, which are part of biblical books or apocrypha.

The gnostic authors have been influenced by the stories of Jewish prostitutes at two levels: first, at the level of the literary genre they use by preserving a gnostic color in their stories and at the same time enriching the materials from Hellenistic novels, as we have seen above; second, at the level of history of tradition: the adventures of Jewish whores appear in the composition of the figure of the soul in our gnostic tales.

The authors of the *Exegesis on the Soul* and *Authoritative Teaching*, even if they do not make any explicit reference to these women's stories, probably know the accounts of their adventures. The desire to explain

71. *Exeg. Soul* 128,34—129,5; *Auth. Teach.* 35,15–19.

the gnostic myth in a nearly romanesque form is linked to the desire to diffuse the esoteric message by presenting it in a simplified manner, opening it to a larger public than do some gnostic theologians.

5. ARE GNOSTIC HEROINES REAL OR IMAGINARY?

It is reasonable to question whether it is possible to discover, under the literary fiction of gnostic myths, some features of the historical and social reality of women in the gnostic communities between the second and the third centuries. It is a matter of fact that we lack texts describing common gnostic ways of life, their habits and daily customs. So, it is more difficult than with other groups of people, for example, the Manicheans, to learn about the style of life they lived and, as is our purpose here, to know which roles women played in gnostic "society" and, more specifically, in the society of their time.

Gnostic communities need to be the object of a microhistorical study. A good point of departure could be the problem of women. One of the bases of such a study would be the collection of even the minimal information that one is able to obtain about specific points and then the comparison of this information with that of a larger social field. For example, let us collect what we know about female figures from the Nag Hammadi texts and then compare it with the general social situation of women in the Greco-Roman world and in Egypt during the same period, the second and third centuries.

We know little about the realities of gnostic life; on the other hand, we have been deeply instructed about their doctrines and "croyances" (beliefs). We can make these doctrines our point of departure. We have seen in the first part of this essay that women play an important role in gnostic mythology, that a female personage is the single chief protagonist of the gnostic myth of salvation, that it is a particular category of women that often intervenes, and finally that women are not objects of desire but really thinking women. I want to emphasize that by a "thinking woman" I mean a cultivated woman, conscious of her destiny, with an active intellectual life. Were thinking women a part of gnostic communities? What kind of women were interested in Gnosticism? Which women became gnostic?

We possess one historical document that shows a cultivated woman strongly interested in Gnosticism. I am referring to Flora, a high-ranking lady of Roman society to whom Ptolemeus, one of the best known gnostic "maîtres," addressed a long letter on gnostic doctrine. As the

letter contains a new gnostic interpretation of Jewish law,[72] we may suppose that Flora had a sufficient education to be able to understand the subtle matters of Ptolemeus's writings.

Marcus too, another gnostic teacher, is said to have converted cultivated women to the new gnostic religion. Unfortunately the sources we have on this subject[73] come only from the fathers of the church, and they are full of malevolent, polemical tones. Marcus is painted as a seducer of naive ladies, yearning for whatever advantage he could take of them.

Why were women attracted by Gnosticism? To understand this fact, we have to be conscious that their role in religion in the Greco-Roman world was severely limited. Women did not play an active role in the leadership of the imperial religion, which called forth little pious fervor anymore. One might well imagine that they were desirous of new cults in which they might participate and take a more active role. The only women who had an important, formal precise function in Roman imperial religion were vestals, a few virgins tending the holy fire, but even their roles were devoid of meaning by the late Empire.

So women, generally, may have been eager for new religious doctrines; this had already been one of the reasons for the diffusion of Christianity in Rome and throughout the Empire. It is easy to imagine that, often taught by their oriental slaves, the ladies of high Roman society could join a religion whose mystical tone and exotic origin seemed to them rich in promise and so different from the sterile Roman cults.[74]

Compared to Christianity, Gnosticism reserves an elevated place for women. We do not find in the Christian literature, later considered orthodox, as many texts where women take an active role as in Gnosticism.[75] Even the historical Marys who followed Jesus in his earthly life received much more attention in Gnosticism than in "orthodox" forms of Christianity. Gnostics have portrayed them as women close to the Lord, aware of his secrets and his deepest teachings. They have become, in Christian Gnosticism, the image of the true knowledge which was reserved for a minority.

72. *Lettre à Flora* (ed. G. Quispel).
73. Irenaeus *Adv. haer.* 1.13.2–3.
74. An exception is represented by Isiac cults, which addressed themselves particularly to women. We thank Professor Douglas Parrott for his precious suggestion. It is probably not without interest that Isiac cults developed in Egypt, where later Gnosticism was highly diffused: both of them give particular attention to women, in theology as well as in reality.
75. *Acta Martyrum* are an exception.

An interest in the complexity of gnostic religion could only come from learned people, men or women. Rich, noble women in the Greco-Roman world were often cultivated, as we said, but common women of other classes were not deeply learned. We have to address ourselves to another group of women to find highly learned persons, educated in different arts. I am speaking about ἑταίραι ("courtesans").

This ancient Greek institution was still alive in the first centuries of our era. Removed early from their families and often taken as slaves by pirates who deprived them of their noble stock, they were educated in art, music, and literature. We even find courtesans in some philosophical academies. They were perfect company for learned men who did not find in their wives cultivated counterparts. The main duty of a wife was to procreate and tend to the daily domestic concerns. Women capable of reading and writing were rare in that period, except for high-ranking ladies. The fact that Simon the Magician, one of the first gnostic teachers, found his partner and his inspirer in a brothel, according to heresiological accounts (see below), is probably no mere legend. Who was the Helena who inspired Simon? Was she a cultivated courtesan to whom Justin and then Irenaeus attributed a lower social rank, calling her a prostitute and despising her by Judeo-Christian moral standards and views, while, on the other hand, these women enjoyed the respect of citizens in Hellenistic culture?

The first testimony about Simon the Magician (Acts 8:20–21, 23) does not tell us anything about Helena. We find the first account of her in Justin's *First Apology* 26.3:

> And almost all Samaritans, amongst other people, recognize Simon as supreme God and worship him, and talk about a certain Helena, who at that time went around with him and who previously had been offering herself for hire in a brothel. She is called the Primary Ennoia engendered by him.

Irenaeus in *Adversus haereses* (1.23.2) adds some details about her:

> He took with him a certain Helena whom he had redeemed by purchase from a life of prostitution in the city of Tyre, in Phoenicia. She, he claimed, was the primary Ennoia of his mind, Mother of All, through whom he had in the beginning conceived the plan of creating angels. . . . After she had generated them, she was held prisoner by them, due to envy since they did not want to be regarded as the offspring of anyone else. . . . They subjected her to every form of humiliation, to prevent her from hastening back to her father. So far did this go that she was even confined in a human body, and for centuries, as if from one vessel to another, transmigrated into other female bodies. She was also in that Helena for the sake of whom the Trojan

war began. . . . Ennoia passed from one body to another, always enduring humiliations. Finally she arrived even in a brothel, and she is the Lost Sheep.

This account has points in common with the *Exegesis on the Soul* and *Authoritative Teaching*. Gnostic writers probably took up Simon's ideas and integrated a real feminine personage into their writings.

6. CONCLUSION

Gnosticism seems to have had cultivated women in its circles. The role of ἑταίραι ("courtesans") probably influenced gnostic writers, surely the first of them, Simon the Magician, in the composition of their myths. The figures of Greek courtesans are certainly not foreign to these authors.

We do not know to which social classes Gnostics belonged. Among them, however, there were cultivated people, able to understand a complex mythology and philosophical subtleties. Women were probably attracted too by a mythology where feminine figures played such an important role.

Finally, I leave you with a last question: Are there women among the gnostic writers? It is my opinion that the sexual accounts of a text such as the *Exegesis on the Soul* are more probably ascribed to a woman than to a man.

Response to "Jewish and Greek Heroines in the Nag Hammadi Library" by Madeleine Scopello

We should all be grateful to Dr. Scopello for her essay. She has skillfully drawn together the two accounts of the important myth of the soul in the *Exegesis on the Soul* (NHC II,6) and *Authoritative Teaching* (NHC VI,3) and has shown significant influences that affected its development. She has also raised some interesting questions.

There are some questions that I must ask right at the start of my response. (1) I was intrigued by her question at the end, and wonder whether she has given any further thought to it: Are there women among the gnostic writers? What aspects of the sexual accounts suggest that the author of the *Exegesis on the Soul* might be a woman? Are there other gnostic tractates that show signs of having been written by women? (2) In trying to understand why women were attracted to Gnosticism, she states that they played no role at all in the other religions of the Greco-Roman world.[1] I wonder whether she would not wish to make an exception with the important religion of Isis. Plutarch, after all, dedicated his *Isis and Osiris* to a priestess of the Isis religion. And was it not that religion which was said to be especially attractive to women?[2]

And I have one other question, which will lead me into the main part of my response. I wonder whether it is correct to say, as Dr. Scopello

1. Dr. Scopello's comments after my response was read at the conference indicated that I had misunderstood her at this point. [M. Scopello has modified her remarks on this point in this revised essay. See p. 88, above.—ED.]
2. [See Sharon Kelly Heybob (*The Cult of Isis Among Women in the Graeco-Roman World*) for an assessment of this point.—ED.]

does, that the accounts of Old Testament women adequately explain the gnostic story.[3] The women in question were Tamar, Rahab, Ruth, and Bathsheba. Dr. Scopello turns to them when the stories of women in the Hellenistic novel appear not to be able to account fully for the literary tradition behind the novel of the soul. It seems to me that what Bathsheba did was not really prostitution. She did not offer herself for sale; she was simply seen and taken by King David. What Ruth did was to make clear to Boaz her legitimate interest in him in a situation in which sexual contact may or may not have occurred.[4] That does not constitute prostitution. And Tamar, although she indeed did act the part of a prostitute, did so for only one man, her father-in-law Judah, and did it in the context of a situation that made it justifiable, even to him. It is clear that she was not really a prostitute. Rahab is the only one in the group who in fact was a prostitute. But her repentance or conversion is not linked to her prostitution, in the sources, but to her acceptance of faith in God (Josh. 2:11), as Dr. Scopello notes in her essay. So, even she is not a good parallel for the story of the soul.

Rather than go so far afield to explain this account, it seems to me that it might be better to turn to the story that is closest to the gnostic myth and must have been in the mind of the author, namely, the Greek story of Cupid and Psyche, which we know only in the form passed on to us by Apuleius in the *Metamorphoses*.[5] Psyche was the most beautiful of three daughters of a king. Her beauty was so great that it inspired a cult, and therefore also the jealousy of the goddess Venus. Hence she falls from divine grace, and then almost literally falls from a mountain crag, where she goes by oracle to await a demon husband. Rather than falling, she is wafted by the wind into a beautiful valley with a lovely palace. There she meets her lover, whom we learn later is Cupid. He insists that she not see his face, and so he comes only at night. Later, naively heeding the doubts implanted by her jealous sisters, she looks at Cupid's face. He then deserts her, and she begins a long journey to find him. At

3. In what follows, I assume that both the *Exegesis on the Soul* and *Authoritative Teaching* are gnostic tractates, although I am aware that questions have been raised about the former. It seems to me that it is precisely the special cast it gives to the story of the soul, which Dr. Scopello has clearly delineated, that marks it as gnostic.

4. Ruth 3:6–13. The text is simply unclear, but one should be cautious about reading back into a story reflecting an ancient traditional agricultural society elements more appropriate to our own time.

5. Apuleius *Metamorphoses* 4.28—6.24. As might be expected, the story, in Apuleius's hands, has striking resemblances to Isiac romances common in the Roman imperial period; see R. E. Witt, *Isis in the Graeco-Roman World*, chap. 18. It is possible, then, that the gnostic author knew the story in a somewhat different form.

one point she decides she must throw herself on the mercy of Venus, and so begins a series of trials set by the goddess, even involving going into the realm of the dead. That experience results in her near-death. But just at that moment Cupid, who has been imprisoned by his mother, frees himself and restores her to life. Psyche is granted immortality by Jupiter, and she and Cupid live happily ever after.

Obvious parallels are the fall, the trials, and the salvation that comes with the appearance of the heavenly bridegroom. But apart from some of the details of the story, there is one striking difference: in contrast to the soul, Psyche does not become a prostitute. She remains throughout faithful to one mate. She is seen by the reader as innocent, although terribly naive.

Assuming that this story was in the mind of the author of the gnostic myth, we must ask why he modified it in such a significant way. It seems to me that searching for an explanation in literary tradition is bound to be fruitless, because the modification has to do with the fundamental convictions of the author. That is, the author, as a Gnostic, believed that the soul, on its own and unaided, was essentially an uncontrolled thing. It was filled with all sorts of desires and occupied its time frantically, and unsuccessfully, trying to get them satisfied. It was a view of the soul that was not unique to the Gnostics, it should be noted; it is found in ascetic literature of every age and in many religions. It seems to me that that conviction is sufficient to account for the crucial modification of the Cupid/Psyche story.

But why was this story chosen to express that view? The answer, I think, reveals the dark side of the topic of this conference, "Images of the Feminine in Gnosticism." Why was not a story about a man chosen? After all, Apuleius, in the *Metamorphoses*, had given the worshipers of Isis the story about Lucius, which was really about the spiritual journey of the soul. It seems to me that the reason was that the Gnostics found that a basic conviction about women converged with their basic attitude about the soul. They were therefore able to use the story of a female to tell about the soul.

The conviction about women, similar to that about the soul, was that, left to themselves, they are filled with uncontrolled desires that lead them more easily into immoral behavior than do the desires of men. Along with this goes the belief that these desires of women can be controlled only by a male sexual partner. This conviction about women's uncontrolled nature, which certainly did not originate with the Gnostics, was never challenged by them. Indeed, they were unable to challenge it,

because it had been built into their set of beliefs about the cosmic drama, upon which their analysis of existence in this world depended. It was because of the uncontrolled desire of Sophia that imprisoning matter came to be. Their acceptance of this conviction led them, as we know, to speak of salvation for women in terms of their becoming male.[6]

Dr. Scopello believes that the gnostic story of the soul reveals something positive about Gnosticism and women—the woman in the story is more active and thinking—and explains why a woman such as Flora might have been interested in it. On the contrary, however, it seems to me that it reveals why she might not have been interested once she found out everything about it. It should be noted that Ptolemeus's letter to her, for all its apparent candor, carefully (I suspect) omits any reference to the doctrine that would have disclosed the basic attitude about women: the fall of Sophia. To enter a gnostic group, once she knew everything about it, a "thinking" woman, such as Flora, would have had a considerable hermeneutic task. She would have had somehow to discount the common belief about the nature of the female, which she would have found at every turn, and at the same time find in the statement of this belief a way of thinking about her own spiritual condition as a *person*. In other words, in some sense she would have had to demythologize it.

That there were women in gnostic groups suggests that many were able to do that, just as women have through the ages in various religions (e.g., with regard to male language and male images that seem to exclude them). But the constant emphasis on the defect of femaleness, and the like,[7] and the use of the image of an out-of-control female to talk about the soul, must have been a special burden to them. It is hard to believe that the presence of Mary, and occasionally some other women, among the special gnostic transmitters of revelation would have relieved the situation much. They, after all, were in the past.

It may be that this problem was influential in the final outcome of the struggle between the orthodox and the Gnostics. Women may have been put down badly in the orthodox churches, but at least they were not burdened with a conception of themselves that was essentially degrading. The account of the fall of Adam and Eve, to be sure, was used polemically against women within orthodox circles (e.g., 1 Tim. 2:11ff.). But what was crucial for faith about that was the fall of male and female,

6. *Gos. Thom.*, logion 114; *1 Ap. Jas.* 41,15–16.
7. E.g., *Tri. Trac.* 78,3–12; *Eugnostos* 85,7–9 (and parallel in *Soph. Jes. Chr.*); *Dial. Sav.* 144,17–22; *Zost.* 1,10–14; 131,5–8.

which marked them with essentially the same mark—they were both sinners, in need of divine grace. There was no negative characteristic, branded as feminine, that was enshrined in the cosmic order.

Sophia as Goddess in the Nag Hammadi Codices

1. APPROACHES TO THE PROBLEM

Most studies of the Sophia figure(s) and associated stories in Gnosticism emphasize the heterodox Jewish roots of this material. Sophia's descent and return to heaven have been linked to the figure of Wisdom.[1] The stories of attacks on Eve/Sophia by the archons and the emergence of the pure race descended from Seth also have links to Jewish apocalyptic and apocryphal material.[2] What is much less evident at the current stage of research is how the two Sophia traditions fit together. One may attempt to discern different stages of mythic elaboration and rationalization as G. C. Stead has done for the Valentinian tradition.[3] But such a typology does not address a more pressing question: What is the significance of Sophia figures in Gnosticism? They clearly lie on the other side of the divide which Judaism (and many of its Christian descendants) had established between God and any manifestation of a goddess.[4]

Is this shift merely an example of the perversity of gnostic hermeneutics? Does it reflect a different patterning of social and religious

1. G. W. MacRae, "The Jewish Background of the Gnostic Sophia Myth," *NovT* 12 (1970) 86–101.
2. See the detailed study by G. Stroumsa, *Another Seed*, 17–134.
3. G. C. Stead, "The Valentinian Myth of Sophia," *JTS* 20 (1969) 75–104.
4. Thus S. Davies concludes his study of the Canaanite-Hebrew goddess ("The Canaanite-Hebrew Goddess," in *The Book of the Goddess, Past and Present* [ed. C. Olson], 68–79) with the observation that although feminine attributes were attributed to God, "for at least the past twenty-five hundred years the Hebrew goddess has been a way of speaking, not a way of worshipping" (p. 79).

symbolism among adherents of the gnostic sects that told these stories? Or have the Gnostics merely provided more subtle variations on a misogynist tradition in which inherent "weaknesses" in the feminine become a source of condemnation?

The classical Greek goddesses emerge in symbolic patterns that suggest deep suspicion of the "women's world" and its power. Mortals who are pursued by divine lovers can only expect rape, torment, or death.[5] P. Friedrich has suggested that the popularity of Demeter was due to the lack of maternal attributes in the four Homeric queens.[6] His treatment of Aphrodite emphasizes the ambiguity which is an essential element in the goddess's characterization. Her beauty, identification with solar attributes, and powerful sexuality are combined in the pattern of "erring female relative." On the one hand, she is linked with the bridal chamber as the loving and passionate wife. On the other, she is associated with infidelity as the dangerously passionate mistress. Aphrodite experiences the powerful passions that she arouses in others.[7] The mythic images of Aphrodite and Eros have been explicitly incorporated into the telling of the story of the lower Pronoia in *On the Origin of the World* (108,14—111,28).[8]

On the Origin of the World appears to be particularly sensitive to the overlap between the gnostic stories of Sophia/Pronoia/Eve and those of the goddesses. The work gives "Greek" and "Hebrew" explanations for the androgynous being, the "Instructor," begotten of the drop that Sophia cast on the water (*Orig. World* 113,30—114,2). M. Tardieu argues that this passage brings together Aphrodite and the ambiguities of grace and deceit associated with the Pandora figure.[9] The "Hebrew" explanation employs an Aramaic wordplay that derives three names from *hwh*: *hw'* ("instruct"); *hy'* ("live"); and *hywh* ("animal").[10] The duality of the androgynous Adam/Eve is represented in the "instructor"/"serpent." On the one hand, the virginal Eve is full of knowledge. On the other, the defiled Eve is full of guile.[11] The "I Am" predications in which Eve

5. See C. R. Downing, "The Mother Goddess Among the Greeks," in *The Book of the Goddess, Past and Present* (ed. C. Olson), 54–58; S. Pomeroy, *Goddesses, Whores, Wives and Slaves: Women in Classical Antiquity*, 8; G. Devereux, *Femme et mythe*, 34.

6. P. Friedrich, *The Meaning of Aphrodite*, 149–50.

7. Friedrich, *Aphrodite*, 79–88.

8. See the extensive discussion in M. Tardieu, *Trois mythes gnostiques: Adam, Eros et les animaux d'Egypte dans un écrit de Nag Hammadi (II,5)*, 141–214.

9. Tardieu, *Trois mythes*, 102–6.

10. See A. Böhlig and P. Labib, *Die koptisch-gnostische Schrift ohne Titel aus Codex II von Nag Hammadi*, 73–74.

11. So Tardieu, *Trois mythes*, 102–6.

proclaims her identity as the "first virgin," not having a husband and the one who "when she gave birth healed herself" (*Orig. World* 114,4–15), have often been compared with the self-predications of Isis. A. Böhlig and P. Labib have also found overtones of the Ephesian Artemis figure in this section.[12]

The Ephesian Artemis figure appears to be more explicitly invoked in the *Gospel of the Egyptians* (56,4–13). The creation goddess, *plēsithea* ("full goddess"), comes to give Seth his seed. He receives it from "her with four breasts, the virgin."[13] Another allusion to classical mythology has been found in the episode in which the spiritual Eve escapes the lust of the archons by turning into a tree (*Hyp. Arch.* 89,25–26).[14] The mixed allusions in these examples do not detract from the overwhelming impression of twisted and inverted Judaism as the substructure of the gnostic Sophia/Eve follows the archaic patterns set in the stories of the goddesses.

The hermeneutical difficulty of appreciating such stories is increased by our distance from any religious environment that is affectively shaped by stories of this type. We evaluate the gnostic Sophia/Eve through a tradition that has no place for the ambiguous "defiled virgin goddess," so we measure Sophia against patterns of "sin," "flaw," and "fault" which may not be appropriate to her story.

2. TOWARD REVALUING THE SOPHIA STORY

W. Burkert's study of structure in Greek mythology has suggested a basic pattern of stories around the mothers of important heroes. The story follows a sequence of five stages:

1. A young girl leaves home—is separated from childhood and family.
2. An idyll of seclusion.
3. The girl is surprised, raped, and impregnated by a god.
4. Tribulation—the girl is severely punished and threatened with death by parents or relatives.
5. Rescue—the mother gives birth to a boy and is saved from death and grief as the boy is about to take over the power to which he is destined.

12. Böhlig and Labib, *Schrift ohne Titel*, 75.
13. See A. Böhlig and F. Wisse, *Nag Hammadi Codices III,2 and IV,2: The Gospel of the Egyptians (The Holy Book of the Great Invisible Spirit)*, 182.
14. B. Pearson, "'She Became a Tree'—A Note to CG II, 4:89,25–26," *HTR* 69 (1976) 413–15.

Though agents, places, motivations, and other details vary, the sequence of departure, seclusion, rape, tribulation, and rescue of the mother as the prelude to the emergence of the hero forms a set pattern.[15]

Much of this sequence still remains in the admittedly more abstract tales of Sophia. Though her consort/savior is often a heavenly aeon rather than an offspring, a number of turns in the story of the lower Sophia do concern actual or attempted rape by the archons. And, in *On the Origin of the World*, Sophia Zoe's drop engenders the Instructor/Eve who is wife, virgin, mother, neonate, and physician (*Orig. World* 113,23—114,15). Creation by the mother out of a "drop" or "in the waters" appears to have been a set topos of gnostic mythology. Within a Greek context such a motif recalls the emergence of Aphrodite from the waters after the castration of Kronos.[16] In the *Sophia of Jesus Christ* (NHC III,4) this theme is linked with Sophia's activity in the lower world through her consort, the androgynous man (*Soph. Jes. Chr.* 101,6–20; 106,24—108,4; BG 119,5–15). In this version, Sophia herself is never "fallen" but is identified with the "mother goddess" (114,14–18).

The "hymn of the Child"[17] in the *Apocalypse of Adam* (77,28—82,19) provides mythological accounts of the coming of the Savior "upon/to the water," which are put forward by the powers. These explanations carry certain common features. The child is conceived unnaturally/ illegitimately (by prophet, god, virgin womb, virgin raped by Solomon and demons, father-daughter incest, parthenogenesis, drop from heaven, sun and moon,[18] cloud); the child is raised in hidden or secret places; the child has a special caretaker. The ambiguity of the various descriptions lies in the fact that the child is clearly the divine Illuminator but is described from the perspective of the divine powers who can only speak of his origins with the language of lustful begettings, which they know through their God, Sakla (*Ap. Adam* 74,3–4).[19] In each case, the divine child receives his "glory and power" during the period in which he is being secretly nourished before coming to the world.

The "false myths" of the powers do contain some of the truth of gnostic revelation: the Savior is not from the lower world but from the heavenly aeons (*Ap. Adam* 82,19–28). But they are also inherently

15. W. Burkert, *Structure and History in Greek Mythology and Ritual*, 6–7.

16. Devereux (*Femme et mythe*, 97–126) traces this theme to the Near East. Aphrodite represents a phallic female who combines masculine and feminine attributes.

17. Stroumsa, *Another Seed*, 88f.

18. The two "illuminators" of the twelfth kingdom (*Ap. Adam* 82,4–7; Stroumsa, *Another Seed*, 90).

19. Stroumsa, *Another Seed*, 90–91.

paradoxical because they represent the accounts available to those who continue to live under the powers that govern the lower world. This example suggests that the paradoxical hymnic affirmations of Sophia in gnostic writings[20] reflect a process in gnostic illumination. They are not intended as a comment on the helplessness or ambiguous divine status of the gnostic Sophia. Rather, they represent a perception of the inherent contradictions in the nongnostic religious traditions of humanity.

Another paradoxical element in the gnostic accounts of Sophia derives from the quest for the "pure origin" of the gnostic race. We have seen that in the *Gospel of the Egyptians* Seth receives his seed from the virgin goddess, Plesithea. The earliest stages of gnostic mythologizing involve expressions that oppose the "other, immovable, incorruptible race" (e.g., *Steles Seth* 120,1–3; *Gos. Eg.* 51,8–9; *Ap. John* NHC II,1 2,24–25; 28,3–4), which is fathered by the "perfect man" or somehow linked to the great Seth, and the other "race" of nongnostic gods and humans. G. Stroumsa has contrasted the gnostic exaltation of the race of Sethians with a tradition of Jewish mythology that had identified the "sons of Seth" with the "sons of God" in Gen. 6:1–4.[21] But gnostic accounts of their origins separate the "pure seed" from that in the stories of Eve's rape by the demiurge.[22] The "defiled seed" will be destroyed in the consummation of the age (e.g., *Gos. Eg.* 59,24–25; *Paraph. Shem* 44,25–26).

The "rape and defilement" stories use this thematic element in the mythological tradition to dissociate the gnostic from what has its origins in lust.[23] This quest for an independent origin is frequently associated with the quest for liberation from the powers and from bondage to fate. The *Apocryphon of John* (28,11–32) makes adultery of the powers with Sophia the source of the "bitter fate" which holds the world in its grip. This plan is repeated after the flood, which the gnostic race escapes by hiding itself in a luminous cloud, when the archons seduce the daugh-

20. E.g., *Orig. World* 114,8–15. This hymnic passage apparently reflects the "titles" used of Eve/Sophia such as we find in *Hyp. Arch.* (89,16–17). The *Thunder, Perfect Mind* expands this genre into a discourse by the female revealer, who reproaches humanity for its failure to acknowledge her (see G. W. MacRae, "The Thunder, Perfect Mind," in *Nag Hammadi Codices V,2–5 and VI* [ed. Parrott], 231f.).

21. Stroumsa, *Another Seed*, 128–34. Josephus (*Ant.* 1.69–71) apparently reflects this tradition. Stroumsa suggests that the story had developed in some circles that at the time of Jared and Enoch most of the descendants of Seth, who had been leading an isolated, pure life, intermingled with the children of Cain. Noah alone preserved the purity of the seed of Seth, which he transmitted to his son Shem (cf. *1 Enoch* 85—90).

22. Stroumsa, *Another Seed*, 101.

23. Stroumsa (*Another Seed*, 101) insists that *genea* in the *Apocalypse of Adam* is not simply metaphorical but has biological overtones.

ters of men and beget children like themselves (*Ap. John* 29,16—30,11). The two rape stories are framed by two episodes of revelation in the long version of the *Apocryphon of John*. The first comes in response to the compassionate revelation of the perfect race by the Mother-Father (*Ap. John* 27,33—28,11). The second is the hymnic declaration of the three-fold descent of the heavenly Pronoia (*Ap. John* 30,11—31,5). In this version of the tale, the compassionate goddess, Pronoia, successfully recovers what is her own from Hades when the Gnostic answers the call to awakening associated with the baptismal rite of the sect.[24]

As in the affirmation of superiority of the powers in the description of the perfect race, other accounts of the attempted rape of Sophia/Eve also express the disjunction between the Gnostic and the powers that rule this world. When Eve begets Seth's sister Norea in the *Hypostasis of the Archons* (91,35—92,3), she exclaims, "He has begotten on me a virgin as an assistance [for] many generations of humanity. (She is the virgin whom the forces did not defile.)" When the archons attack Norea, she proclaims the superiority of her origins (*Hyp. Arch.* 92,21–26). The angel Eleleth, who comes in answer to her further prayers for help, repeats the inviolability of the gnostic race (*Hyp. Arch.* 93,23–32; 96,19–31). *On the Origin of the World* expands on a closely related tradition (116,9—117,5). The archons invent the story of Eve as taken from Adam's rib in order to hide the fact that the spiritual Eve is not derived from their world and to hold her in bondage to Adam. They only succeed in defiling their own body, however, since it is impossible to "defile those who say that they are begotten in the consummation of the true man by means of the word" (*Orig. World* 117,9–11).

S. Pomeroy observes that stories like that of Daphne turning into a tree reflect the helplessness of women before divine power or aggression.[25] The gnostic stories have worked an emotive twist on that theme by discovering that the "powers" of such gods are to be ridiculed.[26] Such

24. A similar baptismal theology is reflected in the *Apocalypse of Adam* (see Stroumsa [*Another Seed*, 101–3], who thinks that the author was opposed to groups who defile the water by subjecting it to the will of the powers [*Ap. Adam* 84,18–23]).

25. Pomeroy, *Goddesses*, 11.

26. The *Testimony of Truth* engages in the most sustained and explicit pattern of ridicule. Mockery of the OT God is employed in a polemic against orthodox Christians (see B. Pearson, "Jewish Haggadic Traditions in the *Testimony of Truth* from Nag Hammadi (CG IX,3)," in *Ex Orbe Religionum: Studia Geo Widengren* (ed. J. Bergman, K. Drynjeff, and H. Ringgren), 1:457–70). The elements of goddess mythology attached to the Sophia stories suggest that the Gnostics also scorned pagan myths. The *Tripartite Tractate* (109,6—114,30) ranks the views of the Greeks and the barbarians below those of the Jews and the prophets.

mockery takes place from a position of "hidden superiority" that shows up the violence, aggression, boasting, folly, rape, and domination of the forces that claim to rule the world as ignorant posturing and pretending to divinity. The truth to which the Gnostic comes by repeating the Sophia stories is not the pathos of a suffering victim but the appropriation of a new identity that is not given in the established, social, religious, and symbolic world that he or she shares with the rest of humanity.

3. THE "VICTIM" IS THE GODDESS

Both the christianization of gnostic myths and the fact that most scholars who study them have interiorized the religious symbolics of a Jewish or a Christian "patriarchal orthodoxy" frequently occlude the feminine side of the gnostic savior. Since the devolution of the lower world is often attributed to Sophia's passion to bring something into being "of herself,"[27] and she must seek the aid of her heavenly consort, or of the whole pleroma, to be restored,[28] the gnostic story easily falls into the gender polarization of Burkert's pattern. The victimized or suffering woman must be saved by her son or another male who can fill the mythic (and psychological) pattern of hero.

The androgyny of the divine pleroma is frequently reduced to a "weak female"[29] which must be saved by being attached to a dominant male. That this is a misreading of the Sophia story is already suggested by the revelatory "I Am" pronouncements, which, as we have seen, are linked to the call of awakening which Sophia brings. The "I Am" speech is commonly associated with Isis, whose popularity in her Hellenized form lies in her superiority to fate and her role as "helper" of humanity.[30] Such superiority is a dominant concern in gnostic stories. Isis provides a further link to these stories in that she must obtain the "seed" of Osiris in order to provide her dead consort with offspring. An Osiris hymn says,

27. Though the result is described as deformed or as an abortion, the activity is a desire to imitate the highest form of divine creativity. It also reflects parthenogenic activity on the part of the gods and goddesses. Hera's jealousy over Zeus's production of Athena leads to the birth of Hephaesto. According to one version of the myth, she throws him out of heaven because of his deformity (see Devereux, *Femme et mythe*, 83f.; Pomeroy, *Goddesses*, 7).

28. Cf. *Ap. John* 9,25—10,23; *Hyp. Arch.* 94,4–34; *Orig. World* 99,23—100,29; *Soph. Jes. Chr.* 114,14–25; *Ep. Pet. Phil.* 135,9—136,15.

29. The weak female may be a Sophia figure in the myths of origins or the representation of the embodied soul as in the *Exegesis on the Soul*.

30. See V. Tran tam Tinh, "Serapis and Isis," in *Jewish and Christian Self-Definition*, vol. 3: *Self-Definition in the Greco-Roman World* (ed. Meyer and Sanders), 105–8.

"She raised the slackness of the weary [= the phallus of Osiris], received his seed and formed his heir." A later hymn calls this achievement a "manly deed": "O Osiris, first of the westerners [= the realm of the dead], I am your sister, Isis; there is no god who has done what I have done; I made myself a man, though I am a woman, in order to make your name live upon the earth."[31]

For the Gnostic, even Isis reflects the mythic pattern exemplified in the "Hymn of the Child." She will have to educate Horus in secret to protect him from the evil designs of Seth until he is old enough to defeat his uncle.[32] To the Gnostic, the "mysteries" which represent her wanderings and sufferings[33] are as flawed in their representation of salvation as the baptismal cults rejected by the *Apocalypse of Adam*. But her story does make it clear that the image of a powerful goddess, victorious over fate and the source of a secret wisdom,[34] can be combined with a story of the goddess suffering, wandering, and weeping for her "lost" consort.

The connection between the Sophia stories and a powerful savior must be traced in the ordering of the gnostic pleroma. That gnostic writings frequently include a feminine figure in the divine triad is well known (e.g., *Ap. John* NHC II 2,13–15; 4,27—5,11; *Trim. Prot.* 38,2–16). The *Trimorphic Protennoia* (42,4—46,3) provides a revelation discourse attached to each of the divine figures. The mother's summons, in a voice that is unknown to the gods of the lower world, calls the Gnostic to awakening (*Trim. Prot.* 44,27–45,20). This summons is much like the pronouncement of Pronoia at the end of the *Apocryphon of John*. She is the source of the spirit possessed by the gnostic race (*Ap. John* 45,20–30). The ritual context of this divine summons is further emphasized in the activity ascribed to the Word. Like the Father, the Word comes into the world to reveal mysteries to the Gnostics. The Father's revelation is associated with breaking the first bonds that hold the Gnostics and with smashing the powers (*Ap. John* 41,26–35). The Word's activity is described in ritual terms. He gives gifts of living water, light, robes, baptisms, enthronement, glorifying, and the five seals from the light of

31. Both passages are cited in C. J. Bleeker, "Isis and Hathor: Two Ancient Egyptian Goddesses," in *Book of the Goddess* (ed. Olson), 34.
32. There is no evidence that the gnostic Seth represents a transformation of the Seth figure in Isis mythology (see B. Pearson, "The Figure of Seth in Gnostic Literature," in *The Rediscovery of Gnosticism*, vol. 2: *Sethian Gnosticism* [ed. Layton], 472–504).
33. Cf. Plutarch *Isis and Osiris*, Moralia 361DE.
34. The Isis cult also made ascetic demands upon its followers, which were publicly known, such as fasting before initiation and bathing in the Tiber during the winter (see Bleeker, "Isis and Hathor," in *Book of the Goddess* [ed. Olson], 39–40).

the Mother (*Ap. John* 48,6–35). Clearly the Voice of the Mother is the one which the Gnostic hears in her or his baptismal awakening.[35]

John Sieber's work on Barbelo as Sophia in *Zostrianos* sheds considerable light on how Barbelo is related to the various Sophia figures in the group of writings we have been studying.[36] Below the true God, the Invisible Spirit, one finds Barbelo and a triad: Kalyptos, Protophanes, and Autogenes. The members of the triad correspond to the Neoplatonic triad: Existence, Mind, and Life. The Invisible Spirit corresponds to the One and Barbelo to the Intellect, which is sometimes tripartite. Here she is the source of the Triad, each of whose members has a quaternity. Thus, Barbelo is the ultimate source of everything that exists.[37] The third member of the triad, Autogenes, is closest to the material world. It includes Adam, Seth, and Mirothea, a title for the Mother.[38]

Sophia is not to be identified with Barbelo but is part of the Autogenes system. As Zostrianos ascends, he is baptized in each of the four aeons of Autogenes. The answers to his questions represent the content of the gnosis he will later reveal. The story of Sophia's "looking down" and the production of the lower world belong to this context (*Zost.* 9,16—10,17; 27,9–21).[39] The *Apocryphon of John* (NHC II 8,16–20) describes the Autogenes Tetrad as Eleleth, Perfection, Peace, and Sophia. She is part of the Eleleth Aeon in the *Gospel of the Egyptians* (56,22—57,5). The *Trimorphic Protennoia* (39,5—40,1) links Eleleth, the "guileless Sophia,"[40] and the disordered Epinoia to the origins of the lower world. The Barbelo Aeon, Sieber suggests, is that in which all things outside the Invisible Spirit come to exist. The material world originates out of its lowest level, the Sophia Aeon of Autogenes. The interrelationship of these aeons makes it possible to pass attributes back and forth between them.[41]

35. The baptismal rite was also the context in which the true name of the savior was pronounced (*Ap. Adam* 77,18–27; 83,4–6; *Melch.* 16,17–18; so Stroumsa, *Another Seed,* 93).

36. J. H. Sieber, "The Barbelo Aeon as Sophia in *Zostrianos* and Related Tractates," in *Rediscovery* (ed. Layton), 2:788–95.

37. Sieber, "Barbelo," 788–91.

38. The *Gospel of the Egyptians* (49,1–10) names her Mother of Adam; see Sieber ("Barbelo," 791–92) for additional references.

39. Sieber ("Barbelo," 793f.) also suggests that the female personage of the Existence, Life, and Blessedness triad (*Zost.* 82,23—83,1; 83,7–10) is Sophia rather than Barbelo, since the same figure is also "darkened" (78,17–19), ignorant (81,1), and not "departing anymore" (81,8–10).

40. "Guileless" appears to be the opposite of the "deceitful countenance" which *Zostrianos* (10,15f.) says makes it impossible for the Archon to capture her likeness.

41. This is possible in the case of the reference to Barbelo as Wisdom in the *Three Steles of Seth* (123,15–17; so Sieber, "Barbelo," 794).

Christianization of many of these gnostic writings consisted either in providing a framework in which Jesus functions as the revealer or in internal identification of Jesus with the heavenly "Seth," "Adam," or "Immortal Man." In the *Apocryphon of John,* Jesus claimed to be the "Father, Mother, Son" and is presented by the framework of the story as the one who speaks. However, Hans-Martin Schenke correctly warns that that identification does not determine the identity of the one who speaks within the body of the writing. The speaker may be female.[42] Questions remain to be resolved about the transmission of the *Apocryphon of John* tradition, since Barbelo's role appears to have been shifted in the various recensions. For example, her cosmogonic function is omitted in the way she is introduced in the short version (BG 27,18—28,4), which also lacks her revelatory speech at the end of the text.[43]

Stead has argued that Valentinian sources show a divided tradition. For some, more congenial to Jewish and Christian monotheism, the ultimate source of all things is a unity. For others, the male/female dyad extends into the source of all things. The figure of a single Sophia who operates outside the pleroma has been duplicated so that the lower Sophia is left wandering in the world until her rescue by Christ.[44] Though Stead considers it likely that Valentinus had thought of an "unfallen" female figure at the head of the hierarchy, it also appears that the Valentinians considered the male to be superior and held that "Father" was the proper name of God.[45]

However, even in the accounts that focus on the "fall(s)" of Sophia as a lesser divine being, she is not blamed for her situation in any of the various reasons given for her plight.[46] It is simply a necessary condition for the mixed situation of the world as we know it.

Elements of this type of Sophia story are incorporated into formulae of ascent for the dying (Irenaeus *Adv. haer.* 1.25.5 [Marcosians]; Epi-

42. H.-M. Schenke, "The Phenomenon and Significance of Gnostic Sethianism," in *Rediscovery* (ed. Layton), 2:611.

43. BG 76,1–4 does allude to earlier activity of the Mother on behalf of her seed. For further discussion of the different versions of the *Apocryphon of John,* see Karen King's essay, "Sophia and Christ in the *Apocryphon of John,*" in this volume.

44. Stead, "Valentinian Myth," 76–88. Duplication also occurs in *On the Origin of the World,* where the heavenly Sophia is "Pistis" (99,1–2; 100,1–16). Despite the likeness which "flows" out of her and her "deficiency and disturbance," Pistis Sophia never leaves the heavenly world (100,28–29). She is able to reveal herself in the waters of the lower world to answer the Archon's impiety and then withdraw to her light (103,28–32). Her daughter, Sophia Zoe, is the consort of Ialdabaoth's repentant son, Sabaoth (107,28–35), and is able to exercise a beneficent function in this world by creating the androgynous, good powers (107,4–14).

45. Stead, "Valentinian Myth," 88.

46. Stead, "Valentinian Myth," 102f.

phanius *Haer.* 36.3.1–6 [Heracleonites]). This formula appears in the
First Apocalypse of James (33,11—35,25). The soul's presence in the world
is due to the "race" brought down from the Preexistent by Achamoth,
who produced them without a father (34,2–15). The Gnostic will confuse
the powers and so be able to pass beyond them by calling upon Sophia,
who is "in the Father," the mother of Achamoth (also produced without
a male; *1 Ap. Jas.* 35,5–23). The identity to which the Gnostic aspires is
"Son of the Preexistent Father," not "offspring of the Mother."

4. SOPHIA IN RITUAL SPEECH

We tend to focus on the myths and other verbal explanations of
ancient religious phenomena because we have so little firsthand infor-
mation about religious praxis.[47] Albert Henrichs's study of the Dionysus
cult calls for the analysis of "sacred speech" as a crucial element in the
study of ancient cults. Such speech, largely intelligible only to insiders,
includes titles of God, titles of worshipers, names of cult objects and
activities, ritual exclamations, hymns, prayers and other invocations,
beatitudes, passwords and rallying slogans, and other esoteric "sacred
words."[48]

Ritual speech is an important element in many of the works we have
been considering. Schenke has insisted that the *Gospel of the Egyptians*
must be interpreted as being about prayer, how properly to invoke the
celestial powers during the rite of baptism.[49] We have already seen that
the Mother's self-declaration in "I Am" formulae and the call to awaken-
ing appear to have been enacted in the context of a baptismal rite, which
seems to have included the ascent of the soul, ritual sealing, dressing the
initiate in special garments, pronouncing the divine name, and, perhaps,
some acclamation of the newly awakened.

The ascent of the soul in the *First Apocalypse of James* concludes with
the cry to the "higher Sophia" that confused and disoriented the powers.
These examples show that the heavenly Sophia was invoked in gnostic

47. However, Schenke raises an important question for textual analysis when he
distinguishes *On the Origin of the World* from related writings such as the *Hypostasis of
the Archons* on the grounds that it appears to be the idiosyncratic work of
systematization whereas other writings reflect the verbal and cultic activity of a larger
group ("Gnostic Sethianism," in *Rediscovery* [ed. Layton], 2:597).
48. A. Henrichs, "Changing Dionysiac Identities," in *Jewish and Christian Self-
Definition* (ed. Meyer and Sanders), 3:155–57.
49. Schenke, "Gnostic Sethianism," in *Rediscovery* (ed. Layton), 2:600.

cult. The divine Triad is the subject of a prayer of thanksgiving by the Perfect Man in the *Apocryphon of John* (NHC II 9,5–10). The *Gospel of the Egyptians* suggests that extensive prayers and thanksgivings were linked with the baptismal rites (NHC III 65,26—68,1). The Mother is mentioned in the concluding section of this baptismal prayer.

Other writings contain prayers that appear to have been part of the communal celebration of the soul's ascent and union with the heavenly powers. In *Melchizedek* (NHC IX 16,25–27), Barbelo is praised in the midst of prayers to the Father and the various lights. The *Three Steles of Seth* includes a lengthy prayer to the male-virgin Barbelo (NHC VII 121,21—124,14) for her saving role in seeing the hidden Father and begetting the multiplicity of aeons. Fragmentary references to Barbelo in *Zostrianos* probably included acclamations and prayer formulae (e.g., NHC VIII 53,10–23; 61,24; 63,13–64,6; 118,9–20; 125,11–12; 129,8–11). Withdrawal into the Barbelo Aeon to contemplate the divine is presumed in the fragmentary text of *Marsanes* (e.g., NHC X 8,23—9,27), though this stage of self-knowledge is marked by silence rather than the prayers alluded to in the later passages of the document.[50] As in the *Three Steles of Seth*, Barbelo's twofold function is described: *(a)* as "female" she engenders the multiplicity of the world; and *(b)* as "male" she withdraws from the world of multiplicity to the One.

In addition to these expressions of prayer, attached to the role of the heavenly Sophia or Barbelo in salvation, we also find examples of the "lower" Sophia praying for repentance and restoration. *A Valentinian Exposition* (XI 34,25–31) has a confessional expression of repentance. In the *Trimorphic Protennoia* (39,28—40,4), the disordered Epinoia prays for her restoration. She is then given a blessing and a higher order.

This rapid survey of prayers and invocations that involve the Mother, Barbelo, or Sophia follows the general lines established in the discursive and narrative material. Though it might seem easy to lose sight of the Mother/Sophia amidst the more numerous masculine figures, her place appears to be firmly anchored in cultic practice. Within that context, the "fall" or "passions" of Sophia are more clearly subordinate to the experience of salvation than might appear to be the case in narratives that are oriented toward giving an explication of how the world came to have

50. See the extensive commentary on this text in B. Pearson, "Marsanes," in *Nag Hammadi Codices IX and X* (ed. B. Pearson), 229–347. The male-virgin Barbelo becomes "feminine" in expanding into multiplicity. She retrieves her masculinity in withdrawal to the unifying contemplation of the divine. This pattern is apparently an image of that pursued by the Gnostic.

the peculiar structure it does. These results would also support Stead's intuition that the Sophia story and that of the "fall of Eve" were not always linked. He proposes that the story of Eve was an addition to Valentinian exposition to bring together divergent conceptions of Sophia's function.[51]

5. CONCLUDING REFLECTIONS ON
GNOSTIC EXPERIENCE

Many of the gnostic tractates evidence an almost scholastic patching and elaboration of traditional mythic and ritual elements. In this endeavor, they may be compared with Plutarch's treatment of Isis and Osiris. Stories of the Jewish *Urgeschichte* have played a critical role in many of the treatises. In others, one finds speculation associated with the Neoplatonic triad and even a detailed exposition of grammatical theories about vowels and diphthongs in *Marsanes*.[52]

Development of Jewish traditions appears to have played a critical role in the negative images of passion, lust, and rape associated with the archons and Eve. Early in the Enoch traditions, the association of the "sons of god" with human females and the pollution of the earth with violence and fornication was interpreted as the occasion of improper revelation.[53] True revelation can be obtained only through the seer's heavenly journeys. Gnostic adaptation of such Jewish traditions often surfaces motifs that go back to an archaic level of goddess mythology. Seduction by, or of, the powers is necessary for the fertility and emergence of life forms on earth. The *Apocryphon of John* (NHC II 29,8–25) has the sons of Ialdabaoth emerge from union with Eve.[54] The persistent pattern of virgin/mother/whore belongs to the pattern of "self-induced" pregnancies, and at an archaic level, "virgin" designated the powerful mother goddess as one without a consort who would still give birth. Her cult included ritual prostitutes, persons held in honor for their association with the goddess.[55]

Domestication of the cult in classical times split apart the archaic

51. Stead, "Valentinian Myth," 103.
52. See Pearson, *Codices IX and X*, 237f. Pearson notes that this piece of expository learning seems to be quite unrelated to the religious concerns of the treatise.
53. J. J. Collins, *The Apocalyptic Imagination: An Introduction to the Jewish Matrix of Christianity*, 41.
54. See also *Hyp. Arch.* 89,17–29 and the discussion in Stroumsa, *Another Seed*, 35–39.
55. Devereux, *Femme et mythe*, 79–85; J. Ochshorn, "Ishtar and Her Cult," in *Book of the Goddess* (ed. Olson), 25. Inanna, a goddess of war and cruelty, is also linked to sexuality through prostitutes (Friedrich, *Aphrodite*, 13–19).

virgin/prostitute figure. "Virgin" is assigned to a young girl and used to idealize marriage. Along with this shift, the image of sexuality as source of pollution is emphasized.[56] The influence of this shift on gnostic stories of Sophia is particularly evident in those variants which stress her passion for a consort or for the Father (*Adv. haer.* 1.2.2; *Ref.* 6.30–31; *Gos. Phil.* NHC II 59,31–32). In some traditions this passion has been intellectualized as the desire for knowledge.[57]

While the intellectualizing of the passion of Sophia (or in Plutarch's case of Isis) as the desire for wisdom belongs to the scribal activity of interpretation, emergence of themes connected with the goddess and stories of the adventures of Sophia/Eve should be viewed in the context of broader cultural shifts in the Hellenistic period. The Greco-Roman novel holds its female and male heroes to an ideal of chastity through various adventures of separation, violence, attempted rape, and the like.[58] The novels show a wide-ranging attitude toward sexuality and also surface motifs that belong to the archaic goddess myths of the Ancient Near East.[59] But their melodramatic character is not entirely divorced from the uprooting and separation that occurred in people's lives. G. Anderson suggests parallel examples from the papyri, such as the following letter:[60]

> Seremilla sends her sincerest greetings to her father Socrates. Above everything else I pray for your good health and every day I make supplication for you in front of Lord Sarapis and the other gods in his temple. I want you to know that I am not alone. You must realize that your daughter is in Alexandria, so that I in turn can know that I still have a father, so that people don't regard me as an orphan.

Among the Nag Hammadi writings, the most novelistic in tone is the account of the soul's wanderings and sufferings, the *Exegesis on the Soul*. Its author delights in the type of details characteristic of the novel: description of her abandoned state; agonized concern over a lost spouse; dreams or premonitions; tears; recalling of trials; and a taste for the psychological dimensions of the action. The scale of this work is more

56. Devereux, *Femme et mythe*, 88–91.
57. Stroumsa, *Another Seed*, 69. The result of Sophia's illegitimate passion is formless, an abortion, or is the "false image" that results from adulterous thoughts even when a woman is impregnated by her husband (*Gos. Phil.* 78,12–20; see Stroumsa, *Another Seed*, 35).
58. See T. Hagg, *The Novel in Antiquity*; and G. Anderson, *Ancient Fiction: The Novel in the Greco-Roman World*. [See also the essay by Madeleine Scopello, "Jewish and Greek Heroines in the Nag Hammadi Library," in this present volume—ED.]
59. So Anderson, *Ancient Fiction*, 112.
60. Anderson, *Ancient Fiction*, 115 (P. Berol. 6901,1–7).

human than the mythic accounts, though its didactic tone separates it from the genre of the novel.[61]

The Greco-Roman novel is the first genre to appeal to women as well as to men. T. Hagg suggests that its social constituency lay in the bureaucracy of the Asia Minor cities. The ability to read had not yet become the facility to do so for pleasure in this group. The novels are structured for recitation, with repetitions, foreshadowing, and plot summaries. Some manuscripts even have cartoon-like illustrations. We are told that Chariton was a lawyer's secretary, and he may have written for his colleagues.[62] Gnosticism also appears to have drawn its adherents from this class. It may be no accident that gnostic sects decline in influence among Christians after the large-scale influx of the intellectual elite into leadership of the orthodox Christian churches in the second half of the fourth century.[63]

What is most striking in the gnostic writings is the severe dissociation evidenced in the treatment of sexuality. Stroumsa has observed that gnostic myth seeks to externalize consciousness. It is a consciousness which is preoccupied with separation of what is evil, unclean, dark, and material from what is "light."[64] Anderson argues that the Gnostics have taken the romance of the chaste heroine and her trials to such an extreme hatred of sexuality and reproduction that they deprive women of that dignity and stature attained by the heroines of the novel.[65] According to this view, the gnostic experience is ultimately misogynist in the extreme.

Anderson's evidence is derived from comparison between the romantic novels and the ascetic Thomas tradition, which may indeed represent the type of reaction he suggests. The Sophia traditions suggest a much less agonistic approach. Some of these writings take a docetic tack. The "spiritual Eve" remains untouched by the lust of the powers, who can only defile/impregnate her shadow.[66] These writings mock verbosity, boasting, combativeness, and aggression on the part of the gods, all typical characteristics of male language and behavior. W. Ong suggests

61. See Madeleine Scopello's essay in this volume; based on her work, see J.-M. Sevrin, *L'Exégèse de l'Ame (CG II,6)*, 41–42.
62. Hagg, *Novel*, 90–98.
63. R. MacMullen (*Christianizing the Roman Empire: A.D. 100–400*, 68) notes that they were the last class to be converted, since they were least likely to respond to the type of literature produced by the church. Earlier representatives of that group came by way of the philosophical schools.
64. Stroumsa, *Another Seed*, 1–3, 31.
65. Anderson, *Ancient Fiction*, 114.
66. Stroumsa, *Another Seed*, 42–44.

that the anthropological significance of such characteristics lies in the requirement that the male separate from and shape an identity independent of the female.[67] Male puberty rites emphasize the ability to "be a loner," while anxiety over being alone or abandoned is characteristic of the female.[68] Public bragging and vituperation of one's opponent, characteristic of the male, especially in situations of stress or combat, appear ridiculous to the female and are cause for either anger or amusement.[69] Sophia's reactions to her braggart son, Ialdabaoth, evidence both amusement and anger.

At one level of gnostic storytelling then,[70] we find characteristics of women's experience that would appear to emerge from the preconscious level of expression rather than from a manipulative exegesis of tradition. We might, then, take up Anderson's challenge and ask if there are other hints in the papyri that illuminate the psychic dissociation attached to the experience of sexuality and childbirth.

One important clue may lie in the Sophia/Ialdabaoth relationship. Ialdabaoth is "deformed," an "abortion," and must be pushed out of the pleroma. For non-Jewish women this story has analogies with the common, legally accepted practice of exposing infants on demand of the father.[71] Female children were particularly at risk, as the following letter from the first century B.C.E. indicates:[72]

> Hilarion to Allis his sister, heartiest greetings, and to my dear Berous and Apolonarion. Know that we are still even now in Alexandria. Do not worry if, when all the others return, I remain in Alexandria. I beg and beseech you to take care of the little child and as soon as we receive wages I will send them to you. If—Good luck to you!—you bear offspring, if it is a male, let it live; if it is a female, expose it. You told Aphrodisias, "Do not forget me." How can I forget you?! I beg you not to worry.

Allis is faced not only with the anxieties of bearing and exposing a child, she must also cope with uncertain financial support from a distant husband, whom she must remind through intermediaries, "Do not forget me." His return is to be delayed even beyond that of his comrades.

Roman legal traditions attempted to exercise some control over the

67. See W. J. Ong, *Fighting for Life: Contest, Sexuality, and Consciousness*, 61–89.
68. Ong, *Fighting*, 85–89.
69. Ong, *Fighting*, 107–111.
70. Though this is probably not so at the level of scholastic exegesis of the stories and traditions, which would seem to require more extensive education than that readily available to women in this class.
71. J. A. Crook, *Law and Life of Rome, 90 B.C.—A.D. 212*, 108.
72. From M. R. Lefkowitz and M. B. Fant, *Women's Life in Greece and Rome*, 111.

exposure of children, protecting males and firstborn females but permitting the killing of any child born a cripple or otherwise misshapen after neighbors had testified to the condition of the baby.[73] The stories of Sophia, her (absent) consort, and Ialdabaoth project all the emotional ambiguities of such experiences of uprootedness in the Greco-Roman cities onto the cosmogonic stage. Neither Judaism nor Christianity in their "orthodox" forms had the symbolic or mythic resources to image the crisis of roots, generation, and family reflected in the Sophia stories. Nor does the romantic ideal of the novel tell the whole story. The Gnostic holds out a biting critique of the world as it is experienced and a promise that the "true seed" comes from an entirely different order.

73. See Lefkowitz and Fant, *Women's Life,* 173.

Very Goddess and Very Man: Jesus' Better Self[1]

As a hen gathers her brood under her wings . . .
Q 13:34[2]

Masculine terminology overwhelms Christology. Jesus himself was male. The Jewish idea of the Messiah is built on the model of David and his male successors as kings of Judah. Masculine endings bind Christos and Kyrios to the male realm. *Son* of God and *Son* of *man* do the same. Even the Word of God produced masculine overtones (log*os*). The one christological title that is an exception is also the one that failed to make

1. In lieu of more detailed notes, reference may be made to various technical articles I have written about specific dimensions of the current essay: "Basic Shifts in German Theology," *Interpretation* 16 (1962) 76–97 (on the Wisdom Christology of Q). "LOGOI SOPHON: On the Gattung of Q," in *Trajectories Through Early Christianity*, 71–113 (on Q as a wisdom book). "Die Hodajot-Formel in Gebet und Hymnus des Frühchristentums," *Apophoreta: Festschrift für Ernst Haenchen*, 194–235 (on the christological hymns embedded in the Jewish-Christian prayers). "On the *Gattung* of Mark (and John)," in *Jesus and Man's Hope* (ed. D. G. Buttrick and J. M. Bald), 99–129, esp. 118–26, repr. in *The Problem of History in Mark and Other Marcan Essays*, 11–39, esp. 31–39 (on the *mythologoumenon* of the mother bird giving birth to the Savior in the *Apocalypse of Adam* and Revelation 12). "Jesus as Sophos and Sophia: Wisdom Traditions and the Gospels," in *Aspects of Wisdom in Judaism and Early Christianity* (ed. R. L. Wilken), 1–16 (on the Wisdom Christology of Q).
2. Chapter and verse numbers of Q follow Luke. The Bible (including the Apocrypha) is quoted according to the Revised Standard Version. In the case of Q, whereas RSV language is used, occasionally the Lukan text is replaced by a nearer approximation of Q from Matthew. New Testament apocrypha are quoted according to E. Hennecke and W. Schneemelcher, eds., English edition edited by R. McL. Wilson, *New Testament Apocrypha*, vol. 1: *Gospels and Related Writings*. The Odes of Solomon are quoted according to J. H. Charlesworth, ed., *The Old Testament Pseudepigrapha*, vol. 2. Enoch is quoted according to R. H. Charles, ed., *The Apocrypha and Pseudepigrapha of the Old Testament in English*, vol. 2: *Pseudepigrapha*.

it: Wisdom (Sophia). The present essay seeks to investigate this aborted feminine Christology.

1. THE BEGINNINGS OF CHRISTOLOGY

Jesus apparently had no Christology. "Why do you call me good? No one is good but God alone" (Mark 10:18). Probably he would have preferred that we deify the cause: the kingdom of *God*. Hence to the extent that we in our day seek to develop a Christology, as did our predecessors, we must assume responsibility for what we say and do, as did they, and not just parrot their language. If they did the best they could, given their conditions, we must do the best we can, in our often changed conditions. One is that we do not live in their mythopoeic world, another is that we live in the world of modern biblical scholarship, another is that we live in a not unchallenged patriarchal society.

First it needs to be said that all due honor was paid to leaders in the movement to which Jesus belonged without Christology. Like Jesus, John the Baptist also gave his life for the cause and was believed to have been divinely vindicated: "John the baptizer has been raised from the dead" (Mark 6:14). Jesus' own praise for John was unsurpassable: "More than a prophet. . . . Among those born of women none is greater than John. . . . From the days of John until now the kingdom of God has suffered violence" (Q 7:26, 28; 16:16). Yet John was not deified as was Jesus. Nor did the New Testament elevate Jesus' successor, Peter, beyond the status of Rock. It is in such an unchristological environment that are to be placed factors that in retrospect might, no doubt anachronistically, be thought of as the beginnings of Christology.

Jesus was not born doing his thing, any more than was John or Peter. He only came to it near the end of his life. The early tradition, going back to Jesus himself, was quite aware of this, and indeed of its theological significance. For the inception of the time of salvation was originally not marked by the birth of Jesus but rather by the ministry of John: "from the days of John until now" (Matt. 11:12 from Q). This Whence of Jesus had its impact on the earliest efforts to produce a Gospel. All three of the oldest known attempts to decide where to begin the Gospel agree, independently of each other, to begin with John: Q, Mark, and John.

Luke may have respected this venerable tradition in composing his Gospel as well. For he appealed to it in defining the kind of person who would be eligible to become one of the Twelve: someone who was present "beginning from the baptism of John" (Acts 1:22). And the

apostolic preaching according to Acts begins its fulfillment of the Old Testament prophecy with John. The impressive synchronized dating of the beginning of the story begins not with Jesus' birth in Luke 1—2 but with John's baptism of Jesus in Luke 3. So the Gospel of Luke may well have begun there, as the now largely discredited Proto-Lucan theory (and more recently Joseph Fitzmyer in his Anchor Bible Commentary on Luke) had it, in suggesting that after composing both Luke and Acts, Luke may have added, as a sort of belated prologue, Luke 1—2. In any case, Luke was so sophisticated that he was able to write an infancy narrative that, like the beginning of the public ministry, also began with John, thus combining the old tradition that the story begins with John with the new tradition that the story begins with Jesus' birth.

Jesus' activity could have been adequately conceptualized in the thought world of that day as a person possessed by God, in a way formally comparable to the unfortunates possessed by a demon. For according to that thought world, the human self-consciousness can be replaced either by an evil or by a holy spirit. Such a divine spirit was portrayed as having come upon Jesus at his baptism by John "like a dove" (Mark 1:10). This should not be intellectualized as some kind of Hegelian Mind, but rather was intended as the kind of animistic spirit-world force that Hermann Gunkel introduced into New Testament scholarship from the Old Testament and the ancient Near East, a history-of-religions corrective for that all too spiritual mental spirit. If Luke described the spirit as "in bodily form" (Luke 3:22), Mark described it very animistically as what "drove him out into the wilderness" (Mark 1:12).

Whereas Jesus would have more naturally understood this simply theologically, by the time of the Evangelists it is understood christologically. As the one that God chose to possess at the time of his baptism, Jesus is described with a heavenly voice: "Thou art my beloved Son" (Mark 1:11). This was not originally intended as an announcement of an inner-trinitarian relationship that has prevailed from all eternity but was meant as a Father-Son relationship that was first set up on this occasion, defining the turning point marked by John christologically in terms of Jesus. A common patristic reformulation of the Lukan parallel (Luke 3:22) reflects the event character of the voice, in adding from Ps. 2:7: "Today I have begotten you." Though this is presumably a secondary "improvement" of the Lukan text, it probably brings to the surface what was latent in this tradition, a first fumbling step toward Christology. That is to say, the early interpretation of who Jesus was, in terms of his

baptism in John's public ministry, had not presupposed his antecedent or perennial divine Sonship, such as is reflected already in Paul and probably in Mark 1:1: "The beginning of the gospel of Jesus Christ, the Son of God" (if the last phrase was originally in Mark—the manuscript evidence and hence scholarly opinion are rather evenly split). This reading back of divine Sonship is carried much farther, for example, by Luke at the Annunciation: "The child to be born will be called holy, the Son of God" (Luke 1:35), or in his genealogy: "the son of Adam, the son of God" (Luke 3:38). Thus the baptismal voice has already been rendered anticlimactic, and the spelling out of its original implications came to be branded the heresy of adoptionism. It is difficult for us to get out of the mind-set thereby imposed on all subsequent theology, much less to penetrate back to the prechristological level at which Jesus himself probably stood. For he probably did not associate his baptism with any kind of divine Sonship.

Perhaps a *pendant* interpretation of the end of Mark from patristic times will help one to catch sight of this primitive Christian way of thinking (heretical though it came to be regarded): "My God, my God, why hast thou forsaken me?" (Mark 15:34) became (in the *Gospel of Peter*): "My power, O Power, thou hast forsaken me," as the moment when the possessing divine and hence immortal spirit left the Galilean mortal to die. This possession by divine spirit and the resultant transient adoptionism fit much better the functional (rather than metaphysical) context of a Jewish understanding of God's relation to the human he chooses to use (or, to put it in our more familiar, and hence bland and unoffensive language, to inspire). For this possessing spirit is originally neither the divine nature of the second person of the trinity, nor the third person of the trinity, but rather a hypostasis of the divine, a notion popular in Judaism at a time when fear of taking God's name in vain led to not taking it at all, but preferring many surrogates (such as kingdom of *heaven*), in the broader context of a polytheistic world where spirits and demons abound.

This part that God took in Jesus, in possessing him so as to become his functional self, thus did not remain within such alternatives as spirit possession and demon possession but modulated into various male-oriented christological titles. At first, clear subordination was retained ("God" for the Father, "Lord" for Jesus; giving glory to *God* was christianized not as giving glory to *Jesus* but as giving glory to God *through* Jesus). But christological titles nonetheless headed in the direction of Chalcedon and the traditional deification of Jesus (and "subordinationism" ended as a heresy). Jesus' christological status was at times

dated from the resurrection: "God has made him both Lord and Christ, this Jesus whom you crucified" (Acts 2:36); "obedient unto death. . . . Therefore God has highly exalted him and bestowed on him the name . . . Jesus Christ is Lord" (Phil. 2:8–9, 11). In this development the more loose, functional relation of Jesus and the divine spirit gradually sedimented into two distinct parts in a tripartite deity that blossomed under Neoplatonic tutelage into the Nicene trinity, with the Holy Spirit as the third person, and then into the Chalcedonian doctrine of the two natures of the second person.

2. THE GENDER OF GOD

The relation of this to the sex of God becomes more apparent when one recalls that the gender of nouns was often taken seriously as indicating the sex of the subject to whom the noun referred. The Hebrew word for "spirit," *ruach*, is usually feminine (though at times it is used masculinely). Thus in a Semitic world of thought the tripartite deity could reflect the core family of father, mother, and child. But the Greek word for "spirit," *pneuma*, is neuter, so that the question became relevant as to whether the third person (the Spirit's position when no longer the mother in the core family) is actually a person at all. Since the Latin word for "spirit," *spiritus*, is masculine, the personality of the Spirit was thereby assured as well as the all-male trinity. Even though a theologian-linguist such as Jerome (in commenting on Isa. 40:9–11) could point out that the three diverging genders of the noun for Spirit show that God has no sex, the metaphorical suggestiveness of the gender of the nouns dominated classical theology. We today would concede Jerome's point at the literal or metaphysical level, and yet would recognize more than he the metaphorical power of the symbols.

In the Semitic branch of early Christianity the femininity of the Spirit and her role as Jesus' mother are made explicit.[3] This is reflected in the apocryphal *Gospel of the Hebrews*, a text with the Semitic overtones that this title suggests. Here the feminine Spirit as Jesus' mother becomes explicit in a fragment quoted both by Origen and by Jerome:

> Even so did my mother, the Holy Spirit, take me by one of my hairs and carry me away to the great mountain Tabor.

3. I am indebted to Stephen Gero for referring me to R. Murray (*Symbols of Church and Kingdom: A Study in Early Syriac Tradition*) for details of this development. See esp. "The Motherhood of the Church and of the Holy Spirit," 142–50, and "The Holy Spirit as Mother," 312–20.

Here a mythological episode about the mother of the Savior is borrowed from a tradition attested in the *Apocalypse of Adam* (NHC V,5) and Revelation 12. For in the *Gospel of the Hebrews* the parenting of Jesus as Son has nothing to do with his birth or with Mary, but takes place at his baptism, cited in Jerome to Isa. 11:2 according to a further text from this apocryphal gospel:

> But it came to pass when the Lord had come up out of the water, the whole fount of the Holy Spirit descended upon him and rested on him and said to him: My Son, in all the prophets was I waiting for thee that thou shouldest come and I might rest in thee. For thou art my rest; thou art my first-begotten Son that reignest for ever.

Here he is not explicitly Son of God the Father but rather is parented by the female Holy Spirit that is an integral part of the baptism story.

In the Syriac *Odes of Solomon*, dated contemporary with the New Testament, the dove at the baptism becomes a female metaphor for the Spirit (24:1–2; 28:1–2):

> The dove fluttered over the head of our Lord Messiah, because he was her Head. And she sang over him, and her voice was heard.

> As the wings of doves over their nestlings, and the mouths of their nestlings towards their mouths, so also are the wings of the Spirit over my heart. My heart continually refreshes itself and leaps for joy, like the babe who leaps for joy in his mother's womb.

This female dove, the "incarnation" of the Spirit, is Jesus' mother (*Odes Sol.* 36:1–3):

> (The Spirit) brought me forth before the Lord's face, and because I was the Son of Man, I was named the Light, the Son of God.

Once Jesus' divine investment was shifted from his baptism back to his conception in the womb of Mary, the femaleness of the Spirit would seem to have excluded a conception by the Spirit according to the *Gospel of Philip* (NHC II 55,23–28):

> Some say, "Mary conceived by the Holy Spirit." They are in error. They do not know what they are saying. When did a woman ever conceive by a woman?

Thus the Apostles' Creed, with its combination of conception by the Holy Spirit and birth from the Virgin Mary, would seem to have blocked the development of the feminine aspects of the Spirit latent in Semitic usage. The divine Mother in the trinity as a core family was replaced in feminine terms by the human mother, whose elevation toward divine status has been a concern throughout the history of dogma.

A parallel development to that which we have sketched regarding the Spirit may have been even more significant at the beginning and may be less well known today, since, unlike the Spirit, the protagonist has faded from the theological aristocracy: Wisdom. Here again the Hebrew word, *hokhmah*, is feminine, as are the Greek *sophia* and the Latin *sapientia*. Thus the survival of Wisdom in the top echelon of deity would have assured a female part at the top (which may be part of the reason that Wisdom was dropped). Wisdom was fading fast by the time the New Testament itself was written. It may be no coincidence that within the canon the strongest attestation for it (and not very strong at that) is early, two texts that are from the central third of the first century rather than from the last third, from which the bulk of the New Testament comes: 1 Corinthians 1—4 among the authentic Pauline letters dated around 50 C.E.; and Q, which is from much the same period, in that it is clearly older than Matthew and Luke which incorporate most of it.

Just *how* the female Sophia speculation was absorbed into a masculine Christology can perhaps best be approached from a form-critical observation. For Christology seems to have grown most rapidly in the exuberance (inspiration) of hymnic ecstasy, and in this ecstasy to have flown on the wings of Wisdom mythology.

The standard outline of a Jewish prayer of the day would be an opening blessing or thanksgiving to God for having done this and that (a couplet in *parallelismus membrorum*). This would then be followed by the body of the prayer, recounting typically in more detail God's mighty works, often oriented in anticipation to the third part, where a petition called upon God to do again now for us the kind of things he had just been praised for having done for others in the past. This Jewish prayer outline could be christianized by reference to Jesus in connection with the thanksgiving to God, as in Col. 1:12–13 ("giving thanks to the Father, who . . . transferred us to the kingdom of his beloved Son"), whereupon the central section could be christological, in hymnic style, beginning with the masculine relative pronoun "who." This would explain this otherwise inexplicable beginning word in the christological hymns Phil. 2:6–11; Col. 1:15–20; and 1 Tim. 3:16. (In 1 Tim. 3:16 the problem is especially difficult, since the apparent antecedent of the masculine pronoun "who" is the neuter noun "mystery." This led to the misreading of "who" [ΟΣ] as "God"—ΘΕΟΣ, abbreviated to ΘΣ—as in the King James version of the Bible.) The comparable christological hymn embedded in the prologue to the Gospel of John does not begin with the masculine relative pronoun but begins in analogy to Gen. 1:1, "In the beginning." But the introduction of the masculine noun *Logos* provides the equiva-

lent male orientation. Thus the high Christology of these hymns, upon which all subsequent high Christologies have been built, had become male-oriented, in conformity to Jesus and the masculine christological titles, though rooted in Jewish speculation about Sophia.

This high Christology, taking place within a generation of Jesus' death, was able to arise so rapidly because the intellectual apparatus it needed was preformed within Judaism. It only needed to be transferred over to Jesus (as was done in the case of other christological concepts such as Christ and Son of man as well), in order for this quasi-divine hypostasis of Jewish wisdom speculation to become perhaps the highest Christology within primitive Christianity. This wisdom speculation could have developed into a trinitarian formulation that might have included the male within the female context, as occurs in gnostified form in the *Trimorphic Protennoia* (NHC XIII,1) where Sophia manifests herself successively as Father, Mother, and Son (also called Logos), thus strikingly parallel to the prologue of John. Instead, in the orthodox tradition the female context of a Logos Christology was suppressed.

3. THE INCLUSIVENESS OF WISDOM CHRISTOLOGY

One of the relevant dimensions of this Wisdom speculation is that, like the title of Prophet (which also did not prevail as a christological title), it was not sensed as exclusively applicable to Jesus. Most christological titles were in their Christian usage "divine" enough to share in the exclusivity of monotheism, in that *only* Jesus is Lord (1 Cor. 8:5–6), Son of man, Son of God (Q 10:22), Savior, and so forth (although of course Jesus having such quasi-"divine" titles alongside the Father as also God was not pure monotheism, as our Jewish colleagues like to remind us; see again 1 Cor. 8:5–6). But Wisdom has spoken down through the ages through various spokespersons whom she has inspired, according to the Jewish wisdom tradition (Wis. 7:27):

> Though she is but one, she can do all things, and while remaining in herself, she renews all things; in every generation she passes into holy souls and makes them friends of God, and prophets.

This approach continued in Jewish-Christian (that is to say, primitive Christian) Wisdom Christology. Q 7:35: "Yet Wisdom is justified by her children." This has to do with the repudiation of John and Jesus by "this generation" in the preceding context. But rather than saying "they" (or "John" and "the Son of man," as they had just been designated), the

punch line speaks only of "Wisdom," as if what was at stake were not the bearers of Wisdom as human individuals but rather the divine Wisdom they bore, and as if it were *her* children, not designated as *them* or *their* disciples, who vindicate her.

The nonexclusivity of the Wisdom Christology may be suggested in another Q text, where a saying is ascribed not to Jesus but to Sophia (as Luke faithfully reports Q, though Matt. 23:34–36 shifts to the first person singular, thus making Jesus the speaker), Q 11:49–51:

> Therefore also the Wisdom of God said, "I will send them prophets and apostles, some of whom they will kill and persecute," that the blood of all the prophets, shed from the foundation of the world, may be required of this generation, from the blood of Abel to the blood of Zechariah, who perished between the altar and the sanctuary. Yes, I tell you, it shall be required of this generation.

The saying in Q apparently continued with what follows in the Matthean context (23:37–39), although Luke has put this continuation elsewhere, Q 13:34–35:

> O Jerusalem, Jerusalem, killing the prophets and stoning those who are sent to you! How often would I have gathered your children together as a hen gathers her brood under her wings, and you would not! Behold, your house is forsaken. And I tell you, you will not see me until you say, "Blessed is he who comes in the name of the Lord!"

The extent to which this refers to Wisdom in all her manifestations and not exclusively to Jesus is apparent from the reference to her "often" appealing to the Jerusalemites.

This can be illustrated by an anecdote from the history of scholarship: One of the traditional debates in the quest of the historical Jesus had to do with the minimum amount of time that must be conjectured for Jesus' public ministry. It was assumed this could be calculated in terms of how many annual Jewish festivals Jesus is said to have attended in Jerusalem during his ministry. Such speculation led to the choice between a public ministry that need not have been more than one year in the Synoptic Gospels and a public ministry in the Gospel of John that would have had to stretch at least into a third year. Since the Synoptic Gospels became the basis of the quest of the historical Jesus, and the Gospel of John was relegated to the role of the "spiritual" Gospel and an honored top billing only in New Testament theology (and Christian theology in general), this meant that Jesus' ministry has been assumed to be one year. But advocates of the Johannine timetable have pointed to this Q

passage in the Synoptic Gospels to argue in favor of the Gospel of John, in maintaining that during his public ministry Jesus had gone to Jerusalem more than once ("how often").

This Wisdom passage is formulated throughout from the point of view of the person of Wisdom, not in terms of John and Jesus as bearers of Wisdom. She has sent "prophets and apostles" (or, according to Matt. 23:34, "prophets and wise men and scribes"), a stream of martyrs "from the blood of Abel to the blood of Zechariah," without any explicit reference to John and Jesus. "Kill and persecute" is Christianized in Matt. 23:34 into "kill and crucify," though "killing the prophets and stoning those who are sent to you" remains in both Gospels unaltered. Thus it is she, rather than John (who was beheaded) or Jesus (who was crucified), who has repeatedly called on the Jerusalemites to gather under her wings. Indeed, the female metaphor of the hen and her brood is introduced in full harmony with the feminine noun Wisdom and the resultant female hypostasis or personification Wisdom.

It may be part of the Wisdom Christology's nonexclusivity that the followers of Jesus are seen as carrying on his mission and message (just as he had carried on John's), Q 10:11: "The kingdom of God has come near" (as the message of the disciples). Q 10:16 (according to Matt. 10:40): "He who receives you receives me, and he who receives me receives him who sent me." In Q, this ongoing activity would seem to take place without the rupture of crucifixion and the subsequent reestablishment of the disciples through Easter experiences and Pentecost (just as Jesus had been able to carry on, without John's death invalidating their shared message, or his resurrection becoming a saving event needed to relaunch the mission and its message). Of course, the disciples must have known of Jesus' terrible death. But they had not elevated it to an exclusive significance as the saving event but had seen it embedded in the suffering of all prophets as bearers of Wisdom. Similarly there would have been in the sayings tradition and its Sophia Christology something equivalent to an Easter faith, but it would seem not to have been brought to expression in the kerygmatic patterns with which we are familiar. These two tragic deaths, like that of the prophets before and since, cannot stop Wisdom, and so the mission and its message go on. To be sure, she can withdraw her presence as an anticipation of judgment (*Enoch* 42:1–2: She "found no dwelling-place" and so "returned to her place . . . among the angels"), as the shaking the dust off the disciples' feet symbolizes, but she will be there at the day of judgment to be vindicated and to save (Q 13:35). And the finality of the abandonment of

"this generation" to its fate seems to have taken place according to Q neither with the murder of John, nor with that of Jesus, but only with the final repudiation of the Jewish mission, at which time a gentile mission is nonetheless envisaged.

Perhaps such a Wisdom Christology, precisely because of the non-exclusivity of its beginnings, would be useful in our society today, when to leave a male deity at the top of our value structuring seems often more like the deification of the omnipotent despot of the ancient Near East than an honoring of God, more a perpetuation of patriarchalism than a liberation of women and men. If we, like Jesus, can be inspired by the feminine aspect of God, we may be able to bring good news to our still all too patriarchal society.

4. THE VISUALIZATION OF THE RESURRECTION

It may be of some relevance in this connection to speak to the question of the "Easter faith" of the Q community, which seems to have had no passion narrative or Easter story, and thus of the "Easter faith" implicit in much of the original Wisdom Christology. For modern concepts of the resurrection of Christ tend to have a monolithic cast that is quite different from that of the first generation. Probably the first resurrection appearances were not experienced like those recorded at the end of Matthew, Luke, and John, upon which our modern assumptions about the resurrection are primarily based. Rather, these texts, from the last third of the first century c.e., tend to be an apologetic tendentious corrective of dangers they perceived as latent (or perhaps already rampant) in the original perception of the resurrection a generation earlier.

Jesus' resurrection seems at the earlier time to have been experienced in a quite different visualization from that with which we are familiar, in that Jesus appeared as a blinding light rather than as a human body mistakable for a gardener or a tourist on the Emmaus road. The only New Testament texts written by persons who actually claimed to have had a resurrection experience describe it as luminosity (Paul in 1 Cor. 15:42–53 and Phil. 3:21, and the seer of Rev. 1:12–16). But such a luminous appearance could perhaps be discounted as just an apparition and become theologically suspect as the kind of appearance that gnostic sources favored. Hence the concern of emergent orthodoxy to prove the actuality and the physicality of the resurrection of Jesus, an apologetic already discernible in the resurrection stories at the end of the canonical

Gospels, would readily lead to a replacement of the luminous visualization with a very human visualization.

It may be that one would have here the explanation for a series of odd and probably not unrelated facts. It was generally agreed (1 Cor. 15:5; Luke 24:34) that the first appearance was to Peter. Yet the narration of that appearance is completely missing from the ends of the canonical Gospels. The apocryphal *Gospel of Peter* does record it, though with some details that might seem to us (and them) excessive, and yet with some details that seem presupposed in some of the canonical narratives, such as a role at the resurrection itself for the two mysterious figures at the tomb in Luke 24:4. The Gospel of Mark, surprisingly enough, narrates no resurrection appearances but only the empty tomb and the promise of Galilean appearances. One may recall the bad press that Peter received in Mark (8:33: "Get behind me, Satan! For you are not on the side of God, but of men"). Mark does record a luminous appearance primarily to Peter (though also to the other two of the inner circle), but it is not at the end of the Gospel as a resurrection story but rather in the middle as a confirmation of Peter's confession. It is the story that we traditionally distinguish from resurrection appearances by calling it the transfiguration. Hence one may wonder whether Mark has not blunted the dangerous implications of the luminous resurrection story, with all its disembodied suggestiveness, by putting it prior to the crucifixion, in the middle of the public ministry, when Jesus' physicality was obvious.

This way of "handling" the story of the resurrection appearance to Peter may find its analogy in the way the story of the resurrection appearance to Paul is narrated (three times) in Acts. Luke tells the story as a luminous visualization. But he places it outside the forty-day time span of resurrection appearances. Furthermore, apostleship was, for Paul, defined by being an eyewitness of the resurrection, whereas Acts 1:22 adds to that definition being an eyewitness of the public ministry, which would exclude Paul. And Acts does not concede to Paul the kind of apostleship that Paul was so eager to maintain for himself (Gal. 1:1), but only in the temporary and rather unimportant meaning that the word *apostolos* could also have, as a delegate of the church of Antioch limited to the first missionary journey.

Perhaps the left wing of bifurcating primitive Christianity had been using the luminous resurrection appearances to put a prime on what Jesus said after the resurrection, when he was no longer shackled by a body of flesh and had recently been to heaven to learn firsthand the

ultimate, as the Gnostics would put it. This would in effect play down the authority of what Jesus said during the public ministry. Thus it may be no mere coincidence that Mark plants this authority-bestowing (9:7: "This is my beloved Son; listen to him.") luminous appearance back into the middle of the public ministry. For it is Mark who is the first to write such a Gospel narrating the public ministry, thereby both playing down the relative importance of Jesus' ongoing sayings in comparison to his miracles, and placing back into Jesus' lifetime whatever sayings Mark does report, rather than acknowledging the validity of those people who claimed they were still hearing from the resurrected Christ. (According to Acts, God continues after the first forty days to communicate through the Holy Spirit rather than through resurrection appearances.) That is to say, Mark and Luke may be clipping the wings of the gnosticizing trajectory visible in the sayings tradition as one moves from Q to the *Gospel of Thomas*.

If thus the resurrection of Jesus during the first generation was experienced in such a luminous visualization, such appearances could well be more characterized by auditions than by actions such as eating fish or having one's wounds touched. The blinding light talked only to Paul (Acts 9:4–6). The faithful Easter witness would then be the proclamation of what the Resurrected said, not the description of how he looked and felt, or what he ate and did. The itinerant preachers who transmitted the Q tradition, prior to its being written down and then incorporated into Matthew and Luke, kept Jesus' sayings alive by reproclaiming them, not as their words but as his or, more accurately, as Wisdom's. In the process they not only reproclaimed what he had said before his crucifixion, they also ascribed to him/her new sayings that continued to emerge throughout that generation. It was the cause for which he/she stood, his/her message, that was still valid, just as John's cause had been still valid for Jesus after John's death. That is to say, the substantive, theologically relevant aliveness of Jesus after his crucifixion was that of his cause, God's reign. Or, put in terms of Wisdom Christology, Wisdom lived on in the ongoing message, much as John's message—that is, Wisdom's message—had survived in Jesus'. And Wisdom would continue as the authority figure until the day of judgment, when her guidance would be vindicated as the criterion determining human destiny. Rudolf Bultmann's dictum that Jesus rose into the kerygma could thus be adapted to Wisdom Christology by saying that Jesus rose into the life of Wisdom's ongoing proclamation.

5. A NEW LEASE ON LIFE

This Sophia Christology, precisely because it did not come to fruition in Western Christianity but shared in the Western neglect of Eastern Christianity, is less a recording of a traceable strand of Christian history than a nostalgic reminiscence of what might have been. Since the mythical world in which Christianity began is for us dead, this stillborn Christology may be forever lost.

But, though we have seen through myths, in recognizing their non-literal and purely symbolic meaning—for example, in demythologization—they may as symbols have a new lease on life. If Gnosticism could engender artificially its mythology out of the myths of the ancient Near East, or Plato could create the myth of the cave to portray his idealism, or Freud could appeal to Greek mythology to interpret the Oedipus complex, it is not inconceivable that this Sophia Christology could have an appeal in our day.

In this connection we should not ignore the problem that besets the usual christological language with which we are quite familiar. Most of Christian myth is weighted down with the all too familiar, all too literal context in which we are accustomed to hearing it. It is easier for en-lightened people today to free themselves of the pre-enlightenment idea that Jesus is a God, however that may have been languaged over the centuries, than to ask what that might have meant then that could still address us today. And to embrace that meaning would seem all too much like a reversion to a premodern world view to which we have no inclination to return. But to turn to Jesus-inspired-by-Wisdom could have a freshness that would make it possible to listen for meaning rather than simply fleeing from obscurantism.

The Wisdom that inspired Jesus is like God's reign he proclaimed. The metaphorical difference may be that Wisdom was portrayed as the personal Spirit that possessed him, whereas God's reign was what he, under the sway of her possession, envisioned. Thus Wisdom would be symbolized as internal, christological, while God's reign would seem external, eschatological. But if mythologically that reign was located at the end of time, one may recall that it was Wisdom that, like the Son of man, would return then for vindication. And conversely God's reign was mythologically experienced as somehow present in Jesus, as was Wisdom: Jesus' exorcisms effected by the finger of God (which Matt. 12:28 interprets as the Spirit of God) were already the coming of God's reign upon the demon-possessed (Q 11:20). But, much more important,

one must come to grips with what these symbols mean unmytholog-
ically, when they were spoken, which was then in the present. It is only
pseudo-theology to seek to reconcile into some harmonious doctrinal
system the various *mythologoumena* by means of which meaning came
to expression.

The shared trait, that one has to do with the Wisdom *of God* and the
Kingdom *of God*, may provide a relevant lead. Jesus' insight is not just
the crowning achievement of some Periclean, Augustan, or Elizabethan
age, any more than his vision is that of a purification of the kingdom of
this world into a Christian establishment (Christendom as the Kingdom
of God). What went into Jesus and came out of Jesus is not of this world.
"Of God" means it is transcendent. Not of course in a literal sense: Just as
Wisdom did not fly down onto Jesus like a bird, the Kingdom is not some
other place, or here in some other time. God's reign is utopia, the
ultimate, just as Wisdom is the purity of intention, the commitment.
Jesus' whole life was caught up in the cause of humanity, which pos-
sessed him with a consuming passion and came to expression through
him with radical vision. Those who are caught on fire by him are
possessed by the same Wisdom and proclaim the same utopian reign.

Response to "Very Goddess and Very Man: Jesus' Better Self" by James M. Robinson

1. REVIEW

Professor Robinson's analyses of Christian origins are always provocative, suggestive, and tend creatively to lead the reader in many directions. I find it helpful, therefore, to review what I consider to be the main points in his essay here, and I will limit my response to them.

1.1. The deification of Jesus of Nazareth was not an inevitable occurrence. There were in the tradition options for understanding him other than by exclusive christological titles. One such option was that he could have been understood simply as a person, a human being, possessed by the Spirit of God, as the Markan baptism scene demonstrates.

1.2. In the context of this alternative way of understanding Jesus of Nazareth as a man possessed by God's *ruach*, the *ruach* (fem.) is understood as a hypostasis of the divine. She comes upon Jesus and *inspires* him until she departs at his crucifixion. Under the influence of resurrection Christology, however, and the changes in language and culture in the church, this feminine aspect *(ruach)* to the inauguration of Jesus is neutered to *pneuma* in Hellenistic Christian communities and eventually masculinized to *spiritus* in the Latin church. The development begun with this early shift from feminine to masculine leads to Nicaea, Chalcedon, the trinity, and the male dominance of deity in Christianity.

1.3. The sociological context that Robinson suggests for this christo-logical elevation of Jesus I find reasonable and plausible. In the context of Jewish-Christian worship, traditional Jewish prayers and hymns (such as thanksgiving psalms) are christianized by the ascription of christological titles to Jesus.

1.4. The historical matrix that Robinson proposes for such a rapid elevation of Jesus is provided by the myth of the preexistent Sophia (Wisdom of Solomon 1—10; Prov. 1:20–33; 8:1–36). Wisdom was God's companion at the creation, and in every generation it is she who seeks and makes prophets and friends for God.

1.5. The early rapid development in the christological trajectory that leads from Jesus as a man chosen by God to the later high christological confession of Chalcedon is expedited by Jesus' early association with Woman Wisdom.

1.6. The significance of Robinson's analysis is that he has identified the vestiges of an early abortive Wisdom Christology that leads off from the baptism of Jesus rather than from the resurrection of Jesus. In this "stillborn Christology," *ruach* (fem.) yields to *hokhmah* (fem.) rather than *pneuma* (neut.) and *spiritus* (masc.), and Jesus is identified as Wisdom's child and eventually as Wisdom herself.

1.7. Unlike what became male-dominated Christology in early ortho-doxy where Jesus' disciples must be commissioned by the resurrected Christ following the crucifixion, Wisdom does not require a reestablish-ment of her children following the demise or death of a teacher of wisdom. Wisdom's message continues as she selects new prophets and inspires them. Hence Wisdom's message by John continues in Jesus after John's death and in Jesus' disciples after Jesus' death, without a need for recommissioning.

1.8. In the context of understanding Jesus as Wisdom's child, the aliveness of Jesus after his crucifixion was in the proclamation of his message or, as Robinson says, put in terms of Wisdom Christology: Wisdom's message lives on, passed by Wisdom from John to Jesus to Jesus' disciples, who are also children of Wisdom.

1.9. According to Robinson, it is this understanding of Jesus as teacher of Wisdom that was overshadowed early on by the high resurrection Christology of early orthodoxy that may yet provide a viable option for our contemporary world specifically because of its inclusivity.

2. CRITIQUE

In general I find Robinson's discussion convincing, but I have some comments about various elements in his discussion. With regard to his discussion of a trajectory in Christology in early Christian communities, one must not understand that a trajectory is a consistent cause-and-effect development, one point on the trajectory flowing out of and being directly stimulated by a preceding point. Rather, I take a historical trajectory to be a series of probably directly unconnected but similar motifs. From our distant perspective, however, the ebb, flow, and eddies of historical current flow together and take on the appearance of a cause-and-effect development or decline. We are seldom fortunate enough to see dramatic shifts in the current at the precise moment of their shift, if indeed any of the points on the trajectory admit of a dramatic shift. Hence, I find Robinson's christological trajectory to be a reasonable way to understand the evidence. Robinson, however, has said of his Wisdom trajectory that it is "less a recording of a traceable strand of Christian history than a nostalgic memory of what might have been," a "stillborn [nonchristological] Christology [that] may be forever lost" (p. 126). I would like to suggest four new points on his trajectory as a way of fleshing it out, and perhaps adding to its general plausibility. Perhaps it will encourage him to be more optimistic about his "sapiential Jesus."

2.1. Romans 1:3–4, a pre-Pauline early Christian confession, seems to reflect a blending of both baptismal and resurrection ways of honoring Jesus:

> the gospel concerning his Son, who was descended from David according to the flesh and designated Son of God in power according to the Spirit of holiness by his resurrection from the dead. (RSV)

Indeed, the first part of the confession accords well with an understanding of Jesus' baptism in terms of it being his "inauguration" as "Son of God":

descended from David
 according to the flesh . . .
designated Son of God in power
 according to the Spirit of holiness. (RSV)

The additional confession *appended* to what appears to be an earlier understanding of Jesus' sonship has the character of a postresurrection interpretation of the confession complete with christological titles:

by his resurrection from the dead, Jesus Christ our Lord. (RSV)

In the confession, one sees clearly a shift in the moment of Jesus' inauguration to sonship. In the first instance Jesus is a man of a special ancestry who is designated Son of God "by a Spirit of holiness." The appended christological titles following the second confession render this first confession anticlimactic and advance Jesus' inauguration to sonship to the moment of the resurrection. Romans 1:3–4 seems to be a clear confirmation of Robinson's observation that Mark 1:11 reflects an early Christian view of Jesus' baptism as the moment of his inauguration to sonship.[1]

2.2. I suggest that the temptation narrative in Q (4:3–12) is an early pre-Q legend that associates Jesus' demonstration of his sonship to Wisdom with his temptation in the wilderness. What is at issue in the narrative is posed by the question: "If you are the Son of God. . . ." Jesus successfully resists the temptations to demonstrate his sonship by mighty deeds and shows it instead through wisdom and the apt response. In Matthew, Mark, Luke, and Q, on the other hand, Jesus is shown as demonstrating his sonship precisely in the context of his mighty deeds (Mark 1:8; Mark 3:22–30 = Q 11:17–23) rather than in the apt response. The word and thoughts of Wisdom poured out to her children enable this child of Wisdom to be delivered from the way of evil:

Behold, I will pour out my thoughts to you; I will make my words known to you. (Prov. 1:23, RSV)

Hear, for I will speak noble things, and from my lips will come what is right. . . . All the words of my mouth are righteous. (Prov. 8:6–8, RSV)

My son, keep my words and treasure up my commandments with you; keep my commandments and live, keep my teachings as the apple of your

1. But cf. R. H. Fuller, *The Foundations of New Testament Christology*, 165–67.

eye; bind them on your fingers, write them on the tablet of your heart. Say
to wisdom, "You are my sister," and call insight your intimate friend; to
preserve you from the loose woman, from the adventuress with her smooth
words. (Prov. 7:1–5, RSV; cf. 2:1–19; 6:20–21)

It is in this way that Wisdom arms her child and evokes the apt response:

To make an apt answer is a joy to a man, and a word in season, how good it
is! (Prov. 15:23, RSV)

The wise of heart is called a man of discernment, and pleasant speech
increases persuasiveness. . . . The mind of the wise makes his speech
judicious, and adds persuasiveness to his lips. Pleasant words are like a
honeycomb, sweetness to the soul and health to the body. (Prov. 16:21–24,
RSV; cf. 25:11–12 and Eccl. 10:12)

The context of the temptation narrative is dispute or debate, a setting
that is not unknown to the wisdom tradition, as Job clearly shows. That
Jesus defends himself against the tempter with quotations from Torah
(Deut. 8:3; 6:16, 13) fits in with late wisdom tradition that wisdom is the
observation of the law:

Keep them [i.e., statutes and ordinances] and do them; for that will be your
wisdom and your understanding in the sight of the peoples, who, when
they hear all these statutes, will say, "Surely this great nation is a wise and
understanding people." (Deut. 4:6, RSV)

In Sir. 24:23–24 (cf. Bar. 3:9—4:3), the celestial Wisdom that descends to
dwell in Israel *is* the law and it is the knowledge of the law that is the
true wisdom, which belongs to the scribe alone. It is not possessed by
those who do not study the law (Sir. 38:24—39:11).

Hence it appears that Robinson's Wisdom Christology is somewhat
better attested and includes Jesus' *designation* as son of God at the
baptism, his defense of sonship through Wisdom in the wilderness, and
his identification with Wisdom in his preaching (Q 11:49–51 in Matthew
and Luke).

2.3. While this understanding of Jesus lost out to emerging resurrec-
tion Christology, it did survive in a type of orthodoxy that inclined
strongly toward Gnosticism. In the *Teachings of Silvanus* (NHC VII,4)
there appears to be clear evidence of the kind of Wisdom Christology
that Robinson finds in Q. *Silvanus* has initially been dated in the late

second or early third century c.e. and, like Rom. 1:3–4, reflects a blending of Wisdom and resurrection Christology.[2]

The text clearly knows the Sophia myth:

> Wisdom summons you in her goodness, saying, "Come to me, all of you, O foolish ones, that you may receive a gift, the understanding which is good and excellent. I am giving to you a high-priestly garment which is woven from every (kind of) wisdom." (*Teach. Silv.* 89,5–12)[3]

Woman Wisdom is also identified in the text as the "Mother" of the penitent:

> Return, my son, to your first father, God, and Wisdom your mother, from whom you came into being from the very first. (*Teach. Silv.* 91,14–16)

And the text also associates Jesus with Lady Wisdom, giving him her name alongside his traditional christological titles:

> For the Tree of Life is Christ. He is Wisdom. For he is Wisdom; he is also the Word. He is the Life, the Power, and the Door. He is the Light, the Messenger, and the Good Shepherd. (*Teach. Silv.* 106,22–30)

> For since he (Christ) is Wisdom, he makes the foolish man wise. It (Wisdom) is a holy kingdom and a shining robe. For it (Wisdom) is much gold which gives you great honor. The Wisdom of God became a type of fool for you so that it might take you up, O foolish one, and make you a wise man. (*Teach. Silv.* 107,3–12)

> O Lord Almighty, how much glory shall I give Thee? No one has been able to glorify God adequately. It is Thou who hast given glory to Thy Word in order to save everyone, O Merciful God. (It is) he who has come from Thy mouth and has risen from Thy heart, the First-born, the Wisdom, the Prototype, the First Light. (*Teach. Silv.* 112,27–37)

> He (i.e., the Word) alone was begotten by the Father's good pleasure. For he is an incomprehensible Word, and he is Wisdom and Life. (*Teach. Silv.* 113,11–15)

The *Teachings of Silvanus* is a text in which has been preserved, if not the essence of Wisdom Christology, at least her title and that in a hypostatized sense. That, it seems to me, clearly shows the continuing presence of Wisdom Christology in Christianity and adds another point to Robinson's trajectory.

2. M. L. Peel and J. Zandee, "The Teachings of Silvanus," in *Nag Hammadi Library* (ed. Robinson), 346–47.
3. All quotations from the Nag Hammadi Codices are from *Nag Hammadi Library* (ed. Robinson).

2.4. In the light of the lengthened trajectory, 1 Corinthians 1—4 should be reexamined. 1 Corinthians 1:24 also links the christological title "Christ" with what appears to be the feminine titles Power (δύναμις)[4] and Wisdom (σοφία). They appear in a syntactically awkward passage seeming to be almost tagged onto the primary sentence:

> But we preach Christ crucified, a stumbling block to Jews and folly to Gentiles, but to those who are called, both Jews and Greeks, Christ the power of God and the wisdom of God. (1 Cor. 1:23-24)

Hans Conzelmann[5] does not recognize a hypostatized use of the term "Sophia" in this passage but does acknowledge that the myth of Sophia is the background for the passage.[6] I do not find convincing his explanation that Sophia in this passage is simply a *concept*; and others do see the mythical Sophia behind Paul's use of the title in 1 Cor. 1:24.[7] In any case, Paul has at the very least, under the influence of the myth of Wisdom, linked the resurrection title *Christos* with the Wisdom title *Sophia*. Paul could scarcely have been unaware of the significance of such a linkage, even if Conzelmann were correct.

2.5. Finally, one might ask, What is "good news" about Wisdom Christology? Of course to describe Wisdom's message through her children as "gospel" or "good news," as Robinson has done, may be something of a misnomer. It is true that Wisdom *proclaimed* through her children, but it may at least be questioned that the proclamation was described as "gospel." In early Christian orthodoxy the term is associated with resurrection Christology (1 Cor. 15:1-4). This is not to say that Wisdom did not proclaim, for example, the reign of God or that her children were not familiar with suffering, but only to question the designation of her proclamation as "gospel."

But if we allow use of the term in a nontechnical sense, what is the "good news" proclaimed by Wisdom's messengers? Robinson explains her message as myth: the proclamation of the reign of God that was present in the exorcisms of her child Jesus and that would come with Wisdom at the end of time. Both the reign of God and Wisdom were present in Jesus. This language Robinson takes to be symbolical and he

4. Note also the presence of the term δύναμις ("power") in Rom. 1:4.
5. H. Conzelmann, *1 Corinthians: A Commentary on the First Epistle to the Corinthians*, 48.
6. Conzelmann, *1 Corinthians*, 45-46.
7. D. W. Davies, *Paul and Rabbinic Judaism: Some Rabbinic Elements in Pauline Theology*, 150-55.

reinterprets it in contemporary existentialist categories. I understand that it is important to demythologize the components of the myth but am always struck by how much more appeal and inspiration—sheer power—lies in a vibrant myth and how our existential reinterpretations seem to lack in resonance. It seems that the symbolical has frequently more potential for meaning than the existential language. For example, consuming passion for utopia would fit a variety of models through the centuries. We must have more flesh with our skin and bones.

One unusually positive note in Wisdom Christology is the nonexclusivity of Woman Wisdom. In Wisdom Christology it appears that God's self-revelation is nonexclusive and permits expression as *Christos, Logos, Sophia, huios, Basileia, dunamis,* and one might also conjecture, *thugatēr.* Hence, in Wisdom *theology* one could say, God is Woman Wisdom who reveals herself in both her υἱοί ("sons") and θυγατέρες ("daughters").

There was a suppressed movement in early Christianity that thought about deity nonexclusively, a movement that could identify the essence of Jesus' inspiration and possession, and the origin of his message in feminine terms. Its day passed, and resurrection Christianity replaced it. The victor, resurrection Christianity, consolidating itself and adjusting itself to life in the world, appropriated social and ethical values from Hellenistic culture, including male dominance. But radical Christianity, in which Wisdom with her nonexclusivity, passion, and utopian ideals is to be included, arises, suffers, and dies only to rise again at some later time. Perhaps Robinson's recovery of the roots of Wisdom Christology may become one such occasion.

Female Figures in the Gnostic
Sondergut in Hippolytus's *Refutatio*

When I began to prepare this essay I found that I could not keep to the title I had at first proposed, "The Christian Gnostic Redactor in Hippolytus's *Refutatio* and the Feminine," for one of the results of my preparation was the observation that the redactor does not show any specific interest in the female figures of his sources as such. Looking over the component parts of the *Sondergut*,[1] with special attention to the role of the feminine, the reader becomes aware that a common denominator among those texts is certainly not to be found in this area. Rather, the individual character of the several component parts of the *Sondergut* shows up clearly in the treatment of female beings as part of the myth, *if* the myth contains such beings at all, for they do not seem to be absolutely necessary. The sections of this essay therefore will indepen-

1. The *Refutatio* of Hippolytus is quoted from P. Wendland's edition (*Refutatio omnium haeresium*; there is a reprint, reduced in size (Hildesheim/New York: Georg Olms, 1977). English translations from other works are the author's unless otherwise indicated. The author wishes to thank Karen King for her editorial polishing of this article. On the *Sondergut* and the methods of its redactor, see L. Abramowski, "Ein gnostischer Logostheologe: Umfang und Redaktor des gnostischen Sonderguts in Hippolyts 'Widerlegung aller Häresien,'" in *Drei christologische Untersuchungen*, 18–62. A much-awaited new analysis of the report on the Naassenes is found in J. Frickel, *Hellenistische Erlösung in christlicher Deutung: Die gnostische Naassenerschrift: Quellenkritische Studien-Strukturanalyse-Schichtenscheidung-Rekonstruktion der Anthropos-Lehrschrift*. Frickel distinguishes a pagan Attis commentary and *two* gnostic redactions. The Attis commentary is described in pp. 42–51. I hesitate to accept *two* gnostic reworkings of the pagan text. No doubt the very tedious printing process that Frickel's monograph underwent explains why there are not enough cross-references to my article.

dently treat (1) reports without female figures, (2) the Sethians, (3) the book of *Baruch*, and (4) the Valentinians.

1. REPORTS WITHOUT FEMALE FIGURES (WITH THE EXCEPTION OF THE SOUL)

Such reports are found in *Ref.* 7.20–27 on Basilides, in 8.8–11 on the Docetes, and in 8.12–15 on Monoimos. In the main corpus of Hippolytus's work these three groups of chapters are the last of the literary complex that I call *Sondergut* ("special material"), though in the *epitome* (*Refutatio* 10) the report on the gnostic Justin is placed after Basilides. Since Hippolytus based his *epitome* not only on his earlier extracts and abstracts from his literary source but referred to the source afresh, he has done some conscious regrouping, either in the earlier books or in the *epitome*.

Basilides and the Docetes present Mary as the mother of Jesus (*Ref.* 7.26.8–9; 8.9.2 the Virgin; 8.10.6-7), but Monoimos holds that it is an essential error of creation to consider the Son as $\gamma\acute{\epsilon}\nu\nu\eta\mu\alpha\ \theta\eta\lambda\epsilon\acute{\iota}\alpha\varsigma$ ("generated of female"; *Ref.* 8.13.3–4; 14.5).[2] To be born of a female is evidently not worth much; it is degrading. Although wisdom is mentioned in Basilides (*Ref.* 7.26.2–3), it is only made through the quotation of Prov. 1:7 and 1 Cor. 2:13 (which is the work of the redactor). Wisdom in these cases does not become an acting person in her own right. In Monoimos 8.12.5 (end) there is an addition to the series of opposing predications that adorn the monad Anthropos, namely: "This (is) Mother, this (is) Father, the two ineffable names." The redactor has taken over these definitions from the report on the Naassenes (*Ref.* 5.6.5) where they properly belong.[3] The "numberless" aeons in the Docetes (*Ref.* 8.9.2) are "all male-female." Ordinarily in the *Sondergut*, "male-female" is an adjective connected with a singular noun: cosmos, sea, dynamis, or anthropos.[4] It is not clear how the male-femaleness effects the system reported here. The aeons function in a rather male way, uniting themselves into a

2. $\Gamma\acute{\epsilon}\nu\nu\eta\mu\alpha\ \theta\eta\lambda\epsilon\acute{\iota}\alpha\varsigma$ is found again in the report on the Sethians (*Ref.* 5.19.14), where it creates difficulties for translation. It is obviously an insertion (by the redactor?) because the unexplained use of $\phi\acute{\upsilon}\sigma\iota\varsigma$ ('the nature') had not been correctly understood. 'H $\phi\acute{\upsilon}\sigma\iota\varsigma$ ('nature'), however, is genuine in the context. Cf. *Ref.* 5.19.5 and 7 and 15 (line 10; in line 9 a whole clause with $\phi\acute{\upsilon}\sigma\iota\varsigma$ belongs to the redactor); see below.

3. Cf. Abramowski, 'Ein gnostischer Logostheologe,' 49 n. 88. On the connection of Naassenes and Monoimos, see p. 50 and n. 93.

4. See Wendland's index.

middle aeon and begetting a "common generated being" (γέννημα
κοινόν) out of the Virgin Mary.

2. THE SETHIANS: μήτρα ("WOMB"; REF. 5.19)

Here the female is presented in a crudely biological manner with only
a few personal traits and is therefore called μήτρα ("womb"). She has a
central function in the first[5] chapter of the report on the Sethians (*Ref.*
5.19–22). This chapter also contains some borrowings from atomism[6] for
an intermediate phase of cosmogony (*Ref.* 5.19.9–12). In our report, "the
movement of the atoms (which atomism regards as) the principle of
world origination"[7] is the movement of powers in "concourses."

In looking at the text carefully, however, it is necessary to distinguish
two treatments of μήτρα ("womb"). The first occurs in 11–12 without any
depreciatory connotations:

> But all the powers of the three originating principles, which are as regards
> number indefinitely infinite, are each according to its own substance reflec-
> tive and intelligent, unnumbered in multitude. And since what are reflec-
> tive and intelligent are numberless in multitude, while they continue by
> themselves, they are all at rest. If, however, power approaches power, the
> dissimilarity of (what is set in) juxtaposition produces a certain motion and
> energy, which are formed from the motion resulting from the concourse
> effected by the juxtaposition of the coalescing powers. For the concourse of
> the powers ensues, just like any mark of a seal that is impressed by means
> of the concourse correspondingly with (the seal) which prints the figure on
> the substances that are brought up (into contact with it). Since, therefore,
> the powers of the three principles are infinite in number, and from infinite
> powers (arise) infinite concourses, images of infinite seals are necessarily
> produced. These images, therefore, are the forms of the different sorts of
> animals. From the first great concourse, then, of the three principles, ensues
> a certain great form, a seal of heaven and earth. The heaven and the earth
> have a figure similar to the womb, having a navel in the midst; and if, he
> says, any one is desirous of bringing this figure under the organ of vision,
> let him artfully scrutinize the pregnant womb of whatsoever animal he
> wishes, and he will discover an image of the heaven and the earth, and of

5. In the *epitome* (*Ref.* 10.11), Hippolytus reports on the Sethians with the material
from *Ref.* 5.19 only. On *Ref.* 5.21, see Abramowski, "Ein gnostischer Logostheologe," 29–
31, 33ff.

6. See also Wendland's reference to Democritus p. 118, *Ref.* 5.19. In 9–12 (twenty
lines of text) the term συναδρομή, singular or plural, is used eight times. Cf. *concursiones*
in Cicero *De finibus* 1.17, quoted by H. Dörrie, "Democritus 1," *Kleiner Pauly* 1.1478, as
"treffliche Darstellung der Atomlehre—sicher aus gutem Handbuch" ("an excellent
presentation of the doctrine of atoms—certainly from a good handbook").

7. See Dörrie, "Democritus 1," *Kleiner Pauly* 1.1478.

the things which in the midst of all are unalterably situated underneath. (And so it is, that the first great concourse of the three principles) has produced such a figure of heaven and earth as is similar to a womb after the first coition. But, again, in the midst of the heaven and the earth have been generated infinite concourses of powers. And each concourse did not effect and fashion anything else than a seal of heaven and earth similar to a womb. But, again, in the earth, from the infinite seals are produced infinite crowds of various animals.[8]

Μήτρα ("womb") is used here for illustration and comparison, but the passage leaves the reader with a feeling of confusion. We are told in 11: Out of the "first great concourse" of the three principles a great image of the seal of heaven and earth (μεγάλη τις ἰδέα σφραγῖδος οὐρανοῦ καὶ γῆς or better *Ref.* 10.10.6 μεγάλης σφραγῖδος ἰδέαν, οὐρανὸν καὶ γῆν) came into being. The shape of heaven and earth is similar to a womb, with the navel in the midst. One could gain an impression of that image by examining the pregnant womb of some animal: one would find the impression of heaven and earth and the middle of all. According to *Ref.* 5.19.12, the shape of heaven and earth became like a womb by the first concourse. In the middle of heaven and earth there were numberless concourses of the powers, each of them affecting the sealing impression of heaven and earth similar to a womb; out of the innumerable seals grew the abundance of living beings.

The stereotyped expression "similar to a womb" in the passage evidently clings to the pair "heaven and earth." What, then, is the ὀμφαλός ("navel") in the middle of them? The likeness to a womb fits very badly into the story of generation by concourses and the seal-like impression affected by the clashes. Normally one would suppose that the *earth* should be compared to a womb.[9] In the *Apophasis Megale* there is a detailed allegorical juxtaposition of the anatomical parts of the womb with paradise (*Ref.* 6.14.7ff.); the examination of a pregnant womb, recommended in *Ref.* 5.19.11, is indeed done there. So I am led to conjecture that p. 118, 12–18[10] is one of the redactor's interpolations; also line 21 "similar to a womb" would be by his pen. The proper place of

8. Hippolytus *Ref.* 5.11–12 (ET quoted from A. Cleveland Coxe, ed., *The Ante-Nicene Fathers* 5:65).
9. Hippolytus (*Ref.* 5.20.5) says that the Sethians took μήτρα ("womb"), ὄφις ("serpent"; cf. *Ref.* 19.18ff.), and ὀμφαλός ("navel"); ὅπερ ἐστὶν ἀνδρεία, "the very essence of manliness," *Ref.* p. 121, 24) from the Bacchica of Orpheus. The Delphic omphalos is of course Gaia's seat of oracle. There is also an omphalos in the sanctuary of the mother earth at Eleusis.
10. The redactor's interpolation extends from σχῆμα δὲ ἔχουσαν to τὴν πρώτην συναρομήν.

μήτρα ("womb") in the Sethian myth is in *Ref.* 5.19.13ff. in the next phase
of the story of becoming. I suppose this set in motion the usual workings
of the redactor's mind by way of very loose association and made him
introduce that term with connotations taken from another context.

The second and proper treatment of μήτρα ("womb") occurs in *Ref.*
5.19.13ff., in the generation of Anthropos ("Man") or Nous ("Mind"):

From the water, therefore, has been produced a first-begotten originating
principle, viz., wind, (which is) violent and boisterous, and a cause of all
generation. For producing a sort of ferment in the waters, (the wind) uplifts
waves out of the waters; and the motion of the waves, just as when some
impulsive power of pregnancy is the origin of the production of a man or
mind, is caused when (the ocean), excited by the impulsive power of spirit,
is propelled forward. When, however, this wave that has been raised out of
the water by the wind, and rendered pregnant in its nature, has within
itself obtained the power, possessed by the female, of generation, it holds
together the light scattered from above along with the fragrance of the
spirit—that is, mind moulded in the different species. And this (light) is a
perfect God, who from the unbegotten radiance above, and from the spirit,
is borne down into human nature as into a temple, by the impulsive power
of Nature, and by the motion of wind. And it is produced from water being
commingled and blended with bodies as if it were a salt of existent things,
and a light of darkness. And it struggles to be released from bodies, and is
not able to find liberation and an egress for itself. For a very diminutive
spark, a severed splinter from above like the ray of a star, has been mingled
in the much compounded waters of many (existences), as, says he, (David)
remarks in a psalm. Every thought, then, and solicitude actuating the
supernal light is as to how and in what manner mind may be liberated, by
the death of the depraved and dark body, from the Father that is below,
which is the wind that with noise and tumult uplifted the waves, and who
generated a perfect mind his own Son; not, however, being his peculiar
(offspring) substantially. For he was a ray (sent down) from above, from
that perfect light, (and) was overpowered in the dark, and formidable, and
bitter, and defiled water; and he is a luminous spirit borne down over the
water. When, therefore, the waves that have been upreared from the
waters have received within themselves the power of generation possessed
by females, they contain, as a certain womb, in different species, the
infused radiance, so as that it is visible in the case of all animals. But the
wind, at the same time fierce and formidable, whirling along, is, in respect
of its hissing sound, like a serpent.

First, then, from the wind—that is, from the serpent—has resulted the
originating principle of generation in the manner declared, all things
having simultaneously received the principle of generation. After, then, the
light and the spirit had been received, he says, into the polluted and
baneful (and) disordered womb, the serpent—the wind of the darkness,
the first-begotten of the waters—enters within and produces man, and the

impure womb neither loves nor recognizes any other form. The perfect Word of supernal light being therefore assimilated (in form) to the beast, (that is,) the serpent, entered into the defiled womb, having deceived (the womb) through the similitude of the beast itself, in order that (the Word) may loose the chains that encircle the perfect mind which has been begotten amidst impurity of womb by the primal offspring of water, (namely,) serpent, wind, (and) beast. This, he says, is the form of the servant, and this the necessity of the Word of God coming down into the womb of a virgin. But he says it is not sufficient that the Perfect Man, the Word, has entered into the womb of a virgin, and loosed the pangs which were in that darkness. Nay, more than this was requisite; for after his entrance into the foul mysteries of the womb, he was washed, and drank of the cup of life-giving bubbling water. And it was altogether needful that he should drink who was about to strip off the servile form, and assume celestial raiment.[11]

The story starts with the wind and the water from Gen. 1:2 and is imagined as a story of sexual excitement and pregnancy. The term μήτρα ("womb") appears frequently (*Ref.* 5.19.19–21), but now as something unclean and abominable. It also is not used for comparison; above all, μήτρα ("womb") in this passage is the water. In *Ref.* 5.19.5 the third principle, τὸ σκότος ("darkness"), was explained as "terrifying water" (ὕδωρ φοβερόν). The wind, itself coming out of the water, is "the cause of all becoming" (πάσης γενέσεως αἴτιος). The "waves" (κύματα), stirred up by it, and pregnancy (ἐγκύμονα γεγονέναι)[12] are connected by the usual pseudo etymology. In 5.19.15, Nous ("Mind"), "by force of nature and motion of wind, is generated out of water" (φορᾷ φύσεως[13] καὶ ἀνέμου κινήματι γεννηθεὶς ἐξ ὕσατος) mixed up with bodies. Note too that φορᾷ ("force") can be equivalent to "passion," among other connotations! Later on, the wind is called "father of the (things) below" (πατὴρ τοῦ κάτωθεν; *Ref.* p. 119, 18), which stirred up the waves and generated the perfect Son. The water, keeping back in itself the light, is subjected to a number of negative predications: dark, dreadful, bitter, putrid (*Ref.* p. 120, 3f).

11. Hippolytus *Ref.* 5.19.13ff. (ET quoted from Coxe, *Ante-Nicene Fathers*, 5:65–66.)

12. What is the grammatical subject of ἐγκύμονα? For grammatical reasons, τὸ ὕδωρ is impossible. The *epitome* has μήτρα ('womb') in the corresponding sentence, *Ref.* 10.11.8. The same difficulty is present with ἐγκύμονα ('pregnancy') at *Ref.* 119.5, where I prefer to read ἔγκυμον (see Wendland's apparatus). Γέννημα θηλείας ('female offspring') is a wrong explanation of φύσις ('nature'), taken from the report on Monoimos by the redactor (?). (See n. 2, above.) Also, in line 9, εἰς ἀνθρωπίνην φύσιν ὥσπερ εἰς ναόν ('into human nature just as into a temple') is wrong in the context. It connects with the catchword πνεύματος ('spiritual'; also in line 9) and alludes to 1 Cor. 6:19—typical for the redactor. The mixture of light with *bodies* is, however, mentioned in lines 10f.

13. For φύσις ('nature'), cf. *Ref.* p. 119, 5 (but *not* p. 119, 9; see last note) and p. 117, 12.8.

Μήτρα ("womb") appears again in one of the lacunae (*Ref.* p. 120, 7). In 19, light and pneuma are kept back in the "unclean, very noxious, wild womb" into which the serpent (i.e., the wind of darkness, the firstborn of the water) enters, begetting Anthropos.

Presently, for the first time, "womb" shows some personal traits: the unclean "womb" knows and loves no form (except the form of the serpent); already in 6 we saw that the darkness is not void of understanding. Here in 20, the Logos of light makes himself like the serpent (!), enters into the unclean womb to liberate the Nous ("Mind") born in the uncleanness of the womb. This is interpreted by the redactor in his characteristic manner in p. 120, 20–22 with the help of Philippians 2: "This, he says, is the form of the servant and this is the necessity of the word of God coming down into the womb of a virgin." The whole of 21 is also by the redactor: it does not suffice that the perfect man, Logos, enters into the womb of the virgin to loosen the "travails"[14] in the darkness there. But after entering the atrocious mysteries of the womb, he washed himself and drank the cup of living water, "which it was altogether needful that he should drink who was about to strip off the servile form, and assume the celestial raiment."

I have remarked elsewhere[15] that the redactor's preference for Philippians 2 and his use of the Gospel of John do not include "the death on the cross" and "the Logos became flesh." In *Ref.* 5.19.21 we can perhaps catch him giving his opinion about the incarnation: it is something which has to be excused, a dire necessity. ("Atrocious mysteries" certainly belongs to the language of the redactor's source.) The "form of a servant" is something the Christian Gnostic has got to be rid of. To obtain salvation, incarnation is not enough: the Logos in the form of a servant has to undergo a double water rite, absolution, and a drink of living water. So must the believer.[16]

14. Wendland refers to Acts 2:24.
15. Abramowski, "Ein gnostischer Logostheologe," 44 n. 72.
16. In the book of *Baruch*, *Ref.* 5.27.2 (end), we read, though only in Hippolytus's abbreviated report: "And he drinks from the living water, which is for them the ablution, as they think, the source of living, spring water." This looks as if drinking takes the place of the bath. Does the sentence in its original form belong to the redactor? In the Naassenes, *Ref.* 5.7.19 (second sentence), again reported by Hippolytus, there is a comment of the redactor (Frickel [*Hellenistische Erlösung*, 216 n. 11] also considers it as belonging to the Pneuma gnostic, who is Frickel's second gnostic redactor) on the bath: "The promise of the bath is according to them nothing else but that the abluted one is entering into imperishable desire according to them by living water, and anointed with ineffable anointment." On the incredible use of Rom. 1:20–23, 26f. in *Ref.* 5.7.18 of this passage, see Abramowski, "Ein gnostischer Logostheologe," 45 n. 78. In 7.14 we hear from Hippolytus that for "them" sexual intercourse between woman and man is something bad. This gives us an inkling of the redactor's encratic convictions.

3. THE BOOK OF *BARUCH*: EDEM (*REF.* 5.23–27)

This is the most detailed story of a female being in the *Sondergut* and it is very convincing from a psychological point of view. The myth in *Baruch* seems to be an original conception, a thing rather rare in gnostic literary circles as we know them. The female figure is called Edem (*Ref.* 5.26.2: Edem and Israel), a name we know from Genesis 2 as Eden. Why has a geographical region been taken for the role of a female principle? Grammatically the association was possible because, in Greek, names of countries are grammatically of the female gender. But the report as we now read it does not reveal any motive for the personification. E. Haenchen calls Edem "eine einzigartige Erscheinung" ("a singular phenomenon").[17] He sees her as an earth goddess and postulates an older myth in which the celestial god Elohim and the earth goddess Edem generated all life.[18] But in fact Haenchen has found no antecedent for Edem as a mythical personage.

The story of Elohim and Edem uses two episodes from the tales of Heracles as allegorical material. The first tells of a mixoparthenos (a being part maiden and part snake) who helped the hero to find his lost horse. Edem too is a mixoparthenos. She is the third and female principle of three unbegotten principles which are conceived in a sharply descending series. The second principle, the Father, is limited as to his "prescience" ($\dot{a}\pi\rho\acute{o}\gamma\nu\omega\sigma\tau os$); the third principle is, so to speak, a mixed character of uncertain temper with a mixed body (*Ref.* 5.26.1).

The Father (i.e., Elohim) and the mixoparthenos fall in love with each other (2) and beget twenty-four angels, twelve of them paternal and twelve maternal. Of the latter, the first two, Babel and Achamot, are recognizably female. The maternal angels keep to their mother Edem:

The number of all these angels together is, says he, the paradise, of which Moses says: "God planted the paradise to the east" (Gen. 2:8), that is to the face of Edem, that Edem should see paradise, that is the angels, forever.[19]

Evidently, "to the face" ($\kappa a\tau\grave{a}\ \pi\rho\acute{o}\sigma\omega\pi o\nu$) is an interpretation of "in the east" ($\kappa a\tau\grave{a}\ \dot{a}\nu a\tau o\lambda\acute{a}s$), an interpretation that presupposes knowledge of the Hebrew word *miqedem*.[20] "In front," "facing" ($\kappa a\tau\grave{a}\ \pi\rho\acute{o}\sigma\omega\pi o\nu$), is a possible (Aramaicizing?) translation of the Hebrew (5). After paradise

17. E. Haenchen, "Das Buch Baruch: Ein Beitrag zum Problem der christlichen Gnosis," in *Gott und Mensch: Gesammelte Aufsätze*, 299–334. The quotation is from p. 325.
18. Haenchen, "Das Buch Baruch," 308.
19. *Ref.* p. 127, 17–21.
20. Haenchen ("Das Buch Baruch," 309 n. 1), who discusses the biblical quotations and allusions under nos. 1–19, did not see this (in no. 1).

came into being by the mutual pleasure of Elohim and Edem, the angels of Elohim fashion man from the best earth, not from the animal but from the human part of Edem; from the animal part originate the animals and other beings (7). Man is made as the symbol of Elohim's and Edem's unity and love. Their powers are put into him: from Edem comes the soul, from Elohim the pneuma. Man, Adam, is the symbol of the love and marriage of Edem and Elohim (8). Eve, however, is the perpetual symbol of Edem, though soul and pneuma are put in her also. Commandments were given to them: "Grow and multiply and inherit the earth," that is Edem (9). (These commandments come from Gen. 1:28 combined with a formula taken from the promise of land.)[21] Edem brought her strength like a dowry into the marriage with Elohim. Until today, the text says, in imitation of that first marriage, women bring a gift for the men, obeying a divine and paternal law that began with Elohim and Edem (10).

Let us look at the story as it is told so far. It is not surprising that of the three principles, the female is the last and the most complex, with some very "human" and even animal traits. What *is* really surprising is the positive evaluation of love and marriage and its result. Eve is a little less than Adam, being the symbol only of Edem and not of both parents, but she also possesses a part of pneuma. The story even results in an aetiology for the custom of dowry, which can be considered as a piece of "moral" exegesis (of which other examples will follow).

The next section (*Ref.* 5.26.11–13) is on the government of the world, executed by the angels of Edem. Elohim and his angels have no part in it, since they are not mentioned. The government is one of trouble and distress. The twelve angels of Edem are grouped to form four principles which are equated with the four rivers of Genesis 2. The angels go about the world, entrusted with administrative power σατραπικὴ ἐξουσία (11). Bad times and epidemics arise; a stream of evil wanders around the world forever according to the will of Edem (13).

The aetiology of evil is, however, the subject of the next section (*Ref.* 5.26.14–20) which takes up again the relationship of Elohim and Edem. In discussing the following, I am purposefully selecting the elements about Edem from the story.

After the making of the cosmos, Elohim wants to ascend to the upper regions of heaven, taking his angels with him:

21. 'Land' is the translation of γῆ in the Septuagint. See numerous instances of κατακληρονομέω from the Heptateuch in E. Hatch and H. A. Redpatch, *A Concordance to the Septuagint and Other Greek Versions of the Old Testament* (1897; 1900). Haenchen ("Das Buch Baruch," 309 n. 1 [3]) did not recognize this.

For he (Elohim) was tending upwards (ἀνωφερής), leaving Edem back below; since she was earth, she did not want to follow the spouse upwards. (14)

Elohim's consequent intention to destroy the cosmos in order to liberate his pneuma and receive it back from humanity is prevented by the Good (the first principle):

> "You (Elohim) cannot do evil since you are with me (the Good). Out of mutual pleasure you have made the cosmos, you and Edem. Let Edem now keep creation as long as she wishes. You, however, stay with me." (18)

Here we have an explanation for the continued existence of the created world, though Elohim, identified with the God of the Old Testament, has left the world for whose creation he was partly responsible. The lesson for the gnostic reader is that the Good can be reached only by retreat from creation, since the creation in which we live now belongs to Edem; and Edem is by constitution unable to ascend to the Good.

The several phases of Edem's reaction as a deserted spouse are painted with psychological insight: she recognizes that Elohim has abandoned her; in her grief she ranges her angels around her; she adorns herself in case Elohim, desiring her, should come down to her again (19). But Elohim is being kept with the Good, so Edem orders Babel (i.e., Aphrodite) to bring adultery and divorce to humankind so that the pneuma of Elohim should be distressed through humankind in the same way that she was by Elohim's desertion of her (20). This is the reason for unhappiness in marriage.

Edem empowers her third angel, Naas, to punish the pneuma of Elohim in humankind so as, in this way, to punish Elohim himself who deserted his spouse contrary to their compact (21). Naas is the tree of knowledge of good and evil. The negative commandment of Genesis not to eat of the tree concerns only him. Therefore the Gnostic is to obey the other eleven angels of Edem because they have "passions" but no "transgression of the law" (22).[22] Naas commits adultery with Eve *and* pederasty with Adam; that is the reason for the existence of those vices in the world. There is some satisfaction here for the female reader in that it is not only woman who is considered to be subject to seduction. This interpretation of the paradise story shows nothing of the usual male smugness.

22. Haenchen, "Das Buch Baruch," 303 n. 3: "D.h. praktisch: Der Gläubige soll sich mit dem Leiden abfinden, aber sich nicht schuldig machen" ("In practical terms, this means that the believer should resign himself to his suffering, but not make himself guilty").

Of considerable interest is the attribution of responsibility for good and evil in what follows. From then on, the good and the evil which rule over human beings have *one* origin, the Father Elohim. By ascending to the Good himself, he showed the path to those who wish to ascend (23); by abandoning Edem, *he* initiated the evil for his pneuma in human beings (24).

In this same paragraph begins the history of salvation through the missions of Baruch[23] (whose role is comparable to that of the Logos in apologetic theology). From now on, the opponents are Naas and Baruch, soul and pneuma. Soul is Edem, pneuma is Elohim. It is expressly stated that both dwell in *all* human beings, male and female (25).

It must be noted that the separation of Elohim/pneuma from Edem is now painted in much darker colors than before. Through the prophets, the pneuma in human beings should be brought to listen and *to take flight* from Edem and from the bad handiwork ($\pi\lambda\acute{a}\sigma\iota s$ $\pi o\nu\eta\rho\acute{a}$)[24] even as the Father Elohim *had taken flight* from her. Naas affected the prophets through the soul so that they did not listen to Baruch (26).[25] Unlike their treatment in 22, the angels are now painted as black as Edem. One can only relate this shift in the key of the narration to something darker (or more normally gnostic). There is no explanation or reflection on this development in the report as we have it in Hippolytus's edition.

The twelve works of Heracles are taken as allegories of the real thing: the "workings" ($\acute{\epsilon}\nu\acute{\epsilon}\rho\gamma\epsilon\iota a$) of the maternal angels.[26] After Heracles has finished his works, Omphale, who is called Babel or Aphrodite,[27] clings to him.[28] She brings about his fall, divests him of his strength, that is, of

23. On the possible antecedents of Baruch, see Haenchen, "Das Buch Baruch," 312–14.

24. Cf. $\kappa\tau\acute{\iota}\sigma\iota s$ $\pi o\nu\eta\rho\acute{a}$ ("the evil creation"), *Ref.* 5.27.3.

25. The same happened with Moses. See 25.

26. Haenchen ("Das Buch Baruch," 304f.) takes the whole episode of Heracles to be a later interpolation. But the beginning of the cosmology was also in some way connected with an episode from the Heracles stories in *Ref.* 5.25.4 (end). Therefore Hippolytus is relating that episode in *Ref.* 5.25.1ff. I see no reason to disconnect these interesting traits from the book of *Baruch*, since they are part of its originality.

27. See *Ref.* 5.26.20, above.

28. For Omphale, see *Kleiner Pauly* 4.298 (H. von Geisau). Heracles was sold to Omphale as a servant for one (or three) year(s). In the myth of Heracles and Omphale "kamen Vorstellungen von der 'Dienstehe' der matriarchalischen Gesellschaftsordnung . . . zum Ausdruck; der Kleidertausch (Omphale mit Löwenfell und Keule, Herakles in weiblicher Tracht und Beschäftigung) beruht z.T. auf kultischen Bräuchen. Beide Motive geben der Komödie und dem Satyrdrama Veranlassung, den Mythos im Sinn erotischer Hörigkeit auszugestalten" (In the myth of Heracles and Omphale "is expressed . . . the marriage of bondage of the matriarchal social order; the exchange of clothing [Omphale with the lion's skin and club, Heracles in woman's dress and occupation] is based in part upon cultic practices. Both motifs provide the occasion for the comedy and for the

the commandments of Baruch, and invests him with her own garment, which is the power of Edem, the power below. Thus the works and prophecy of Heracles become ineffective.

In Nazareth, Baruch finds the son of Joseph and Mary and announces to him all things that happened, beginning with Edem and Elohim (29). On the cross Jesus leaves the body of Edem and ascends to the Good (31). He says to Edem (cf. John 19:26): "Woman, here you have your son" (γυναί, ἀπέχεις[29] σου τόν υἱόν), that is, psychic and choic man (32).[30]

Some hermeneutic rules for the reading of Greek myths and Old Testament texts are indicated in 34–36: the swan is to be identified with Elohim; Leda with Edem; gold with Elohim; and Danae with Edem. The prophecy of Isa. 1:2 ("Hearken, O Heaven, and give ear, O Earth; the Lord has spoken") is to be interpreted like this: "Heaven" is the pneuma of Elohim in man. "Earth" is the soul which is in man together with the pneuma. The "Lord" is identified with Baruch and "Israel" with Edem. Edem is also called "Israel," the spouse of Elohim, based on an allegorical interpretation of Isa. 1:3: "Israel has not known me (Elohim)." She does not know that he is with the Good, otherwise she would not have punished the pneuma in man, which is located there because of paternal ignorance (37). In this last sentence, it seems that Edem is treated in the more objective manner that prevailed before the onset of the blacker view.

In *Ref.* 5.27.4, there is another prophetic sentence adapted to the story of Elohim and Edem, Hos. 1:2:

> And when, he says, the prophet says to "take to himself a wife of fornica-tion, because fornicating the earth will fornicate away from the lord," that is Edem away from Elohim. In these (things), he says, the prophet clearly

satyr drama in order to develop the myth in the sense of an erotic bondage"). This last-mentioned level of interpretation of the material is presupposed in our text.

29. 'Ἀπέχειν means "das empfangen haben, worauf man Anspruch hat" ("to receive something that one has a claim to"; Menge-Güthling, *Enzyklopädisches Wörterbuch der griechischen . . . Sprache)*. This is an excellent rendering of the meaning in the context here.

30. I agree with Haenchen ("Das Buch Baruch," 305 and 320; read "Abschnitt 26, 32f." there in the first line in place of "26, 33f.") that the end of 32 (the identification of the Good with Priapus) together with 33 (connection with Naassenes *Ref.* 5.7.20–29) is an interpolation. Haenchen denies *literary* connections, but that is just what is the case here. Ill-fitting interpolation in the context is characteristic of the redactor. One of the common traits of the *Sondergut* as we read it is that the several parts are made to "quote" each other. Priapus does not appear in the Naassene text (which treats phallic gods), as edited by Hippolytus, but that silence would be caused by one of his abbreviations. I am even prepared to consider our passage in *Baruch* as proof for the occurrence of Priapus in the Naassene part of the *Sondergut* in its original form, before the editing done by Hippolytus.

speaks the whole mystery, and it (he?) is not listened to because of the wickedness of Naas.

This interpretation does not fit very well into the story of Edem, who was utterly distressed at being abandoned by Elohim. There was no indication that she was seeking sexual satisfaction elsewhere. She sought vengeance indeed but not in this manner. In *Ref.* 5.26.26, the prophets themselves were led astray through their souls by Naas. "In these (things), the prophet clearly speaks the whole mystery," is a typical summarizing remark of the redactor. Cf. *Ref.* 5.7.19: "For in these words, through which Paul spoke, is contained, he says, their whole hidden and ineffable mystery of blessed lust." All this indicates that the comment on Hos. 1:2 is one of the interpolations of the redactor.

4. THE VALENTINIANS: SOPHIA (*REF.* 6.29–37)

The report as it is given here belongs to the systems that start with three principles (though Hippolytus knows the other variants of Valentinianism and mentions them) which fits into the general interest of the *Sondergut*. The Father is a monad (*Ref.* 6.29.2); the mother, a dyad (*Ref.* 6.29.6)—while in Irenaeus *Adv. haer.* 1.1.1 the development of the pleroma starts with the "Pythagorean tetraktys," as Irenaeus calls it.

In relating the story of Sophia, I want to draw attention at the same time to a theme that does not belong to the subject of our meeting but one that I became conscious of while rereading the text in preparing this essay. And since the story of Sophia in the Valentinian systems is so very well known, it may be useful to note this other subject or motif which is not unconnected with it.

The Father's motive for generating is "love" (ἀγάπη; *Ref.* 6.29.6), a term that sounds biblical and that was certainly used consciously. The Father was wholly love, and love cannot be love without the (thing) beloved. There is, in fact, an answer to the Father's love, and it is described in the liturgical language of "giving thanks" (εὐχαριστεῖν) and "offering" (προσφέρειν) in *Ref.* 6.29.7. Nous and Aletheia, the first two offspring of the Father, are *thanking* the Father that their "products" (γεννήματα) have become "productive" (γόνιμα) in their turn, and are *offering*[31] him the perfect number, ten aeons (*Ref.* 6.29.8). The term "to be glorified" (δοξάζεσθαι; *Ref.* 6.29.8) also belongs to the liturgical sphere: the perfect Father had to be *glorified* by the perfect number. The celestial liturgy is

31. The term again is προσενεγκεῖν.

imitated on the next level of interpleromatic development. Logos and Zoe see the Father *glorified* by Nous and Aletheia and wish to *glorify* him themselves (*Ref.* 6.30.1). They *glorify* him with the imperfect number, twelve (2).

If we look back to the Valentinians in Irenaeus, we find that there also the syzygies have a liturgical relationship with the Propator:

> These Aeons having been produced for the glory of the Father, and wishing, by their own efforts, to effect this object, sent forth emanations by means of conjunction (. . . in gloriam patris emissos . . . volentes et ipsos de suo clarificare patrem).[32]

> These beings sang praises with great joy to the Propator (cum magno gaudio dicunt hymnizare propatorem).[33]

Thus the *Sondergut* of Hippolytus does not show any new developments in Valentinian theology, though it does show the liturgical aspect much more clearly than Irenaeus's narration of the myth—but this difference could also be the result of Irenaeus's way of reporting.

The youngest aeon is of course Sophia. Her femininity is stressed in 6: "being female and called Sophia" (θῆλυς ὢν καὶ καλούμενος Σοφία). She wishes to imitate the Father by generating without a spouse (6–7), a unique privilege of the Father. Sophia, as a generated being and since she was generated after the other aeons, could not possess the "ungenerated power" (ἀγέννητος δύναμις; 7). The Ungenerated One, the Father, is virtually male-female, though the term is not used. It is only said: "In the Ungenerated all is at once, says he" (8). The information desired is supplied by what follows. In generated (beings), the female is "substance" or "essence throwing forth" (οὐσία προβλητικός), while the male gives the form. Sophia, without spouse, is able only to produce something formless and "unwrought" (ἀκατασκεύαστον).[34]

The ignorance of Sophia and the formlessness of the being produced by her[35] frighten the aeons lest their products should be similarly imperfect and they themselves should come under "corruption" (φθορά; *Ref.*

32. Irenaeus *Adv. haer.* 1.1.2 (ET from Coxe, *Ante-Nicene Fathers*, 1:316).
33. Irenaeus *Adv. haer.* 1.2.6 (ET from Coxe, *Ante-Nicene Fathers*, 1:318). The Greek of this passage and of the one above is preserved in Epiphanius *Haer.* xxxi, secs. 9–32.
34. 9 is a remark of the redactor, singularly badly fitting. See Abramowski ("Ein gnostischer Logostheologe," 30 n. 35 [a]) for this interpolation. My statement that "die Interpretation durch den Redaktor ist also gegen den Sinn des Interpretierten vorgenommen" ("The interpretation by the redactor is against the sense of what he is interpreting") has to be applied again and again to his strange doings.
35. Κατά, which appears twice in p. 158, 15f., is to be translated by "with," since the *genitivus absolutus* has a temporal meaning.

6.31.1). The aeons flee to the Father and intercede with him that he should quiet the mourning Sophia, lamenting over her "untimely birth" (ἔκτρωμα). The Father accepts their supplication, commiserates, and orders an "additional production" (ἐπιπροβαλεῖν). Nous and Aletheia produce Christ and the Holy Spirit for the forming and separation of the "untimely birth" (ἔκτρωμα) and for the consolation of Sophia (2). Christ and the Holy Spirit separate the misshapen product of Sophia from the perfect aeons in order that they should not be shaken by its sight (4). Outside of *horos*, the boundary of the pleroma, is the ogdoad. This ogdoad is the Sophia outside the pleroma, whom Christ shaped and made into a perfect aeon, which is not inferior to any of the aeons (7). Thus the Sophia outside is nothing but the former "untimely birth" (ἔκτρωμα). It is surprising (and gratifying) that she obtains the same level as the aeons in the pleroma. (Might there be in all this a connection with 1 Cor. 15:8?)

Christ and the Holy Spirit return to the pleroma and there *glorify* the Father (8). Peace and harmony now reign in the pleroma and the aeons praise the Father:

> After, then, there ensued some one peace and harmony between all the Aeons within the Pleroma, it appeared expedient to them not only by a conjugal union to have magnified the Son, but also that by an offering of *fitting* fruits they should glorify the Father.[36]

Not only is the Father to be praised by the syzygies but the praise is to take the form of an *offering of fitting fruit*. "Peace" and "harmony" are ecclesiological terms, and the "offering of fitting fruit" is part of the liturgy as we see from the *Traditio apostolica*: "Fructus natos primum, quam incipiant eos omnes festinant offere episcopo."[37] The report of Irenaeus alludes more clearly to the *first* fruit and to the participation of every[38] aeon:

> Then out of gratitude for the great benefit which had been conferred on them, the whole Pleroma of the Aeons, with one design and desire, and with the concurrence of Christ and the Holy Spirit, their Father also setting the seal of His approval on their conduct, brought together whatever each one had in himself of the greatest beauty and preciousness; and uniting all

36. *Ref.* 6.32.1 (ET from Coxe, *Ante-Nicene Fathers*, 5:87, with one alteration [emphasized]).
37. *Traditio apostolica* (Bernard Botte, ed., *La tradition apostolique de saint Hippolyte: Essai de reconstruction*), 31. For the *fitting* fruit, see 32, where are enumerated the fruit which the bishop is to bless and those which he is not to bless (and which therefore are not fit to be offered).
38. See "omnes" in *Traditio apostolica*, 31.

these contributions so as skillfully to blend the whole, they produced, to the honour and glory of Bythus, a being of most perfect beauty, the very star of the pleroma, and the perfect fruit [of it], namely Jesus.[39]

The aeons offer one joint fruit as symbol of their unity and peace. This fruit is Jesus. I am sure that this also implies an allusion to Luke 1:42, "the fruit of your womb."

As the Sophia inside the pleroma had her phase of mourning, so now has the Sophia outside. The duplication of the figure entails a reduplication of the experience. Sophia seeks Christ and the Holy Spirit. She is afraid of losing her existence after the savior who "formed" and "established" her has gone back. In 3 are described the thoughts, some of them suspicious of envious meddling (by whom?), which assail her. She turns with prayer and supplication to him who has left her. In this phase it is not the Father but Christ in the pleroma and all the aeons who commiserate with her. They send the joint fruit of the pleroma, Jesus, to be the spouse of the Sophia outside. His task is to correct the passions of Sophia which she suffered in her search for Christ (4). The "fruit" separates the four passions from Sophia. They become so many "substances" or "essences" (οὐσίαι), making possible the generation of the cosmos and also the return of the psychic "substance" (οὐσία; 5–6).

No doubt Sophia is the most interesting figure in the Valentinian precosmic myth, since without her there would be no disturbance in the pleroma and no outer cosmos. She is fitted with psychic proprieties and behavior considered typically feminine. It is remarkable, I think, how well she and her offspring are treated by the inmates of the pleroma. But without help, she is helpless. What she does or is always needs a complement, and the complement has to be male.[40]

39. Irenaeus *Adv. haer.* 1.2.6: "Et propter hoc . . . unumquemque aeonum quod habebat in se optimum et florentissimum conferentes collationes fecisse." For the Greek, see Epiphanius *Haer.* xxxi, secs. 9–32. The ET is from Coxe, *Ante-Nicene Fathers*, 1:318.

40. During the conference at Claremont, Jorunn J. Buckley kindly drew my attention to two papers on the book of *Baruch*, more or less identical, by M. Olender, and to one by herself, then at press. This last has now appeared: Buckley, "Transcendence and Sexuality in the *Book of Baruch*," *HR* 24 (1984/1985) 328–44. The author is unaware of the work done on the *Sondergut* in the *Refutatio*, including my article, and she treats the Priapus passage as an authentic element in the original book, with a decisive influence on her interpretation of it. Olender's articles are (1) "Le système gnostique de Justin," *Tel Quel* 82 (1979) 71–88; (2) "Eléments pour une analyse de Priape chez Justin le Gnostique," in *Hommages à Maarten J. Vermaseren*, 2:874–97. Olender's main argument is that Priapus has a broader range of qualities and functions than just the sexual-creative and that he can be the (highest and) good divine being. Therefore the identification of the first principle, "the Good," with Priapus has nothing strange about it. (This evidently was also the idea of the gnostic redactor of the *Sondergut*.) Against this it must be stated again that in the book of *Baruch*, the creative (and sexual) is explicitly

distinguished from the Good, which is certainly fashioned after the Platonic Good. In *Studia Patristica* 18.1 (papers from the 1983 Oxford Patristic Conference), there will appear an article by J. Montserrat-Torrents, "La philosophie du *Livre de Baruch* de Justin."

Response to "Female Figures in the Gnostic *Sondergut* in Hippolytus's *Refutatio*" by Luise Abramowski

It is a pleasure to be invited to respond to Professor Abramowski's essay. For most of us, it is surely fair to say, the exhilaration produced by the discovery and publication of the Nag Hammadi codices has tended to diminish an interest in the study of patristic sources. Nevertheless, the essay of Abramowski should serve to remind us not to overlook the material significance of early Christian heresiological literature for an inquiry into the texts and traditions of ancient Gnosticism. Indeed, to cite just one example, only in Hippolytus can we find a version, edited but extant, of Justin's book of *Baruch*, a primary source document of gnostic spirituality whose conceptual originality will be the concern of the majority of my remarks in this response.

The opening comments of Abramowski's essay are important. When she began her investigation, she tells us, she proposed the title "The Christian Gnostic Redactor in Hippolytus's *Refutatio* and the Feminine." One of the results of her research, however, is the observation that the redactor does not show a specific interest in the female figures of his source(s) as such. Accordingly, her revised title indicates that the texts in Hippolytus are not to be grouped together in accordance with an individual redactor's interest in or attention to the role of the feminine. This means that the description of female figures in the *Refutatio* is part of the tradition, not a later redaction. Whereas the individual character of the several parts of the *Sondergut* is visible in its treatment, if any, of female beings as part of a particular gnostic mythology, the redactor's hand can be detected primarily through the techniques of (1) interpolating biblical quotations into the *Sondergut*, (2) using terms from one source to inter-

pret another, and (3) taking whole quotations over from one source to another, in such a way that the several parts of the *Sondergut* are made to "quote" each other.[1]

In the remarks that follow, I would like to focus my attention on Justin's book of *Baruch* (*apud* Hippolytus *Ref.* 5.23.1—27.5) and Abramowski's treatment of it. By limiting my discussion essentially to this one document, I do not intend to suggest either that the other texts in Hippolytus or Abramowski's treatment of them are to be ignored. Rather, I shall concentrate on this one text in order to keep my response brief and because *Baruch* is an extremely engaging document which also contains the most detailed story of a female being in the *Sondergut*. Conceptually, moreover, the book of *Baruch* is singular in that (1) by virtue of the fundamental presupposition of its mythological system, in which "there were from the beginning three unbegotten principles of the universe,"[2] *Baruch* avoids the necessity of having to speak of a fall of the divine; (2) the origin of evil is explicitly stated to be a result of the Father Elohim's abandonment of Edem, and is not understood to derive from an error of the female; and (3) it is the Father Elohim (and not the highest principle, the Good) who bestows the divine spirit *(pneuma)* on humankind.

The central mythic paradigm in *Baruch* is the abandonment of Edem by Elohim. As Michael Williams has noted, what is striking is the ambivalence with which this motif is charged. On the one hand, the abandonment of Edem and Elohim's ascent to the Good "form the paradigm for ultimate salvation." On the other hand, however, this very act of abandonment is described negatively in the text as "the violation of the previous vows that Elohim had made to Edem."[3] The actions of Elohim alone, therefore, not those of Edem, are understood to provide the common origin of good and evil:

> From that time both evil and good held sway over humankind, springing
> from one origin, that of the Father (Elohim). For by ascending to the Good
> the Father showed a way for those who are willing to ascend, but by

1. See L. Abramowski, "Ein gnostischer Logostheologe: Umfang und Redaktor des gnostischen Sonderguts in Hippolyts 'Widerlegung aller Häresien,'" in *Drei christologische Untersuchungen*, 18–62.

2. R. van den Broek, "The Shape of Edem According to Justin the Gnostic," *VC* 27 (1973) 35.

3. M. A. Williams, "Uses of Gender Imagery in Ancient Gnostic Texts," in *Gender and Religion* (ed. Bynum, Harrell, and Richman), 201. I quote (without pagination) throughout from the author's typescript with his permission. See also Williams's contribution to this present volume.

departing from Edem he made a beginning of evils for the spirit of the Father that is in humankind. (5.26.23–24)[4]

The book of *Baruch* states (5.26.14–18) that "the necessity of evil" came about when Elohim, who was rising upward, ascended to the Good and saw "what eye has not seen and ear has not heard and has not occurred to the human mind."[5] When Elohim thus recognized that the lofty realm of the Good was superior to the world below, he wished to destroy the world which he had helped make, for he wanted to reclaim those portions of his spirit bound within humankind. Once granted access to the realms of light above, however, Elohim was not permitted to return personally to the creation below; that creation was to belong to Edem so long as she willed. Abramowski interprets this passage as an etiology of evil:

> Here we have an explanation for the continued existence of the created world, though Elohim, identified with the God of the Old Testament, has left the world for whose creation he was partly responsible. The lesson for the gnostic reader is that the Good can be reached only by retreat from creation, since the creation in which we live now belongs to Edem; and Edem is by constitution unable to ascend to the Good.

But is this really "*the* lesson for the gnostic reader"? To be sure, the Good can be reached only by separation from the imperfection of creation. But what is the nature of that separation, and how does it take place? Abramowski's explanation is not incorrect, I think, just insufficient.

A clue to the nature and intent of that separation may be gleaned from the way in which male and female, represented mythically in the text by Elohim and Edem, are implicitly enjoined to transcend their this-worldly union. Williams has perceptively observed that, in *Baruch*, "existence in this world is experienced as the union of male and female, a union that must be broken in order to achieve transcendence. . . . The relationship of male to female," of Elohim to Edem, is understood to be

4. E. Haenchen, trans., "The Book *Baruch*," in *Gnosis* (ed. Foerster; trans. and ed. Wilson), 1:55, adapted. Haenchen's translation of this passage is also cited in the discussion of J. J. Buckley ("Transcendence and Sexuality in *the Book Baruch*," 334–35), whose statement that "the Greek text does not have 'of the Father' in the last line" (p. 335 n. 15) of this quotation is in error.

5. "What eye has not seen . . ." (5.26.16) is a topos that was widespread in antiquity, occurring three times in *Baruch* itself (cf. 5.24.1; 5.27.2), and probably should not be regarded as a quotation of 1 Cor. 2:9 (*pace* E. Haenchen, "Das Buch Baruch," 133 n. 1, 139 with n. 2) or an interpolation of the redactor. See the catalogue of references to this topos in M. E. Stone and J. Strugnell, *The Books of Elijah: Parts 1—2*, 41–73, to which these three citations from *Baruch* should be added.

"a voluntary contractual relationship" between partners in marriage (cf. 5.26.21: *tas synthēkas*):[6]

> The picture the myth presents . . . is one of heartfelt love between Elohim and Edem, for which the created humans stand as symbols at two levels: individually by each possessing both soul and spirit, and together by their relationship as husband and wife.[7]

Collectively every human marriage may be said to be "an image and symbol of the archetypal, sacred marriage of Elohim and Edem."[8] In this sense the book of *Baruch* functions to offer mythic support to the institution of marriage.[9] But individually men and women function as paradigms for the union of spirit (male) and soul (female) in all persons. The ascent of Elohim, who supplied the human creature with the spiritual element, thus serves to indicate the upward path that the spirit is to take in all human beings, women as well as men. Accordingly, the objective intimated by the text is for the human spirit to leave behind its (male or female) body and ascend to the Good. Although gender distinction is explicit from the fact that Elohim is pictured as contributing the spirit and Edem the soul to the creation of humanity (5.26.8), the ascent, insofar as it is to be attained in the lives of all human beings, is not gender specific, inasmuch as the pneumatic element in all individuals is transcendent.[10]

What, then, is the purpose of the book of *Baruch?* What is the relationship of the myth of Elohim and Edem to the ritual (of initiation) that is described at the end of Hippolytus's excerpt? These are important questions yet to be addressed by Abramowski. It is Elohim's abandonment of Edem, not his marriage to her, that is the paradigm for initiation into the mysteries that transcend the cosmos. Hippolytus reports that

> there is written also in the first book entitled *Baruch* an oath which they make those swear who are about to hear these mysteries and be perfected by the Good. This oath (Justin says) our Father Elohim swore when he came before the Good, and did not repent of having sworn it. . . . And the oath is this: "I swear by him who is above all things, the Good, to preserve these mysteries and to declare them to no one, neither to turn back from the Good to the creation." When he swears this oath, he goes into the Good and

6. Williams, "Uses of Gender Imagery," 199.
7. Ibid, 200.
8. Van den Broek, "The Shape of Edem," 40.
9. So Williams, "Uses of Gender Imagery," 203; see also R. M. Grant, *Gnosticism and Early Christianity*, 23; and van den Broek, "The Shape of Edem," 43.
10. This crucial observation is convincingly argued by Williams ("Uses of Gender Imagery," 199–205). See also his contribution to the present volume.

sees "what eye has not seen and ear has not heard and has not occurred to the human mind," and drinks from the living water, which is for them a baptism *(loutron)*, . . . a well of living water springing up. For there is a distinction (Justin says) between water and water, and the water below the firmament is of the evil creation, in which choic and psychic people bathe, and there is above the firmament the living water of the Good, in which the pneumatic, living people bathe, in which Elohim bathed and did not repent of such a baptism. (5.27.1–3)[11]

Just as Elohim swore an oath and bathed with living water, so also did the Gnostics of Justin's community. Just as Elohim was able to ascend to the Good, so also were women and men to undergo an "initiation which was structured in gender categories" (as symbolized by the abandonment of the female "soul" and body by the male "spirit") "but in which the sexuality of the initiates was irrelevant."[12] The invitation to witness "what eye has not seen and ear has not heard," which both introduces (5.24.1) and concludes (5.27.2) the book of *Baruch* as Hippolytus has preserved it, is given narrative form in the body of the text (5.26.16) in the account of the ascent of Elohim. Accordingly, *Baruch* should be understood as a mythic justification of and representation for that community's ritual activities.

11. Haenchen, trans., "The Book *Baruch*," 1:57–58, adapted. Note that the phrase "when he came before the Good" ($\pi\alpha\rho\grave{\alpha}$ $\tau\hat{\omega}$ $\grave{\alpha}\gamma\alpha\theta\hat{\omega}$ $\gamma\epsilon\nu\acute{o}\mu\epsilon\nu os$) in the second sentence of this quotation was inadvertently omitted from the text of Haenchen's translation in both the English edition (p. 57) and the German edition (E. Haenchen, trans., "Das Buch Baruch," 78) of Foerster's anthology. It is included, however, in the German translation of this passage ("als er zum 'Guten' gekommen war") in Haenchen's article, "Das Buch Baruch," 130.
12. Williams, "Uses of Gender Imagery."

Sophia and Christ in the
Apocryphon of John

1. TOWARD DEFINING TASKS AND METHODS

As Michael Williams has demonstrated so clearly and pointedly in his essay in this volume, "Variety in Gnostic Perspectives on Gender," there is no uniformity concerning the uses of gender language and imagery in Gnosticism. Not only do the various texts show a wide range of diversity and interests in the usage of gender language and imagery but a range of diversity can also be present even in an individual text. Using the *Apocryphon of John*[1] as an example, I propose to show the various ways in which a single text can be analyzed with reference to the problem of gender.

To understand the problem of images of the feminine in Gnosticism as applied to the *Apocryphon of John*, the meaning of the text, its possible social setting, and the underlying presuppositions of the text regarding gender need to be considered. These issues are all interrelated and each is legitimate in itself, but each demands a different methodology and each reflects a different set of interests.

The first question asks, What role(s) does gender imagery play within the text's internal logic? In the case of the *Apocryphon of John*, we can appropriately ask, What role does gender imagery play with regard to

1. All translations from the *Apocryphon of John* are the author's, using for the Berlin Codex the edition of W. C. Till and H.-M. Schenke, *Die gnostischen Schriften des koptischen Papyrus Berolinensis 8502*, 78–195, with reference to the ET of M. Krause and R. McL. Wilson, in *Gnosis* (ed. Foerster), 1:105–20; for NHC II, the text of the Coptic Gnostic Library, supplied by the Institute for Antiquity and Christianity, with reference to the ET by F. Wisse in *Nag Hammadi Library* (ed. Robinson), 99–116.

such issues as the portrayal of deity, cosmology, anthropology, and salvation? This question requires an analysis of the text with a view to comprehending the internal logic and meaning of the text.

Second, we can ask, How might the use of gender imagery reflect real-life gender roles inside a communal setting? An answer to this question requires a tentative, imaginative application of the text to a possible social situation. Such inquiry is directed toward a social history of Gnosticism. In my opinion, this direction of inquiry is the most tentative of the three for reasons that are well known; in the case of Gnosticism, the lack of data is the most overwhelming problem.[2] Nonetheless, because it is impossible to interpret a text apart from a social situation (real or imagined, past or present) and because we cannot claim to be disinterested in how gnostic beliefs actually affected the lives of those who believed them, it is worth the risk involved at least to ask the question.

Third, we need to ask what presuppositions are at work in framing the way in which gender imagery is used. What is significant about such presuppositions for our understanding and appropriation of the text's meaning? This third direction of inquiry is one that seeks to examine the presuppositions that direct the text's use of gender language and imagery. This is aimed not only at antiquarian interests but more directly at the issue of appropriation for the modern audience.

These issues will be addressed in the following selected examples from the *Apocryphon of John*.

2. TURNING TOWARD THE TEXTS

The problem of images of gender in the *Apocryphon of John* is a thorny one not only because of the internal complexities of the text but also because of the differences among the five surviving witnesses to the text: Irenaeus, *Adversus haereses* (1.29.1–4), BG (19,6—77,7), NHC II (1,1—32,9), NHC III (1,1—40,11), and NHC IV (1,1—49,28). The text of Irenaeus shows knowledge of only a part of the text preserved in the other witnesses.[3] Among the four remaining witnesses, it is possible to distin-

2. This is due in good part to the nature of the texts and the tradition itself. Gnosticism is simply not interested in history, in the events and relations of this lower world, and therefore did not waste much ink on them, at least so far as the texts that have been preserved indicate.

3. Irenaeus begins with the generation of Barbelo and ends with the claim of the Proarchon: "I am a jealous God and beside me there is no one." He shows no knowledge of the frame story, nor of the negative theology describing the Father.

guish two recensions of the text, a shorter version represented by BG
and NHC III, and a longer version represented by NHC II and IV.

These witnesses show quite clearly that the *Apocryphon of John* has
been edited to a considerable degree throughout its transmission history.
Though the similarities among the texts are precise enough for us to
assume that each could trace its history back to a common foundational
text, this is most certainly several stages behind the Coptic translations
that have survived. Each of the recensions has clearly passed through a
series of hands that led their development in independent directions.
These hands included those of copyists and translators as well as pos-
sible abbreviators or interpolators. M. Tardieu maintains that it is now
impossible to trace that history in any detail with certainty. The variety
and character of the divergences do not allow us to state in each and
every case when any difference is due to a translator, a copyist, an
abbreviator, or an interpolator.[4] It is almost as difficult to say whether
the longer or the shorter recension represents a more original version of
the text.[5] Although it is possible to argue convincingly that certain
additions to the longer recension of the text are late, that does not mean
that every reading in the longer version is later than in the shorter ver-
sion.[6] It is not possible to posit that one text *always* contains an earlier or
more authentic version of the *Apocryphon of John* in comparison with the
others. Each text may contain both earlier and later material.

There is, however, one set of materials in the longer recension that is
clearly secondary. This is the material of the frame story which includes
the initial setting of John's troubles in the temple, his questions, and the
dialogue material between the apostle and Christ throughout the entire
text.[7] The addition of these materials has turned a gnostic treatise on
theology, cosmology, anthropology, and salvation into a Christian-
gnostic dialogue between the savior Christ and the apostle John. Indeed,
since Christ appears only in these places (or at others where he is
peripheral or where his presence is confusing), it has been argued that
the text was secondarily christianized by the addition of the frame story

4. See M. Tardieu, *Ecrits gnostiques*, 26.
5. The longer additions to the text are of such a character that it is quite as possible
to imagine them being omitted as added. Tardieu argues that BG and NHC III represent
an abridgment of the longer recension represented by NHC II and IV.
6. See J.-M. Sevrin, *Le dossier baptismal Sethien: Etudes sur la sacramentaire gnostique*,
chap. 1, pt. 1 A. He cites III 11,8–22 and II 13,5–13 as examples.
7. See the arguments of S. Arai, "Zur Christologie des Apokryphons des Johannes,"
NTS 15 (1968–69) 302–18; H.-M. Schenke, "Nag-Hamadi Studien 1: Das literarische
Problem des Apokryphon Johannis," *ZRGG* 14 (1962) 57–63; and idem, "Gnostic Seth-
ianism," in *Rediscovery* (ed. Layton), 2:588–616.

and a number of smaller changes within the text.[8] Though this must have happened early since it is clearly a Christian text by the time of Irenaeus, the thesis explains a number of difficulties and allows us to establish at least one line of development in the transmissional life of the text.

What I propose to do here is to attempt to see whether it is possible to delineate consistent but differing patterns in each text's use of gender imagery by comparing them with one another. As John Turner aptly points out in his critique of this essay, one may not frame this question in terms of "direction of development," because we do not know with any surety which readings are earlier and which are later. One can talk about such development only with regard to the influence of the frame story and the addition of the figure of Christ into the text, but since this is present in all of our extant texts, it does not help us to determine the value of any reading in a text relative to another.

Because of the relatively good condition of the manuscripts of BG and NHC II in comparison with NHC III and IV and in the interests of simplifying our discussion, I shall present a comparison of BG and NHC II, focusing on their use of gender imagery with regard to the issue of salvation. The conclusions therefore apply, not to the *Apocryphon of John* in general, but to these two manuscripts only. The discussion similarly does not take into account the use of gender imagery in the discussion of theology, cosmology, and anthropology except as they impinge upon the discussion of salvation.

2.1. Codex Berolinensis 8502 (BG)

Excluding consideration of the frame story (BG 19,6—22,17), the text begins with the description of the true God, the Father of the All, the holy Invisible Spirit (BG 22,17—26,13). From the image that the Father saw in the pure water of life surrounding him came forth the Pronoia of the All, the thought (Ennoia) and image of the Father, Barbelo (BG 26,15—27,15). She knows the Father from whom she came forth (BG 27,17). She is the first Ennoia, the First Man, the virgin Spirit, the Triple-Powered One, the Thrice-Male, the Thrice-Begotten, the Thrice-Named Androgynous One (BG 27,18—28,4). She requests the Father to give her First Knowledge, Incorruptibility, and Eternal Life. He consents and they are manifested (BG 28,5—29, 14). These three, together with the First Man and Ennoia, form the androgynous pentad of the Father (BG

8. See Arai, "Zur Christologie des Apokryphons des Johannes," esp. 303 and 318.

29,16–18). This description of Barbelo, the "Mother" figure and consort of the Father, makes it clear that "she" is not unambiguously feminine. She can be described as Mother, Thrice-Male, or as androgyne. Barbelo then gives birth to the Son, not by requesting him from the Father, but:

> The pure Barbelo of light gazed intensely toward the unbegotten Father. She turned toward him; she gave birth to a blessed spark of light, but it was not equal to her in greatness. (BG 29,18—30,4)

The being whom she bears is called the Only-Begotten, the divine Autogenes, the firstborn Son of the All, the Spirit, the pure light. He did not originate with the permission of the Father, but in a manner similar to that by which the Father himself produced Barbelo, his perfect image. But unlike the product of the Father, this Son which Barbelo brings forth is inferior to her; he is imperfect, in need of salvation, since he does not know the Father. This salvation comes speedily:

> The Invisible Spirit rejoiced over the light which had come into being, the one who was first revealed in the first power, which is his Pronoia, Barbelo. And he anointed him with his goodness, so that he became perfect and was without deficiency in him, the Christ, since he anointed him with his goodness for the Invisible Spirit. It was through the Virgin Spirit that he poured forth into him and he received the anointing. (BG 30,9—31,1)

Salvation here is described as being perfected through receiving knowledge of the Father (the Invisible Spirit) and anointing by Barbelo (the Virgin Spirit). The initiative to act comes from the Father, but the act of salvation itself is completed by Mother and Father acting together.[9] In his new, perfected state, the divine Autogenes is called Christ, the anointed one.

When Christ wishes to create, he does not make the mistake that Barbelo did; everything that he wishes to be brought into being is accomplished with the consent of the Father. The perfect true man, Adam, comes into being at the resolve of the Invisible Spirit and Autogenes together. From Adam comes Seth, the seed of Seth, and the souls of those who will come to know perfection.

The creation of the perfect pleroma above clearly provides the pattern for the subsequent creation of the world below. The account of the perfection of the Son above also provides a complete model of salvation for those lower beings who will be created below. The Son was an

9. See Arai, "Zur Christologie des Apokryphons des Johannes," 309 and 310. He lists three examples: (1) III 23,19—24=BG 51,1–17; (2) III 32,9–22; compare BG 63,16—64,13; and (3) BG 71,5–13.

imperfect being, brought into existence by the Mother alone, but perfected at the instigation of the Father and the act of the Mother through "anointing with goodness" and by the gift of knowledge of the Father. When the drama of cosmology and the origins of evil begin below, therefore, the reader already knows the pattern that events must follow and is assured of a final happy outcome if events follow the pattern established already in the perfection of the Son by the Father and Mother.

The drama of cosmology begins when Sophia, the third aeon of the fourth light of Autogenes, wants to reveal a likeness out of herself without the "consent" of the spirit or of her partner, a shadowy figure who is never named. The product of her endeavors is a male being inferior to her; he is imperfect and is characterized by deficiency.

Following the pattern established by the generation of Autogenes-Christ by Barbelo, we expect an act by the Mother at the instigation of the Invisible Spirit to correct this deficiency. It comes swiftly:

> But when the Mother (Sophia) recognized that the abortion of darkness was not perfect, because her consort had not joined with her, she repented and cried with great weeping. And he (the Invisible Spirit) heard the prayer of her repentance, and her brothers (siblings?) prayed for her. The holy Invisible Spirit assented. When the Invisible Spirit assented, he poured upon her a Spirit from the perfection. Her consort came down to her in order to set right her deficiency. He willed it through a Pronoia to put right her deficiency, and she was not brought up to her own aeon, but because of the great ignorance which appeared in her, she is in the nonad until she sets right her deficiency. A voice came to her: "The man exists, and the son of man." But the first archon, Ialdabaoth, heard (it) and did not think that this voice came down from the height. The holy perfect Father, the first man, taught him in the form of a man. The blessed one manifested his likeness to them. (BG 46,9—48,5)

What happens here is in part expected, in part unexpected. The reader expects the Father to act immediately and decisively. He does. What is unexpected is that his saving act seems directed at first toward Sophia, not the abortion. She repents—and thereby the text implies that she must have sinned. She is now put in charge of rectifying her deficiency—she becomes the savior at the direction of the Father.

On the other hand, the revelation of the Father is directed both toward her *and* toward her son, the demiurge, and his cronies. The voice comes to Sophia, but the teaching and revelation in the form of Man are given to the demiurge and those with him. This initiates the creation of the lower, psychic Adam, following the drama of Genesis. Salvation at

this juncture would seem to require the return of Sophia to the pleroma and the perfection of the abortion. These salvific acts, however, are not accomplished as simply as was the perfection of the Son. Instead, the long drama of creation ensues.

When the wicked archons create Man, the power of the Mother passes through the demiurge to the Man. Because of jealousy, the archons take the wise and good Man and "brought him down to the regions beneath all matter" (BG 52,15–17). The Father takes pity on the power of the Mother and sends down the Epinoia of Light so that the Mother's power might prevail over the body. This female power is called Zoe:

> It is she who labours for the whole creation, troubling (herself) over it, establishing it in her own perfect temple, enlightening it about the descent of its deficiency, telling it about its ascent upward. And the Epinoia of light was hidden in him so that the archons would not recognize (her), but (so that) our own sister, Sophia, who resembles us, might set right her deficiency through the Epinoia of light. (BG 53,10—54,4)

She works in Adam for the salvation of the power of the Mother. It is she who speaks through the tree of the knowledge of good and evil:

> Through the authority of the height and the revelation, Epinoia taught him (Adam) understanding. Through the tree in the form of an eagle, she instructed him to eat the understanding, that he might take thought for his perfection; for the offense of both (man and woman) was ignorance. (BG 60,16—61,7)

Note that here again it is the Father who initiates but the feminine figure who acts.

According to the text, the subordination of woman to man and the act of marital intercourse come about because of the ignorance and wickedness of the demiurge, Ialdabaoth (BG 61,6–15; 63,2–9). The creation of marital intercourse, however, also works against the demiurge insofar as the procreation of Adam follows the heavenly pattern of the generation of Seth and the seed of Seth. Through them, the deficiency will be corrected:

> He (Adam) recognized his substance which is like him. Adam begot Seth. And, according to the generation which is in heaven among the aeons, in this manner the mother sent the one who belongs to her. The Spirit (of the Mother) came down to her (the power of the Mother, Ennoia/Zoe) to waken the substance which is like him (Man/Adam/Seth) according to the pattern of the perfection, to waken them (man and woman) out of the forgetfulness and evil of the grave (material existence). And in this way, he (the Spirit of the Mother) remained for a long time and laboured on behalf

of the seed, so that when the Spirit comes from the holy aeons, he might set them (the seed) upright, away from the deficiency, for the establishment of the aeon, that he (Adam, the seed) might become a holy perfection, that he might become now without deficiency. (BG 63,12—64,13)

What becomes increasingly clear throughout is that the restoration of Sophia and the correction of her deficiency are achieved through the salvation of Adam and the seed of Seth. Salvation means here to be stirred out of forgetfulness and the moral wickedness which attaches to life in the body. If, however, the pattern of salvation established for Autogenes-Christ above is to be followed in achieving the salvation of the unwavering race of the perfect Man, the method must be the same: all deficiency will be healed through anointing with goodness and reception of the knowledge of the Father/First Man.

That Epinoia was sent to be the savior for all Gnostics, male and female, is quite clear from the way in which actual sexuality is treated in the text. The creation of differentiated sexes from an (androgynous?) Adam was a false attempt by the demiurge to regain the power of the Mother/Epinoia which had passed from him to Adam. Similarly, the decree that man should be master of woman was also an ignorant mistake of the demiurge, "since he did not know the mystery which existed by the design of the holy height" (BG 61,12–15). The real meaning of marriage (based on an interpretation of Gen. 2:23) is that the consort will raise up the Mother (BG 60,5ff.). Carnal, marital intercourse derives from the archon who "planted in Adam a desire for seed, so that it is from this substance that a likeness from their counterfeit (image) is brought forth" (BG 63,5–9). Sexual differentiation, then, plays no role in real salvation, which is a matter of the spirit, not of physical gender. This view is underlined in the following statement of the mission of the female savior, Epinoia:

> Through the authority of the height and the revelation, Epinoia taught him (Adam) understanding. Through the tree in the form of an eagle, she instructed him to eat the understanding, that he might take thought for his perfection; for the offense of *both* was ignorance. (BG 60,16—61,7; see also BG 57,20—58,1; my emphasis)[10]

To belong to the seed of Seth, then, is not a matter of being of male gender. Indeed, salvation is not a matter of gender at all.

So far we have spoken only of one savior figure, Epinoia. This over-

10. First the masculine singular is used, then the plural, to indicate both the man and the woman.

looks, of course, another important figure: Christ. As was stated above, the major portrayal of Christ as savior belongs to the frame story, that is, to those portions of the text which frame the whole as a revelation discourse from Christ to his apostle, John. This includes not only the introduction (BG 19,6—22,17) and conclusion (BG 76,5–end) but also the dialogue format within the text. Here Christ alone appears as savior. He is portrayed as the bringer of secret, saving revelation. He calls himself the Father-Mother-Son, the one who came in order "to teach you about what is, and what has come into being, and what will come into being, so that you may know the invisible things and the visible things, and to teach you about the perfect man" (BG 22,2–9). The teaching that he gives is intended only for the unwavering race of the perfect man (see BG 22,14–16 and 75,19—76,1). In the conclusion, the text reads enigmatically that first Christ came up to the perfect aeon (BG 75,14–15) but also says that the Mother came once again before him (BG 76,1–3). This confusion is perhaps a sloppy attempt to reconcile the content of the revelation (where the savior figures are exclusively feminine) with the frame's presentation of the male Christ as savior.[11]

The only other male figures who take part in the drama of salvation are the consort of Sophia (who is never named) and Autogenes, who is sent by the Father with his four lights to advise the demiurge so that the power of the Mother would come out of him (see BG 51,9–14). These are relatively minor roles.

In conclusion, the following statements can be made about the use of gender imagery in the text with regard to salvation. In the text's theology, the ideal is sometimes presented in terms of the patriarchal family structure: Father, Mother, Son. (As was stated above, Barbelo appears to be unambiguously gendered and is not always described as Mother, or even female.) All acts are to take place only with the consent of the Father. Deficiency is caused by the female working alone. Salvation comes when male and female work in concert, though always with the male/Father in a position more primary than that of the female/Mother,

11. Arai ("Zur Christologie des Apokryphons des Johannes," 303) has argued: "Schon auf den ersten Blick kann man leicht feststellen, dass die Christusgestalt oder das christliche Gedankengut überhaupt meist in der Rahmenhandlung, sehr selten dagegen in der eigentlichen Geheimlehre auftritt" ("Already at first glance, one can easily secure that the form of Christ or the Christian materials appear mostly in the frame story, and to the contrary very seldom appear in the secret teaching proper"). He goes on to examine every case where Christ/Logos appears, arguing that every case can be shown to be secondary. See also H.-M. Schenke, "Gnostic Sethianism," in *Rediscovery* (ed. Layton), 611–12.

both in terms of sequence and in terms of power. Nonetheless, the female figures are never depicted as passive or weak. The Father seems to be associated more closely with what we might call mental qualities or attributes of will. He is the one who gives assent, to whom all requests or pleas are addressed. But it is the female who acts. The primary savior figure in the text, the Epinoia of Light, is female. On the other hand, the text does not seem to find it problematic to add the male savior Christ through the frame story. Indeed, it does not seem to find it problematic at all to see in Christ the male-female trinity of the Father-Mother-Son. This point clearly indicates that salvation itself has no relation at all to gender or real sexuality, at least as far as the *Apocryphon of John* is concerned. Rather, salvation for both men and women is a matter of receiving esoteric knowledge and is connected with the rite of baptism.[12]

2.2. Nag Hammadi Codex II

Although the course of the narrative in Nag Hammadi Codex II closely parallels that of the Berlin Codex, there are a number of places where there are some significant differences with regard to the use of gender imagery and salvation. I shall discuss the most important of these below.

The first of these passages is the presentation of the generation of Christ. In the Berlin Codex, the Son was produced by the Mother alone. In Nag Hammadi Codex II, it is the Father who produces the Son by impregnating Barbelo with his spark. The Son is considered *his* offspring, not hers.

> He begot a spark of light in a light of a corresponding blessedness, but it was not equal to his greatness. This one who appeared was the only-begotten of the Mother-Father; it is his only begetting, the only-begotten of the Father, the pure light. (NHC II 6,13–18)

The Son is then anointed with the goodness of the Father "until he became perfect, not lacking in any goodness" (NHC II 6,24–25). No revelation of the Father is necessary. Nor is it clear that the Son had a deficiency that needed to be rectified. He seems to have required anointing with goodness, but it is unclear why, except insofar as generation is

12. See Sevrin, *Le dossier baptismal Sethien*, chap. 1: "L'Apocryphon de Jean." He argues that there are two distinct allusions to baptism in the text: (1) in discussing the pleroma, BG 26,14—27,6; NHC III 7,1–33; NHC II 4,18–28; NHC IV 6,19–29; and (2) in the Pronoia hymn, NHC II 31,11–27; NHC IV 48,14—49,8. The rite of baptism is conferred with or by the five seals and is definitely associated with anointing. This is present especially in the longer version of the *Apocryphon of John* (see pt. V.1).

perhaps presupposed to be a process of degeneration. At any rate, we do not have here a paradigm that will provide a pattern for salvation below or an assurance of its success, as in the Berlin Codex.[13]

A second difference can be seen at Nag Hammadi Codex II 22,3–10:

> But that which is called the tree of knowledge of that which is good and that which is wicked, i.e., the Epinoia of the light, they stayed in front of it in order that he (Adam) might not look up to the pleroma and recognize the nakedness of his shamefulness. But it was I (Christ) who set them upright in order to eat.

Here *Christ* plays the role of savior which in the Berlin Codex belongs to the female Epinoia. Similarly in Nag Hammadi Codex II 23,21–37, Christ again takes up a savior role assigned in the Berlin Codex to Epinoia:

> Our sister Sophia (is) she who came down in innocence in order to correct her deficiency. Because of this she was called "Zoe," that is, the mother of the living. Through the Pronoia of the authority and through her, they tasted the perfect knowledge. I (Christ) appeared in the likeness of an eagle upon the tree of knowledge, i.e., the Epinoia from the Pronoia of pure light in order to instruct them and awaken them out of the depth of slumber. For they were both debased and they recognized their nakedness. Epinoia appeared to them, being light (and) she awakened their thought.

The presentation here is somewhat confused. It says that *Christ* appeared in the form of an eagle to teach them and waken them out of sleep, but in the next sentence, it says that *Epinoia* appeared to them as light and awakened their thinking. We know already from the text (see NHC II 20,25–28) that the Father sent Epinoia to Adam as a correction for the deficiency of the Mother. Why is Christ necessary? It is unclear.

In both these places, Christ appears to have taken over roles belonging to Epinoia secondarily. His presence in the garden scene confuses rather than explains anything. He is superfluous. The question then becomes: Why has he been added to these scenes? The simplest answer seems to be that the text is developing secondarily in the direction of placing Christ at the center of salvation—at the expense of the female savior, Epinoia.[14]

13. For this reason, the passage seems to be secondary.

14. The presence of Christ in these passages can also be explained as an intrusion of the frame story into the content of the revelation discourse (see n. 9, above). In the case of Nag Hammadi Codex II, the process of systematically reading the interior of the text in terms of the frame story has progressed further than in the Berlin Codex. Christ is more a character in the story he relates in Nag Hammadi Codex II than in the Berlin Codex. In NHC II 27,33—28,5 compared with BG 71,5–13, Arai sees a further example of Christ taking over a role of Sophia ("Zur Christologie des Apokryphons des Johannes," 313–14).

The most important passage of Nag Hammadi Codex II for our inter-
ests is, however, the so-called "Pronoia hymn" at the end of the text
(NHC II 30,11—31,29). It is one of the sections found in the longer recen-
sion of the *Apocryphon of John* but absent from the Berlin Codex and Nag
Hammadi Codex III. The hymn describes in eloquent language the triple
descent of the savior to call forth to the sleeping spirit to arise and
remember and follow the root upward. The savior raises him up and
seals him in the light of the water with five seals.[15]

The passage presents clearly the pattern of salvation which we know
so well from the Berlin Codex: the gift of knowledge and the "sealing" of
baptism bring salvation. The question is, Who is this savior? In Nag
Hammadi Codex II, the entire hymn is put in the mouth of Christ. But
inside the hymn itself, the savior claims, "I am the Pronoia of the pure
light; I am the Thought of the virgin Spirit" (NHC II 31,12–13). The figure
is the perfect Pronoia of the All and the remembrance of the pleroma.[16]
Nothing is more clear than that Christ has appropriated a hymn that
originally belonged in the mouth of the female savior, Pronoia.

Up to this point, one might argue that the development of Nag Ham-
madi Codex II's Christology has led to the figure of Christ taking over

This is against the argument by R. van den Broek: "The development of the Pleroma
as described in the Apocryphon of John is the result of the mergence of quite different
traditions into a complicated, incoherent and contradictory system. Our sources repre-
sent different stages of this merging process" ("Autogenes and Adamas: The Mytho-
logical Structure of the Apocryphon of John," in *Gnosis and Gnosticism* [ed. M. Krause],
16). The two traditions are the Anthropos myth and a trinitarian theology that gives a
clear place to the Mother figure, originally only "the female aspect of the androgynous
God" ("Autogenes and Adamas," 25). In van den Broek's opinion, the trinitarian scheme
is secondary. It does seem to me that the direction of development shown in Nag Ham-
madi Codex II is toward an elaboration of a Christ-centered Anthropos myth, but it is
impossible to argue that this was primary and the appearance of female figures was
secondarily developed in the interests of Christian trinitarian theology. This makes little
sense of the major roles of Sophia and Epinoia in the cosmological and anthropological
sections of the text and the virtual absence of Christ or any male savior figure. And it
makes little sense of the nature of salvation as presented in the Berlin Codex. The only
role that female figures can play in an Anthropos myth is to account for evil; they can
play no real role in salvation. Yet this is manifestly not the case in every version of the
Apocryphon of John that we possess. Arguments against van den Broek's position are
difficult to find if one confines oneself solely to the account of the pleroma, as he does.
But if one considers the text as a whole, especially the anthropology and soteriology,
then the argument seems to shift in the other direction, i.e., toward a consideration of
the Anthropos material as secondary. This is the direction of work by both Schenke
and Arai. Both see the frame story and dialogue as literarily secondary developments
(see n. 9, above). Once they are removed, the role of Christ becomes almost incidental,
and this is especially true, of course, in the Berlin Codex as compared with Nag Ham-
madi Codex II.

15. See Sevrin, *Le dossier baptismal Sethien*, n. 12, above.

16. This is corrupted twice where Christ claims that he is the remembrance of the
Pronoia (NHC II 1,30.24 and 35).

roles belonging to the female savior figures, Sophia, Epinoia, and Pronoia, and that it does so without any intentionally (whether conscious or unconscious) negative attitudes toward the feminine. There are, however, two places where readings differing from the Berlin Codex indicate that in addition to the development of Christology in Nag Hammadi Codex II, there are other decidedly patriarchal (misogynist?) elements. The first is NHC II 23,37—24,3:

> But when Ialdabaoth recognized that they withdrew themselves from him, he cursed his earth. He found the woman preparing herself for her husband. He was lord over her though he did not know the mystery which had come to pass through the holy design for they were afraid to blame him.

Compare this with the Berlin Codex 61,7–18:

> Ialdabaoth recognized that they withdrew from him. He cursed them, but even more he added that the man should be lord over the woman for he did not know the mystery which existed by the design of the holy height. But they were afraid to curse him and to expose his ignorance.

Despite the (perhaps purposeful?) ambiguity of the pronominal references in Nag Hammadi Codex II, it seems clear that according to that text, the authority of man over woman is part of holy decree. After all, it is Eve who prepares herself for her husband. She is clearly a seductress. In the Berlin Codex, to the contrary, the domination of woman by man is due to an ignorant and wicked plan of the demiurge, a plan that stands in sharp contrast to the decree of the holy height.

The second place that indicates a more clearly patriarchal view in comparison with the Berlin Codex is at Nag Hammadi Codex II 24,27–31:

> To the present day, sexual intercourse continued due to the chief archon. And he planted sexual desire in her who belongs to Adam. And through sexual intercourse, he set up the generating of the likeness of bodies, and he inspired them with his hypocritical spirit.

Compare with the Berlin Codex 63,2–9:

> Marital intercourse came into being through the first archon. He planted in Adam a desire for seed, so that it is from this substance that a likeness from their counterfeit (imitation) is brought forth.

In both cases, sexual intercourse is presented as the evil work of the chief archon. But in Nag Hammadi Codex II, sexual desire is placed in woman; in the Berlin Codex, the desire for seed is placed in Adam. Not only is the location of desire different but also its nature. Woman desires

intercourse; Adam desires offspring. The implication in Nag Hammadi Codex II is of course that woman is a temptress. It is she who draws man down into the filth of fleshly intercourse.

It is clear, then, even from this partial analysis of the gender imagery relating to salvation in the Berlin Codex and Nag Hammadi Codex II, that two related tendencies are clearly at work in the latter in comparison with the former: (1) a larger soteriological role for the male Christ within the text and (2) a distinct devaluation of the feminine and of women. I do not mean to imply that the Berlin Codex does not contain any secondary attempts to give savior roles originally belonging to female figures to the male Christ or that it does not contain any patriarchalizing elements; it is only that these tendencies are more noticeably developed in Nag Hammadi Codex II.

3. CONCLUSION

Let us return now to the three directions of inquiry raised at the beginning of this essay.

3.1. What role does gender imagery play within the interior logic of the text with regard to the issue of salvation?

The gnostic myth of the fall and restoration of Sophia can be perceived as essentially gender related: female weakness/error/imperfection is strengthened/corrected/completed by male intervention. But the *Apocryphon of John* does not present the issue of salvation this way. Even in the clear account of Sophia's error,[17] salvation is not presented as a matter of gender (in clear contrast to the *Gospel of Philip* or the Barbelo gnosis of Justin, for example).[18] The fact that a female aeon, Sophia, is responsible for the production of the deficiency is a reflection of general Hellenistic patriarchal views that associate the female with materiality and reproduction. This fact is essential to understanding the text's use of gender with regard to cosmology, but it is not essential to the text's concept of salvation. The logic of the text with regard to salvation seems more closely tied to the theme that the process of generation is a process

17. Schenke argues that Sophia and Barbelo were originally the same figure. See his "Nag-Hamadi Studien I," 61; and idem, "Nag-Hamadi Studien III: Die Spitze des dem Apokryphon Johannis und der Sophia Jesu Christi zugrundeliegenden gnostischen Systems," *ZRGG* 14 (1962) 361.

18. See Williams, "Uses of Gender Imagery," in *Gender and Religion* (ed. Bynum, Harrell, and Richman), 199–211.

of degeneration. The root of deficiency is ignorance, not gender. The issue at stake in salvation has to do with the correction of ignorance by the reception of knowledge. Although a good deal of gender terminology is used, gender is not the critical issue of salvation. Rather, knowing, hearing, remembering, rising up, awakening, receiving power, anointing, and sealing are the primary metaphors of salvation. To use the category established by Williams, one may conclude, at least with regard to the issue of salvation, that gendered imagery is not used here primarily for the sake of its gendered character.[19]

3.2. How might the use of gender imagery
reflect actual social practice
in gnostic groups?

Let us imagine one possibility. If it is right to claim that the masculine Christ figure has secondarily taken over functions that originally belonged to female figures, might this reflect changes in gender roles within the group(s) or among the persons who knew this text? Let us look more closely at a specific example.

The Pronoia hymn at the end of Nag Hammadi Codex II in itself clearly presents baptism being given by a female savior figure. When the hymn is put in the mouth of Christ, it thereby depicts baptism as deriving from him. One cannot but speculate that this change may reflect movement toward a superior social status for men within the group at the expense of women. Although we cannot directly attribute the practice of baptism by women to contemporary gnostic groups who may have known the *Apocryphon of John*, it is easier to imagine women practicing baptism within a community when the savior who initiates baptism is female than when that figure is male.[20]

What we critically lack at this point, of course, is information about the social situation(s) behind the texts that might provide an avenue of approach. It would seem reasonable on the one hand to posit that the

19. The use of gendered imagery here is due to its function to explain (by myth and metaphor) the production of the aeons. The movement is from one to two, from male to female, from unity to the simplest multiplicity.

20. This same movement toward the exclusion of women from roles of authority within the cult is clearly to be seen in the development of so-called "orthodox catholic" Christianity. See Elisabeth Schüssler Fiorenza, *In Memory of Her: A Feminist Theological Reconstruction of Christian Origins*. This does not mean that Christianity and androcentricity are necessarily synonymous. It means that Christianity contained original theologies that were less repressive of imagery of the feminine and quite possibly of the social roles of women but later developed along one line only—toward androcentrism—both within catholic and gnostic Christian theologies. See the essay by J. M. Robinson in this volume.

Apocryphon of John merely expresses a trend in early Christianity to place the male Christ at the center of salvation. At the same time, it is possible imaginatively to associate the rising influence of Christ-centered soteriology at the expense of female saviors with a decline in the importance of women within Christian-gnostic groups. There is no hard evidence for this, but it is nonetheless consistent on the basis of the above to speculate that decreasing the importance of feminine savior figures and increasing the importance of Christ's role in salvation, such as we see with the Pronoia hymn, may have had social repercussions or reflect social changes. Whether this can be tied to a changing importance in the social status of women within gnostic groups is debatable, but such a visualization of baptismal practices would be consistent with the shift in the soteriology of the texts.

Similarly, we might speculate that differences in attitudes toward gender in the Berlin Codex and in Nag Hammadi Codex II may well reflect differences or changes in the social and cultic status of men and women. For example, in the Berlin Codex, perfection is viewed as male-female, that is, complete. In Nag Hammadi Codex II, the Father and Son bring salvation; the Mother brings error. The two genders are complementary in the first case. In the second, one gender is superior to the other. These differences alter the meaning of gender relative to theology and soteriology and thereby may also have influenced or reflected gender roles in the community and cult.

3.3. What presuppositions are at work in framing the way in which gender imagery is used? What is the significance of such presuppositions for our understanding and appropriation of the text's meaning?

These questions may well seem suspect from the historian's point of view, since the second at least is not a historical question and it directs the line of inquiry raised in the first. But since we never work in a vacuum, divorced from issues of relevance, it seems to me appropriate, in the interests of methodological completeness, to attempt to address it here.

As we have seen, both versions of the *Apocryphon of John* that we have discussed presume a dominance of male over female in their portrayal of deity. Although the Invisible Spirit is literally beyond gender distinction, nonetheless he is consistently portrayed as the masculine Father. The gender of the second figure, the Mother-Barbelo, is portrayed ambig-

uously, but she always is subordinate to him in terms of both sequence and power. He is the first principle; she is his image. She exists and is defined by her relation to the Father. In terms of power, she requests; he grants. The portrayal is thoroughly patriarchal. But at the same time, female figures are consistently portrayed as active and powerful.

When gender imagery is used with regard to the creation of the lower world, it is the feminine (in the guise of Sophia) that is consistently made responsible for deficiency and is associated with the corruption of the material realm. The portion of the light trapped below in the prison of the psychic and material body is referred to as the "power of the Mother." In this sense all Gnostics, whether of male or female gender, are female in their spiritual substance. The male portion remains above in the realm of the pleroma, escaping the evils of corruption and deficiency. Only in the context of the frame story where Christ comes down is this pattern broken, and that secondarily. We see here again the common association in antiquity of the male with (positive) heavenly or spiritual qualities, the female with (negative) material aspects.

In the realm of actual material sexuality, the general pattern of patriarchalism continues. Sexuality is of course repudiated as belonging to the realm of evil matter. It is the product of the ignorant and wicked demiurge. Along similar lines, the Berlin Codex asserts that the subordination of women to men is also a product of the wicked mechanizations of Ialdabaoth. Thus at one level, the *Apocryphon of John* denies that real gender distinctions have anything to do with spiritual substance and affirms that Gnostics, both men and women, possess the power of the Mother, the spiritual substance of the light. The Epinoia of Light is sent to awaken this spiritual principle. Male and female, then, do not refer to real gendered persons but to spiritual realities. On the other hand, as we saw above in comparing the Berlin Codex and Nag Hammadi Codex II, it was possible for the latter to locate the evils of sexuality in the woman and make her responsible for the wickedness of intercourse. Here the Berlin Codex stands in clear contrast with Nag Hammadi Codex II. In the former "the desire for seed" is placed by the demiurge in Adam; in the latter "the desire for intercourse" is placed in the woman as she is preparing herself for her husband. The Berlin Codex's use of gender imagery throughout the text is consistent insofar as it dismisses any association between male and female spiritual qualities on the one hand and actual men and women on the other. Sexuality is roundly condemned as wickedness of the soul entrapped in matter. By associating intercourse with the woman, however, Nag Hammadi Codex II is using

gendered language differently from the use in the rest of the text. It no longer refers to spiritual principles, but to social relations. Again, it reflects a strong patriarchalism, this time of the most virulent, anti-feminine sort. Woman is the evil temptress, leading the man into the pits of material perdition. It would be hard to conceive a stronger condemnation of women in the mouth of a Gnostic. Yet this view is consistent with the general trend of how salvation is presented in Nag Hammadi Codex II: the Father and Son bring salvation; the Mother, error.

We are now in a position to ask what significance these patriarchal presuppositions may have for our understanding and appropriation of the text's meaning. In the broadest strokes, we can say that the primary concern of the *Apocryphon of John* is salvation. This salvation is achieved by illuminating the Gnostic's understanding of Self and liberating it from the prison of the body. The interest of the text is in self-understanding and liberation. These are concerns of interest to us today as well. The question now is whether we can learn anything from the *Apocryphon of John* about ourselves and whether we can appropriate anything of that understanding to aid in our own liberation.

It is at this point in the hermeneutical circle that the pole of interpretation moves its focus from the text to the interpreter. A modern person might hear in these texts the expression of persons who found in the gnostic message an understanding of the nature of evil that allowed them to see themselves as good and divine and at the same time in a (quite cowardly) way escape the frustrations of trying to improve a world in which one feels powerless. Certainly one arena where the *Apocryphon of John* acknowledges its sensitivity to wickedness and painful ignorance is in its treatment of the theme of women's subordination to men. The Berlin Codex treats subordination unequivocally as a product of wickedness and ignorance, which define its nature and essence. Unlike the presentation in Genesis, the account in the Berlin Codex does not affirm that this is a curse given by the true God under which we must passively endure. To the contrary, it is part of the fight against the demiurge and must be overcome. Again, it seems to me the text itself takes a rather cowardly way out, since its answer to gender role subordination is a condemnation of real sexuality. This "equality," then, is based on a blurring of difference, and thereby of identity that can affirm persons as sexual beings. Nonetheless, we can respect the feeling behind the text's assessment that the evils of patriarchalism are so intolerable, so pervasive, that their only vision of liberation is liberation from sexuality. The text's vision that freedom in equality belongs

only to a genderless spiritual state is surely a result of the incapacity to conceive such freedom and equality within the confines of social-sexual gender roles as they experienced them. A modern person might hear in the text a voice calling out for a perfect and whole existence in which the evils that persist in patriarchal social structures have been obliterated, freeing the women and the men trapped in the prisons of those structures for a new life of liberation—though I do not believe an ancient Gnostic would have ever phrased the issue or understood it in this way.

In conclusion, it is possible to state that an analysis of the *Apocryphon of John* shows the gender imagery to be functioning differently at several levels. At the level of the text's internal logic, it plays no real role in describing salvation (although it is certainly necessary for the portrayal of deity and cosmology). At the level of sociology, we can only speculate that a view of the Self as spiritually feminine, but unrelated to actual sexual gender, may have opened the possibility of a social and cultic equality within gnostic communities, perhaps in administering baptism. This possibility does not exist in Nag Hammadi Codex II, which associates sexuality with real women and perhaps removes the justification for their participation in the cult by making the male Christ, not the female Pronoia, responsible for bringing baptism. At a third level, it is now clear that presuppositions associating the feminine with earthly materiality and improper generation/sexuality and associating the male with heavenly spirituality and purity have affected the text's use of gender imagery in the presentation of theology, cosmology, and soteriology. On the other hand, the text presents the feminine as active, powerful, and divine—and as a power for both men and women. And the Berlin Codex at least can clearly conceive of gender subordination as a product of wickedness and ignorance.

Response to "Sophia and Christ in the *Apocryphon of John*" by Karen L. King

Karen King has produced a clear and sensitive examination of the use of gendered imagery in the Sethian gnostic treatise the *Apocryphon of John*, utilizing the shorter recension of this text from the Berlin Gnostic Codex and its longer recension from Nag Hammadi Codex II. In particular, she seeks to discover (1) the role played by gender imagery in the *Apocryphon of John*'s portrayal of deity, cosmology, anthropology, and salvation, (2) whether this gender imagery might reflect real-life gender roles within a communal setting, and (3) the degree to which underlying patriarchal assumptions may inform the way the *Apocryphon of John* uses this gender imagery.

After examining some key passages, she concludes that gendered imagery plays no essential role in the internal logic of the text's portrayal of the salvific process. On the other hand, the text's presuppositions about both the divine and the human social hierarchy as well as its implications about the exterior form of the cult are shot through with a patriarchally oriented bias such as was typical of the entire Greco-Roman conceptual environment in which it was composed.

In order to raise these questions and suggest these answers, Dr. King must assume two things which she herself does not discuss: namely, the question to what extent it is possible to map out the social structure of a community using its mythological literary products as evidence and the question whether texts such as the *Apocryphon of John* are products and indices of a social or communal group, or are instead to be understood as the productions of individual creative authors, to wit: Is there an

identifiable Christian-gnostic cultic group behind these texts for which it would make sense to delineate the relative social and cultic status of men and women? She does of course believe that such a mapping is possible and that an identifiable community may be found behind them. I am not about to challenge these assumptions, and I hold them also myself, but they need to be made explicit, since almost all questions about the results of her study ultimately relate to these assumptions, and some scholars have questioned the very existence of uniquely identi-fiable gnostic sects or communities.[1]

Perhaps the most direct path to the question of the social instantiation of gender roles reflected in a text such as the *Apocryphon of John* is to attend to the role that Christ plays in its salvific scheme. Almost all scholars regard the *Apocryphon of John* as an originally non-Christian text that has been secondarily christianized. Dr. King refrains from such a claim on the grounds that the earliest evidence for the text, perhaps to be found in Irenaeus's work *Adversus haereses* (1.29.1–4), already shows Christian features. Instead, she maintains that in various places in the text, Christian redactional activity has caused the masculine figure of Christ to take over functions that in the earliest hypothetical form of the text belonged to female savior figures. She suggests that the most obvious reason for this is the trend in early Christianity to place Christ at the center of the salvific process. But Dr. King clearly wishes to ramify this suggestion by relating this process also to a relative decline in the importance of women within Christian-gnostic communities. That is, the christification of originally feminine savior figures entailed also their masculinization; insofar as cultic leaders enacted certain functions of the savior on the human plane, one may reasonably speculate that the gender of the human officiant would be chosen to match that of the savior figure whose action is represented in the cult. One may easily imagine women playing the role of cultic officiants when the savior who initiates a certain cultic act such as baptism is herself female. Thus christification led to the gradual replacement of female by male offi-ciants without necessarily altering in any way the basic understanding of the salvific process.

The basic difficulty with this thesis is the one that Dr. King herself states: The supposed decline in the social status of women within gnostic groups, Christian or not, is a hypothesis for which we have little

1. E.g., F. Wisse, "Stalking Those Elusive Sethians," in *Rediscovery* (ed. Layton), 2:563–76.

or no evidence. I am not at all sure that the prominence of female savior figures in certain gnostic texts means that gnostic theology arose for one brief moment from the darkness of the repressive tendency of the Greco-Roman world to identify the feminine negatively with lower matter and the masculine positively with the higher realms of intellect, but then later moved in the direction of androcentrism in the wake of christianization. Granted, it is easier to imagine women performing cultic roles within a community when the savior who initiates those rites is female rather than male. But we do not really know this to be the case. And no matter to what extent the figure of Christ dominated the salvific scheme of the *Apocryphon of John* at various points along its compositional history, at all stages, as Dr. King correctly notes, the *Apocryphon of John* presumed the dominance of male over female in the portrayal of deity. The high deity and his First Thought Barbelo, who is the dominant savior figure in all versions of this text, are both regarded as androgynous, yet the deity is generally referred to in masculine terms and his thought, usually referred to in feminine terms, is consistently subordinate to him in power and precedence; she is his feminine aspect and his image; her very being is defined in terms of the high deity.

One of the principal difficulties in assessing the gendered imagery in the gnostic documents is the extraordinary ambiguity involved in tracing the reference of gendered pronouns in Coptic to their antecedents. A related difficulty is the ambiguity caused by the imagery of androgyny as applied to many of the dramatis personae in the gnostic myths. Given also the frequently dubious quality of Coptic translation from Greek exemplars, these dual sources of ambiguity make the analysis of gendered imagery a very risky business indeed. A few examples of this which affect the interpretation of passages relevant to Dr. King's arguments will suffice.

For example, she detects at work in the *Apocryphon of John* a more or less consistent pattern of salvation in which lower beings are perfected by higher beings. The lower being is produced by the immediately superadjacent female and thus shares in the imperfection of the female, which is rectified at the instigation of the next higher male being, who causes the mother figure to anoint the offspring with goodness and receive knowledge of the father figure. An imperfect lower being is perfected by the instigation of a higher male being acting through a female being of a rank between the two. Thus the Autogenes Son, identified as Christ, is said to be produced by Barbelo, but since he is inferior to his mother, he needs perfection. BG 30,1—31,1 says:

> The Invisible Spirit rejoiced over the light which had come into being, which was first manifested in the first power—which is his Pronoia, Barbelo. And *he* anointed him with *his* goodness, so that he became perfect and there was no deficiency in him (and he became) Christ, because *he* anointed him with *his* goodness "for" (or: "of," "in," "by") the Invisible Spirit. *He* revealed himself to him and he received the anointing through the *Virginal Spirit.*

In this case the difficulty is caused by the ambiguous references of the third person masculine singular pronouns and the term Virginal Spirit. Is the antecedent of the "he" who anoints the Autogenes Son Barbelo or the Invisible Spirit? The conclusion of the passage names the agent of the anointing as the Virginal Spirit, who three pages earlier (BG 27,18) was identified with Barbelo. But up until the reference to the Virginal Spirit, the more natural reading of the masculine pronouns would refer them to the Invisible Spirit, the ultimate deity, rather than to his Pronoia, Barbelo. The ambiguity is increased by the phrase "he anointed him with his goodness for the Invisible Spirit," since the preposition here translated as "for" could be translated equally well as "of" or "as" or "in" or "by" or "with," depending on whether it governs a genitive, dative, or instrumental phrase; in the nominal construct form, only the context can decide. I myself would opt for an epexegetical genitive, "he anointed him with his goodness of the Invisible Spirit," that is, the Invisible Spirit anointed him with his goodness. If the more natural reading is invoked at the expense of the concluding identification of the anointer as the Virginal Spirit (Barbelo), then it is the Invisible Spirit himself who both initiates and carries out the anointing and enlightening of the Autogenes Son; the mother figure has no role other than to bring him forth. At least in this case, the pattern of male instigation and female execution is not clearly established.

This seems to be confirmed by another passage to which Dr. King refers in BG 46,9—48,5, in which it says that the imperfect act of Sophia in producing the demiurge required that the Invisible Spirit anoint her with a Spirit from the perfection. Upon this, her consort, apparently identified as a certain "Pronoia"—would this be Barbelo?—corrects Sophia's deficiency, upon which the voice of the holy perfect Father, the First Man, earlier identified with Barbelo, reveals to the demiurge that "Man exists, and the Son of Man." Thus it would appear that the pattern of salvation involves an anointing by the Invisible Spirit, and reception of revelation from either the Invisible Spirit (in the case of Christ's perfecting) or Barbelo (in the case of Sophia's perfecting). Throughout the remainder of the BG, however, it is the Epinoia of light, an unfallen

equivalent to Sophia, who is sent by the Father to reveal knowledge to and correct the deficiency of the lower beings. But now the "Father" who initiates these saving acts is not the ultimate Father, the Invisible Spirit, but is instead Barbelo, who is called the blessed and merciful Father in BG, and in an uncharacteristically nonpatriarchal fashion named in Codex II as "the merciful Mother-Father." In short, the salvific pattern of initiation by the male and execution through the female is not consistent, and the ambiguous references of the masculine pronouns are sure to foil any attempt to find a consistent pattern.

In my opinion, most of the preceding sorts of ambiguity are due to the gender speculation characteristic of later Jewish and gnostic interpretation of Gen. 1:26–27 according to which man is made in the image of God as male and female, such that both image and archetype can be considered as androgynous. For example, the Ophite system of Irenaeus *Adv. haer.* 1.30.1 depicts the primal figures as consisting of three male figures and a female. The high deity is called (First) Man and is Father of All. His Thought (ἔννοια) which proceeds from him is the Son of Man. Below these is the Holy Spirit from whom the First Man begets Christ, the "Third Male" (*tertius masculus;* perhaps a garbled version of the Sethian Triple-Male or vice versa). This or a similar development of Gen. 1:2 and 26–27 suggests an androgynous high deity named Man whose image is the Son of Man, the androgynous Thought of the high deity. But as Thought (ἔννοια), which is feminine in gender, this Son could also be considered in terms of the female aspect of its androgyny, which could be hypostatized as the Mother of the Third Male. If one eliminates the figure of the Spirit, or identifies it with the Thought, one is left with a divine triad of Father (Man), Mother (Thought, Son of Man, image of the high deity), and Son (Third Male, Son of the Son of Man, Christ), as one finds in the Sethian literature.

That identifications like these were made on the basis of gender distinctions is suggested by various designations of Barbelo. The *Trimorphic Protennoia* (NHC XIII 46,21) informs us that Barbelo or Protennoia is called the Male Virgin (as in the *Apocryphon of John;* cf. the Virgin who became male by division from the male in *Marsanes,* NHC X 9,1–4) by virtue of being or possessing a hidden Intellect (νοῦς). As both feminine Thought and masculine Mind, she can be both Father and Mother. The *Apocryphon of John* designates her in the context of her redemptive acts as "the merciful Father" (BG 8502) or "the merciful Mother-Father" (NHC II,1). Thus Barbelo, the principal savior figure of the *Apocryphon of John* and other Sethian treatises, can be referred to either as male or as female, and indeed as both simultaneously. Such a

phenomenon certainly contributes to the extraordinary ambiguity of the gendered pronominal references in these treatises.[2]

With especial reference to the *Apocryphon of John*, there is the additional problem of multiple versions of the text. This helps to clarify some of the ambiguities of the translation, but as Dr. King notes in agreement with M. Tardieu,[3] we know little about the recensional history and therefore the relative priority of the various versions of the text. Dr. King discovers, in my opinion correctly, that the Codex II version displaces and devalues the feminine in favor of the masculine in two basic ways. First, not the Pronoia, but Christ causes the protoplasts to eat the fruit, enlightens them in the form of the eagle, and delivers the baptism of the Five Seals. Second, it is the Invisible Spirit, not Barbelo, who begets the Autogenes Son; it is not Adam but Eve in whom the demiurge implants a desire for sexual intercourse, and the social dominance of man over woman is ascribed, not to the decree of the demiurge, but instead to a "holy decree," presumably from the upper world.

Thus patriarchal tendencies are more evident in the Codex II version

2. As R. van den Broek ("Autogenes and Adamas," in *Gnosis and Gnosticism* [ed. Krause], 16–25) has suggested, the myth in the second part of the *Apocryphon of John* (BG 8502,2 44,19—77,5; NHC II,1 13,3—31,25) presupposes the myth of Irenaeus *Adv. haer.* 1.30.1 in the episode of the voice from heaven, "Man exists and the Son of Man" (BG 8502,2 47,15—48,4; NHC II,1 14,13–25). But the first part of the *Apocryphon of John* (BG 8502,2 19,6—44,19; NHC II,1 1,1—13,13), along with Irenaeus *Adv. haer.* 1.29.1–4, exhibits the trinity of Father (Invisible Spirit), Mother (Barbelo, First Thought, Ennoia, Pronoia, the image of the Invisible Spirit, Father of the All, Mother-Father, thrice-male, etc.), and Son (Christ, Autogenes). The Son figure might also be identified with (Ger-)-Adamas *(Three Steles of Seth* and *Zostrianos)* or the Triple-Male Child *(Apocryphon of John* and *Gospel of the Egyptians* where he is called first to appear, "Protophanes"), or the third Male (Irenaeus *Adv. haer.* 1.30.1). He is truly male in threeness, since he was androgynous, or, in arithmological terms, he is the three (an odd and thus male number) who came from the Monad (the Father, considered as both male and female, odd and even) and the Dyad (the male-virgin Mother Barbelo; even numbers are female). The most convincing etymology of Barbelo still seems to be Harvey's b'arb' 'elōh, "in four (letters) is God," a hypostatization of the tetragrammaton YHWH, the name of God. M. Scopello ("Youel et Barbelo dans le traité de l'Allogenes," in *Colloque internationale sur les textes de Nag Hammadi, Québec, 22–25 août 1978* [ed. B. Barc], 374–82), observing that in the *Gospel of the Egyptians*, NHC IV,2 56,21, Yoel is written where one expects Barbelo, points also to the figure of Yaoel in the *Apocalypse of Abraham X*, who contains the ineffable name of God, a name which Metatron in *3 Enoch* 48d also contains; she also points to an analogy between Authrounios in *Zostrianos* and Metatron, probably assuming that both refer to the concept of the divine "throne." This female being could be viewed alternatively as the Wisdom of God, as has often been noted. In fact, in Sethian tradition she seems to have many doubles or alter egos. Among these one finds Barbelo, Silence, Ennoia, Pronoia, Youel (or Yoel, both from Yaoel?), Meirothea mother of Adamas, Prophania (mother of Seth and the four Lights, probably a feminine analogy to the Son Protophanes), Plesithea mother of the angelic seed of Seth, Sophia or Epinoia the mother of the Creator, (her restored aspect) Metanoia, and probably others. These beings function as Barbelo's projection beyond her own Aeon.

3. Tardieu, *Ecrits gnostiques*.

than in the BG version. But then Dr. King concludes on the basis of these features of Codex II that original Christian theologies that were less repressive of female imagery and social roles later developed only in the direction of androcentrism within both gnostic and catholic Christianity. The difficulty here is that we do not know how to assess such trends in the tradition behind the versions of the *Apocryphon of John*. What if, as Tardieu supposes, the shorter BG version is a later abridgment of the longer Codex II version? In that case, since the degree to which the action of the feminine savior is repressed in favor of that of the masculine Christ is greater in Codex II than in BG, if BG is secondary to Codex II, BG would then be evidence for the reverse process: feminization. Thus BG might represent a tendency in the tradition represented in the *Apocryphon of John* to decrease the degree of patriarchalization and Christocentrism relative to that found in the supposedly earlier version of Codex II. On the other hand, if the Codex II version is an expansion of the BG version, then that would support Dr. King's generalization about the increasing degree of patriarchalization. The point is that a decision on this question about the *Apocryphon of John* and possibly about the Sethian tradition to which it likely belongs is dependent on an acceptable assessment of the recensional history of the versions of the *Apocryphon of John*.

In my opinion, a possible starting point may be offered by the Pronoia hymn found toward the end of the longer version of the *Apocryphon of John*, which Dr. King correctly observes was originally recited by Pronoia, the female savior presently featured in the *Apocryphon of John*, but which the frame story of the *Apocryphon of John* has succeeded in appropriating for Christ, who now appears to recite it. As such, the hymn as it now stands depicts the Sethian baptismal rite of the Five Seals as deriving from Christ, with the implication that this change reflects the clear movement toward the superior cultic status of males within Sethianism at the expense of female cultic leadership.

On past occasions, I have maintained that one of the more direct outworkings of this Pronoia hymn, which is a first person aretalogical recitation of the three descents into this world undertaken by the divine First Thought, Barbelo, is to be found in the *Trimorphic Protennoia*, which is essentially an expansion of the Pronoia hymn.[4] In the *Tri-*

4. See J. D. Turner, "The Gnostic Threefold Path to Enlightenment: The Ascent of Mind and the Descent of Wisdom," *NovT* 22 (1980) 324–51; idem, "Sethian Gnosticism: A Literary History," in *Nag Hammadi, Gnosticism, and Early Christianity* (ed. C. W. Hedrick and R. Hodgson), 55–86; and idem, "Sethian Gnosticism and the Johannine Tradition: The *Trimorphic Protennoia* and the Fourth Gospel" (unpublished paper).

morphic Protennoia, it is quite definitely Protennoia or Barbelo who thrice descends into the world of chaos to awaken and raise up her fallen members and who finally succeeds in administering the Five Seals, a spiritualized baptismal rite consisting of a visionary ascent into the divine world. Yet the *Trimorphic Protennoia* is, like the *Apocryphon of John*, christianized, and the form in which Protennoia appears on her third descent is quite definitely a masculine one. She descends first as the masculine Voice of the First Thought to illumine her members, the second time as the feminine Speech of the First Thought to bring the old age to an end, and the third time she descends as the Word *(logos)* of the First Thought in order to enable her members' final enlightenment through the gift of the Five Seals.

But whereas in the *Apocryphon of John*, Pronoia is identified with the Christ of the church, in the *Trimorphic Protennoia*, Protennoia as Logos is said to be mistakenly identified with the Christ of the church. Indeed, she merely disguised herself as the Christ to elude the archons who thought that she was their Christ. Although she appeared to the world and its powers as the Christ, the Son of God, an angel, and as the Son of Man, she was actually the Father of everyone who in fact had to rescue Jesus from the cross and raise him to the Father's dwelling place along with all the other sons of the light.

Thus in the case of the *Trimorphic Protennoia*, even though the Protennoia appears as the male Logos who appears in the tents of human beings, we actually see an example of dechristification. In my opinion, this dechristification was a polemical device used in a christological debate between the Sethians and the apostolic churches over the proper interpretation of the Fourth Gospel. Be that as it may, the *Trimorphic Protennoia* shows us that there was no clear monolithic tendency at work within Sethianism to depreciate the role of female saviors at the expense of male saviors including Christ. The Protennoia appears here first and third as male and second as a female because she was from the very beginning an androgynous being. Again, in the first third of the *Trimorphic Protennoia* (37,3—40,30), we observe traditions about the appearance and anointing by Barbelo of the Autogenes Son, the Christ, which closely parallel the similar material in the *Apocryphon of John* and Irenaeus's Barbeloite report. Once he establishes the Four Lights, one then reads the story of the demiurge and his ignorant creative activity, except that, unlike the account of the *Apocryphon of John* but in agreement with the account in the *Gospel of the Egyptians*, Sophia, here identified with the Epinoia of Light, is innocent of any fault

in the appearance of the demiurge; instead, it is Eleleth, the last of the Four Lights established by Christ, who is to blame for the appearance of Sophia's son. Sophia or Epinoia is only an innocent victim. Perhaps here too we have evidence of a tendency, whether singular or not, to exalt the status of the female over the male.

But perhaps I have overstepped the bounds of the present discussion which should be limited to the discussion of the versions of the *Apocryphon of John* only. In fact, I regard one of the merits of Dr. King's presentation that she restricts herself to the treatment of a single text without trying to import too many speculations about its provenance within a larger, more encompassing group of texts known as Sethian, and thus fall afoul of the vexed questions about the existence of a Sethian community whose doctrine and praxis are defined by these texts. Yet it remains true that Dr. King is very interested in the question of the social status of women in gnostic groups, that is, what the gender imagery of the *Apocryphon of John* implies for actually existing social groups. And this, it seems to me, leads inevitably to the question of a Sethian community whose outlook and practices only take on dimension from the perspective of a rather larger collection of texts, not all of which are by any means consistent in their gender imagery. What I see to be her most enduring result is her acute observations about the patriarchal developments in the *Apocryphon of John* of Codex II. I am, however, unable to go so far as she does in saying that the *Apocryphon of John* of Codex II has in effect removed the possibility of female participation in the cult, presumably as officiants, by making the male Christ rather than the female Pronoia responsible for the introduction of the baptismal rite. To be sure, there is here clear evidence of patriarchalism. But what this means for the sociology of the wider Sethian movement or of gnostic groups in general is difficult to determine, given the conflicting evidence.

There is, though, one sociological conclusion that Dr. King draws that really hits the mark not only for the *Apocryphon of John* but for the bulk of the Sethian texts we now possess. This is their almost omnipresent tendency to condemn the sexual life as bondage to the demiurge, a bondage that is only transcended by liberation from the body through celestial enlightenment. This being the case for the Sethian documents we possess, one cannot help turning to the testimony of Epiphanius concerning the Sethians, Archontics, Phibionites, Stratioci, and Borborians whom he apparently encountered in his travels in the later fourth century (Epiphanius *Haer.* 25.2.7—26.13.7; 39.1.1—40.8.2). Here

one sees later bearers of traditions that are at least in large part undoubt-
edly Sethian, but by this time they certainly embrace sexuality to such
an extent as to make this impressionable bishop stand up and take
notice. Rather than the baptismal rite, which Epiphanius says was ex-
plicitly rejected by the Archontics, these late Sethians seem to be pre-
occupied with a sort of sexual sacramentalism in which wives are shared
among the brethren, sex is had for the pleasure of it, seminal and
menstrual fluids are consumed and worshiped, and abortions are freely
performed. By consuming the generative fluids rather than permitting
impregnation to occur, it is said that the power of the soul resident in
them is transmitted to heaven along with the worshiper. There are
apparently also those who do not consort with women but engage in
masturbatory practices with more or less the same sacramental aims in
view. All of this is not sexuality of a normal sort but seems to be instead a
parody of sexuality as an institution of society, probably an explicit
parody of the ordinary procreative sexuality traditionally understood to
have been instituted and ordained by the creator god, which these
Gnostics took to be a seductive form of bondage to the creator and his
hapless world. By such nonprocreative sexual activity, these Gnostics
thought they were replicating the acts of the savior in gathering up and
restoring the souls fallen from the divine world.

Thus even in this way, as Dr. King affirms in the case of the earlier
Apocryphon of John, the Gnostics fought the demiurge by condemning
traditional sexuality through parody instead of abstinence, although I
am unable to say whether this particular option is acceptable to modern
sensibilities or not. In any case, these Gnostics realized the true source of
the constriction of patriarchal structures to lie in the demiurge. In regard
to these later accounts, if Epiphanius is not engaging in mere hyperbole,
I can do no better than to conclude in the words of Dr. King: "There is a
voice in these texts [too] crying out for an existence conceived as per-
fection and wholeness in which the evils that persist in patriarchal social
structures have been obliterated, freeing the women and the men
trapped in the prisons of those structures for a new life of liberation."
Perhaps behind the trappings of the patriarchal, ascetic, and even
libertine language of these texts there really is such a voice that still can
speak to us today.

Pursuing the Spiritual Eve:
Imagery and Hermeneutics
in the *Hypostasis of the Archons*
and the *Gospel of Philip**

The title of the conference suggested that we were proposing to investigate a consistent theme or image—or an identifiable group of such themes or images—in gnostic texts. But what are we looking for? And for what purpose? Are we assuming that exploring feminine imagery in gnostic texts will tell us something about a range of early Christian attitudes toward women (and toward experiences associated with women)? Having shared and helped to propagate that assumption in the past, I have been led by my own research to answer yes: the way gnostic and orthodox Christians use, or avoid, feminine images certainly connects with and expresses social and sexual attitudes. This approach has yielded some useful results, especially when evidence gleaned from internal reading of gnostic texts receives confirmation in the heresiologists' observations of gnostic practice.

* Prepared for private distribution among participants in the conference "Images of the Feminine in Gnosticism," Institute for Antiquity and Christianity, Claremont, California, November 1985.

The author requests that scholars engaged in research on these texts refer to the more detailed and technical articles rather than to this abbreviated summary presented at the conference—namely: E. Pagels, "Adam and Eve, Christ and the Church: A Survey of Second Century Controversies Concerning Marriage," in *The New Testament and Gnosis* (ed. A. H. B. Logan and A. J. M. Wedderburn), 146–75; and idem, "Exegesis and Exposition of the Genesis Creation Accounts in Selected Texts from Nag Hammadi," in *Nag Hammadi, Gnosticism, and Early Christianity* (ed. C. Hedrick and R. Hodgson, Jr.), which has a fuller discussion of the *Hypostasis of the Archons*, with an appendix comparing the Coptic of the *Hypostasis of the Archons* with Greek parallels in Pauline passages.

Yet many of us recognize too that this approach has its limits. We realize, first of all, that symbolism is not sociology. Pursuing feminine images through the murky marshes of gnostic texts, we risk falling into the error of the archons pursuing the spiritual Eve. You recall the story: she turns into a tree—the tree of life!—and laughs at the folly that leads her pursuers to mistake spiritual (read symbolic) transactions for merely sexual ones! So in this essay I am exploring a different approach—one that takes gnostic texts, in effect, at their word. Let us begin with the premise that gnostic authors concern themselves (as they say they do) above all with the dynamics of religious experience. And let us grant, for our present purposes, that they engage issues concerning gender and sexuality only insofar as they believe that these involve—or, more typically, interfere with—religious experience.

What proves to be far more consistent throughout a wide range of gnostic texts than any specific image or group of images is their authors' hermeneutical approach. What "the feminine" signifies in each text may be explored, I suggest, in terms of the hermeneutical presuppositions each author assumes and the hermeneutical pattern each adopts. Various gnostic texts reveal, of course, a wide range of hermeneutical presuppositions—theological, psychological, and practical. Yet I suggest we start by asking the question, How do various gnostic exegetical approaches tend to differ from those of orthodox exegetes? And what do these differences have to do with the way gnostic authors interpret sexual imagery?

Let us begin where our gnostic authors often begin: with Genesis 1—3. This approach offers a certain consistency—the common starting point of a familiar text—and challenges us to explore a wide range of exegeses as variations on that well-known theme. What is it, then, that gnostic Christians hope to understand or "explain" from their diverse exegeses of the creation accounts? Scholars often have repeated the cliché that Gnostics concern themselves primarily with "cosmological speculation." This certainly states the obvious. The *Hypostasis of the Archons* and the *Apocryphon of John,* for example, each depict a dazzling array of spiritual beings contending against a wide range of hostile forces. Yet closer investigation reveals that these gnostic authors are wrestling with the same kind of theological, anthropological, and practical questions that exercise their Jewish and Christian contemporaries: Whence come evil and suffering? What is the origin of humanity? What does it mean that we are created "in the image of God"? Gnostic

Christians, no less than their orthodox contemporaries, concern them-
selves simultaneously with the practical questions that arise from these
and, in particular, the relationship of sexuality to spirituality. How are
Christians to relate themselves to the divine order established, in Jesus'
words, "in the beginning"? Did Jesus and Paul, commenting on the story
of Adam and Eve, intend to confirm the original created order or to
liberate us from it?

Besides sharing with orthodox Christians many of the same questions,
gnostic Christians generally agree that the place to look for answers is in
the Scriptures. What differentiates gnostic from orthodox exegesis is the
Gnostics' conviction that the written texts, far from giving authoritative
and complete direction, contain only the bare husks of meaning. The
spiritually minded Christian must "search the Scriptures" to discover
what the text does not reveal directly—indeed, what it may intentionally
conceal from the naive reader.[1] Accused of treating the Scriptures with
contempt, gnostic Christians might well reply that they hold them in
highest regard precisely by not accepting their mere face value. Even the
most unlikely passages, such as Genesis 2—3, may yield, through
spiritual exegesis, insight into the deepest truths. So the author of the
Testimony of Truth, for example, who regards the "books of the gener-
ation of Adam" as of slight value compared with Christ's revelation,
claims to find, through spiritual exegesis, profound meaning even in
"Moses'" benighted story of Adam and Eve: the serpent of Eden, whom
the creator calls "devil," is Christ himself! (*Testimony of Truth* 47—49).

Despising the law for its commands to "take a husband or a wife and
to beget and to multiply" (*Testim. Truth* 29,25—30,10), the author of the
Testimony of Truth bases the contrast between the law's "pollution" and
the purity of Christian celibacy upon a literal—and negative—reading of
Genesis (especially, no doubt, those passages traditionally taken as
divine commands to procreate and to marry, Gen. 1:28 and 2:24). Many
ascetically inclined exegetes agree, taking these passages, as well as the
story of Eve's creation (Gen. 2:18f.), as signaling the end of Adam's pure
and solitary communion with God—in Philo's words, "the beginning of
all evils" (*De opificio mundi* 152). Yet other gnostic Christians, while fully
endorsing this negative view of procreation and marriage, adopt dif-
ferent patterns of exegesis. Some develop exegetical patterns that enable
them to read, in the images of Adam and Eve, opposite valences. For one

1. Cf. Tertullian *De praescriptione haereticorum* 9—18.

who reads "spiritually," not literally, even Gen. 1:28 and 2:24–25 may yield hidden meanings, meanings not only unexpected but even contradictory to those which the orthodox find there. Reading the story of creation "spiritually"—taking, for example, Gen. 2:18–19 as a symbolic description of a spiritual process—gnostic Christians claim to find in this very passage inspiration for sexual renunciation.

The author of the *Exegesis on the Soul*, for example, taking an opposite hermeneutical approach from the *Testimony of Truth*, treats passages from the creation account as "prophetic" sayings spoken through the spirit's inspiration (*Exeg. Soul* 133,1–4). The words of Gen. 2:24–25 concerning "the first man and woman" ("the two shall become one flesh"), although often *mistaken* as referring to mere "carnal marriage," actually signify, this author explains, the soul's reunion with her heavenly bridegroom (*Exeg. Soul* 132,27—134,6).

This same "spiritual exegesis"—that Adam's intimate union with Eve symbolizes a state of harmony between the soul and the indwelling divine spirit—dominates, with considerable variation, several influential currents of gnostic Christianity. Represented in texts as diverse as the *Exegesis on the Soul*, the *Hypostasis of the Archons*, and the *Gospel of Philip*, this theme finds classic expression in the *Apocryphon of John*. Reading Gen. 2:24, the author of the *Apocryphon of John* explains that Adam's divinely sent helper, far from being a mere human partner, manifests the luminous *epinoia* ("intelligence") called Zoe, who "helps the whole creation" as she teaches Adam in order to restore him to his fullness (*plērōma; Ap. John* 68,19). Genesis 2:24–25, read "spiritually," then, initiates not his degrading involvement with carnal marriage but rather his restoration to primordial union with his spiritual *syzygos* ("counterpart").

Adam's first encounter with Eve, narrated in Gen. 2:23–25, thus receives, in the *Apocryphon of John*, a positive interpretation. When Adam first sees beside himself the woman formed by the creator, the luminous *epinoia* appears simultaneously, so that he recognizes in her his "counterimage" (*Ap. John* 23,9), the spiritual power of Sophia. Adam expresses this act of spiritual recognition in an amplified version of Gen. 2:24–25:

> "This is indeed bone from my bones and flesh from my flesh." Therefore the man will leave his father and his mother and he will cleave to his wife and they will both be one flesh, for they will send him his consort, and he will leave his father and his mother. . . . Our sister Sophia (is) she who came down in innocence in order to rectify her deficiency. Therefore she was

called Life which is the mother of the living. (*Ap. John* 23,10–24; cf. Gen. 3:20)

Adam's experience prefigures that of the gnostic Christian, who, while imprisoned within the body, is awakened, like Adam, and raised from the "deep sleep" of ignorance, when the *pronoia* of the pure light, "the thought of the virginal Spirit," appears to him (*Ap. John* 30,32— 31,22).

This example suggests, too, the extent to which imagery may depend upon hermeneutical approach. The fact that we find, in the *Apocryphon of John* and the *Exegesis on the Soul*, positive images of the feminine lacking in most literally or historically minded exegesis (whether gnostic or orthodox) need not indicate different attitudes toward gender, sexuality, or even, for that matter, toward women *as* women. In some cases, what opens up the range of feminine imagery to include a positive as well as negative range is the pattern of exegesis an author adopts.

The *Hypostasis of the Archons*, like the *Testimony of Truth*, the *Apocryphon of John*, and the *Exegesis on the Soul*, expresses the conviction that sexuality bears a direct—but antithetical—relationship to spirituality. Intending to offer "spiritual exegesis" of the story of Adam and Eve, its author promises, too, to reveal the nature of the spiritual struggle hidden in the events narrated in Genesis 1—4. But how does the gnostic interpreter explore that "deeper meaning"? Where does the exegete look for clues to trace that primordial drama? Birger Pearson, characterizing the creation account in the *Hypostasis of the Archons* as "an epexegetical comment on Genesis 2:4f. (and other passages) . . . on how man derives his spiritual nature," says that here "traditional exegesis on Gen. 2:7 has been overlaid with new interpretations peculiar to this discussion."[2] What sources have contributed to these "new interpretations"? Pearson does not mention them, but his analysis agrees with that of other commentators, including Bentley Layton: they are to be found primarily in Jewish apocrypha, on the one hand, and, on the other, in Greek philosophic sources (such as Plato's *Timaeus*).[3]

My own analysis suggests, on the contrary, that the author of the *Hypostasis of the Archons* draws these "new interpretations" from another body of sources which this author regards as second in importance

2. B. Pearson, *The Pneumatikos-Psychikos Terminology in 1 Corinthians*, 61.
3. Pearson, *Pneumatikos-Psychikos*, 51–81; see also idem, "Jewish Haggadic Traditions in the *Testimony of Truth* from Nag Hammadi (CG IX,3)," in *Ex Orbe Religionem* (ed. Bergman, Drynjeff, and Ringgren), 1:457–70; Layton, "Hypostasis of the Archons," pt. 1, *HTR* (1974), 351–426; pt. 2, *HTR* (1976), 31–102.

only to Genesis (or, perhaps even more important than Genesis, holding the key to its interpretation)—the letters of Paul. The opening lines of the *Hypostasis of the Archons*, citing two passages attributed to "the great apostle,"[4] offer to reveal the reality of the "powers of darkness" (Col. 1:13)[5] and "spirits of wickedness" (Eph. 6:11–12) which preside in the heavens. These lines signal, I believe, the author's intent to read Genesis through Paul's eyes (and not, as others have suggested, a superficial attempt to christianize other sources, or glosses tacked onto non-Christian material by a hypothetical redactor). Following this opening, the *Hypostasis of the Archons* proceeds to tell the "story behind the story" of creation, using as its basis 1 Corinthians 15, which the author regards, apparently, as Paul's own exposition of Genesis 2—3! Second, when turning from the theme of creation to that of revelation, the author draws especially upon 1 Corinthians 2 (as well as other passages, including Ephesians 3—5) to interpret the second, redemptive act of the cosmic drama. The author intends, I suggest, both to follow and mythically to elaborate, through hints attributed to "the great apostle," the hidden meaning of the cryptic account given in Genesis 1—4.

Our author begins by invoking the authority of the "great apostle, inspired by the Spirit of the Father of Truth" (*Hyp. Arch.* 86,20–21) to explain the nature of the spiritual struggle. Referring apparently to Col. 1:13, the author may have in mind Paul's prayer that his readers be "filled with knowledge of (the Father's) will, in all wisdom and spiritual understanding" (ἐν πάσῃ σοφίᾳ καὶ συνέσει πνευματικῇ), Col. 1:9–10. Yet in the *Hypostasis of the Archons* the Pauline terms σύνεσις ("understanding") and σοφία ("wisdom") have become transformed into hypostatized figures, personified as the power of Sophia (ⲧⲥⲟⲫⲓⲁ) and the angel Eleleth (ⲧⲙⲛ̄ⲧⲣⲙⲛ̄ϩⲏⲧ, which Layton takes as the Coptic translation of σύνεσις), who reveal to Norea the spiritual meaning of the process of creation. The gnostic author, explaining that "starting from the invisible world the visible world is created" (*Hyp. Arch.* 87,10–12), seems to have in mind, too, Col. 1:15, which describes how the "image of the invisible God" came to be revealed in creation. So, the *Hypostasis of the Archons* continues, that invisible "image of God" first appears to the authorities in the waters (cf. Gen. 1:3; *Hyp. Arch.* 87,13–14). To explain how the authorities failed to grasp its essentially spiritual nature, the

4. As Layton rightly notes ("Hypostasis of the Archons," pt. 1, 364).
5. Layton translates ⲛⲉϫⲟⲩⲥⲓⲁ as "Authorities" ("Hypostasis of the Archons," pt. 1, 395). Here, unless otherwise noted, I use my own translation, but his notation.

gnostic author invokes (and paraphrases) 1 Cor. 2:14: "for psychics cannot grasp the things that are spiritual" (87,14–15).

These opening passages already indicate the hermeneutical approach that the rest of the text clearly demonstrates. The author takes Pauline words and phrases as veiled allusions to acts in the primordial drama. Words that we generally read as abstract nouns (σοφία and σύνεσις) become personified beings; phrases we read as statements of spiritual axioms (cf. 1 Cor. 2:14) become clues to the "story behind the story" of Genesis 1—3. Nor are such techniques original. Basilides, for example, had taken the saying, "The fear of the Lord is the beginning of wisdom," as referring to the demiurge's terror at discovering Wisdom.[6] Valentinian exegetes, similarly, interpret 1 Cor. 2:14 in reference to his ignorance of his mother, Wisdom.[7]

The theme expressed in this saying ("The psychic cannot grasp the things that are spiritual") first plays itself out between the archons and Imperishability (representing τὸ ψύχικον ["the psychics"] and τὸ πνευμάτικον ["the spiritual ones"], respectively). The drama of the *Hypostasis of the Archons* turns on the contrast between psychic and pneumatic forms of perception and their manifestation in the contrast between "carnal knowledge" and spiritual knowledge (γνῶσις). The first act of the drama, to be recapitulated throughout the whole, involves the archons' attempt to possess and pollute the divine image that appears in the waters, as they wholly fail to grasp its spiritual nature.

The archons' futile attempt to capture that image leads to the second act, the story of human creation. This section shows how the contradictory energies of the primordial world—spiritual and psychic—come to be incarnated in human nature. Here the author intends to show the meaning of Paul's saying that "our contest is not against flesh and blood," that is, that the opposition to spirituality that human beings encounter within their own passions derives not merely from our mortal nature ("flesh and blood") but from sinister forces ("spirits of wicked-

6. Hippolytus *Ref.* 7.25.3. Note that, according to Hippolytus, Basilides cites Prov. 1:7 to describe the Great Archon's terror at discovering the powers above him (*Ref.* 7.26.2); receiving oral instruction through Christ, he learns the "wisdom spoken in a mystery" (cf. 1 Cor. 2:7), "not in words taught by human wisdom, but in those taught by the spirit" (1 Cor. 2:13)—wisdom "not known to previous generations" (Eph. 3:4b–5a; *Ref.* 7.25.3). For discussion, see D. K. Rensberger, "As the Apostle Teaches: The Development of the Use of Paul's Letters in Second Century Christianity" (Ph.D. diss., Yale University, 1981), 134–40. Cf. also Luke 8:10 and 10:21. I am grateful too to Prof. M. Williams for his comments on the Hippolytus passage.

7. Irenaeus *Adv. haer.*

ness") that, having created these impulses, express themselves through them.

The author, conflating Gen. 1:26 and 2:7, shows how the archons, having proposed to make a "man of dust from the earth," form him "entirely of the earth" (ϵγρ⳯ⲛⲕⲁ2; *Hyp. Arch.* 87,25–26). Yet, the author continues, the archons, in their weakness, failing to recognize the "power of God," could not raise their creation from earth: "and man became psychic upon the earth for many days" (*Hyp. Arch.* 88,4–5). Despite their incapacity, the spirit above "saw the psychic man on the earth," descended upon him, raised him up, and "the man became a living soul" (88,11–15).

What informs this exegesis, I suggest, is the passage the author takes as Paul's *own* exegesis of Genesis 2—namely, 1 Cor. 15:35–36. The gnostic author, noting Paul's reference to Gen. 2:7 in 1 Cor. 15:48, intends this account to "act out," so to speak, the hints Paul gives in that passage. Rather than an eschatological account of resurrection, the author sees in 1 Cor. 15:43b–48 reference to the original creation, as the archons, having created humanity "in weakness," discover that the spirit has raised him "in power."

> Sown in weakness, he is raised in power (σπείρεται ἐν ἀσθενείᾳ, ἐγείρεται ἐν δυνάμει). What is sown a psychic body is raised a pneumatic body (σπείρεται σῶμα ψυχικόν, ἐγείρεται σῶμα πνευματικόν). If there is a psychic body, there is also a pneumatic body (ἐι ἔστιν σῶμα ψυχικόν, ἔστιν καὶ πνευματικόν). Thus it is written, "The first man Adam became a living soul"; the last Adam became a life-giving spirit. But it is not the pneumatic which is first, but the psychic, and then the pneumatic (ἀλλ᾽ οὐ πρῶτον τὸ πνευματικόν, ἀλλὰ τὸ ψυχικόν. ἔπειτα τὸ πνευματικόν). The first man was made of earth, *choic* (ὁ πρῶτος ἄνθρωπος ἐκ γῆς, χοϊκός); the second is from heaven (ὁ δεύτερος ἄνθρωπος ἐξ οὐρανοῦ). Like the choic, so are those who are choic; and like the heavenly, so are those who are heavenly.

These Pauline statements, transformed into mythic action, yield a highly charged drama engaging the archons in contest with the spirit. First Adam is "sown in weakness" (1 Cor. 15:43) by the archons, who, according to the *Hypostasis of the Archons*, "did not understand the power of God, because of their weakness" (88,4–5). But, the *Hypostasis of the Archons* continues, the spirit above, seeing "the psychic man (ⲡⲣⲱⲙⲉ ⲛ̄ⲯⲩⲭⲓⲕⲟⲥ) upon the ground ... descended and came to dwell with him, and 'the man became a living soul'" (Gen. 2:7; cf. 1 Cor. 15:44–45). This "explains," then, how "the first Adam became a living soul," *psychic*, and indeed *choic* (ἐκ γῆς, χοϊκός; 1 Cor. 15:46–48); while the last man Adam became a "life-giving spirit," *pneumatic*, just as Paul says (1 Cor. 15:45b).

Adam, having received the spirit, proceeds to name the animals (cf. Gen. 2:19–20; *Hyp. Arch.* 88,16–24). Then the archons, attempting to withdraw the spirit (Eve) from Adam, cut open his side. The spirit departs, "and Adam became wholly psychic" (ⲘⲮⲨⲬⲒⲔⲟⲤ ⲦⲏⲢϤ; 89,31). The archons substitute for her the carnal woman (hoping, apparently, that Adam, rendered oblivious, would not notice the switch).

From this point in the drama, the thematic contrast between psychic and pneumatic modes of perception turns on the paradox of Eve's identity. The author of the *Hypostasis of the Archons* seems deliberately to omit any mention of Gen. 2:24–25 (in which the man recognizes the woman who appears to him as "bone of my bone and flesh of my flesh"). Although certain other gnostic exegetes interpret this passage "spiritually," declaring that in these phrases Adam recognizes his pneumatic "co-likeness," the author of the *Hypostasis of the Archons* avoids the passage, presumably because of its association with sexual union and marriage. Instead, to emphasize that Adam here awakens to spiritual, not carnal, knowledge, the author relates that the "spiritual woman" whom the text later calls "his wife" is Adam's pneumatic "co-image, Eve," the spiritual presence who manifests Wisdom, his spiritual mother.[8] As the author of the *Hypostasis of the Archons* chooses to tell it, then, Adam addresses to her not the words of Gen. 2:24–25 but those of Gen. 3:20: "It is you who have given me life; you shall be called, 'Mother of the Living'" (*Hyp. Arch.* 89,14–16).

While Adam, now raised a second time from psychic to pneumatic perception, recognizes Eve spiritually, the archons are aroused instead to passion and attempt to "know" her sexually. As the revelation section of the *Hypostasis of the Archons* will show even more clearly, the author alludes to Paul's account of wisdom's hidden identity in 1 Cor. 2:6–8, reading this too in terms of dramatic myth:

> We speak wisdom among the initiates ($\tau\epsilon\lambda\epsilon\acute{\iota}ois$), not the wisdom of this age, nor of the archons of this age, who are passing away. But we speak the wisdom of God hidden in a mystery, the hidden one, whom ($\mathring{\eta}\nu$) God ordained before the aeons for our glory, whom none of the archons of this age know ($\mathring{\eta}\nu$ οὐδεὶς τῶν ἀρχόν τῶν τοῦ αἰῶνος τούτου ἔγνωκεν)."[9]

8. For detailed discussion, see Pagels, "Exegesis and Exposition." Although Layton misses this point ("Hypostasis of the Archons," pt. 2, n. 57), B. Barc does not (see *L'Hypostase des Archontes (NH II,4): Traité gnostique sur l'origine de l'homme, du monde, et des archontes*, 93–94).

9. I translate $\mathring{\eta}\nu$ as "whom," rather than "which," merely to illustrate how a mythically inclined reader looking for hypostases rather than abstractions might read the passage.

When the archons' third attempt to "grasp what is spiritual" ends in failure, as do the others, Eve laughs at their foolish confusion of sexual with spiritual knowledge (*Hyp. Arch.* 89,25). Their folly and consequent condemnation recall not only the verse that our author previously paraphrased (1 Cor. 2:14) but also its context:

> The psychic . . . does not receive the things of the spirit of God: for they are *foolishness* to him (μωρία γὰρ αὐτῷ ἐστι), nor can he know them (καὶ οὐ δύναται γνῶναι) because they are spiritually discerned (ὅτι πνευματικῶς ἀνακρίνεται).
> But the pneumatic judges all things, but himself is judged by no one (ὁ δὲ πνευματικὸς ἀνακρίνει μὲν πάντα, αὐτὸς δὲ ὑπ᾽ οὐδενὸς ἀνακρίνεται).

Escaping rape at their hands, "she became a tree." "In the original exegesis implied by this metamorphosis," as Layton notes, "undoubtedly (she became) the 'Tree of Life' (Genesis 2:9), since the Aramaic *ḥayyayā*ʾ, 'life,' gives another pun on the name *Ḥawwāh*, 'Eve.'"[10] The pun probably extends, as Layton and Pearson agree, to her next metamorphosis as the Instructor manifested in the form of a serpent (*Hyp. Arch.* 89,33).[11] Yet the author's familiarity with the verbal connection among Eve, Life, Instructor, and Beast, as well as his later identification of Eve with Wisdom (95,17–18), suggests a more direct scriptural source of inspiration: the Wisdom passages of Proverbs 1—4. Proverbs 3:18 specifically identifies Wisdom as a "tree of life": "She is a *tree of life* to those who lay hold upon her; those who hold her fast are happy." Proverbs 4:13 not only combines the image of "holding on" to wisdom with the term for Instruction: "Do not let her go; guard her, for *she is your life* (Eve)."[12]

Eve's escape, separating her spiritual being from its bodily form, again focuses the dramatic tension on the paradox of her identity. The pneumatic feminine principle (†ΠΝΕΥΜΑΤΙΚΗ), appearing as Instructor (fem.: ΤΡΕϤΤΑΜΟ), now engages in dialogue with her "sarkic" counterpart (ΤΟϨΙΜΕ ΝΟΑΡΚΙΚΗ), who, after receiving spiritual instruction, partakes of the tree of knowledge and persuades her husband, so that "these psychic beings ate" (*Hyp. Arch.* 90,15). Recognizing their spiritual naked-

10. Layton, "Hypostasis of the Archons," pt. 2, 57.
11. Layton, "Hypostasis of the Archons," pt. 2, 55; cf. Pearson, "Jewish Haggadic Traditions." Pearson recently has added to his previous research an example of a Pompean mosaic that illustrates similar transformation (B. Pearson, "'She Became a Tree'—A Note to CG II, 4:89,25–26," 413–15.
12. Note too that Prov. 1:11f. warns "fools" who attempt to "get gain by violence" that their own acts deprive them of "life" (Prov. 1:19). Like the Eve of the *Hypostasis of the Archons*, Wisdom, in Proverbs 1, herself laughs "at their calamity" and eludes their pursuit.

ness, they respond by covering their sexual organs (90,18–19). Partaking of the fruit of the tree of knowledge reveals to the man and the woman the secret truth—the antithesis between sexual and spiritual knowledge —that the archons tried to obliterate.

Let us skip, for the sake of brevity, to the second section of the *Hypostasis of the Archons*, where the story of creation gives way to the story of redemption. Eve, having fulfilled the command of Gen. 1:28 ("increase and multiply") *spiritually*, as well as literally, bears, as her spiritual offspring, Seth and Norea. With their advent, humanity began to "multiply and improve" (*Hyp. Arch.* 92,3).

The archons, aroused at this new subversion, decide to obliterate the whole creation. Opposed by their ruler, who attempts to sabotage their plan, they encounter Norea's outright defiance. The drama reaches its climax when the riddle of the mother's identity explodes into open confrontation.

The archons, responding with their characteristic error, go to meet Norea in order to seduce her. Their ruler declares to Norea, "Your mother Eve came to us"—sexually (*Hyp. Arch.* 92,20–21). But Norea challenges them all, for, in her view, it is a case of mistaken maternity. She attacks them where they are most vulnerable; again they are confusing sexual with spiritual knowledge: "You did not *know* my mother: instead, it was your female counterpart that you *knew*" (*Hyp. Arch.* 92,23–25). Having raped the female *plasma*, they imagined that they had "known" Eve. Norea declares, however, that they never "knew" her, since she is "known" only spiritually. Norea sets them straight: having mistaken her mother's identity, they mistake hers as well. Norea knows that she is not born from the female *plasma*, wife of "their Adam." She is born rather from his feminine counterpart, "Eve," the spirit: "I am not your descendant; rather, it is from the world above that I come" (*Hyp. Arch.* 92,25–27). And, as Norea soon learns from Eleleth, Eve's *own* mother is wisdom, "whom none of the archons of this age knew" (1 Cor. 2:8).

But the arrogant archon, rejecting the revelation of Eve's true identity —and, consequently, Norea's—persists in his error, demanding that Norea submit sexually to him and his archons, "as did your mother Eve" (*Hyp. Arch.* 92,30–31). Norea, recognizing her own need for spiritual understanding, cries out for help to "the God of the Entirety," pleading for help from the holy spirit.

What sources inform this part of the drama? For the second act, I suggest, involves free mythical invention no more than the first. Instead,

having drawn upon 1 Corinthians 15 (among other passages) to inter-
pret the story of creation, the author returns primarily to 1 Corinthians 2
to explain the story of redemption. Let us recall that mysterious passage,
as a Greek reader looking for clues to the primordial myth of Sophia
might have seen it. Refusing to reveal his wisdom teaching to merely
"sarkic" (σαρκικοῖς) believers, Paul boasts, nevertheless, that

> we do speak wisdom among the initiates, not the wisdom of this age
> (σοφίαν δὲ οὐ τοῦ αἰῶνος τούτου) nor of the archons of this age (οὐδὲ τῶν
> ἀρχόντων) who are passing away. But we speak the wisdom of God hidden
> in a mystery, whom (ἣν) God preordained before the ages for our glory,
> whom none of the archons of this age recognized for, had they known her
> (εἰ γὰρ ἔγνωσαν), they would not have crucified the Lord of glory. (1 Cor.
> 2:6–8)[13]

Our author reads this passage, no doubt, in terms of the double meaning
of "knowledge" suggested in Genesis 1—4, as darkly hinting at Wis-
dom's primordial history.

What cannot be known without revelation from above, the author
goes on to show, Eleleth, personifying spiritual understanding (σύνεσις;
cf. Col. 1:9), reveals to Norea. The Pauline passage continues with words
that other Gnostics too took as initiation formulae:[14]

> For, as it is written, "Eye has not seen, nor ear not heard, neither has it
> entered into the human heart, what God has prepared for those who love
> Him. God has revealed them to us through the spirit. For the spirit searches
> all things; even the depths (τὰ βάθη) of God." (1 Cor. 2:9–10)

The passage continues with those words our author (as well as Basilides
and the Valentinians) previously applied to the foolish archons' igno-
rance of the spirit ("the psychic . . . does not receive the things of the
spirit," 1 Cor. 2:14). The *Hypostasis of the Archons* concludes with
prophetic promises concerning the three types of "seed"—a passage that,
I believe, depends upon and develops Paul's discussion of the various
kinds of "seeds" in 1 Cor. 15:38–41 (as well as a plethora of deutero-
Pauline passages; for details, see references, and discussion in "Exegesis
and Exposition").

A similar claim to Paul's authority pervades the *Gospel of Philip*'s
exegesis of the story of Adam and Eve. Its author begins, apparently,
from the same central image—Eve's presence in Adam symbolizing the

13. But see Pagels ("Exegesis and Exposition") for full explication, notes, and a table
of comparison of the Coptic text with the Greek of the Pauline passages.
14. Hippolytus *Ref.* 5.19, 21, 22.

spirit within the human soul—but develops this theme typologically. Intending to decipher the "great mystery" of Adam and Eve, this author follows Ephesians 5: the key to understanding that "mystery" is the typological connection between Adam and Eve, on the one hand, and, on the other, Christ and the church.[15]

The Valentinian author narrates the drama of creation and redemption in three "acts": the first two, told through Adam and Eve, are *primordial union* and, the second, *separation and division* of the two partners; the third, told through Christ and the church, is *reconciliation and reunion* in "perfect marriage."[16] Originally, "when Eve was still in Adam, death did not exist (*Gos. Phil.* 68,22–23). Adam, here as elsewhere, represents the *psyche* and Eve the *pneuma* (*Gos. Phil.* 70,22–29). Another Valentinian exegete explains that when Adam recognized Eve as "bone of my bones, and flesh of my flesh" (Gen. 2:23), he referred to Eve, hidden and contained within Adam as the *pneuma* is concealed within *psyche*, or "spiritual marrow" within the "bone" of the "rational and heavenly soul" (*Ex. Theod.* 53.5).

Adam's separation from Eve "became the beginning of death" (*Gos. Phil.* 70,11–12): each member of the syzygy, weakened by their separation, became vulnerable to seduction by the evil powers. For being constituted in syzygy,[17] neither member of the divided pair can stand alone. Alienated from one another, each plunges into inferior relationships. The first transgression, according to the author of the *Gospel of Philip*, was adultery (*Gos. Phil.* 61,5–6). That Eve "commits adultery" with the serpent signifies, for him, how pneumatic being, separated from its union with *psyche*, joins instead with *hyle* ("matter"; *Gos. Phil.* 61,5–9). Since "every act of sexual intercourse which has occurred between those unlike one another is adultery" (*Gos. Phil.* 61,10–11), *pneuma's* union with *hyle* violates her original nature. From Eve's separation from Adam "death came into being" (*Gos. Phil.* 68,24). So Eve, the *pneuma*, although born as the offspring of divine wisdom, becomes the "little wisdom," the "wisdom which knows death" (*Gos. Phil.* 60,10–15).

Adam undergoes analogous experience. Rendered vulnerable to evil powers through disobedience (*Gos. Phil.* 73,27—74,12), he (or, the *psyche*) becomes enslaved to them. Separated from his spiritual syzygos, he does not partake of the tree of life (*zoe*), which would nurture his true

15. For a far more detailed discussion of the following, see Pagels, "Adam and Eve," in *The New Testament and Gnosis* (ed. Logan and Wedderburn), 146–75.
16. For discussion and references, see Pagels, "Adam and Eve," 162–63.
17. Cf. *Val. Exp.* 36,29–34; for discussion, see Pagels, "Adam and Eve," 161.

humanity, but "from the tree which produced beasts, and becoming a beast, he begat beasts" (*Gos. Phil.* 71,24–27). Like Eve, who also joins with the "beast," the "serpent" that symbolizes the hylic element, so Adam too becomes identified with *hylē*. Fed "from the tree which produced beasts," the hylic nature increases its hold over him.

Once he is clothed with the physical body (the "coats of skin" of Gen. 3:21; cf. *Ex. Theod.* 55.1), Adam finds that his hylic nature, alienated from the rational soul and from spirit, drives him "into seed and procreation" as if he were now "incapable of withstanding" his identification with bodily impulses (*Ex. Theod.* 55.1–2). Thus Adam becomes the prototype of fallen humanity. The author of the *Excerpts from Theodotus* 56 concludes this exegesis citing 1 Cor. 15:47: "Therefore our father Adam is 'the first man from earth, earthly'" (*Ex. Theod.* 56.1–2). The author of the *Gospel of Philip* apparently alludes to the same passage to contrast Adam, the "earthly man," with Christ, the "man from heaven" (*Gos. Phil.* 58,17–22; cf. also 56,26–30, which cites 1 Cor. 15:50).

Such theologians offer the closest analogy I have seen in second-century sources to the doctrine later enunciated by Augustine: "All who are begotten in the world are begotten of nature" (*Gos. Phil.* 58,26–29) in a process vitiated by sin that generates them inevitably toward spiritual and physical death. Yet some Valentinians insist (as will Augustine, adopting a very different line of argument) that such theology does not intend to indict sexuality per se but only that debased form of sexuality resulting from the Fall. One Valentinian, rejecting the usual interpretation of a passage from the *Gospel to the Egyptians*, declares that Christ does not impugn birth itself, "since (birth) is necessary for the salvation of believers" (*Ex. Theod.* 67.1). The same teacher declares, indeed, that, had Adam "sown from the *psychic* and *pneumatic* elements, as well as from the hylic," had he, that is, maintained the three elements of his being in their original harmony, his progeny would have been "equal and righteous, and the teaching would have been in all" (*Ex. Theod.* 56.2). But the disjunction within the primordial couple (and, consequently, within Adam himself) effectively separated Adam's procreative energy from its harmony with *psychē* and *pneuma*, and so brought suffering and death upon him and his descendants. The author of the *Gospel of Philip*, following Paul (cf. Romans 7), sees Adam, consequently, bound under the law, capable of discerning good from evil, but wholly incapable of using his knowledge to make himself good or to remove from himself the evil that has overtaken him (*Gos. Phil.* 74,1–13).

To repair this disruption—specifically, that of the psychic element,

symbolized by Adam—"the pneumatic element was sent forth, so that it might here be joined and united in syzygy with the psychic (*Adv. haer.* 1.6.1):

> Therefore Christ (embodying the pneumatic element) came, in order that he might remove the separation which was from the beginning, and again unite the two, and that he might give life (*zōē* = Eve/*pneuma*) to those who died in the separation, and unite them. . . . But the woman is united to her husband in the bridal chamber. (*Gos. Phil.* 70,12–18)

But if, since Adam, human sexuality had come to be dominated by hylic passions, how could anyone generated through sexual intercourse remain free from pollution? To answer this question, apparently, Valentinian theologians interpret the virgin birth as a symbol for the holy spirit's participation in Jesus' conception. While the rest of humanity, then, was generated from Adam in his alienation from Eve (and so from *pneuma*), Christ alone was born from a dynamic union of spiritual powers (cf. *Gos. Phil.* 71,5–12; *Ex. Theod.* 68; *Adv. haer.* 1.15.3). Valentinian exegetes interpret Gabriel's announcement to Mary ("The holy spirit shall come upon you, and the power of the most high shall overshadow you," Luke 1:35) as referring to the joint participation, in Jesus' conception, of the two primordial syzygies that form the second Tetrad. These two, *logos* and *zōē*, *anthrōpos* and *ekklēsia*, prefigure, indeed, Adam and Eve, Christ and the Church.[18] And if the author of the *Gospel of Philip*, for example, considers bodily existence "despicable" in comparison with that of the soul that animates it (*Gos. Phil.* 22), he warns in a eucharistic passage that far from simply despising the body, one must recognize its indispensability as an instrument of revelation: "do not despise the lamb (the "lamb of God," the actual body of Christ, cf. Heracleon, frg. 10), for without it one is not able to see the king" (*Gos. Phil.* 58,14–15).

Christ came, then, to reunite Adam and Eve, and to consummate their reunion by restoring to himself his own alienated (and internally divided) bride, the *church*. The author of the *Gospel of Philip*, speaking a "mystery" (cf. Eph. 5:32), describes how Jesus, embodying spiritual harmony, himself came forth from the union of the "Father of all" with the "virgin who came down," that is, the Mother, the holy spirit (*Gos. Phil.* 71,5–12). Following Wilson's reading, we learn that "he" (apparently, the savior) revealed "the great bridal chamber," that is, the

18. Cf. Irenaeus *Adv. haer.* 1.15.3; *Ex. Theod.* 60; cf. Pagels, "Adam and Eve," 160ff.

plērōma. "Because of this," the author continues, "his body, which came into being on that day, came out of the bridal chamber."[19]

Such Valentinian references to Christ's "body" often involve ambiguity that plays upon its various connotations. The author of the *Gospel of Philip*, sustaining, apparently, the image given in Eph. 5:23ff. ("We are members of His body . . . the church . . ."), follows Valentinian tradition by interpreting, as "his body," the church.

The author of the *Gospel of Philip* sees in Mary Magdalene an image of the church whom Christ came to purify and redeem in love (*Gos. Phil.* 63,33—64,12). The *Gospel of Philip* 63,30-32 suggests the church's relationship to Sophia, as 64,1-12 suggests her relationship with the primordial, preexistent ἐκκλησία ("church"). The *Gospel of Philip* 59,6-11 suggests that the "three Maries" (the Savior's virgin mother, his sister, and Mary Magdalene) serve as images of Christ's spiritual syzygos in her triple manifestation, respectively, as holy spirit, Wisdom, and as his bride the church. Heracleon sees in the Samaritan woman of John 4 a similar image of the church—one whose experience vividly recapitulates that of Eve, and so, of course, in Valentinian myth, of Wisdom. The Savior finds "the pneumatic church," like her prototype, "lost in the deep matter of error" (frg. 23). Her suffering, like Eve's, is expressed in sexual terms, as adultery, signifying her immersion in materiality (*Gos. Phil.* 61,5-13; frg. 18). But when the Savior approaches her, he invites her to "call her husband," indicating, Heracleon explains, her "true husband and pleroma," with whom the Savior comes to reunite her.

What humanity lost in the separation of Adam from Eve, *psychē* from *pneuma*, Christians now may recover through the sacraments that enact Christ's reunion with his church. The gnostic Christian receives baptism, then, not only, as psychics do, as a "going into death" (cf. *Gos. Phil.* 77,11; cf. Rom. 6:3-4) and purification from sins but as a reunion with the syzygos Adam lost in separating from Eve. The participant, once born naturally ("from Adam"), now receives, through baptism, "the gift of the holy spirit" (*Gos. Phil.* 64,26; 77,14). Yet the process that baptism initiates (rebirth through the holy spirit) receives completion only in chrism ("anointing"), which effects, as well, rebirth in the image of her syzygos Christ. Those receiving chrism are reborn from a complete syzygy, becoming children "of the bridal chamber" (*Gos. Phil.* 72,20-21; compare *Ex. Theod.* 68.79—80.1-3). The author of the *Gospel of Philip* explains that:

19. For discussion and references, see Pagels, "Adam and Eve," 164-66.

Through the holy spirit we are indeed born but we are born again through Christ. In the two we are anointed through the Spirit, and when we have been born we are united.

Those who experience, through these first two sacraments, spiritual reconciliation then receive the eucharist as a celebration of "spiritual love" (*Gos. Phil.* 59,1–6), participating with Christ in the eucharistic prayer that consecrates the "mystery of marriage" (*Gos. Phil.* 64,31–32): "You who have joined the perfect, the light, with the holy spirit, unite the angels with us also, the images" (*Gos. Phil.* 58,10–12).

Partaking of the eucharistic bread and wine, the gnostic Christian perceives these, in turn, as symbols of the masculine and feminine elements of the pleromic syzygy. Interpreting John 6:53, "Whoever does not eat my flesh and drink my blood has no *life* in him," the author of the *Gospel of Philip* suggests that "his flesh is the *logos* (in which dwells life, as Eve in Adam; cf. John 1:4) and his blood, the *holy spirit*. Whoever has received these has food and drink and clothing" (*Gos. Phil.* 57,2–8).

Participation in this whole sacramental "mystery," then, undoes the effects of Adam and Eve's transgression. The participant receives, first of all, "clothing," having "put on Christ," in baptism, to cover the nakedness that shamed the fallen Adam and Eve (*Gos. Phil.* 56,26—57,22). Second, while Adam, eating from the tree of knowledge, lost access to the tree of life, bringing death upon his progeny, the eucharist restores to the recipient—in the oil of chrism—the fruit of the tree of life (*Gos. Phil.* 73,15–20). Third, since Adam's progeny, following his transgression, could find "no bread in the world," that is, nothing to nourish their true humanity, "man used to feed like the beasts" from the trees that symbolize "the enjoyment of things that are evil" (*Tri. Trac.* 107,1–2), nourishing only their hylic nature. But when Christ, the perfect man, came, he brought bread from heaven (cf. John 6:53) so that man might be nourished with "human food" (*Gos. Phil.* 15). Whoever partakes of that food (*logos* and *pneuma*) in the eucharist receives the "resurrection in the flesh," life that cancels the penalty of death (*Gos. Phil.* 57). The sacraments, as the author of the *Gospel of Philip* emphasizes, consecrate the whole person, including, in particular, the body (*Gos. Phil.* 77,2–7).

From this, Irenaeus says, the Valentinians derive direct implications concerning sexual activity. Those who have experienced that "mystery of syzygies" are enjoined to enact marital intercourse in ways that express their spiritual, psychic, and bodily integration, celebrating the act as a symbol of the divine pleromic harmony. But those who remain uninitiated are to refrain from sexual intercourse. For these, remaining

bound in the state symbolized by Adam's separation from Eve, still experience their sexual impulses as dominated by "the power of lust" (*Adv. haer.* 1.6.4). Some scholars (myself included) have sometimes taken Irenaeus's statement as evidence that Valentinian Christians rejected the ascetic practice that other gnostic Christians based upon similar exegesis.[20] Clement's statement that "the Valentinians approve marriage" (*Stromateis* 3.1) appears to confirm this, as does the vitriolic condemnation of Valentinians by the ascetic author of the *Testimony of Truth* (56,1–20). Yet now I find myself more cautious about drawing such implications. Irenaeus's account, after admitting that some Valentinians are models of chastity, goes on to accuse others of peddling aphrodisiacs in order to seduce and rob their potential victims (*Adv. haer.* 1.6.1–3). Clement's endorsement of Valentinian views of marriage comes, too, from a man who himself approved and endorsed, above all, *celibate* marriage. Might not some of the Valentinians whose views he approves agree with him? The inconclusiveness of the evidence suggests to me that Valentinian Christians, like the orthodox, may have expressed a wide range of views and tolerated a wide variety of practices.

Whether gnostic Christians celebrated the "mystery of syzygies" in acts of sexual intercourse,[21] then, we do not know. But if the sources remain silent on the literal question, they speak clearly concerning symbolic ones. The *Gospel of Philip,* in particular, declares that gnostic Christians celebrate that "mystery" in their union with all who belong to the pneumatic church, the "bride of Christ." The eucharistic "kiss of peace" expresses their oneness with one another and produces spiritual "fruit":

> For the perfect conceive through a kiss and give birth. Because of this we also kiss one another. We receive conception from grace which is among us. (*Gos. Phil.* 59,3–7)

The same author urges the members of that "body" to repudiate adultery (referring, apparently, to "intercourse" with the hylic element; cf. *Gos. Phil.* 61,5–6) and to live in a way that becomes the pure "bride of Christ":

20. Notably G. Quispel, in his numerous publications; cf. also Pagels, "Adam and Eve," 169–74. M. Williams presents the opposite case; see his essay, above in this volume, "Variety in Gnostic Perspectives on Gender."

21. Note R. M. Grant, "The Mystery of Marriage in the Gospel of Philip," *VC* 15 (1961) 129ff.

You who live together with the Son of God, love not the world but love the Lord, that those you bring forth may not be like unto the world, but may be like the Lord. (*Gos. Phil.* 78,20–24)

If many Christians in the early centuries felt some uneasiness about Genesis 1—4, perplexed about how to interpret these passages in the light of Christ's revelation, gnostic Christians stood among those who most emphatically insisted that they could not be taken literally. Are suffering, pain, labor, and death, they asked, special punishments that God has visited upon human attempts to gain knowledge? Are procreation and marriage, in fact, among God's first and primary ordinances? Refusing assent to such conclusions, gnostic Christians, rather than rejecting the Genesis accounts altogether, chose to treat them as a shimmering surface of symbols, one that invites the spiritually adventurous to plunge in and explore their hidden depths.

Adam and Eve, whom Jewish and Christian exegetes generally take as characterizing male and female nature, interaction, and roles, and whose example they often invoke to order social and sexual behavior, gnostic Christians transform into interacting elements within human nature. Yet, as even this brief exploration has shown, gnostic Christians sharply disagree on the nature of this interaction. The author of the *Hypostasis of the Archons*, as we have seen, interprets Genesis 1—3 as showing that *psychē* and *pneuma* express contradictory impulses that derive from diametrically opposed spiritual forces. The body, caught in this civil war, functions essentially as a trap that threatens to capture *pneuma* and enslave it to tyrannical psychic energies. The author of the *Gospel of Philip*, on the contrary, reads the relationship between *psychē* and *pneuma* as essentially and necessarily complementary. When *psychē* and *pneuma* are alienated from each other, this author shows, passions may dominate us without restraint. But when the two are reintegrated and brought into harmony, even the body itself can become "holy."

What conclusions, if any, can we draw about the social implications of such religious convictions? Here I am glad to claim the privilege of this essay as a preliminary work, and defer drawing definitive conclusions, hoping that some may emerge from our collaboration and discussion. Yet let me suggest, at least, the following: The gnostic practice of displacing attributes of gender from actual men and women onto qualities inherent in every person may tend to minimize actual gender difference. This practice tends to imply that anyone, man or woman, contends with similar forces (whether these are envisioned as contra-

dictory or complementary) when engaged in spiritual struggle. Many gnostic Christians, I suspect, would endorse that statement only in the case of those who remain celibate. Those attracted to such radical teachings as those expressed in the *Hypostasis of the Archons*, for example, regard celibacy as the precondition for spiritual awareness and the prerequisite, no doubt, for spiritual recognition between men and women. Valentinian Christianity, as reflected in the *Gospel of Philip*, at any rate, seems to allow for a greater range of practice, including marriage between gnostic Christians which some may have interpreted as celibate marriage.

Such conclusions remain, however, partly guesswork. What the texts show clearly, on the other hand, are their authors' primary concerns: that "spiritual exegesis" is essential for understanding the Scriptures; that mutual "spiritual recognition" between Christians is the basis for the gnostic understanding of the church. Finally, we can see that gnostic exegesis, as exemplified in the *Hypostasis of the Archons* and the *Gospel of Philip*, is not simply "free invention" but involves a process of meditation —and improvisation—on the scriptures by those seeking to "discover" mythical actions hidden within cryptic words and phrases. And we can see, too, that gnostic teachers as different as the authors of the *Testimony of Truth*, the *Hypostasis of the Archons*, and the *Gospel of Philip* all regard Paul—truly the "apostle of the heretics"![22]—as their great teacher.

22. Tertullian, *De praescriptione haereticorum*.

Response to "Pursuing the Spiritual Eve: Imagery and Hermeneutics in the *Hypostasis of the Archons* and the *Gospel of Philip*" by Elaine Pagels

It is my aim to focus our discussion by underlining three major points in Elaine Pagels's essay. First, the essay reminds us that symbolism is not sociology, that a range of sexual options can be endorsed by the same symbolization. Second, it locates the distinction between gnostic and orthodox exegesis in hermeneutics. Third, the essay provides new readings of the *Hypostasis of the Archons* and the *Gospel of Philip*, readings that find the exegetical key to their interpretations of Genesis in 1 Corinthians and Ephesians. My response will examine each of these contributions in greater detail, but before I do so, I wish to note that in using the problematic word "orthodox," I am referring to the authors who define themselves as "catholic" (Irenaeus, Clement, Origen, Hippolytus, and Tertullian [at least the pre-Montanist works]) over against the "heretics" we regard as gnostic.

1. SYMBOLISM IS NOT SOCIOLOGY

First, then, this essay contains a reminder that symbolism is not sociology, that the relations between exegesis and praxis are extremely complex. Thus, Professor Pagels argues that the *Gospel of Philip* should not be taken to enforce celibacy as the only option for the true Gnostic. I wish to express my accord and to observe that the opposite also is true. Differing theological stances can endorse the same range of social and sexual options. Thus, orthodox theology and exegesis and the *Gospel of Philip* endorse the same set of sexual options: abstinence is preferred,

but marriage is endorsed.[1] Professor Pagels also suggests that other gnostic proponents of sexual asceticism spiritualize Gen. 2:23–24, while the *Hypostasis of the Archons* (89,10–20) avoids using this verse.[2] In the light of these ambiguities she asks us to view the occurrence of positive feminine imagery in the *Apocryphon of John* and the *Exegesis of the Soul* as a result of a pattern of exegesis that deals with the text in terms of symbol and myth rather than history, and not of a different attitude toward gender, sexuality, and women as women.

2. HERMENEUTICS AND EXEGESIS

Thus a second major premise of this essay is that hermeneutics distinguishes gnostic exegesis from the exegesis of orthodoxy: "What differentiates gnostic from orthodox exegesis is the Gnostics' conviction that the written texts, far from giving authoritative and complete direction, contain only the bare husks of meaning. The spiritually minded Christian must 'search the scriptures' to discover what the text does not reveal directly—indeed, what it may intentionally conceal from the naive reader."[3] While I agree that hermeneutics is indeed the distinguishing factor, I find it much more difficult to identify the ways in which the hermeneutical principles differ. It is certainly the case that the Gnostics regard the text as "mere husks which must be filled with meaning"; but I would argue that everyone does that. Orthodox interpretation is "historical" only as it chooses. Even the fact that the Gnostics read certain biblical texts as deceptive will not adequately distinguish their exegesis;[4] the orthodox also see the Bible as mined with temptations that may cause the unwary interpreter to think or speak of God in terms unworthy of divinity.[5] Indeed, Origen could hardly ask for a

1. "Quid tamen bono isto melius sit accipimus ab apostolo, permittente quidem nubere, sed abstinentiam preferente" (Tertullian *Ad uxorem* 1.3.2. *Ad uxorem* is generally considered to be pre-Montanist). See also Clement *Stromateis* 3, esp. 3.1.4; 3.11.71— 3.12.86; and Origen *On 1 Corinthians 7* in the edition of C. Jenkins, *JTS* 9 (1908) 500–510.

2. Here caution must be exercised; for Josephus's comments on the creation of Eve also avoid the explicit mention of "bone of my bones" (*Ant.* 1.36). Both Josephus and the *Hypostasis of the Archons* stress her naming as woman and Eve, mother of the living (Gen. 3:20). The striking contrast is that in *Antiquities*, Adam recognizes her as from himself, while in the *Hypostasis of the Archons* he recognizes that he comes from her (89,12–18).

3. E. Pagels, p. 189, above.

4. *Ap. John* 13,15–25; 22,20–25; 23,1–5; for a rationale, see *Ptolemy to Flora* in Epiphanius *Haer.* 33.3–8.

5. Origen *De principiis* 4.2.9.

better explanation of his task than Professor Pagels's description of the spiritually minded Christian.

The distinguishing factor must be far more closely defined; I believe that it should be defined in terms of hermeneutics as theological stance rather than as exegetical method. Thus the Gnostics' view that the scriptures contain deliberate deception is distinguished from Origen's recognition of temptations in the text by their differing views of the creator of the world,[6] and of the author of scripture, not by a method that allows them to ignore the text as history and to encounter it as a world of symbols. Indeed, Origen claims that gnostic views of the creator derive from their overly literal interpretation of Genesis.[7]

3. EXEGESIS OF GENESIS IN THE
HYPOSTASIS OF THE ARCHONS

The question of what forms gnostic exegesis brings us to the third contribution of the essay, the reading that it gives to the *Hypostasis of the Archons* and the *Gospel of Philip*. Professor Pagels has argued that the hermeneutical keys of these texts are to be found in 1 Corinthians and Ephesians respectively. I am more familiar with the *Hypostasis of the Archons* and found the reading of that text particularly engaging. In Professor Pagels's view, the *Hypostasis of the Archons* uses Genesis 1—3 to explain the distinction between the psychic and the spiritual in 1 Corinthians 2 and 15. The psychic (the archons) cannot "know" the spiritual (1 Cor. 2:14)—that is, they are able neither to rape nor to recognize Norea. Professor Pagels suggests that not only the distinction between psychic and spiritual but also the accounts of the creations of Adam and Eve are formed by 1 Corinthians 15. I am convinced that Genesis and 1 Corinthians are being read together in the *Hypostasis of the Archons*. It may even be possible to extend this suggestion. The high divinity of the *Hypostasis of the Archons* is called Incorruptibility in several places.[8] Incorruptibility is mentioned in 1 Cor. 15:42, 50, and 54. The first occurrence, 1 Cor. 15:42, bears a particularly striking relationship to the creation of Adam in the *Hypostasis of the Archons* which

6. N. A. Dahl has argued that the gnostic revolt is a revolt against the creator rather than the world and has traced some of the ways this revolt guided the gnostic interpretation of Genesis. See N. A. Dahl, 'The Arrogant Archon and the Lewd Sophia,' in *Rediscovery* (ed. Layton), 2:689–712.

7. Origen *De principiis* 4.2.1.

8. *Hyp. Arch.* 87,1,12–15,21; 88,18–20.

could be read, "He [Adam] is raised by Incorruptibility" (ἐγείρεται ἐν ἀφθαρσίᾳ). It may be that the *Hypostasis of the Archons* has taken the divine title from the "incorruptibility" spoken of in 1 Cor. 15:42, 50, and 54, personifying incorruptibility and understanding it both as divine nature and as resistance to the pollution of the archons.

Questions arise for me when we begin to speak of 1 Corinthians as the key to the exegesis or the source of the transformation of traditional exegesis of Genesis that the *Hypostasis of the Archons* offers.[9] The distinction between the spiritual and the psychic is not peculiar to 1 Corinthians 15 and 2, as Birger Pearson has shown.[10] And the double meaning in the statement that the archons cannot grasp (understand/seize) what is spiritual appears not only in 1 Cor. 2:14 but also in John 1:5: "The light shines in the darkness, and the darkness did not grasp (οὐ κατέλαβεν) it." These observations do not imply that 1 Cor. 2:14 plays no role in the interpretation of Genesis but rather that something more is at work here. For the *Hypostasis of the Archons* has not only transformed the traditional exegesis of Genesis by placing it in the context of 1 Corinthians; it has also reread 1 Corinthians 15 in the context of Genesis. For instance, for the *Hypostasis of the Archons*, 1 Corinthians 15 applies not to the original and eschatological Adams but to the origins of spiritual and psychic humanity.[11] Both Genesis and 1 Corinthians are remade. May it not be more true to say that Genesis 1—6 and 1 Corinthians 15 and 2 (and perhaps John 1:15) are read together through another "key": the story of Norea's resistance to the archons or, as Anne McGuire has suggested, the experience of a certain kind of resistance to a certain kind of power?

Professor Pagels's essay and my response stand together in the conviction that hermeneutics is the factor that determines the exegesis of any given author. I am asking that hermeneutics be defined not in terms of method but in terms of the theological stance of the text. To give an adequate account of hermeneutics of any text we need continually more close readings of the text like this one and like "Virginity and Subversion."

9. Pagels, p. 192–93, above.

10. Pearson, *The Pneumatikos-Psychikos Terminology in 1 Corinthians*, 17–26.

11. If Pearson's treatment of 1 Corinthians 15 is correct, the *Hypostasis of the Archons* represents a return to the view of Paul's opponents in 1 Corinthians (Pearson, *Pneumatikos-Psychikos*, 24–26).

"The Holy Spirit is a Double Name": Holy Spirit, Mary, and Sophia in the *Gospel of Philip**

1. INTRODUCTION

Gospel of Philip 60,10–20[1] testifies to the doubleness of the Sophia figure—a doubleness that may be discerned in other parts of the *Gospel* as well. The immediately preceding passage (60,5–10) invokes another female entity, the Holy Spirit, who also possesses a double character. A third female is Mary, of whom there are three, according to *Gospel of Philip* 59,5–10. The three Marys comprise Jesus' mother, Mary Magdalene, and the sister of Jesus' mother, but the three sometimes blur into interchangeable personalities. Functioning as the *Gospel of Philip*'s primary female metaphors,[2] the elusive Mary, the Holy Spirit, and the double Sophia seem to play similar parts and often appear outrightly identified with one another.

G. S. Gasparro, Y. Janssens, and B. Barc[3] have observed—and ably argued for—such identification. Many male scholars have been less

* This essay is a reworked, condensed version of chap. 6 in my book *Female Fault and Fulfilment in Gnosticism* (Chapel Hill and London: University of North Carolina Press, 1986).
1. See W. W. Isenberg, ed. and trans., "The Gospel of Philip," in *Nag Hammadi Library* (ed. Robinson), 136. All translations in the text of this essay are from this version.
2. Eve is another, though largely negatively evaluated, figure.
3. G. S. Gasparro, "Il personaggio di Sophia nel Vangelo secondo Filippo," *VC* 31 (1977) 245, 252 n. 29, 270, 280–81; Y. Janssens, "L'Evangile selon Philippe," *Le Muséon* 81 (1968) e.g., 93, 99, 132; and B. Barc, "Les noms de la triade dans l'Evangile selon Philippe," in *Gnosticisme et monde hellénistique: Actes du Colloque de Louvain-la-Neuve, 11–14 mars 1980* (ed. J. Ries), 369–70, 373–75. Barc's is an excellent study.

attuned to this viewpoint, though they may hint at it.[4] For instance, Hans-Martin Schenke suggests that the Holy Spirit can be seen as Christ's pleromatic syzygos, Sophia as the partner of the Soter in the Ogdoad, and Mary Magdalene (or alternatively: Jesus' mother, Mary) as the companion of the earthly Jesus.[5] But such a tripartite division runs the risk of preventing the notion of an identification of the three females.

Moreover, one will note that the *Gospel of Philip* insists on interaction between or among the realms (whether three or two) in spite of the divisions they represent. To provide an example: Truth is said to bring "names into existence into the world because it is not possible to teach it without names. Truth is one single thing and it is also many things for our sakes" (54,10-20). Preexistent, Truth "is sown everywhere. And many see it as it is sown, but few are they who see it as it is reaped" (55,20-25). The only way to receive Truth—which "did not come into the world naked"—is through "types and images" (67,5-10). The *Gospel* underlines that one may know Truth exclusively through symbols, never directly.[6]

I would argue that the varied appearances of Truth, and the doubleness of the Holy Spirit, of Sophia, and of the Mary figure, can all be correlated. In addition, when the Holy Spirit, Sophia, and Mary appear as the female syzygos of Christ/Jesus, they may by extension symbolize the spiritual as well as the earthly partner for the (male) human being.

Seeking to avoid any impression of a static, strict separation into realms—à la Schenke, above—I suggest a collapse of tripartite as well as dualistic models into a synthetic view. To my mind, it is in the bridal chamber ritual[7] that such a collapse is actively sought and made possible. This most important sacrament in the *Gospel of Philip* achieves the unity of male and female *in this life*, thereby creating the transcendent

4. Two perceptive examples are S. Giversen, *Filipsevangeliet*, 27; and J.-M. Sevrin, "Les noces spirituelles dans l'Evangile selon Philippe," *Le Muséon* 87 (1974) 163.

5. H.-M. Schenke, "Das Evangelium nach Philippus," in *Koptisch-gnostische Schriften aus den Papyrus Codices von Nag Hammadi* (ed. J. Leipoldt and H.-M. Schenke), TF 20 (1960) 33–65 or *TLZ* 84 (1950) 34. Note, however, that the term "Ogdoad" does not appear in the *Gospel of Philip*. Schenke is echoed by R. McL. Wilson, *The Gospel of Philip*, 96; by J.-E. Ménard, *L'Evangile selon Philippe*, 14–15; and by Sevrin, "Les noces spirituelles," 163.

6. Cf. J.-E. Ménard, "L'Evangile selon Philippe et l'Exégèse de l'Ame," in *Les textes de Nag Hammadi* (ed. J.-E. Ménard), 61–62; and J. J. Buckley, "A Cult-Mystery in the *Gospel of Philip*," 570–73.

7. See Buckley, "A Cult-Mystery in the *Gospel of Philip*," 570–73, 575–81.

pleroma here and now. The bridal chamber aims at such a unification by providing spiritual rebirth for the partakers; one's "original nature" (53,20–25) is regained, and immortality is ensured.

For the Holy Spirit, Sophia, and Mary, the bridal chamber means resolution of their double role. The human beings in the bridal chamber effect the dissolution of this female's double nature precisely by embodying her envisioned state. Thus reflecting the goal of the female entity, the human being works to heal both itself—as split into male and female, Adam and Eve—and the divided Spirit. There are two interdependent integrations: that of the human being, male with female, and that of the split female entity, Holy Spirit-Sophia-Mary, who rejoins her lower to her upper self. In the enactment of the bridal chamber "the world has become the aeon" (86,10–15), that is, the world with its divisions has been abolished.

I take the *Gospel of Philip*'s utterance, "'The Holy Spirit' is a double name" (59,10–15), to refer to the Holy Spirit's division into a lower, kenomatic and a higher, pleromatic condition, a "worldly" and a "Holy" Spirit. Beyond her separation, the figure is in reality *one*, and if she again becomes simply "Spirit," the epithets "Holy" and "of the world" will disappear and the dualism dissolve. For "the Holy Spirit" may well belong among the names that "are in the world to deceive.... They have an end in the aeon" (53,35—54,1).

I will first examine the *Gospel of Philip*'s treatment of Mary and her relationship(s) with Jesus. His interactions with her may allude to the goal, the bridal chamber. Second, I will concentrate on the metaphors "wind," "breath," and "fire" for the Spirit. Parallels and differences between Adam's birth and Jesus' birth are treated here. Next, I will deal specifically with the *Gospel's* portrayal of the doubleness of the Holy Spirit and of Sophia. This section also examines the prayer by Jesus at the Thanksgiving (58,10–15) and the apostles' petition for Sophia (59,25–30). In my view, both prayers express the quest for the syzygos. Finally, I will argue that the earthly marriage should be seen as a symbol and a prerequisite for the bridal chamber sacrament. In this regard, the earthly marriage warrants a positive evaluation. My conclusion will be tied in with the resolution of the female entity's doubleness. It is the human being that plays the main part in effecting this resolution, for the bridal chamber activity momentarily resolves the plight of the split hypostasis. This is so because the ritual affects not only the actual, human partakers but also Sophia, "the virgin who came down" (71,5–10).

2. MARY'S ROLES

Right after the statement concerning Truth which is seen by few "as it is reaped"[8] comes the passage:

> Some said, "Mary conceived by the Holy Spirit." They are in error. They do not know what they are saying. When did a woman ever conceive by a woman? Mary is the virgin whom no power defiled. She is a great anathema to the Hebrews, who are the apostles and [the] apostolic men. (55,20–30)

Here one recognizes the Syrian Christian notion of the Holy Spirit as female. "The virgin whom no power defiled" recalls the Spirit figure in other gnostic texts.[9] While the *Gospel of Philip* disavows one particular kind of connection between Mary and the Holy Spirit,[10] it establishes another tie by associating Jesus' mother with the virgin, the Spirit. Further, it is noteworthy that Mary and the apostles are juxtaposed. The equation of Hebrews with apostles might be compared with another passage in the *Gospel*: "When we were Hebrews we were orphans and had only our mother, but when we became Christians we had both father and mother" (52,20–25).[11] In the light of *Gospel of Philip* 55 one might say that those who do not appreciate Mary as the spiritual woman remain Hebrews. She is the mother, and Jesus the father, of true Christians.

The *Gospel of Philip*'s section on the three Marys reads: "There were three who always walked with the Lord: Mary his mother and her sister and Magdalene, the one who was called his companion. His sister and his mother and his companion were each a Mary" (59,5–15). The adverb "always" suggests that the woman may have been closer to and more ardent followers of Jesus than were the other (male) disciples. Inconsistently, the second Mary is called the sister of Jesus' mother, and then *his* sister, but this might be a scribal error. According to J.-E. Ménard, she is Mary-Salome of Matt. 28:56, an important gnostic figure.[12] "Companion"

8. See p. 212, above.
9. Consult references in Ménard, *L'Evangile*, 136.
10. Cf. J. Lagrand, "How Was the Virgin Mary 'Like a Man' (ﬡ)? A Note on Mt. i:18b and Related Syriac Christian Texts," *NovT* 22 (1980) 97–107; and B. McNeil, "New Light on Gospel of Philip 17," *JTS* 29 (1978) 143–46.
11. For gnostic parallels, see Ménard, *L'Evangile*, 125–26; and Wilson, *The Gospel of Philip*, 68. In the Mandean *The Thousand and Twelve Questions (Alf Trisar Šuialia)*, ed. E. S. Drower, the text makes puns on *Yahuṭaiia* ("Jews") and *iahṭa* ("abortion"), 255 (198) and 276 (358).
12. Ménard, *L'Evangile*, 150.

(ⲋⲱⲧⲣⲉ) for Mary Magdalene can mean "spouse" or "wife."[13] I think the last sentence can be interpreted as an identification of the three Marys;[14] they mark an integration of Jesus' syzygos.

Ménard observes that the blurring of Mary the mother and Mary Magdalene can be found in the work of the Syrian Ephrem. He makes Mary the mother the resurrection witness and the recipient of the prohibition to touch the risen Christ in John 20:17.[15] Such an identification of the two females serves deliberately to weaken Mary Magdalene's position as Jesus' possible spouse. For, "by the end of the second century Mary Magdalene had become identified with Mary the sister of Lazarus and the woman in Luke 7:36–50," informs R. M. Grant.[16]

The theologically threatening position of Mary Magdalene is further amplified in one of the most perplexing sections of the *Gospel*—an admittedly badly broken part of it:

> And the companion of the [Savior is] Mary Magdalene. [But Christ loved] her more than [all] the disciples [and used to] kiss her [often] on her [mouth]. The rest of [the disciples were offended] by it [and expressed disapproval]. They said to him, "Why do you love her more than all of us?" The Savior answered and said to them, "Why do I not love you like her?" (63,30—64,10)[17]

The disciples obviously feel left out of their master's love. One wonders why Jesus kisses Mary in the disciples' presence; the kiss is not a private, ritual act belonging in a secluded cultic context. But the kiss may not express any sexual love for Mary, although the disciples appear to interpret it that way. Do they wish to be kissed as Mary is? Their disappointed question meets with no real answer—a tactic known from the *Gospel of Thomas*, for instance logion 18, where Jesus answers by

13. Giversen, *Filipsevangeliet*, 53 n. 3.

14. Wilson's translation seems to bring this out: "For Mary was his sister and his mother and his consort" (35,10–11). A. Orbe sees three Marys in heaven corresponding to those on earth. The three earthly ones reflect "la triple eficacia de María, la virgen incontaminada" ("the triple efficacy of Mary, the uncontaminated virgin"). See Orbe, "'Sophia Soror': Apuntes para la teología del Espíritu Santo," in *Mélanges d'histoire des religions offerts à Henri-Charles Puech*, 360.

15. J.-E. Ménard, "Le milieu syriaque de l'*Evangile selon Thomas* et de l'*Evangile selon Philippe*," *RevScRel* 42 (1968) 264.

16. Grant, "The Mystery of Marriage in the Gospel of Philip," 138.

17. Giversen leaves the text broken (*Filipsevangeliet*, 62), while others emend it: Schenke, *Das Evangelium nach Philippus*, 47; Ménard, *L'Evangile*, 71–73; and K. H. Kuhn, "The Gospel of Philip," in *Gnosis* (ed. W. Foerster; trans. and ed. R. McL. Wilson), 2:86. For "companion" (κοινωνός), see W. Meeks, "The Image of the Androgyne: Some Uses of a Symbol in Earliest Christianity," *HR* 13 (1974) 190 n. 111; and for references to traditions depicting rivalry between Mary and Jesus' male disciples, see, e.g., Pagels, *The Gnostic Gospels*, 64–65.

nearly echoing the inquiry. If Mary is Jesus' syzygos and if his love for
her is that of a man toward a woman, then one may assume that this
love differs from his feelings toward his male disciples. On the other
hand, Jesus' near-mocking reply may indicate that the disciples fail to
understand the meaning of the kissing. I think the kiss hints at the
nonpublic activities in the bridal chamber ritual.

Jean-Marie Sevrin shrewdly observes the disciples' archontic role.[18]
His insight supports my suspicion that the disciples fall short of compre-
hending the kisses between Jesus and Mary; therefore they are not yet
perfect Christians, are perhaps still in the "Hebrew" stage! Sevrin wavers
on the issue of whether the kiss belongs in the bridal chamber context.[19]
To make Mary "concevoir des semences spirituelles" ("conceive spiritual
seeds"), says Sevrin, accords with another *Gospel of Philip* section,
namely 58—59, which speaks of conception and giving birth.[20] This
passage occurs just before the information about the three Marys. Full of
lacunae in the beginning, it reads:

> [place. . . .] from the mouth, [because if] the word has gone out from that
> place it would be nourished from the mouth and it would become perfect.
> For it is by a kiss that the perfect conceive and give birth. For this reason we
> also kiss one another. We receive conception from the grace which is in
> each other. (58,30—59,10)

The writer includes himself among the "we," those fed from the
mouth of the Logos who provides himself as nourishment. It is in this
context that Jesus' kissing Mary ought to be understood. The Logos lives
in those whom he has kissed, hence the disciples' jealousy, for they are
not yet worthy of the kiss. Because Jesus is not directly available in
Gospel of Philip 58—59—in contrast to 63—64—the perfect receive his
substance, χάρις ("grace"), from one another.

Neither the kisses between the perfect nor the kissing of Jesus and
Mary Magdalene appear to belong in any secret context; both seem
public occurrences. And the perfect in *Gospel of Philip* 58—59 are prob-
ably both male and female, even though sexual differences have ceased
to matter, for spiritual conception and birth hardly depend on two
opposed genders. In short, the kisses in 58—59 do not carry explicit
sexual connotations. However, the kissing activity between Jesus and
Mary *does* appear in a different light, because the sexual associations are

18. Sevrin, "Les noces spirituelles," 185 n. 112. Compare *Gos. Phil.* 70,5–30, where the
"powers" envy the Spirit-endowed Adam who speaks words incomprehensible to them.
19. Sevrin, "Les noces spirituelles," 185–86, 191–92.
20. Sevrin, "Les noces spirituelles," 185 n. 112; 163 n. 63.

still strongly present here. I think Jesus deliberately provokes the male disciples' jealousy in order to demonstrate that they do not understand the kiss. Jesus is making Mary "spiritually" pregnant; if she had not been female, one might more comfortably compare the kisses she receives with those exchanged among the perfect in 58—59.

With varying results, scholars have attempted to make sense of the spiritual "sex life" depicted in these passages. Hans-Georg Gaffron wonders what the "spiritual birth" in *Gospel of Philip* 58—59 would mean, noting that the kiss here is collective.[21] Wayne Meeks takes issue with Gaffron's denial that the kiss has anything to do with the bridal chamber sacrament.[22] If the perfects' kissing is public, however—a kind of greeting, perhaps—I suspect their action alludes to, but does not itself constitute, the bridal chamber ritual. It seems reasonable to interpret the perfect as imitating Jesus and Mary.

Jesus' kissing Mary is a cunning, paradoxical action, which gives rise to opposed interpretations by different audiences. According to the traditions echoed in the *Gospel of Philip*, Jesus himself has a double nature and is the product of a double birth. Therefore, the pointedly two-tiered character of his actions should not be underestimated. As Logos, Jesus feeds the perfect with the seed for their own rebirth, and he impregnates Mary with spiritual substance. It is now pertinent to investigate the *Gospel of Philip*'s thoughts on some particular spirit symbols: wind, breath, and fire.

3. WIND, BREATH, AND FIRE. JESUS' BAPTISM

Distinguishing between "the spirit of the world" and the Holy Spirit, the *Gospel of Philip* (77,10–20) states that when the former "blows, it brings the winter. When the Holy Spirit breathes, the summer comes."[23] Elsewhere, summer and winter are identified as the aeon and the world, respectively (52,25–30). Here the text informs, "Those who sow in winter reap in summer."[24] The believers are exhorted to behave in this fashion,

21. H.-G. Gaffron, *Studien zum koptischen Philippusevangelium unter besonderer Berücksichtigung der Sakramente,* 214 and 216. See also Giversen, *Filipsevangeliet,* 27, regarding the "pregnancy of grace"; and consult Sevrin, "Les noces spirituelles," 183–85.

22. Meeks, "The Image of the Androgyne," 190 n. 111.

23. Janssens ("L'Evangile selon Philippe," 119) notes that the Coptic word for summer (ⲡϣⲱⲙ) has here turned feminine (ⲧϣⲁⲙⲏ) in order to accord with the Holy Spirit's feminine character.

24. Cf. Gasparro's comments, "Il personaggio," 263 n. 73.

for summer follows winter, the world gives way to the aeon. Another passage states that for the human being in the bridal chamber sacrament "the world has become the aeon" (86,10–15).[25] This bears directly on the imagery of the seasons, for in the bridal chamber the partakers actively accomplish the abolishment of the world, the winter. To put it another way: the spirit of the world gives way to the Holy Spirit. One should note, however, that both spirits are rendered by the term *pneuma* and that both create their kind of life in their respective seasons.

The Spirit acts in a double fashion: "Those . . . whom the Spirit (itself) begets usually go astray also because of the Spirit. Thus, by this one and the same breath, the fire blazes and is put out" (60,5–10). Lacking the epithets "Holy" or "of the world," the Spirit has a twofold, contradictory task: it gives life and destroys it. One may read *Gospel of Philip* 60 as a warning both against the assumption that there are *two* diametrically opposed Spirits—one saving, the other destructive—and against too smug a feeling of spiritual accomplishment. Perhaps only the bridal chamber finally secures the reborn into the safety of the aeon, in which the Spirit no longer acts in a worldly way.

The *Gospel of Philip* (67,5–10) distinguishes between the formless fire and the white, "bright and beautiful" one. This may not be a statement about two distinct fires, however: Janssens compares the two fires to the doubleness in the Holy Spirit's action and to the double aspect of Sophia.[26] Thus, she refuses radically to divide the fires into two, unlike Ménard, who—more traditionally dualistic—designates the material fire a creation by Achamoth and the archons.[27]

It may now be time to present the most succinctly antidualistic statement of the *Gospel of Philip*:

> Light and darkness, life and death, right and left, are brothers of one another. They are inseparable. Because of this neither are the good good, nor the evil evil, nor is life life, nor death death. For this reason each one will dissolve into its original nature. But those who are exalted above the world are indissoluble, eternal. (53,10–25)[28]

Dichotomies are illusory and will disappear for those who are able to free themselves from the dualism of the world. Opposites are make-

25. See p. 213, above.
26. Janssens, "L'Evangile selon Philippe," 104.
27. Ménard, *L'Evangile*, 155.
28. For a parallel antidualism in Mandeism, see e.g., J. J. Buckley, "A Rehabilitation of Spirit Ruha in Mandaean Religion," *HR* 22 (1982) 60–84, esp. 73–84.

shifts, as are names, "types and images."[29] Truth and names relate to one another as do the "exalted" to the dichotomies headed for obliteration.

Gospel of Philip 63 distinguishes between glassware and pottery: the former, if they break, can be redone, because they were created by breath. Perhaps earthenware jugs are demiurgic creations, as suggests Janssens;[30] in any case, it is clear that glass vessels—already once infused with Spirit—may be re-created. In view of Gospel of Philip 60, one may speculate whether the same Spirit (breath) that vivified the glassware might also ruin it.

The most pertinent example of a breath-born being is, of course, Adam. He "broke" because of his spouse (equivalent to the Spirit) but was also reborn through her (70,20–30). According to Gen. 2:7, Adam is made of spirit and earth; he is a double creature. In view of Gospel of Philip 63 and 70, then, Adam the "glass decanter" can be redone. Indeed, he appears to have needed immediate repair: Eve—Adam's "lost soul"— broke away (literally "broke" her spouse), and his true companion is now the Spirit. "If the woman had not separated from the man, she would not die with the man. His separation became the beginning of death," says Gospel of Philip 70,5–15. One suspects that Adam's new spiritual spouse can help him escape the death sentence by re-creating him into a spiritual entity.

Eve, like Adam, is a breath-born soul, for she was in Adam at his creation (Gos. Phil. 70). Consequently, they both relate to the Spirit. Here we can begin to see the twofold speculations on the syzygy, Adam and the Spirit, Jesus and Mary Magdalene; on the other hand, the Gospel of Philip attests to a same-gender "pair" constituted by a lower and a higher image for the same being.[31] Eve as soul is still connected to the Spirit who forms Eve's higher self, a self that is no other than Adam's new wife. Paradoxically, Adam has both lost and gained a spouse, the same spouse.

Adam has two virginal mothers: Spirit and earth, according to Gospel of Philip 71,15–20.[32] These two connote the double birth expressed in the

29. See p. 212, above; Gos. Phil. 53,10–25; and Buckley, "A Cult-Mystery in the Gospel of Philip," 570–71.

30. Janssens, "L'Evangile selon Philippe," 97.

31. See p. 213, above; and consult J. J. Buckley, "The Mandaean Šitil as an Example of 'the Image Above and Below,'" Numen 26 (1979) 185–91 and idem "Two Female Gnostic Revealers," HR 19 (1980) 259–69, esp. 266–69.

32. W. Till (Das Evangelium nach Philippus) notes (6) that the Coptic ⲕⲁϩ ("earth") is masculine but Greek γῆ is feminine, which, to the author, speaks of a Greek original.

glass/earth imagery. The passage continues: "Christ, therefore, was born from a virgin to rectify the fall which occurred in the beginning" (15–25). Wishing to stress the difference between Adam and Christ, the text also furnishes the link, virgin birth, between the two.[33]

Further on in *Gospel of Philip* 71, one reads:

> Is it permitted to utter a mystery? The Father of everything united with the virgin who came down, and a fire shone for him on that day. He appeared in the great bridal chamber. Therefore, his body came into being on that very day. It left the bridal chamber as one who came into being from the bridegroom and the bride. So Jesus established everything in it through these. It is fitting for each of the disciples to enter into this rest.[34]

Generally this section is taken to refer to Jesus' baptism. After appearing (= being spiritually born)—as fire?—Jesus leaves the bridal chamber, presumably in order to teach others about it. For the disciples' goal is to enter the bridal chamber,[35] which means both to be joined spiritually, as the Father and the virgin were, and to be reborn as spiritual beings. Jesus is the paradigmatic "son of the bridal chamber."

At his baptism Jesus had an effect on the water, emptying "it of death" (77,5). If death resided in the water, the baptized would emerge covered with the correlate "spirit of the world," the destructive aspect of the Spirit. A "Christ"-body to be put on, the water is a pneumatic element precisely because Jesus perfected it.[36] Another passage dealing with baptism speaks of the Holy Spirit's role: "Through the Holy Spirit we are indeed begotten again, but we are begotten through Christ in the two. We are anointed through the Spirit. When we were begotten we were united" (69,1–10).

I venture that one may relate "the two" to the parents in *Gospel of Philip* 52.[37] The mother—whose children are (Hebrew) orphans—can be equated to the Spirit. When the Spirit acquires a male partner, her

33. Referring to P. Krüger, Ménard observes that according to Syriac Christianity, Mary is the "living earth" which further emphasizes the parallel between Adam and Christ (*L'Evangile*, 204). Recalling in *Gos. Phil.* 55 the denunciation of Mary's alleged pregnancy by the Holy Spirit, one now sees that *Gos. Phil.* 71 wishes to guard against the suspicion that Christ too may have had two virgin mothers.

34. See Wilson's interpretation in his *The Gospel of Philip*, 147. (For "the virgin who came down," see p. 213, above.)

35. The bridal chamber has both a preexistent and an eschatological dimension, says Ménard (*L'Evangile*, 59).

36. I think Janssens is mistaken when she judges water baptism to stem from the demiurge ("L'Evangile selon Philippe," 100 and 133).

37. See p. 214, n. 11, above. Wilson (*The Gospel of Philip*, 137) and Till (*Das Evangelium nach Philippus*, 69, 117, lines 4–8) have a different translation here. See also Giversen, *Filipsevangeliet*, 71, and compare Ménard's comments, *L'Evangile*, 193.

offspring become Christians. Eve, as Adam's soul, aspires to the same goal; this is the uniting through begetting. As Jesus was engendered in baptism by *his* parents, so Jesus' followers must be begotten by Spirit and Logos.

To recapitulate this section: Spirit emerges in both a positive and a negative aspect. As kindler and extinguisher of the life-fire, the Spirit creates both life and death; one recalls that this is one of the deceptive pairs of opposites in *Gospel of Philip* 53![38] Beyond the Spirit's divisive attributes, the entity is in reality *one*, a nonconceptual force. I will now deal with passages testifying to this character's doubleness, and then, with the decidedly positive aspect of the Spirit, namely, in the eucharist. So, the emphasis on the paradoxical qualities of the Spirit will yield to the positive ones that are, understandably, quite at home in the sacramental context.

4. THE AMBIGUOUS SPIRIT. THE EUCHARIST

The statement, "And the companion of the [Savior is] Mary Magdalene,"[39] is immediately preceded by, "As for the Wisdom who is called 'the barren,' she is the mother [of the] angels." The text here appears to correlate the two figures, Mary Magdalene and Wisdom (Sophia). "Barren" Wisdom paradoxically has angel-children, putatively the envisioned product of Jesus' spiritual impregnation of Mary.[40]

Sophia also appears in this passage: "The apostles said to the disciples, 'May our whole offering obtain salt.' They called [Sophia] 'salt.' Without it no offering [is] acceptable" (59,25–35). Petitioning for their syzygos Sophia, the apostles ask for their own salvation through a sacrament, the bridal chamber. "Offering" refers to the apostles themselves, as I see it, and they are expressing their hope: unification with the syzygos. Only in that way will they become "acceptable" offerings.[41]

Gospel of Philip 60 reveals more about Wisdom: "Echamoth is one thing and Echmoth another. Echamoth is Wisdom simply, but Echmoth is the Wisdom of death which is . . . the one which knows death, which is called 'the little Wisdom'" (60,10–20).[42] Echamoth corresponds to the more common name for Wisdom, Achamoth. "One thing" and "another"

38. See p. 218, above.
39. See p. 215, above.
40. Consult Janssens's comments, "L'Evangile selon Philippe," 99.
41. Gasparro, "Il personaggio," 260, with nn. 61–63. For additional references, see Wilson, *The Gospel of Philip*, 100.
42. The text repeats "the Wisdom of death which is," indicated by ellipsis points.

are both rendered by ⲕⲉⲟⲩⲁ, which may make it possible to doubt whether the passage really makes a distinction between two separate entities; rather, the lacking "a" in Echmoth may indicate that the "little Wisdom" forms an aspect of Echamoth.[43] Parallels emerge, then, between Echamoth/Sophia/Holy Spirit and Echmoth/"little Wisdom"/ spirit of the world. It is also worth noting that 60,10–20 follows as a logical continuation of the (previously treated) sentence: "Thus, by this one and the same breath, the fire blazes and is put out." I am therefore inclined to see the Echamoth/Echmoth passage in line with "this one and the same breath."

In the same section the "perfect man" is portrayed as harnessing the powers, here seen as domestic animals. Acting similarly, the Holy Spirit is said to rule "tame" and "wild" powers, "as well as those which are unique" (60,25–35).[44] Separated into three categories,[45] the powers are all subjected to the Holy Spirit. This hypostasis—whom W. W. Isenberg calls "he," the entity's female nature notwithstanding—is the judge deciding the fate of all three groups.[46]

Gospel of Philip 59 tells that "a disciple asked the Lord one day for something of this world. He said to him, 'Ask your mother and she will give you of the things which are another's'" (59,20–30). The unexpected gift, ἀλλότριον (better translated as "something alien," i.e., something not of this world[47]), will be given by the mother, the Holy Spirit, whom the disciple does not yet know, it seems.[48] This request reflects the petition by the apostles (to the disciples!) for salt, seen in 58, a quest for the syzygos that emerges most clearly in Jesus' prayer: "You who have joined the perfect, the light, with the Holy Spirit, unite the angels with us also, the images" (58,10–15). Here the lower, "image"-Jesus includes himself among the "us" asking for salvation.[49] The first set of syzygies is the perfect and their spouse, the Holy Spirit;[50] the second pair, images

43. Cf. Barc, "Les noms de la triade dans l'Evangile selon Philippe," 373 n. 20.
44. Compare *Gos. Phil.* 55,15–20 and 59,15–30.
45. The three-part schema recalls the previously treated oppositions to which were added the "indissoluble, eternal" ones (*Gos. Phil.* 53).
46. See Gasparro's comments on the relationship between the perfect man and the Holy Spirit ("Il personaggio," 257 n. 55).
47. So Wilson (*The Gospel of Philip*, 99), and Gasparro concurs ("Il personaggio," 257), *contra* Janssens ("L'Evangile selon Philippe," 92), for whom the "alien" is a material, worldly substance.
48. Both Schenke (*Das Evangelium nach Philippus*, 44 n. 4) and Janssens ("L'Evangile selon Philippe," 92) identify the Holy Spirit as the mother.
49. Sevrin ("Les noces spirituelles," 152) feels that Jesus should not need to ask for salvation, for he has already achieved it in his tripartition as logos, angel, and human being.
50. See Schenke, *Das Evangelium nach Philippus*, 43 nn. 3–4.

and angels, has not yet been united.[51] It seems safe to say that the eucharist here is connected to the bridal chamber ritual,[52] and I suggest that the former may be a prerequisite for the latter.

Comparing *Gospel of Philip* 58 with 57 and 75 (57,1–10 and 75,15–20) and with other passages that invoke the perfect, one may conclude that the eucharist is a precondition for knowing how to harness the powers (*Gos. Phil.* 60, above) and for the begetting of spiritual children by help of transmitted grace (58–59).[53] Containing in themselves Christ and the Holy Spirit, the perfect have achieved syzygial status: they are "unique" (*Gos. Phil.* 60) and "indissoluble, eternal" (53).[54] In these beings the primordial split between Adam and Eve has been overcome, death vanquished.

5. THE EARTHLY MARRIAGE AND THE BRIDAL CHAMBER RITUAL

With respect to *Gospel of Philip* 57—and referring to 58 and 75—Ménard notes the similarity between the eucharist and the sacrament of marriage, for both the Logos and the Holy Spirit engender spiritual children.[55] The imagery in 58 particularly—where Jesus asks for "us" to be joined to the angels—evokes associations with marriage. A. H. C. van Eijk is puzzled by this passage, because the *Gospel* "nowhere else talks about the eschatological marriage as the union between the angel and its εἰκών."[56] Angel and image (εἰκών), however, quite clearly form the eschatological correlate to husband and wife in the earthly union.[57]

The *Gospel's* treatment and evaluation of earthly marriage have caused diverging scholarly interpretations. Some scholars incline toward outright denigration of material marriage as portrayed in the *Gospel of Philip*,[58] perhaps on the basis of the following passage:

51. See p. 214 and p. 222, above, for *Gos. Phil.* 63, 30–35. The angels can be seen as the children of Wisdom, the Holy Spirit.
52. A. H. C. van Eijk comments on this in "The Gospel of Philip and Clement of Alexandria: Gnostic and Ecclesiastical Theology on the Resurrection and the Eucharist," *VC* 25 (1971) 104.
53. See p. 216, above.
54. See p. 218 and 222, above.
55. Ménard, *L'Evangile*, 142.
56. Van Eijk, "The Gospel of Philip and Clement of Alexandria," 104.
57. See *Gos. Phil.* 65,20–25.
58. E.g., Schenke, *Das Evangelium nach Philippus*, 38; Sevrin, "Les noces spirituelles," 181; and G. S. Gasparro, "Aspetti encratiti nel 'Vangelo secondo Philippo,'" in *Gnosticisme et monde hellénistique* (ed. J. Ries, Y. Janssens, and J.-M. Sevrin), 394–423, e.g., 400–401.

Indeed marriage in the world is a mystery for those who have taken a wife.
If there is a hidden quality to the marriage of defilement, how much more is
the undefiled marriage a true mystery! It is not fleshly but pure. . . . It
belongs not to the darkness or the night but to the day and the light. (82,1–
15)[59]

A careful reading of this, however, does not warrant a totally negative
view of earthly marriage. To those engaged in it, their situation seems a
"mystery." This term is usually reserved for aeonic, transcendent acti-
vities and qualities, but here it appears equivalent to the "hidden
quality" of "the marriage of defilement." The veiled connection between
the two types of union is that they are both mysteries, though only one is
the "true mystery." In the last sentence one recognizes the proper imag-
ery for the world, "darkness" and "night," and for the aeon, "day" and
"light." These contrasts do not, in my opinion, represent a rejection of
earthly marriage; instead, this union forms the condition necessary for
eligibility for the bridal chamber marriage.[60]

The earthly marriage is described as a "mirrored ($\epsilon\dot{\iota}\kappa o\nu\iota\kappa\acute{o}s$) bridal
chamber" (65,10–15). From this union, one receives the powers to com-
bat the unclean spirits. Men may be attacked by female unclean spirits,
women by male ones. Obviously, the single state presents dangers,
leaving a person vulnerable to the unclean spirits, for only the mirrored
bridal chamber ensures against their advances (65,20–30). *Gospel of
Philip* 66,1–5 explicitly informs us that the presence of the Holy Spirit
protects against unclean spirits. One may therefore see the powers in 65
as impersonators of the Holy Spirit, for this entity constitutes the male
power in the female and vice versa. The Holy Spirit being one's true
spouse recalls the Spirit as Adam's partner.

Gospel of Philip 67,15–20 claims that "the image must rise again
through the image. The ⟨bridegroom⟩ and the image must enter through
the image into the truth: this is the restoration."[61] Here, image has two
referents: first and third, to the earthly spouse, and second and fourth, to
the mirrored bridal chamber. But the bridegroom can now be seen not
only as the earthly husband but also as the Holy Spirit male power
protecting his wife. Those who enter the truth "shall go in there by
means of lowly types and forms of weakness" (85,20–30). These "means"
refer to the earthly marriage and probably also to the spouse(s).

59. See also *Gos. Phil.* 64,30–35.
60. See Ménard, *L'Evangile*, 29; Grant, "The Mystery of Marriage in the Gospel of
Philip," 138; and Buckley, "A Cult-Mystery in the *Gospel of Philip*," 576–77.
61. Pointed brackets indicate translator's correction.

Returning to the imagery of fire, *Gospel of Philip* 86–87 deals with the fire that burns in worldly as well as in otherworldly marriages. Eventually put out in the worldly marriages, the fire persists in the bridal chamber. "If anyone becomes a son of the bridal chamber, he will receive the light. If anyone does not receive it while he is in these places, he will not be able to receive it in the other place" (86,1–10).[62] Again, the *Gospel* insists on accomplishments in *this* world, "in these places," in order to achieve the aeonic correlate. "In the other place" does not refer to any post-mortem goal but to the ritual occasion of the bridal chamber wherein the partakers create the aeon *in place* of the world (86,10–15).

S. Giversen allows that the bridal chamber metaphor may connote a ritual act, "an evaluation of marriage as sacrament."[63] Could there be some kind of carnal activity in this ritual? E. Segelberg and H.-G. Gaffron say no.[64] Gaffron, in particular, has no high esteem for any gnostic ritual, and he asserts that the bridal chamber sacrament belongs to the moment immediately before death.[65] This thesis has not found much support. If Jesus' kissing Mary Magdalene alludes, as I think it does, to some secret activity in the bridal chamber, the possibility of a "carnal" ritual does not seem precluded.[66] The bridal chamber ceremony aims at restoring the primordial unity of Adam and Eve: their division, which led to death, is now overcome (68,20–30).

Another section explicitly connects the reuniting with the bridal chamber:

> If the woman had not separated from the man, she would not die with the man. His separation became the beginning of death. Because of this Christ came to repair the separation which was from the beginning and again unite the two, and to give life to those who died as a result of the separation and unite them. But the woman is united to her husband in the bridal chamber. Indeed those who have united in the bridal chamber will no longer be separated. Thus Eve separated from Adam because she was never united with him in the bridal chamber. (70,5–25)[67]

62. For "son of the bridal chamber," see Ménard, *L'Evangile*, 125.

63. Giversen, *Filipsevangeliet*, 24; compare Ménard, *L'Evangile*, n. 60, above.

64. E. Segelberg, "The Coptic-Gnostic Gospel According to Philip and Its Sacramental System," *Numen* 7 (1960) 198; and Gaffron, *Studien*, 213.

65. Gaffron, *Studien*, 218 and 225. See Buckley, "A Cult-Mystery in the *Gospel of Philip*," 576, for a brief discussion of Gaffron's theory; and consult Sevrin, "Les noces spirituelles," 165 and 186–88.

66. See my treatment, pp. 215–18, above; and note Gaffron, *Studien*, 109–10, saying that the bridal chamber is the only sacrament termed μυστήριον.

67. See p. 219, above. E. Pagels discusses this passage in "Adam and Eve," 164. (The reference there is given incorrectly; it should be to *Gos. Phil.* 70, not 78–79.) In the light

"Woman" and "husband" here refer to the spouses on two levels: to material wife and husband and to image and angel. The *Gospel of Philip* deliberately uses the terms for the earthly spouses in order to convey what cannot really be revealed, for the bridal chamber ritual secrets must remain secrets.

The two marriages correspond to other patterns of complementary opposition in the text, such as the Holy Spirit/spirit of the world, angel/image, Adam/Eve. For all these, unification is the goal, and thus the earthly marriage finds its higher image in the bridal chamber sacrament. Dualistic schemes are necessary in the world, but both world and its patterns are temporary. The aeonic goal is a third, unique state beyond the oppositional models.

One of the elements in this pattern, however, appears sometimes to be the envisioned destination: Adam both belongs in the oppositions and, when united, embodies the third state. This seems to be the case with the Spirit too. But here there is a difference, for the Holy Spirit's aim is to become simply "Spirit," devoid of her attributes "Holy" or "of the world." The third element—"simply Spirit," united angel and image, and joined Adam—does away with the dualistic scheme and encodes the salvific state. The *Gospel of Philip* intriguingly juggles both dualistic and tripartite patterns only to abolish both in the end.[68]

The most obvious company of three is, of course, the trinity, frequently evoked in the text. But the *Gospel of Philip* warns that the names of the trinity members give rise to misunderstanding, for people fail to perceive the reality behind the names (53,20—54,10). When Gaffron attempts to distinguish the Holy Spirit as trinity member from the entity's role as syzygos,[69] he misses the *Gospel's* clever play on the Holy Spirit's varied functions.

Gospel of Philip 59 reveals, "'The Father' and 'the Son' are single names, 'the Holy Spirit' is a double name. For they are everywhere: they are above, they are below" (59,10–15). Then, the Holy Spirit is specifically singled out (in 59,15–30) as being below and above, "in the revealed" and "in the concealed." She is set apart from the others by her double name, which conveys double nature, "Holy" and "of the world."[70]

of Eph. 5:32 and other documents, Pagels sees *Gos. Phil.* 70 as referring to Jesus and the church, an interesting but to me unconvincing thesis.

68. E.g., *Gos. Phil.* 60,15–35 (see p. 226, above). The tripartition (*Gos. Phil.* 66,5–25) is of a different kind, for here the evaluation of the third element is the most negative.

69. Gaffron, *Studien*, 180–81.

70. See Ménard, *L'Evangile*, 222; Gasparro, "Il personaggio," 258–59; and Barc, "Les noms de la triade dans l'Evangile selon Philippe," 372–73. (*Gos. Phil.* 56,1–15 also speculates on Jesus' various names.)

Aiming to render dichotomous entities equal by uniting them (*Gos. Phil.* 67,30–35), the Lord may indeed include the double-named, double-natured Spirit in his salvation program. Her previous epithets "Holy" and "of the world" can be compared to the varied appearances of Truth in *Gospel of Philip* 67.[71]

The Spirit's oppositional roles come to an end at the completion of the salvation work, that is, when the human being/Adam/Jesus is united to the Spirit. Like the children of the bridal chamber who all share *one* name, the Spirit too will become one: Echmoth merges with "Wisdom simply." As noted, the unification takes place both between a higher and a lower aspect of the same entity, and between entities of apparently opposite genders. These two metaphors, however, cover *one* unification, so that there is no question of two kinds of mergings. It is in the bridal chamber, by human action, that the redemption comes about, *in this life.*

One may add another identity for the Spirit in her "spirit of the world" aspect, namely, that of the male and female unclean spirits preying on humankind. The presence of the Holy Spirit deters these attacks, which means that the Spirit is in combat with herself, her "Holy" part opposed to her lower one. The presence of the higher prevents the lower from advancing and conquering. As long as the Spirit remains set against herself, world, winter, and death reign. But Jesus' activities with his syzygy produce spiritual life and healing for the partners and show the way for the human beings in the bridal chamber sacrament.

71. See p. 212, above.

Response to "'The Holy Spirit is a Double Name': Holy Spirit, Mary, and Sophia in the *Gospel of Philip*" by Jorunn Jacobsen Buckley

Dr. Buckley's essay is part of her book *Female Fault and Fulfilment in Gnosticism* (1986). The chapter she presents here is called "The Holy Spirit Is a Double Name." The arguments used by her are undoubtedly related to the context of the new book, with which I am not acquainted.

So far as I understand her essay, she is trying to give reasons for the following two statements:

1. The three female figures of the *Gospel of Philip*—Spirit (Pneuma), Wisdom (Sophia), and Mary—can all be correlated to each other, including their double meanings, that is, the spiritual as well as the earthly. There is no strict separation between them, because the system underlying the *Gospel of Philip* is a dynamic, not a static, one (p. 212).

2. The earthly or worldly realization of the unity between the separated sexes (male and female) has taken place according to the *Gospel of Philip* in the ritual of the "bridal chamber." This is not only a spiritual performance, metaphor, or eschatological sacrament, but ritual practice. The bridal chamber ritual aims at such "pre-paradisial" unification by providing spiritual rebirth for the partakers (p. 213). Dr. Buckley thinks that the possibility of a "carnal" ritual (such as a *hieros gamos?*) should not be precluded (pp. 225). Like the earthly marriage, the ritual for restoring the primordial unity of Adam and Eve has a sacramental value, probably connected with the kiss mentioned twice in the text. Behind this "unification" ritual stands the idea of two independent integrations: that of the human being (male/female) and that of the split of the female entity, Holy Spirit-Sophia-Mary. In the enactment of the bridal chamber "the world has become the aeon" (86,13–15), that is, the world with its

divisions has been abolished (p. 213). By responding to these assertions, I am not delivering a counteressay in order to try to pick holes in Dr. Buckley's arguments. It should be very easy to point out some misunderstandings or misinterpretations of the *Gospel of Philip* which I found in reading the essay. Nevertheless, I appreciate the new investigation undertaken by her, since it opens a fresh discussion of the very difficult and intriguing sections of the so-called gospel. There is, as you know, no full agreement in the scholarly world about the character, purpose, and especially the sacramental system of this Coptic text from Nag Hammadi (Codex II 51—86). Let me choose some of the main problems in connection with Dr. Buckley's presentation, with special attention to the discussion to follow. I would like to make four statements clarifying the problems of the related texts or sections of the *Gospel of Philip*.

1. THE LITERARY FORM OR GENRE OF THE
GOSPEL OF PHILIP

I think Martin Krause, Hans-Georg Gaffron, and recently D. H. Tripp are right to designate the *Gospel of Philip* as a kind of homily or homiletic treatise.[1] It is not a collection of sayings like the *Gospel of Thomas*; rather, it is a collection of instructions for the purpose of a homiletic discourse. It gives "deeper," "spiritual" understanding of gnostic-Christian (semi-Valentinian) interpretation of sacraments (foremost) or ritual performances. Tripp called it "an example of sermon notes" with a "retreat-address" style.[2] His demonstration of the practical purpose is convincing, especially if one looks at the closing part (*Gos. Phil.* 77—86). The same is true if one reads the entire text and its sacramental sequence along the same line as a "model of spiritual progress."[3] "'Philip' sees the sacramental initiation of the true Christian as a model of the possibility of this growth, and therefore also as a proof of the need to experience this growth, lest the believer remain on the common-or-garden level (what the Gnostic known to Irenaeus called the *katholikos* level, *Adv. haer.* 3.15.2)." Included is the polemic tone against official Christian

1. M. Krause, "Das Evangelium nach Philippos," *ZKG* 75 (1964) 181; idem, "Das Philippusevangelium," in *Die Gnosis* (ed. W. Foerster), 1:93; idem, "The Gospel of Philip," in *Gnosis* (trans. and ed. R. McL. Wilson), 77; H.-G. Gaffron, *Studien*, 13ff.; and D. H. Tripp, "The 'Sacramental System' of the Gospel of Philip," *Studia Patristica XVII* (ed. E. A. Livingstone), 1:251—60.
2. Tripp, "The 'Sacramental System,'" 251. See also W. W. Isenberg in the introduction to his translation of the text in Robinson, *Nag Hammadi Library*, 131.
3. Tripp, "The 'Sacramental System,'" 253ff.

theology and the church. The people addressed by the author are a closed community, more an "elite" group than simple Christian-gnostics: it is *harte Speise* ("heavy food") for the believers of this branch of Gnosticism (Valentinianism).[4]

2. PHILOSOPHY OF NAMES

A "master key" for understanding the entire homily is its "language theory" or "philosophy of names." This is a topic that I very much missed in the essay of Dr. Buckley. Klaus Koschorke has written one of the best articles on the *Gospel of Philip* on this topic.[5] Many problems of understanding can be solved by looking at that side of the gospel. Koschorke writes: "Ambivalenz kennzeichnet durchgehend die Denk- und Ausdrucksweise des PhEv" ("The entire thinking and phraseology of the *Gospel of Philip* is marked by ambiguity").[6] The fundamental statement, like a hermeneutical principle of the *Gospel*, is made in 53,23—54,5:

> The names that are given to worldly (things) contain a great error. For they turn away their heart from things that are firmly established to those that are not firmly established. And he who hears "God" does not perceive what is firmly established, but he has perceived what is not firmly established. So also with the "Father" and the "Son" and the "Holy Spirit," and "life" and "light," and the "resurrection" and the "church" [and] all other (names): they do not perceive things that are firmly established but they perceive those that are [not] firmly established unless they have learned the things that are firmly established. The na[mes which are heard] are in the world [to deceive]. If they were in the aeon, they would not be named in the world on any day, nor would they be put among worldly things. They have an end in the aeon. . . . The truth has brought forth names in the world for our sakes, because it is impossible to learn it without names. One and only is the truth. It is manifold, and (that) for our sakes, to teach this one alone (or: who learn this one alone) in love through many.[7]

In 54,18–31 the author points out that the archons wanted to deceive man and introduced wrong (false) names: "they took the name of those that are good (and) gave it to those that are not good, that they might deceive him by names and that they might bind them to those that are not good." For in the *Gospel of Philip*, the problem of gnosis (or knowledge) and salvation is set forth as a problem of names given in

4. For more about this, see Krause, in *Die Gnosis* (ed. Foerster), 76.
5. K. Koschorke, "Die 'Namen' im Philippusevangelium," *ZNW* 64 (1973) 305–22.
6. Koschorke, "Die 'Namen,'" 310. Here Koschorke quotes (n. 10) the similar statement by Janssens, "L'Evangile selon Philippe," 111.
7. Translation according to Krause, in *Gnosis* (ed. Foerster; trans. and ed. Wilson), 79f.

different ways to worldly things in contrast to the only one of truth. Unity stands against diversity, one name against many names or languages (56,4–13), one revelation against many appearances (62,7–17; 57,28—58,14) and many sacraments or signs (images) (63,21–25; 74,12–22). There is a loss of orientation in this world. Our traditional names and notions are not able to catch the truth or the true nature of the object because they are confusing and infected with the error of the ruling powers of the cosmos. Therefore the notions of darkness and light, death and life, right and left are not real contrasts, since they are brothers one of another (53,14–23). They are only relative designations without any value before the real one, the reality of truth. "In this world there is no good and evil. Its good things are not good and its evil things are not evil. But there is evil after this world which is truly evil." Before the revelation of the truth there is no real death or life, and a blind man and one who sees are not different from one another, both being in the darkness. "When the light comes, then he who sees will see the light, and who is blind will remain in darkness" (63,30—64,5). According to the *Gospel of Philip*, language consists of:
•ἀντίτυποι, counterparts of the truth, and
•weak and despised manifestations of the truth.

The use of it depends on the content of the true revelation and on the relation of the truth to the body or matter in the shape of signs, types, and images. Behind that stands a new understanding of matter and body (cf. 77,2–7: the purity of the body [σάρξ] depends on the holiness of the man, and receiving the sacraments as worldly "manifestations" or "images" of the truth).

The polemic of such a dialectical argumentation is directed against the official church and its understanding of Christian tradition. Each of the names or notions, such as body, spirit, resurrection, God, Jesus, and so forth, are paradoxical designations carrying different meanings in proportion as one looks at them from the hidden reality of truth or from the view of worldly life and understanding. The latter is represented for the author by the official church which uses wrong, false notions and names in order to confuse the believers. The church is keeping the archontic *Namensverwirrung* ("confusing of names")[8] in its terminology and traditional vocabulary. Behind the arguments of the *Gospel of Philip* stands its polemic against the official Christianity of the masses. From the view-

8. Koschorke, "Die 'Namen,'" 319.

point of the gnostic author, he tries to differentiate between the official, open, and the hidden, mysterious, meaning of the tradition, that is, destroying the error of the archons by rectifying the true use of our notions or names.

3. FEMALE FIGURES

Actually, we should do the same for our intention, namely, talk about the female figures in the *Gospel of Philip* in order to understand one side of the treatise. It is right to say that the three female names, Mary, Sophia, and Pneuma (Spirit), are only expositions or manifestations of the female part of the pleroma which very often is stressed in gnostic tradition. The diversity of them in our text depends, I think, on the diversity of names used in this world. Thus far Dr. Buckley is correct to say that they represent one reality with interchangeable figures playing their roles on earth. This is particularly true concerning the three Marys and the two Sophiae; it is more difficult to claim for the relation or identification of the several forms of Spirit (Pneuma).

3.1. Mary, Marys

The *Gospel of Philip* knows of three figures called Mary: (1) the mother of Jesus (Mary the virgin); (2) his sister (actually maybe it means the sister of his mother, according to John 19:25: Mary, wife of Cleopas; or, according to Matt. 27:56, the mother of James and Joseph, the so-called "other Mary"; but Epiphanius, *Haer.* 78.8; *Ancoratus* 60, reports on one of Jesus' sisters with the name Mary);[9] and (3) Mary Magdalene, the companion or consort of Jesus (59,6–11). All of them were always walking with Jesus Christ (ibid.). In the Gospel of John 19:25, the three were standing near the cross.

Mary Magdalene represents the female part *(koinōnos)* of Jesus, since unity consists of both only, male and female, and Jesus is bringing and practicing the primal unity of the sexes. In 63,30—64,5, Sophia as "mother of the angels" runs parallel to Mary Magdalene, who is loved by Jesus more than (all) the disciples; "he kissed her [often] on her [mouth]." It may be that this kissing was the pattern of the ritual kiss performed in the community, but to my mind it has nothing to do with the ritual of the bridal chamber. The close relation of Jesus to Mary Magdalene is also reported in the gnostic *Gospel of Mary* (BG 8502,1).[10]

9. Cf. E. Hennecke and W. Schneemelcher, *New Testament Apocrypha*, 1:418.
10. Cf. D. Parrott, *Nag Hammadi Codices V.2–5 and VI with Papyrus Berolinensis 8502, 1 and 4*, 453–71; and J. M. Robinson, *Nag Hammadi Library*, 470–74.

Mary, the mother, is called the virgin not defiled by the archons (powers) and not conceived by the Holy Spirit, because no woman conceives by a woman, that is, by the *pneuma* or (Aramaic) *ruha* (55,23–36). Here we can compare *Hypostasis of the Archons* (NHC II,4) 92,2–3, but that passage is related to Eve, not to Mary. That Mary the virgin is said to be "barren" reminds us of the same designation of Sophia in 59,31—60,1 (like 63,30—64,5). According to the above-mentioned "language philosophy" of the author, she is called "Mother of the angels" at the same time that Mary the virgin is the mother of Jesus. Here we touch the paradox of beyond and below.

3.2. Sophia

Next is Sophia, or "wisdom." It is well known that the *Gospel of Philip* (like the Valentinian school) knows two Sophiae. According to 60,10–15, they are called Echamoth and Echmoth (i.e., Hebrew or Aramaic for "wisdom"); the first one "is simply the Sophia," the last "is the Sophia of death" or "the little Sophia." She is the one who is living outside the pleroma and is involved in creation and death (therefore she is called by some Valentinians the "lower Sophia" [Irenaeus *Adv. haer.* 1.21.5]). But there is no other reference to the double role of Sophia in our text; therefore it is not clear which kind of Sophia, mentioned in 59,27–31 and 63,30—64,5, she is to be. In both sections she is called "barren"; in 63,30–64,5 "mother of the angels," which means that she is the Sophia who is responsible for the creation of the archons through her son, the demiurge (cf. Irenaeus *Adv. haer.* 1.11.1). In this case she is the "little Sophia," standing outside the pleroma and living in the Ogdoad. Apart from the relation of "barrenness" to salt, or wisdom to salt, her identification with "salt" in 59,27–31 reminds me of her role as origin of the "light seed," representing the spiritual part of world and mankind.

3.3. Spirit, Holy Spirit

Much more is reported in the *Gospel of Philip* on Spirit (*pneuma*) and "Holy Spirit" (ⲡⲡ̅ⲛ̅ⲁ ⲉⲧⲟⲩⲁⲁⲃ). As Dr. Buckley has pointed out, the Holy Spirit has its double role too, as does Sophia; as we know, both are called "barren." In 59,11–18 (in distinction to the "single names" of the Father and the Son), her "double name" is related to her situation as being everywhere: above, below, in what is hidden, in what is manifest. According to 60,15–33, the Holy Spirit is the ruling power of the cosmos: "It (she) shepherds everyone and rules (all) the powers, the 'tame' ones and the 'wild' ones, as well as those which are unique." It (she) secretly brought about everything through the archons as it (she) wished (55,14–

19). It (she) blinded the evil powers which are serving the saints or Gnostics whose mother is the Holy Spirit (59,6–11). If they have it (her), no unclean spirit would cleave to them; they are protected by it (her) (65,1—66,4). The same spirit *(pneuma)* leads those who have gone astray and those who have received salvation (60,6–9).

Most of the references to the Holy Spirit are connected with the sacraments, that is, with baptism, the eucharist or last supper, and the anointing. The Holy Spirit is delivered through baptism (64,22–31), in order to give rebirth (69,5–8). In 77,7–15, this act is compared with the coming of the summer in contrast to the "worldly spirit," who makes the winter come. The anointing or chrism delivers the Holy Spirit, too, apart from light, resurrection, and cross (74,12–22). The blood (wine, water) of the eucharist is the Holy Spirit, while the flesh (bread) is the *logos* (56,26—57,19). The "cup of prayer" is full of the Holy Spirit and belongs to the wholly perfect man, who is received by drinking the cup (75,14–21). In the "prayer of Eucharist," Jesus has said, according to 58,11–14: "You who have joined (or united, ϩⲱⲧⲣ̄) the perfect, the light, with the Holy Spirit, join (unite) the angels with us also, the images." A similar statement is made, as we shall see, in connection with the bridal chamber (65,1—66,4).

Some sections in the *Gospel of Philip* dealing with Adam and the Spirit are part of the anthropological speculations. So according to 70,22–34, Adam's soul *(psychē)* came into being out of (from) a breath (ⲛⲓϥⲉ) which is the same as spirit *(pneuma)* and is called his mother, who replaced his soul *(psychē)*, "thus he was united to the spirit *(pneuma).*" But the powers separated him from this spiritual union and thus they perverted the spiritual or symbolic bridal chamber by defilement of men (70,22–34). Adam was born of two virgins: the spirit *(pneuma)* and the "virgin earth" (ⲡⲕⲁϩ ⲙ̄ⲡⲁⲣⲑⲉⲛⲟⲥ). But Christ was born of only one virgin, that is Mary (71,16–21). The soul *(psychē)* and the spirit *(pneuma)* came into being out of water and fire, but out of water and fire and light the "Son of the Bridal-chamber" (ⲡϣⲏⲣⲉ ⲙ̄ⲡⲩⲙⲫⲱⲛ) [came into being] (67,2–9). Fire is compared with the oil or chrism (anointing), but it is light as well. (As in 57,22–28, there is a hint at anointing as used in the bridal chamber.)

3.4. Eve

Only twice is Eve mentioned in our text (68,17–26 and 70,17–22). She was a part of Adam in primordial times when there was no death. After her separation from Adam, death arose. The final completion, pre-

figured either by Christ and Mary Magdalene or by the perfect ones and the virgins, would destroy death again. Curiously, there is an assertion in 70,17–22 that Eve was not united with Adam in the bridal chamber and there she separated from him. "But those who have been united in the 'bridal chamber' shall no longer be separated," that is, they shall not die. Obviously Eve is not a favored model, because her separation from Adam had disastrous effects for humankind (cf. 70,9–17).

As we can see, the *Gospel of Philip* is full of sexual terminology, for example, "union" and "intercourse" (78,25—79,13; 70,9–17; 61,20–35). Behind it stands, I guess, the interrelationship between the worldly images and types and the pattern beyond. An important part of this relation is the female side of the cosmos which is separated from the male side on earth but which is (temporarily) united in some places (such as in the earthly marriage or bridal chambers) and again in the world that is to come.

4. THE BRIDAL CHAMBER

The so-called bridal chamber is one of the vexed problems of the *Gospel of Philip*. Looking at the sacramental expressions in general, we have to keep in mind that the author is arguing from the viewpoint of sacramental practice but is gaining a new understanding of it (cf. 77,2–7). Compared with the unity of the undivided truth, there are many sacraments that are only "types" or "images" (*eikones*), the so-called "forms of weakness" (85,5), not the truth itself. "Truth did not come into the world naked, but it came in types and images. It (the world) will not get it in any other way" (67,9–27). Every type and image or sign has a real counterpart in the world beyond or is related to the undivided, monistic truth. "It is fitting that the bridal chamber and the image (of it) through the image enter the truth which is the restoration" (67,16–18). Therefore, partaking in the sacraments means getting the truth temporarily (cf. 74,12–22, 25–36). The author of our text tries (as in the other topics) to differentiate between the official or false understanding or appropriation and the hidden, mysterious or real conception (76,17–22; 74,12–22, 25–36). Not until death will the believer or Gnostic receive the proof or certainty that he obtained the true, real sacrament and its effect.

Concerning the bridal chamber, either ⲚⲨⲘⲪⲰⲚ or ⲠⲀⲤⲦⲞⲤ is used, three times in a special context *koitōn* ("bedroom"). Most of the instances are quoted in the last part of the text (from 65 to the end). Reading the relevant passages deeply, we can state the following facts:

a. There are two bridal chambers, the "great" or superior one and the earthly or "image-like" ('mirrored') bridal chamber (ⲡⲛⲩⲙⲫⲱⲛ ⲛ̄ϩⲓ-ⲕⲟⲛⲓⲕⲟⲥ; 65,1—66,3; 67,2–9; 69,14—70,4; 70,22–34; 71,3–15).

b. The "great bridal chamber" (ⲡⲛⲟϭ ⲙ̄ⲡⲁⲥⲧⲟⲥ) is (according to 71,3–15) revealed by the Father of the All (or: he appeared in it, ⲁϥϭⲱⲗⲡ ⲉⲃⲟⲗ) on the day when he was united with the virgin (i.e., Sophia) and his body *(sōma)* came into being, that is, his manifestation in a shape took place; probably that refers to Christ (cf. 67,2–9, where the "Son of the Bridal Chamber" came into being out of water, fire, and light). Jesus Christ established the All *(plērōma)* in it (John 1:3?). "It is fitting that each one of the disciples enters his rest" (71,14–15). Here, we see, the bridal chamber is a part of a special name of the pleroma or world of light. Therefore the members of the true race, the seed of the "Son of Man" (Jesus), are called "Sons of the Bridal Chamber" (ⲛ̄ϣⲏⲣⲉ ⲙ̄ⲡⲛⲩⲙⲫⲱⲛ; 76,5–6). In the bridal chamber the Father gave to Jesus, who is also called "Son of the Bridal Chamber," resurrection, light, cross, and the Holy Spirit (74,12–22). In all of these cases "bridal chamber" means a supermundane world of light, the Pleroma (All: ⲡⲧⲏⲣϥ̄). It is named after the special place of the Jerusalem temple "the holy of the holies" (69,14—70,4 and 84,14–23) which is hidden, beyond our imagination. It is the holiest place of the heavenly Jerusalem. In the same way the expression "bedchamber" *(koitōn)* is used for the place beyond, for the "[un]alloyed (unmixed) light," the "secret of truth," the perfect glory, the Power that exalts powers, and so on (84—86).

c. In contrast to the foregoing heavenly or spiritual bridal chamber, the worldly one was introduced by the evil powers (the archons), according to 70,22–34. It gave them the opportunity to bring defilement with it or in it (70,22–34). Therefore the worldly marriage is defiled and became its "image in the defile[ment of appearance]" (64,37—65,1). The children of the (worldly) marriage are ministered to by the "children of the (unseen) bridal chamber" (72,21–22). "If the marriage of defilement (ⲡⲅⲁⲙⲟⲥ ⲙ̄ⲡⲭⲱϩⲙ) is hidden, how much more is the undefiled marriage a true mystery. It is not carnal but pure. It does not belong to lust but to the will. It does not belong to the darkness or the night, but it belongs to the day and the light" (82,4–10; cf. 85,29—86,4). Here one can see how a devaluation of the earthly marriage is stated, and that the author only applied the notion "marriage" in order to explain the "mysteries" of the hidden and expected union of the sexes in the eschatological future.

d. Now to the ritual meaning of the term. There is no doubt that

"bridal chamber" is also an expression of a ceremony or part of one. This is clearly stated in 67,27–30, where the Lord established it together with baptism, anointing (chrism), eucharist, and redemption (ⲥⲱⲧⲉ). The bridal chamber is said to be superior to the other sacraments, like baptism (69,14—70,4; 74,12–22). But what we do not know is the content of the ritual or sacrament. There are only some hints at the performance, its meaning and its effect:

- It has to do with anointing (74,12–22) and fire (67,2–9; 57,22–28; see pp. 234–35, above).
- It has to do with redemption (ⲥⲱⲧⲉ; 74,12–22).
- It has to do with restoration (67,2–9; cf. also 67,27–30).
- It is only appointed to "free men and virgins" (69,1–4, where beasts, slaves, and defiled women are excluded from the bridal chamber).
- It is said that the believers or "images" should rejoin (unite) the angels (65,1—66,4; cf. the "prayer of the eucharist" in 57,28—58,14, above, p. 234).
- This will take place in the "perfect marriage" after death, performed not at night (like the earthly marriage) but in daytime and in the light (85,29—86,4; cf. 81,34—82,26).

Important is the saying in the last section of the gospel (86,4–7): "If someone becomes a child of the bridal chamber, he will receive the light. If someone does not receive it while he is in these places, he will not be able to receive it in the other place." This leads us back to the questions of the performance of the ritual on earth. There are several explanations and possibilities. One of them is treated by Dr. Buckley (is she thinking of a kind of *hieros gamos?*). Hans-Martin Schenke[11] connected the ceremony with the kiss, mentioned in 58,33—59,6 and 63,30—64,9 (but without reference to the bridal chamber). Hans-Georg Gaffron, who wrote the most comprehensive study on the topic, interprets it as a ceremony performed at the end of life, shortly before or after death, like the well-known "apolytrosis" ritual of the Valentinians (according to Irenaeus *Adv. haer.* 1.21.5) or the *massiqta* of the Mandeans. Tripp[12] denies there is a special ceremony of the bridal chamber and identifies it with the eucharist as a kind of anticipation of the final union (see above, 57,28—58,14).

I personally believe that the bridal chamber as a ritual was neither a

11. J. Leipoldt and H.-M. Schenke, *Koptisch-gnostische Schriften aus den Papyrus Codices von Nag Hammadi*, 38.
12. Tripp, "The 'Sacramental System,'" 256f.

sort of *hieros gamos* nor a kiss. Until now the only interpretation that convinces me is that of Gaffron, since without any doubt the term is strongly related to the pleroma, to the desired goal of the Gnostics, to the heavenly wedding feast, to the reunification of the images (i.e., the believers) and the angels, of the female and the male as "virgins and 'free men,'" like the Father of the All and his virgin Sophia or like Jesus and his consort, the virgin Mary Magdalene. Perhaps the bridal chamber ritual is the lifelong practice of the "free men" and the "virgins" living together in one community but without marrying, as do couples of the world. Such "spiritual marriages" are well known in early Christianity, particularly in encratic circles and among cenobites. According to the *Gospel of Philip*, the bridal chamber is described as a protection against the behavior of unclean male and female spirits who are trying to defile the perfect ones (65,1—66,4; 81,34—82,26). And it is a weapon for an unchecked journey to heaven as well. The realization of the eschatological approach begins in this world, that is the full meaning of the term discussed.

Virginity and Subversion:
Norea Against the
Powers in the *Hypostasis*
of the Archons

The texts of Nag Hammadi demonstrate clearly that gnostic literature abounds in images of sexuality and gender. Most scholars agree that these images served as powerful vehicles of gnostic expression and that they had a variety of meanings in gnostic thought and practice. Yet beyond the recognition of variety in these uses of gender imagery,[1] there appears to be little agreement on precisely how this imagery functions and what it signifies in Gnosticism generally or in individual texts.

This essay seeks to address the question of the significance of gender imagery in Gnosticism by focusing on an individual text: the *Hypostasis of the Archons*.[2] This remarkable text offers a retelling of the primordial myth of Genesis as a story of confrontation and subversion.[3] At the center of the drama is the conflict between the Archons, or Rulers, of this world and Norea, the virginal daughter of Eve. The dramatic account of

1. Michael Williams (in his essay "Variety in Gnostic Perspectives on Gender," in this volume) has clearly illustrated the diversity in gnostic uses of gender imagery and argued effectively for a methodological program which attends to the significance of gender in *specific* texts before constructing a *general* account of gender in Gnosticism. On these points I stand in complete agreement with Williams; on the significance of gender imagery in individual texts, such as the *Hypostasis of the Archons*, we take somewhat different perspectives, as is shown below.

2. *Hypostasis of the Archons* 86,20—97,23. All citations of the Coptic text are taken from the edition of B. Layton, "The Hypostasis of the Archons," pt. 1 *HTR* 67 (1974), 351–425, with commentary and notes in idem, "The Hypostasis of the Archons," pt. 2 *HTR* 69 (1976), 31–101. See also B. Barc, *L'Hypostase des Archontes*.

3. This description of the *Hypostasis of the Archons* as a "story of confrontation and subversion" represents a deliberate alternative to Michael Williams's description of the *Hypostasis of the Archons* as "a story of escape." Though we agree that the myth focuses on the struggle between the "Rulers" and the "spiritual children of Adam and Eve," we disagree on the center and purpose of the narrative's depiction of that struggle.

their confrontation explicitly discloses the true reality or nature *(hypostasis)* of the Archons, as it reveals the power of Norea against the archontic powers that would dominate her.

Previous studies have demonstrated that the retelling of Genesis in the *Hypostasis of the Archons,* as in other gnostic texts, characteristically "inverts" the meaning of Genesis and other exegetical traditions on which it draws.[4] This essay builds on these studies and grounds its analysis of the characters, action, structure, and gender imagery of the *Hypostasis of the Archons* in a view of the nature of mythic narratives adopted from Paul Ricoeur's analysis of biblical narrative.

Ricoeur offers a hermeneutical perspective on the "world" of biblical narrative that may prove useful to the interpretation of gnostic myth. In Ricoeur's analysis, biblical narrative creates a possible world and invites its readers imaginatively to enter that world and thereby expand their sense of their own possibilities and their own world. "Texts such as this," Ricoeur writes of biblical narratives, "do not exhaust their meaning in some functioning which is purely internal to the text. They intend a world which calls forth on our part a way of dwelling there."[5] The meaning of the text thus does not lie "behind the text," but "in front" of it, "in a way of being in the world which the text opens for us."[6]

In Ricoeur's terms, it is the task of the interpreter to open up the meaning of the text by disclosing to us its world: "What has to be appropriated is the meaning of the text itself, conceived in a dynamic way as the direction of thought opened up by the text. In other words, what has to be appropriated is nothing other than the power of disclosing a world that constitutes the reference of the text."[7]

4. Scholarship on the text has illuminated the relation of the *Hypostasis of the Archons* to exegetical and philosophical traditions. See esp. the commentaries of Layton and Barc; and the essays of B. Pearson, "'She Became a Tree'—A Note to CG II, 4:89,25–26," 413–15; "The Figure of Norea in Gnostic Literature," in *Proceedings of the International Colloquium on Gnosticism, Stockholm, August 20–25, 1973* (ed. G. Widengren), 143–52; and "Revisiting Norea," in this present volume. While much attention has been paid to the gnostic inversion of biblical tradition, relatively little attention has yet been paid to literary analysis and social function of gnostic myth.

5. P. Ricoeur, "Naming God," *USQR* 34 (1979) 226. William Placher ("Paul Ricoeur and Postliberal Theology: A Conflict of Interpretations?" an unpublished paper distributed among members of the "Narrative Interpretation and Theology Group," and discussed at the Annual Meeting of the American Academy of Religion in Anaheim, November 25, 1985) alerted me to the significance of this text for the interpretation of biblical narrative, especially the parables. I am grateful to Placher for helping me to see that Ricoeur's analysis might prove more useful for the interpretation of gnostic myth than his published reflections on myth and Gnosis, such as *The Symbolism of Evil* (trans. E. Buchanan), 164–74.

6. P. Ricoeur, *Hermeneutics and the Human Sciences* (trans. J. B. Thompson), 141, 177.

7. P. Ricoeur, *Interpretation Theory: Discourse and the Surplus of Meaning,* 92. A. Y.

If gnostic myths may be described as narratives that create a "world" of meaning in which they invite their readers to dwell, the task of interpreting gnostic myth may be similarly described. Through literary analysis of the depiction of character, action, and structure in gnostic narratives, the interpreter may be able to open up the meaning of the text by disclosing its vision of the world. Such analysis can open the world of the text to its readers, as it opens its readers to the world of the text, inviting them imaginatively to adopt that world as their own. Through close analysis of gender imagery and narrative patterns in the text, but especially in the account of Norea's struggle against the Rulers, this essay attempts to offer such an analysis of the *Hypostasis of the Archons*.[8] It seeks to open up the "world" of the *Hypostasis of the Archons* and provide a new perspective on the relation between literary form and social function, between gender imagery and the "world" it helps to shape.

The analysis starts from a reading of Norea's confrontation with the Rulers as a confrontation between two modes of power, each of which has a distinctly sexual and social force. In the *Hypostasis of the Archons*, the confrontation of archontic and spiritual power is symbolized in a series of encounters in which the Rulers of this world attempt to grasp the female spiritual power. Twice their efforts take the form of attempted rape. In its representation of the struggle between the Rulers and the female manifestations of Spirit, the *Hypostasis of the Archons* creates a world in which issues of power are directly linked to issues of gender. Throughout the narrative, the Rulers display their power in efforts to dominate and defile. Norea displays her virginal power, by contrast, in the ability to resist, subvert, and rename the Archons who would falsely claim to rule Norea, her children, and the entire world.

The *Hypostasis of the Archons* can thus be read as a story of subversion and promise: the narrative depicts the subversion of archontic power by the virginal power of Norea and promises the transfer of such power to her "children." This depiction carries important implications for the reader of the text. For in creating a mythic "world," the *Hypostasis of the*

Collins (*Crisis and Catharsis: The Power of the Apocalypse,* 18–22) illustrates the usefulness of this hermeneutical perspective for the interpretation of the Book of Revelation.

8. Especially important to the development of this essay have been recent works in feminist literary criticism, esp. E. Schüssler Fiorenza, *Bread Not Stone,* and P. Trible, *Texts of Terror.* For more general discussion, see A. Y. Collins, ed., *Feminist Perspectives on Biblical Scholarship,* and E. Showalter, ed., *The New Feminist Criticism: Essays on Women, Literature, and Theory.*

Archons invites its readers to enter that world and adopt its analysis and critique of "archontic" power in the world. Similarly, it invites its readers to hear the promise to Norea and her children and to receive the "virginal spiritual power" that subverts the powers of the Archons in the mythic world of the text and, perhaps, to exercise that power of critique and subversion in their own world.

The analysis that follows is divided into four parts:[9] (1) the reality of the Rulers in the world of the *Hypostasis of the Archons*; (2) the birth and naming of Norea; (3) Norea's struggle against the Rulers; (4) the promise to Norea and her children. This analysis is followed by a concluding interpretation of the Norea narratives and of the significance of gender imagery in the world of the text and the world of its reader.

1. THE REALITY OF THE RULERS IN THE WORLD OF THE *HYPOSTASIS OF THE ARCHONS*

The world of the *Hypostasis of the Archons* is governed by the "Authorities" against whom "the great apostle" warned and about whom the narrator now writes: "[I have] sent you this because you (sing.) inquire about the reality *(hypostasis)* [of the] Authorities."[10] These are the "Authorities of Darkness" (Col. 1:13) about whom the apostle "told us, 'Our struggle is not against flesh or blood, but against the Authorities of the Cosmos and Spirits of wickedness' (Eph. 6:11–12)."[11]

With these references to Ephesians and Colossians, the prologue gives the reader a double message. On the one hand, in referring to "our struggle" against the Authorities, the prologue suggests that the Authorities have a continuing reality *(hypostasis)* against which the narrator and the readers must struggle. In this respect, the narrative may serve to inform the readers about the reality and the nature of the Authorities so they may better be prepared for the struggle that continues. On the other hand, the references to the apostle remind the attentive reader of another story and another reality: the power of God, who "delivered us

9. Because this essay is more concerned with the world of the text than the world behind the text (the world of the author and his sources), it will not be concerned with the theory that an *Apocalypse of Norea* was a source for the *Hypostasis of the Archons*. For discussion, see Birger A. Pearson's essay in this volume, "Revisiting," n. 42. Similarly, this essay is not concerned with the hypothesis of Barc (*L'Hypostase*, 45–48) that the present text is the result of two redactions.

10. *Hyp. Arch.* 86,26–27.

11. *Hyp. Arch.* 86,20–25.

from the domain of darkness and transferred us to the Kingdom of His beloved Son" (Col. 1:13).[12]

The reader may thus already know what the mythic narrative of primordial times will reveal. The reality of the Rulers is such that there continues to be a struggle, but their reality has been exposed and overcome by God. In the eschatological promise of the narrative, their "rule" will be broken; in the eschatological perspective of the Pauline text, their "rule" has been broken by God, who offers empowerment for the struggle against them.[13] The Rulers constitute a real threat, as the Pauline text implies, but the eschatological victory is, in some sense, already obtained.[14] Yet at the same time, their reality persists, the struggle continues, and the reader must be exhorted to enter the struggle, recognizing that against the spiritual power from above, the Rulers have no power.

Within the primordial world of the *Hypostasis of the Archons*, the Authorities rule the cosmos, falsely assuming it to be the only world. The chief of the Rulers, known alternately as Samael, Sakla, and Ialtabaoth,[15] appears from the beginning of the narrative as a blind god and "god of the blind."[16] Because of his power, ignorance, and arrogance, he claimed to be the only god:[17]

12. Eph. 6:10–17 focuses less than Colossians on the redemption already offered and more on the continuing struggle. It assures the reader of God's empowerment for those who heed the exhortation: "Finally, be strong in the Lord and in the strength of His might. . . . Take the whole armor of God, that you may be able to withstand (*antistēnai*) in the evil day, and having done all, to stand (*stēnai*)."

13. Barc (*L'Hypostase*, 74) sees the function of these references somewhat differently. From his perspective, the citation of the apostle "invite le lecteur chrétien à voir dans les mythes d'origine de l'homme et des Archontes, l'expression symbolique du combat spirituel dont parle l'apôtre."

14. Layton, "Hypostasis of the Archons," pt. 2, n. 1, 44: the "point is that the heavenly Rulers constitute, as Paul implies, an objectively real threat—but that against the spirit-endowed gnostics they have no power." This reading may underemphasize the extent to which the struggle is real and the reader needs to be awakened to the reality of his or her own power against the Rulers.

15. Layton, "Hypostasis of the Archons," pt. 2, n. 12, 46–47, and n. 167, 72–74. Samael (one of the principal names for Satan in Judaism from the Aramaic term for "blind") appears at *Hyp. Arch.* 87,3; 94,25–26; Sakla (the usual Aramaic term for "fool") at 95,7; Yaltabaoth at 95,8; 95,11–12; 96,3–4. Barc (*L'Hypostase*, 75–76) puts forward the view that in the first redaction, Ialdabaoth and Sabaoth were identified as the two sons of the chief Ruler. In his view, the second redactor identified Samael with Yaldabaoth, and made Sabaoth his son.

16. "Their chief is blind" (*Hyp. Arch.* 86,27); "You are mistaken, Samael (which is, 'god of the blind')" (87,3–4; also, 94,25–26).

17. On the appearance, origin, and function of this claim in gnostic myth, see N. A. Dahl, "The Arrogant Archon and the Lewd Sophia: Jewish Traditions in Gnostic Revolt," in *Rediscovery* (ed. Layton), 2:689–712.

It is I who am God; there is none [apart from me]. When he said this, he sinned against [the Entirety]. And this utterance got up to Incorruptibility, and a Voice (fem.) came forth from Incorruptibility, saying, "You are mistaken (кр̄ пλαnaсөє), Samael, which is 'god of the blind.'"[18]

This passage introduces a pattern that recurs throughout the narrative: the vain and arrogant claims of the Archons evoke a voice of rebuke from the realm of Incorruptibility. The rebuking voice from above unmasks the ignorance and error of the Rulers, shatters their assumptions, and subverts their claims to authority. This narrative pattern, like the voice itself, discloses the nature of the Rulers as blind and powerless in the face of a higher power from above and sets the stage for further action.

The interactions of the Archons and powers from above can also be described as setting a pattern of gender representation in the world of the text. The Archons appear in androgynous and specifically male forms, while the higher power from above is manifested in images, voices, and characters almost exclusively of the female gender. In several scenes, the *Hypostasis of the Archons* depicts the struggle against the Authorities as a struggle between the androgynous Archons and female manifestations of the virginal spirit from above.

In the case of the first rebuke, a voice (fem.) from Incorruptibility (fem.) projects the Image (fem.) of Incorruptibility in the waters below. Enamored of this spiritual and female Image, the Rulers vainly attempt to capture it by modeling a male human being "after their body and after the image that appeared in the waters."[19]

They said, "Come let us lay hold of it (the image) by means of the form that we have modelled, so that it (fem.) may see its male counterpart (пєцϣврєινє). . . . and we may seize it with our modelled form (пм̄пλαсмα)."[20]

The Rulers assume that the "male counterpart" will attract the female image from above. Yet because they are powerless and do not understand the force of God or the power of the Image, they are unable to make their modeled male form arise.[21]

It is only after a Spirit (fem.) from the Adamantine land comes to dwell in the human being (пршмє) that he becomes a "living soul" and receives the name "Adam, since he was found moving upon the

18. *Hyp. Arch.* 86,30—87,4.
19. *Hyp. Arch.* 87,30–33.
20. *Hyp. Arch.* 87,33—88,1.
21. *Hyp. Arch.* 88,1–10.

ground."[22] A Voice (fem.) then comes from Incorruptibility (fem.) for the assistance (ТВОНΘΙΔ; fem.) of Adam,[23] and he becomes empowered to give names to all the animals of earth and birds of heaven.

> And the Rulers gathered together all the animals of the earth and all the birds of heaven and brought them in to Adam to see what Adam would call them (ΝΑΜΟΥΤΕ ΕΡΟΟΥ), that he might give a name (ΤΡΕϤϯ ΡΑΝ) to each of the birds and all the beasts. (88,19–24)

A voice (fem.) from Incorruptibility is thus manifested a second time as a spiritual power of speech. In this appearance, however, the power of speech is not a rebuke against the Rulers but an assistance to Adam and, indirectly, to the Rulers whose creatures he names.

As the narrative continues, the Rulers bring a deep sleep of Ignorance upon Adam, and "they opened his side like a living Woman."[24] With this act, the Spirit leaves Adam and enters the woman separated from his side. She is now described as the "Spiritual Woman" (ΤϹϨΙΜΕ Ν̄ ΠΝΕΥΜΑΤΙΚΗ) and "Mother of the Living."[25] Her presence, like that of the image in the waters, arouses the Archons. They respond with their second attempt to grasp a manifestation of the female Spirit from above. In this attempt, the Rulers try to "sow their seed" (ϹΠΕΡΜΑ) in her. But the Spiritual Woman they desire leaves her carnal form behind and enters a tree.[26] The Rulers, mistaking the carnal form "stamped in her likeness" for the Spiritual Woman herself, succeed only in defiling the carnal woman left behind. "And they defiled (ΑΥΧΩϨΜ̄) the form that she had stamped in her likeness."[27] In this act of rape, the Rulers and the carnal woman conceive Cain.[28]

Upon leaving the woman, the Spiritual Woman (ϯΠΝΕΥΜΑΤΙΚΗ)[29] enters the serpent and instructs the man and woman to eat from the tree of recognizing evil and good, against the Rulers' command. This act of

22. *Hyp. Arch.* 88,16–17. Layton ("Hypostasis of the Archons," pt. 2, n. 47, 52–53) notes that this is a secondary correction and elaboration of the usual etymology of Adam's name.

23. *Hyp. Arch.* 88,17–19.

24. *Hyp. Arch.* 89,3–8.

25. *Hyp. Arch.* 89,11; 89,15.

26. *Hyp. Arch.* 89,21–31.

27. *Hyp. Arch.* 89,28–29.

28. *Hyp. Arch.* 91,11–12: "Now afterwards, she bore Cain their son (ΠΟΥϢΗΡΕ)." Layton ("Hypostasis of the Archons," pt. 2, n. 84, 60) interprets ΠΟΥϢΗΡΕ to refer to Cain as "son of the Rulers."

29. Layton's translation here, "the Female Spiritual Principle," does not obscure the gender identification of this term, but it does depersonalize this representation of the female spirit. My translation deliberately seeks to repersonalize the reference for the purposes of gender analysis.

spiritual instruction is simultaneously an act of insubordination. Upon
questioning Adam, the Rulers learn that the woman gave to him from
the tree and they curse her.[30] She in turn informs them: "'It was the
Snake who led me astray.' . . . From that day, the Snake came to be
under the curse of the Authorities; until the All-powerful Human Being
(ⲡⲧⲉⲗⲉⲓⲟⲥ ⲛ̅ⲣⲱⲙⲉ) was to come, the curse fell upon the snake."[31] The
Rulers then cast Adam and the woman out of the Garden and throw
humanity into a life of distraction and toil, so that they "might be
occupied by worldly affairs and not have the opportunity of being
devoted to the Holy Spirit."[32] In this setting, Eve gives birth first to "their
son" Cain. She then conceives with her husband and gives birth to
Abel.[33] The account of these births completes this portion of the nar-
rative and forms the transition to the Norea narratives.

Four of the themes outlined above bear directly on the representation
of gender and power in the *Hypostasis of the Archons* and prepare the
reader for the depiction of Norea's struggle against the Rulers. These are:
(1) the desire of the androgynous Rulers for the female manifestations of
the Spirit from above, taking the form of violent efforts to grasp and
rape; (2) the hostility of the Rulers toward the modeled creatures they
would dominate, but who in fact are more powerful than they; (3) the
mobility of the Spirit in its manifestations as the Voice from Incorrup-
tibility and the Spiritual Woman (both female); and (4) the spiritual
power of speech and naming.

In the Norea narrative, these themes find dramatic expression and
resolution in three crucial moments of disclosure around which the
narrative can be ordered. The first occurs around the birth and naming
of Norea; the second in the depiction of Norea's struggle against the
Rulers' attempt to rape her and subordinate her to their power; the third
appears in the eschatological promise of Eleleth to Norea and her
children. Considered together, these moments of disclosure provide
crucial insight into the significance of gender and power in the mythic
world of the *Hypostasis of the Archons*.

2. THE BIRTH AND NAMING OF NOREA

Norea's spiritual identity is signaled immediately in the account of her
birth as one of two "spiritual children" of Eve.

30. *Hyp. Arch.* 90,19–30.
31. *Hyp. Arch.* 90,30—91,3.
32. *Hyp. Arch.* 91,4–11.
33. *Hyp. Arch.* 91,13–14. Layton, "Hypostasis of the Archons," pt. 2, n. 85, 61.

Adam [knew] his female counterpart Eve, and she became pregnant, and
bore [Seth] to Adam. And she said, "I have borne [another] human being
(ρωμε) through God in place [of Abel]." Again Eve became pregnant, and
she bore [Norea]. And she said, "He has begotten on me a virgin (ογπαρ-
θεnoc) as an assistance (ñβοηθεια) for many generations of humanity."
She is the virgin whom the Forces did not defile. Then humanity began to
multiply and improve.[34]

The close juxtaposition of the births of Norea and Seth have suggested
to some that Norea may be considered "a female counterpart to Seth."[35]
In one sense, she is. The narrative sets Norea and Seth apart and points
to their relation as the "spiritual children" of Eve. Yet in another sense,
she is not. Viewed from the perspective of the subsequent narrative, the
juxtaposition of their births points even more to a difference in their
significance and to an asymmetry of gender in the text.

In contrast to other Nag Hammadi texts, especially the other members
of the "Sethian" corpus,[36] the *Hypostasis of the Archons* gives far more
attention to Norea and her children than to Seth and his seed. It is not
his birth but *hers* that captures the attention of the reader; not *his*
character but *hers* that plays the central role in the narrative. As the
narrative continues, it becomes increasingly clear that Norea is not
merely "female counterpart" to her brother Seth in this "variant" of the
"Sethian" system[37] but a female figure of greater significance and power
than her male counterpart Seth.

Within the narrative world of the *Hypostasis of the Archons*, Norea
stands apart as a figure of spiritual insight and power. Like the female
image in the waters, Norea is a figure whose spiritual significance cannot

34. *Hyp. Arch.* 91,30—92,4.

35. See esp. the comments of Birger Pearson in his essay "Revisiting Norea" in this
volume.

36. H.-M. Schenke ("Das sethianische System nach Nag-Hammadi Handschriften," in
Studia Coptica [ed. P. Nagel, 165–73], and idem, "Gnostic Sethianism," in *Rediscovery*
[ed. Layton, 2:588–616]) has argued most compellingly for a common "Sethian" system
of thought and a "Sethian" corpus of texts of which the *Hypostasis of the Archons* is a
member. The "Seminar on Sethian Gnosticism" of the International Conference at Yale
discussed and debated the hypothesis of a distinctively "Sethian" variety of Gnosticism
without coming to agreement. See *Rediscovery* (ed. Layton), 2:457–685, for the papers
and discussions of the seminar.

37. G. Stroumsa (*Another Seed*, 53–60) focuses on Norea as a female figure who
escapes from the "rapist archons." Like Pearson, Stroumsa offers a very useful
discussion of gnostic inversion, and describes Norea as female counterpart of Seth.
Such a description subordinates Norea to Seth and places the *Hypostasis of the Archons*
under the interpretive framework of the Sethian system. Close analysis of the
Hypostasis of the Archons and the texts of the "Sethian" corpus suggests instead that the
Hypostasis of the Archons turns away from the "Sethian" pattern of mythmaking and
recharges the mythic drama with a new and different kind of tension: the tension of
androgynous sexuality vs. virginity and of the power of dominance vs. the power of its
subversion.

be grasped as if she were a "counterpart" or subordinate to the Rulers, or even to her brother Seth. She stands apart, rather, as a figure who subverts such schemes of dominance and displaces the Rulers, Seth, and perhaps even our own readings from their positions of dominance in the world of the text and the world of scholarship.

In her first appearance in the text, Norea receives two epithets, from her mother and the narrator respectively, that immediately focus the reader's attention on her spiritual identity. Both recall the language of earlier scenes in the narrative, but more important, they point forward to Norea's manifestations of spiritual power in the struggle with the Rulers and in the eschatological promise to her children.

In the words of her mother Eve, Norea is "[a] virgin *(parthenos)* begotten as an assistance for many generations of humanity." In the words of the narrator, "She is the virgin *(parthenos)* whom the Forces did not defile." In identifying Norea as *parthenos,* both epithets point to her gender (fem.), her sexual purity, and her spiritual identity. Both point to her relation to divine power as they anticipate the identification of the Spirit itself as virginal in Eleleth's assurance to Norea: "Your (pl.) abode is in Incorruptibility, where the Virginal Spirit (ⲡⲡⲛⲁ ⲙ̄ ⲡⲁⲣⲑⲉⲛⲓⲕⲟⲛ) dwells."[38]

As both epithets name Norea *parthenos,* each of them refers to a specific aspect of Norea's virginal identity. The first epithet identifies the nature of Norea's spiritual identity as Assistance. Eve announces at her daughter's birth that "He (the "Father of the Entirety")[39] has begotten on me a virgin as an 'assistance' *(boētheia)* for generations of mankind." The use of the term *boētheia* recalls the "voice which came forth from Incorruptibility for the assistance *(boētheia)* of Adam."[40] It is this voice which empowers Adam to name the birds and beasts gathered by the Rulers "to see what he would call them."[41] The first epithet thus suggests that the spiritual identity of Norea is connected to the spiritual power of speech and naming.

Like the voice from Incorruptibility that assists Adam, Norea's assist-

38. *Hyp. Arch.* 93,29–32.

39. Layton ("Hypostasis of the Archons," pt. 2, n. 96, 62) resolves the ambiguity of the male pronoun by identifying the subject of the verb with the "God" through whom Seth was also begotten: the Father of all. This sets the paternity of Seth and Norea apart from that of Cain, "fathered" by the Rulers, and Abel, fathered by Adam.

40. *Hyp. Arch.* 88,17–19. Layton, "Hypostasis of the Archons," pt. 2, n. 48, 53: "Verbal communication is divine, for it is the means by which *gnōsis* will ultimately be transmitted to mankind and save them from the Rulers."

41. *Hyp. Arch.* 88,17–24. This passage represents another "inversion" of the Genesis narrative; in this case, of Gen. 2:18–22.

ance will be manifested in the power of speech and naming. Analysis of the two episodes suggests further parallels and differences. As the Voice from Incorruptibility assisted Adam, Norea will be a "voice" assisting mankind.[42] This comparison suggests further that the "voice" of Norea, like the "voice" that came to Adam, has a divine origin; even more important, it suggests that the "voice" of Norea, like the Voice that comes to Adam, will display its assisting function in the act of *naming*.

Yet alongside these similarities are important differences. In Adam's case, the voice from above comes for *Adam's* assistance. He uses the assistance in the Rulers' presence, and presumably with their approval, in naming the birds and beasts.[43] In Norea's case, it is she who is the "assistance" *and* the "voice." Even more important, unlike the voice manifested in Adam, Norea's voice will not serve Adam and the Rulers. Rather, Norea will assist many generations of humanity by using her power of speech in another, more subversive act of naming, directed not for but against the interests of the Rulers.

The object and effect of Norea's power of naming is suggested in the earliest depiction of the divine Voice and in the second epithet. In its earliest appearance, the divine Voice rebukes the Chief Ruler's claim to be the only God, thereby exposing his ignorance and projecting the female image in the waters. According to the second epithet, Norea is "the Virgin whom the Forces did not Defile." This epithet anticipates Norea's ability to retain her sexual purity, as it sets up a contrast between the virginal Norea and the carnal woman, Eve. Unlike the carnal woman, who was defiled by the Rulers,[44] Norea resists their advances and remains "the virgin whom the Forces did *not* defile."[45] This epithet, together with the earlier account of the rebuking Voice from above, sets the framework for the central drama of the text: Norea's struggle against

42. Layton, "Hypostasis of the Archons," pt. 2, n. 96, 62: "The word *boētheia*, which here refers to Norea, calls to mind the heavenly faculty of speech implanted in Adam 'for his *boētheia*' (cf. n. 48). Norea will be the 'voice' of the Divine addressed to future generations. . . . Likewise just as the 'voice' of Adam came from above, from the 'Virgin' Spirit, so Norea is a *parthenos* and thus a human replica and reminder of the Spirit above."

43. *Hyp. Arch.* 88,17–24: "A voice came forth from Incorruptibility for the assistance of Adam; and the Rulers gathered together all the animals of the earth and all the birds of heaven and brought them in to Adam to see what Adam would call them, that he might give a name to each of the birds and all the beasts." As Layton points out ("Hypostasis of the Archons," pt. 2, n. 49, 53), Adam imitates the Spirit which has just named him.

44. *Hyp. Arch.* 89,27–28: "And they defiled [it] (Eve's shadowy reflection) foully. And they defiled the form that she had stamped in her likeness."

45. *Hyp. Arch.* 93,27–32, Eleleth assures Norea: "These Authorities cannot defile you and that generation; for your (pl.) abode is in Incorruptibility, where the Virgin Spirit

the Rulers who attempt to rape her and subordinate her to their false powers.

3. NOREA'S STRUGGLE AGAINST THE RULERS

The prelude to Norea's central confrontation with the Rulers takes place at the ark. Immediately after the announcement, "Then mankind began to multiply and improve," after the birth of Seth and Norea, the narrative focuses on the Rulers' plan to "cause a deluge without hands and obliterate all flesh (sarx) from human to beast."[46] The Ruler of the Forces subverts this plan by instructing Noah to build an ark "and hide in it—you and your children (ⲛⲉⲕϣⲏⲣⲉ) and the beasts and the birds of heaven from small to large, and set it on Mount Sir."[47] When Norea comes to him (ⲁⲥⲉⲓ ⲇⲉ ⲛ̄ϭⲓ ⲱⲣⲉⲁ ϣⲁⲣⲟϥ), "wanting (ⲉⲥⲟⲩⲱϣ) to board the ark,"[48] Noah resists her advances. Norea responds with a demonstration of her power: "And when he would not let her, she blew upon the ark and caused it to be consumed by fire."[49]

Although this episode does not narrate a direct confrontation between Norea and the Forces, it points to three crucial oppositions: (1) between the Rulers and "all flesh"; (2) between the Rulers and the Ruler of the Forces (probably to be identified not with Ialdabaoth but Sabaoth), who saves Noah and his children from obliteration; and (3) between Noah, the faithful servant of the Ruler of the Forces, and Norea. This sets Norea in a context of opposition on three fronts: against the Rulers who want to obliterate all flesh; against the Ruler of the Forces, who wants to protect Noah and his children but not her; and against Noah, who wants to preserve his special status and prevent Norea from entering the ark.

Against Noah, Norea shows the superiority of her spiritual power when she consumes Noah's vessel of archontic service with her fiery breath. Immediately after this demonstration of power Norea encounters more formidable foes: the Forces who would defile her. Her response to them reveals both the source and the consequences of the

dwells, who is superior to the Authorities of Chaos and to their universe." In a note to this passage, Layton ("Hypostasis of the Archons," pt. 2, n. 135, 68) points out that the Coptic verb ϫⲁϩⲙⲉ ("defile") has previously appeared in *Hyp. Arch.* 89,27–28, but fails to mention its two important connections with the Norea epithet: the adjective *parthenikon*, here applied to the Spirit, and the use of the verb "to defile."

46. *Hyp. Arch.* 92,4–8.
47. *Hyp. Arch.* 92,8–14.
48. *Hyp. Arch.* 92,14–15.
49. *Hyp. Arch.* 92,16–18.

virginal power by which she will function as an assistance for many generations of humanity.

> The Rulers went to meet her, wishing (ⲉⲩⲟⲩⲱϣ) to lead her astray (ⲣ̄ⲁⲡⲁⲧⲁ). Their Great One (supreme chief) said to her, "Your mother Eve came to us (ⲁⲥⲉⲓ ϣⲁⲣⲟⲛ)."[50]

The words of the Rulers attempt to lure Norea, but their formulation reminds the reader of their misguided attempt to "sow their seed" in Norea's mother, the spiritual woman Eve. This points to a similarity between the episodes; but the language of this episode also reminds the reader of the immediately preceding encounter of Norea with Noah at the ark, where "Norea came to him, *wishing* to board the ark," as they "went, *wishing* to lead her astray, . . . and claimed, . . . 'She came to us.'"

Together, these connections lead the reader to see that the application of the same verb to Norea and the Rulers points to the different objects of their wishing, even as the narrative shows that opposition prevents the fulfillment of their wishes. The words of the Rulers also expose the Rulers' ignorance of their own failure to defile the spiritual woman Eve and even to recognize the difference between the spiritual Eve and the carnal woman in whom they sowed their seed.

The connections also point to the similarity and the difference of Norea and her mother. Both are *said* to come to a male figure, but the reader knows that the words of the Rulers ("Your mother Eve came to us") are false; the true mother of Norea did not in fact come to them; but Norea did come to Noah. Finally, the connections expose the inability of the Rulers to perceive the difference between the carnal and the spiritual Eve or between the carnal woman and Norea. It also shows them unable to perceive the relation between the spiritual woman Eve and Norea, or to see the nature and power of Norea, displayed so recently in the destruction of the ark.

Against their efforts to convince her, "Your mother Eve came to us," Norea confronts them in a bold confrontation and displays her power with even greater force as a power of speech.

> But Norea turned to them and said to them, "It is you who are the Rulers of Darkness; you are accursed. And you did not know my mother; instead it was your *female counterpart* (ⲧⲉⲧⲛ̄ϣⲃⲣ̄ⲉⲓⲛⲉ) that you knew. For I am not your descendant; rather it is from the World Above that I am come." The arrogant Ruler turned with all his power . . . and his countenance became

50. *Hyp. Arch.* 92,18–21.

like He became presumptuous and said to her, "You must render service to us, [as did] your mother Eve, for. . . .[51]

This exchange represents the turning point of the mythic narrative. The words of Norea represent the first human expression of the Voice from above *against* the Rulers of this world. With this bold rebuke, Norea inverts previous patterns of signification in the narrative. She names the Rulers as "Rulers of Darkness" and curses those who previously cursed Adam and Eve.[52] She corrects the Rulers' foolish claim to have *known* her mother and renames the woman they knew as their "female counterpart." This distinguishes her true mother, the Spiritual Woman, from the carnal woman they knew, but more important, it links that failure to grasp the Spiritual Woman to their previous failure to grasp the female Image that appeared in the waters by modeling a "male counterpart" for it.

In this third effort to grasp a spiritual woman, the Rulers once again fail to discern properly the spiritual woman they desire, as they mistakenly identify Norea as the daughter of "their female counterpart," the carnal woman. Against their false claims, Norea asserts her spiritual origin and demonstrates her spiritual power. Against their claims to possess her and rule her, Norea claims divine parentage for herself. They are the Rulers of Darkness; she is from the world above. Norea thus escapes the clutches of their acquisitive and domineering power by renaming them ("Rulers of Darkness") and renaming herself as one who is "from the World Above."

The Rulers would claim to have power over Norea and to make her subordinate, to have her "render service" to them. But even before the divine revelation of the Illuminator Eleleth,[53] Norea exhibits in her speech the Gnosis and power of the divine voice against the Rulers. Norea exercises her spiritual power of naming by exposing the Rulers' identity and revealing her own. In this way, the narrative discloses how she will be an "assistance" for many generations of humanity.

From the perspective of gender analysis, the Rulers' demand that Norea render them service can be read as an attempt to submit the female spiritual power to the Rulers whose nature *(hypostasis)* is mani-

51. *Hyp. Arch.* 92, 21–32.
52. Layton ("Hypostasis of the Archons," pt. 2, n. 107, 63) notes: "The Rulers' curse upon Adam and Eve (91,6) is now turned against them."
53. Pearson ("Revisiting Norea") appears to overlook the extent to which Norea has already demonstrated power before Eleleth appears.

fested overtly in their presumptuous claims to sexual dominance. Their encounter exposes their authoritarian "power" as illegitimate and ultimately powerless tyranny. At the same time, it reveals Norea's power as virginal and superior. Norea's response to the Rulers might thus be read as a rejection of false claims to dominate and subordinate the spiritual powers from above.

In the primordial world of the *Hypostasis of the Archons*, spiritual power is depicted almost exclusively as "female"[54] and archontic power almost exclusively as "androgynous" and/or "male." This should not be taken to mean that in the world depicted in this text, or in the world of the reader, spiritual power is manifest only in females and archontic power only in males. It does suggest, however, that the pattern of gender representation in the text, especially archontic efforts to dominate female spiritual characters, may correspond *symbolically* to a pattern of relations which the narrative seeks to expose and displace.

Norea's speech provides a model for subverting the claims of illegitimate power through the power of the Spirit. In renaming those powers who would dominate her, Norea frees herself from their clutches, declares her independence, and asserts her superiority to the Rulers: "I know who you are. You are the Rulers of Darkness." This strips them of their false claims to power and frees Norea to cry out in a loud voice to the God of the Entirety:

> The arrogant Ruler turned with all his power (ϩⲛ̅ⲧⲉϥϭⲟⲙ). . . . He became presumptuous and said to her, "You must render service to us, [as did] your mother Eve, for . . ." But Norea turned, with the power (ϩⲛ̅ ⲧϭⲟⲙ) of [. . .]; and in a loud voice [she] cried out [up to] the Holy One, the God of the Entirety. "Rescue me (ⲉⲡⲓ ⲃⲟⲏⲑⲉⲓ) from the Rulers of Unrighteousness and save me from their clutches—forthwith!"[55]

This summons for divine assistance *(boētheia)* brings a response from Eleleth, or "Understanding," who stands in the presence of the Great Invisible Spirit.[56] The revelation of Eleleth begins the third part of the Norea narrative and brings the third moment of disclosure: the promise to Norea and her children and the transfer of Norea's virginal power to "her children," including the reader of the text.

54. Exceptions to the female manifestation of Spirit are the Father of the Entirety, the True Human Being who is promised, and Eleleth, who reveals the promise to Norea.

55. *Hyp. Arch.* 92,26—93,2.

56. *Hyp. Arch.* 93,18–22 presents these predications as self-disclosures of Eleleth.

4. THE PROMISE TO NOREA AND HER CHILDREN

In his revelation, Eleleth asks Norea a question that appears rhetorical but is crucial to the disclosure of Norea's identity and to the meaning of the text.

> Do you think these Rulers have any power (бом) over you (sing.)? None of them can prevail against the Root of Truth; for on its account he appeared in the final ages (corrupt); and these Authorities will be restrained. And these Authorities cannot defile (naꟸ xaϩme an) you and that generation; for your (pl.) abode is in Incorruptibility, where the Virgin Spirit (пп̅п̅a м̅ parѳenikon) dwells, who is superior to the Authorities of Chaos and to their cosmos. (93.18–32)

This revelation discloses to Norea the source of the power she has *already* demonstrated in her confrontation of the Rulers. It is the Root of Truth that preserves Norea and her children against the Authorities. Their abode is in Incorruptibility where the Virgin Spirit dwells, and none of the Rulers can prevail against the Root of Truth, because it is superior to the Authorities of Chaos and their cosmos.

Norea then asks Eleleth to teach her about the Authorities and their cosmos: "How they came into being, and by what kind of *hypostasis*, and of what material, and who created them and their force?"[57] Eleleth then reveals the origin and pattern of the Rulers and their cosmos. To explain the nature (*hypostasis*) of the Rulers, Eleleth narrates events that preceded those narrated at the beginning of the text. Eleleth begins with Sophia's attempt to create something alone without her consort and continues with the shaping of this product in matter. He then returns to the vain claim of the chief Archon and moves on to the repentance of Sabaoth and the completion of the entire sum of Chaos.[58]

This placement of a narrative (the revelation of Eleleth) within the larger narrative (*Hyp. Arch.*) works as a literary device to allow Norea, and the attentive reader as well, to see more clearly the larger pattern in which Norea's struggle with the Rulers fits. The revelation places Norea's struggle with the Rulers in the larger context of the origin and genesis of the Rulers and so allows her (and the reader) to see more clearly the relation between the presumptuous claims of the Rulers against her and the manifestation of divine power against the Rulers.

57. *Hyp. Arch.* 93,32—94,2.
58. *Hyp. Arch.* 94,4—96,15.

The power of Norea's words is thus seen to be one manifestation of a pattern manifest already in the activity of Sophia, Zoe, and her mother Eve.

At the conclusion of his revelation,[59] Eleleth places these events in the larger context of the eschatological promise to Norea and her children. After three generations, he tells Norea, the spiritual seed sown in her and her offspring will become known:

> You, together with your children (ΝΟΥϢΗΡΕ), are from the Primeval Father, from Above, out of the imperishable Light, their souls are come. Thus the Authorities cannot approach them because of the Spirit of Truth present within them; and all who have become acquainted with this Way exist deathless in the midst of dying Mankind. Still that Sown Element (ΠΕΣΠΕΡΜΑ) will not become known now. Instead after three generations it will come to be known, and free them from the bondage of the Authorities' error (ΤΠΛΑΝΗ).[60]

In response to her question: "How much longer?" Norea receives the promise that "when the True Human Being (ΠΡΩΜΕ Ν̄ΑΛΗΘΙΝΟΣ), within a modeled form (ΠΛΑΣΜΑ), reveals the existence of the Spirit of Truth, which the Father has sent,"[61] then the previously hidden sown spiritual element will become known and the tyranny of the Authorities will be overturned.

The revelation of Eleleth concludes with a full account of what will happen when the True Human Being comes:

1. He will teach them about everything;
2. He will anoint them with the unction of Life eternal, given him from the undominated generation.
3. They will be freed of blind thought;
4. They will trample death, which is of the Authorities, underfoot;
5. They will ascend into limitless light, where this sown element belongs.
6. Then the Authorities will relinquish their ages;
7. Their angels will weep over their destruction;
8. Their demons will lament their death.
9. Then all the Children of the Light will have Gnosis of the Truth and their Root and the Father of the Entirety and the Holy Spirit.

59. *Hyp. Arch.* 94,2—96,17.
60. *Hyp. Arch.* 96,17–28.
61. *Hyp. Arch.* 96,32—97,1.

10. They will all say with a single voice: The Father's truth is just, and
the Son presides over the Entirety. And from everyone unto the
ages of ages, Holy Holy Holy! Amen![62]

With this conclusion, the revelation of Eleleth, and the mythic narra-
tive as a whole, places the reader in the last days, as it relates the
primordial Norea to the eschatological True Anthropos, showing that
her action anticipates the work of the last days and establishes its
recipients. The reader has thus come to know the primordial Norea as
the virgin whom the Forces did not defile because she has the divine
faculty of speech, the voice which has the power to rename and resist
the Rulers themselves. She will pass on that power to her children,
Eleleth assures her and the reader. Norea's children, the eschatological
revelation of Eleleth promises, will receive the revelation and anointing
of the True Anthropos, and thus will inherit the promise to Norea and
her virginal spiritual power.

In depicting this mythic drama, the *Hypostasis of the Archons* thus
invites the reader to identify himself or herself with the children of
Norea. The telling of the narrative allows the reader to perceive the
reality of the Rulers and of the Root of Truth; it thus allows the "children
of Norea" to see their place in a pattern that begins in primordial times
and extends to the eschatological subversion of the Rulers.

The telling of the narrative also invites the readers to perceive the
patterns of the narrative and to connect them with their own lives.
Against the distorted and oppressive androgynous power of the Rulers,
Norea's virginity preserves the purity and power of divine androgyny,
but, more particularly, of her divine and human mothers, the Virginal
Female Spirit, Sophia, Zoe, and Eve. This power is transmitted to the
children of Norea, which makes them heirs of the promise of Eleleth
and participants in the virginal power of their mother Norea and her
mothers, the spiritual Eve, Zoe, Sophia, and the Female Virginal Spirit
from above.

By this reading, the *Hypostasis of the Archons* not only depicts but
actualizes the female subversion of false archontic claims to dominance.
By tapping the divine power above and within her, Norea is able to
rename the "Powers" and strip them of their power. The account of
Norea's struggle against the Rulers thus extends the subversive power of

62. *Hyp. Arch.* 97,1–21. The numbering is designed solely to enumerate the features
of the eschatological promise.

Norea's speech as it specifies the character of her "assistance" to genera-
tions of humankind. Her children are those who have been anointed by
the True Human Being, who are called now to understand themselves as
inheriting the promise to Norea and her children. This means also that
they inherit the faculty of divine speech from her and from the manifes-
tation of the True Human Being.

By identifying with the children of Norea, the reader—male or
female—who has witnessed the depiction of power in the text, is
invited, or empowered, to take on the virginal power of Norea and
exercise it in the same way.

In conclusion, I want to suggest that the meaning and power of
gender imagery in the *Hypostasis of the Archons* resides in its projection
of an image of subversion: Norea stands as a model of spiritual subver-
sion of the oppressive powers that illegitimately claim to rule the cos-
mos, the social order, the psyche, and the body. That she is female and
they are androgynous or male in representation has symbolic signif-
icance. This does not mean that spiritual power is almost exclusively
female in manifestation or that archontic power is almost exclusively
male in manifestation. It suggests instead that the unmasking of illegi-
timate male domination by female figures of spiritual power proved to
be a powerful vehicle for the expression of the gnostic revolt against the
powers. As mythic symbol, the gendered representation of Norea and
the Rulers does not point to a historical world behind the text in which
women, like Norea, revolted against the oppressive rule of men. Rather,
the mythic symbols of Norea and the Rulers may gain their repre-
sentational power from a correspondence to the social world of the
original audience or the contemporary reader, but their symbolic signif-
icance remains open-ended. In one sense, their symbolic power resides
in their ability to use that correspondence to depict and subvert the
reality (*hypostasis*) of false powers—male, female, androgynous, neuter
—but in another, the symbolic power of Norea's struggle against the
Rulers stands against efforts to delimit the meaning and power of the
narrative by identifying, or naming, the powers in the reader's world
that correspond to the spiritual and archontic powers in the world of the
text.

The mythic narrative of the *Hypostasis of the Archons* invites the
reader to dwell in the imaginative world depicted in the text, to see
things as the revelation of Eleleth and Norea's confrontation with the
powers reveal them, and to discern their respective modes of exercising
power. Under this reading, the *Hypostasis of the Archons* invites its

readers to dwell in a world marked by struggle between spiritual and archontic powers, but it also empowers its readers to recognize the powers at work in their world, and to participate in the exercise of Norea's virginal power against the powers of the Rulers. In this way, the *Hypostasis of the Archons* challenges its readers to identify with the "children of Norea," to inherit the promise, and to resist and rename those powers that would claim falsely to rule in their world, as Norea renames and subverts the false powers of her world.

Response to "Virginity and Subversion: Norea Against the Powers in the *Hypostasis of the Archons*" by Anne McGuire

First, I would like to thank Anne McGuire for a stimulating, productive essay that presents a constructive counterpoint to previous discussions of the character of Norea in the *Hypostasis of the Archons*. That McGuire's analysis is so different from that of previous scholars reminds us that texts such as the *Hypostasis of the Archons* are richly multivalent, lending themselves easily to different readings. If these texts can generate so many and such different interpretations on the part of trained scholars, this only underscores the importance of the audience/auditor and the fact that our different interpretations must be understood, at least in part, by the differing perspectives and agendas that we, as scholars, bring to these texts.

What I particularly admire about McGuire's essay is that it moves beyond discussion of the history of the traditions about Norea to questions about the functions of the text and how the ancient reader might not only interpret the text but act on it. McGuire allows us to consider not only how gnostic readers of the *Hypostasis of the Archons* might have exegeted the text but how they might have understood the implications of the text for their own lives.

McGuire raises two sets of questions for me. The first concerns the relationship between texts and social reality; the second, the implications of the text, and others like it, for our understanding of Judaism in antiquity.

1. THE RELATIONSHIP BETWEEN TEXTS
AND SOCIAL REALITY

The relationship between texts and social reality in the case of the *Hypostasis of the Archons,* the *Thought of Norea,* and other related texts is a fascinating one, even if our ability to decipher the relationship is limited. What is the relationship between the character of Norea and the actual lives of women in the gnostic circles who wrote, read, and copied these texts? What direct evidence do we have for such women, and what indirect evidence do such texts offer? What is the relationship between the images of the divine, expressed in both feminine and masculine language, and the communities for which such language was comfortable? Why is gnostic literature replete with so much feminine metaphor for the divine when other Jewish and Christian communities of the same period were much more restricted in their use of gendered metaphor for the divine? Can the differences be attributed to differing social realities? Are the relationships between men and women in gnostic communities significantly different from those between men and women in nongnostic environments, and if so, what is the relationship between male-female relationships and images of the divine?

Clearly, the problems of method that we face in attempting to answer these questions are substantial, and the absence of hard, independent evidence for the social structure of gnostic communities (assuming we can even speak with assurance of gnostic communities) leaves us able to do little more than ask the questions and hope that someday we may have the evidence to provide some answers. For now, we are probably limited to proceeding by analogy: to asking what we know about the relationships between myth, language, and society in cases where we have both texts and social data, and trying, tentatively, to extrapolate.

In this regard, I was sorry not to have heard the discussion at the conference in response to Michael Williams's paper,[1] because he does attempt to handle some of these issues, and I found some of his observations quite constructive. But it seems to me that while recognizing that gendered language can have varying degrees of meaning (I liked his example that "Necessity is the mother of invention" is a statement about mothers only in the broadest sense), I do think that the use of gendered language is not simply "there because it's there." In a volume of pro-

1. See Michael Williams, "Variety in Gnostic Perspectives on Gender," the first essay in this volume.

ceedings from a conference on "Images of the Feminine in Gnosticism" what follows may be a superfluous observation, but one of the things that has distinguished gnostic texts from much other Greco-Roman religious literature has been their marked use of gendered language and particularly their marked use of feminine imagery for the divine.

In contrast, then, to Williams's analysis of the gendered language in the *Hypostasis of the Archons*, I find McGuire's interpretation more compelling. In the *Hypostasis of the Archons*, Norea's gender, and that of her female ancestors (and perhaps her female descendants as well), *is* significant, if not in the intention of the author (to which we have virtually no access), then certainly in the possibility of its interpretation by its readers.

If we hope to proceed by analogy, in the absence of useful social test data, we need to ask what test cases we might have from antiquity itself. While little research has been done so far, we do have Jewish and Christian communities whose social circumstances we can at least partly reconstruct and whose male-female relationships can begin to be correlated with the texts and imagery they produce. Such work needs to be pursued, for it would enable us to begin to formulate some answers, or at least hypotheses.

The question of exegetical tradition as the origin of gendered language also needs to be addressed at least briefly. In the history of our discipline, it is sometimes suggested that the texts themselves generate certain exegesis, with the implication that the social location of the exegete has little if any bearing. Texts and their interpretation are viewed as creatures more or less independent from their creators and interpreters. In our specific case, some scholars locate the proliferation of gendered language in gnostic texts in the development of the Adam and Eve traditions, in which many of the female figures of gnostic literature are developments, in some form or other, of Eve.

This may or may not be the case, but it is really beside the point. Not everyone who read Genesis shared the gnostic interpretation of those texts. The variety of ancient understandings of Genesis requires us to seek the explanation for those multiple and divergent readings in the readers rather than in the text. In fact, it is precisely those diverse interpretations which allow us some understanding of the people who developed and shared a particular exegetical tradition. I think we need to ask how the exegesis of Genesis was used to justify male and female roles, relationships, and so forth, particularly in the light of evidence that different communities managed to use the same text to justify fairly

different views of male and female relationships. Finally, we need to ask whether everyone for whom Genesis figured in their "received" tradition considered it paramount in their understanding of male and female relationships, and if so, which portions of Genesis they used and which they did not!

2. IMPLICATIONS FOR OUR UNDERSTANDING OF JUDAISM

Both McGuire's essay and the work of previous scholars on Norea raise a number of questions relating to the nature of Judaism in antiquity, and probably our understanding of Jewish women as well.

In Birger Pearson's evaluation, Norea's description here depends on, and reacts to, Jewish exegesis on the wife of Noah. Initially, Pearson observes that "a personage who is regarded as wicked in Jewish haggadah for her machinations against Noah is regarded oppositely in the gnostic version of the myth."[2] For Pearson, the gnostic tradition is clearly secondary to the rabbinic: "Norea, a naughty girl in Jewish legend, has *become* for the gnostics a moving symbol of cosmic redemption" (emphasis added).[3]

Whether the haggadic tradition is a response to the gnostic (which Pearson considers impossible, despite the late date usually attributed to Genesis Rabbah [from which most of the haggadic evidence for Norea/Naamah comes] and the difficulty of dating haggadic materials generally) or the gnostic to the haggadic, the question of Jewish-gnostic relationships becomes intriguing. One almost wants to ask why we must posit the relationship in these terms. Why should we not consider the *Hypostasis of the Archons*, or at least the view of Norea that it espouses, as a Jewish position? Clearly the text has in its present form a thin Christian veneer, but as always the question of definition, particularly of what is Jewish but also of what is Christian, what gnostic, and what pagan, looms large, if often unanswered.

I am particularly struck by the resemblances between Norea and the figure of Aseneth in the *Conversion and Marriage of Aseneth*,[4] a text that

2. B. Pearson, "The Figure of Norea in Gnostic Literature," in *Proceedings of the International Colloquium on Gnosticism, Stockholm, August 20–25, 1973* (ed. G. Widengren), 151.

3. Pearson, "The Figure of Norea," 152.

4. The *Conversion and Marriage of Aseneth* (generally titled *Joseph and Aseneth*), text and French translation in M. Philonenko, *Joseph et Aséneth: Introduction, texte critique, traduction et notes*; ET in *The Apocryphal Old Testament* (ed. Hedley F. D. Sparks), 465–504; and in *Maenads, Martyrs, Matrons, Monastics: A Sourcebook on Women's Religions in*

virtually all scholars now view as unambiguously Jewish, though not necessarily rabbinic, and that no one has suggested we should consider gnostic.

Like Norea (if Pearson is correct that Norea is a development on the wife of Noah, or is perhaps the counterpart of Seth), Aseneth represents the development of material around a female figure whose biblical identity is extremely shadowy. Like Norea, Aseneth is a virgin who receives divine revelation and whose receipt of that revelation has implications for others. Norea becomes a *helper* to others; Aseneth becomes the City of Refuge (15.6). Like Norea, Aseneth bears a strong resemblance to a divine female being, Metanoia (Repentance), the daughter of God, who ceaselessly petitions God on behalf of those who repent, as Aseneth has done.

Are these similarities coincidental or do they represent something more? If the latter, who develops this interest, this tradition of strong female figures whose repentance and receipt of knowledge have implications for future generations? One of the remarkable aspects of *Aseneth* is that it lacks any denigration of Aseneth for her receipt of this revelation: it lacks any hint of misogynism or negativity toward Aseneth because she is a woman.

Elsewhere I have suggested that *Aseneth* may offer a paradigm of conversion to Judaism, for women, and perhaps for men as well.[5] If so, given the similarity between the two, what might we conclude about Norea? We must consider the possibility that these traditions about Norea, and Aseneth, originate or flourish in communities characterized by the presence and public activity of women not unlike Norea and Aseneth. In the format of a brief response, I cannot go beyond these suggestions, but they point the way for further research.

3. COMMENTS SPECIFIC TO McGUIRE'S ESSAY

In the written form of what were originally oral comments, these may be irrelevant, but I did have a few questions specific to McGuire's text which she addressed during the conference and which may be of interest to the reader: What are the social ramifications of "the virgin

the Greco-Roman World (ed. R. Kraemer). For a different reconstruction of the Greek text, see C. Burchard, *Joseph und Aseneth,* Judische Schriften aus hellenistiche-römischer Zeit, (Gutersloh, 1983); ET in *The Old Testament Pseudepigrapha* (ed. James H. Charlesworth), II:177–247.

5. Ross S. Kraemer, "The Conversion of Women to Judaism in the Greco-Roman Period," a paper presented to the Women in the Biblical World Section of the Society of Biblical Literature, Annual Meeting, Dallas, 1983.

who subverts schemes of dominance"? What are the functions or the effects of naming? What are the social messages regarding virginity? To what extent does Norea function as a paradigm for Gnostics? Would the gender of the Gnostic have made a difference? If the narrative invites the reader to see patterns and connect them, with what consequences (e.g., social, political, personal, cultic)? And finally, how is it that the virginal Norea has children?

Revisiting Norea

My first real "visit" with that fascinating woman, Norea, took place as I listened with my mind's ear to her plaintive cry addressed to the divine world on page 27 of Nag Hammadi Codex IX ("It is Norea who [cries out] to them").[1] In connection with my research on that manuscript[2] I was constrained to learn more about Norea, studying her other appearances in gnostic literature and in patristic testimonia, in an effort to ascertain her function in gnostic mythology and to plumb the various facets of her character as presented in the sources. Indeed, I learned more about her than I had originally thought possible, for I discovered that our gnostic heroine has a fascinating prehistory and even had a different name originally. Before she appeared as a pure, undefiled virgin in her gnostic manifestation she had had a rather dubious career as a Jewish "naughty girl." The results of this research were presented to the International Colloquium on Gnosticism in Stockholm in August of 1973.[3]

In brief, the argument presented in that paper is as follows: Norea appears in a wide range of gnostic literature (including Manichean and Mandean) under the following names: Norea, Noraia, Orea, Oraia, Horaia, Nora, Noria, Nuraita, and Nhuraita. She is represented in the sources as the daughter of Adam and Eve, as the wife-sister of Seth, or even the wife of Noah or Shem. She is typically portrayed as the intended victim of rape by the creator-archons. Comparative analysis of

1. NHC IX,2: *Thought of Norea* 27,21–22.
2. See B. Pearson, ed., *Nag Hammadi Codices IX and X*, esp. 87–99. Cf. also J. M. Robinson, *Nag Hammadi Library*, 404–5.
3. Pearson, "The Figure of Norea in Gnostic Literature," in *Proceedings of the International Colloquium on Gnosticism, Stockholm, August 20-25, 1973* (ed. Widengren), 143–52.

the gnostic sources, together with certain Jewish haggadoth concerning the biblical Naamah (cf. Gen. 4:22), reveals that the gnostic figure of Norea has been developed out of the Jewish material featuring Naamah. The original Greek form of her name is Horaia ('Ωραία, meaning "pleasing," "lovely"), the semantic equivalent of Hebrew Na'amah (נַעֲמָה, "pleasing," "lovely"). In certain Jewish traditions Naamah is presented as a Cainite woman with a reputation for lewdness. Her role as a seductress of the "sons of God" (Gen. 6:2) has, in fact, been transposed in the gnostic literature, in a typically gnostic hermeneutical inversion, as a successful evasion of rape by the wicked archons. In the gnostic sources Norea is featured as a "saved savior," whose own salvation is a paradigm for that of her spiritual race, that is, gnostic humankind.[4]

This interpretation of the figure of Norea and her origins has met with considerable acceptance.[5] Indeed, additional supportive evidence has recently been put forward by G. A. G. Stroumsa regarding the Jewish background of Norea. He cites a story found in the *Midrash of Shemhazai and Azael* (= ch. 25 of the *Chronicles of Jerahmeel*) according to which one of the fallen angels, Shemhazai, tried to seduce an attractive maiden. The maiden pronounced the Tetragrammaton and ascended into heaven, becoming a star. The maiden's name is given as Esterah or Istahar, but she is also called Naamah in some sources. Stroumsa argues convincingly that the story of Esterah (Naamah) and that of the Gnostic Norea (Naamah) ultimately deal with the same figure.[6] Indeed, the gnostic traditions concerning the lustful archons are derived from, and

4. For the texts, with complete discussion, see Pearson, "Figure of Norea." For other published "visits" with Norea on my part, see, in addition to the items cited in n. 2, above, "The Figure of Seth in Gnostic Literature," in *Rediscovery*, vol. 2: *Sethian Gnosticism* (ed. Layton), 472–504, esp. 479–80, 482–83; and "Jewish Sources in Gnostic Literature," in *Jewish Writings of the Second Temple Period* (ed. M. Stone), 443–81, esp. 467–69.

5. Layton incorporated the essentials of my Stockholm paper (then still unpublished) into his edition of, and commentary on, the *Hypostasis of the Archons*; see "The Hypostasis of the Archons or the Reality of the Rulers," pt. 1 (1974), 351–425; pt. 2 (1976), 31–101; see esp. pt. 1, 369–71. H. Koester tacitly accepts my explanation of the origin of the name "Norea" and its connection with Jewish scriptural exegesis, referring in his bibliography to Layton's commentary on the *Hypostasis of the Archons* (but not to my article); see Koester, *Introduction to the New Testament*, vol. 2: *History and Literature of Early Christianity*, 211–12. For G. Stroumsa's treatment, see n. 6, below. On the other hand, B. Barc and M. Roberge accept the etymology of the name "Norea" first advanced by W. Bousset: Norea ⟨ Heb. Na'ara (נַעֲרָה), "maiden." See Barc, *L'Hypostase des Archontes* (NH II,4), and Roberge, *Noréa* (NH IX,2), 108, 164; cf. W. Bousset, *Hauptprobleme der Gnosis*, 14.

6. Stroumsa, *Another Seed*, 56–58. A new edition, with translation, of the *Midrash of Shemhazai and Azael* is given by J. T. Milik, *The Books of Enoch: Aramaic Fragments from Qumran Cave 4*, 321–28 (cited by Stroumsa, *Another Seed*, 56 n. 82).

based upon, the Jewish myth of the fallen angels (Gen. 6:1–4) as elaborated, probably as early as the third century B.C.E., in the Enochic *Book of Watchers* (= 1 *Enoch* 1—36) and other sources.[7] The myth of Esterah-Naamah discussed by Stroumsa shows that the theme of Naamah's purity and her rescue from an attempted rape was already elaborated in nongnostic Jewish tradition, perhaps as a minority opinion over against the negative interpretation of Naamah as a (Cainite) seductress.

In what follows in this "visit" with Norea, I want to survey all of the relevant sources for the purpose of constructing a typology of this important figure, with special emphasis on her role as a gnostic savior figure. The *Hypostasis of the Archons* (NHC II,4) is an especially important text for this purpose, but my focus is larger than a single text. I consider Anne McGuire's study of the *Hypostasis of the Archons*, published in this volume, to be a model study of that text, and I find myself in basic agreement with her interpretation.[8]

In any discussion of Norea it seems to me necessary to take into account, at the same time, the figure of Seth. Indeed, I think that Norea can best be seen as a feminine counterpart to Seth, just as Eve is the "female counterpart" to Adam.[9] Moreover, I think it is specifically within the so-called "Sethian" Gnosis that the gnostic figure of Norea is at home.[10] It used to be the fashion in gnostic studies to look upon the ancient gnostic systems in terms of a male-female dichotomy, that is, to posit an "Anthropos" type of Gnosis in distinction to a "Sophia" type of Gnosis. Scholars would argue which came first, "Anthropos" Gnosis or "Sophia" Gnosis.[11] But such a dichotomy tends to break down upon

7. This has been conclusively demonstrated by Stroumsa (*Another Seed*, esp. 15–70). On the *Book of Watchers*, see, e.g., J. T. Milik, *Books of Enoch*, 4–88, esp. 22–41.

8. I had not seen her essay at the time mine was written.

9. See *Hyp. Arch.* 91,31. By "counterpart" I mean neither "subordinate" nor "rival." It is evident that Norea's role in the *Hypostasis of the Archons* is far more important than Seth's. Cf. A. McGuire's criticism of the use of the term "counterpart" (p. 248).

10. I continue to think that there is such a thing as "Sethian Gnosticism," in the sense that certain discrete features of a "Sethian" system can be extrapolated from our available texts, and also in the sense that there actually existed people who referred to themselves, in a special spiritual (gnostic) self-designation, as "the seed of Seth" or "children of Seth." See the articles in the second volume of the Yale Conference volume, especially H.-M. Schenke, "Gnostic Sethianism," in *Rediscovery* (ed. Layton), 2:588–616; also Schenke, "Das sethianische System nach Nag-Hammadi Handschriften," in *Studia Coptica* (ed. P. Nagel), 165–72. For an excellent full-length treatment of "Sethian Gnosis in the Light of the Nag Hammadi Texts," unfortunately unpublished, see Jørgen Verner Hansen, "Den Sethianske Gnosis i Lyset af Nag Hammadi-Teksterne."

11. See the penetrating discussion of the respective views of W. Bousset and G.

closer examination of the sources and, in my view, is completely inap-
propriate to Sethian Gnosticism, in which Anthropos and Sophia play
their respective roles in the anthropogonic and cosmogonic phases of
the total gnostic myth.[12] And if, in the Sethian system, Seth is seen as the
primary "savior" figure, it is also clear that the soteriological function is
shared with a feminine principle as well, whether this principle is called
the "Epinoia of Light," as in the *Apocryphon of John*,[13] or "Norea," as in
other Sethian texts, such as the *Hypostasis of the Archons*. What is also of
interest, in this connection, is that (secondary!) *christianization* of some
gnostic texts also leads to a *masculinization* of gnostic soteriology. For
example, in the *Apocryphon of John* the primary saving role assigned to
the feminine "Epinoia of Light" is taken over by Christ in the secondary
christianizing redaction.[14] Similarly, in the *Hypostasis of the Archons*, a
secondary christianizing redaction (96,27—97,21) presents the "True
Man" (= Christ) as savior.[15]

In looking at Norea as a counterpart to Seth, it will be useful to set
forth a typology of the figure of Norea along the lines of a typology of
the gnostic Seth presented at the Yale Conference on Gnosticism in
1978.[16] That typology consisted of the following elements: (1) the birth
of Seth; (2) names and titles of Seth; (3) Seth as progenitor of the gnostic
race; (4) Seth as recipient/revealer of gnosis; and (5) Seth as savior.
(Items 1, 2, and 3 treated the identity of Seth and 4 and 5 the function of
Seth.)

1. THE BIRTH OF NOREA

Irenaeus, in his *Adversus haereses* (1.30), presents a gnostic system
identified later by Theodoret (*Haereticum fabularum compendium* 1.14) as
"Sethian" or "Ophite," in which four children of Adam and Eve are
named: Cain, Abel, Seth, and Norea. Of the last two it is reported:

Quispel in H.-M. Schenke, *Der Gott "Mensch" in der Gnosis: Ein religionsgeschichtlicher
Beitrag zur Diskussion über die paulinische Anschauung von der Kirche als Leib Christi*, 67–
68.

12. Cf. Schenke, *Der Gott "Mensch"*; Hansen, "Sethianske Gnosis," 224.
13. See Karen King's important essay in this volume, "Sophia and Christ in the
Apocryphon of John."
14. Cf. above, King, "Sophia and Christ," esp. p. 168. For my analysis of the structure
of *Ap. John* and its secondary "christianization," see Pearson, "Jewish Sources," 458–64,
esp. 461 n. 116. Cf. also Hansen, "Sethianske Gnosis," 168.
15. On this passage as a christianizing redaction, see Barc, *L'Hypostase*, 128–30.
16. Pearson, "Figure of Seth," in *Rediscovery* (ed. Layton). Cf. also Pearson, "Egyptian
Seth and Gnostic Seth," and G. W. MacRae, "Seth in Gnostic Texts and Traditions,"
Society of Biblical Literature Seminar Papers, 25–43 and 17–24, respectively.

After them (Cain and Abel) by the providence of Prunicos they say that Seth was conceived, and then Norea; from them they say the rest of the human multitude is descended.[17]

Of Seth and Norea, in contrast to Cain and Abel, it is reported that they were conceived by divine providence, Prunicos (= Sophia) being singled out here in this connection.[18] It is most likely that Seth and Norea are here singled out as the progenitors of *gnostic* humanity, rather than "the rest of the human multitude," and that Irenaeus has obscured this detail in his rendition.[19] While Cain, Abel, and Seth are all derived from the Genesis account, Norea is an extraneous figure, doubtless introduced here as the sister-wife of Seth.[20] It is likely that the gnostic author is relying on extrabiblical Jewish lore here.[21]

A similar midrash on the Genesis story is presented in the *Hypostasis of the Archons* in a more expansive form. The birth of Seth, "through God," is narrated in a way that reflects the use both of Gen. 4:25 and 4:1 (originally of Cain!).[22] The birth of Norea is given greater emphasis, in terms of its significance for (gnostic) humanity:

Again Eve became pregnant, and she bore [Norea]. And she said, "He has begotten on [me a] virgin as an assistance [for] many generations of mankind."[23]

It is thus Norea, sister of Seth, who renders for humanity the "assistance" ($\beta o\acute{\eta}\theta\epsilon\iota\alpha$, cf. Gen. 2:18) requisite for salvation.[24] Her begetting is the result of divine intervention; "he" in Eve's exclamation refers not to Adam but to God, the Father of All.[25]

The birth of Norea is not recounted in other Sethian texts, but the *Apocryphon of John* mentions, in connection with the begetting of Seth,

17. Irenaeus *Adv. haer.* 1.30.9, as translated in *Gnosis* (ed. W. Foerster; trans. and ed. R. McL. Wilson), 1:91.
18. Cf. the role of Sophia, "the Mother," in connection with the birth of Seth, as recounted in the *Apocryphon of John* (NHC II 24,35—25,7). On that passage, see below. On the term "Prunicos," see Anne Pasquier's essay in this present volume.
19. So Stroumsa, *Another Seed*, 55 n. 77.
20. Cf. Epiphanius's account of the "Sethians," according to which "Horaia" (Norea's real name in Greek) is the wife of Seth (*Haer.* 39.5.2–3).
21. Cf. "Naamah" in Pseudo-Philo *Bibl. Ant.* 1.1 and *Chronicles of Jerahmeel* 26 (corrupted as "Noaba" and "Noba" respectively); cf. Pearson, "Figure of Norea," 149. Cf. also the unnamed "twin sister" of Cain referred to in *Targum Ps.-Jonathan* Gen. 4:1–2; and Pearson, "Figure of Seth," 479.
22. Pearson, "Figure of Seth," 479.
23. *Hyp. Arch.* 91,34—92,2, as translated by Layton in *Nag Hammadi Library* (ed. Robinson), 156. Translations of Nag Hammadi texts in this article are from *Nag Hammadi Library* (ed. Robinson).
24. On this theme, see below.
25. See Layton, "Hypostasis of the Archons," pt. 2 (1976), 61–62.

the descent of the "spirit" of the Mother, a feminine entity which corresponds to Norea in the *Hypostasis of the Archons*:

> And when Adam recognized the likeness of his own foreknowledge, he begot the likeness of the son of man. He called him Seth according to the way of the race in the aeons. Likewise the mother (Sophia) also sent down her spirit which is in her likeness and a copy of those who are in the pleroma, for she will prepare a dwelling place for the aeons which will come down.[26]

2. NAMES AND PREDICATIONS OF NOREA

The various forms of the name Norea have been mentioned above. It is possible, in fact, that some of these variations reflect alternative etymologies or wordplays, associated with various of her functions, though (as previously argued) the original form of her name is Horaia.

In the passage from the *Hypostasis of the Archons* quoted above, Norea is called a "virgin" (παρθένος) who is to render "assistance" (βοήθεια) to humanity. Her virginity is stressed in the text: "She is the virgin whom the Forces did not defile" (92,2–3). Her original abode, and that of her "generation," is "in Incorruptibility, where the Virgin Spirit (πνεῦμα παρθενικόν) dwells" (93,29–31). It is possible that a wordplay on Norea as naʿara ("maiden") is reflected here.[27] It is also possible that the alternative name for Seth's sister-wife in Jewish tradition, Azura (עֲזוּרָה, "helper"), is alluded to in the emphasis given to Norea's saving function as an "assistance" to humanity.[28]

Norea is also associated with "fire" and "light" in some gnostic traditions. Epiphanius claims that the name given to Noah's wife by the Nicolaitans, Noria, is an attempt to provide a Semitic translation for the name of the flood hero Deucalion's wife in Greek mythology, Pyrrha (cf. Greek: πῦρ; Aramaic: נוּרָא, "fire").[29] The story of the burning of Noah's ark by Noria/Orea suggests an association with "fire."[30] The Mandean

26. *Ap. John* II 24,34—25,7. Cf. Epiphanius *Haer.* 39.2.4, on the birth of Seth according to the "Sethians." The same account later mentions "Horaia" as the "wife" of Seth (39.5.2–3). Cf. Pearson, "Figure of Seth," 481–83.

27. Cf. n. 5, above. Epiphanius, countering the Nicolaitans' claim that "Noria" was Noah's wife, claims that the real name of Noah's wife was "Barthenōs" (*Haer.* 26.1.6), which Bousset takes to be a corruption of Greek παρθένος ("virgin") (*Hauptprobleme*, 14). Cf. Pearson, "Figure of Norea," 147.

28. Cf. Barc, *L'Hypostase*, 109. Cf. עֵזֶר in MT of Gen. 2:18. The name "Azura" is given to Seth's sister-wife in *Jub.* 4:11; cf. also Epiphanius *Haer.* 39.6.4.

29. Epiphanius *Haer.* 26.1.4–5. Epiphanius tries to counter this etymology, somewhat illogically, by pointing out that *noura* is the "Syriac" (Aramaic) word for "fire," not the Hebrew word, which is *hēsath* (*sic*; the word is אֵשׁ).

30. Epiphanius *Haer.* 26.1.7–8; *Hyp. Arch.* 92,14–17. Cf. Pearson, "Figure of Norea," 144–46; and Stroumsa, *Another Seed*, 59–60.

versions of Norea's name, Nuraita and Nhuraita, reflect an association both with "fire" and with "light."[31] And the Manichean "Virgin of Light" is probably to be construed as a variant of our Norea figure. The "Virgin of Light" (Middle Persian: *kanīgrōšn*) is not given a proper name in most Manichean sources, but her original name, Horaia, does appear in one Greek source.[32] There can hardly be any doubt that Sethian gnostic traditions were utilized in the development of Manichean mythology.[33]

It is possible that the name Plesithea, which occurs in the *Gospel of the Egyptians* and *Zostrianos*, is to be understood as an epithet of Seth's counterpart, Norea.[34] This suggestion, however, brings us to the next section of our typology.

3. NOREA AS MOTHER OF THE GNOSTIC RACE

One of the most characteristic self-designations of the Sethian Gnostics is "seed" or "generation" of Seth.[35] It is obvious, given the state of medical knowledge in antiquity, according to which human formation in the womb is attributed solely, or mainly, to the male sperm,[36] that Seth, rather than Norea, would be the dominant figure in the spiritual generation of the Gnostics in gnostic myth. In the development of this mythology, Gen. 4:25 ($\check{\epsilon}\tau\epsilon\rho o\nu$ $\sigma\pi\acute{\epsilon}\rho\mu\alpha$, "another seed") is a key text.[37] Even so, we have noted, in texts already cited (esp. *Adv. haer.* 1.30.9), that Norea, as Seth's sister-wife, is by implication the "mother" of gnostic humankind. As such, she is addressed in the *Hypostasis of the Archons* by the angel Eleleth with the following words:

> You, together with your offspring (ⲚⲞⲨϢⲎⲢⲈ), are from the Primeval Father; from Above, out of the imperishable Light, their souls are come.[38]

31. Cf. the Mandean words *nura* ("fire") and *nhura* ("light"); cf. Drower and Macuch, *A Mandaic Dictionary*, 294, 291. Cf. also Pearson, "Figure of Norea," 145.

32. *Acta Archelai* 19. Cf. Pearson, "Figure of Norea," 145–46; and Stroumsa, *Another Seed*, 154–58.

33. This has been admirably demonstrated by Stroumsa, *Another Seed*, 145–67.

34. This has recently been suggested by Hansen, "Sethianske Gnosis," 137–38.

35. See discussion in Pearson, "Figure of Seth," 489–91. Hansen points out that the term "seed" ($\sigma\pi o\rho\acute{\alpha}$ or $\sigma\pi\acute{\epsilon}\rho\mu\alpha$) occurs *only* in Sethian texts, whereas "generation" ($\gamma\acute{\epsilon}\nu o s$ or $\gamma\epsilon\nu\epsilon\acute{\alpha}$) occurs also in non-Sethian gnostic literature; see Hansen, "Sethianske Gnosis," 192.

36. Cf. the interesting discussion of birth symbolism in gnostic mythology in Gilhus, "Gnosticism—A Study in Liminal Symbolism," *Numen* 31 (1984), 106–25, esp. 112 and n. 37, where Aristotle *Gen. An.* 729a–30a is cited. See also Richard Smith's contribution to this volume.

37. Pearson, "Figure of Seth," 479, 481–82, 486–91; Stroumsa, *Another Seed*, esp. 73–77.

38. *Hyp. Arch.* 96,19–22; cf. "that generation" (ⲦⲦⲈⲚⲈⲀ ⲈⲦⲘ̄ⲘⲀⲨ) at *Hyp. Arch.* 93,28.

Turning now to the *Gospel of the Egyptians,* in a passage immediately
following the request by Seth for his "seed" (σπορά, III 56,3), we read the
following:

> Then there came forth from that place the great power of the great light,
> Plesithea, the mother of the angels, the mother of the lights, the glorious
> mother, the virgin with the four breasts, bringing the fruit from Gomorrah
> as spring and Sodom, which is the fruit of the spring of Gomorrah which is
> in her. She came forth through the great Seth. (III 56,4–13)

The figure referred to here as Plesithea, "full goddess,"[39] is clearly to be
seen as a syzygos of Seth, the mother of his seed, and thus the equi-
valent of Norea in other Sethian texts.[40] Her maternal role is stressed by
means of a threefold repetition of the word "mother"; she is also a
"virgin," whose fecundity is nevertheless stressed with reference to a
double endowment of breasts.

The role of the divine "Mother" in Sethian Gnosticism is a very
important one. This figure occurs in gnostic mythology on several dif-
ferent ontological levels, from Barbelo downward. Norea, in fact, is just
another projection of the gnostic divine Mother on the plane of gnostic
salvation history. The Sethian Gnostics can, in fact, be described, in
Eugène de Faye's terms, as "les adeptes de la Mère."[41]

4. NOREA AS RECIPIENT/TRADITOR OF GNOSIS

Just as Seth is credited in gnostic tradition with numerous revelatory
books,[42] so also is Norea singled out as a revealer of gnosis and author of
written revelations. A book called "Noria" is reported by Epiphanius to
have been in circulation among the Nicolaitan Gnostics, and books are
attributed respectively to "Noraia" and "Oraia" in the treatise *On the
Origin of the World.*[43] Norea is the focus of the second tractate in Codex
IX,[44] and as we have seen, plays a key role in the *Hypostasis of the
Archons.*

It is very likely that something like an "Apocalypse of Norea" was

39. Cf. the commentary in Böhlig and Wisse, *Nag Hammadi Codices III,2 and IV,2: The
Gospel of the Egyptians,* 182.

40. Cf. Hansen's discussion in "Sethianske Gnosis," 137–38. The name "Plesithea"
occurs in *Zostrianos* 51,12, but the manuscript is very fragmentary at that point.

41. The title given by Eugène de Faye to the fourth chapter of his book *Gnostiques et
gnosticisme,* 357–90. De Faye's term is applied to the Sethian Gnostics by Hansen in his
perceptive discussion of the Sethian Gnostic "Mother" figure in her various manifes-
tations ("Sethianske Gnosis," 126–40).

42. Cf. Pearson, "Figure of Seth," 491–96.

43. Epiphanius *Haer.* 26.1.3; *Orig. World* 102,10–11, 24–25.

44. That tractate has no title in the manuscript; the *Thought of Norea* is a modern
editorial appellation. Cf. Pearson, *Nag Hammadi Codices IX and X,* 87–99.

utilized as one of the sources of the *Hypostasis of the Archons*.[45] That
tractate consists of two main parts: (1) a midrash on Genesis 1—6,
prominently featuring Norea (86,27—92,32); and (2) a revelation given
to Norea by the angel Eleleth (92,32—97,21). Norea is the putative
mediator of Eleleth's revelation (93,13). This second main part of the
Hypostasis of the Archons can legitimately be called an "apocalypse of
Norea" and seems to me to be based upon a preexisting source, a
"Norea" book.[46]

In sum, just as Seth is a prominent traditor of gnosis, producing
revelatory books, so also is Norea, his feminine counterpart, an impor-
tant transmitter of salvific knowledge. This, indeed, is an aspect of her
role as a gnostic savior, for the chief purpose of a savior is to reveal
gnosis to the elect here below and thus awaken them to life. I might also
venture to suggest here the possibility that books were written in the
name of Norea as counterparts to books of Seth. Female members of
Sethian gnostic groups could have been the authors of such books.

5. NOREA AS SAVIOR

One of the distinctive features of Sethian Gnosticism is its doctrine of
salvation history and the division of that history into various epochs
delimited by the catastrophic events of flood, fire, and end time judg-
ment.[47] The periodization of history organized around the three major
cosmic events results in a quadripartite division of history and of
humankind, corresponding, in some Sethian texts, to the four "lumi-
naries" (Harmozel, Oriel, Daveithai, and Eleleth).[48] In all of these world
periods Seth plays a major salvific role.

But not only Seth. Norea too is involved in the salvation history of the
gnostic race. In the *Hypostasis of the Archons*, Norea's role begins already
in the time of (the earthly) Seth (91,34—92,3), extends through the time
of Noah and the flood (92,14–18), and into the present era of the Sethian
seed (96,19–24).[49] And in the *Thought of Norea* (IX,2), Norea's role
extends into prehistory, "before the world came into being" (28,14–17).[50]

45. Schenke suggests that an "apocalypse of Norea" was a source used in common by
On the Origin of the World and the *Hypostasis of the Archons*; see "Gnostic Sethianism,"
596. Cf. my discussion of the *Hypostasis of the Archons* in "Jewish Sources," 464–69.
46. A different source analysis is proposed by Barc, *L'Hypostase*, 1–48.
47. See, e.g., Schenke, "Sethianische System," 168–69; and Stroumsa, *Another Seed*,
81–113, esp. 103–13, where the Jewish apocalyptic background is stressed.
48. Schenke, "Sethianische System," 168–69; and *Another Seed*, 105.
49. Cf. Barc, *L'Hypostase*, 47–48: 111, 114–15.
50. Roberge, *Noréa*, 155.

Norea's role as a savior is, more specifically, that of a "saved savior."
Her precosmic restoration to the pleroma (*Norea* 27,22–24; 28,14–17) is
equivalent to the "repentance" and restoration of the Mother Sophia in
the *Apocryphon of John* (II 13,36—14,13).[51] The salvific "assistance"
(βοήθεια, *Hyp. Arch.* 92,1) that she renders represents "assistance" that
she herself needs to receive from "the four holy helpers" (ΒΟΗΘΟΣ,
Norea 28,28), especially Eleleth, whose saving revelation to Norea comes
in response to her cry for "help" (ΕΡΙ ΒΟΗΘΕΙ, *Hyp. Arch.* 93,1) from the
oppression of the wicked archons, and that constitutes the revelation
that she herself passes on to the elect in the second main part of the
Hypostasis of the Archons, the "Apocalypse of Norea."[52] Norea as "savior"
is, at the same time, a symbol of the human soul and its salvation.
Indeed, in this respect we might say that Norea is a more nuanced and
convincing "savior" figure than Seth himself, even if it is his "seed"
which constitutes the gnostic elect. For we do not see in the texts any
mythic-symbolic exploration of Seth's own salvation, though the com-
ing of Norea can be seen as an aspect of his salvation. In that case, Norea
is, at least implicitly, Seth's savior.

The significance of Norea's salvific role in the Sethian-gnostic religion
can be understood more completely when we look at the biblical text
that is ultimately being exegeted, especially as the gnostic interpretation
contrasts with alternative interpretations current in antiquity. I refer to
the text in Genesis from which the word for "help, assistance" derives:

> And the Lord God said, "It is not good for man to be alone; let us make for
> him a helper in accordance with him (βοηθὸν κατ᾽ αὐτόν)."[53]

In the biblical text the creation of woman (Gen. 2:21–22) answers to
the need of man for a "helper" (Gen. 2:18, 20). An interesting interpre-
tation of this passage is found in Philo, according to whom "sense-
perception" (αἴσθησις) is the feminine "helper" (βοηθός) to the male
"mind" (νοῦς).[54] The Gnostics, in contrast, see in the scriptural reference

51. Roberge, *Noréa*, 155. Cf. Pearson, "Figure of Norea," 151; and idem, *Nag Hammadi
Codices IX and X*, 88–93.

52. See discussion on p. 272, above.

53. Gen. 2:18 LXX, my translation. Cf. the RSV rendering of the MT, "a helper fit for
him" (כְּנֶגְדּוֹ עֵזֶר), which may originally have meant "a power equal to him." See R. D.
Freedman, "Woman, A Power Equal to Man," *Biblical Archaeology Review* 9/1 (1983) 56–
58."

54. Philo *Legum Allegoriae* 2.24. Cf. my discussion of that text in relation to the
doctrine of the "Epinoia of Light" in the *Apocryphon of John*, in "Philo and Gnosticism,"
in *Hellenistisches Judentum in römischer Zeit: Philon und Josephus* (ANRW II 21:1; ed. W.
Haase), 295–342, esp. 338.

to the "helper" a feminine spiritual aspect of human salvation. In the *Hypostasis of the Archons* a heavenly voice comes to the lifeless Adam as a "help" ($\beta o\eta\theta\epsilon\iota\alpha$, 88,18) to him, and the "spiritual woman" (ⲧⲥϩⲓⲙⲉ ⲙ̅ⲡⲛⲉⲩⲙⲁⲧⲓⲕⲏ) comes and gives him life (89,11–14). Just as the heavenly Eve functions in the text as an agent of salvation to Adam, so also does Norea function as an agent of salvation ($\beta o\eta\theta\epsilon\iota\alpha$, 92,1) for Seth and the subsequent generations of the elect.

In sum, as we look at the various roles assigned to Norea in the gnostic texts, and especially as we perceive her function as a gnostic "saved savior," we are also confronted with a countercultural interpretation of received scripture and tradition as well as a fascinating "image of the feminine" in the gnostic religion.

Corinthian Veils and
Gnostic Androgynes*

Without question, 1 Cor. 11:2–16 is "one of the most obscure passages in the New Testament."[1] Perhaps the most fascinating but vexingly elusive issue of all is: Why did Corinthian women uncover their heads? Here one's imagination must build a credible model for explaining this behavior using only the debris left us in Paul's infelicitous demolition of it.

This essay attempts to disambiguate the passage by relating this activity to speculations on the primordial androgyne in antiquity, especially among Christian Gnostics. We shall proceed (1) by surveying other explanations for the removal of veils or the altering of coiffures, (2) by examining evidence for cultic recovery of the primordial androgynous state particularly in Christian versions of Gnosticism, and (3) by checking our proposal against 1 Cor. 11:2–16 itself.

1. PROPOSED EXPLANATIONS FOR WOMEN
ALTERING HEAD COVERINGS

1.1. Scholars have proposed five explanations. According to the first, Corinthian women were simply resisting Paul's attempt to introduce Jewish fashion.[2] The veils of Greek women cascaded from the crown of

* The thesis of this essay is more fully developed in my book *There Is No Male and Female: The Fate of a Dominical Saying in Paul and Gnosticism.*

1. W. A. Meeks, *The Writings of St. Paul*, 38. For a partial *Forschungsbericht* on this passage in English publications, see L. Mercadante, *From Hierarchy to Equality: A Comparison of Past and Present Interpretations of 1 Cor 11:2–16 in Relation to the Changing Status of Women in Society.*

2. E. Evans, *The Epistles of the Apostle Paul to the Corinthians*, 115–16; A. Schlatter,

the head down over the hair, the neck, and the shoulders, but did not conceal the face. The heads of unmarried women and maidservants were uncovered; the heads of married women were covered in public except in unusual situations.[3]

However, the veils of Jewish women—like those of Near Eastern women in general—often covered the face as well as the head and were worn by married women whenever out of doors and sometimes even at home.[4] Even unmarried women usually wore them.[5] A woman found in the street with unbound hair exposed could be summarily divorced.[6] According to Dio Chrysostom, a younger contemporary of Paul, even the women in Tarsus, Paul's Hellenized hometown, observed the Eastern practice of covering both head and face.[7]

To illustrate the hypothesis that the issue at Corinth was Greek resistance to Jewish custom, one could point to an analogous situation in northern Africa at the end of the second century when Tertullian wrote his tractate *On the Veiling of Virgins*. Tertullian insisted that all women after puberty, virgins and matrons, be veiled whenever in public in accord with Jewish practice.[8] Clement of Alexandria too expected women to veil their heads and faces whenever in public.[9]

From these parallels it might indeed appear that Corinthian women resented the imposition of Jewish fashion. Paul, on the other hand, as a

Die Korinthische Theologie, 23 and 54–55; W. G. Kümmel, in H. Leitzmann, *An die Korinther I–II*, 183–84; G. Delling, *Paulus' Stellung zu Frau und Ehe*, 109; K. Thraede, "Ärger mit der Freiheit: Die Bedeutung von Frauen in Theorie und Praxis der alten Kirche," in *"Freunde in Christus werden . . ." Die Beziehung von Mann und Frau als Frage an Theologie und Kirche* (with Gerta Scharfenorth), 104–6; H. Thyen, *". . . nicht mehr männlich und weiblich . . .' Eine Studie zu Galater 3,28,"* in *Als Mann und Frau geschaffen: Exegetische Studien zur Rolle der Frau* (ed. F. Crüssemann and H. Thyen), 181–82.

3. Plutarch *Roman Questions* 267a and *Sayings of Spartans* 232c; Apuleius *The Golden Ass* 11.10; Virgil *Aeneid* 7.524–525; Clement of Alexandria *Paidagogos* 3.11; *Martyrdom of Perpetua and Felicitas* 20. The first-century Roman historian Valerius Maximus says that a certain "C. Sulpicius divorced his wife because he saw her going about in public with her head uncovered" (*Factorum ac dictorum memorabilium libri IX* 6.3.10). See esp. R. and C. Kroeger, "An Inquiry Into Evidence of Maenadism in the Corinthian Congregation," *Society of Biblical Literature 1978 Seminar Papers* (ed. P. J. Achtemeier), 2:331–33.

4. Philo *On the Special Laws* 3.56; and *Kethuboth* 72a. See also *b. Yoma* 47a (baraitha), where a woman brags that not even the beams of her home have seen her hair (H. L. Strack and P. Billerbeck, *Kommentar zum Neuen Testament aus Talmud und Midrasch*, 3:430). Cf. *Sifre Numbers* 5:18; *b. Nedarim* 30b, *Gittin* 90a, *Numbers Rabbah* 9. On the other hand, the women depicted in the art of the Dura Europas synagogue, though veiled, have uncovered faces.

5. *Exodus Rabbah* 41:5.

6. *Kethuboth* (M) 7,6; cf. 5:8 and *Tosephta Sota* 5:9.

7. Dio Chrysostom *Discourse* 33.48.

8. Tertullian *On the Veiling of Virgins* 2.

9. Clement of Alexandria *Paidagogos* 3.11.

Jew and a Tarsian, would have expected all holy women to veil them-
selves.

There is, however, a telling objection to this hypothesis. The women
seem to have deviated from general practice only when praying and
prophesying. If we take Paul's language strictly, they came to the public
meeting covered, remained covered except when actively participating,
and presumably went home covered. Paul's primary complaint is that at
particular cultic moments the women blurred distinctions between their
appearance and the men's. Surely it is unlikely that these women
objected to the imposition of Jewish customs only when praying and
prophesying.

1.2. According to Heinrich Weinel, Corinthian women had adopted
without complaint Jewish veils that covered not only the head but the
nose and mouth as well, thus hampering speech. The women removed
them not out of protest but merely to be more articulate when praying
and prophesying.[10]

This explanation, too, is implausible. Surely the women need not have
removed their veils completely in order to uncover their mouths. Paul
does not demand a covering on the πρόσωπον ("face") or στόμα
("mouth") but on the κεφαλή ("head").

1.3. Stefan Lösch cited two Peloponnesian inscriptions as evidence
that certain Greek cults prohibited women from participating in proces-
sions or entering the temple with braided hair or veiled heads, inasmuch
as braids and veils were considered pretentious and irreverent.[11] Lösch
further suggested that some of the Corinthian women, once priestesses
in just such cults, unveiled their heads in worship as a natural contin-
uation of former practice. Paul's adamance that women observe
Jewish veiling customs issued from his fear that they might lapse into
paganism.

Though ingenious and in many respects attractive, this hypothesis too
fails. The inscriptions forbid only braided hair, not veils, unless one
agrees with Lösch's unnecessary emendation of the Arcadian inscrip-
tion. Unemended, it prohibits a *man* from entering the temple "covered."

10. H. Weinel, *Paulus: Der Mensch und sein Werk: Die Anfänge des Christentums, der
Kirche und des Dogmas*, 202. For a refutation of this position, see J. Leipoldt, *Die Frau in
der antiken Welt und im Urchristentum*, 264 n. 10.

11. S. Lösch, "Christliche Frauen in Corinth (I Cor 11,2–16): Ein neuer Lösungs-
versuch," *ThQ* 127 (1947) 216–61.

More objectionable is Lösch's failure to make Paul's theological argumentation directly germane to the women's motivations.

1.4. Elisabeth Schüssler Fiorenza too proposes that Greco-Roman religious convention influenced Corinthian women, but in her proposal the issue was not veils but hair styles, and the motivation not sartorial simplicity but corybantic ecstasy:

> During their ecstatic-pneumatic worship celebrations some of the Corinthian women prophets and liturgists unbound their hair, letting it flow freely rather than keeping it in its fashionable coiffure. . . . Such ecstatic frenzy in oriental cults was a highly desirable spiritual phenomenon and a mark of true prophecy. Disheveled hair and head thrown back were typical for the maenads in the cult of Dionysos, in that of Cybele, the Pythia at Delphi, the Sibyl, and unbound hair was necessary for a woman to produce an effective magical incantation. . . . Paul, on the other hand, is bent on curbing the pneumatic frenzy of the Corinthians' worship.[12]

Schüssler Fiorenza rightly relates the practice to Corinthian enthusiastic worship. In the chapters immediately following, Paul addresses the Corinthians' public rituals and by so doing reveals how prayer and prophecy were conducted there. Prayer at Corinth seems virtually synonymous with glossolalia. These ecstatic utterances of "mysteries in the spirit" (1 Cor. 14:2) were so wild that Paul feared that outsiders would think them mad (1 Cor. 14:23). Therefore, when Paul speaks in chapter 11 of women praying and prophesying, he probably had in mind precisely such frenzied activity.[13]

However, Schüssler Fiorenza errs in supposing that in such worship women let down their hair. The most natural reading of the text suggests they removed veils, and this is how most ancient interpreters understood it. Many early manuscripts in fact read κάλυμμα, or in Latin *velamen* ("veil"), in place of ἐξουσία ("authority"; 11:10). The clever lexical arguments used for claiming that the issue was hair styles fail to accomplish what their champions wish them to. Even if one granted—and I do not—that the phrase (κατὰ κεφαλῆς ἔχων; 11:4) is best rendered "having something descending from his head," it surely could apply to veils which also descended from one's pate.[14] The argument that the phrase

12. Schüssler Fiorenza, *In Memory of Her*, 227–28.
13. I consider unworthy of comment Noel Weeks's proposal that the women in Corinth were praying by means of being uncovered ("Of Silence and Head Covering," *WTJ* 35 [1972] 25–27).
14. The same phrase appears in Plutarch and clearly refers to a garment (κατὰ τῆς κεφαλῆς ἔχων τὸ ἱμάτιον; *Sayings of Kings and Commanders* 13).

"for a garment" (ἀντὶ περιβολαίου; 11:15) must be translated "instead of a garment" surrenders before a host of uses in which ἀντὶ best means "for," "as," or "equivalent to."[15] When Paul refers to hair lengths in 11:14–15 he does so not because hair itself was at issue but in order to argue by analogy. Nature has supplied woman with a natural "garment," her long hair. What nature began, let women complete by retaining fabric garments on their heads.[16]

1.5. The fifth solution advanced for explaining the behavior of Corinthian women is by far the most common, and it almost invariably involves Gal. 3:28. For example, Archibald Robertson and Alfred Plummer suggest that the women "argued that distinctions of sexes were done away in Christ (Gal iii, 28), and that it was not seemly that a mark of servitude should be worn in Christian worship."[17] According to P. Tischleder, the Corinthian women had an "ill-timed and dangerous lust for emancipation."[18] Jean Héring too attributes the practice to "feminist

15. See H. G. Liddell and R. Scott, *A Greek-English Lexicon*, 153; and W. Bauer, W. F. Arndt, and F. W. Gingrich, *A Greek-English Lexicon of the New Testament and Other Early Christian Literature*, 73.

16. See J. P. Meier, "On the Veiling of Hermeneutics (I Cor. 11:2–16)," *CBQ* 40 (1978) 222–23.

17. A. Robertson and A. Plummer, *A Critical and Exegetical Commentary on the First Epistle of St. Paul to the Corinthians*, 230. See also L. Zscharnack, *Der Dienst der Frau in den ersten Jahrhunderten der christlichen Kirche*, 67; P. Bachmann, *Der erste Brief des Paulus an die Korinther*, 355–57, 366; D. Bornhäuser, "'Um der Engel willen' 1 Kor. 11,10," *NKZ* 41 (1930) 482–83; J. Weiss, *Der erste Korintherbrief*, 268–69; L. Brun, "'Um der Engel willen' 1 Kor. 11,10," *ZNW* 14 (1913) 302–3; F. J. Leenhardt, "La place de la femme dans l'église d'après le Nouveau Testament," *ETR* 23 (1948) 22–23, 31; C. Spicq, "Encore 'la puissance sur la tête,' (I Cor XI,10)," *RB* 48 (1939) 557, 560; C. T. Craig, "The First Epistle to the Corinthians," in *The Interpreter's Bible*, 10:125; Leipoldt, *Die Frau*, 171–72 (who likens the removal of veils to German women taking up smoking in the 1920s); J. Jervell, *Imago Dei: Gen 1:26f im Spätjudentum, in der Gnosis und in den paulinischen Briefen*, 294–95; J. Kürzinger, *Die Briefe des Apostels Paulus: Die Briefe an die Korinther und Galater*, 28; F. W. Grosheide, *Commentary on the First Epistle to the Corinthians*, 250 and 258; L. Morris, *The First Epistle of Paul to the Corinthians*, 151; P.-H. Menoud, "Saint Paul et la femme," *Revue de Théologie et de Philosophie* 19 (1969) 323–24; J. Ruef, *Paul's First Letter to Corinth*, 109; J. B. Hurley, "Did Paul Require Veils or the Silence of Women? A Consideration of I Cor 11,2–16 and I Cor 14,33b–36," *WTJ* 35 (1973) 190–200, and idem, *Man and Woman in Biblical Perspective: A Study in Role Relationships and Authority*, 171 and 177; R. P. Spittler, *The Corinthian Correspondence*, 52–58; G. W. Knight, *The New Testament Teaching on the Role Relationship of Men and Women*, 32; J. Duncan M. Derrett, "Religious Hair," *Studies in the New Testament*, vol. 1: *Glimpses of the Legal and Social Presuppositions of the Authors*, 171; B. K. Waltke, "I Corinthians 11,2–16: An Interpretation," *Bibliotheca Sacra* 135 (1978) 46; R. Jewett, "The Sexual Liberation of the Apostle Paul," *JAAR* 47 Supplement B (1979) 67; M. Evans, *Woman in the Bible*, 94; and R. N. Longenecker, *New Testament Social Ethics for Today*, 79–80. L. Hick combines this explanation with the first—i.e., Greek resistance to Jewish custom—claiming that some women were feminists, some Greek conservatives (*Stellung des hl. Paulus zur Frau im Rahmen seiner Zeit*, 118–21).

18. P. Tischleder, *Wesen und Stellung der Frau nach der Lehre des heiligen Paulus*, 156. Similarly, R. Perdelwitz, "Die exousia auf dem Haupt der Frau," *Theologische Studien*

tendencies."[19] Similarly also do John P. Meier, Franz J. Leenhardt, Wayne Meeks, Jerome Murphy-O'Connor, Else Kähler, Walther Schmithals, Otto Bangerter, and Constance A. Parvey.[20]

There can, in fact, be little doubt that women interpreted the removal of veils as an act of sexual liberation. In spite of the wide diversity of actual veiling practices in antiquity, the veil consistently represented a woman's inferiority and subordination and was used by Jews, Greeks, Romans, and Christians as an effective agent for social control. According to Roland de Vaux, the veil in the ancient Near East, including ancient Israel, made clear to others that a woman was the property of her father or husband, thus protecting male rights.[21] In Hellenized Judaism too, veils were considered evidence that women were under a man's authority and emblems of modesty shielding women from men's gazes.[22] Women without veils were considered shameless.[23] So too in rabbinic Judaism:

> Why does a man go about bareheaded while a woman goes out with her head covered? She is like one who has done wrong and is ashamed of people: therefore she goes out with her head covered.[24]

Conversely, a man's uncovered head symbolized his freedom.[25]

Even though veiling practices were more liberal among non-Jews, here too the veil was an emblem of shame.[26] According to Tertullian, the veil symbolized a woman's inferiority:

> I pray you, be you mother, or sister, or virgin-daughter . . . veil your head: if a mother, for your sons' sakes; if a sister, for your brothers' sakes; if a

und Kritiken 86 (1913) 612; and E.-B. Allo, Saint Paul: Première épître aux Corinthiens, 254 and 258.

19. J. Héring, The First Epistle of St. Paul to the Corinthians (trans. A. W. Heathcote and P. J. Allcock, from the second edition), 102. See also C. K. Barrett, The First Epistle of St. Paul to the Corinthians, 247.

20. J. P. Meier, "On the Veiling of Hermeneutics (I Cor. 11:2–16)," CBQ 40 (1978), 217; Leenhardt, "La place de la femme dans l'église," 31; Meeks, "The Image of the Androgyne," 202; J. Murphy-O'Connor, "Sex and Logic in 1 Corinthians 11:2–16," CBQ 42 (1980) 490; E. Kähler, Die Frau in den paulinischen Briefen: Unter besonderer Berücksichtigung des Begriffes der Unterordnung, 50; W. Schmithals, Gnosticism in Corinth (trans. J. E. Steely), 239; O. Bangerter, Frauen im Aufbruch: Die Geschichte einer Frauenbewegung in der Alten Kirche: Ein Beitrag zur Frauenfrage, 33–35; and C. F. Parvey, "The Theology and Leadership of Women in the New Testament," Religion and Sexism: Images of Women in the Jewish and Christian Traditions (ed. R. R. Ruether), 124–25.

21. R. de Vaux, "Sur le voile des femmes dans l'orient ancien," RB 44 (1936) 411–12.

22. See Strack and Billerbeck, Kommentar, 3:435–39. Cf. Josephus, Against Apion 2.200–201; Philo On the Special Laws 3.56.

23. 3 Maccabees 4:6–10.

24. Bereshith Rabbah 17:8, as quoted in Parvey, "Theology and Leadership," 125–26.

25. A. Jaubert, "Le voile des femmes (I Cor XI.2–16)," NTS 18 (1972) 421–23. See Exodus Rabbah 18:10; Targum Onkelos on Exod. 14:8 and on Judg. 5:9.

26. Aristophanes Lysistrata 326–33.

daughter, for your fathers' sakes. All ages are periled in your person. Put on
the panoply of modesty; surround yourself with the stockade of bash-
fulness; rear a rampart for your sex.[27]

Tertullian's misogyny, though more articulate than that of most early
Christian authors, is not unique. In *Acts of Thomas* 56, women who go
about in the world bareheaded are shameless and will suffer in hell by
being hung by the hair. The *Shepherd of Hermas* depicts demonic women
with heads unveiled and hair unfastened (*Similitude* 9.9 and 15). What-
ever else might be said concerning veils in antiquity, their removal could
symbolize a revolutionary change in a woman's sexual and social status.
The veil was hardly a woman's glory, as Paul would have us think.

However, the hypothesis that Corinthian women removed their veils
out of "a lust for emancipation," like the other hypotheses, fails fully to
account for the activity opposed in 1 Corinthians 11. Why would women
have removed their veils only when actively speaking in worship? They
seem to have had no objection to wearing veils, their cultural symbols of
submission, at other times. If they were so bent on equality, one might
suppose they would have remained uncovered forever. Surely it is more
likely that they considered ecstatic worship a suspension of one's nor-
mal condition, as a momentary denial of mortal contingencies, as a
liminal event in which one achieved a more perfect ontology.[28] If so, it
would be helpful to know more precisely what they might have under-
stood this ritually achieved ontology to be.

In this essay, I shall argue that the myth of the primordial androgyne
such as we find it in some Christian gnostic texts provides the most
plausible framework for understanding the motivation of these Corin-
thian women. By arguing this case, I in no way propose that the Corin-
thians themselves were Gnostics, only that speculations on the primal
human and Genesis 1—3 later common among Christian Gnostics were
influential at Corinth by the time Paul wrote 1 Corinthians.

2. THE CONCEPTUAL FRAMEWORK PROPOSED
HERE: GNOSTIC ANDROGYNY

2.1. The myth of the primordial androgyne, formative already in
Empedocles' cosmogony, by the time of Philo had been linked with a
distinctive two-tiered interpretation of Genesis 1—3. Briefly expressed,

27. Tertullian *On the Veiling of Virgins* 16. See also *Didascalia Apostolorum* 3; and
Jerome, Letter 22, *To Eustochium* 25.
28. So also C. Senft, *La première épître de saint-Paul aux Corinthiens*, 141.

Genesis 1—3 narrates two accounts of the human creation. In the first, the human created in the image of God was incorporeal and androgynous. In the second, the creature was corporeal and was separated into male and female. This interpretation was common also among Gnostics. For example, Irenaeus wrote that the Marcosians "hold that one human was formed after the image and likeness of God, masculo-feminine, and that this was the spiritual human; and that another was formed out of the earth."[29]

2.2. With the soul's fall into materiality and sexual division it lost its primordial authority over the spirit world. It became subject to dark powers. This notion is so pervasive that illustration seems hardly necessary. Nevertheless, I refer you to the fall of the soul in the *Exegesis on the Soul:* "As long as she (Psyche) was alone with the Father, she was virgin and in form androgynous. But when she fell down into a body and came to this life, then she fell into the hands of many robbers," that is, the archons (*Exeg. Soul* 122,22–27).

In contemporary Jewish speculation, this loss of authority over the spirit world also was read into Genesis 1—3. According to Gen. 1:26–28, God's image granted Adam "dominion over the fish of the sea and over the birds of the air, and over the cattle, and over all the earth, and over every creeping thing that creeps upon the earth" (1:26). Rabbinic interpreters supposed that this authority of the image extended to domination over angels as well, who, it was claimed, were created on day one, or two, or as late as day five, along with the "swarms of living creatures," "birds," and "great sea monsters." At their fall, however, the primordial couple lost their authority over the powers.[30]

2.3. From some communities for whom salvation was a return to the divine image we find evidence that the two sexes were reunited cultically, usually in baptism or in the rite of the bridal chamber. One attending consequence of this ontological recovery was freedom from the spirit world. Hear the *Gospel of Philip:*

> The powers do not see those who are clothed in the perfect light, and consequently are not able to detain them. One will clothe himself in this light sacramentally in the union.
> If the woman had not separated from the man, she would not die with

29. Irenaeus *Adv. haer.* 1.18.2.
30. See *Life of Adam and Eve* 12–15 and 37–39; *Apoc. Mos.* 10:3; and *Genesis Rabbah* 23:6 (=24:6). Cf. Philo *On the Creation of the World.*

the man. His separation became the beginning of death. Because of this
Christ came to repair the separation which was from the beginning and
again unite the two, and to give life to those who died as a result of the
separation and unite them. But the woman is united to her husband in the
bridal chamber. Indeed those who have united in the bridal chamber will
no longer be separated. Thus Eve separated from Adam because she was
never united with him in the bridal chamber. (*Gos. Phil.* 70,5–22)

2.4. This final observation is the most debatable but the most impor-
tant for making the case that such anthropogonic speculations best
account for the behavior of Corinthian women. I am convinced that for
most Christian Gnostics the primal androgyne conformed in function to
Wendy O'Flaherty's "male-androgyne." In her study of Hinduism,
O'Flaherty observed that

> the androgyne may be primarily male—playing male social roles, having
> overwhelmingly male physical characteristics, manifesting male sexual
> patterns—and be regarded as highly positive by an androcentric society.[31]

> The male androgyne is an example of the positive theology of the *coinci-*
> *dentia oppositorum* . . .; the female androgyne is, however, generally
> regarded as a negative instance of *coincidentia oppositorum*.[32]

Although Valentinians claimed that the sexes became one in the rite
of the bridal chamber, they also insisted on destroying "the works of the
female."[33] Clement of Alexandria accepted and Tertullian rejected this
Valentinian paradox of uniting the sexes and making the female male.
The following passage is from Clement's *Stromateis*:

> (To the true gnostic) his wife after conception is as a sister . . . as being
> destined to become a sister in reality after putting off the flesh, which
> separates and limits the knowledge of those who are spiritual by the
> peculiar characteristics of the sexes. For souls themselves by themselves are
> equal. Souls are neither male nor female when they no longer marry nor
> are given in marriage. And is not the woman translated into a man when
> she is become equally unfeminine, and manly and perfect? (*Stromateis*
> 6.12.100)

Valentinians claimed already to have taken off the flesh and to have
returned to a state of sexual unity. But this sexual unity is not true

31. W. O'Flaherty, *Women, Androgynes, and Other Mythical Beasts*, 284.
32. O'Flaherty, *Women, Androgynes, and Other Mythical Beasts*, 333.
33. The *Gospel of the Egyptians* in Clement of Alexandria, *Stromateis* 3.9.63, and *Dial. Sav.* 138,15–20 and 144,15—145,5.

androgyny; it is reconstituted masculinity: the female must become male.[34]

Likewise in the *Gospel of Thomas*, in spite of Jesus' repeated command that the two sexes become one, he also says that in order to retain Mary in the ranks of the disciples he will "make her male, that she too may become a living spirit resembling you males. For every woman who makes herself male will enter the Kingdom of Heaven" (logion 114). Notice too that in Gal. 3:28, Paul claims that believers are no longer male or female inasmuch as they have become one male person—the masculine εἷς, not the neuter ἕν.

Instead of dismissing these examples either as unassimilated conflations of conflicting traditions or as undisciplined speculation, I would argue that the cause of this apparent inconsistency was a consistent exegesis of Genesis 1—3. The primordial unity was disrupted by the creation and fall of the woman. Therefore a return to that unity necessitates an undoing of "the works of the female." Contrary to the opinion of many interpreters, the androgyne myth is not antiquity's answer to androcentrism; it is but one manifestation of it.

Now we must return to 1 Cor. 11:2–16 to see whether this constellation of concepts can account for the Corinthian practice of removing veils.

3. THE CULTIC RETURN TO THE DIVINE IMAGE AT CORINTH

Without question the most obstreperous verse in 1 Cor. 11:2–16 is v. 10: διὰ τοῦτο ὀφείλει ἡ γυνὴ ἐξουσίαν ἔχειν ἐπὶ τῆς κεφαλῆς διὰ τοὺς ἀγγέλους ("For this reason a woman should have an authority on her head because of the angels"). The problem is that there is no parallel in Greek for ἐξουσία ("authority") representing a veil, and there is no clear indication why angels should figure into the discussion here. On the other hand, this verse is the most crucial inasmuch as it caps off Paul's argument. Διὰ τοῦτο ("for this reason") shows that it continues the argument in vv. 3–9, while v. 11 abruptly begins a new idea. Why is Paul so obscure at the apex of his discussion?

I suggest that the Corinthians would not have thought Paul obscure at

34. According to the Naassenes, Attis had achieved the ideal state of being "male-female" (ἀρσενόφηλυς), but the elect must become wholly male (Hippolytus *Ref.* 5.7.15 and 5.8.44).

all. The women had removed their veils in worship for the very purpose of dramatizing their authority over the angels, and they did so because of their reading of Genesis 1—3.

At the beginning of his argument, Paul gives his own understanding of the order of creation (11:3), in the middle he discusses Gen. 1:26–27 and Gen. 2:18–24 (11:7–9), and returns to creation in 11:11. According to Jacob Jervell, the fact that Paul's discussion of the divine image in this passage is foreign to his usual understanding of Genesis 1—3 suggests that it was concocted as a specific response to a rival interpretation of primeval history.[35]

The Corinthians did indeed have a rival interpretation of Genesis. They, like Philo and others, divided the creation accounts into a sequential two-staged creation of the human. We know this from 1 Cor. 15:45–49, where Paul awkwardly debates it. The first human was "spiritual" (πνευματικός), "from heaven" (ἐξ οὐρανοῦ), and therefore "heavenly" (ἐπουράνιος). The second human was "psychic" (ψυχικός), "from the earth" (ἐκ γῆς), and therefore "clayish" (χοϊκός). Apparently they called the natural human state "wearing the image of the *anthrōpos* of clay" and their own transcendent condition "wearing the image of the *anthrōpos* of heaven."

These "pneumatikoi" thought they had special authority as the result of having attained the image of the first human. In all of Paul's writings the word ἐξουσία ("authority") appears seventeen times, twelve of these in his letters to Corinth; of these twelve, ten appear in 1 Corinthians. The cognate verb ἔξεστι ("it is permitted") occurs five times in Paul, all in letters to Corinth, all but one in 1 Corinthians. The verb ἐξουσιάζω ("I bring under authority") occurs three times, all in 1 Corinthians. The Corinthians in fact had a slogan that Paul quotes four times: "All things are permissible to me," or "I have authority to do anything" (1 Cor. 6:12; 10:23). There can be little doubt that freedom and its limits were central to the conflict between Paul and these pneumatics. Therefore it is significant that when Paul tells women to cover their heads he refers to the covering using their own catchword: ἐξουσία ("authority").

Furthermore, the Corinthians claimed that their exalted status resulted in invulnerability with respect to the spirit world. In 15:22–28, once again referring to Adam, Paul insists that it is only in the eschaton that believers can claim victory over the powers:

35. J. Jervell, *Imago Dei*, 295.

Then comes the end, when he delivers the kingdom to God the Father after destroying every rule (ἀρχήν) and every authority (ἐξουσίαν) and power (δύναμιν). (1 Cor. 15:24)

I would suggest that the Corinthian women removed their veils to symbolize their cultically achieved authority over the spirit world. After all, veils were commonly assumed to be one of the curses on Eve for her sin, which resulted in the human's vulnerability to the powers.

For example, in *Pirke de R. Eliezer* 14 and *Aboth de R. Nathan* (B) 9:25 and 42:117, women are required to wear a veil as a sign of mourning for Eve's sin:

> Why does woman cover her head and man not cover his head? A parable. To what may this be compared? To a woman who disgraced herself, she is ashamed in the presence of people. In the same way Eve disgraced herself and caused her daughters to cover their heads. (*Aboth de R. Nathan* (B) 9:25)

Also in *b. Erubin* 100b Eve's curse resulted in women being "wrapped up like a mourner, banished from the company of all men."[36]

The veil as a sign of mourning for Eve's sin was current also among early Christians. Tertullian tells women to be attired

> as Eve mourning and repentant, in order that by every garb of penitence she might the more fully expiate that which she derives from Eve,—the ignominy, I mean, of the first sin, and the odium (attaching to her as the cause) of human perdition. . . . And do you not know that you are (each) an Eve? . . . You are the devil's gateway: you are the unsealer of that (forbidden) tree: you are the first deserter of the divine law: you are she who persuaded him whom the devil was not valiant enough to attack. You destroyed so easily God's image, man. On account of your desert—that is, death—even the Son of God had to die.[37]

It would therefore appear that the Corinthian order of creation was (1) God; (2) the pneumatic, sexually unified *Urmensch*, who, by dint of the image of God, enjoyed hegemony over the spirit world; (3) the psychic, sexually divided human made out of clay according to Gen. 2:7, no longer in God's image and therefore not sovereign over angels; and (4) Eve, whose fall women mourn by wearing veils. If this were more or less their interpretation of Genesis 1—3, their return to the divine image

36. See also *Aboth de R. Nathan* (A) 1. For veils used in mourning, see Strack and Billerbeck, *Kommentar*, 3:430. See also *b. Moʻed Katan* 15 and 24; and *Pirke de R. Eliezer* 17.

37. Tertullian *On the Apparel of Women* 1.1. Cf. Tertullian *Against Marcion* 5.8; and *On Prayer* 22.

might well have been symbolized by women removing their veils. They compensated for Eve's sin by climbing a rung on the ladder of being, by reuniting the primordial androgyne, and thereby enjoying authority over the angels.

But why did they symbolize this in acts of ecstatic worship? Hermann Baumann, an ethnological expert in ritual transvestism, argues that because garments are extensions of one's personality and ontology, changes in garments are common in religious rites associated with ontic changes.[38] The exchange of garments in early Christian baptisms is a good example. Baumann also claims that in cultures that understand the human essence—say, soul or spirit—to be sexually unified, or the deity to be asexual or bisexual, the cultic participant sometimes dons attire of the opposite sex in order to symbolize attainment of the power of the soul or the deity, a power often including protection from the spirit world.[39] This, I suggest, is precisely what happened at Corinth.

One story from antiquity illustrates the cultic implications of women becoming male and removing their veils of shame: *Joseph and Aseneth*, an Alexandrian Jewish romance.[40] The story—elements of which are unquestionably traditional—explains how it was that the patriarch Joseph married a non-Jew, the daughter of a pagan priest! Presumably, Aseneth served as the paradigmatic convert, a model of how Gentiles, especially gentile women, should become Jews.

When Aseneth first meets Joseph she wears an expensive robe, jewelry engraved with the names of Egyptian deities, and several layers of head coverings: a tiara, a diadem, and a veil (3:10–11). Later, she abandons her gods, takes off her robe and head coverings, puts on sackcloth and ashes, fasts for seven days, and prays that God may protect her from the devil and his servants, the Egyptian gods (12:9–10). At dawn on the eighth day Michael appears and tells her to put off her black garment, shake the ashes from her head, wash her face in living water, put on a new untouched robe, and gird her loins with a double

38. H. Baumann, *Das doppelte Geschlecht: Ethnologische Studien zur Bisexualität in Ritus und Mythos*, 46. E. Crawley also discusses ritual transvestism in *Dress, Drinks, and Drums: Further Studies of Savages and Sex*. See also M. Eliade, *Mephistopheles and the Androgyne: Studies in Religious Myth and Symbol* (trans. J. M. Cohen), 78–124. W. C. van Unnik has collected evidence from ancient sources in which women ritually let down their hair and removed jewelry. His explanation that Christian women did so in baptism to symbolize repentance and to allow water to penetrate their hairdos probably is too rationalistic ('Les chevaux défaits des femmes baptisées: Un rite de baptême dans l'ordre ecclésiastique d'Hippolyte," *VC* 1 [1947] 77–100).

39. Baumann, *Das doppelte Geschlecht*, 45–57.

40. C. Burchard, *Untersuchungen zu Joseph und Aseneth: Überlieferung, Ortsbestimmung*, 142–43.

girdle of virginity (14:13). All this she does, but in addition she covers her head with a veil (14:17). Michael immediately commands her to remove the veil, "because today you are a pure virgin and your head is like that of a young man" (15:1). After she removes it, he tells her: "From today you will be renewed, remolded and made alive once more, and you will eat the bread of life and drink the cup of immortality and be anointed with the chrism of incorruption" (15:4). Joseph will be her bridegroom forever, so she must put on her ancient, first wedding robe, her primordial garment (15:10). She offers the angel a meal of bread and wine (15:14), but the angel also wants a honeycomb. Since she has none, the angel miraculously supplies one made from the bees of Paradise who ate from the roses of Eden. It is the food of angels, and those who eat it never die (16:8). To prepare for the wedding, she puts on her first robe which shone like lightning (18:3), and on her glowing head she puts a golden wreath and a veil (18:5-6). They marry and live happily ever after.

The element of the story most relevant to the present discussion, of course, is the angel telling Aseneth to remove her veil "because today you are a pure virgin and your head is like that of a young man." Several aspects of this trenchant statement merit comment. In the first place, earlier in the narrative we are told repeatedly that Aseneth already was a virgin. Like many good maidens of *Märchen*, she is locked up in a tower and protected by a retinue of other virgins. In other words, she did not become a virgin when she met the angel, she had been one all along, and even as a virgin she wore her three protective head coverings. Furthermore, it is only in the presence of the angel that she removes her veil. When he leaves, she once again covers her head with a wreath and a veil. Her appearance as a young man is not permanent. Why? It would seem that the veil was inappropriate to her cultically achieved status as one who had attained the primordial state in the presence of an angel.[41]

I suggest that these pneumatic Corinthian women in their ecstatic worship believed they too had climbed a rung on the ontological ladder and transcended sexual differentiation.[42] To symbolize their new status,

41. It may be worth noting that in Philo's fascinating description of the Therapeutae in *The Contemplative Life* we are told these sectarians celebrated a meal after which the men and women would separate from each other, carry on like Maenads throughout the night by singing and dancing, and at dawn the two groups would merge with each other as the crowning moment. Philo's forced, rationalizing explanation helps little for understanding the function of this strange confluence of the sexes at dawn. Could this ecstatic moment have symbolized the reuniting of the sexes into the primordial androgyne?
42. R. Jewett likewise states that Paul "appears to be arguing primarily against

they removed their veils. As with Aseneth, their heads for a time became "like that of a young man," like Eve's before her fall. This proposal fits well with Paul's debunking in 1 Cor. 11:2–16.

As we have seen, the Corinthians had an order of creation that informed their denial of a bodily resurrection (15:45–49). Their order seems to have been (1) God, (2) the incorporeal, sexually united Adam in the image of God, and (3) the corporeal, second Adam, (4) from whom the woman was formed. For Paul, on the other hand, the *ordo creationis* was (1) God, (2) Christ, (3) Adam, and (4) Eve. Not only is Paul's ordering different, its function is different too. The pneumatics apparently used theirs to encourage a return to the state of the spiritual Adam. Paul uses his to sanction as divine the ontological inferiority of women.

Paul objects that the undifferentiated appearance of men and women prophesying violates natural order and dishonors the woman's "head," that is, her husband, by breaking with socially approved fashions. The veil is not the result of a curse on Eve but is required by God's very act of creation. Furthermore, a woman cannot symbolize authority by removing her veil, because the veil itself is an authority over the angels. A man, on the other hand, because he is more fully participant in the image of God, dishonors Christ, his metaphorical head, if he covers his head, for by so doing he denies the authority of God's image.

We need not suppose with Tertullian and a host of subsequent interpreters that the angels in question were demonic, like the "watchers" of Gen. 6:1–4. Paul considered all angels ambiguous and potentially dangerous powers.[43] It remains unclear, however, what Paul understood as the source of the veil's authority. Perhaps Paul meant that the veil, as a sign of marital subordination, represents the authority of a husband. However, such metonymic uses of ἐξουσία ("authority") are unknown.

It is more likely that Paul had in mind some active meaning. Perhaps he feared that in ecstasy women were especially vulnerable to spirits and considered the veil an apotropaic talisman, like a charm against curses or an amulet against the evil eye. Martin Dibelius has collected several parallels from ancient sources illustrating the assumed magical powers of head coverings.[44]

androgyny" ("The Sexual Liberation of the Apostle Paul," 67). See also Bangerter, *Frauen im Aufbruch*, 34–35.

43. A. Richardson claims: "There are no good angels in St Paul" (*An Introduction to the Theology of the New Testament*, 209). See also G. Kittel, "Angelos, etc.," *Theological Dictionary of the New Testament* (ed. G. Kittel; trans. G. W. Bromiley), 1:85–86; and J. C. Hurd, Jr., *The Origin of I Corinthians*, 184 n. 4.

44. M. Dibelius, *Die Geisterwelt in Glauben des Paulus*, 19–20. See Homer *Odyssey* 312–380, where Ino's veil protects Odysseus from Poseidon.

4. WOMEN'S LIBERATION AT CORINTH

In spite of the obvious sexism implicit in the notion that women must become male, we should acknowledge the emancipating emotional release that women experienced in ecstatic removal of their symbols of subordination. Female worshipers in Greco-Roman religions frequently removed their veils and let down their hair. The watershed in Aseneth's legendary development from a cloistered virgin under her father's rule to a Hebrew matriarch was her cultic unveiling. Thecla, the archetypal liberated Christian woman in the *Acts of Paul*, symbolized her freedom by cutting her hair short and wearing men's clothing.[45] One night, Perpetua dreamed she was about to fight the devil and saw herself stripped naked for the contest and transformed into a man.[46] Jerome complains that some ascetic women "change their garb and assume the mien of men, being ashamed of being what they were born to be— women. They cut off their hair and are not ashamed to look like Eunuchs."[47] The Council of Gangra (fourth century) legislated against women donning men's clothing when they take vows of chastity. Only if the practice had been widespread would it have merited such official denunciation.

> If a woman, under pretence of leading an ascetic life, change her apparel, and instead of the accustomed habit of women take that of men, let her be anathema.[48]

No matter how strange this religiously motivated transvestism may appear to us, for these women wearing men's clothing surely was a sign of freedom.[49] We must, however, not view Paul's opposition to cultic transvestism in Corinth simply as a sexist reaction to woman's liberation. For him, women's freedom consists not in their becoming like men in cultic transcendence of the soul but in their indispensability *as women* in procreation and "in the Lord," that is, in the Christian community (1 Cor. 11:11–12).

In this respect, most feminists would agree more with Paul than with the Corinthians. Behind much of the misogyny of Western cultures is the platonic devaluation of the body and the attending male contemp-

45. *Acts of Paul* 3.25 and 40. For the significance of Thecla in the early church, see D. R. MacDonald, *The Legend and the Apostle: The Battle for Paul in Story and Canon*.

46. Clement of Alexandria *Martyrdom of Perpetua and Felicitas* 10.7.

47. Jerome, Letter 22, *To Eustochium* 27.

48. Crawley, *Dress, Drinks, and Drums*, 154.

49. On celibacy and women's liberation, see R. R. Ruether, "Mothers of the Church: Ascetic Women in the Late Patristic Age," *Women of Spirit: Female Leaders in the Jewish and Christian Traditions* (ed. R. R. Ruether and E. McLaughlin), 71–98.

tuous fascination with the female anatomy. Consequently, women rightly have seen that their liberation in part requires a transvaluation of embodiment and especially of women's anatomical functions. "Our bodies ourselves" is a celebrative expression of corporeality. Modern feminists, therefore, in all likelihood would side with Corinthian women in their removal of tokens of ontic inferiority, but with Paul in his rejection of disembodiment and becoming male as soteriological goals.

It would be naive for us simply to decide whether the Corinthians or Paul were more "liberated." The issues historically and theoretically are far too complex to permit such a facile choice. It is our task not to choose sides, but to inquire of ourselves how the oppressed status of women in most human societies might be transformed.

Response to "Corinthian Veils and Gnostic Androgynes" by Dennis Ronald MacDonald

Dennis MacDonald's study of 1 Cor. 11:2–16 is both thorough and creative. He employs a dialogical model for understanding the passage. That is, he proposes a reconstruction of the Corinthian situation and reads the passage in the light of that reconstruction. MacDonald's approach is in line with that of such scholars as Walther Schmithals and Dieter Georgi, who emphasize that one's understanding of Paul is influenced by one's understanding in the Corinthian community. I find this approach to be useful, even though no single reconstruction of the opponents' views has been able to attract a majority of Corinthians' commentators to its side. In 1 and 2 Corinthians, Paul is clearly responding to a particular practice and a particular theology. Refinements in the interpretation of the Corinthian correspondence are therefore most likely to emerge from discussion of such lucid reconstruction of the opponents' views and praxis as that offered here by MacDonald.

MacDonald proposes that the practical issue addressed is that of the veiling of women. He argues that the conceptual framework for the Corinthian women removing their veils is the myth of the primordial androgyne such as is found in some Christian gnostic texts. He further argues that the androgyne myth in antiquity is a manifestation of androcentrism. This androcentrism is expressed in the Corinthian order of creation based upon their reading of Genesis 1—3: "(1) God; (2) the pneumatic, sexually unified *Urmensch*, who, by dint of the image of God, enjoyed hegemony over the spirit world; (3) the psychic, sexually divided human made out of clay according to Gen. 2:7, no longer in God's image and therefore not sovereign over angels; and (4) Eve,

whose fall women mourn by wearing veils" (p. 287). MacDonald suggests that the Corinthian women, who saw Eve as the lowest rung on the ladder, removed their veils and climbed to level two, that of the sexually unified androgyne, thereby enjoying "authority because of the angels." The Corinthian women thus removed their veils at the price of their identity as women.

MacDonald's reconstruction raises a number of questions. He assumes that the primary issue in 1 Cor. 11:2–16 is the veiling of women. Jerome Murphy-O'Connor, however, has convincingly shown that the hair styles of men are as much at stake as the hair styles of women.[1] He cites such parallels as Philo, Pseudo-Phocylides, and Musonius Rufus to demonstrate the ancient view that long hair or dressed hair on men is effeminate. The admonition to the man to be covered is in fact the first admonition of the passage (v. 4). Paul does not focus primarily on women's appearance, adding on men's appearance merely as a supporting argument for his main point. Structurally, both *gynē* and *anēr* are woven into the fabric of the text, *gynē* occurring sixteen times throughout it and *anēr* fourteen times. Paul is as concerned that a man not dishonor his head (v. 4), that he not relinquish the honor due to him as a man by wearing long hair (v. 14), as he is that a woman not have her head uncovered (v. 5).

MacDonald further assumes that the women are removing their veils only during the worship service, that they otherwise wear them. The text does not bear out the assumption. Paul does speak of the man and the woman praying and prophesying. In fact, the context within 1 Corinthians is a liturgical one. The Lord's supper (1 Cor. 11:17–34) follows immediately upon the appearance of women and men while praying or prophesying. Paul's focus *is* worship, but the text does not lead one to believe that the women unveiled themselves only during the worship service. When one takes the men into account, a transformation of appearance only during worship becomes even less likely. According to v. 14, "nature itself teaches you that for a man to wear long hair is a dishonor to him." The statement is a general one, not restricted to worship. Physically, of course, hair length cannot be changed and changed back, so that to the extent to which the passage is as much

1. J. Murphy-O'Connor, "Sex and Logic in 1 Corinthians 11:2–16," 482–500, esp. 483–88; see also R. and C. Kroeger, "St. Paul's Treatment of Misogyny, Gynephobia, and Sex Segregation in First Corinthians 11:2–6 [sic]," in *Society of Biblical Literature Seminar Papers,* 1979 (2 vols.; ed. P. J. Achtemeier), 214–21, esp. 218.

about the hair length of women and men as it is about veiling—which I hold to be the case—a practice occurring only during worship is excluded.

If my view is correct, that Paul disagrees with certain dress practices of both women and men and that these dress practices occur not only during worship, then MacDonald's explanation of the Corinthians' behavior becomes somewhat problematic. While the women might plausibly have removed their veils as an expression of their elevated androgynous state, MacDonald's reconstructed Corinthian order of creation gives no basis for the men to have something on their heads, either long hair or veils. Further, if the Corinthians were deviating from Paul's plan for gender differentiation in appearance not only during the worship service but outside it, they may not have had a theological order of creation as the basis for their behavior. Explanations proposed by other scholars for removing the veil, especially that to remove the veil is to remove a mark of servitude, regain their plausibility.

Motivations for men wearing long hair or headdress and for women going without a veil or wearing short hair are very difficult to establish. Transvestism, whether partial or full, is in fact a much misunderstood phenomenon. Cultural explanations on the part of its despisers should not be equated with the motivations of men who dress as women and women who dress as men. For this reason I am hesitant to assume that Corinthian women who removed their veils did so at the loss of their identity as women. In *Joseph and Aseneth*, Michael tells Aseneth to remove her veil, saying that she is a pure virgin and her head like that of a young man (15:1), but this does not mean that women who removed their veils understood themselves to be like men. Lucian of Samosata, in his *Dialogues of the Courtesans* 5, describes a woman named Megilla who removes her wig, thereby revealing short hair which had been concealed under the wig. Megilla thereupon announces that her name is Megillus and that the woman Demonassa is her wife. Other ancient male writers also describe women who love women as having become like men.[2] Similarly, Philo and some other ancient authors depict men who love men as effeminate in dress and behavior. We should not assume that those who wrote about transvestism and same-sex love in antiquity held the same views of these phenomena as those who practiced them. I am

2. See B. J. Brooten, "Paul's Views on the Nature of Women and Female Homoeroticism," in *Immaculate and Powerful: The Female in Sacred Image and Social Reality* (ed. C. W. Atkinson, C. H. Buchanan, and M. R. Miles), 61–87, esp. 63–71.

not convinced that women who dressed as men or who loved women perceived themselves as masculine or that men who wore long hair or who loved men perceived themselves as being like women.

Scholars who discuss women's veils seldom take into account the physical aspects of the veil. A veil is physically restricting. Removing it gives a woman greater freedom of movement. Perhaps freedom of movement is part of the cultural definition of masculinity within male-centered thinking. Cutting one's hair or wearing male dress can also give a woman freedom of travel in a culture in which women are otherwise potential victims to male aggression. Again, perhaps the freedom to travel alone is defined as masculine in such a culture.

My methodological point here is that one should not identify cultural understandings of behavior with individual or group perceptions of their own behavior. This problem is exacerbated when using male sources to describe women's motivations for their own behavior. I do not mean to deny the influence of male thinkers on women's lives or that women and men who cross-dressed would never have seen themselves as many of the larger culture did. My point is that we should be extremely cautious and hesitant about such identification. Applying this to MacDonald's essay, I am hesitant to assume that a woman who removed her veil saw herself to be a sexually unified androgyne, a being in some way more male than female.

A further, related methodological point is that one should not identify the Corinthian women with the Corinthian men. Since their behavior in the worship service was not the same and their cultural self-understanding was not the same, I do not assume that the Corinthian women who removed their veils and the Corinthian men who wore long hair had the same theological understanding of femaleness and of maleness. Again, I am not implying that we have the historical sources to distinguish between the women and men in the Corinthian community, nor that they could never have agreed upon an order of creation as outlined by MacDonald. I do argue that the tension in the community concerning gender differentiation in appearance, as well as concerning sexual behavior and gender roles (see also 1 Cor. 6:12—7:40) makes it unlikely that the women in Corinth had exactly the same theological anthropology as the men.

First Corinthians 11:2–16 is one of the more opaque Pauline passages. I can hardly imagine any two thinking New Testament scholars coming together to discuss it without a dispute. I wish to thank Dennis MacDonald for having provided the stuff of a good dispute.

Flee Femininity: Antifemininity in Gnostic Texts and the Question of Social Milieu

1. INTRODUCTION

The gnostic tractate *Zostrianos* exhorts its readers to "flee from the madness and bondage of femininity" (NHC VIII 131,5f.). Similar statements are found in other Nag Hammadi texts, and the sentiment they express is not uncommon in late antiquity. This essay will analyze the meaning of the various expressions of antifemininity in the Nag Hammadi tractates. Further, it will consider whether antifemininity is an integral aspect of Gnosticism and whether it implies a special social milieu for the texts in which it occurs.

The word "femininity" which will be used in this study is an awkward term, but it has the advantage that it is appropriately abstract and that it is indefinite in meaning. More established synonyms, such as femaleness, feminineness, and womanhood, which are normally used to translate γυναικεία, or ⲙⲛⲧⲥϩⲓⲙⲉ, have the problem that they bring along connotations that may be misleading. Femininity can more easily take on a new meaning if the context requires this.

For the modern reader, antifemininity has a range of at least four possible meanings. On the one end of the spectrum is misogyny, though if this meaning were intended in our texts, one would expect a warning against women rather than against femininity. Moving to increasing abstraction, one expects on the other end of the spectrum the devaluation of or aversion to anything of the feminine gender or associated with it. To the educated Greek, this category would include even a larger group of nouns. The author of the *Exegesis on the Soul* (NHC II,6) appeals

to the feminine gender of the word *psychē* in order to portray it as a woman.[1] A striking example of this in some gnostic as well as nongnostic texts is the tendency to hypostatize divine attributes of the feminine gender as divine female beings.[2] There is no evidence, however, that negative connotations were attached to femininity in this broadest sense of the word.

Between these two possible meanings of femininity, there are more restricted usages which refer to something normally associated with women but which can be distinguished from them. One such meaning is effeminacy which, to be sure, most ancients felt was something men should avoid. Greek has special words for effeminacy,[3] however, and thus it can be ruled out as a possible meaning of femininity. But other restricted meanings are possible of "evils" which in late antiquity were associated with women but which might also hold men in "bondage." A modern analogy of this would be "machoism" which is more specific than masculinity but not of the essence of being male. Thus it is quite possible for a man to be "antimachoistic" or for a woman to act in a "macho" fashion. It would seem that we must look for such a meaning of antifemininity that potentially could apply to both men and women.

The point of studying the various occurrences of antifemininity in the Nag Hammadi texts is not simply to elucidate these passages but, if possible, to draw some conclusions concerning the relationship between antifemininity and Gnosticism. Since the reason for limiting the examples to Nag Hammadi tractates is mainly practical, it becomes questionable whether it is legitimate to draw general conclusions on the basis of these occurrences. There is, first, the possibility that the Coptic owner or owners of the Nag Hammadi Codices selected tractates for inclusion on the basis of their antifemininity stance. If this was the case, then there must also have been other selection principles, for most tractates do not speak to the issue, though none contradict it.

In defense of the limited group of texts on which conclusions will be based, it can be said that there is no secure basis available to draw general conclusions for Gnosticism.[4] The contours of Gnosticism are too

1. *Exeg. Soul* 127,20f.; also Origen refers metaphorically to the soul as a woman (*Comm. in Matt.* 12.4).

2. E.g., Sophia, Ennoia, Epinoia, and Pronoia in the *Apocryphon of John* (NHC II,1; III,1; IV,1; BG 8502,2).

3. Γυναικοειδής, γυναικικός, γυναικοτραφής, etc.

4. I have argued that for normal purposes the gnostic tractates in the Nag Hammadi Codices can be considered representative for Gnosticism (F. Wisse, "The 'Opponents' in the New Testament in Light of the Nag Hammadi Writings," in *Colloque international sur les textes de Nag Hammadi* [ed. B. Barc], 103f.).

blurred, and while it can be said that gnostic texts share a certain world view, there appears to be no consistency in the way this is expressed. Thus, finding a number of texts associated with Gnosticism that differ greatly in character and content but agree more or less in their view of femininity is a remarkable and significant fact that would permit one to speak of a trend or tendency. As with all generalizations pertaining to Gnosticism, conclusions will need to be modest and open to qualification.

To draw inferences from gnostic texts concerning their social milieu is even more hazardous than to draw general conclusions relevant to Gnosticism. The topics are often so far removed from the normal concerns of daily life that they give no solid clues for the *Sitz im Leben* ("life situation"). The assumption made already by the ancient heresiologists that these texts expressed the official teachings and practices of various sects appears to be mistaken.[5] Only in a strictly orthodox setting would one expect a text to stay within the confines of the official teaching and practices of the sect in question.[6] There can be little doubt that gnostic tractates were written within an uncontrolled, heterodox milieu. Thus they more likely reflect the idiosyncratic visions and opinions of an individual than those of a group or sect. This in itself has social implications, though not very definite ones. It suggests a situation that left room for heterodox speculative thought which could count on at least a limited appreciative readership.

There is, however, a factor that may make it possible to be more definite about social milieu. Antifemininity has obvious implications for self-understanding and life style. The reader of these texts is expected to be able to escape the bondage of femininity. We must see whether this suggests a particular social setting.

2. ZOSTRIANOS (NHC VIII, 1)

Perhaps the most striking occurrence of antifemininity is found in *Zostrianos*, a long and poorly preserved tractate, which is mainly concerned with obscure speculations about the heavenly world but which

5. See F. Wisse, "The Nag Hammadi Library and the Heresiologists," *VC* 25 (1971), 205–23; and idem, "Prolegomena to the Study of the New Testament and Gnosis," in *The New Testament and Gnosis: Essays in Honour of Robert McL. Wilson* (ed. A. H. B. Logan and A. J. M. Wedderburn), 139–42.

6. See F. Wisse, "The Use of Early Christian Literature as Evidence for Inner Diversity and Conflict," in *Nag Hammadi, Gnosticism, and Early Christianity* (ed. Hedrick and Hodgson), 41.

has a fascinating parenetic section at the end. It is presented as the preaching of Zostrianos to the holy seed of Seth after his return to earth and reentry into the body. I shall quote the main part of the preaching of Zostrianos:

> Strengthen the innocent, [elect] soul, and [observe] the (state of) change here and seek the unchangeable unborn state. [The] Father of all of these invites you. [Though they] wait for you and do you harm, he will not forsake you.
>
> Do not baptize yourselves in death, nor entrust yourselves to those inferior to you instead of those who are superior. Flee from the madness and bondage of femininity, and choose for yourselves the salvation of masculinity. It is not to suffer that you came, but you came to dissolve your bonds. Release yourselves and that which binds you will be dissolved. Save yourselves, in order that that one (fem.) may be saved. (130,20—131,14)[7]

There is also a reference to femininity near the beginning of the tractate just before Zostrianos leaves his body and the perceptible world to receive the divine revelations. It reads:

> After I separated from the bodily ($\sigma\omega\mu\alpha\tau\iota\kappa\acute{o}\nu$) darkness which is in me, and the natural ($\psi\upsilon\chi\iota\kappa\acute{o}\nu$) chaos in mind, and the femininity of lust ($\grave{\epsilon}\pi\iota\theta\upsilon\mu\acute{\iota}\alpha$) [that is] in darkness, I did no longer make use of it. (1,10–15)

Antifemininity is not incidental to the tractate. It forms the center of the preaching to the "straying multitude" and it figures prominently in the author's self-understanding. The context is that of metaphysical and anthropological dualism common in late antiquity. The innocent soul needs to be saved from the perceptible world of change which is hostile to it, and from the bondage of femininity which is connected with lust and darkness. Salvation is found in the unchangeable state of unbornness which appears to be linked with masculinity, that is, the state of being released from the bondage of femininity.

The passage at the beginning of the tractate makes clear that it is possible to separate from femininity already in this life, though it is closely associated with bodily existence. The passage does not describe Zostrianos's separation from the body—that happens in 4,20–25—but his preparation for the revelation experience. It probably meant that he was no longer governed by "bodily darkness," "natural mental chaos," and "the femininity of lust."

7. The translation of this and the following passages is my own. Significant differences with text editions will be noted. As yet there is no text edition for *Zostrianos*. My translation differs considerably from the one published in *Nag Hammadi Library* (ed. Robinson), 393.

The preaching of Zostrianos is for "a living generation and to save those who are worthy and to strengthen the elect" (4,15–17). Though this, no doubt, excludes much of humankind, there is no hint that it excludes women. Femininity in the meaning of sexuality and procreation is something that can enslave everyone, and its opposite, masculinity, does not appear to be a natural quality of males but a state that all must seek in order to be saved.

It should be noted that the antifemininity in *Zostrianos* is found together with a description of a heavenly world in which hypostatized female beings play an important and positive role. Further, mythologoumena link the tractate to so-called Sethian Gnosticism as represented in the *Apocryphon of John*, and vocabulary and the title link it to early Neoplatonic circles.[8]

3. THE DIALOGUE OF THE SAVIOR (NHC III,5)

In sharp contrast with *Zostrianos*, the *Dialogue of the Savior* is a heterodox Christian writing which stands in an unclear relationship to Gnosticism. The passage relevant to antifemininity reads:

> The Lord said, "Pray in the place where there is no woman." Matthew said, "Pray in the place where there is [no woman]," he tells us, meaning, "Destroy the works of femininity," not because there is any other (manner of) [birth], but because they will cease [giving birth]. Mary said, "They will never be obliterated." (144,15–23)

The dialogue about the obliteration of the works of femininity continues in the tractate, but unfortunately lacunae obscure the meaning. Helmut Koester and Elaine Pagels, who wrote the introduction to the text edition of the *Dialogue of the Savior*, believe that this passage "does not suggest a metaphysically motivated sexual asceticism."[9] Their reason for this remains unclear. It is hard to deny that the passage has strong ascetic overtones. Prayer and the presence of women are claimed to be incompatible. In the tractate this saying is interpreted by Matthew to mean the same as the saying, "Destroy the works of femininity," which we know also from the *Gospel of the Egyptians*.[10] The works of femininity are specified as procreation. The *Dialogue of the Savior* goes well beyond

8. See J. H. Sieber, "An Introduction to the Tractate *Zostrianos* from Nag Hammadi," *NovT* 15 (1973) 237f.
9. S. Emmel, ed., *Nag Hammadi Codex III,5: The Dialogue of the Savior*, 15.
10. As quoted by Clement of Alexandria in *Stromateis* 3.63.

1 Cor. 7:5 which indicates that sexual abstinence is appropriate during a time of prayer.

There is a striking parallel to the obliteration of the works of femininity in the sectarian, encratic treatise *Testimony of Truth* (NHC IX 30,18—31,5). It portrays the descent of the Son of man upon the Jordan as the end of "the dominion of carnal procreation." This supports the interpretation that antifemininity in the *Dialogue of the Savior* is an encratic rejection of the sexual process of procreation.

4. THE *FIRST APOCALYPSE OF JAMES* (NHC V,3)

The *First Apocalypse of James* is a heterodox Christian treatise that makes use of Valentinian traditions. Two passages refer to femininity:

> Since you have [asked] concerning femininity, femininity existed, but femininity was not [first]. And [it] prepared for itself powers and gods. (24,25–29)

> The perishable has [gone up] to the imperishable, and the work of the femininity has arrived up to the work of this masculinity. (41,15–19)

Though the fragmentary state of the *First Apocalypse of James* makes interpretation difficult, something can be said about the meaning of femininity. The first passage refers most likely to the fall of Sophia and the evil archons who came into being through her. The second passage echoes 1 Cor. 15:53. It is likely that the work of femininity is not just parallel to what is perishable but identical with it, and the same can be said for masculinity and imperishability. This would link the passage to *Zostrianos*, though the antithetical tone of the latter has been replaced by more moderate transformational language. The two passages in the *First Apocalypse of James* are linked by the identification of femininity with the perishable, created order. While one cannot speak of antifemininity in these two passages in the *First Apocalypse of James*, they do share with *Zostrianos* a radical devaluation of femininity rooted in classical metaphysical dualism.

5. THE *TRIPARTITE TRACTATE* (NHC I,5)

This lengthy and very complex Valentinian treatise contains one curious reference to femininity. The relevant part of the passage reads:

> . . . the faces, which are forms of masculinity, since they are not from the illness which is the femininity, but are from this one who already has left behind the illness. (94,16–20)

In a learned note, Harold W. Attridge and Elaine Pagels tried to elucidate the passage.[11] They understand the illness of femininity to refer to the offspring that Sophia begot without the help of her male partner, the Savior. They suggest further that the imagery derives from patriarchal marriage law. In spite of all kinds of background material drawn from other Valentinian sources, the passage in the *Tripartite Tractate* remains impenetrable, as do many other ones in this treatise.

The little that is clear is that femininity is something negative and masculinity is positive. Is leaving behind the illness of femininity similar to fleeing the bondage of femininity? Even if there is a distant relationship, it should be noted that the *Tripartite Tractate* does not draw from its negative view of femininity practical applications for the life of the believer.

6. THE *BOOK OF THOMAS THE CONTENDER* (NHC II,7)

This ascetic, Christian treatise includes one reference to femininity. It reads:

> Woe to you who love the practice (συνήδεια) of femininity and her polluted intercourse. (144,8–10)[12]

In this case it is clear that femininity is identical to sexuality. The message is similar to the one in the parenetic section in *Zostrianos*.

7. THE *GOSPEL OF THOMAS* (NHC II,2)

Logion 114 of the *Gospel of Thomas* does not use the term "femininity," but it deserves to be treated in the context of antifemininity. It reads:

> Simon Peter said to them, "Let Mary leave us, for women are not worthy of the life." Jesus said, "Behold, I shall lead her in order that I may make her male, that she too may become a living spirit which resembles[13] you males. For every woman who will make herself male will enter the Kingdom of Heaven." (51,18–26)

It is not surprising that this saying has received much comment. Recently it has received a full treatment in an article by Jorunn Jacobsen

11. H. W. Attridge, ed., *Nag Hammadi Codex I (The Jung Codex)*, 369f.

12. J. D. Turner translates "the intimacy with womankind and polluted intercourse with it" (*The Book of Thomas the Contender*, 33 and 179). It is difficult to support this meaning on the basis of the Coptic.

13. The translation "resembling you males" wrongly suggests that the antecedent is Mary rather than a living spirit.

Buckley which includes a summary of previous interpretations as well as her own attempt at finding the saving *hermēneia*.[14]

Before commenting on the meaning of any of the logia, the opening words of the *Gospel of Thomas* need to be considered, for they present the modern reader with a serious predicament. The author of these words claims that the logia he has collected are the hidden sayings of Jesus. In other words, he believes that they are mysterious by their very nature. This means that as far as he is concerned, *their meaning is not known!* Great value is put on seeking and finding the meaning; those who find it "will not taste death" (32,10–14).

It would appear that modern commentators of the *Gospel of Thomas* do not really believe the author's claim that the meaning of the logia is a mystery. To be sure, they admit that the sayings are difficult to understand, but they take for granted that the author had a definite meaning in mind and that one can discover this meaning if one sees it against the background of Gnosticism as known from other sources.

Before we make such far-going assumptions, however, the claim of the author deserves to be taken more seriously. It can hardly be denied that all the sayings would appear "hidden" to the normal reader. We should not be deceived by the fact that as scholars we know that a number of them were not meant to be mysterious in their original setting. This does not make them less enigmatic to the author of the *Gospel of Thomas* and his intended readers.

The *Gospel of Thomas* does not give us any reasons to assume that the logia are only enigmatic on the surface and have a sensible meaning if one can break the gnostic code. Neither would it have made sense for the author to give some of the hidden sayings he found in the tradition an openly gnostic slant after telling the readers that the meaning is mysterious. The predicament of the modern interpreter is now clear. The author's "theology" is limited to the opening words. He believed that an esoteric, and most likely mystical, interpretation of enigmatic sayings would lead to salvation. The author may have followed his own advice and may have had certain meanings in mind for the sayings, but we do not know what they were, and it is useless to speculate on them. We cannot even be sure that he was a Gnostic. We know, for example, that mystical interpretation of enigmatic speech was practiced in early Pachomian monasticism.[15]

14. Buckley, "An Interpretation of Logion 114 in the *Gospel of Thomas*," *NovT* 27 (1985) 245–72.
15. See H. Quecke, *Die Briefe Pachoms*, chap. 2.

The modern interpreter can only hope to find the meaning of a certain logion if there is reason to believe that it was not enigmatic in its original setting. This appears to be the case for many of the sayings. But this nonmysterious meaning should not be attributed to the "author" of the *Gospel of Thomas*. Some sayings may have come from a gnostic or encratic or early catholic environment, but this need not have been the same as that of the "author." The sayings as a group have only one factor in common: their apparent enigmatic nature. To attribute a coherent gnostic theology to them can be done only through eisegesis.

For logion 114 this means that it was either enigmatic from the start, and thus without a recoverable meaning, or was assumed to be enigmatic by the "author" of the *Gospel of Thomas*, but clear in its original setting. The conflict between logia 114 and 22, which has puzzled modern interpreters, is no longer a problem, for it is to be expected in a collection of mystery sayings from different backgrounds. There is also no justification to look for clues in logion 61 and others to unravel the hidden meaning of logion 114.[16]

If logion 114 was not originally "hidden," then it means what it says. Taken that way, the logion shows remarkable similarities to the anti-femininity passages in the other Nag Hammadi texts. Peter's words should not simply be dismissed as a misogynic remark which is corrected by Jesus.[17] The need for Mary to leave the company of disciples is not far removed from the dominical injunction in the *Dialogue of the Savior* "to pray in the place where there is no woman." The words of Jesus in logion 114 do not contradict Peter, for they affirm that Mary cannot enter the kingdom if she remains a woman. The work of femininity must be destroyed, but there is salvation in masculinity which is the state of being a living spirit.[18]

8. ANTIFEMININITY

The meaning of femininity in the passages under discussion appears to focus on sexuality and birth. To the pre-Freudian, male mind which was ignorant of the male libido, sexuality appeared to be located in the female and thus was identical with femininity.[19] Masculinity, on the

16. This is the procedure followed by J. J. Buckley in her article.
17. Buckley, "An Interpretation of Logion 114 in the *Gospel of Thomas*," 246.
18. For a list of similar statements in late antiquity, see *RAC*, 8:242f.
19. This is the understanding reflected in the quotation from the *Gospel of the Egyptians* in *Stromateis* 3.63. Clement, who represents a moderate position on marriage,

other hand, was thought to be free from sexuality and birth. Men and
women must flee the bondage of femininity and seek the salvation of
masculinity. The message and context of antifemininity is basically
encratic.

9. GNOSTICISM

Antifemininity is at home in gnostic texts but is certainly not limited to
them. It appears weakest in Valentinian types of speculation and
strongest in encratic Christian writings. Antifemininity is readily com-
bined with speculations of the "Sethian" type, which tend to see sexu-
ality as an evil invention of the forces of darkness to prevent living
spirits from returning to the pleroma.[20] There is also a connection
between antifemininity and Neoplatonism as *Zostrianos* and the writ-
ings of Plotinus and Porphyry indicate.[21] The obvious link between
antifemininity and gnostic literature should caution interpreters against
drawing inferences concerning the role of women in Gnosticism from
the positive role of hypostatized female beings in the pleroma.

10. SOCIAL MILIEU

To flee femininity, that is, the "works" of birth and sexuality and
corruptibility, does not only necessitate an ascetic life style but naturally
leads to a form of monasticism. For men this meant avoiding the
company of women entirely, as was the rule in Egyptian monasticism[22]
and as is still enforced on Mount Athos in Greece. The visions of comely
maidens, which continued to trouble hermits and monks, were ex-
plained as temptations from the devil.[23]

It is likely that the gnostic writings that espouse antifemininity pre-
suppose such an encratic setting of which there are many examples in
the late second and the third centuries C.E. Gnostic writings need not
have given rise to encratism, but they would have found a sympathetic
environment in encratic circles. This is supported by the fact that the

is in agreement with it but rejects the need for encratism, since he believed that
begetting children can be, and should be, an act of the will rather than of desire
(*Stromateis* 3.57).

20. E.g., the *Apocryphon of John* (NHC II 24,26–31) and *On the Origin of the World*
(NHC II 109,1–29).

21. Cf. Plotinus *Ennead* 3.5.1 and Porphyry *De abstentia* 2.34.45; 4.20.

22. See *RAC*, 8:260 and K. Heussi, *Der Ursprung des Mönchtums*, 226f.

23. See *RAC*, 8:259.

Christian heresiologists did not draw a clear distinction between Encratites and Gnostics. Already the first patristic reference to encratism, Irenaeus's treatment of Tatian, includes gnostic traits.[24] A certain Severus, who according to Eusebius[25] became the head of the Encratite sect following Tatian, is portrayed by Epiphanius as a full-blown Gnostic.[26] Encratism lies at the heart of Marcionism and Manicheism, and even if Montanism and Valentinianism were not encratic in the technical sense of the word, both movements incorporated a profound form of asceticism.

The Nag Hammadi Codices as a collection witness to the close connection between Gnosticism and encratism. Not only are gnostic and encratic tractates found in the same codex, but not a few of the texts combine gnostic and encratic themes. A good example of this is the *Testimony of Truth* (NHC IX,3) which can be described equally well as an encratic document which makes use of gnostic material or as a gnostic treatise on the necessity of celibacy.

This overlap between Gnosticism and encratism appears to extend even to the original setting of the Nag Hammadi Codices. Evidence from the bindings strongly suggests that they were copied and used by Pachomian monks around the middle of the fourth century C.E.[27] Apparently the early cenobitic movement drew on a wide variety of heterodox ascetics who brought along the books they cherished. Gnosticism lost its home in the Christian ascetic movement when the orthodox church hierarchy brought the monastic movement under its control during the second half of the fourth century C.E.[28] Apart from Manicheism, this appears to have eliminated Gnosticism from the bounds of the Roman Empire.

24. Irenaeus *Adv. haer.* 1.28.2.
25. Eusebius *Historia ecclesiastica* 4.29.4f.
26. Epiphanius *Haer.* 45.
27. See the discussion in F. Wisse, "Gnosticism and Early Monasticism in Egypt," *Gnosis: Festschrift für Hans Jonas,* 433–40.
28. This also involved the purging of heretical books in the possession of monks; it provides us with a likely reason for the burial of the Nag Hammadi Codices at some distance from the Pachomian monastery. (See Wisse, "Gnosticism and Early Monasticism," 436f.)

The Social Functions of
Women's Asceticism in
the Roman East

1. INTRODUCTION

One consensus from initial studies of the Nag Hammadi texts is that these Gnostics were, on the whole, ascetic in practice.[1] Their fame as libertines seems to have been largely a gift of their opponents. But little has been done to date to determine the forms and functions of their ascetic practice. I want to take up one aspect of this study by probing into the social functions of sexual asceticism among women who claimed wisdom. Ignoring the divisions commonly drawn between Jewish and Christian texts and between orthodox and gnostic texts, I will consider a range of materials from the Roman East: two Jewish texts from Egypt, the *Confession and Prayer of Aseneth* and Philo's *On the Contemplative Life*; two first-century Christian sources, Luke's Gospel and Acts and Paul's first letter to Corinth; two selections from the Apocryphal Acts, the *Acts of Thecla* and the *Acts of Thomas*; and four dialogues of Christ and his disciples, the *Sophia of Jesus Christ*, the *Dialogue of the Savior*, the *Gospel of Mary*, and *Pistis Sophia*.[2]

1. For a review of the literature, see R. van den Broek, "The Present State of Gnostic Research," *VC* 37 (1983) 41–71.
2. The following editions and translations have been used, listed in order of their discussion: M. Philonenko, *Joseph et Aséneth: Introduction, texte critique, traduction et notes*; "Joseph and Aseneth" (trans. C. Burchard), in *The Old Testament Pseudepigrapha*, vol. 2 (ed. J. H. Charlesworth); Philo Judaeus, "On the Contemplative Life," *Works*, vol. 9 (trans. F. H. Colson); Nestle-Aland, *Novum Testamentum Graece*; C. von Tischendorf, ed., *Evangelia apocrypha*; E. Hennecke and W. Schneemelcher, eds., *New Testament Apocrypha*, vol. 2; E. Junod and J. D. Kaestli, *Acta Iohannis*; A. F. J. Klijn, *The Acts of*

Ross Kraemer[3] has pointed out that the life and identity of women in this period are defined by their sexual and family roles, whereas men are defined by their roles in citizenship, landownership, and client systems, so that success and failure cannot be gauged on one scale for both. I would specify that a woman of whatever standing had a three-part role defined by her relationship to her parents, her husband, and her children and/or slaves. Rich and poor parents give a daughter in marriage in order to improve their social and economic status, rich and poor husbands take a wife with similar factors in mind, and all children depend on mothers for a start in their social and economic life. Although a broader public status accrued to a woman through the males with whom she was so linked, this status was due to the effective functioning of these roles and was exercised largely through them. The occasional individual exception of a Cleopatra or the regional exception of landowning women in Egypt only highlight what was everywhere else the rule.

Because of woman's three-part social role, sexual asceticism among women had different social functions than among men. Kraemer's study describes these functions largely under the category of compensation.[4] A more precise analysis is needed of what impact certain ascetic practices had on woman's three-part social role. From the study of texts written in the first centuries C.E., I propose six different possible social functions of asceticism in this period.

1. The safeguarding function. Here temporary ascetic practices assure woman's fulfillment of the three-part social role. She is kept virgin before marriage or is provided cultic outlets that safeguard faithfulness to husband and children.
2. The complementing function. Here long-term sexual asceticism is combined with fulfillment of nonsexual aspects of the three-part role. Sexual asceticism complements an otherwise usual home life.
3. The compensating function. Where circumstances make fulfillment

Thomas: Introduction—Text—Commentary; D. M. Parrott, ed. and trans., *Nag Hammadi Codices III,3–4 and V,1 with Papyrus Berolinensis 8052,3 and Oxyrhynchus Papyrus 1081: Eugnostos and Sophia of Jesus Christ;* S. Emmel, ed., *Nag Hammadi Codex III,5, The Dialogue of the Savior;* D. M. Parrott, ed., *Nag Hammadi Codices V,2–5 and VI with Papyrus Berolinensis 8502,1 and 4;* C. Schmidt, ed., and V. MacDermot, trans. and notes, *Pistis Sophia;* and J. M. Robinson, *Nag Hammadi Library.*

3. R. Kraemer, "Ecstatics and Ascetics: Studies in the Functions of Religious Activity for Women in the Greco-Roman World."

4. R. Kraemer, "Ecstatics and Ascetics," 117–21, 172–82, 188, 199–202, 215–19.

of the three-part role impossible, sexual asceticism can be a substitute. It compensates for an inadequate family situation.

4. The eroding function. Sexual asceticism in a time of social change or destabilization can further undermine the three-part role. This asceticism erodes an already unstable family life.

5. The supplanting function. A task that involves abstinence may be given priority over the three-part role and supplant home tasks.

6. The rejecting function. Sexual asceticism may programmatically reject the three-part role and function socially to encourage a similar rejection by others.

Although I watch for all signs in the texts of what sexual asceticism means to the writer and the characters, I focus not on the religious motivation for asceticism but on what the narrative suggests is the impact of this practice on women's three-part role. Sometimes more than one of the above-named functions seem to be involved, either where two or more are compatible or where a difference of views is evident between tradition and writer or between writer and intended audience. I trust that my errors in this general analysis will stimulate corrective work by others interested in how women's social identity and women's ascetic practices are related in early Judaism and Christianity.

2. EGYPTIAN JEWISH TEXTS

2.1. The *Confession and Prayer of Aseneth*

First I take up what may be an early second century C.E. Jewish story entitled, in what seems to be the best Greek text, the *Confession and Prayer of Aseneth, Daughter of Pentephrey*. The obvious function of Aseneth's abstinence in this narrative is to safeguard woman's three-part role. Living at home in her private tower with seven other virgins born on the same day, Aseneth has never seen a man. At the moment, as the story tells, when every fruit in her garden is ripe, Joseph, second only to the pharaoh, comes to oversee the grain collection and stay with her father the priest (1—3). Though a devoted daughter, she has already lashed out at her father's proposal that she marry this man she claims is a foreigner sold into slavery who abandoned his father and slept with his master's wife (4). But when Joseph arrives in white tunic on a snow-white horse, virgin and chaste, they fall in love and it is he who will not take her as his wife because she worships dead idols and not the living God (5—8). She falls into deep mourning for her insults against him,

fasts in sackcloth and ashes for a full week, then confesses her sin against the living God in a day-long prayer (9—13). That night through an angelic visit she is forgiven and initiated (14—17). They marry and she immediately conceives two sons from Joseph and goes to pay a visit to his father, Jacob (21.2—22.10). Unquestionably Aseneth's abstinence safeguards, and her conduct everywhere glorifies, the family structure and the woman's roles in it.

Yet this story not only encourages continence for the unmarried but also depicts Aseneth receiving a divine visitation and mystical experience, suggesting a broader social function for her asceticism. After the light-man comes down from the star where the sky splits open, he calls her by name and insists that she rise from the ground, stand on her feet, take off her veil and speak to him, because, as he says, "You are a holy virgin and your head is like that of a young man" (14.2—15.1). She is renamed the "city of refuge for many nations" and is told that Repentance, the Mother of Virgins, is preparing a heavenly marriage chamber for her (15.7). He then seizes her head, blesses her for having seen God's mysteries revealed, and feeds her from a honeycomb made by the bees of paradise for the angels to eat who never die. The bees come out of the comb, white as snow, with purple wings and gold crowns, and cover her from head to toe, and the queen bees seize her lips. Then, as suddenly, they fly away to a nearby tower and the honeycomb and the man disappear in fire (16.12–23).

The writer points out that the light-man is dressed like Joseph (14.9); possibly he is a heavenly Joseph purifying her for this marriage. Yet the visitation story also connects her virginity with standing and reflecting and speaking functions, whose role in preparing her for marriage is not clear. Why must she stand unveiled like a man and eat the food of immortality and have the light-man seize her head and the queen bees seize her lips? Possibly other tellings of the story made more of this. But this writer also sees her as a channel of wisdom, especially in her confession and prayer. Something more is being safeguarded than her personal three-part role. We could say a fourth part is added to make her the mouthpiece of the repentant proselyte, serving not only parents, husband, and children but also the nation, which becomes through her a "city of refuge for many nations." Her story in this way legitimates Egyptian wives among the Jews and attracts Egyptian women to conversion. The wise woman safeguards the Jewish people by drawing others into woman's crucial three-part role. At the same time this may provide a "safe place" for the cultivation of a kind of female wisdom that could later function to supplant or reject traditional women's roles.

2.2. On the Contemplative Life

Philo describes the Therapeutrides, ascetic women living the solitary life in a first-century community near Alexandria. They are virgins by choice, largely elderly, by Philo's description having chosen wisdom for their life mate and having "given up mortal offspring for immortal children sown by God in their spiritual rays, by which they are able to see the truths of wisdom" (68). They study the Scriptures and allegorical interpretations, compose hymns and prayers, and live alone except for their Sabbath and festival gatherings (24—30). These women appear to be of about equal number to the men in the community, occupying half the sanctuary, sitting on one side of the Sabbath table and making up one of the two antiphonal choirs which on festal nights, as Philo describes, mix and join into a single ecstatic choir, "drunk with the drunkenness in which there is no shame" (32, 69, 89). Kraemer has proposed a compensating social function for these women's asceticism, this life taking the place of children never born to them.[5] But Philo's point is surely that these women as well as men choose this life freely because of its own rewards (68), indicating a primary function of supplanting one task with another, replacing the care of persons with the care of the Scriptures through allegorical interpretations for individual edification, and by the care of God in praise through hymns and prayers. Since they write and perhaps speak as well as read and meditate, these are to be classified as social tasks. It is also possible that some erosion of women's traditional role may be occurring because of wider opportunities for women in Hellenistic Egypt, as studies in the papyri seem now to be indicating.[6]

3. NEW TESTAMENT

3.1. 1 Corinthians

Because 1 Corinthians is not a narrative but an argument, what it says about the social function of the wise woman's asceticism can be read accurately only if we distinguish the author's persuading voice from the situation that has provoked this persuasion. The author often addresses

5. Kraemer, "Ecstatics and Ascetics," 218–19.
6. For a list of some recently published papyri on Egyptian women's financial transactions, see G. H. R. Horsley, *New Documents Illustrating Earliest Christianity: A Review of the Greek Inscriptions and Papyri Published in 1977*, vol. 2 (1982), 28–29; also vol. 3 (1983), 16–17. An interpretation of the evidence is given in S. B. Pomeroy, *Women in Hellenistic Egypt: From Alexander to Cleopatra*.

all believers, including doubtless the women, sometimes he makes explicit that men and women are both intended, and very occasionally he speaks of women only. Each of these three forms of address gives some indications of his aims for the Corinthian women, and the way he tries to persuade betrays their situation at the time of writing.

On principle, Paul advocates that women not be touched by men (7:1). He would like each of them to be single, as he is (7:7), explaining that the unmarried and virgin woman is "anxious about the Lord's concerns in order to be pure in body and in spirit," whereas "she who has married is anxious about the world's concerns, how to please her husband" (7:34). Clearly Paul's ideal is that women's asceticism function to supplant the three-part role with another all-consuming task under pressure of the shortness of time. If his desire that women be "pure in body and spirit" and his principle "that a man not touch a woman" do reflect some substantive deprecation of sexuality, he does not let this flower here in any call to reject traditional roles. In his nuanced argument Paul does have some awareness of a compensating role for women's asceticism in particular. The widow will be happier unmarried (7:40), the abandoned woman should consider herself unbound (7:15), the divorced woman may stay that way (7:11)—all these women may not advantageously fit back into the three-part role and need not look back.

But more important for Paul in 1 Corinthians than these social functions of asceticism is his effort to safeguard family and, by corollary, church stability. To some extent, continence can do this. Temporary times of withdrawal for prayer if one's husband agrees can safeguard a marriage within devotion to the Lord (7:3–5). But that is not sufficient. Paul's shocked descriptions of immorality in a man taking a father's wife or other men going to prostitutes accentuate this problem. His response is less an admonition to those charged with offenses—all of whom are males—than it is a warning to the whole church, including females, about polluting Christ who is their paschal feast and desecrating the Spirit's temple which is their common body (5:1–8; 6:12–20). After he has made it their problem, he proposes one major solution: though continence would be ideal, because of immorality each man should have his own wife and each woman her own husband (7:1, 2). Paul has not charged women with immorality, but his approach indicates that they have contributed to it by not being married to the men. Paul's sudden change from alarmist rhetoric to a judicious tone, modest use of authority, and meticulous equality in demands on men and women would be particularly effective to persuade ascetic women.

Otherwise they could well think more is being required of them than of the men—as of course it is if some men are ready for marriage or remarriage and they are not.

Paul's succeeding instructions to various groups show how asceticism has been functioning among the Corinthian women. Some have chosen continence within marriage—and this neither temporarily nor by mutual consent, or Paul would not have so carefully specified these restrictions for the future (7:3–5). Theirs is a radical asceticism that seeks nonetheless to function socially as a complement to women's three-part role, a practice not unknown later in the church. Other women have separated from believing husbands, still others from nonbelievers, and Paul, with significant exceptions, calls everyone to live as they did when called—which means in marriage for the great majority of women at the time (7:10–24). Still other women have not married at all (7:25–38). Paul takes these virgins (a feminine noun, see 7:34, 38) as a problem for their suitors or fiancés. The men are the ones told they may marry if they cannot live in continence (7:36–38). Among women, only the widows and once-married are given the free choice not to marry (7:8–9, 39–40).

Paul clearly intends to tighten church order through safeguarding women's three-part role—largely not by asceticism but by marriage; only where women's services are not needed for social order does he reassert his preference to supplant old roles with a new task. It is less clear why the ascetic women choose this life. If their intent is beyond our reach, certain suggestions can be made about what function their action has in the context. A general erosion of women's three-part role in the community seems to be occurring as women of so many age groups choose continence. But changes of women's roles in the wider society are so much less radical that this function should not be overdrawn. Women were carrying some new tasks that could have supplanted marriages: witness Paul's references to women's prayer, prophecy, and speaking in the assembly (11:5; 14:34–35). A concerted rejection of women's three-part role is also possible in a community where some were claiming to be filled, to be rich and to rule (4:8), to judge all things and be judged by none (2:15). The extent of the movement suggests that rejection, supplanting, and erosion of the three-part role may all have been occurring to some degree in Corinth.

3.2. The Gospel of Luke and the Acts of the Apostles

Interpreting what Luke's two-volume narrative can tell about the functions of women's asceticism is complex for somewhat different

reasons. Taking the persona of a historian, Luke incorporates pieces from various sources into a thick collage. Yet his very free hand in selecting, arranging, personalizing, and perhaps even creating stories for his audience provides his own very clear signature. His accounts of women outside the three-part role are interesting vignettes from Hellenistic culture but are not on the whole structurally central to his composition.

The only exception to this is the key role of three such women in his introduction (Luke 1—2). Elizabeth's childlessness could be said to safeguard her for the miracle of birth in old age, just as Mary's youthful virginity safeguards her to receive God's Spirit. But this is not the heart of their characterization. Luke's larger picture is clear in his description of the prophetess Hannah, who has been waiting over a half century for Israel's redemption without leaving the temple day and night. This is a widow's compensation, one could say, but Luke sees that the greater longing has supplanted the lesser. It is those who lack a traditional fulfillment—the barren wife, the poor virgin, and the old widow—who find it supplanted by an in-breaking spirit: "And Elizabeth was filled with the Holy Spirit and shouted with a loud cry, 'Blessed are you among women'" to which Mary responds, "My soul magnifies the Lord and my spirit rejoices in God my savior, for he has noticed the humbling of his slave girl, for look, from now on all generations will call me blessed" (Luke 1:41–42, 46–48). Luke says Hannah "blessed God for this and told everyone waiting for Jerusalem's redemption about [the child]" (Luke 2:38). The task that supplants traditional fulfillment for these women is to perceive through the Spirit and to voice the good news which their story announces.

Luke gives only glimpses in his continuing story of women functioning outside the three-part role. In Galilee "many women" are said to have left homes and to be following Jesus, but Luke ignores any itinerant's speaking role. The task he sees supplanting their home life is financial support of the disciples, perhaps an anachronism from Luke's later time and place, since women who desert families are unlikely to retain wealth and few rural women have it. Elsewhere an apparently single woman named Mary leaves the serving role to Martha and takes on the task of learning; Tabitha, probably a widow, is praised for making clothing, as is Lydia for providing hospitality (Luke 10:38–42; Acts 9:36–42; 16:14–15). The one woman said to be teaching, Priscilla, is married (Acts 18:26). Only twice after his introduction does Luke speak of Spirit-filled women who foresee and announce the truth. When a

slave girl in Philippi repeatedly shouts that Paul and Silas are God's servants, Paul exorcises the spirit from her (Acts 16:16–18). And the four virgin daughters of Philip prophesy, apparently concerning Paul's arrest in Jerusalem (Acts 21:9). In this case prophecy clearly supplants marriage and childbearing, if not the filial role. Conceivably the women at the tomb who see two figures and tell the disciples what they will not believe also qualify as women of the Spirit, though Luke's focus on a physical resurrection counters this. In all, Luke does not develop and sustain the picture prominent in the first stories that he uses of women whose traditional roles have been supplanted by a special access to God's Spirit. Yet his occasional stories to this effect show that some Christians of the first century did link women's spiritual prophecy with elements of an ascetic life style.

4. THE APOCRYPHAL ACTS

The Apocryphal Acts incorporate many stories about ascetic women who claim wisdom. The dominant women in most stories are betrothed or just married to powerful men where compensation as I have defined it—making up for restricted opportunity to fulfill the three-part role—is not indicated. A recent study by Virginia Burrus argues that the authors of these texts incorporate women's oral traditions to claim chastity as autonomy.[7] These are unique among the texts under discussion here for dramatizing the social consequences of these women's asceticism. Family opposition on all fronts escalates into political opposition, imprisonments, and sometimes deaths. Here the domestic structures of domination come alive as women reject their given roles. Much as in martyrdom stories of the period, the oppressive powers are exposed as helpless before the women's commitment to God alone.

4.1. The Acts of Thecla

It is Thecla's mother who first objects to her sitting "like a spider" in her window listening to Paul's voice in an adjoining house (8—9). She calls for Thecla's fiancé to break the spell, and when he fails to get her attention, he mobilizes the men of the city to bring Paul before the governor for misleading the young (10—16). Thecla by this time has bribed her way out of her own locked door and into Paul's prison, and she comes to trial with Paul (18—19). Paul is beaten and expelled from

7. Virginia Burrus, *Chastity as Autonomy: Women in the Stories of the Apocryphal Acts.*

town. Thecla is sentenced to be burned, thanks to her mother's cry to the governor, "Burn this law-breaking girl! Burn this engagement-breaker in the middle of the theatre so all the women taught by this man will be made afraid" (20)! Thecla fears only the one God who sends a cloud to pour water down on her pyre and rescue her (22). Her mother's violence here is that of a widow depending on her only child's marriage—as is shown when Thecla offers her money at the end of the story (43). Yet it is not the mother who seeks compensation for a marginal three-part role in asceticism. It is Thecla, engaged to the first man of the city, who directly rejects a promising three-part role. Later in Antioch she reenacts this rejection when she spurns the advances of the prominent Alexander by knocking the crown off his head (26). There is even a unison lament over Thecla in her home by representatives of each of the three roles: "Those in the house wept bitterly, Thamyris for loss of a wife, Theocleia for loss of a daughter, and the maidservants for loss of a mistress" (10).

Thecla's obsession with Paul's word and her later itinerant mission in male clothing through Myra, Iconium, and Seleucia (40—43) show that her three-part role is also soon supplanted by a new task. Yet the focus remains on Thecla's rejecting the traditional roles. The stories celebrate that God alone is to be feared, making continence the only Christian life, with baptism its seal and resurrection its reward. This is the "wisdom of Jesus Christ" that Paul teaches Thecla and that she herself teaches when she converts Queen Tryphaena and most of her maidservants to the same life (5, 6, 39). Socially this functions for women, first, to reject the three roles upon which female social identity is based, and, second, to supplant these with a new, speaking role to transmit this wisdom to other women.

4.2. The Acts of Thomas

The story of Mygdonia is the final tale in the long series of adventures or acts of Thomas on his way to India. His first adventure has already set the tone: forced to bless a wedding couple in their bridal chamber, Thomas prays for Jesus to help them, whereupon Jesus appears to them in the form of Thomas his twin when they are alone and persuades them to adopt the celibate life. His primary argument is the trials of raising children—their financial needs drive you to rob and defraud widows and then the children turn out to be either dependent invalids or healthy adulterers and murderers. If they accept continence, he offers them living children and an incorruptible marriage in the immortal bridal chamber. Jesus speaks with the bride first and she is first to report their

decision the next morning. She tells her distraught father that she is still unveiled and unashamed because she is yoked, not to a short-term husband, but to the true human being (9—16). The social function of asceticism dramatized here is the rejection of duties to father, husband, and children, with hints of supplanting roles in relation to "living children" which are not socially specified.

Mygdonia's story is told more completely and allows a test of the social function of women's asceticism to see whether it is understood here more as a byproduct of a new social task which supplants given roles or as the rejection of these roles as an end in itself. The "heavy burden of sons and daughters" is mentioned only once in this story (126), as is responsibility to family (135). In Mygdonia's case the entire drama is focused on her role as wife of Karish, the king's kinsman.

Mygdonia hears Thomas from inside a sedan chair when he is blessing her bearers with the words of Jesus to the heavy-laden and calling them to abstain from all evil, especially "filthy intercourse." She dashes out to beg the apostle to pray for her (82—88). From then on, she will neither eat nor sleep with her husband, though he is reasonably kind and does everything to woo and persuade her. She surpasses him in wealth and wisdom, we are told, and he is afraid she will make him a laughingstock and a proverb in India (95, 106). She looks forward to the eternal marriage feast and prays to go "where there is neither day and night, nor light and darkness, nor good and evil, nor poor and rich, male and female, no free and slave, no proud that subdues the humble" (129). It is her boldness ($\pi\alpha\rho\rho\eta\sigma\iota\alpha$) which dominates the story, her refusal to be subdued even when she herself is imprisoned and the apostle who taught her is killed. Clearly the dominant social function of her asceticism is her rejection of the role of wife which has been her identity. She does take on certain new social tasks. She says to Thomas, "I have received the seed of thy words and will bring forth fruit like this seed" (94), and she converts the king's wife (135—137) and anoints the woman in baptism (157). Yet after Thomas is killed, two male converts are made presbyter and deacon, and of Mygdonia it is said only that, despite her husband's great pressure, she "lived according to her own will" (169). This rejection of the wife's role is the featured social function of Mygdonia's asceticism. If the final note about her husband's continued pressure means they still live in one house, then her asceticism may be complemented by fulfillment of some other aspects of the three-part role.

5. CHRISTIAN REVELATION DIALOGUES

In four revelation dialogues women are featured prominently among the disciples questioning the Savior. The texts are by no means a uniform set. The dialogue called the *Sophia of Jesus Christ* was apparently made by inserting questions into a non-Christian epistle on cosmology, *Eugnostos the Blessed* (NHC III,3 and V,1). In the *Dialogue of the Savior*, Jesus speaks briefly and then fields many quick questions from the disciples, with the film further speeded up by many missing frames. What we have left of the *Gospel of Mary* is Jesus' departure and parts of Mary's vision together with the disciples' reaction. Our text of *Pistis Sophia* overcompensates for the sparseness of the last two with almost two hundred unbroken pages of answers about the ascent of Jesus and the release of Sophia and other bound souls into the First Mystery. Though these dialogues apparently stretch from relatively early to late Christian Gnosis, their use of the dialogue form shows that certain Christians continued to want direct, authoritative answers to their questions, particularly questions about their origin and ultimate fate, and that women disciples are seen as the source of many of their questions and some authoritative answers. The search for wisdom and the call to renounce the body appear in all this material. Because the texts may not represent one view, I take them up very briefly in turn, recognizing that they do not stand in linear progression.

5.1. The *Sophia of Jesus Christ*

The writer of the *Sophia of Jesus Christ* shares the interest of its more philosophical source document in the divine generation of the imperishable world. But the new dialogue framework shifts the focus onto the disciples' questioning which culminates in Mariamme's final question: "Holy Lord, your disciples, whence came they, and where do they go and (what) should they do here?" (114,8–12). Though she poses the question in the third person about the disciples, Jesus' answer to her in the second person shows that she is pictured asking also for herself and the six other women who are already "discipling" Jesus when the dialogue begins (90,14—91,2).

The first part of her question, "Whence they came," has been answered earlier when the writer inserted into a description of the immortal self-begotten ones over whom there is no kingdom the words, "You yourselves have been revealed among these men" (99,13–22). Thus they

are from the heavenly world of the source. But the writer can only answer the second question about "where they go" by leaving heaven and telling how they got where they are now through the divine consort Sophia's defective generation of the arrogant Almighty and his sleeping world (106,25—107,11; 114,13–19). The Savior is sent to awaken the "drop from the light," "so that Sophia might be justified in regard to that defect in order that her sons might not again become defective but might attain honor and glory, and go up to their Father, and know the words of the masculine Light" (107,1; 107,11—108,4). The third question, "What shall they do here?" is answered in the next lines, "And you were sent by the son . . . [to] remove yourselves from the forgetfulness of the authorities . . . [and] the unclean rubbing that is from the fearful fire that came from their fleshly part. Tread upon their malicious intent" (108,4–16; cf. 93,16–24). By a conscious rejection of sexual intercourse with its forgetfulness and πρόνοια (here translated "malicious intent," perhaps better "premeditation") they can be instrumental in the reversal of the cosmic power structure. The generating of subjects for the authorities will therefore cease, and the released "defect of the female" can recover its identity in the "masculine light." This language from the culture of sexual oppression highlights the fact that for women the recovery by asceticism of an independent self "where there is no kingdom" is a radical rejection of the identity called female which is based on the three-part role.

The writer ends with "from that day on" they "began to preach" (119,10–15), suggesting that their asceticism may also function to supplant the three-part role with a speaking role. But the final words of the Savior to Mary show that this task does not bring on sexual asceticism due to time or place constraints but that speaking is an extension of the rejection: "You, therefore, tread upon their graves, humiliate their malicious intent, and break their yoke, and arouse my own. I have given you authority over all things as sons of light, so that you might tread upon their power with [your] feet" (119,1–8).

5.2. The *Dialogue of the Savior*

The *Dialogue of the Savior* takes place in this same world. Divine generation of the elements—water and fire, even honey, oil, fruits, and roots—is good (129,20—131,18; 132,19—133,13). But the greatest good is to understand how the body, a seed from a deficient power, became the "root of wickedness," because this knowledge is an awakening of the word that cannot perish (134,1–24). Judas, Matthew, and Mary are taken

up, see a flash of lightning and watch a soul receive a garment of life the eternal vision remains future (134,24—136,24). Meanwhile they are to search Jesus' teachings for the difficult path that leaves the world (139,4–13), overcome evil with goodness (142,5–9), and in their own conduct destroy the works of womanhood because "whatever is born of woman dies" (144,12–24; 140,11–14). Though Mary is instructed with the others in "abandoning the works that will not be able to follow you" (141,8–11), that is, in rejecting the three-part role, she functions more prominently in what survives of this tractate as a seeker of wisdom and an interpreter of Jesus' sayings, the "woman who had understood completely" (139,12–13; 140,14–23; 143,6–10). Her task of interpretation among the disciples in this dialogue does supplant any usual female role. But her sexual asceticism is not pictured as a byproduct of this task but as a programmatic rejection of sexual procreation.

5.3. The *Gospel of Mary*

Reflecting a similar point of view, the *Gospel of Mary* as we have it begins with Jesus' admission to the disciples that the passion that disturbs the whole body is generated contrary to nature, yet all nature can be restored to its root if they will seek, find, and preach the one who is within—as long as they do not multiply rules (BG 7,1—9,5). When Jesus leaves, Mariam comforts the disciples and Peter asks her, as Jesus' most loved among the women, to tell the Savior's words which are hidden from the disciples (9,6—10,6). She recounts a vision, most of which is missing from our manuscript, that ends in an ascent of the soul overcoming each power in turn, including ignorance and every desire of the flesh (10,7—17,9). Andrew and Peter then question that Jesus really said these strange ideas, preferring to speak privately to her rather than openly to them, but Levi rebukes Peter for rejecting her whom the Lord knew well and made worthy (17,10—18,21). In this text Mariam represents yet more explicitly the authority of visionary teaching which the author is defending perhaps against those in the church who identify themselves with Peter.

The specific issue at stake is apparently not sexual asceticism. In fact, it is the author who does not want rules multiplied by others—possibly rules limiting the authority of visionary teaching. He accuses Peter of "contending against the woman as the adversaries do," but Peter is reconciled at the end, not identified with the powers. The writer still holds to the programmatic rejection of sexual relations in the struggle against the powers as the vision indicates, but the shift of focus to the

authority issue suggests the possibility that the social task of visionary teaching could attract some women to asceticism in this context, supplanting their other roles, rather than that the vision of an overthrow of powers alone is causing a rejection of family roles.

5.4. *Pistis Sophia*

The long and elaborate dialogue called *Pistis Sophia* centers on the account of Sophia's thirteen-step restoration by the Savior, each step interpreted by a disciple using a psalm or ode, and the Savior's subsequent teaching the disciples the First Mystery so they too can escape the authorities and preach to others. They are to say, "Renounce the whole world and all the matter within it, and all its cares, and all its sins, in a word, all its relationships which are in it, so that you may be worthy of the mysteries of the light" (102). Yet this is interpreted in three pages of renunciations of everything from talkativeness to theft to adultery to sorcery, culminating in the ultimate renunciation of false teachings (102). Either encratism is so much assumed that it remains unspoken, or, more likely, radical sexual asceticism has been modified by this writing into general social discipline and knowledge of how to escape punishment. The Lord's word, "He who does not leave father and mother and come and follow me is not worthy of me," is now interpreted as, "You should leave your fathers, the archons, so that I make you sons of the First Mystery forever" (131).

This could be intended to allegorize away the literal ascetic requirement. But what follows shows that ascetic practice was still an issue. Salome expresses alarm at the law of Moses' curse that "whoever leaves father and mother will surely die." Mary embraces her and reassures her that she has misread the meaning—apparently to condemn her own leaving her parents. She is greatly relieved and embraces Mary when she hears that the father she must not leave is the savior without whose mysteries she will die (132). If there is no longer a rejection of the three-part role throughout this community, the women who speak may yet represent such an option. And Mary who is called "superior to all the disciples" (17; 97) represents a supplanting of traditional female roles as well with her key role seeking and interpreting wisdom.

5.5. Conclusion on Revelation Dialogues

None of these Christian revelation dialogues prove conclusively that ascetic women are functioning in the writing context in the same way that the other genres reviewed demonstrate for Corinth or among the

Therapeutrides. But if the legendary literary pieces about Aseneth and Thecla and Mygdonia could themselves be used by women—Tertullian is witness that Thecla's story was told "to maintain women's right to teach and baptize" (*De baptismo* 17)—something like that cannot be excluded here. Yet the social context described is not, as in the Apocryphal Acts, the enraged husband and his friend the king against their mutinous wives but an ascetic circle receiving revelations. Three of the four dialogues discussed mention a number of women; Mary Magdalene in each case has a key questioning role and twice unmistakably speaks as the authoritative human voice. If the male disciples in these dialogues are made to present questions that belong to the time of writing, as can hardly be denied, it seems probable that the women also play some hermeneutical role for those who readily identify with them. The struggle to reject the three-part role may no longer be the burning issue in a circle where all have rejected the "works of the female" to recover the "true man." Now visions vie against new rules, mysteries against Scripture interpretations. It appears that the authority of the women's visions —which may be the community's visions—are under fire and must be defended as an appropriate supplanting of the three-part role in spite of the community's language that associates women with physical generation rather than self-understanding. If this is accurate, the biblical women are being used to confirm later women's rejection of sexuality and birth and to legitimate visionary wisdom as their present task.

6. GENERAL CONCLUSION

I refrain from any general schematization of findings. Because this has been a survey of representative texts only, its findings are specific to each text as given above. Further methods to determine social functions of asceticism need to be applied. Eventually the major traditions can be distinguished and their mutual relationships seen. The chief contribution of this study has been to focus on a wide scope of texts and show in what a significant variety of ways women's asceticism functions among Jews and Christians of the Roman East.

Response to "The Social Functions of Women's Asceticism in the Roman East" by Antoinette Clark Wire

I always look forward to reading something by Professor Antoinette Clark Wire, not because I always agree with her but because she raises interesting questions for further discussion. The original title of her essay ("'Women Consecrated in Body and Spirit': The Functions of Virginity Among the Wise") led me to expect to learn something about the cultic function of virginity or the interaction of feminine symbolism and virginity in the cults of antiquity, Judaism, and early Christianity. I expected that the essay would discuss the interrelatedness of virginity, prophecy, wisdom theology, and asceticism for instance in the first letter of Paul to Corinth and its social-religious "world" or that it would attempt to delineate the development of the ascetic ideal for women in the early church. Her present essay no longer seeks to speak about the theological understanding of women's consecration and of virginity among the wise, but it asks about the social function of sexual asceticism among women who claimed wisdom. It would be interesting to explore more fully why the topic was reformulated in such a fashion, since reformulation of a topic always entails a different starting point in conceptualization.

It will not surprise anyone familiar with my work that I welcome such a reformulation, one that does not focus on theological notions about women but seeks to place women's lives at the center of research and reflection. My questions are not intended to challenge this focus on women; they only aim to point out that a functional-literary method needs to go hand in hand with a historical-reconstructive one. My remarks are formulated in response to the original paper presented

orally in Claremont and my questions seek to express my appreciation for her work. Although Professor Wire has modified the paper as it appears in this volume in the light of my response, I do think the issues that my response raises are in need of still further exploration.

My first question pertains to the issue of analytic concepts and reconstructive categories. How does the sociological category of "gender or sex roles" relate to that of "status," understood in terms of the patriarchal household of antiquity? Of particular interest to me here would have been not only a review of feminist sociological discussions about the categories of sex roles and/or gender roles and their theoretical assumptions and implications but also a discussion of the concept of classical patriarchy which I have elaborated in *In Memory of Her* and *Bread Not Stone*. Instead, the essay explores the social but not the religious function of sexual asceticism in terms of women's "almost universal three-part social role."

Although she is critical of Ross Kraemer's one-dimensional focus on the compensatory function of asceticism, Professor Wire adopts Kraemer's assumption that, like that of contemporary women, the life and identity of women in this period are defined by their sexual and family roles, whereas men are defined by their roles in citizenship, landownership, and client systems. This is surely the case—but only to a certain extent, and such "roles" are not parallel to those of our own society. For example, we should not overlook the fact that the social status of *pater familias* also determined men's public-political standing and function and that the emperor defined himself in terms of this role as the *pater patrum* or the *pater patriae*. Women, on the other hand, were landowners (e.g., in Roman Egypt), possessed slaves—women and men—and functioned as patronesses in Hellenistic and Roman times. Sexual asymmetry is without question a given in Greco-Roman and Jewish society, but it needs to be defined with reference to the dominant structures of antiquity which are rooted in the institutions of the patriarchal household. We cannot simply assume that sexual asymmetry was an almost universal given that specified women's role as daughter, wife, and mother in the same fashion as today, and in all areas of the Empire in the same way. We know, for example, that there was a considerable difference in women's social role depending on whether they lived in Asia Minor, Greece, Palestine, Syria, Egypt, or Rome.

Moreover, it is debatable that "the woman of whatever standing had a three-part role defined by her relation to her parents, her husband, and her children." In the patriarchal household the life of all women, as well

as that of subordinate men, was determined by the *pater familias*. According to Roman law, women's role as a wife was still determined by her father or a male relative as long as she had not contracted a *manus* marriage. Only when she contracted such a marriage did she move from the patriarchal control and authority of her father to that of her husband. Neither the social role of the wife nor that of the mother should therefore be understood in terms of the modern nuclear family.

More important, the social "role" of the *mater familias* or the freeborn woman was certainly very different from a slave woman's "role" as daughter, wife, or mother. When we consider the situation of slave women, it becomes obvious that social status in antiquity and contemporary "gender roles" are quite discrete categories, since the *pater familias* not only had sexual access and control over his wife and children but also had such access and control over all his slave women and their children. One must ask, therefore, whether sexual asceticism was only a privilege of freeborn or freed women but not possible for slave women. If this is the case, then the social function of asceticism must be assessed not in terms of gender role but in terms of social status. Finally, we must also consider the social roles of those women who in one way or another had become free from the control of either fathers or husbands, for example, emancipated women, divorced women, widows—women who lived a marriage-free life but did not aspire to sexual abstinence.

The second methodological issue I would like to raise is the distinction between androcentric texts, or men's texts about or injunctions for women, on the one hand, and women as historical subjects, on the other hand. In her discussion of Paul's prescriptive statements in 1 Corinthians on the one hand and of the argument of the Corinthian women on the other hand, Professor Wire has applied this distinction with great benefit. She is, however, in danger of disregarding this distinction in her cursory treatment of other source materials. The tensions between the rhetorical aims of an author and the social-historical situation to which a text is addressed can be traced only through a careful analysis of particular texts and works, not in a generalizing survey of writings from very different times and sociohistorical situations.

A classification or structural typology of social functions must be constructed on the basis of a careful historical and literary analysis of particular texts if it does not want just to reproduce the social function that androcentric texts assume or prescribe for women. We can move beyond the texts to the sociohistorical situation of women only if we delineate carefully the differences and contradictions in and between

particular androcentric texts. In other words, the "social functions of sexual asceticism" need to be worked out in terms of the literary as well as the historical functions of particular texts before they can be "classified," because a system of typification always has the tendency "to level in" historical particularities in terms of the dominant overall theoretical grid.

Third, I wonder whether the first among the six social functions, namely, the safeguarding function, is qualitatively different from the others insofar as it seems to express patriarchal sexual control, while the other functions might help women to live on their own terms within a patriarchal society or household. Moreover, one could ask whether the fifth and sixth functions—if they are assumed to be in sequence— should be reversed and renamed. It seems that women in antiquity could not overthrow the patriarchal institution of the household and the roles derived from it. They could, however, reject and supplant these by creating alternatives to the patriarchal institution of the household based on sexual control and relationships of dominance and subordination.

Early Christianity did not create, but certainly has promoted, ascetic communities of virgins and widows and transformed them into status groups within the Christian church. The new roles of virgins and widows have given women new possibilities of community, independence, mutual support, and social and intellectual opportunities not open to married women of the time. Such communities, however, not only have provided possibilities for a life not defined by the patriarchal family but also have engendered a symbol system of theological legitimization that seems to be strongly influenced by a negative understanding of sexuality, of women's nature, and of spiritual perfection. There are indications that women's and men's sexual asceticism has received different theological valuations and institutional expressions which affected women's and men's social roles differently. It would be interesting to explore the interaction between these social and religious functions and their mutual influence.

Finally, it would have been therefore important to trace the social functions of women's sexual asceticism in the context of developing patriarchal church structures in different geographical areas. An analysis of the pastoral epistles, Ignatius, or "patristic" church orders would have been important. Did ascetic women reject or overthrow their societal roles of daughter, wife, and mother only to find themselves in the long run in new ecclesiastical-patriarchal roles as daughters of the church,

brides of Christ, and spiritual mothers under the control of theological or ecclesiastical fathers? How long could women preserve their relative freedom from social patriarchal roles bought by sexual asceticism?

I do hope my remarks have indicated how much I appreciate Professor Wire's attempt to construct a model that allows us to see and understand the various and different functions of sexual asceticism in the life of women. As she has shown, such an approach helps us to understand the multiple social functions of women's asceticism rather than to reduce them to a single explanation. I do think, however, that such a reconstructive model should not either separate social from religious-theological functions or conceive of "social roles" independently from the social-religious institutions of which they are a part.

Libertine or Liberated: Women in the So-called Libertine Gnostic Communities

Recent studies have brought into focus the special attraction that Gnosticism and asceticism offered to women of the early centuries C.E. It has been recognized that women found opportunities in gnostic communities that were closed to them in the "orthodox" church. This is seen not only in the number of female leaders in gnostic circles but also in the prominence given to the feminine in gnostic sources.[1] Similarly, it has been argued that women discovered in the ascetic life style a path through which to escape from the gender-defined constraints imposed upon them by Roman society. This path supplied an alternative to marriage through which a woman could use her talent and power to God's and her own glory.[2] While the significance of these conclusions for women's existence in the Roman world is under debate,[3] the reality of the appeal of these ideologies to certain women is beyond dispute.

1. E. Pagels, *The Gnostic Gospels*, 57–83; idem, "What Became of God the Mother?" 293–303; K. Rudolph, *Gnosis: The Nature and History*, 211–12, 270–72; and R. Mortley, *Womanhood*. The bibliography on the various feminine aeons in Gnosticism is large. References may be found in the standard bibliographies on Gnosticism. David M. Scholer, *Nag Hammadi Bibliography 1948–1969*. This bibliography is supplemented yearly in *NovT*.
2. E. A. Clark, "Ascetic Renunciation and Feminine Advancement: A Paradox of Late Ancient Christianity," *ATR* 63 (1981) 240–57; R. Kraemer, "The Conversion of Women to Ascetic Forms of Christianity," *Signs* 6 (1980/81) 298–307; R. R. Ruether, "Mothers of the Church: Ascetic Women in the Late Patristic Age," in *Women of Spirit: Female Leaders in the Jewish and Christian Traditions* (ed. Ruether and McLaughlin), 71–98; A. Yarbrough, "Christianization in the Fourth Century: The Example of Roman Women," *CH* 45 (1976) 149–65.
3. Elizabeth Anne Castelli, "Virginity and Its Meaning for Women's Sexuality in Early Christianity," *Journal of Feminist Studies in Religion* 2 (1986) 61–88.

Given that many gnostic communities expressed their hostility to-
ward creation through the practice of asceticism, the attraction of
women to Gnosticism may have been in part a result of their attraction
to asceticism. Not all Gnostics, however, expressed their opposition to
the created world through asceticism. Some gnostic individuals and
communities expressed their beliefs through a practice that underscored
their absolute freedom from the created order, a stance most often
termed libertine.[4] It is clear from the reports of the heresiologists that the
participation of women in these so-called libertine gnostic communities
was as extensive as in the ascetic branches of Gnosticism. Irenaeus
reports, for example, that the proselytizing success of the Valentinian
Marcus in Lyon involved his special attraction to many women with
whom the bishop charges he had illicit sexual affairs.[5] According to the
same bishop, it was the woman Marcellina who first brought the
teachings of the Carpocratians to Rome.[6] Epiphanius's encounter with
the Phibionites in Alexandria in his youth involved the attempt of a
number of the women of the community to seduce him.[7]

Scholars have not distinguished in the past between the libertine and
ascetic branches of Gnosticism in their discussion of its attraction to
women in the Roman world. In fact, the attraction of women to libertine
gnostic movements and the roles that they assumed in them have not
been dealt with in the literature, to the best of my knowledge.[8]

The place and function of women in such communities, however, is
not easily recovered. The role of libertine gnostic women is distorted not
only by those factors which distort women's history in gnostic commu-
nities in general—namely, the biases of the patriarchal sources and the

4. While the term "libertine" derives from the Latin for freedperson, it has come to
connote deviation from the accepted sexual mores of a society. One has only to note
the synonyms for libertinism given in Roget's Thesaurus (profligacy, dissoluteness,
licentiousness, wildness, debauchery, venery, wenching, and whoring) to recognize the
modern connotation of the term. This derogatory sense necessarily affects the view of
the groups that the term is used to describe. As such, it uncritically perpetuates the
presentation of these groups found in the heresiologists. I shall use the term in this
essay for lack of a better alternative, though it is to be understood throughout in a
neutral sense of liberty from the customary laws of nature and society.

5. Irenaeus *Adv. haer.* 1.7.1–6.

6. Irenaeus *Adv. haer.* 1.25.6; cf. Origen *Contra Celsum* 5.62; Epiphanius *Haer.* 27.6.1;
and Augustine *De haeresibus* 7.

7. Epiphanius *Haer.* 26.17.4–9.

8. Rudolph (*Gnosis*, 211), e.g., uses side by side the Carpocratian Marcellina and the
possible Valentinian convert "sister Flora," to whom Ptolemaeus wrote his famous letter,
as examples of the major role played by women in Gnosticism. No discussion or
distinction of the appeal of the libertine teachings of the Carpocratians over against the
more ascetic stance of Ptolemaeus's letter is presented. The distinction is simply not
recognized in connection with the appeal of Gnosticism to women.

opposition of the communities' "orthodox" opponents—but also by the opposition of the society in general to the communities' breach of customary law.[9] The fact that this opposition to custom involved deviation from sexual norms served only to heighten the passion of their opponents and thus further distort the reports about these communities and individuals.

This societal opposition to sexual deviation is not unique to these early gnostic communities. Opposition to a group whose practices involve supposed or real deviation from the accepted sexual behavior of the larger society invariably focuses on this behavior. Sexuality underlies the fabric of a society and must be controlled if the society is to maintain the status quo. To permit a group to redefine sexual practice and law is to permit it to challenge the social structure of the society at its very core. Opposition to the group is demanded.

The reality of this dynamic is observed again and again throughout history. The introduction of the Bacchic religion in Italy drew angry opposition from the conservative Roman senate. Its attraction to women and its challenge to the accepted sexual norms of Roman society are underscored in Livy's account.[10] The cult of Antinous in Antinoopolis, Egypt, in the second century C.E. was condemned by Celsus along with Christianity for its immorality.[11] In the Middle Ages the charge of sexual libertinism was widely used by the church against various groups that challenged its authority. The attraction of women to the movement of Priscillian brought with it widespread charges of sexual license.[12] The

9. The frequent charges of immorality leveled against the paganism of late antiquity in general have been recognized as an oversimplification of the situation based on Christian biases. Adultery and fornication are treated very seriously by Roman law (Lefkowitz and Fant, eds., *Women's Life in Greece and Rome*, 181–89). While the free expression of sexuality existed in certain circles, it is incorrect to conclude that it had the full and widespread support of the entire society (R. F. Hock, "The Will of God and Sexual Morality: I Thessalonians 4.3–8 in Its Social and Intellectual Context," unpublished). The common charge of sexual immorality used by pagans against their Christian opponents underscores the pagan opposition to such practices.

10. Livy 39.8–18.

11. Origen *Contra Celsum* 5.63; cf. 3.36–38. The practice of libertine sexual rites by some Christians may ultimately depend in part upon similar pagan practices. Likewise the significant role of women in such groups may represent a continuity with women's involvement in magic and witchcraft. Cf. M. Smith, *Clement of Alexandria and a Secret Gospel of Mark*, 270.

12. H. Chadwick, *Priscillian of Avila: The Occult and the Charismatic in the Early Church*, 37, 47–56, 143. The charge of immorality was supported by the association of the Priscillian movement with magic and nighttime gatherings. Priscillian was identified by his opponents as a crypto-Manichean, and charges of sexual immorality were part of the standard attack on the Manichean religion by this time (Ambrose *Ep.* 50.14; Augustine *De moribus* 2.19–20, 67–75; *De haeresibus* 46).

Bogomils, whose early theology appears diametrically opposed to libertinism, are nonetheless so charged.[13] The Cathars and Free Thinkers are likewise rebuked for their practice of sexual freedom, though recent studies have again questioned the extent and meaning of such practices as charged by their opponents.[14] Even the apparent references in their own surviving literature are open to the question of the relationship between spiritual language and physical practice.[15]

Here of course one confronts the major methodological problem in interpreting the surviving evidence from these so-called libertine groups. The charge of sexual deviance is part of the rhetoric of opposition. What appears most often to be the case, however, when one has evidence from the group itself is that the opposition has distorted the facts. The group's use of sexual language on a spiritual plane may thus be distorted by its incorrect translation to the physical level of ritual. In such a case, the charge is unfounded and represents a complete distortion of the group's practice.[16] It may also be but one of a stock set of charges aimed against an opponent, much as the charge of Manicheism became a standard part of the heresiological vocabulary of the Middle Ages.[17] It may, on the other hand, be a misrepresentation of the practice and its meaning within the group's theology. The fact of sexual deviation is all that matters to the opponent, who then proceeds to interpret that fact through his or her own theology instead of through the theology of the practicing group. Given the ascetic stance of "orthodox"

13. D. Obolensky, *The Bogomils: A Study in Balkan Neo-Manichaeism*, 150–52.

14. Cathars: M. D. Lambert, *Medieval Heresy: Popular Movements from Bogomil to Hus*, 131; E. L. Ladurie, *Montaillou: The Promised Land of Error*, 139–203; H. G. Kippenberg, "Gnostiker zweiten Ranges: Zur Institutionalisierung gnostischer Ideen als Anthropolatrie," *Numen* 30 (1983) 147–48, 170 n. 4. Freethinkers: Lambert, *Medieval Heresy*, 178–81; and R. E. Lerner, *The Heresy of the Free Spirit in the Later Middle Ages*.

15. Lambert, *Medieval Heresy*, 178. Sexual language and imagery is common in Gnosticism (cf. *Exeg. Soul*, NHC II,6). The spiritual bridal chamber found in the Nag Hammadi *Gospel of Philip* may have been translated among certain gnostic groups into a physical rite that involved sex. Whether it did so or not, the heresiologists found in the language ready ammunition for such an understanding (below, pp. 334–35).

16. The orthodox Christians well knew the specious use of such charges in religious debate. The pagan opponents of Christianity had early brought such charges against the Christians: Athenagoras 32–35; Justin Martyr *1 Apology* 26; Tertullian *Apology* 4.7; Minucius Felix *Octavius* 9; cf. Pliny *Epp.* 10.6; R. L. Wilken, *The Christians as the Romans Saw Them*, 15–25.

17. The unfounded charge of Manicheism was basic to the orthodox attack on Priscillian (Chadwick, *Priscillian of Avila*, 55–56, 98–99, 143–44). It was commonly used to describe any dualist heresy (Lambert, *Medieval Heresy*, 13, 32–33, 63, 143). It becomes such a standard label for wrong thinking that Gregory of Tours can report that there are some who believe that Pontius Pilate was a Manichean (*Historiae Francorum* 1.24).

Christianity in such matters, such interpretations inevitably represent
the basis of the sexual deviation in terms of lust. The nineteenth-century
utopian Oneida community was originally driven out of Vermont on
such charges connected with its founder's ideas on communal marriage.
We know now from the community's own literature that, while the
practice was a part of their belief structure, it was carefully controlled. It
was not a matter of orgies for the sake of sexual pleasure, as their
opponents asserted, but a practice based on ideas of utopian commu-
nism.[18] The Mormon practice of polygamy produced similar charges
from the non-Mormon community.[19] Finally, the distortion of such
groups may involve the universalized interpretation of deviation within
a smaller subgroup as representative of the group as a whole or the
translation of a later development within the group as indicative of the
group's beliefs and practices from the start.[20]

What do these factors mean for our interpretation of the varied
gnostic libertine communities? First, there are no recognizable sources
from these communities themselves through which to test the accounts
of the heresiologists.[21] One sees them only through the eyes of their self-

18. R. DeMaria, *Communal Love at Oneida: A Perfectionist Vision of Authority, Property,
and Sexual Order;* and M. L. Carden, *Oneida: Utopian Community to Modern Corporation.*
19. Early anti-Mormon invective often charges that polygamy was called forth by
lust. An example of such invective is found in J. H. Beadle, *Life in Utah; or, the Mysteries
and Crimes of Mormonism,* 349–50. Beadle begins his account of polygamy (332–33) by
revealing the typical association of sexual deviation and heresy in the mind of the
"orthodox," in this case clearly Protestant, heresiologist. He states that "gross forms of
religious error seem almost invariably to lead to sensuality, to some singular perversion
of the marriage relation or the sexual instinct; probably because the same constitution
of mind and temperament which gives rise to the one, powerfully disposes toward the
other. The fanatic is of logical necessity either an ascetic or a sensualist; healthy
moderation is foreign alike to his speculative faith and social practice. He either gives
full rein to his baser propensities under the specious name of 'Christian liberty,' or with
a little more conscientiousness, swings to the opposite extreme and forbids those
innocent gratifications prompted by nature and permitted by God. Of the former class
are the Mormons, Noyesites of Oneida, the Antinomians, and the followers of St. John
of Leyden; of the latter the Shakers, Harmonists, monks and nuns, and a score of
orders of celibate priests."
20. Charges leveled against Christians by their pagan opponents, including the
charge of infanticide, may be dependent in part on the pagans' attribution to Chris-
tianity in general of practices limited to a small minority, i.e., the Phibionites and their
kind (W. Speyer, "Zu den Vorwürfen der Heiden gegen die Christen," *Jahrbuch für
Antike und Christentum* 6 [1963] 129–35). Late charges of libertinism were leveled against
the Bogomils in general in spite of the fact that their early theology was diametrically
opposed to it (Obolensky, *The Bogomils,* 150–52).
21. While it is true that no source exists today that derives recognizably from a
libertine gnostic group, it by no means follows that we possess no gnostic source used
by a libertine group. Gnostic sources rarely deal with gnostic ritual, and even when a
source does, e.g., the *Gospel of Philip* from Nag Hammadi, the references do not make

righteous and ascetically oriented opponents. Hence it is only through an understanding of the character of their opponents and the nature of the rhetoric of opposition that one can begin to unravel the reality and meaning of their practices and the significance of these practices for the women who participated in these communities.

I want now to look briefly at two rather distinct cases labeled by opponents in some way as libertine: the prophet Marcus of Lyon and the Phibionite community in Alexandria. The "libertine" charges against the Valentinian Marcus in Lyon seem to involve, as those brought some-what later against Priscillian,[22] the teacher's particular attraction to the wealthier women of the community. They are directed more against the individual and his behavior than against the beliefs and practices of the group at large. On the other hand, Epiphanius attacks the Phibionite community in terms of their ritual.

It was in the middle of the second century in the upper Rhone valley at Lyon in Gaul that a Valentinian prophet named Marcus appeared and sought to convert members of the Christian community to his particular brand of the Christian religion.[23] He taught a Valentinian Gnosticism transformed through sophisticated number speculation and alphabet mysticism. His followers participated in a developed system of prophecy and ritual.[24] While the complex nature of his speculative thought might seem to have doomed his efforts among the general population from the beginning, the ritual dimension appears to have led to his considerable

the ritual itself very clear. Various gnostic texts known to us may have been used by libertine groups as well as by the original ascetic gnostic communities that produced them. Sexual language used to discuss spiritual matters is not uncommon in the preserved gnostic sources. The translation of spiritual practices into physical rites by certain groups may well account for many libertine sects (Rudolph, *Gnosis*, 251). The Phibionite community used books about Ialdabaoth and Seth and employed the figure of Barbelo extensively in its mythology (below, p. 341). From this it is not inconceivable that these gnostic libertines used various texts that we today label Sethian. We know that they used other books not originally theirs in their religion, namely, the Old and New Testaments. Jürgen Dummer, "Die Angaben über die gnostische Literatur bei Epiphanius, Pan. Haer. 26," in *Koptologische Studien in der DDR zusammengestellt und herausgegeben vom Institut für Byzantinistik der Martin-Luther-Universität Halle-Witten-berg*, 205–8; cf. S. Benko, "The Libertine Gnostic Sect of the Phibionites According to Epiphanius," *VC* 21 (1967) 103–19.

22. See n. 12, above. Jerome understood the patronage of heretics by well-to-do women as a general phenomenon (*Ep.* 133; Chadwick, *Priscillian of Avila*, 37).

23. The account of Marcus's activity in Lyon is preserved by Irenaeus in his *Adversus haereses*. The text is found in Harvey, ed., *Sancti Irenaei, Episcopi Lugdunensis, Libros quinque adversus haereses*, 1:114–88. Rudolph offers a good account of Marcus's activity (*Gnosis*, 213–15, 241–42, 324–25).

24. Irenaeus *Adv. haer.* 1.7.2; 1.14.1–2.

success.[25] Irenaeus, the "orthodox" bishop of Lyon, reports that many men and women converted to Marcus's cause.[26]

The role played by women in the Marcosian movement was significant, to judge from Irenaeus's report. The nature of their participation, however, has been distorted by the bishop's opposition to the movement, his cultural conservatism, and his patriarchal biases. For Irenaeus, women who truly possess the fear of God are not deluded by Marcus but rather abhor him.[27] The women who succumb to his teachings, on the other hand, are deluded and wicked. They are, in fact, less than real women (γυναικάρια).[28]

Marcus attracted many women from the wealthier elements in the community.[29] While Irenaeus uses this evidence to attack Marcus, presumably to suggest his greed, one recalls the similar appeal of early Christian asceticism among the aristocratic women of Rome.[30] It may be that Marcus offered these women, in particular, a means to express their religious convictions outside the more typically patriarchal structure of the church. They represented the class of women who had the time and the means to explore the alternatives.

Irenaeus accuses Marcus of seducing these women through the use of deceit and magic. He reports that the seduction involved the use of ritual. His understanding of the Marcosian rituals, however, is inadequate. He first reports that Marcus "goaded the women on to ecstatic prophecy" through the use of a eucharistic rite that involved the par-

25. The ritual dimension of Gnosticism surely accounts in part for its widespread success. Irenaeus's account of the success of Marcus reveals the important role that ritual played in gnostic missionary activity. While a detailed account of the speculative Marcosian theology is given, one meets the converts within the discussion of the ritual dimension of the movement. They are not present to discuss or debate subtleties of the theology (though many undoubtedly did) but to participate in the sacraments and to receive the gift of prophecy.

26. Irenaeus *Adv. haer.* 1.7.1. Irenaeus of course reports their conversion in terms of their "having been led astray" (πεπλανημένα). The extent of the bishop's rebuttal underscores the serious nature of Marcus's challenge to the Christian community in Lyon. One might suspect that it was this experience that convinced Irenaeus of the need to compose and circulate his *Adversus haereses.*

27. Irenaeus *Adv. haer.* 1.7.3. Even here, however, Irenaeus seems to say that these women accepted Marcus at first and only then had the "good" sense to return to his flock.

28. Irenaeus *Adv. haer.* 1.7.2, 5. Γυναικάρια appears as *mulierculas* in the Latin version. The negative sense of simple or silly is clear. The faithful women are called simply γυναί (1.7.3). In Epiphanius's account of the Phibionites, the men and women of the sect are labeled γυναικάρια καὶ ἀνθρωπάρια (*Haer.* 26.5.8).

29. Irenaeus *Adv. haer.* 1.7.2.

30. Clark, "Ascetic Renunciation and Feminine Advancement," 240–57; Yarbrough, "Christianization in the Fourth Century," 149–65.

taking of the blood of Charis.[31] In the next paragraph, however, Irenaeus relates that the Charis is received by the women through a ritual of the bridal chamber. He offers the following citation of Marcus's seductive words:

> I wish to share my Charis with you, since the Father of all sees your angel continually before his face. The place of the greatness is in us. We must be united.[32] Receive the Charis first from me and through me. Adorn yourself as a bride awaiting her bridegroom, so that you may be what I am and I what you are. Establish the seed of light in your bridal chamber. Receive the bridegroom from me and contain him and be contained in him. Behold the Charis has descended upon you. Open your mouth and prophesy.[33]

The language is Valentinian, with its notion of the heavenly counterpart of the Gnostic's soul. Irenaeus uses it to suggest the physical nature of the rite of the bridal chamber. The first person singular suggests Marcus's involvement in the ritual, which Irenaeus wants the reader to assume involved sexual intercourse. It is interesting to note, however, that Irenaeus reports shortly after this point that it is only after the woman prophesies that she yields up to him her person.[34]

At the very least it would seem that Irenaeus has confused the Marcosian practices here in his attempt to equate the religious and sexual "seduction" of the women. In fact, the eucharist and the bridal chamber were two distinct rituals which may have represented different stages of initiation. It is possible that Irenaeus is correct in asserting that the Charis and gift of prophecy were bestowed by both rituals, though this fact may also represent his own confusion.

The nature of the ritual of the bridal chamber must remain uncertain. At a later point when he is describing the ritual in more abstract terms, Irenaeus says that the Marcosians assert that it is a spiritual marriage ($\pi\nu\epsilon\nu\mu\alpha\tau\iota\kappa\dot{o}\nu$ $\gamma\acute{a}\mu o\nu$).[35] There is no hint at this point that the rite involved sexual intercourse. It is only when Irenaeus moves from the abstract to concrete examples that he reports the rite in terms of seduction and sexual intercourse. For Irenaeus, the bridal chamber was simply a vehicle of seduction. While all of the individual accounts that are

31. Irenaeus *Adv. haer.* 1.7.2.

32. The text is supplied from the Latin, *oportet nos in unum convenire*. The Greek text is given by Harvey as follows: ὁ δὲ τόπος τοῦ μεγέθους ἐν ἡμῖν ἐστι δι᾽ ἡμᾶς ἐγκαταστῆσαι [l. δεῖ ἡμᾶς ἐν καταστῆσαι].

33. Irenaeus *Adv. haer.* 1.7.2. The translation is mine.

34. Irenaeus *Adv. haer.* 1.7.2.

35. Irenaeus *Adv. haer.* 1.14.2.

reported involve only Marcus, Irenaeus does note that Marcus's disciples likewise deceived and defiled many women.[36]

It is difficult to interpret this evidence. The Marcosian theology that is preserved by Irenaeus does not in itself suggest a libertine dimension to the bridal chamber. It is a spiritual marriage, a ritual union with one's heavenly counterpart. If Irenaeus is correct in his assertion that the rite involved sexual intercourse, the theological undergirding behind the practice was certainly more significant than he portrays. It is doubtful that Marcus was the charlatan that Irenaeus wants the reader to believe. This portrayal of the teacher is more likely to be attributed to Irenaeus's rhetoric of opposition and the bishop's view of women as simpletons who can be seduced in great flocks by clever sophistries.

The recognition of the heresiologist's biases, however, does not automatically translate into a more objective definition of women's participation in the movement. One may speculate about the alternatives, but one cannot claim the opposite reality simply on the basis of a single witness's biases. Nonetheless, the silence of the groups themselves and the obvious biases of the opposing witnesses demand an exploration of the alternatives, if only to counter our own inherent patriarchal biases that accept too readily those of the ancient heresiologists.

The Marcosian system is complex. Irenaeus records it in great detail. Yet he seems to suggest that Marcus attracted his male disciples through the teaching and that together they seduced the women into participation. The bias is obvious. Women and sex are limited in Irenaeus's account to the beginning, where he reports the rituals or concrete activity of Marcus and his followers. They are absent from the major portion of his account wherein he records the movement's theology. This division surely reveals more about the bishop's view of women than about their role in the Marcosian movement. The role played by women, whether the movement actually involved sexual intercourse or not, was a major one. This Irenaeus cannot deny. Rather, he counters it by trying to show that their involvement was superficial, an involvement based not on intellectual acceptance of the complex Marcosian theology but on sexual seduction.[37]

If indeed women were as prominent in the Marcosian movement as

36. Irenaeus *Adv. haer.* 1.7.5.

37. It is undoubtedly true that there were those who joined libertine communities for less than respectable reasons. The reasons for joining the movement or being "seduced" into joining, however, are not gender-defined. It is most likely true, because of the patriarchal nature of ancient society, that more women than men were "seduced" or compelled into joining the movement.

the evidence suggests, one may speculate that on occasion they too converted male members of the wider community to the movement. Irenaeus cannot suggest this, however, because he cannot conceive of the women in a dominant role. His rhetoric of opposition is based on his portrayal of the women as simpletons who were seduced because of their sexual nature through rituals that involved sex. To suggest that they converted or even "seduced" men into the Marcosian movement would run counter to this portrayal.

The latter image of women as those who used their sex to seduce men away from "orthodoxy" is not unknown in the heresiological literature. The account of the Phibionite community in Alexandria includes such a report. Its author, Epiphanius, presents the participation of the female members of this community in its rituals as dependent on their "natural" sexual appetite. The women are viewed as sexual beings whose lust led them even to attempt to seduce the "righteous" Epiphanius himself.[38]

The Phibionites (also called Gnostics or Borborites) are known chiefly through the account preserved by Epiphanius in his *Panarion haereses*.[39] This account conflates his own experience of a group in Egypt (probably in or near Alexandria)[40] with materials that he gleaned from elsewhere. He presents the group as a generic sect. He recognizes different names for the organization in different geographical areas and in the account often refers to "others" (ἄλλοι δέ) as a designation for different segments of the generic group.[41]

It must be pointed out that scholars are not unanimous in their acceptance of Epiphanius's report. Many view his explicit descriptions of the Phibionites' sexually based rituals as a heresiological invention designed to discredit the sect. In spite of Epiphanius's statement of his own youthful contact with the group, it is argued that any such involvement would have been superficial and would not have given

38. One must point out that Epiphanius considers all members of the community, both male and female, as driven by sexual lust. Yet of course it is the women who seek to seduce him.

39. Epiphanius *Haer.* 25—26. Epiphanius offers chap. 26 as his account of the Phibionites and their kind. He presents chap. 25 as an account of the Nicolaitans. It has been demonstrated, however, that the material used in chaps. 25 and 26 properly belong together. Epiphanius's description of the Nicolaitans in chap. 25 is designed to link the Phibionites with this archetypical libertine gnostic group. Dummer, "Die Angaben über die gnostische Literatur," 194–95; C. Schmidt, *Gnostische Schriften aus koptischer Sprache*, 570–73; and de Faye, *Gnostiques*, 423.

40. Epiphanius *Haer.* 26.17.4–8. The reference to the expulsion of eighty Phibionites from the city (τῆς πόλεως) suggests that the events took place in or near Alexandria. Schmidt, *Gnostische Schriften*, 575; L. Fendt, *Gnostische Mysterien: Ein Beitrag zur Geschichte des christlichen Gottesdienstes*, 12; and idem, "Borborianer," *RAC* 2.511.

41. Epiphanius *Haer.* 26.2.5–6, 3.7.

him access to their inner rituals. His descriptions are thus rhetorical inventions, or at best a product of his imagination which was influenced by the sexual imagery that he found in their sacred texts.[42] Others have been more convinced of the basic accuracy of Epiphanius's report.[43] These scholars argue that the rituals presented by Epiphanius are to be understood in relation to the reconstructed theology of the group.[44] The detail and complexity of Epiphanius's account, the inner continuity between Phibionite theology and ritual, and the scriptural support of their practices cited by the heresiologist suggest to this author a reality behind his presentation. This conclusion is supported by the fact that the practices of the Phibionites and the resultant horror in which the group was held are documented outside Epiphanius's account.[45] While it was certainly not a mainstream movement, we must not let our own puritanism or the more ascetic nature of the surviving gnostic sources preclude our openness to such libertine alternatives.[46]

Epiphanius reports that the Phibionites reject the stance of the "orthodox" church with respect to the understanding of the body. They are not ascetic in even the most limited sense of the word. Fasting

42. J. L. Jacobi ("Gnosis," *Realencyklopädie für protestantische Theologie und Kirche* [2d ed.], 5:246–47) asserts with respect to Phibionite rituals that "trotz Epiphanius Versicherung sie kaum für möglich halten möchte." More recently Kraft has doubted the reliability of the accounts (H. Kraft, "Gnostisches Gemeinschaftleben: Untersuchungen zu den Gemeinschafts- und Lebensformen häretischer christlicher Gnosis des zweiten Jahrhunderts," 77–83, 158). Koschorke, under the influence of the Nag Hammadi texts, questions in general the reliability of the patristic evidence for libertine Gnosticism (K. Koschorke, *Die Polemik der Gnostiker gegen das kirchliche Christentum,* 123–24); Wilken (*The Christians,* 20–21) is cautious, but unwilling to "dismiss such reports out of hand."

43. Fendt, *Gnostische Mysterien,* 3–22; idem, "Borborianer," 510–13; Benko, "The Libertine Gnostic Sect," 103–19; idem, "Pagan Criticism of Christianity During the First Two Centuries A.D.," *ANRW* 23:2 (1980) 1081–89; S. Gero, "With Walter Bauer on the Tigris: Encratite Orthodoxy and Libertine Heresy in Syro-Mesopotamian Christianity," in *Nag Hammadi, Gnosticism, and Early Christianity* (ed. Hedrick and Hodgson, Jr.) 287–307; F. E. Williams ("Were There 'Immoral' Forms of Gnosticism?" [paper presented at the "Rediscovery of Gnosticism" conference at Yale University, March 1978]) offers a careful discussion of Epiphanius's reliability; Rudolph, *Gnosis,* 247–50; Schmidt, *Gnostische Schriften,* 566–76, esp. 573–74; de Faye, *Gnostiques,* 421–28, esp. 423–24; Gaffron, "Studien," 355 n. 4; Dummer, "Die Angaben über die gnostische Literatur," 191–219; Speyer, "Zu den Vorwürfen der Heiden," 129–35; and H. J. Schoeps, *Aus frühchristlicher Zeit: Religionsgeschichtliche Untersuchungen,* 260–65.

44. Fendt, *Gnostische Mysterien,* 3–22; and Benko, "The Libertine Gnostic Sect," 103–19.

45. *Pistis Sophia* 147; *Second Book of Jeu* 43; cf. Clement of Alexandria, *Stromateis* 2.2; Minucius Felix *Octavius* 9. A detailed account of the Syro-Mesopotamian evidence has been supplied by Gero ("With Walter Bauer").

46. Gero ("With Walter Bauer," 306) suggests that "the Borborites constituted for the most part a secret society that led a clandestine existence within other Christian groups."

belongs to the archon of this world, and care and adornment of the body
are not scorned (*Haer.* 26.5.8, 13.1, 17.8). One must be careful, however,
in moving beyond this stance to Epiphanius's interpretation of it as one
of whoring and drunkenness (κοίταις τε καὶ μέθαις σχολάζοντες).[47] The
sect does practice an elaborate table fellowship which Epiphanius
charges is followed by an orgiastic sharing of sex partners (*Haer.* 26.4.3).
The Phibionites term this after-dinner fellowship the Agape. It involves
the sharing of sexual mates and a sacrifice of the male semen and female
menstrual blood which is apparently modeled on the Christian eucha-
rist.[48] The semen is taken in the hands, offered in prayer as the body of
Christ, and eaten with the words of supplication: "This is the body of
Christ; and this is the Pascha, because of which our bodies suffer and are
made to acknowledge the passion of Christ" (*Haer.* 26.4.7). The menses is
likewise offered up as the blood of Christ (*Haer.* 26.4.8). In the hetero-
sexual Agape, *coitus interruptus* was practiced in order to avoid procrea-
tion and gather the semen for the sacrifice. If conception did take place,
the group performed an abortion and made a meal of the fetus (*Haer.*
26.5.4–6). The gathering of the semen was also accomplished, according
to Epiphanius, through masturbation and homosexual practices (*Haer.*
26.5.7, 11.1, 7).

Epiphanius is, of course, scandalized by these practices and portrays
the members as persons seeking only sexual self-gratification (*Haer.*
26.5.2; etc.). The practice of *coitus interruptus* and the use of abortion
suggest rather that their theology (a matter of little interest to Epi-
phanius) centered on the avoidance of procreation (*Haer.* 26.5.2, 16.4).
Space here does not permit a detailed analysis of Phibionite theology.[49]
It is sufficient to point out that the negative stance toward creation
coupled to the identification of the human sexual emissions with the
element of the divine in humanity accounts for the Phibionite practices.
The separation of the original Adam into male and female worked to
divide further the divine "light" caught in the material creation and
hence hinder its eventual reunification into the pleromatic realm. Pro-
creation was the demiurge's device to effect this further division. The

47. Epiphanius *Haer.* 26.5.8. Such descriptions are clearly dependent on Epiphanius's
rhetoric of opposition.
48. Fendt (*Gnostische Mysterien*, 3–22) offers the fullest study of the sacramental
nature of the cult. He believes that it represents the christianization of an originally
pagan cultus (p. 14).
49. A number of good accounts exist: Rudolph, *Gnosis*, 247–50; Schmidt, *Gnostische
Schriften*, 566–77; Benko, "The Libertine Gnostic Sect," 103–19; Fendt, "Borborianer,"
510–13; idem, *Gnostische Mysterien*, 3–22; and de Faye, *Gnostiques*, 419–28.

Phibionite practice represents a short-circuiting of this process. The "light" of the pleroma, which is drawn out of individuals in their sexual emissions, is gathered and offered to the divine. The practice is a ritual enactment of conclusions drawn from this basic gnostic theological conception. It is not, as Epiphanius presents it, simply a group seeking fulfillment of sexual fantasies.

It is interesting in this light to reevaluate the role of women in this particular "libertine" group. Epiphanius would have his readers believe that the women were simpletons, used by the male members of the sect as sacrifices to the archons (*Haer.* 26.9.6). Women are deceived by the men (*Haer.* 26.11.9) and made foolish (*Haer.* 26.9.8). In the Agape rite, it is the male members who give their wives to other brothers (*Haer.* 26.4.4). At best, the women are victims (*Haer.* 26.9.8).

Closer examination of the material suggests that Epiphanius's presentation of the female members of this group suffers as much distortion as a result of his patriarchal biases as his presentation of the group's practices suffers from his "orthodox" assumptions. It is interesting in this connection to examine Epiphanius's account of his own encounter with the group in his youth (*Haer.* 26.17.4–9). He emphasizes the fact that the Phibionite women tried to seduce him, which corresponds well with his general presentation of the group. Yet it is an interesting fact that it is precisely and only the female members who first speak to the young Epiphanius of the group's theology (*Haer.* 26.17.4) and then attempt as part of the conversion process to involve him in the Agape.[50] It is understandable that the old Epiphanius would view this as an attempted seduction. It was in all likelihood understood by the women involved as part of the salvation process, an attempt to win a convert and gather more "light" for God.

This fact raises in turn the question of Epiphanius's presentation of the role of women in the sect's rituals in general. One might suspect, for instance, that the sharing of sexual partners in the Agape was not simply a case of husbands' giving of their wives to other brothers but rather a free communal interchange. Why could not women also take the initiative in the exchange? It is only Epiphanius's patriarchal conservatism that leads him to ignore this possibility.

Various factors in Epiphanius's account point to the high regard in which the feminine was held by the Phibionites. Thus the incorporation of the menses as the blood of Christ alongside the semen as the body of

50. This may be in part a result of his desire to stress the sexual nature of the group. Yet it is significant that the women took the initiative.

Christ in the Phibionite ritual underscores the positive involvement of the women. According to Aristotle's account of the reproductive process, the contribution of the female, represented in the menses, was the material portion of the new creature. The male semen contributed the soul.[51] On the basis of this theory, the Gnostic might be expected to show interest only in the semen, which represented the portion of humanity that required salvation. While the Phibionite inclusion of the menses in their ritual may be in part a result of the influence of the eucharistic pattern of "body and blood," it nonetheless argues for the high regard of the female partner. She is not just a victim used to withdraw the male element. She too contains a part of the divine which must and can be gathered!

While Epiphanius does not report on the writings and myths of the group in any detail, he does offer enough material to reveal the importance of the feminine in the Phibionite texts. The list of books with which he associates these groups in his chapter 26 is already fascinating in this regard. They include *Noria* (26.1.3), a *Gospel of Perfection* (26.2.5), a *Gospel of Eve* (26.2.6), *Questions of Mary* (26.8.1), *Greater Questions of Mary* (26.8.2), *Lesser Questions of Mary* (26.8.2), the *Birth of Mary* (26.12.2), a *Gospel of Philip* (26.13.2), books about Ialdabaoth (26.8.1; 25.3.5), and books in the name of Seth (26.8.1).[52] The number of these books attributed to women or about women is indeed remarkable. While we cannot know the titles of the books about Ialdabaoth and Seth, six of the remaining eight titles bear the name of a woman.[53]

While the Phibionite cosmogony includes a large array of aeons (*Haer.* 26.9.6, 10.1–4), the place of the feminine aeon Barbelo appears from Epiphanius's account to be foremost in the sect's understanding of its ritual life. Barbelo occupies the eighth and highest heaven (*Haer.* 26.10.4). She is the one from the powers on high, the opposite of the archon (*Haer.* 26.1.9). What has been taken from the Barbelo, the mother on high, by the demiurge, that is, the "light," is that which must be gathered by the Phibionites in their Agape ritual (*Haer.* 26.1.9).

The Phibionite practice is in fact an earthly rendition of the seduction of the archons, which Barbelo herself performs in the heavenly realm (*Haer.* 25.2.4).[54] As the beauty of the Phibionite women (*Haer.* 26.17.7–8)

51. Aristotle *Gen. an.* 738B, 26–28.
52. They also use the Old and New Testaments (26.6.1).
53. It is to be recognized that the *Lesser and Greater Questions of Mary* (26.8.2) may be identical with the *Questions of Mary* mentioned earlier (26.8.1).
54. Fendt, *Gnostische Mysterien*, 6–7; and de Faye, *Gnostiques*, 422.

is designed to "seduce" the men into releasing their "light" in the form of the ejaculation of semen, so Barbelo's beautiful form brings the archons to climax and ejaculation, through which she recovers her power (*Haer.* 25.2.4). As such it is the role of the woman which, though a role of seduction, mirrors the pattern of the divine Barbelo. It is as positive a pattern in Phibionite mythology as it is negative for Epiphanius. Epiphanius's patriarchal orthodoxy with its emphasis on an ascetical approach to the world simply precluded the recognition or in any event the acceptance of any alternative interpretation to the Phibionite practices other than his own.

While each of the points made above with respect to the Phibionite women require further investigation, it seems clear that the presentation of them by Epiphanius is distorted by his own view of women. He presents the Phibionite women as "orthodox" women gone astray. They are simple and theologically naive. They have been misled by the male Phibionite members to whom Epiphanius surely credits the theology of the group.

We have seen that Phibionite theology places a strong emphasis on the feminine aeon of Barbelo and that the books of the group were predominantly attributed to women. The practice of the Agape, which Epiphanius viewed as the unregulated use of the women by the male members, was more likely a practice that involved both sexes equally in the communal recovery of the lost "light" in the semen and menses. The "seduction" of men by Phibionite women, evidence of their depravity to Epiphanius, was more likely understood within the Phibionite community as an earthly reenactment of Barbelo's seduction of the archons.

What does this mean for the women in these libertine gnostic communities? I suspect that many women who joined the Phibionite community did so with a full awareness of the theological foundation of the group. They were not simply led astray or lured into the community by lustful men. This is not to deny that many women may well have been taken advantage of by the male members of the sect or by their husbands who chose to join the group. It is, rather, to argue that the distinction between "simple" members who were deceived by others and more astute devotees who developed the theology and practice of the group is not a division that breaks down on sexual lines. The sexual definition of that division represents, rather, the interpretation of the patriarchal Epiphanius. He could understand it in no other way. Certainly there were as well simple men who were "deceived." Epiphanius himself in his youth apparently came close to the "fall." Likewise there

were certainly women in such groups, particularly judging from the theological emphases, who were theologically astute.

Thus, were the libertine gnostic women liberated? One should not use terms loaded with modern ideas to label persons from the past. It is fair to say that there were Phibionite women who were instrumental in the group's development and that they found in the group an avenue to express their release from the societal constraints imposed upon them by their sex. The libertine path offered this possibility to some women in much the same way that the ascetic path did for others.

If indeed the Phibionite Agape is understood as an earthly reenactment of the seduction of the archons by Barbelo, then the role of women in this rite takes on heightened significance. It has been argued that in asceticism women remained bound to the patriarchal past, since they simply replaced an earthly husband with a heavenly male Christ.[55] In the Phibionite system they function in the dominant role. The Phibionite women are the earthly representative of the Mother who recovers her lost power through the seduction of the male archons.[56]

55. Castelli, "Virginity and Its Meaning."
56. The fact that the Phibionites borrowed the figure of Barbelo from another group (Fendt, *Gnostische Mysterien*, 9) is of little relevance.

Sex Education in
Gnostic Schools

This is not an essay about the feminine, nor femaleness, nor even women. It is about those certain parts of a woman that make her precisely a woman: the private parts, the αἰδοῖα, the unmentionable, shameful parts. And it is about their male counterparts. This is an essay about the vagina, the womb, and blood; it is about the penis, the testicles, and semen. It is about sexual intercourse, embryology, and birth.

Language about the sex act and organs pervades those texts which we call gnostic. Upon occasion, scholars have pointed from passages in those texts to parallels in Hellenistic medical writings.[1] It may be useful to take a step or two back to look at ancient medicine in a wider perspective. Ancient theories of sexual reproduction differ, for many reasons, from present-day descriptions of the same process. Their notions are often quaint, frequently amusing, and offensively misogynous. Instructed in the Greco-Roman schools of gynecology and embryology, we can then, from our same wide perspective, take a look at those Gnostics.

Let us begin with Aristotle, the most influential writer on sexual reproduction. Although he himself was not a physician, Aristotle was the son of a medical doctor and he had a lifelong interest in physical

1. H. Leisegang (Die Gnosis) mentions Hippocrates (p. 48), Galen (p. 76 n. 1), and Aristotle (pp. 97, 194–95) in connection with various gnostic theories. For recent comparisons of gnostic motifs to the medical literature, see P. Fredriksen, "Hysteria and the Gnostic Myths of Creation," UC 33 (1979) 287–90; I. S. Gilhus, "Gnosticism—A Study in Liminal Symbolism," Numen 31 (1984) 112 n. 37; and P. Perkins, "On the Origin of the World (CG II, 5): A Gnostic Physics," VC 34 (1980) 37–38.

science. His opinions are focused in his book on the subject, *On the Generation of Animals*. In it, Aristotle opines that the male semen provides the form (εἶδος) of the embryo (κύημα) and makes it perfect (τελειόω). The function of the female sex organs is to receive the sperm and to provide matter (ὕλη) and nourishment (τροφή) for the embryo. There is an extensive series of associations, all of which Aristotle considers superior (κρείττων), with the male semen. Semen has power (δύναμις), it has heat (θερμότης), it has activity (κίνησις), and it has soul (ψυχή). The female's role is simply cast in contrast to the male's. Instead of his power, she has inability (ἀδυναμία) and weakness (ἀσθενής); while he is hot, she is cold (ψυχρός); in place of soul, she has matter; as he is active, she is passive (παθητικόν); and instead of having divine (θεῖον) form, femaleness (θηλύτης) is a natural (φυσική) deformity (ἀναπηρία). All of these associations, Aristotle considers inferior (χείρον).[2]

The reason Aristotle can argue this sustained comparative evaluation of the male and female contributions to the embryo is that each of the parents' individual contributions, semen and menses, is a more or less developed formation of the same substance, blood. The semen and menses are both produced out of blood, semen having been thickened (πέσσω) or concocted more than the menses. This thickening process is brought about by heat. Males are capable of concocting blood into semen because they are hotter. Females, having a weakness of heat, are incapable, and thus their unconcocted blood periodically discharges as the menses. This inability to form the blood into semen, Aristotle compares to diarrhea.[3] In a famous simile, Aristotle likens the generative process to the curdling of milk into cheese. Just as an outside agent, or rennet, curdles milk into cheese, so soul acts on the male's blood to form semen. Likewise, the male semen acts on the matter provided by the female blood to concoct a fetus, just as a coagulant curdles milk into cheese.[4]

Aristotle cannot be held fully responsible for the erroneous theories that he promulgated. The theory that the male seed alone is responsible for generation had prior currency. It found literary expression in the *Eumenides*, in the debate between Apollo and Athena. "The mother is no parent of that which is called her child," Apollo argues, "but only nurse of the new-planted seed that grows. The parent is he who mounts. A stranger, she preserves a stranger's seed." As proof of this argument,

2. Aristotle *Gen. an.* (LCL) 726b, 727a–b, 729a, 732a, 765b, 775a.
3. Aristotle *Gen. an.* 727a, 728a 15ff.
4. Aristotle *Gen. an.* 729a 10ff., 739b 21ff.

Apollo points to Athena herself, born directly from Zeus and not from "the dark of the womb."[5] This judgment also found expression in the pre-Socratic tradition, in Anaxagoras and Diogenes of Apollonia. Aristotle also continues other theories from the earlier philosophers. The function of heat and cold in generation comes mainly from Empedocles. In Aristotle's theories on generation, earlier philosophical and perhaps folk traditions culminate.[6] His own influence on later generations is impressive. In the 160s C.E., Lucian wrote a satirical piece in which a group of philosophers is auctioned off. Among these philosophers is an Aristotelian, who is hawked as one who knows "all about sperm and conception and the shaping of the embryo in the womb."[7] Later in the same century, Clement of Alexandria, while explaining the significance of Christ's blood, knowledgeably employed the theories of Aristotle. Semen comes from the blood, he says, and the power in the semen, its spiritual heat, forms and compacts the embryo in the womb. Clement even employs Aristotle's simile "as the rennet curdles milk" into cheese.[8] Aristotle made it possible for Clement to exploit the birth process for theological intent, to associate the bodily fluids with his divinity. Clement's contemporaries, the Gnostics, forced this exploitation to its extremest bounds, as we shall see.

To examine the Gnostics' use of generation language in the wake of Aristotle's influence alone would be to slant the evidence. There was widespread disagreement with Aristotle's theories in antiquity, especially from the medical profession. Aristotle's crucial argument that the male alone produces seed and the female contributes matter did not find much support. Although there was disagreement within the medical profession itself, the consensus was that the female also produced semen. This theory was around before Aristotle. He was aware of it, referring it to Democritus, but he rejected it.[9] The theory is found in the medical tradition as early as the Hippocratic text *On the Seed.* "Both the man and the woman have sperm (ἐν τῇ γυναικὶ καὶ ἐν τῷ ἀνδρὶ ἔστι

5. Aeschylus *Eumenides* (LCL) 658–665; ET Richmond Lattimore, *Aeschylus* (New York: Modern Library, 1942), 1:177.

6. For surveys of the theories of sexual reproduction in antiquity, see E. Lesky, *Die Zeugungs- und Vererbungslehren der Antike und ihr Nachwirken,* 1227–1425; G. E. R. Lloyd, *Science, Folklore and Ideology: Studies in the Life Sciences in Ancient Greece,* 86–111; J. Needham, *A History of Embryology,* 9–59; and J. V. Ricci, *The Genealogy of Gynaecology,* 45–150.

7. Lucian *Vitarum auctio* (LCL) 26.

8. Clement of Alexandria *Paedagogus* (ed. Otto Stählin, *Clemens Alexandrinus*) 1.6.48–49.

9. Aristotle *Gen. an.* 764a.

γόνος)," says that text. Both partners produce male and female sperm, the author maintains, male sperm being stronger and female sperm being weaker. The predominance of one sperm over the other, strong or weak, results in the sex of the child.[10] Such claims remained speculative, of course, because ancient scientists did not have the advantage of later methods of observation. Even the direct observation of the internal human organs through dissection was avoided. Many early specula-tions, including Aristotle's, resulted from this ignorance and from the mistaken example of animal anatomy. The theory of the female seed, however, was scientifically advanced with the dramatic post-Aristo-telian discovery and description of the female testicles. This was accom-plished around 300 B.C.E. by Herophilus when, for a brief period at Alexandria, the human body was dissected.[11] That Herophilus was nearly unique in this practice is apparent from the evidence that later writers on internal anatomy had to refer to him as their source. Soranus, a physician of the early second century C.E. who specialized in gyne-cology, relies on Herophilus for his description of the female parts, because Soranus himself considers dissection useless for the practical business of healing people.[12] Soranus's book *Gynecology* is a technical manual, perhaps written for midwives, and rather free from speculation about how reproduction takes place. He does, however, accept and use Herophilus's terms for the female testicles (δίδυμοι) and the seminal ducts (σπερματικοὶ πόροι) that run from each of them into the uterus.[13] A generation after Soranus, Galen picks up the argument in his book *On the Semen*. Galen quotes Herophilus's description of the female testicles, invokes the Hippocratic discussion of the female seed, and refutes Aristotle.[14] In spite of the fact that Galen argues for the production of female seed, and against the idea that the menstrual blood is the material of the developing embryo, he has great respect for Aristotle and

10. Hippocrates *The Seed* (ed. E. Littré, *Oeuvres complètes d'Hippocrate*) 7:6–7; ET I. M. Lonie, *Hippocratic Writings* (ed. G. E. R. Lloyd; New York: Penguin Books, 1983), 317–23.

11. Tertullian singles out Herophilus as "that dissector" and calls him "the butcher" (*De anima* 10.25). For Tertullian's familiarity with the medical traditions, see J. H. Waszink, *De anima: Edited with Introduction and Commentary*.

12. Soranus *Gynaikeia* (ed. Johannes Ilberg, *Soranus*); ET O. Temkin, *Soranus' Gynecology*.

13. Soranus *Gynaikeia* 1.12.

14. Galen *De semine* (ed. C. G. Kühn, *Claudii Galeni opera omnia*) 4:595–98. Galen prefers the term ὄρχεις to Herophilus's term δίδυμοι for the female and male testicles. The argument of these authors loses its point if we translate these words with "ovaries." Mammalian ovaries and ova were not named until the second half of the seventeenth century.

tries to conform his own discussion with Aristotle's. In his book *On the Usefulness of the Parts of the Body*, Galen says, "Aristotle was right in thinking the female less perfect than the male (τὸ θῆλυ τοῦ ἄρρενος ἀτελέστερον)." Aristotle, however, did not carry out his argument to its conclusion, but missed its main point. Galen makes the point for him. The reason the female is less perfect is that she is colder (ψυχρότερον). From this follows a compelling but curious argument. Men and women have the same sexual organs, Galen says, except for one important difference. The male organs are on the outside, the female's are on the inside. He asks us to imagine the vagina, uterus, female testicles, and so forth, turn them inside out, and we have a penis, scrotum, and male testicles. The instrument (ὄργανον) that brings about this development is heat (θερμότης). Since the male has more heat than the female, he is more formed (διαπλάσσω) and therefore more perfect than the female, whose sexual organs never grew out. Females, in fact, especially their sexual organs, are imperfect (ἀτελής) and deformed (ἀνάπηρον).[15] It is a thoroughly ingenious argument, but it leaves Galen with one nagging worry. If the female has all the parts of the male, and if she too produces semen in her testicles, what, he wonders, prevents the female alone from inseminating herself (τὸ θῆλυ μόνον εἰς αὐτὸ σπερμαῖνον) and thus bringing forth a fetus without a male?[16]

That question certainly brings us to the Gnostics. Let us turn to that familiar, yet ever fruitful story about the willful attempt of Sophia at self-generation, her fall from the Valentinian aeons, and the ensuing creation of the world. Sophia, by all accounts, wanted to procreate without copulating with her consort (ἄνευ τῆς ἐπιπλοκῆς τοῦ συζύγου),[17] as a single parent (ἄζυγος). This is in opposition to the ordained mode of aeonic existence, which is to engage in eternal heterosexual copulation (κατὰ συζυγίαν). This copulation is in worshipful imitation of the proto-copulation of the original aeonic couple. The first couple was generated by the Father, the Father who is unfeminine (ἄθηλυς), unmarried (ἄζυγος), and alone (μόνος). He is the one whom Sophia tries to imitate, not knowing that only he can procreate alone.[18] The Sethian gnostic tradition carries on a similar non-Valentinian, probably pre-Valentinian

15. Galen *De usu partium* (ed. Kühn, vol. 4) 14.6; ET Margaret Tallmadge May, *Galen: On the Usefulness of the Parts of the Body* (2 vols.; Ithaca, N.Y.: Cornell University Press, 1968). Galen was in Alexandria studying from 152 to 156 C.E.; he wrote *UP* between 169 and 175.
16. Galen *UP* 14.7.
17. Irenaeus *Adv. haer.* (ed. Harvey, *Sancti Irenaei*) 1.1.2.
18. Hippolytus *Ref.* (ed. P. Wendland, *Hippolytus Werke*) 6.29–30.

version of Sophia's desire. The *Apocryphon of John* says that Sophia "thought a thought from herself," and "she wanted to reveal an image out of herself."[19] Other texts tell us that "she wanted to produce something alone, without her consort (ⲁⲭⲛ ⲡⲉⲥϩⲱⲧⲣ̄),"[20] "by herself to cause the existence of beings without her male (ⲁⲭⲙ̄ ⲡⲉⲥϩⲟⲟⲩⲧ)."[21]

Can she do it? Let us return to the predicament in which we left Dr. Galen. No, he claims, she cannot. "The female semen is exceedingly weak (ἀσθενής) and unable to advance to that state of motion in which it could impress an artistic form (μορφὴ τεχνικὴ) upon the fetus." Without the male semen, the fetus lacks perfection (τελειότης).[22] Theodotus the Valentinian likewise writes about the male semen and the female semen, employing the same terminology (τὸ σπέρμα ἀρρενικόν, τὸ σπέρμα θηλυκόν). That which the female alone bears (τῆς θηλείας μόνης τέκνα), says Theodotus, is weak, formless, and imperfect (ἀσθενής, ἄμορφος, ἀτελής).[23] The *Valentinian Exposition* from Nag Hammadi also says that the seeds of Sophia are imperfect and formless (ⲁⲧⲭⲱⲕ ⲁⲃⲁⲗ, ⲁⲙⲟⲣⲫⲟⲥ),[24] as do the Valentinians quoted by Irenaeus (*informe, et sine specie, et imperfectum*).[25] Such weak female seed cannot conceive by itself, says Galen, for, as everyone in antiquity knew, there was only one animal that could conceive without the help of a male: the hen. Hens become impregnated by the wind,[26] but their wind-eggs are imperfect and do not hatch young birds. Some people, says Galen, on the analogy of the wind-egg, point to that unformed flesh (σάρξ ἀδιάπλαστος) which women sometimes conceive. That unformed flesh is called a mole, because it is a hard lump like a μύλη or millstone. Galen denies that even a mole can be produced without the help of a male, but he is clearly arguing his case against those who disagree with him.[27] Aristotle also maintains that the mole only occurs following sexual intercourse. The woman "thinks she has conceived," but she only brings forth a piece of flesh. Nature, in these cases, has a weakness of heat and is unable to bring her work to perfection.[28] The Hippocratic *Diseases of Women*

19. *Ap. John* 9,25–30.
20. *Hyp. Arch.* 94,6–7.
21. *Soph. Jes. Chr.* 114,16–18.
22. Galen *UP* 14.7.
23. Clement of Alexandria *Excerpta ex Theodoto* (ed. R. P. Casey, *The Excerpta ex Theodoto of Clement of Alexandria*); 2.21.68. Cf. Galen's terminology τὸ σπέρμα τοῦ θήλεος, τοῦ ἄρρενος.
24. *Val. Exp.* 35,12–13.
25. Irenaeus *Adv. haer.* 2.28.
26. C. Zirkle, "Animals Impregnated by the Wind," *Isis* 25 (1936) 95–130.
27. Galen *UP* 14.7.
28. Aristotle *Gen. an.* 775b 25—776a 10.

blames the mole on a pregnancy from "little and sickly seed." The resulting fetus, says the text, is illegitimate.[29] Soranus, on the other hand, says the mole only "has the appearance of pregnancy."[30] All of these authors were probably describing a wide variety of uterine growths, including fibroid tumors, various cysts, and hydatids. A hydatidiform mole is caused by the enlarged growth of placental tissue. It grows in grapelike clusters, kills the fetus, and comes forth as a nightmarish horror. Such productions have given rise throughout history to legends about the birth of monsters.

What does Sophia bear, with her weak female seed? She bears flesh, says Theodotus, formless, like a miscarriage ($\check{\epsilon}\kappa\tau\rho\omega\mu a$). Our sources are unanimous in condemning Sophia's fetus as a miscarriage. How could it be otherwise? It has none of the features that could have been provided by the male semen. It has no form, no shape, no perfection, no spirit.[31] Irenaeus's description of this whole business is contemptuous. How can these heretics possibly claim that one of their female aeons separates and procreates without copulation, he says, just like a hen?[32] Sophia herself is grief-stricken over her misconception. She throws the miscarried substance ($o\dot{v}\sigma i a$) away to hide it from the other aeons, for it is a beast, a serpent with the face of a lion. "Its name is Ialdabaoth, and he has neither form nor perfection." Furthermore, since it came from matter ($\check{v}\lambda\eta$), it was androgynous (ϩΟΥΤϹϨΙΜΕ) in its nature ($\phi\dot{v}\sigma\iota s$).[33] It makes sense that it would be androgynous, for sexual differentiation is a result of formation. "By nature only," says Galen, "we would be neither male nor female."[34] Aristotle, discussing the sex of offspring and their resemblance to either parent, holds up the ideal of a male child resembling his father. The farther and farther deviation of nature from that masculine ideal results in the birth of monsters ($\tau\acute{\epsilon}\rho as$), and the first stage in that deviation toward a monstrosity is a female offspring.[35] Elsewhere, Aristotle draws a correspondence between the mother's failure to bring a fetus to perfection, androgynes, monsters, and miscarriages ($\check{\epsilon}\kappa$-$\tau\rho\omega\mu a$).[36] Lack of formative ability seems to be behind the Hippocratic aphorism, "When a pregnant woman has frequent diarrhea, she is likely

29. Hippocrates *Diseases of Women* (ed. Littré, vol. 8) 1.71.
30. Soranus *Gynaikeia* 3.37.
31. Clement of Alexandria *Ex. Theod.* 68; Irenaeus *Adv. haer.* 1.1.7; Hippolytus *Ref.* 6.31; *Orig. World* 99,9–10; *Ap. John* 10,3–4.
32. Irenaeus *Adv. haer.* 2.13.3; cf. Tertullian *Adversus Valentinianos* 10.
33. *Ap. John* 10,8–13; *Hyp. Arch.* 94,15–19; *Orig. World* 101,10–11; 106,28–29.
34. Galen *De semine* 2.6.
35. Aristotle *Gen. an.* 767b.
36. Aristotle *Gen. an.* 737.

to have a miscarriage" (ἔκτρωσις).[37] The Hippocratic *Diseases of Women*
discusses dangerous activities that can cause a miscarriage (φθορή):
shouting, fainting, eating too much or too little, becoming frightened, or
taking a leap (πηδάω).[38] Sophia too, we recall, took a leap *(exsilio)*.[39]

Along with suffering a miscarriage, Sophia undergoes another malady
common to women who keep themselves apart from a proper sexual
relationship with a male. She displays the symptoms of that ancient
female malady "the wandering womb." Before we examine the patient,
however, we must learn something about the womb. The womb is a
two-chambered or "bicornuate" organ. From one neck, or cervix, two
cavities separate and curve upward like horns, ending in points. Think
of it as resembling something like a two-pointed fool's cap, the little
bells on the end of each point being the woman's testicles. Most animals,
in fact, says Galen, have several cavities in their wombs. The number of
cavities is exactly the same as the number of nipples the animal has.
Greek words for the womb, therefore, were often plurals (μῆτραι,
ὑστέραι). "A male embryo is on the right, a female on the left," as a
Hippocratic aphorism says. The reason for this, as you can imagine, is
that the right cavity is warmer than the left, an interpretation that goes
back to Empedocles.[40] Pythagoras called the left, or female side of
things, darkness; and the right, male side, light. From all of this followed
the belief that males were formed faster than females, in thirty days
against forty-two, according to the Hippocratic *The Nature of the Child*.[41]
From all of this also followed gnostic, especially Valentinian, specula-
tions about the left and the right. Those on the left are material (ὑλικόν)
and incapable of receiving the breath of incorruption (πνοὴ ἀφθαρσία).
Those on the right, of a psychic nature (τὸ ψυχικόν), are capable of
receiving that which is spiritual and of thereby being formed (μορφόω,
passive).[42] This Valentinian speculation depends not only upon descrip-
tions of the two-chambered uteri but also upon the theories of Aristotle
about the role of spirit (πνεῦμα), soul (ψυχή), and matter (ὕλη) in human
reproduction. The spirit contained in the semen moves the soul to form

37. Hippocrates *Aphorisms* (LCL; Cambridge: Harvard University Press, 1953) 5.34.
38. Hippocrates *Diseases of Women* 1.25; ET Ann Ellis Hanson, "Hippocrates: Diseases
of Women 1," *Signs* 1 (1975) 567–84.
39. Irenaeus *Adv. haer.* 1.27.2.
40. Aristotle *Gen. an.* 765a; Galen *UP* 14.4, 11; Hippocrates *Aphorisms* 5.48. Cf. the
Tjet amulet portraying the genitals of Isis, E. A. Wallis Budge, *Amulets and Talismans*;
and the bicornuate uterus of a heifer, A. Gardiner, *Egyptian Grammar*, sign-list F45, N41,
used as a determinative in *ỉdt* (Coptic ⲟⲟⲧⲉ).
41. Hippocrates *The Nature of the Child* (ed. Littré, vol. 7) 18, 21; ET Lonie, *Hippo-
cratic Writings*, 329–33.
42. Irenaeus *Adv. haer.* 1.1.11.

matter, as a carpenter uses tools to give form and shape (μορφὴ καὶ εἶδος) to the wood.[43]

The womb is not fully described by its appearance and function. It also has a personality, with its own likes and dislikes (ἐπιθυμητικόν, ἀγανακτέω).[44] Aretaeus, a medical writer of the late second century, says that it is an animal within an animal (ζῷον ἐν ζώῳ). "Furthermore, the womb has a wandering (πλανώδης) nature."[45] Soranus and Galen both deny that the womb is a separate animal, or that it roams about inside the body, but the belief did have the authority of Plato. Not only did this doctrine have authority, it had endurance. It lasted from at least 1500 B.C.E. until it was put to rest in the year 1616 C.E.[46] Thus we have the ancient womb: a horned creature, a womb errant. It could wander into the chest and choke (πνίξ) the woman, it could push against the other organs, it could make its way downward and push itself out through her vagina. Since it was attracted to sweet smells and repelled by foul smells, the womb could be drawn or chased back to its proper place by fumigating it through the vagina or nostrils. If that did not work, she could go to the corner magic shop and buy a spell written on a little piece of tin (πρὸς μήτρας ἀναδρομήν). "I exorcise you, O Womb! Amichamchou and chouchaō cherōei! Get back to your seat and stop straying around in the rib cage! Hallelujah! Amen!"[47] The Hippocratic corpus best describes the cause, symptoms, and cure for this common affliction. The cause is lack of sexual intercourse. The womb dries out, being deprived of the secretions of the sexual organs, and goes out on its own to seek moisture. One complication is the stoppage of the menstrual flow, as a result of the cervix's drying up, or from the womb's turning in its wanderings. The blood, unable to flow out, backs up and causes the main symptoms of the disease. These are insomnia, grinding teeth, fainting, chills, numbness, insanity, madness, craziness. All in all, the woman becomes hysterical (ὑστερικός), which simply means "womby." The Hippocratic text *On Virgins* prescribes a cure. "The young woman should cohabit with a man as quickly as possible. If she becomes pregnant, she will be cured."[48]

43. Aristotle *Gen. an.* 730b, 736.
44. Plato *Timaeus* (LCL) 91c.
45. Aretaeus *On the Causes and Symptoms of Acute Diseases* (ed. K. Hude) 2.11; ET F. Adams, in *Women's Life* (ed. Lefkowitz and Fant), 225–26.
46. The Ebers medical papyrus contains a remedy to enable the uterus of a woman to return to its proper region. The theory survived until Charles Lepois in 1616 and Thomas Willis in 1667 published works disproving it. Ricci, *The Genealogy of Gynaecology*, 19, 387–90.
47. PGM 7, 260–71.
48. Hippocrates *Diseases of Women* 1.2; Hippocrates *On Virgins* (ed. Littré, vol. 8); ET Mary R. Lefkowitz, in *Women's Life* (ed. Lefkowitz and Fant), 95–96. My diagnosis of

The woman we are examining has a similar problem, with a similar cause, symptoms, and cure. Sophia separates herself from her spouse and stops having sexual intercourse. She suffers fear, sadness, perplexity, and fright, and she gets cured. In one version of the story, all of the aeons together, knowing that marital union (κατὰ συζυγίαν) is good and that producing children (διὰ προσφορᾶς καρπῶν) is better, agree to produce a child jointly. This child is named Jesus, and he is sent out as a husband for Sophia (σύζυγον τῆς Σοφίας).[49] "This is the will of the Father," says the *Valentinian Exposition*, "not to allow anything to happen in the Pleroma apart from a spouse (σύζυγος). Again, the will of the Father is: always produce and bear fruit (†ΚΑΡΠΟΣ). . . . And whenever Sophia receives her spouse, then the Pleroma will receive Sophia joyfully."[50] In a variation of the story, the intention (ἐνθύμησις) of Sophia is personified as a separate figure, Achamoth. In this version the aeons produce Jesus as well as a bodyguard (δορυφόροι, "spear-carriers," Sigmund!) of angels similar to him. Jesus gives form to her substance, then the whole team of angelic bodyguards makes her pregnant and she bears children in their image.[51] The Valentinian cure for this woman who refused to have sex, whose neurotic sufferings became a cosmic hysteria, is exactly what most Greco-Roman medical doctors would have prescribed in such a case: a husband, or even a gang of men, to copulate with her, to make her pregnant, and to stop all this nonsense. Make no mistake about it. These texts tell us that a woman cannot create, cannot form, cannot perfect. That is a man's prerogative, and if she tries to deviate from her role, the doctors know just what she needs.

Consider the *Exegesis on the Soul*, that text of unknown provenance. The soul is like a woman, says the text, "she even has her womb." She does not use her sex organ like a woman, though; she uses it like a male sex organ, turned inside out where it can actively pursue its own sex objects. With this strange womb-penis, the soul "runs around everywhere copulating." Finally, "she perceives the straits she is in and weeps." Then the Father takes her womb and turns it right side in, as a woman's womb should be. One is reminded of Galen's description of the female and male genital organs, the same but turned inside out. After having her proper womb restored, she wants, of course, to bear

Sophia is indebted to Lefkowitz's essay "The Wandering Womb," in her book *Heroines and Hysterics*, 12–25.

49. Hippolytus *Ref.* 6.32.
50. *Val. Exp.* 36,28–34; 39,28–33.
51. Irenaeus *Adv. haer.* 1.1.7–8.

children. "But," says the text, "since she is a female, by herself she is powerless to beget." So the Father sends her a savior, a husband, and she sits waiting for him. Things have obviously been restored to their right order. She is passive; he is active. They have sexual intercourse, she receives from him "the semen that is the life-giving spirit, she bears children and nourishes them." This birth process leads to her own "rebirth."[52]

There is ample evidence from antiquity that a woman reversing her sex role—that is, performing the man's active role—was intolerable.[53] From the medical profession, this intolerance focused on the female genitalia, specifically the clitoris ($\nu\acute{\nu}\mu\phi\eta$). If the clitoris is large, it is too much like a penis. The chapter "On Enlarged Clitoris and Its Removal" is missing from the fourth book of Soranus's *Gynecology*, but its contents might be guessed from later medical compilations. "An enlarged clitoris presents a shameful deformity," writes Paul of Aegina. "It is subject to erections and induces sexual desires. The treatment consists in grasping the part with forceps and amputating it. Be careful not to cut too deeply."[54]

Another renegade womb causes problems in gnostic literature. The whole world is personified as a womb in the *Paraphrase of Seth*.[55] Three primary principles—Light, Darkness, and Spirit—are rapidly personified as cosmic sexual organs. The principles come together and produce the image of a pregnant womb. They come together because darkness, also called water, which is powerless and weak, wanted to have some of the light. As the dark water moves toward the light, spirit, which is in between the two opposing forces, blows the water into waves and thus the dark water becomes pregnant. This makes sense only when we understand the nature of semen. "Semen is a pneuma and like foam," says Galen.[56] Aristotle says that "it is a compound of pneuma and water." That is why it is white, because of the bubbles.[57] This now pregnant cosmic womb has trapped some particles of the light, which it retains. The text uses a word for retain ($\kappa\alpha\tau\acute{\epsilon}\chi\omega$) that Galen employs as a

52. *Exeg. Soul* 127,20—134,7.
53. Brooten, "Paul's Views on Female Homoeroticism and the Nature of Women," in *Immaculate and Powerful* (ed. Atkinson, Buchanan, and Miles), 61–87.
54. Paul of Aegina, *Gynecological Résumé* 6.70, in Ricci, *The Genealogy of Gynaecology*, 202. Soranus's chapter (Περὶ ὑπερμεγέθους νύμφης καὶ νυμφοτομίας) is also preserved by Aetius of Amida.
55. Hippolytus *Ref.* 5.19–20. The related text the *Paraphrase of Shem* (NHC VII,1) is more difficult to summarize.
56. Galen *UP* 14.9.
57. Aristotle *Gen. an.* 736a; also Hippocrates *The Seed* 1.

technical term to describe the ability of the womb to retain an embryo.[58] Something, however, has gone wrong, for the dark watery womb, "the dirty, hurtful and disorderly womb," continues to imprison the light. The light struggles to be free, but it cannot, for it is only a tiny spark, a detached fragment from the light above, and it is overwhelmed by all the water. A savior is sent in the form of a ray of light from above. This ray of light is the perfect word (τέλειος λόγος) and it assumes the form of a snake (ὄφις). This snake, and snake certainly implies penis, penetrates the womb and frees the spark of light or perfect mind (τέλειος νοῦς). It is a confusing tale, but the moral is clear. The world is a womb and we are trapped in it.[59] We are like seeds in that womb, a womb which Apollo argued is "a stranger to a stranger" (ξένῳ ξένη).[60] Thus Basilides referred to Gnostics as "the seed," and also said that they are "strangers to the world" (τοῦ κόσμου ξένος).[61]

Salvation comes to this world as a penis enters a woman. More frequently than the genital itself, salvation is described as a result from the secretion of the male genital organ, the semen. The language frequently used to describe the state of salvation is language that is invariably used by the medical writers to describe the male semen: power, form, perfection. There are endless examples. "The power (δύναμις) will descend on everyone . . . for without it no one can stand, and after they are born, the power (ϭοм) comes and strengthens the soul and no one can make it wander (ⲣ̄ⲡⲗⲁⲛⲁ)," says the Apocryphon of John.[62] And in the Trimorphic Protennoia, the father says, "I have come down, hidden within my own, empowering (†ϭοм) them, giving them shape (ϩⲓⲕⲱⲛ)."[63] In the Valentinian Tripartite Tractate, the aeons are like a fetus (ⲃⲉⲕⲉ) upon whom the father sowed a thought like a seed (ⲥⲡⲉⲣⲙⲁ), and so that they might know, he gave them their first form. "Forms of maleness" (ⲙⲟⲣⲫⲏ ⲙ̄ⲙⲛ̄ⲧϩⲁⲟⲩⲧ), the text goes on to say, not the weakness (ⲱⲱⲛⲉ) which is femaleness (ⲙⲛ̄ⲧⲥϩⲓⲙⲉ).[64] This contrast between the virtues of the male's contribution over the female's is pervasive. "As long as the seed is yet unformed it is the offspring of the

58. Galen On the Natural Faculties (LCL) 3.2.

59. For another approach to the Paraphrase of Seth with a more positive assessment of the cosmic womb, see A. A. Barb, "Diva Matrix: A Faked Gnostic Intaglio in the Possession of P. P. Rubens and the Iconology of a Symbol," Journal of the Warburg and Courtauld Institutes 16 (1953) 193–238.

60. Aeschylus Eumenides 660.

61. Hippolytus Ref. 7.25; Clement of Alexandria Stromateis (ed. Stählin) 4.26.

62. Ap. John 26,13–17.

63. Trim. Prot. 40,29–34.

64. Tri. Trac. 60,34—61,10; 94,16–18.

female," says Theodotus, "but when it was formed it was changed to a man, no longer weak."[65] From the *Valentinian Exposition* we have this: "Since the seeds of Sophia are imperfect and formless," Jesus descended as a representative of the father, the father who "brings forth into form." Not just formed, furthermore, but "changed from seminal bodies into bodies with a perfect form (ΜΟΡϕΗ Ν̄ΤΕΛΕΙΟΝ), from cold into hot, from souls into perfect spirits."[66] In the *Sophia of Jesus Christ*, a drop sent by Sophia is breathed on by the great male light, and it becomes hot from that breath. The Savior wakens the drop so that Sophia's sons may not be defective (ϣⲱⲱⲧ), and he perfects (ⲭⲱⲕ ⲉⲃⲟⲗ) the drop.[67] What leads into the pleroma, say the Valentinians, "is not practices, but the seed, sent out helpless and here brought to perfection."[68]

From a very different school of Gnosticism, the Peratae, comes a similar teaching. There is the Father and there is Matter (ὕλη). Between them is the Son. The son is the word, the snake (ὄφις). The son receives power (δύναμις) from the father, and in turn passes power to matter, giving it form (ἰδέα). "Just like," says the text, "the power in conception (ἐγκίσσημα)." Then the author employs a simile close to Aristotle's. "Just as a painter imprints forms to his surface, so the son, by means of his power, imparts the character of the father into matter. Those who receive this character are sons of the father and return to him. Those who do not are like a miscarriage (ἔκτρωμα)." Thus the snake draws up from the world the perfect (τέλειος) and consubstantial race. The Peratae prove their doctrine by pointing to an example from human anatomy. The sperm flows down from the brain, carrying the forms or "ideas" down to matter.[69] This is a notion found in Plato's *Timaeus*.[70] The Hippocratic school also taught that the seed flowed down the spine from the head. One can sterilize a man, by the way, by making a small incision near his ear to stop the flow.[71] Another gnostic group, the Naasenes, virtually deifies the penis and the semen. The origin of everything is the semen, "that first and blessed substance." Not itself anything, yet shaping all things. It is the mystical word. This mystery is revealed in the penis (αἰσχύνη "shameful part") of Osiris, naked and erect (ἔστηκε γυμνόν). It is in the penis of Hermes impelled from below to

65. Clement of Alexandria *Ex. Theod.* 79.
66. *Val. Exp.* 35,2–28; 42,23–37.
67. *Soph. Jes. Chr.* 120,4–6.
68. Irenaeus *Adv. haer.* 1.1.12.
69. Hippolytus *Ref.* 5.17.
70. Plato *Timaeus* 73B–D.
71. Hippocrates *The Seed* 1–2.

the above.[72] This gnostic sexual metaphor is repeated with little varia-
tion throughout the literature. Gnostics are trapped in a woman's parts,
and rescue comes down out of the sky as a logos-penis-snake with its
potent and perfecting semen of salvation. The Valentinians so exegete
Luke 2:23, "Every male that opens the womb." Not opening it as a baby
in birth, but opening it as a fully virile man in copulation, as Christ
copulated with Achamoth.[73] The semen comes down, and upward
return the perfected souls. The theme is summed up in the *Apocryphon of
John* as the teaching about the descent of the seed ($\sigma\pi\epsilon\rho\mu\alpha$) and the way
(ⲙⲁⲉⲓⲧ) of ascent.[74] Compare the gnostic image with Galen's clinical
description of the cervix ($\alpha\dot{\upsilon}\chi\dot{\eta}\nu$) of the womb as "the path ($\dot{o}\delta\dot{o}\varsigma$) by
which the semen enters and the perfected fetus exits."[75]

Let us return one final time to Sophia. She has been saved, but her
miscarried creation is still out there, and things are happening. Even
though her production was imperfect and strange (ⲁⲧⲭⲱⲕ ⲁⲩⲱ
ⲉϥϣⲃ̄ⲃⲓⲁⲉⲓⲧ), it had power because of its mother, says the *Apocryphon of
John*.[76] The Valentinians seem to agree. Even though her intention
($\dot{\epsilon}\nu\theta\dot{\upsilon}\mu\eta\sigma\iota\varsigma$) was shapeless and formless, yet it was a spiritual substance
possessing some of the nature of an aeon.[77] This is starting to sound
contradictory, and there is a reason for that. A role shift is taking place
that will end up displaying the patriarchal god of old as an effeminate
fool and the mother goddess as a masculine savior. Ialdabaoth is
described in terms we have seen applied to women. He is weak (ϣⲟⲛⲉ);
he is ignorant of the forms ($\dot{\iota}\delta\epsilon\alpha$). When he himself tries to create, his
product is inactive and motionless (ⲛ̄ⲁⲣⲅⲟⲛ ⲁⲩⲱ ⲛ̄ⲁⲧⲕⲓⲙ). Ialdabaoth
and his archons cannot make their creation arise "because of their
powerlessness (ⲙⲛ̄ⲧⲁⲧϭⲟⲙ)."[78] In order to redeem her creation, Sophia
begins to perform as a male. Inasmuch as Sophia is a female character,
she can only create an imperfect malformation. Inasmuch as she is to
save that creation, she must assume male characteristics. As Irenaeus
tells it, she deposits a spiritual production in Ialdabaoth and he carries it
as in a womb *(in utero)*.[79] This episode is in clear imitation of the original

72. Hippolytus *Ref.* 5.7.
73. Irenaeus *Adv. haer.* 1.1.5.
74. *Ap. John* 20,22–24.
75. Galen *UP* 14.3.
76. *Ap. John* 10,1–4.
77. Irenaeus *Adv. haer.* 1.1.3.
78. *Ap. John* 11,15; Irenaeus *Adv. haer.* 1.1.9; *Ap. John* 19,14; *Hyp. Arch.* 88,5–6.
79. Irenaeus *Adv. haer.* 1.1.10.

male and female aeons nine chapters earlier in the story, where the
father deposits his production in the female "as seed is deposited in the
womb."[80] Thus the Valentinians say that the soul and the body come
from the demiurge and the earth, but the spiritual person comes from
the mother, Achamoth.[81] Throughout gnostic literature, Sophia and
other female goddesses are given characteristics that, in the reproductive
process at least, are usually ascribed to males. The second of the *Three
Steles of Seth* is addressed to Barbelo, a sometime female goddess. In an
understandable confusion of pronominal gender, Barbelo is praised:
"You have given power (бом) and forms ($\epsilon\hat{i}\delta os$) in birth (хпо)."[82] In
Allogenes, a related text, Barbelo has completely lost her sex. She/he
possesses the patterns and forms ($\epsilon\hat{i}\delta os$) of those who truly exist. He
works within the individuals with either craft ($\tau\acute{\epsilon}\chi\nu\eta$) or skill or with
partial instinct ($\phi\acute{v}\sigma\iota s$).[83] The use of craft or art to describe the formative
process again recalls Aristotle's comparison between the craftsman and
the semen. In a similar manner Valentinus, in one of the few authentic
fragments we have, compares Sophia to a painter ($\zeta\omega\gamma\rho\acute{a}\phi os$), trans-
ferring the reality of a living being (the True God) to the image (the
demiurge).[84] That transferring, crafting function, is the role of male
semen. The Gnostics, of course, are not entirely to blame for robbing the
old wisdom goddess of her sexuality. That operation was well per-
formed by Philo, who wrote: "While Wisdom's name is feminine, her
nature is manly. As indeed all the virtues have women's titles, but
powers and activities of consummate men ($\dot{a}\nu\delta\rho\hat{\omega}\nu\ \tau\epsilon\lambda\epsilon\iota o\tau\acute{a}\tau\omega\nu$). Let us,
then, pay no heed to the gender of the words, and let us say that the
daughter of God, even Wisdom, is not only masculine but father, sowing
and begetting ($\sigma\pi\epsilon\acute{\iota}\rho o\nu\tau a\ \kappa a\grave{\iota}\ \gamma\epsilon\nu\nu\hat{\omega}\nu\tau a$) in souls, knowledge, good
action," and other virtues.[85]

Thus Marcus the Valentinian can call himself the womb ($\mu\acute{\eta}\tau\rho a$), in a
receptive relationship to the female aeon. Marcus, having received seed
($\sigma\pi\acute{\epsilon}\rho\mu a$) from that female aeon, can then reverse roles and inseminate
his female disciples during a ritual that probably involved physical
intercourse. The female sexuality of the divine figure has been sup-
pressed, then changed into masculine sexuality. Marcus can therefore

80. Irenaeus *Adv. haer.* 1.1.1.
81. Irenaeus *Adv. haer.* 1.1.10.
82. *Steles Seth* 122,31–32.
83. *Allogenes* 51,13–24.
84. Clement of Alexandria *Stromateis* 4.13.
85. Philo *De fuga* (LCL) 51–52.

call her, the female aeon, the bridegroom (νυμφίος). She is not, further-
more, a sexually aggressive female, she is hardly a female at all.[86]

It was the tendency of Gnostics, especially Valentinians, to cast
Sophia in a breeches part. Tertullian says they put a beard (barba) on
her.[87] Given this tendency, it was a logical step for an author such as the
man who wrote the *Tripartite Tractate* to transvest the whole Sophia
myth into a logos myth.[88] To trace the further development of this
tendency is probably a sad and infuriating job, but it is not the job of this
essay. The offspring of these motifs are, no doubt, still running around
in our society. I have traced not the progeny, but only tried to indicate a
few forefathers of these beliefs, and to try something of an answer to
one of Gnosticism's central questions, τί γέννησις, "What is birth?"[89]

86. Irenaeus *Adv. haer.* 1.7.1—8.1.
87. Tertullian *Adversus Valentinianos* 21. "A breeches part" refers to the eighteenth-
century fashion for women actresses, dressed as men, to play the handsome hero role.
88. *Tri. Trac.* 51,1—138,25.
89. Clement of Alexandria *Ex. Theod.* 78.

Response to "Sex Education in Gnostic Schools" by Richard Smith

Richard Smith's "Sex Education in Gnostic Schools" demonstrates a very important connection between gnostic language about generation (in cosmological and soteriological contexts) and contemporary medical discourse. My response will not challenge Smith's basic thesis, which I find to be soundly articulated and defended. Rather, I want to suggest a few points at which the discussion of the medical literature could be more nuanced, as well as to raise a couple of methodological questions, and to comment on the implications of his essay for discussions of gender, ideology, and discourse in antiquity.

1. MEDICAL DISCOURSE

Generally, the discussion of ancient medical discourses on generation would benefit from being recast to represent the varieties of theories on generation that were operative in antiquity rather than setting up Aristotle's articulation of his theory as the norm against which all other theories are to be measured or read as deviations. While it is clear that Aristotle's ideas eventually became the most influential, they also represent a minority position in the already vital debates on these questions, debates that spanned several centuries.[1] Such a recasting of the status of

1. The most complete examination of theories of generation in antiquity continues to be E. Lesky, *Die Zeugungs- und Vererbungslehren der Antike und ihr Nachwirken*. A more recent treatment may be found in G. E. R. Lloyd, *Science, Folklore and Ideology: Studies in the Life Sciences in Ancient Greece*, pt. 2: "The Female Sex: Medical Treatment and

Aristotle's discourse would highlight the ideological aspect of the discourse: Aristotle's way of thinking about and describing generation was not the only available way, and although his often-erroneous ideas eventually won the day and held sway for centuries afterward, other systems not only were possible in antiquity but were actually predominant.

Related to this observation is the fact that Smith's comparison of Galen and Aristotle could well have been drawn with greater contrast. It is clear that Galen was extremely critical of Aristotle on several fundamental points.[2] First, Galen argues against Aristotle's view of the function of testicles in the male: while Aristotle thinks that testicles merely anchor the seminal passages (which originate in the brain, the source of sperm), Galen argues for their generative capacity.[3] Second, Galen challenges Aristotle's view that the male is the sole producer of seed which, in turn, provides form for the matter supplied by the female.[4] Galen also contests Aristotle's claim that semen from the male acts as the efficient cause in generation[5] and the notion that menses from the female is the matter from which the fetus is formed.[6] Smith is correct in saying that Galen agrees with Aristotle on the imperfection and coldness of the female;[7] further, Galen does claim that the female seed itself is imperfect.[8] Nevertheless, there are these serious points of disagreement between the two thinkers, and these differences should be placed in sharper focus in order to represent the heterogeneous character of ancient medical discourse.

Biological Theories in the Fifth and Fourth Centuries B.C.," 58–111. Also noteworthy is A. Rousselle, "Observation féminine et idéologie masculine," *Annales: Economies/Sociétés/Civilisations* 35 (1980) 1089–113.

2. An extended discussion of the relationship between the two may be found in A. Preus, "Galen's Criticism of Aristotle's Conception Theory," *Journal of the History of Biology* 10 (1977) 65–85.

3. Aristotle *Gen. an.* 717a: "This then is the object for which the testes have been contrived: they make the movement of the seminal residue more steady. In the Vivipara, . . . and also in man, they do this by maintaining in position the doubling-back of the passages . . ., since the testes are no integral part of the passages: they are merely attached thereto, just like the stone weights which women hang on their looms when they are weaving" (LCL, 21). Cf. also *Gen. an.* 787b, 788a. Galen's critique is found in *De semine* 1.13; 1.15.

4. Aristotle *Gen. an.* 727b–728a; Galen *De semine* 2.1, where he quotes the Hippocratic text, *Nat. puer.*, which asserts that both parents provide seed for generation.

5. Galen *De semine* 1.3; 2.2. Cf. Aristotle *Gen. an.* 729a, 737a.

6. Galen *De semine* 1.5; *UP* 14.3; Aristotle *Gen. an.* 727a.

7. Galen *UP* 14.5–6.

8. Galen *De semine* 1.7; *UP* 14.6.

2. METHODOLOGICAL ASSUMPTIONS

To advocate a reading of these ancient medical sources which high-lights their variety and diversity is to argue for a broader methodological caution in the use of these texts for reconstructing history. Unless one is especially careful to examine critically the process by which the dominant view eventually carried the day and the alternate viewpoints that were present though eventually discarded, one might be tempted to imply more of an ideological hegemony than is actually the case for a particular period, especially one as distant as Greco-Roman antiquity. Although the texts may well be in general agreement on a particular question, this does not mean that they necessarily represent the range or balance of views that were current during the period. Especially in the case of the history of women and the study of cultural constructions of gender in remote historical periods, when the available evidence has been to a large extent molded by the exigencies of a system of male privilege in whose interests it is to portray a particular perspective as both universal and true, one quickly learns to pay special attention to the exceptions and to the texts that suggest disagreement with the dominant position.[9]

3. IMPLICATIONS FOR THE STUDY OF THE CONSTRUCTION OF GENDER

Several points that Smith touched on invite deeper investigation and articulation. The notion that the male is the norm and the female is derivative is a fundamental point in the medical discourses, where the male is considered physically normal *and* normative and where the female is an imperfect derivative—and is, in fact, considered as a deviation from *nature* (as Smith describes it), the first in a line along the continuum that runs between the male and the unformed miscarriage: in between are females, androgynes, and monsters. In general, then, muddied distinctions are understood as deviations from nature.

9. One particularly provocative example of a methodology that "denaturalizes" the androcentrism of ancient culture and that reconstructs a countermovement to that androcentrism from texts and other artifacts which have up to now been interpreted simply as representations of the thoroughgoing and monolithic nature of male dominance may be found in E. C. Keuls, *The Reign of the Phallus: Sexual Politics in Ancient Athens.*

This points to a more basic interpretation of gender, one that Simone de Beauvoir articulated so eloquently almost forty years ago in her classic feminist theoretical work, *The Second Sex*. There she describes the asymmetry of gender (a culturally constructed phenomenon, not a natural one), whereby Western cultural discourse constructs the Woman as Other:

> The terms *masculine* and *feminine* are used symmetrically only as a matter of form, as on legal papers. In actuality, the relation of the two sexes is not quite like that of two electrical poles, for man represents both the positive and the neutral, as is indicated by the common use of *man* to designate human beings in general; whereas woman represents only the negative, defined by limiting criteria, without reciprocity. . . . [I]t is understood that the fact of being a man is no peculiarity. A man is in the right in being a man; it is the woman who is in the wrong.[10]

The point here, and in the idea of sexual difference as deviation, is that *the female is the one who is being different*. The fact of being a man is no peculiarity; the fact of being a man is a norm from which the female deviates and is less perfect. This idea is, then, entirely consistent with its companion notion, that muddied distinctions are deviations: here, woman is *like* man in being derivative but also just one step on the road to the monstrous by means of her inadequate likeness, her nagging difference.

In the texts that are relevant to Smith's discussion, one finds just such an importance attached to sexual differentiation. Aristotle, in fact, uses sexual differentiation to classify the species as more and less perfect. For Aristotle, the greater the differentiation between the sexes, the more perfect the species, with human beings being the most perfect of the species, the model to which other species may aspire.[11] In addition, Aristotle says it is better that there be sexual differentiation, because it is good for the superior to be kept separate from the inferior.[12] In these

10. S. de Beauvoir, *The Second Sex* (ET H. M. Parshley), xvii–xviii.

11. Aristotle *Hist. an.* 608a–b: "In all the kinds in which male and female are found, nature makes more or less a similar differentiation in the character of the females as compared with the males. This is especially evident in man, in the larger animals and in viviparous quadrupeds. . . . Traces of these characters occur more or less everywhere, but they are especially evident in those whose character is more developed and most of all in man. For he has the most perfected nature, and so these dispositions are more evident in humans" (ET Lloyd, 98–99).

12. Aristotle *Gen. an.* 732a: "That is why there is always a *class* of men, of animals, of plants; and since the principle of these is 'the male' and 'the female,' it will surely be for the sake of generation that 'the male' and 'the female' are present in the individuals which are male and female. And as the proximate motive cause, to which belongs the *logos* and the Form, is *better* and more divine in its nature than the matter, it is *better* also that the superior one should be separate from the inferior one. That is why wherever possible and so far as possible the male is separate from the female, since it is

examples, the point that is being made is clear: asymmetrical gender difference grounds these systems, whereby the masculine is constructed as the norm and the feminine as the deviant and derivative Other.[13] Masculine and feminine must not be allowed to muddy their differences, for the result would be a monstrosity.[14]

This notion that muddied distinctions are monstrous suggests an interesting challenge to the notion of androgyny which has been adopted in some feminist circles (especially those influenced by Jungian analysis). In gnostic literature, androgyny is characteristic (for example) of the monstrous abortion, Ialdabaoth; Smith writes, "For sexual differentiation is a result of formation." This is fascinating, because androgyny is usually invoked popularly and in some scholarly arguments as a redemptive condition: clearly here, androgyny is understood as an imperfect state, because it represents the absence of clear gender distinction.[15]

Another point raised by Smith has to do with the transfer of gender roles, as in his example, on the one hand, of the *Exegesis on the Soul,*

something *better* and more divine in that it is the principle of movement for generated things, while the female serves as their matter" (LCL, 131–33).

13. M. C. Horowitz ("Aristotle and Woman," *Journal of the History of Biology* 9 [1976] 183–213) argues persuasively that asymmetrical gender difference was not an assertion that Aristotle felt he needed to defend but rather was a presupposition that undergirded other assertions in other realms. I thank Karen King for bringing this article to my attention.

14. This is not the only way in which medical discourse constructs the notion of sexual difference. In contrast to Aristotle's position, one may turn to the Hippocratic work *On Regimen,* where male and female parents may each produce male and female seed; the various combinations that result produce offspring along a continuum of sexual difference: "Now if the bodies secreted from both happen to be male, . . . the babies become men brilliant in soul and strong in body. . . . If the secretion from the man be male and that of the woman female, should the male gain the mastery . . . these [offspring], while less brilliant than the former, nevertheless, . . . turn out brave *(andreioi),* and have rightly this name. But if male be secreted from the woman but female from the man, and the male get the mastery . . . these turn out hermaphrodites *(androgynoi)* and are correctly so called. . . . In like manner the female also is generated. If the secretion of both parents be female, the offspring prove female and fair. . . . But if the woman's secretion be female and the man's male, and the female gain the mastery, the girls are bolder than the preceding, but nevertheless they too are modest. But if the man's secretion be female, and the woman's male, and the female gain the mastery, . . . the girls prove more daring than the preceding, and are named 'mannish' *(andreiai)"* (Hippocrates *Vict.* 1.28–29; LCL, 4:267–71).

15. The contemporary feminist debate about androgyny is represented in M. Vetterling-Braggin, ed., *Femininity, Masculinity, and Androgyny: A Modern Philosophical Discussion.* For a positive interpretation of the notion of androgyny in antiquity, see Meeks, "The Image of the Androgyne," *HR* 13 (1974) 165–208. An alternative theoretical perspective on androgyny and the androgyne, which takes into account this tension between androgyny as a positive notion implying balance and androgyny as a negative notion implying muddied differences, is O'Flaherty, *Women, Androgynes, and Other Mythical Beasts,* 283–334.

where the soul has female genitalia but uses it aggressively, and, on the other hand, of the transformation of Sophia into a masculine savior. My question has to do with how these two things can be reconciled, or whether they can: the soul in the *Exegesis on the Soul* is in trouble for acting like a man, whereas Sophia is presumably doing the right thing by acting in a salvific role, even while she does so by means of masculine behavior. How do these two apparently opposite characterizations measure against each other?

My final point concerns Smith's documentation of salvation as a phallic event. To quote him, "Gnostics are trapped in a woman's parts, and rescue comes down out of the sky as a logos-penis-snake with its potent and perfecting semen of salvation." The connection of notions of salvation with this unabashed phallogocentrism is extremely interesting, and it would be a fruitful investigation to pursue the implications of such a connection. Specifically, if Gnosticism is not viewed as an aberration of Western culture but rather is placed on a continuum of possible and logical religious expressions springing from the same general ground as orthodox Christianity, for example, then the logocentrism of orthodox Christianity and its invocation of a male savior might well be reinterpreted in this light. In any case, Smith's description of gnostic soteriology here complicates any simple attempt to use gnostic systems to save Christianity for feminism, as some have tried to do.

In conclusion, I think that Smith has implicitly and successfully critiqued the problem created by naturalized readings of the construction of the notion of gender in gnostic texts and that he has also begun to describe a very complex matrix of cultural discourse in which biology, ideology, and mythology interact and reinscribe one another.

Vitiated Seeds and Holy Vessels:
Augustine's Manichean Past

1.

The chasm between Augustine's youthful yearning for scientific certainty[1] and his later admissions of ignorance[2] is but one indication of his progressively "darkening" vision.[3] Although this ignorance prompted his praise of God's mysterious omnipotence,[4] the older Augustine, far from grasping the design of the universe,[5] could fathom neither how fetuses were formed nor how they received their souls.[6] Yet worse than scientific ignorance was heresy, and at the end of his life, Augustine

1. *Confessiones* III.10(6); VII.8–10(6) (CCL 27.31–32, 97–99); *Contra epistolam Manichaei quam vocant fundamenti* 5; 12; 14; 18 (CSEL 25.197, 208, 210–12, 215).

2. Ibid.; also see his confession in *De animae et ejus origine* IV.6(5) (CSEL 60.386), that he was ignorant about many topics pertaining to the human body. Augustine suffered profound disappointment that the Manicheans could not deliver the "truth" they constantly promised.

3. For the fading of Augustine's early optimism, see P. Brown, *Augustine of Hippo: A Biography*, chap. 15.

4. See esp. Augustine's expressions of wonder at miracles in *De civitate Dei* XXII.8 (CCL 48.815–27).

5. Like many of his era, Augustine had early been interested in astrology and had hoped the Manicheans would furnish answers to his questions. See esp. *Confessiones* IV.4–5(3); V.3–6(3) (CCL 27.41–42, 58–60); and Brown, *Augustine of Hippo*, 56–58, for discussion. Later in the *Confessions*, Augustine chastises those who praise the wonders of nature but do not look within themselves (X.15[8] [CCL 27.162–63]) and the "futile curiosity," masked as scientific interest, which stems from slavery to the senses (X.54[35] [CCL 27.184]).

6. *Confessiones* IX.73(13); *De anima et ejus origine* I.25(15); IV.5(4); 6(5) (CSEL 60.323–25, 384–85, 386); and *Epp.* 143.5–11; 164.7, 19; 166 (a short treatise on the origin of the soul); 180.2 (CSEL 44.255–61, 538, 545–85, 698). The soul's origin will become a topic for dispute in the quarrel between Julian and Augustine; see p. 383, below.

found that his theology of reproduction brought charges of "Manicheanism" against him.[7] Pelagian critics such as Julian of Eclanum alleged that Augustine's theory of original sin, transmitted through the sex act and corrupting the offspring conceived, was a throwback to the Manichean notion of "natural evil" that Augustine had accepted in his youth.[8] According to Julian, both Augustine's Manichean (i.e., overly ascetic) view of marriage and his Manichean (i.e., docetic and Apollinarian) Christology stemmed in part from his deficient understanding of human biology. In the course of the controversy—which we know only from Augustine's rejoinders to Julian—Julian moved from a more general accusation of "Manicheanism" to pinpoint the source of Augustine's error: his view of "vitiated seeds."

Julian's charge cannot be immediately dismissed, for despite Augustine's belief that human seed was the carrier of Adam's sin, he could not explain the mechanism by which this happened. Although Augustine appealed to virgin birth theory, Catholic teaching on marriage and asceticism, Scripture, pagan learning, common experience, and horticulture to bolster his supposition of the *tradux peccati*, he managed only to offer his opponent unwitting support. To the end, Augustine foundered on the "scientific" points raised by Julian. Although the mixing of seeds with evil is given a very different—indeed, contrasting—evaluation in Augustine's myth of Eden than in the Manichean foundation myth (and thus arguably is anti-Manichean), the very fact that the mixing of seeds with evil is the key to *both* myths suggests that Julian had ferreted out in Augustine's theology of reproduction a carry-over from Manicheanism. To unravel the charge will lead us through the development of Julian's argument and back to Augustine's Manichean past.

7. Earlier, around 400 C.E., the Donatist leader Petilian had charged Augustine with his Manichean past. Petilian's allegations, however, do not appear to center on Augustine's theology. See Augustine *Contra litteras Petiliani* III.11(10); 19(16); 20(17) (CSEL 52.172, 177–78). See W. Frend, "Manichaeanism in the Struggle Between Saint Augustine and Petilian of Constantine," in *Augustinus Magister: Congrès International Augustinien, Paris, 21–24 Septembre, 1954*, 2:859–65, esp. 864–65. See also Frend's brief overview of Manicheanism in North Africa: "The Gnostic-Manichean Tradition in Roman North Africa," *JEH* 4 (1953) 13–26; and the two magisterial volumes by F. Decret, *Aspects du manichéisme dans l'Afrique romaine: Les controverses de Fortunatus, Faustus et Felix avec saint Augustin* and *L'Afrique manichéenne (IVe–Ve siècles): Etudes historiques et doctrinales.*

8. *Contra duas epistolas Pelagianorum* I.4(2); 10(5); (CSEL 60.425, 431); *De nuptiis et concupiscentia* II.15(5); 34(9); 38(23); 49(29); 50(29) (CSEL 42.266-68, 288, 291–92, 304, 305); *Contra secundam Juliani responsionem opus imperfectum* I.24; 115 (CSEL 85.21, 132–33); and many other places.

2.

Although the early Pelagian controversy centered on the explanation of God's goodness and justice in relation to human sin, the issues pertaining to sexuality, marriage, and the transmission of original sin that became central in Julian's attack were present in Augustine's first anti-Pelagian treatise, *De peccatorum meritis et remissione*, dated to 412 C.E. Here Augustine formulates his view that original sin is revealed in the "disobedient excitation of the members"[9] that causes all children to be born with concupiscence;[10] the "injury" is transferred to infants through the "sinful flesh" of those who produce them.[11] Psalm 51:5 is enlisted in support of the theory: "I was brought forth in iniquity, and in sin did my mother conceive me."[12] Augustine also appeals to his earlier ascetic writings to demonstrate the sinfulness revealed in our "disobedient members."[13] From virgin birth theory he borrows the theme that Jesus' sinlessness stems from his not having been conceived "through concupiscence and a husband's embrace."[14] Augustine further notes the christological correlate of his views: Jesus did not have our "sinful flesh," but only the "likeness of sinful flesh" (Rom. 8:3),[15] nor as an infant did he suffer "weakness of mind."[16] Moreover, the treatise reveals that by 412 the Pelagians had posed the questions with which Augustine would struggle until his death in 430: Why do regenerated Christians not beget regenerated children?[17] Why if we have remission of sins through Christ do we still suffer death, on Augustine's theory a penalty for sin?[18] Is the soul propagated or not?[19]

9. *De peccatorum meritis et remissione* I.57(29) (CSEL 60.56).

10. *De peccatorum meritis* II.4(4) (CSEL 60.73).

11. *De peccatorum meritis* III.2(2) (CSEL 60.130).

12. *De peccatorum meritis* III.13(7) (CSEL 60.140).

13. *De peccatorum meritis* I.57(29) (CSEL 60.56).

14. *De peccatorum meritis* I.57(29); II.38(24) (CSEL 60.57, 110).

15. *De peccatorum meritis* II.38(24); 48(29) (CSEL 60.110, 118), citing Rom. 8:3.

16. *De peccatorum meritis* II.48(29) (CSEL 60.119).

17. *De peccatorum meritis* II.39(25) (CSEL 60.111): If Heb. 7:9–10 testifies that Levi paid tithes in the loins of Abraham, the Pelagians ask, why should we not think that regeneration is received by those still in the loins of baptized and regenerated fathers?

18. *De peccatorum meritis* II.53(33) (CSEL 60.123).

19. *De peccatorum meritis* II.59(36) (CSEL 60.127–28). Augustine responds with the answer to which he will forever adhere: we don't know, since Scripture gives no "certain and clear proofs." Augustine even rallies Pelagius's support for his caution: III.18(10) (CSEL 60.144). On this point, it is useful to recall that Augustine was well aware of the theological difficulties that positions about the soul might entail: see *Ep.* 73.6(3) (CSEL 34.270–71) for his acknowledgment of reading Jerome's *Contra Rufinum*, a central document of the Origenist debate. Also see Augustine's *Epp.* 143.6–11; 164.19–

Augustine's anti-Pelagian works of the next five years add nothing new to the "biology" underlying the debate.[20] Then, between 417 and 419, Augustine began to explore the *process* by which original sin was transmitted. He now details how the sin in Eden affected human sexual functioning and speculates on what the first couple's relationship would have been if they had remained sinless. The best-known elaboration of these views is found in book XIV of *The City of God:* if Adam and Eve had not sinned, there would have been no unruliness of lust to disturb peace of mind and blot out mental functioning.[21] Although Adam and Eve would have engaged in sexual intercourse in order to reproduce,[22] their sexual organs would have moved at the command of their wills, tranquillity would have prevailed, defloration and labor pains would have been unknown.[23] No quarrel would have existed between lust and the will; rather, the genital organs would have moved at the will's command, as do our other bodily parts.[24] That the sin in Eden affected all later human beings is proved to Augustine by both our unruly sexual members and our sense of shame at sexual intercourse.[25] Significantly, Augustine borrows a phrase from Virgil's *Georgics* to describe how the first man would have begotten children calmly had the sin not intervened: Adam would have resembled the farmer who prepares his mares for the seed to be sown "on the field of generation."[26]

Horticultural analogies are used in Augustine's other writings from this period as well. In *Epistle* 184A, dated to 417 C.E., Augustine expresses the same theory of ideal sexual relations in paradise that he did in *The City of God.*[27] Here for the first time he finds an example that will provide his controlling metaphor to illustrate the transmission of sin: from the

20(7); 166; 180.2 (CSEL 44.255–61, 538–39, 545–85, 698) for further reflections on the origin of the soul.

20. Nothing new, e.g., is contained in *De natura et gratia* (dated to 415); *De perfectione iustitiae hominis* (dated to 415); *De gestis Pelagii* (dated to early 417) on the "biology" of original sin.

21. *De civitate Dei* XIV.10; 15–16 (CCL 48.430–31, 437–39).

22. An advance over his earlier position, when he was dubious on the point. Now he affirms that "reproduce and multiply" meant genuinely sexual relations, not an allegory about spiritual qualities "multiplying" (*De civitate Dei* XIV.22 [CCL 48.444]). For the development of Augustine's position, see M. Müller, *Die Lehre des hl. Augustinus von der Paradiesesehe und ihre Auswirkung in der Sexualethik des 12. und 13. Jahrhunderts bis Thomas von Aquin*, 19–26.

23. *De civitate Dei* XIV.23; 26 (CCL 48.444–46, 449–50).

24. *De civitate Dei* XIV.23; 24 (CCL 48.444–48).

25. *De civitate Dei* XIV.18–20 (CCL 48.440–43). Augustine in chap. 20 (unlike elsewhere) denies that Diogenes the Cynic could have had sexual intercourse in public: the act would not have been pleasurable.

26. *De civitate Dei* XIV.23 (CCL 48.446), citing *Georgics* III.136—although Virgil's horses are far lustier than Augustine's ideal first couple.

27. *Ep.* 184A.3(1) (CSEL 44.733–34).

cultivated olive tree are produced only wild olive trees, not cultivated ones. God providentially provided this dendrological example to teach us that regenerated parents pass on to their offspring only their old "carnal" natures, not their state of spiritual rebirth.[28] Augustine uses the example of the olive trees again in a letter to Pope Sixtus and in *On the Grace of Christ and Original Sin*,[29] both dated to 418 C.E. "Seeds" are now manifestly on his mind. He explains to Albina, Melania the Younger, and Pinianus, recipients of the *De gratia Christi*,[30] that God constitutes and blesses the seeds of his creatures, despite the transmission of the original sin through them.[31] He also draws implications for virgin birth theory from his evaluation of human seed: Christ's birth is different from ours because he was not *seminatus* or *conceptus* in carnal concupiscence; and Ambrose's words that the Holy Spirit's "immaculate seed" (rather than a husband's spoiled seed) caused Mary's impregnation are cited.[32] Thus we can safely assert that Augustine's interest in the biology of original sin had already been piqued by the year in which Julian most likely wrote his first attack upon Augustine, the year 419 C.E.

The course of the controversy between Julian and Augustine developed as follows: After the condemnation of Julian and other Pelagian bishops in 418, those condemned wrote to friends in Rome and to Count Valerius at the imperial court in Ravenna defending their cause and alleging that the opinions of Augustine (and others) on marriage were "Manichean."[33] In 419, Augustine wrote book I of the *De nuptiis et concupiscentia*, championing his theories against the "new heretics" who

28. *Ep.* 184A.3(1) (CSEL 44.734).

29. *Ep.* 194.44(10) (CSEL 57.122); *De gratia Christi et de peccato originali* II.45(40) (CSEL 42.202).

30. *De gratia Christi* I.1(1) (CSEL 42.125). The association of the family with Pelagianism has been explored by P. Brown, "The Patrons of Pelagius: The Roman Aristocracy Between East and West," *JTS* n.s. 21 (1970) 56–72 (=*Religion and Society in the Age of Saint Augustine*, 208–26), and by E. A. Clark, *The Life of Melania the Younger: Introduction, Translation and Commentary*, 143–44.

31. *De gratia Christi* II.46(40) (CSEL 42.204): but only humans, not animals, suffer the "fatal flaw" transmitted through those seeds, for animals do not possess reason and thus cannot partake of either the misery or the blessedness appropriate to humans.

32. *De gratia Christi* II.47(41) (CSEL 42.205-6), citing Ambrose's *Expositio evangelii secundum Lucam* II.56; *Ep.* 184A.3(1) (CSEL 44.733).

33. *Contra duas epistolas Pelagianorum* I.3(1); 4(2) (CSEL 60.424-25). On the history of the quarrel between Julian and Augustine, see A. Bruckner, *Julian von Eclanum: Sein Leben und seine Lehre: Ein Beitrag zur Geschichte des Pelagianismus;* Y. de Montcheuil, "La polémique de saint Augustin contre Julien d'Eclane d'après l'*Opus Imperfectum*," *RSR* 44 (1956) 193–218; F. Refoulé, "Julien d'Eclane, théologien et philosophe," *RSR* 52 (1964) 42–84, 233–47; shorter summaries in M. Meslin, "Sainteté et mariage au cours de la seconde querelle pélagienne," *Mystique et continence: Travaux scientifiques du VIIe Congrès International d'Avon*, 294–95; Brown, *Augustine of Hippo*, chap. 32; Schmitt, *Le mariage chrétien dans l'oeuvre de saint Augustin: Une théologie baptismale de la vie conjugale*, 56–61.

said he condemned marriage,[34] and sent it to Count Valerius, who (according to Augustine) had observed "marital chastity."[35]

Apparently Augustine did not know the full details of the Pelagian charges when he wrote book I of De nuptiis, for in the book he merely repeats arguments that he had already elaborated before Julian's attack. Thus he upholds the goodness of creation in general and human nature in particular.[36] He repeats his interpretation of Eden wie es gewesen ist and as it should have been.[37] He discusses shame's entrance to the world.[38] He describes his sexual and marital ethic[39] and links it to his understanding of the virgin birth and the marriage of Joseph and Mary.[40] Borrowing points from his anti-Manichean writings, he explains and defends the polygamy of the patriarchs.[41] Last, he again calls up his example of the seed of the olive tree that produces only wild olives to explain how regenerated parents produce unregenerate children.[42] (God's "pruning" is necessary to remove the corruption from the carnal seed, and this is accomplished through baptism.[43]) Augustine in book I of De nuptiis seems unaware that Julian had more detailed and trenchant criticisms of his theory of the tradux peccati.

When Julian read book I of the De nuptiis, he launched a more probing attack upon Augustine's theology of reproduction. Extracts of his now-lost work, addressed to a certain Turbantius, were given to Count Valerius, who in turn dispatched them to Augustine. Augustine responded with book II of the De nuptiis.[44] About the same time, he wrote Contra duas epistolas Pelagianorum, again defending his views against Julian.[45] Meanwhile, Augustine received all four volumes of Julian's treatise addressed to Turbantius, of which he had earlier seen only

34. De nuptiis et concupiscentia I.1(1) (CSEL 42.211).
35. De nuptiis I.2(2) (CSEL 42.212–13).
36. De nuptiis I.23(21) (CSEL 42.236).
37. De nuptiis I.6(5), 7(6) (CSEL 42.216–19).
38. De nuptiis I.24(22), 6(5), 8(7) (CSEL 42.237, 216–17, 219–20).
39. De nuptiis I.5(4), 9(8), 11(10), 13(11), 17(15), 19(17), 23(21) (CSEL 42.215–16, 220–21, 222–23, 225, 229–30, 231–32, 236).
40. De nuptiis I.12(11), 13(11), 1(1) (CSEL 42.224–25, 211).
41. De nuptiis I.9(8), 10(9) (CSEL 42.221–22).
42. De nuptiis I.21(19), 37(32), 38(33) (CSEL 42.234, 248–49).
43. De nuptiis I.38(33) (CSEL 42.249).
44. De nuptiis II.1(1), 2(2) (CSEL 42.253, 254); Opus imperfectum, praefatio (CSEL 85¹.3); Retractationes II.53.1 (CCL 57.131). Also see A. Bruckner (Die vier Bücher Julians von Aeclanum an Turbantius: Ein Beitrag zur Charakteristik Julians und Augustins) for a discussion of the treatise that prompted De nuptiis II, with a reconstruction of the fragments contained in Augustine's work.
45. Contra duas epistolas Pelagianorum I.3(1), 4(2), 9(5)—10(5), II.1(1) (CSEL 60.424–25, 429–31, 460–61).

extracts, and responded more fully with the *Contra Julianum*.[46] Without seeing (as far as we know) this response of Augustine, Julian wrote an even longer, eight-book treatise against his Catholic opponent, to which Augustine replied in the last, exhaustive work of his life, the *Contra secundam Juliani responsionem opus imperfectum*.[47]

Judging from book II of the *De nuptiis* onward, we can see that Julian was arguing from different grounds than Augustine: for Julian, Augustine's theology of original sin was the superstructure resting on a very dubious biological substructure, and he resolved to force Augustine to explicate the biological underpinnings of his theory. Although in the face of Julian's assault, Augustine grudgingly and belatedly allowed that there *might* have been sexual desire in a sinless Eden (albeit very different from the raging lust we now feel),[48] his attempt to explain his theory of vitiated seeds succeeded only in leaving him more liable to charges of "Manicheanism." Julian's insinuations about the "Manichean" remnants in Augustine's theology are indeed more precise than some modern critics have acknowledged.[49]

To be sure, Julian's charge of "Manicheanism" that prompted book II of the *De nuptiis* rested also on some broader issues of the Pelagian-Augustinian debate: whether sin was a matter of nature or will,[50] how creation could be said to be good if children were born evil,[51] how God's justice could be squared with the condemnation of infants for what they personally did not choose.[52] Augustine probably would have preferred to keep the argument on grounds such as these, for here he could wax eloquent on God's justice and mercy, on human sinfulness and regeneration, and could appeal to Scripture and his revered ecclesiastical prede-

46. *Contra Julianum* I.1(1)—3(1) (*PL* 44.641–43); *Retractationes* II.62.1 (CCL 57.139).
47. *Opus imperfectum*, praefatio (CSEL 85¹.3–4).
48. *Contra duas epistolas Pelagianorum* I.10(5), 31(15), 34(17), 35(17) (CSEL 60.431, 448, 450–51, 451–52); *Opus imperfectum* II.122 (CSEL 85¹.253); also the new *Ep.* 6*, 5; 7 to Atticus (CSEL 88.34–35, 35–36) on the difference between *concupiscentia nuptiarum*, which *would* have been present in paradise even if Adam and Eve had not sinned, and *concupiscentia carnis*, which would not.
49. See, e.g., the rather loose accusations of Augustine's "Manicheanism" in A. Adam, "Der manichäische Ursprung der Lehre von den zwei Reichen bei Augustin," *TLZ* 77 (1952) 385–90; and idem, "Das Fortwirken des Manichäismus bei Augustin," *ZKG* 69 (1958) 1–25. He is rightly criticized by W. Geerlings, "Zur Frage des Nachwirkens des Manichäismus in der Theologie Augustins," *ZKT* 93 (1971) 45–60.
50. *De nuptiis* II.15(5) (CSEL 42.266–67).
51. *De nuptiis* II.50(29), 31(16), 36(21) (CSEL 42.305, 284–85, 290–91).
52. The case of babies is raised in *De nuptiis* II.4(2), 24(11), 49(29), 56(33), 60(35) (CSEL 42.256, 276, 304–5, 313–14, 318–19); more explicitly argued in *Contra Julianum* III.11(5); V.43(10) (*PL* 44.708, 808–9); *Opus imperfectum* II.28, 236.2 (CSEL 85¹.181–83, 349).

cessors, especially Ambrose, to bolster his argument. Although Julian also could argue theologically, citing biblical verses and writings of earlier church fathers,[53] he wanted Augustine to make explicit the biology of the *tradux peccati*, for here he could show that Augustine's views were unscientific, ridiculous—and deeply "Manichean." Augustine could no longer rest his case, as he had so often done in his anti-Manichean writings, on an argument from the unity of God's goodness and justice, or on his understanding that evil was no substance but a lack. He would have to answer Julian's questions, and his counterattack would have to be on Julian's own ground.

3.

Book II of the *De nuptiis* shows how Julian proceeded in his attempt to discredit Augustine. Just what *is* it about marriage, he asks, that the devil can claim its offspring as his own? It cannot be the difference between the sexes, for God made us in two sexes. It cannot be the union of male and female, for God blessed this in Gen. 1:28 and 2:24. It cannot be human fecundity, for reproduction was the reason why marriage was instituted.[54] Augustine's response—"none of the above, but carnal concupiscence"[55]—leads Julian to his next task, to show that Augustine's understanding of "concupiscence" was not properly scientific.

Here Augustine gave him easy assistance, for in several places, Augustine had already affirmed that "concupiscence" was not necessarily a sexual term, since we can have "lust" for vengeance, money, victory, and domination, among other things.[56] Moreover, for Augustine there were good kinds of "concupiscence": the lust of the spirit against the flesh (Gal. 5:17), for instance, or the lust for wisdom (Wis. 6:21).[57] But

53. See Julian's appeal to Ambrose in *Opus imperfectum* IV.121 (*PL* 45.1415–16), since Augustine had effectively co-opted Ambrose for his side of the debate. Julian got bored with Augustine's constant citations of Ambrose: *Opus imperfectum* IV.109 (*PL* 45.1404).
54. *De nuptiis* II.13(4) (CSEL 42.264–65).
55. *De nuptiis* II.14(5) (CSEL 42.265).
56. *De civitate Dei* XIV.15 (CCL 48.438). For discussions of the meaning of "concupiscence" for Augustine, and differences between his view and that of Julian, see Meslin, "Sainteté," 298–99, 300–301, 303); Refoulé, "Julien," 70–71; Schmitt, *Le mariage*, 95–105; G. I. Bonner, *"Libido" and "Concupiscentia" in St. Augustine*, 303–14; F.-J. Thonnard, "La notion de concupiscence en philosophie augustinienne," *Recherches Augustiniennes* 3 (1965) 59–105, esp. 80–95; A. Sage, "Le péché originel dans la pensée de saint Augustin, de 412 à 430," *Revue des Etudes Augustiniennes* 15 (1969) 75–112, esp. 91–97; and E. S. Lodovici, "Sessualità, matrimonio e concupiscenza in sant' Agostino," in *Etica sessuale e matrimonio nel cristianesimo delle origini* (ed. R. Cantalamessa), esp. 251–62.
57. *De nuptiis* II.23(10) (CSEL 42.275).

usually for Augustine, concupiscence had a specifically sexual reference —and a negative connotation.[58] As Augustine cites him in *De nuptiis* II, Julian wished to substitute phrases such as "the natural appetite"[59] or "the vigor of the members"[60] for concupiscence. Augustine was quick to note (and to complain) that Julian's terminology removed the issue from the realm of religious or moral discourse.[61] Yet Julian does not in his treatise to Turbantius argue at length about the implications of "nature," as he will later; he is content to affirm that God is the creator of sexual desire and of the seeds formed by it.

The ways in which Julian shifted the discussion away from theology per se and toward a "bio-theology" of reproduction are revealed in his handling of several scriptural passages. When, for example, Gen. 4:25 states that Seth was the seed God raised up from Adam, Julian interprets the verse to mean that God stirred up sexual desire in Adam, through which the seed was "raised" in order to be "poured" into Eve's womb.[62] God, he asserts, is the ultimate cause of the seminal elements present in our bodies[63] (this is the meaning of 1 Cor. 15:38, "God gives to every seed its own body")[64] as well as of the "ardor" and the pleasure—but the seed is formed through sexual desire.[65] Using another agricultural metaphor, Julian reminds Augustine that wheat from stolen seeds produces no worse a crop—that is, that seed itself is not affected by an adulterous relationship.[66] Seed is a biological phenomenon, whatever the morality of human agents.

Julian also turned to Rom. 1:27 (Paul's condemnation of homosexuality) to champion the "naturalness" and hence the goodness of sexual desire. If Paul condemns the "unnatural use," he must intend to praise the "natural use," that is, heterosexual relations. To Julian's mind, the misuse that Sodomites make of their sexual organs provides no basis for adopting a Manichean stance against heterosexual relations.[67]

We also learn from *De nuptiis* that Julian interpreted the story in Gen.

58. Made clear already in *De civitate Dei* XIV.16 (CCL 48.438–39).
59. *De nuptiis* II.17(7) (CSEL 42.269).
60. *De nuptiis* II.59(35) (CSEL 42.317).
61. *De nuptiis* II.17(7) (CSEL 42.269–70).
62. *De nuptiis* II.19(8) (CSEL 42.271). Augustine's response: the author means only that God gave him a son.
63. *De nuptiis* II.26(13), 41(26) (CSEL 42.279, 294).
64. *De nuptiis* II.27(13) (CSEL 42.279). Augustine rejoins: Paul is talking of seeds of corn, not human seeds.
65. *De nuptiis* II.25(12) (CSEL 42.277).
66. *De nuptiis* II.40(25) (CSEL 42.293–94).
67. *De nuptiis* II.35(20) (CSEL 42.289). Augustine rejoins: Paul means only to contrast the "natural use" with the "unnatural," not to give special praise to sexual relations.

20:18 (God's closing of the wombs of the women in Abimelech's household as a punishment) to mean that God removed the women's sexual desire. Augustine replies, So what? Lust isn't essential to women's sexual and reproductive role, as it is to men's. If God were going to take away lust as a hindrance to begetting, he should have taken it from the men rather than the women.[68] Julian later will argue that through such expressions, Augustine seems to make males more responsible for the transmission of sin than females.[69]

Julian has thus pressed Augustine into a discussion of more specifically sexual issues in *De nuptiis* II. To be sure, by using the example of the seed of the olive tree three times in *De nuptiis* I,[70] Augustine set the stage for the discussion of seeds on which Julian would needle him in subsequent books. In *De nuptiis* II, however, the argument is not pressed very far, and Augustine reverts to his vision of Adam the Edenic farmer, sowing his sperm with the calm and rational purpose with which he would sow seeds of corn.[71]

Gathering from Augustine's discussion in the *Contra Julianum*, we can posit that Julian became more interested in the issue of "seeds" between the time of his first attack upon Augustine and his book to Turbantius that prompted the *Contra Julianum*. From book III of the *Contra Julianum* on, seeds come in for extensive discussion. Augustine's position is this: he agrees with Julian that God makes all men from seed, but (unlike Julian) he believes that it is seed already condemned and vitiated.[72] Against Julian, Augustine holds that the seed is created by God directly and does not receive its formation from "lust."[73] Thus the child that results is a divine work, not a human one.[74] If God were to withdraw his good action in producing seeds, caring for them, and quickening the fetus, there would be no begetting, and what was already begotten would lapse into nothingness.[75]

Augustine argues that although the seed was in essence good, the devil "sowed the fault" in it—a phrase that alludes to Genesis 3 as well as the parable of the tares.[76] In support of his view, he cites Rom. 5:12[77] and

Later Augustine adds that on Julian's premises, he would have no way to criticize the emission of seed for other than reproductive purposes: II.59(35) (CSEL 42.317–18).

68. *De nuptiis* II.30(15) (CSEL 42.283–84).
69. See p. 387, below.
70. *De nuptiis* I.21(19), 37(32), 38(33) (CSEL 42.234, 248–49).
71. *De nuptiis* II.29(14) (CSEL 42.283).
72. *Contra Julianum* III.33(17) (PL 44.719).
73. *Contra Julianum* IV.12(2) (PL 44.742).
74. *Contra Julianum* V.34(8) (PL 44.804).
75. *Contra Julianum* VI.59(19) (PL 44.858).
76. *Contra Julianum* III.51(22) (PL 44.728); cf. Matt. 13:24–30.
77. *Contra Julianum* III.51(22) (PL 44.728).

his own *De nuptiis*: "The semination of the children in the body of that life would have been without that disease without which it cannot now exist in the body of this death."[78] It is a tribute to God's mercy that he does not withhold his creative power even from the seed "vitiated by the paternal prevarication."[79] Augustine suggests that perhaps a regenerated man has two kinds of seeds: the immortal ones from which he derives life and the mortal ones through which "he generates the dead,"[80] that is, doomed children.

As cited in the *Contra Julianum*, Julian devised new arguments after he read *De nuptiis* I that he here employs in addition to his earlier charges.[81] Some of his new arguments rest on Aristotelian analysis, a point noticed by Augustine[82] as well as by modern commentators.[83] First, Julian undertakes what Augustine calls a "medical dissection" of concupiscence using Aristotelian categories. Thus Julian writes that the "genus" of concupiscence lies in "the vital fire" (a term borrowed from Stoic analysis),[84] its "species" in the genital activity, its "mode" in the conjugal act, and its "excess" in the intemperance of fornication.[85] Augustine, who considers concupiscence a moral category,[86] is annoyed that Julian censures only the excess of concupiscence, not the thing itself; he must imagine that concupiscence constitutes an original endowment of humankind, present even in paradise.[87] Julian indeed *does* believe this: according to him, concupiscence was one of the original senses that human beings received,[88] a point he will further develop.

A second argument mounted by Julian involves Aristotle's discussion of accidents inhering in subjects: "That which inheres in a subject cannot

78. *Contra Julianum* III.59(26) (*PL* 44.732), citing *De nuptiis* I.1(1).
79. *Contra Julianum* VI.5(2); cf. 26(9) (*PL* 44.823–24, 837–38).
80. *Contra Julianum* VI.14(5) (*PL* 44.831).
81. E.g., God's closing the wombs of the women of Abimelech's house is interpreted as the removal of lust from the women (*Contra Julianum* III.37[19] [*PL* 44.721–22]) (Augustine here takes the story as an illustration of how "contagion" can pass); that the "power of the seeds" produces children from adultery as well as from marriage (*Contra Julianum* III.53[23] [*PL* 44.729–30]); that "reproductive heat" is good in its own way (*Contra Julianum* IV.7[2] [*PL* 44.739]); that "natural concupiscence" is a good (*Contra Julianum* IV.52[8] [*PL* 44.764]).
82. *Contra Julianum* V.51(14); VI.55(18)—56(18) (*PL* 44.812, 855–56).
83. See Bruckner, *Julian*, 90–99; Refoulé, "Julien," 233–47; and F.-J. Thonnard, "L'aristotélisme de Julien d'Eclane et saint Augustin," *Revue des Etudes Augustiniennes* 11 (1965) 295–304.
84. On the "heat" of the soul in Stoic philosophy, see E. Zeller, *Die Philosophie der Griechen in ihrer geschichtlichen Entwicklung*, III¹, 194–97, with references to the primary sources.
85. *Contra Julianum* III.26(13) (*PL* 44.715).
86. Ibid.
87. *Contra Julianum* III.27(13); V.27(7) (*PL* 44.716, 801).
88. *Contra Julianum* IV.65(14) (*PL* 44.769–70).

exist without the thing which is the subject of its inherence." Julian concludes, "Therefore, the evil which inheres in a subject cannot transmit its guilt to something else to which it does not extend, that is to say, to the offspring."[89] Aristotle was right: accidental properties cannot "wander off" from their proper subject to another.[90] Julian faults two points in Augustine's view. First, he writes, "natural things cannot be transformed by an accident"; hence human nature cannot be changed forever by one act of a man's will.[91] Second, if parents don't have something (namely, sin), they can't transmit it; if on the other hand they do transmit it, as Augustine holds, they never lost it (in regenerating baptism).[92] Augustine's image of the olive tree is ridiculous; illustrations cannot help us to defend points that by their very nature are indefensible.[93] If Augustine wants to indulge in horticultural examples, why doesn't he turn to Matt. 7:17–18, the good tree that bears good fruit, which illustrates the goodness of human nature and what is produced from it?[94]

Julian also appeals to religious arguments: God's power and goodness are called into question if we believe that "in the womb of a baptized woman, whose body is the temple of God," is formed a child under the power of the devil.[95] And last, Julian faults Augustine's notion of sin: "How could a matter of will be mixed with the creation of seeds?"[96] From Julian's standpoint, Augustine has confused a matter of morals (the will's determination of sin) with a biological issue (the creation of sperm).

Augustine found Julian's arguments dangerous. Armed with Julian's exaltation of concupiscence, married people might be encouraged to indulge in sexual relations whenever they wanted. Did Julian so behave in his own marriage, Augustine nastily inquires?[97] Any sexual act, so long as it was heterosexual, would have to be praised on the basis of

89. *Contra Julianum* V.51(14) (*PL* 44.812).

90. *Contra Julianum* V.51(14) (*PL* 44.813). Besides, says Julian, even if infants contract evil, a merciful God would cleanse them of it (V.53[15] [*PL* 44.813]). Cf. Aristotle *Categories* 2,1a 23–29. I thank Michael Ferejohn for assistance with this reference.

91. *Contra Julianum* VI.16(6) (*PL* 44.831–32).

92. *Contra Julianum* VI.18(7) (*PL* 44.833).

93. *Contra Julianum* VI.15(6) (*PL* 44.831).

94. *Contra Julianum* I.38(8) (*PL* 44.667).

95. *Contra Julianum* VI.43(14) (*PL* 44.846).

96. *Contra Julianum* VI.24(9) (*PL* 44.837): "Qui fieri potest ut res arbitrii conditioni seminum misceatur?"

97. *Contra Julianum* VI.28(14) (*PL* 44.716). Cf. Paulinus of Nola's epithalamium on the occasion of Julian's marriage: the chastity of the couple is praised; Paulinus even hopes they will not consummate their marriage (*Carmen* 25.233–34 [*CSEL* 30.245]).

Julian's analysis of Rom. 1:27.[98] We could not categorically state that consent to concupiscence was an evil (as Augustine thinks it is), since the thing itself would be a good.[99]

In response to Julian's point about qualities inhering in a subject, Augustine agrees with Julian (and Aristotle) that they do so inhere and that they do not "wander." But he holds that qualities can pass by "affecting" other things. Thus Ethiopians beget black children (the blackness "affects" the children's bodies); the color of Jacob's rods "affected" the color of the lambs produced.[100] A medical writer (later identified as Soranus) testifies that an ugly king had his wife gaze at a portrait of a handsome man while they had sexual relations so that the child would be "affected."[101] Moreover, parents *can* transmit accidental qualities: a man who lost the sight of one eye produced a son with sight in one eye, so that what had been an "accident" for the father became "natural" for the son. And parents can also transmit what they *do not* themselves have, as is proved by the same father's producing a fully sighted son[102] and by circumcised fathers begetting sons with foreskins![103] Thus with so much "scientific" evidence, why can we not believe that original sin "affects" an offspring?[104] In addition to his genetics of "affection," Augustine also speaks of the transfer of properties by "contagion,"[105] in which "another quality of the same kind is produced," as when diseased parents transmit their affliction to their offspring.[106]

As for Julian's objection that the omnipotent God could not let the fetus of a baptized woman fall under the power of the devil, Augustine misconstrues his point (namely, that God is simultaneously powerful, just, *and* merciful). Augustine thus rebukes Julian for thinking that enclosure in a narrow womb could limit or defile God,[107] an argument

98. *Contra Julianum* III.40(20) (*PL* 44.722).
99. *Contra Julianum* IV.12(2) (*PL* 44.742).
100. *Contra Julianum* V.51(14) (*PL* 44.812).
101. Ibid. In *Retractationes* II.62.2 (CSEL 57.139) Augustine reports that he mistakenly wrote that Soranus had given the king's name (Dionysius); he hadn't, and Augustine must have gotten the name from elsewhere. Augustine's reference is important because it shows he knew something of Soranus's works, which were in Latin translation by the later fourth century. See n. 167, below.
102. *Contra Julianum* VI.16(6) (*PL* 44.832).
103. *Contra Julianum* VI.18(7); 20(7) (*PL* 44.833, 834).
104. Julian, of course, believes in sin "by imitation." See his interpretation of Rom. 5:12, given on pp. 386–87, below.
105. *Contra Julianum* V.51(14) (*PL* 44.813).
106. *Contra Julianum* VI.55(18) (*PL* 44.855).
107. *Contra Julianum* VI.43(14) (*PL* 44.846–47).

used by both pagan and Manichean opponents of the incarnation.[108]
Augustine responds that God is everywhere and is defiled by nothing.
Besides, infants in the womb are not really part of their mothers' bodies,
as is evidenced by the fact that they have to be baptized separately, for a
fetus, who is "not a temple of God," is created in a woman who is.[109]

As for Julian's argument that sin is a matter of will and has nothing to
do with the biological phenomenon of the creation of seeds, Augustine
rejects it because he rejects Julian's restriction of sin to the act of a single
rational being. He writes, if the will could *not* be mixed with seeds, there
would be no way to hold that infants are "dead."[110] That is, of course,
Julian's very point: infants *cannot* be held responsible for sin. Augus-
tine's zeal to damn unbaptized infants seemed cruel and unjust to
Julian;[111] Augustine's counterargument (that Julian himself is "cruel" in
not opening Christ's saving grace to infants)[112] is beside the point, given
Julian's understanding of sin and human development.

In the work that prompted the *Contra Julianum*, Julian also must have
pressed Augustine on the consequences of his theory of original sin for
his understanding of marriage and the virgin birth. Many years earlier,
Augustine had elaborated his notion of the threefold goods of marriage
(offspring, fidelity, and the sacramental bond)[113] and had affirmed
Mary's virginal vow and her perpetual virginity.[114] In *De nuptiis* I, he had
reaffirmed the threefold goods,[115] and had used his interpretation of
them to argue that Joseph and Mary had a genuine marriage. Joseph and
Mary shared "affection of soul" and hence deserve to be called "parents"
(Luke 2:41), just as Mary is called a "wife" (Matt. 1:20).[116] Reflecting on
the "bond" between Joseph and Mary, Augustine avers the permanence
of marriage even when there are no offspring, or when one partner
commits adultery or insists on divorce.[117] A sexless marriage is sanc-
tioned for those with sufficient fortitude.[118]

As early as *De nuptiis* II, Julian reveals his discomfort with Augustine's

108. See pp. 392–93, below, for discussion of this point.
109. *Contra Julianum* VI.43(14) (*PL* 44.847).
110. *Contra Julianum* VI.24(9) (*PL* 44.837).
111. *Contra Julianum* V.43(10) (*PL* 44.808–9).
112. *Contra Julianum* VI.9, 24 (*PL* 44.836–37); also see *Contra duas epistolas Pelagianorum* I.11(6); IV.5(4), 9(5) (*CSEL* 60.431–32, 525, 530); *Opus imperfectum* I.32; II.236.2 (*CSEL* 85¹.24–25, 349).
113. *De bono conjugali* 3(3); 4(4) (*CSEL* 41.190–93).
114. *De sancta virginitate* 2(2); 3(3); 4(4); 27(27) (*CSEL* 41.236–38, 264).
115. *De nuptiis* I.11(10), 23(21) (*CSEL* 42.222–23, 236).
116. *De nuptiis* I.12(11), 13(11–12) (*CSEL* 42.224–26).
117. *De nuptiis* I.19(17) (*CSEL* 42.231).
118. *De nuptiis* I.13(12) (*CSEL* 42.226).

praise of sexless marriage and his view, derived from Ambrose, that Jesus was free from "sinful fault" because he was not born from sexual union. Does Julian dare to call Ambrose a Manichean (as Jovinian had), counters Augustine.[119] At least Jovinian never denied the necessity of Christ's saving grace to redeem babies from the devil![120] Julian, although an advocate of the virgin birth, disliked Augustine's use of the example of Joseph and Mary to suggest that sexual union was not necessary in marriage. "Show me any bodily marriage without sexual union!" he demands of Augustine.[121] Augustine, for his part, scorned Julian's notion of marriage as overly sexual: does Julian imply that the "shedding of seed" is the ultimate pleasure of the union rather than the conception and birth of a child?[122] Augustine was gradually abandoning a sexual understanding of marriage and stressing more centrally the bond between the partners. To Julian, this movement betokened "Manicheanism."

Such criticisms are amplified by Julian in the treatise to which Augustine responded in the *Contra Julianum.* "Marriage consists of nothing else than the union of bodies," Julian wrote.[123] Since Joseph and Mary never engaged in sexual intercourse, they cannot be considered married.[124] On Augustine's view of their relationship, we might infer that Adam and Eve could have been "married" in Eden without sexual union.[125] When Augustine asserts that Christ was born sinless because he was born "not of the seed of man,"[126] or, alternately, because he was not begotten from "the concupiscence of sexual intercourse,"[127] Julian puts some difficult questions to him.

First, even if Joseph was not involved in Christ's conception, why did not Mary have "concupiscence" from her own birth that she transferred to her son (recall that for Julian, this was a natural quality, akin to the five senses)?[128] If she came from the stock of Adam, she must have given him the same flesh that we have, flesh (*contra* Augustine) that is not

119. *De nuptiis* II.15(5) (CSEL 42.267).
120. *De nuptiis* II.15(5) (CSEL 42.268).
121. *De nuptiis* II.37(22) (CSEL 42.291).
122. *De nuptiis* II.19(8) (CSEL 42.271).
123. *Contra Julianum* V.62(16) (PL 44.818). Augustine fears that this definition would allow adultery and other sexual relationships to count as marriage.
124. *Contra Julianum* V.46(12) (PL 44.810). Scripture calls Joseph Mary's husband because it follows the common view (V.47 [12] [PL 44.810–11]).
125. *Contra Julianum* V.48(12) (PL 44.811). Augustine denies the charge.
126. *Contra Julianum* II.8(4) (PL 44.678–79); Ambrose is cited as being in agreement (II.10[5] and 15[6] [PL 44.681, 684]).
127. *Contra Julianum* V.54(15) (PL 44.814).
128. See p. 377, above.

sinful.[129] If Augustine insists that Jesus did not have one of the senses with which we are born, Jesus is not a human being and Augustine is guilty of Apollinarianism.[130] Moreover, since Augustine does not hesitate to assert that Christ's body was of a "different purity" from the bodies of other human beings because of the lack of concupiscence (and hence original sin) involved in his conception,[131] Julian suspects him of harboring a docetic, that is, "Manichean," view of Jesus.

Thus we see that in Julian's first two attacks on Augustine, he pinpointed some problematic aspects of Augustine's theology of reproduction that kindle his suspicions of Augustine's orthodoxy: that ideal marriage might not involve sexual relations, that sexual intercourse transmits original sin, and that Jesus does not share all of our human qualities. These points Julian will pursue in his last work against Augustine that is excerpted in Augustine's *Opus imperfectum*.

4.

From Julian's words cited in the *Opus imperfectum*, we gather that he had reflected further on the implications of Augustine's theology and was prepared for a still lengthier attack. Five points either absent from or undeveloped in the earlier controversy emerge as central in Julian's last set of charges. First, Julian adds a new "science" to those from which he had drawn his earlier arguments: anthropology, understood in the modern, not the classical theological sense. Anthropological data were useful to Julian in demolishing Augustine's appeal to the shame surrounding nudity and sexual intercourse as evidence for original sin. Julian earlier had explained that Adam and Eve at first had gone naked because they had not yet developed the art of making clothing, a product of "human inventiveness" that came in time.[132] Thus for Julian, the use of clothing was not related to sin's entrance to the world and the desire to cover the unruly genitals, as it was in Augustine's interpretation.[133]

129. *Contra Julianum* V.52(15) (*PL* 44.813): Paul in Rom. 8:3 does not mean to imply that bodies are sinful.
130. *Contra Julianum* V.55(15) (*PL* 44.814).
131. *Contra Julianum* V.52(15) (*PL* 44.814–15).
132. *Contra Julianum* IV.81(16) (*PL* 44.780). Augustine responds, was it sin that made us so clever? Julian also apparently argued that the parts Adam and Eve covered were their "sides," not their genital organs. Augustine faults both Julian's Greek and his shamelessness: is he raising the *perizōma* up to their shoulders and leaving the turbulent members in full view? *Contra Julianum* V.7(2) (*PL* 44.785–86).
133. See esp. *De civitate Dei* XIV.17 (*CCL* 48.439–40).

In his last anti-Augustinian work, Julian drew arguments from the Cynic philosophers, who faulted customary ideas of shame; from the animals, who exhibit no shame at their public sexual activities;[134] and from the diverse customs of human beings. Borrowing Aristotle's notion that virtuous behavior depends on knowing which people may perform what activities in which circumstances and how,[135] Julian observes that we do not shun nudity at the baths, but clothe ourselves for public assemblies; that our nightgowns are loose and *seminudus*, but our street attire covers us more carefully; that we don't blame artisans, athletes, or sailors (witness Peter in John 21:7) for their state of undress, since their activities require it. Moreover, the Scots and other barbarians go naked without shame. Augustine's teaching that universal shame accompanies nudity is "destroyed" by such evidence, Julian asserts.[136] Augustine's appeal to "universal facts" turns out to be an appeal to culturally conditioned behavior that is not universal. More important, from Julian's viewpoint, Augustine veers dangerously close to a condemnation of the human body that can be labeled "Manichean."

Julian's next piece of anthropological evidence concerns birthing experience. Against Augustine's view that labor pains are the penalty for original sin, Julian suggests that such pains are natural to the human (and animal) condition, and hence are not to be associated with sin.[137] Surely Augustine must realize that the intensity of labor pains varies widely among human beings. Rich women suffer more than poor ones, and barbarian and nomadic women give birth with great ease, scarcely interrupting their journeys to bear children. How then can Augustine say that labor pains are universal and the penalty for sin?[138] He has not taken a properly scientific approach to the issue.

Julian's second new argument concerns the origin of the soul, a question on which Augustine had consistently pronounced his igno-

134. *Opus imperfectum* IV.43 (PL 45.1362). Augustine replies (1362–63) that animals do not suffer concupiscence as humans do and hence have no shame about their sexual acts.

135. Aristotle *Nicomachean Ethics* II.2.4, 6.11, 6.18, 9.2, 9.7.

136. *Opus imperfectum* IV.44 (PL 44.1363–64). Augustine responds (1364–65) that we should look to the "parents of all nations," Adam and Eve, not just to a particular group like the Scots. The first couple were not originally corrupted with evil doctrine, as were the Cynics, nor did they have to work (as Peter did; his nudity is excused).

137. *Opus imperfectum* VI.26 (PL 45.1562). Augustine responds (1563) we do not know what animals feel when they give birth. Do their sounds portend joyous song or grief? Perhaps they feel pleasure, not pain. Cf. *De Genesi contra Manichaeos* II.29(19) (PL 34.210).

138. *Opus imperfectum* VI.29 (PL 45.1577). Augustine responds (1578), so what if the pain varies; *all* women still suffer; hence all are affected by original sin.

rance.[139] Augustine had been content to affirm the existence of original sin, whether we believe that the soul's corruption came about with the body's conception or that the soul was corrupted after having been placed by God in the body "as in a faulty vessel."[140] He had earlier advised Julian to adopt the position of the mother of the seven Maccabean brothers, who confessed her ignorance about the soul's origin.[141] Julian now pressed the creationist view against Augustine's notion of a *tradux peccati*. Since the soul is a new creation of God and does not come from the bodily seed, how can it be said to pass sin from parents to offspring?[142] And Julian claims that he knows Augustine's position, even if Augustine does not: since Augustine believes that sin becomes mixed with the seeds and makes the *conceptus* guilty,[143] he is a traducian,[144] and traducians are to be equated with Manicheans.[145] Both traducians and Manicheans assert that evil contracted from some ancient and unfortunate event is passed down by reproduction through the ages. When Augustine argues that all men are "in Adam" and thus receive his sin, he must mean that the soul as well as the body is transmitted, for to be a "man" means to have both.[146] Does not Augustine know that traducianism was condemned both in Tertullian's and in Mani's teachings?[147] Although the traducians (i.e., Augustine) find themselves "shut up in the cave of the Manicheans," Julian, by expounding his own theories, will turn the key so the captives may make their escape from confinement![148]

Third, we learn from reading the *Opus imperfectum* that Julian now developed a more explicit argument about the immutability of "nature." Against Augustine's view that all human nature was ever after changed by Adam's sin,[149] Julian argues that "human nature" (including our senses and concupiscence)[150] does not change, since God bestows our

139. See n. 6, above.

140. *Contra Julianum* V.17(4) (*PL* 44.794).

141. *Contra Julianum* V.53(15) (*PL* 44.814), citing 2 Macc. 7:22. Neither is Augustine ashamed of his ignorance: *Opus imperfectum* II.178.3 (CSEL 85¹.299).

142. *Opus imperfectum* II.24, 1 (CSEL 85¹.178).

143. *Opus imperfectum* II.8 (CSEL 85¹.168).

144. *Opus imperfectum* I.6; II.14 (CSEL 85¹.9, 172).

145. *Opus imperfectum* I.27, 66; II.27.2; 202; III.10 (CSEL 85¹.23, 64, 181, 314, 355).

146. *Opus imperfectum* II.178.2 (CSEL 85¹.298). Augustine does not know *how* all men were "in Adam," but asserts *that* they were.

147. *Opus imperfectum* II.178.1 (CSEL 85¹.297). Actually, the church had not officially pronounced on whether traducianism or creationism was correct.

148. *Opus imperfectum* II.27.2 (CSEL 85¹.181).

149. *Opus imperfectum* VI.37 (*PL* 45.1596).

150. *Opus imperfectum* III.142 (CSEL 85¹.447–48). In I.71.2 (CSEL 85¹.81), concupiscence is called a "natural and innocent *affectio*."

essential human constitution[151] and neither sin nor grace has the power
to change our essential being.[152] The things Augustine believes were
penalties for the first sin—labor pains, sweat, work, the submission of
woman to man—are all part of the original order of nature and thus are
unchangeable.[153] If original sin had truly become part of our nature, as
Augustine holds, it could not be eradicated.[154]

Julian's reflection on "nature" leads him to a fourth accusation, that
Augustine's views on Jesus' conception and physical constitution have a
docetic or Apollinarian (i.e., "Manichean") cast. Although Julian cham-
pions the virgin birth,[155] he suspects that Augustine's praise of the
virginal conception stems mainly from his desire to avoid a "damnable
sexual connection," not (as Julian thinks) to demonstrate God's power
through a miracle.[156] To say, as Augustine does, that Jesus had no
concupiscentia sensuum is to say that he has different flesh than we do,
and this is "Manichean."[157] Since Jesus ate, slept, sweated, worked, bled,
and grew a beard, he must have had the same bodily *concupiscentia* as
we do. His willingness to take all our bodily organs ("which Mani's
impiety refuses to give him") reveals the great love the Savior felt for
us.[158] Moreover, Julian draws the conclusion of Augustine's position for
ethics: what kind of model for us can Jesus be if he did not have a real
human nature? Why praise his chastity if he had no "virility," if his
chastity stemmed only from "sexual weakness"? What meaning have his
forty-day fast and the cross if he felt no pain?[159]

Augustine defends his position by differentiating the senses (which
Jesus had) from concupiscence (which he did not have).[160] He even
allows that if Jesus had wanted to beget children, he could have; after
all, he was not a eunuch, incapable of *seminandi filiorum*.[161] But Augus-
tine rejects Julian's moral theory, because it implies that virtue is meas-
ured by the degree of struggle. On this theory, Christ would have had

151. *Opus imperfectum* III.109.2–3, 142.2; IV.120; V.46 (CSEL 85¹.429, 447; PL 45, 1414, 1482).
152. *Opus imperfectum* I.96; II.94 (CSEL 85¹.111, 227).
153. *Opus imperfectum* VI.26, 27, 29 (PL 45.1561–62, 1566–68, 1577).
154. *Opus imperfectum* I.61 (CSEL 85¹.58).
155. *Opus imperfectum* I.141,1 (CSEL 85¹.158): those who refuse to believe the doctrine are called "vessels of earth" by Julian (cf. Isa. 45:9).
156. *Opus imperfectum* I.66 (CSEL 85¹.64).
157. *Opus imperfectum* IV.47; VI.41 (PL 45.1365, 1604).
158. *Opus imperfectum* IV.53 (PL 45.1369–70); cf. IV.50 (PL 45.1368).
159. *Opus imperfectum* IV.50 (PL 45.1368).
160. *Opus imperfectum* IV.48, 69, 29 (PL 45.1366, 1379, 1353).
161. *Opus imperfectum* IV.49, 52 (PL 45.1367, 1369).

greater virtue if he had had a greater libido.[162] We should, rather, exempt Christ from that disruptive war between the flesh and the spirit which the rest of us suffer.[163] Christ had a holy body, free from all offense because his conception did not involve the *commixtio* of the sexes.[164] It is blasphemous for Julian to put the divine flesh of Christ on a par with our own, which suffers the discord between its desires and the spirit.[165] And Augustine insists that his own position is *not* Manichean.[166]

Last, and for our purposes most important, Julian launches a sharper attack upon Augustine's view of seeds and their connection with sin. Strictly speaking, Julian probably accepted the same medical theory as Augustine that deemed male seed largely responsible for the creation of a child.[167] (His claim that children are born *de vi seminum* is meant to challenge Augustine's view that sin is transmitted through the reproductive act,[168] not to stand as a biological statement about the relative contributions of male and female.) In his treatise that elicited the *Opus imperfectum*, however, Julian needles Augustine on a point at which he had hinted earlier but develops only here: Augustine, by connecting original sin with the male seed, suggests that sin is a peculiarly male problem.[169] Julian attacks Augustine's argument from two directions: from the interpretation of Rom. 5:12 ("through one man sin entered the world") and from a discussion of virgin birth theory.

Fortunately for Julian, Rom. 5:12 was one of Augustine's favorite texts which he had employed throughout the entire Pelagian controversy.[170]

162. *Opus imperfectum* IV.49, 52, 53 (*PL* 45.1367–68, 1369, 1370).
163. *Opus imperfectum* IV.49 (*PL* 45.1367).
164. *Opus imperfectum* IV.134 (*PL* 45.1429).
165. *Opus imperfectum* IV.122 (*PL* 45.1418).
166. *Opus imperfectum* VI.33 (*PL* 45.1586–87).
167. See Galen *Peri physikōn dynameōn* 2.3: the semen works like an artist (e.g., Phidias) on the woman's blood; it is the active principle, the blood provides the "matter." According to Soranus (*Gynecology* 1.3.12), the "female seed" seems not to be used in generation, since it is excreted. Soranus's *Gynecology* was influential in the West by the late fourth century (O. Temkin, *Soranus' Gynecology*, xxix). For Augustine, children are "poured off" (*transfunduntur*) from the man to the woman: *Opus imperfectum* II.178.2 (*CSEL* 85¹.299).
168. E.g., *Opus imperfectum* II.40, 41, 112 (*CSEL* 85¹.191–92, 243). Julian reports on various medical opinions about the creation of the seed in *Opus imperfectum* V.11 (*PL* 45.1440).
169. See p. 376, above. Readers may rightly argue that already in *De civitate Dei* XIV.16, Augustine's description of original sin manifesting itself was depicted in typically male examples (erection and impotence).
170. See Augustine's use of Rom. 5:12 in *De perfectione iustitiae hominis* 39(18); 44(21); *De gratia Christi* I.55(5); II.34(29); *De nuptiis* I.1(1); II.3(2), 8(3), 15(5), 20(8), 24(11), 37(22), 42(26), 45(27), 47(27); *De peccatorum meritis* I.8(8), 9(9), 10(9), 11(10); III.8(4), 14(7), 19(11); *De spiritu et littera* 47(27); *De natura et gratia* 9(8); 46(39); 48(41); *De anima et ejus origine* I.28(17); II.20(14); *Contra duas epistolas Pelagianorum* IV.7(4), 8(4), 21(8).

Julian argues that since Paul asserts that sin came into the world "through one man," he could not possibly mean "through generation," for everyone knows that reproduction takes two.[171] Julian intends his readers to conclude, on the basis of Paul's words, that sin arose through *imitation* of the first man, not by transmission.[172]

Nonsense! Augustine rejoins. If Paul had wished to claim that sin arises by imitating bad examples, he would have mentioned the woman, since she sinned first and gave the example of sin to the man.[173] Paul is correct in saying that sin entered through the male because it enters through the *semen generationis* which is cast off from the male and through which the woman conceives.[174] Paul writes as he does because it is "not from the seed which conceives and bears" (i.e., the woman's contribution to conception) "that generation takes its beginning, but from the male seed *(a viro seminante)*."[175] Since the man's *seminatio* precedes the woman's conceiving, Paul speaks correctly. Everyone knows that women "conceive" or "bear," but they don't "generate."[176] The Bible confirms the point, Augustine claims, for in it a woman doesn't *genuit*, only a man does.[177] There can be no mistaking Augustine's meaning when he expresses himself so plainly and so often: the offspring contracted the original sin from Adam, the male who engendered; the woman receives the already vitiated seed from him, conceives, and gives birth.[178]

Augustine's notion of the *tradux peccati* also relates to his discussion of the virgin birth. It is because Christ is not conceived *ex semine* of a man that he is *liber a nexu seminatricis concupiscentiae*.[179] It was because *(propterea)* Christ was not conceived *virili semine* but by the Holy Spirit

171. *Opus imperfectum* II.56.1, 75 (CSEL 85¹.203, 218).
172. *Opus imperfectum* II.56.1, 61, 194 (CSEL 85¹.203, 207–8, 209).
173. *Opus imperfectum* III.85.1 (CSEL 85¹.411–12). Julian's explanation for why the man is named although the woman sinned first is that fathers have more *auctoritas* than women; possessing the *potestas* of the male sex, a man's example (Adam's) would carry more weight than a woman's (Eve's): *Opus imperfectum* II.190 (CSEL 85¹.307).
174. *Opus imperfectum* II.56 (CSEL 85¹.204–5). In II.173.1 (CSEL 85¹.293), Augustine asserts that we have a choice of just two views: the one here espoused or that Eve is included with Adam in the phrase "one man." Augustine does not pursue the latter alterative.
175. *Opus imperfectum* II.83 (CSEL 85¹.221).
176. *Opus imperfectum* III.85.4 (CSEL 85¹.413).
177. *Opus imperfectum* III.88.3–4 (CSEL 85¹.415–16).
178. *Opus imperfectum* II.179 (CSEL 85¹.299–300).
179. *Opus imperfectum* IV.104 (PL 45.1401). Cf. other expressions of this idea in Augustine's sermons, such as that Jesus was "conceived in a womb no seed had entered" (*Sermo* 192 [Ben.], 1 [PL 38.1012]); and that he was "born of his Father without time, of his mother without seed" (*Sermo* 194 [Ben.], 1 [PL 38.1015]). Augustine's Christmas sermons in particular often mention the "seedless" conception of Jesus, but

that he lacks carnal concupiscence and thus is able to release others from original sin, not contract it himself by being "generated."[180]

Julian presses this point by asking Augustine to comment on John 14:30, that the devil found no trace of sin in Christ. If original sin is "natural," as Julian thinks Augustine believes, why didn't the devil find a trace of it in Christ? Augustine replies (as we would now expect) that Christ does not have "sinful flesh," because he alone was not born from the "commingling of the sexes."[181]

Julian argues that if sin is natural to the human condition, then either Christ was born culpable or he was not made a man[182]—and Augustine will be shown to hold a docetic (i.e., "Manichean") Christology. Julian, of course, wishes us to deny the premise (that sin is natural to the human condition), but his argument has the effect of pushing Augustine even closer to stating that the male gives original sin. Julian presses further: if, as Augustine claims, sin is a condition of the flesh, Christ should have contracted sin from his mother[183] (recall here Augustine's theory of "affection"). Augustine admits in reply that Mary, by condition of her own birth, would have been "submitted to the devil" (i.e., under the sway of original sin) if the grace of regeneration had not loosed that condition.[184] This is as close as Augustine comes to espousing the later doctrine of the immaculate conception of Mary, a doctrine necessary if Augustine and others want to avoid the conclusion that Mary could have transmitted to Christ the sin present in her from her own birth. Julian here emerges as an important contributor to the development of the argument regarding the immaculate conception.

Julian finds Augustine's views so antisexual, antibody, and antiscientific that he cannot resist imagining what Augustine's notion of ideal reproduction would be. He goes Augustine's image of the "happy farmer"[185] one better: Augustine would have preferred for the world to

since the sermons are difficult to date, they are not useful in a historical argument as are treatises or letters that can be dated with some precision.

180. *Opus imperfectum* VI.22 (*PL* 45.1553).
181. *Opus imperfectum* IV.79 (*PL* 45.1384)).
182. *Opus imperfectum* IV.80 (*PL* 45.1384–85).
183. *Opus imperfectum* IV.51 (*PL* 45.1369).
184. *Opus imperfectum* IV.122 (*PL* 45.1418). On Augustine's Mariological theory, see J. Huhn, "Ein Vergleich der Mariologie des hl. Augustinus mit der des hl. Ambrosius in ihrer Abhängigkeit, Ähnlichkeit, in ihrem Unterschied," in *Augustinus Magister: Congrès International Augustinien, Paris, 21–24 Septembre 1954* 1:221–39; and H. Frévin, *Le mariage de saint Joseph et de la sainte Vierge: Etude de théologie positive de saint Irénée à saint Thomas*, 239–67. For background, see H. Koch, *Virgo Eva–Virgo Maria: Neue Untersuchungen über die Lehre von der Jungfrauschaft und der Ehe Mariens in der ältesten Kirche*.
185. *De civitate Dei* XIV.23 (*CCL* 48.446); *Opus imperfectum* V.14 (*PL* 45.1444–45).

be so constituted that wombs and penises would have been unnecessary. The woman's entire body would have been fecund, like the earth; children would have "sweated forth" from the pores and joints of her body (like lice, Julian adds). The male would have assisted her in her reproductive task, but not with his genitals, which would have been replaced with plowshares and hoes. Thus he would plow her and "forest" the unbridled fecundity of her body.[186] Poor woman, scraped over by plows and hoes! Such sentiments are worthy of Manicheans, Julian concludes, who blame God's works and deny that God created our bodily parts to be so perfect that we cannot imagine any better ones.[187]

Julian has forced Augustine to make plain the antisexual and antiscientific roots of his theology of sin. Yet Augustine has conceded only one point: that in a sinless Eden, there might have been libido, although one controlled by the will, not the unruly and disobedient libido we know today.[188] For the rest, Augustine repeats the same arguments in the *Opus imperfectum* that he had raised earlier in the controversy.[189] Despite the fact that Augustine won the controversy in terms of the later course of Catholic theology, it is not so clear that he won the debate with Julian. Had Julian responded to the *Contra Julianum* and the *Opus imperfectum*, we suspect he would have faulted Augustine for becoming progressively *more* Manichean as the controversy unfolded. Early on, the accusation was simply that the theory of original sin made marriage

186. Does Julian here hint that he approves of "bridling" women's fecundity through contraceptive measures?
187. *Opus imperfectum* V.15 (PL 45.1445).
188. *Opus imperfectum* I.68.5 (CSEL 88^1.75): originally libido was never contrary to the movement of the will. In II.122 (CSEL 85^1.253) Augustine gives three choices: either there was no libido in Eden before sin; or there was libido, but it didn't go before the will or mind; or at least it didn't exceed them. Also see *Contra duas epistolas Pelagianorum* I.10(5), 31(15), 35(17) (CSEL 60.431, 448, 451–52) for the possibility of libido and "motion of the members" in Eden. In the new *Ep.* 6* to Atticus (5.1; 7.2 [CSEL 88.34, 35–36]), Augustine distinguishes the *concupiscentia nuptiarum* which would have been present, from the *concupiscentia carnis*, which would not.
189. Scripture affirms original sin (Ecclus. 40:1 is a favorite proof text; see *Opus imperfectum* I.27, 49; VI.3, 23 [CSEL 85^1.23, 41–42; PL 45.1507, 1556]); the church fathers affirm original sin (Ambrose's *Commentary on Luke* is cited over three dozen times, by my count; Julian would push all the woes of this life into paradise (*Opus imperfectum* I.67.7; III.154, 187.2–3; IV.114; V.23; VI.16, 21 [CSEL 85^1.72, 459–60, 488–89; PL 45.1408, 1458, 1537–38, 1549–50]); that Julian is cruel not to allow Christ's grace to be effective for babies (*Opus imperfectum* I.32, 54; II.2, 117, 236.3; III.48, 126, 146 [CSEL 85.24–25, 49–50, 165, 249, 350, 388, 441, 452–53]); that he does not hold a Manichean "mixing of natures" (*Opus imperfectum* I.85, 120; VI.20, 25, 36, 41 [CSEL 85^1.98, 136; PL 45.1547, 1559, 1592, 1608]); Julian's praise of concupiscence and the sexual relation puts illicit and licit sexual relations on the same footing (*Opus imperfectum* III.209 [CSEL 85^1.502–3]).

and the reproductive process seem evil; as the debate proceeded, the charge became considerably more precise.

Julian came to the controversy well armed with Augustine's writings, especially with such anti-Pelagian treatises as *On the Remission of Sins*,[190] *Against the Two Letters of the Pelagians*,[191] *On the Grace of Christ*,[192] and *On Nature and Grace*.[193] He also knew Augustine's *Confessions*.[194] But what he knew of Augustine's anti-Manichean writings remains less clear. Julian faults Augustine for changing his theology between the period after his conversion and the present,[195] an accusation that suggests that he had read some of Augustine's early anti-Manichean writings. Yet actual citations from the anti-Manichean books are much harder to locate than one would imagine on the basis of Albert Bruckner's claim that Julian had studied both the anti-Manichean and the anti-Pelagian works of Augustine.[196] I have found no sure references to any anti-Manichean work of Augustine except *On Two Souls*[197] in the citations from Julian.

From whatever source, Augustine or the Manicheans themselves, Julian knew at least the outlines of the Manichean foundation myth.[198] He was familiar with some of their ritual practices, such as the Elects' eating of fruit to release the particles of God trapped therein.[199] He tells us that years before on a visit to Carthage, he had met Augustine's friend Honoratus, "a Manichean like you," with whom he discussed the origin of the soul.[200] Most important, Julian knew and cited from Mani's (or the Manichean) *Epistle to Menoch*, a work unknown to Augustine,[201] and from Mani's *Epistle to Patricius*.[202] The former in particular he put to

190. Shown in *Opus imperfectum* II.178.1; IV.104 (CSEL 85¹.297; PL 45.1399).
191. Shown in *Opus imperfectum* II.178.2 (CSEL 85¹.298).
192. Shown in *Contra Julianum* IV.47(8) (PL 44.762).
193. Shown in *Contra Julianum* V.10(3) (PL 44.788).
194. Shown in *Opus imperfectum* I.25 (CSEL 85¹.22).
195. *Contra Julianum* VI.39(12) (PL 44.843).
196. Bruckner, *Julian*, 85.
197. Shown in *Opus imperfectum* I.44; V.40 (CSEL 85¹.31; PL 45.1476).
198. See *Contra Julianum* VI.68(22) (PL 44.864); *Opus imperfectum* I.49.1; 2 (CSEL 85¹.41, 115); perhaps also V.15 (PL 45.1445).
199. *Opus imperfectum* VI.23 (PL 45.1555).
200. *Opus imperfectum* V.26 (PL 45.1464).
201. *Opus imperfectum* III.166; cited from 172 on (CSEL 85¹.469, 473ff.). Augustine does not know the letter (III.172.3 [CSEL 85¹.473]). Mani's authorship has been doubted (though not the Manichean origin of the work) by G. J. D. Aalders, "L'Epître à Menoch, attribuée à Mani," *VC* 14 (1960) 245–49.
202. *Opus imperfectum* III.186.2 (CSEL 85¹.484). Augustine in *Contra epistolam fundamenti* 12 (CSEL 25.207–8) cites Mani's words responding to Patticius. The name is now known from the *Cologne Mani Codex* (no. 89: "Pattikios"); see discussion in Decret, *L'Afrique manichéenne*, 117–22.

good purpose, showing how Mani's notion of the transmission of souls[203] and his belief that *concupiscentia* is the stratagem by which the devil snares human beings[204] were similar to Augustine's teaching. He points out that Mani, like Augustine, frequently cites Paul's words in Rom. 7:19, "The good I want I do not do, and I do the evil I do not want."[205] Both Mani and Augustine subscribe to the view that the human race degenerated from its original state.[206] Both think concupiscence is the origin of evil.[207] If Mani's name did not appear in the title of his *Epistle to Menoch,* Julian concludes, people would think the work had been written by Augustine![208]

Yet the one piece of Manichean lore that would have been most useful to him in his quarrel with Augustine he seems not to know: the myth of the seduction of the archons. Although it was *against* this myth—and its real-life consequences—that Augustine had constructed his sexual and marital ethic, yet, I posit, it was this myth that gave Augustine his first explanation of how seeds became corrupted. Even if Julian did not know this aspect of the Manichean myth, he knew that Augustine's version of the *tradux peccati* through seed sounded Manichean to his ears. To Augustine's Manichean past we thus must turn.

<div align="center">5.</div>

Augustine, by his own account, had been a Manichean Auditor for nine years.[209] Struggling to answer questions about the presence of evil in the world, Augustine turned to the Manichean myth of the ancient battle that had resulted in God's defeat by Darkness and his entrapment, as pieces of Light, in matter.[210] The human soul was seen as part of

203. *Opus imperfectum* III.173, 174 (CSEL 85¹.474, 475).
204. *Opus imperfectum* III.174 (CSEL 85¹.475). Manichean documents consistently condemn lust and reject "defiling intercourse." See, e.g., Psalm 270, l. 29; Psalm 268, ll. 31–32 (*A Manichean Psalm-Book, Part II*, ed. C. R. C. Allberry; Manichean Manuscripts in the Chester Beatty Collection II), 88, 86; *Kephalaia* 78, ll. 19–20; 94, ll. 20–21 (*Manichäische Handschriften der Staatlichen Museen Berlin I* [ed. H. Ibscher]), 190, 239.
205. *Opus imperfectum* III.185 (CSEL 85¹.483).
206. *Opus imperfectum* III.186.2 (CSEL 85¹.484); cf. *Contra epistolam fundamenti* 12 (CSEL 25¹.208).
207. *Opus imperfectum* III.187.1–5 (CSEL 85¹.485–87).
208. *Opus imperfectum* III.187.7 (CSEL 85¹.488).
209. *Confessiones* III.11.20; IV.1.1 (CCL 27.38, 40); *Contra epistolam fundamenti* 10 (CSEL 25.206); *De moribus Manichaeorum* 68(19) (PL 32.1374); *De moribus ecclesiae catholicae* 18.34 (PL 32.1326). P. Courcelle (*Recherches sur les Confessions de saint Augustin,* 78) has argued for a Manichean period of at least ten years.
210. For overviews of Manicheanism and the Manichean myth, see H. Jonas, *The Gnostic Religion: The Message of the Alien God and the Beginnings of Christianity,* chap. 9;

God's nature,[211] the body as the product of malevolent forces.[212] Two natures, good and evil, thus warred within humankind.[213]

One consequence of the Manichean view of human nature was that Christ could not be ascribed a fleshly body or birth from a woman. Indeed, Augustine's Manichean opponents consistently denied the reality of Christ's birth.[214] According to the Manichean Faustus, Jesus enjoined his disciples to teach others the commandments, not that he was born.[215] When Jesus asked, "Who are my mother and my brothers?" and then gestured to the crowd before him, he meant to indicate that he had no fleshly human relations.[216] The Manicheans also attacked the genealogies in Matthew and Luke, pointing out their discrepancies, as a way to discount Jesus' birth.[217] According to Augustine, even the Manichean attack upon the polygamy, sexual profligacy, lying, and other dubious acts of the patriarchs was motivated by their desire to discredit the incarnation by slandering Christ's ancestors.[218] Since the Manicheans did not believe that Christ was born, they of course rejected theories about the virginity of Mary before, during, and after birth that were gaining acceptance in the late fourth century.[219]

Specifically, the Manicheans complained that "confining" Christ to a womb limited God's nature[220] and subjected him to "defilement."[221]

H.-C. Puech, *Le Manichéisme: Son fondateur–sa doctrine*; G. Widengren, *Mani and Manichaeism*, esp. chaps. 3 and 4; L. J. R. Ort, *Mani: A Religio-Historical Description of His Personality*; H. J. Polotsky, "Manichäismus," PW Suppl., vol. 6 (1935), 240–71; and C. Colpe, "Manichäismus," *RGG³* (1960), 4:714–22.

211. *De anima et ejus origine* I.24(15); II.4(2), 6(3) (CSEL 60.323); *De Genesi contra Manichaeos* II.11(8), 38(25) (PL 34.202, 216); *De moribus Manichaeorum* 11.21 (PL 32.1354); *Contra Faustum* XX.98 (CSEL 25¹.705) among many references.

212. *De Genesi contra Manichaeos* II.38(26) (PL 34.217); *Contra Faustum* XX.22 (CSEL 25¹.565–66).

213. *De duabus animabus* I.1 (CSEL 25¹.51); *Opus imperfectum* VI.6 (PL 45.1510–11).

214. *Contra Faustum* II.1; XVI.4; XXVI.6; XXVIII.2; XXXII.7 (CSEL 25¹.253, 442–43, 734–35, 744–45, 766); *Contra epistolam fundamenti* 9 (CSEL 25¹.202).

215. *Contra Faustum* V.3 (CSEL 25¹.273). On Faustus (and with a restoration of his *Capitula*), see P. Monceaux, *Le manichéen Faustus de Milev: Restitution de ses Capitula*.

216. *Contra Faustum* VII.1 (CSEL 25¹.303); Denis *Sermo* 25.5 (*Miscellanea Agostiniana*, vol. 1: *Sancti Augustini Sermones* [Rome: Tipografia Poliglotta Vaticana, 1930], 160).

217. *Contra Faustum* II.1; III.1; VII.1 (CSEL 25¹.253–54, 261–62, 302–3); also see *Sermo* 51.11(7)—16(10); 27(17) (PL 38.339–42, 348–49); *De consensu Evangelistarum* II.2(1)—16(5) (PL 34.1071–79); *Retractationes* II.16, 55.3 (CCL 57.103, 134).

218. *Contra Faustum* XXII.64 (CSEL 25¹.660). Much of *Contra Faustum* XXII is dedicated to this issue, as is a surprisingly large portion of *De bono conjugali*.

219. *Contra Faustum* XXIX.1; 4 (CSEL 25¹.743, 747). According to Faustus, Jesus became Son of God at his baptism, not at his birth: *Contra Faustum* XXIII.2 (CSEL 25¹.707–9).

220. A point also worried about by pagan critics of Christianity; see Augustine's correspondence with Volusian: *Epp.* 135.2; 137.1, 2; 2, 4 (CSEL 44.91, 98, 100–101).

221. *Confessiones* III.7.12 (CCL 27.33); *Contra Secundinum* 23 (CSEL 25².940); *Contra Faustum* XX.11; XXIII.10 (CSEL 25¹.549–50, 716–17).

Those who wish to avoid their own future reincarnations, asserted the Manichean Secundinus, should not shut Christ up in a womb![222] The *Manichean Psalm-Book* provides further examples of this aspect of Manichean teaching:

> ... He (Jesus) was not born in a womb corrupted:
> not even the mighty were counted worthy of him for him to dwell beneath
> their
> roof, that he should be confined in a womb of a woman of low degree(?).[223]

> Many the marvels of thy begetting, the wonders of thy cross. . . .
> When I say "thy begetting," yet who created thee? . . .
> They came to the son of God, they cast him into a filthy womb. . . .
> (I) hear that thou didst say: "I am the Light of the world." . . .
> (Then) who gave light to the world these nine months?
> When I say "The son was begotten(?)," I shall find the Father also at his side
> Shall I lay waste a kingdom that I may furnish a woman's womb?
> Thy holy womb is the Luminaries that conceive thee.
> The trees and the fruits—in them is thy holy body.[224]

Over against these Manichean views, the young Augustine confessed his belief in the genuine humanity of Jesus. Far from the "feigned flesh" that the Manicheans attribute to Christ,[225] Augustine in his anti-Manichean writings upholds the reality of Jesus' flesh, both preresurrection and postresurrection,[226] and attacks the Apollinarian denial of a human

222. *Epistola Secundini* (CSEL 25².899).

223. Psalm 245, ll. 23–26 (cf. Luke 7:2–6), Allberry, *Manichean Psalm-Book, Part II*, 52. I thank my colleague Orval Wintermute for assistance with the text. For a discussion of Manichean views of Christ, see E. Rose, *Die manichäische Christologie*, esp. 121–23. Augustine asks of the Manicheans, if you discount Jesus' birth, why do you allow Mani to be born?: *Contra epistolam fundamenti* 8 (CSEL 25¹.201–2). On Manichean views of Jesus in Eastern Manichean texts, see O. G. von Wesendonk, "Jesus und der Manichäismus," *OLZ* 30 (1927) 221–27; and E. Waldschmidt and W. Lentz, "Die Stellung Jesu im Manichäismus," *Abhandlungen der Preussischen Akademie der Wissenschaften, philosophisch-historische Klasse* 1926–27, no. 4, 1–131.

224. *A Psalm to Jesus*, ll. 19–32, passim (Allberry, *A Manichean Psalm-Book, Part II*, 120–21). The "begetting" of Christ, for the Manicheans, always means the heavenly begetting from the Father. That Jesus' body was present in the fruit of trees was the background of the notion of *Jesus patibilis* (see, e.g., *Contra Faustum XX.11* [CSEL 25¹.549–50]). The *Psalm to Jesus* also (l. 31) mocks the Magi, another feature of the Christian birth story that probably was repulsive to those whose leader had suffered from the ill will of the Magi.

225. *De continentia* 23(9); 24(10) (CSEL 41.170); *Contra duas epistolas Pelagianorum* IV.5(4) (CSEL 60.525).

226. *Confessiones* VII.19, 25 (CCL 27.108–9); *De bono conjugali* 26(21) (CSEL 27.220–21); Mai *Sermo* 95.3 (*Miscellanea Agostiniana*, 1:342); Guelferbytana Append. VII, 1 (*Miscellanea Agostiniana*, 1:581–82); Morin *Sermo* 17.1–2 (*Miscellanea Agostiniana*, 1:659); and numerous other places in Augustine's doctrinal, moral works, letters and sermons. For a review of Augustine's Christology, see T. J. van Bavel, *Recherches sur la christologie de saint Augustin: L'humain et le divine dans le Christ d'après saint Augustin.*

mind to Christ.[227] Christ was so much part of the human race, Augustine asserts in these early writings, that he even took mortality from his mother.[228] Against the Manichean belief that a human birth would have "confined" Jesus to the womb, Augustine constantly affirms that God is everywhere and cannot be subjected to "confinement."[229] He did not abandon the government of the earth and the heavens, or leave the presence of his Father, when he became man.[230]

Nor is Christ "contaminated" by his sojourn in a woman's womb.[231] Augustine mocks his Manichean opponents: certainly the womb of the Virgin Mary was purer than the manured ground that grows the fruit in which Manicheans think Jesus is trapped![232] Mary's virginity before, during, and after birth is a guarantee for Augustine that her vessel remained "undefiled."[233] Her womb is like a marriage chamber in which the humanity and the divinity became "one flesh" and from which Christ emerged, like "a bridegroom leaving his chamber."[234] Augustine scoffs at Manicheans who disdain to think of Christ in Mary's womb, yet (according to their myth) subject God to imprisonment in the wombs not just of ordinary women but even of beasts.[235] Manicheans would undoubtedly have preferred Mary to engage in sexual intercourse without reproduction than in motherhood without sexual intercourse, given their perverted ethical views.[236]

Augustine in his anti-Manichean writings cites Rom. 8:3 ("the likeness of sinful flesh") to argue the *reality* of Christ's body against the Manicheans,[237] an ironic note, given Julian's claim that Augustine's constant appeal to this verse only reveals the docetic, that is, "Manichean,"

227. *Confessiones* VII.19.25 (CCL 27.109); *De anima et ejus origine* I.31(18) (CSEL 60.332); Denis *Sermo* 5.7 (*Miscellanea Agostiniana*, 1:28); and numerous other places. See van Bavel, *Recherches*, 122–28.

228. *Contra Adimantum* 21 (CSEL 25^1.180); *Contra Felicem* II.11 (CSEL 25^2.840).

229. *Contra Faustum* XXIII.10 (CSEL 25^1.716); *Contra epistolam fundamenti* 20 (CSEL 25^1.216); *Confessiones* V.2.2 (CCL 27.57).

230. *Contra Faustum* XXIII.10 (CSEL 25^1.716).

231. *Contra epistolam fundamenti* 8 (CSEL 25^1.202); *Contra Faustum* XX.11 (CSEL 25^1.549–50); *Confessiones* V.10.20 (CCL 27.69); *De bono viduitatis* 13(10) (CSEL 41.319); *Sermo* 12.12(12); 51.3(2); 215.3 (PL 38.106, 334, 1073).

232. *Contra Faustum* XX.11 (CSEL 25^1.549).

233. A particularly strong theme in Augustine's sermons. See, e.g., *Sermones* 51.18; 184.1; 186.1; 188.4; 189.2; 190.2–3; 191.2–4; 192.1; 193.1; 195.1; 170.3.3; 291.6; 231.2.2; 215.2; and numerous others.

234. Citing Ps. 19:5: found in such works as *Sermones* 191.2(1); 192.3(3); 195.3; 126.6(5); 291.6 (PL 38.1010, 1013, 1018, 701, 1319); *Tractatus in Johannis Evangelium* 8.4 (CCL 36.84); *Ennarationes in Psalmos* 148.8 (CCL 40.2171).

235. *Contra Secundinum* 23 (CSEL 25^2.940); *Contra Faustum* III.6 (CSEL 25^1.267–68).

236. *Contra Faustum* XXX.6 (CSEL 25^1.755).

237. *Contra Adimantum* 21 (CSEL 25^1.180).

tendency of his Christology.[238] For Julian, a Christ without *concupis-centia*, or ignorance as an infant, or struggle against temptation, is not a genuinely human Christ but a "Manichean" one.[239] Yet Augustine had earlier staunchly defended the real flesh and real birth of Jesus against Manichean detractors.

A second consequence of the Manichean myth was the prohibition against reproduction, which further entrapped particles of God's substance in fleshly darkness. Sexual activity was allowed to Manichean Auditors with the stipulation that they circumvent conception. That Augustine learned Manichean contraceptive techniques (a primitive form of the "rhythm" method[240] and perhaps *coitus interruptus*[241] is suggested not just by his explicit testimony[242] but also by his failure to produce any children during his long period as a Manichean—a period in which he engaged in regular sexual activity.[243]

As a Catholic convert, Augustine became sharply critical of Manichean sexual practice and theory. He thought the Manichean boast of continence was false.[244] Reporting on the dubious sexual morality of Manicheans, he insinuates that they eat human seed, as well as fruits and vegetables, to free the divine light within.[245] While they frown on

238. *De nuptiis* I.13(12) (CSEL 42.226); *Contra Julianum* V.55(15) (*PL* 44.815); *Opus imperfectum* IV.60, 79; VI.34 (*PL* 45.1375, 1384, 1588). Interestingly, a Manichean psalm (probably) cites the verse as part of its docetic Christology [Allberry, *Manichean Psalm-Book, Part II*, 194 (l. 1)].

239. See p. 385, above.

240. *De moribus Manichaeorum* 18.65 (*PL* 32.1373). See J. Noonan, *Contraception: A History of Its Treatment by the Catholic Theologians and Canonists*, 151–54. According to Soranus *Gynecology* I.10.36 (pp. 34, 36 Temkin), the woman's fertile period came at the end of menstruation; if some argue for other times, do not pay attention to such "unscientific" arguments.

241. So Noonan infers from *Contra Faustum* XXII.30 (CSEL 25¹.624): in intercourse, the Manicheans "pour out their God by a shameful slip" (Noonan, *Contraception*, 153–54). Recall Augustine's interpretation of the sin of Onan as *coitus interruptus*; see p. 000, below.

242. *De moribus Manichaeorum* 18.65 (*PL* 32.1373): the Manicheans advised Augustine to refrain from sexual relations during the woman's fertile period. Cf. *Confessiones* IV.2.2 (CCL 27.41): on how we begrudge the birth of children, though love them after they arrive; and *Contra Faustum* XX.23 (CSEL 25¹.567), on married Manichean Auditors who have children, "albeit they beget them against their wills."

243. On Augustine's early sex life, see *Confessiones* II.2.2, 4; III.1.1; VI.11.20—15.25; VIII.7 (CCL 27.18, 19, 27, 87–90). On a (probable) later reflection concerning his relationship with his mistress, see *De bono conjugali* 5(5) (CSEL 41.193–94). P. Brown has wisely warned us not to view Augustine's relationship with his mistress in terms of "animal passions"; the "late Roman caste system" provides a better explanation of his behavior (P. Brown, *Augustine and Sexuality*, 1–2).

244. *Confessiones* VI.7.12 (CCL 27.82); *De continentia* 26(12) (CSEL 41.175); *Contra duas epistolas Pelagianorum* III.14(5) (CSEL 60.503); *De moribus ecclesiae Catholicae* 2(1) (*PL* 32.1311); *Retractationes* I.7.1 (CCL 57.18).

245. *De moribus Manichaeorum* 68; 70–72(19) (*PL* 32.1374, 1374–75); *De continentia*

motherhood, they boast that prostitutes "spare God";[246] probably they
would have preferred the prophet Hosea's woman to have remained a
prostitute than to have become an honorable wife and mother![247]

Against Manichean theory, Augustine developed a proreproductive
and anticontraceptive marital ethic that became the hallmark of Catho-
lic sexual teaching until our own century.[248] For Augustine the Catholic,
only the desire to produce children rescues sexual intercourse for God's
good plan. Thus "offspring" stand in first place among the threefold
goods of marriage in his earlier writings.[249] He defends the polygamy
and sexual activities of the patriarchs from Manichean attacks: our
Hebrew forefathers, he claims, wished only to raise up children for God,
a fitting goal for the period in which they lived, even if not so glorious
now that Christian virginity is an option.[250] The use of contraceptive
measures is thus tantamount to "adultery" for Augustine, since it strikes
against a central purpose of marriage[251] which Manicheans who use the
woman's sterile period for sexual intercourse attempt to thwart.[252]
Moreover, it is in Augustine's anti-Manichean polemic that he develops
his infamous interpretation of the sin of Onan in Genesis 38: God
punished him (and should punish others who imitate him) for practicing
coitus interruptus.[253]

Most important for our purposes, Augustine understands the function
of the Manichean foundation myth to be a justification and court of
appeal for Manichean sexual practices. When Manicheans teach that
Adam was produced from the abortive princes of darkness and that

27(12) (CSEL 41.177); *De natura boni* 45–47 (CSEL 25².884–88); *De haeresibus* 46.5, 9, 10,
11 (CCL 46.313, 314–15, 316); *Contra Fortunatum* 3 (CSEL 25¹.85); for suspicions about
their practices, see also Cyril of Jerusalem, *Catecheses* VI.33 (PG 33.597); Possidius, *Vita
Augustini* 16 (PL 32.46–47); cf. Epiphanius on the Barbeloites, *Adversus haereses* 1.2.26.4
(PG 41.338–39).
 246. *Contra Secundinum* 21 (CSEL 25².938).
 247. *Contra Faustum* XXII.80 (CSEL 25¹.682–83).
 248. Augustine's "three goods of marriage" is still the structuring device of Pius XI's
encyclical *Casti Connubii* of 1930.
 249. *De moribus ecclesiae Catholicae* 63(30) (PL 32.1336); *De sancta virginitate* 12(12)
(CSEL 41.244–45); *De bono conjugali* 32(24) (CSEL 41.226–27).
 250. *Contra Faustum* XXII.31–32, 43, 45, 47–50, 81 (CSEL 25.624–27, 635–36, 637, 639–
44, 683); *De sancta virginitate* 1(1) (CSEL 41.235–36); *De bono viduitatis* 10(7) (CSEL
41.314–15); and throughout *De bono conjugali*, esp. secs. 26–35 (CSEL 41.221–30).
Augustine rejects the Manichean tendency to pit the asceticism of some New Testament
passages over against the proreproductive view of the Old Testament: *Contra
Adimantum* 3; 23 (CSEL 25¹.118–22, 182); *Contra Secundinum* 21; 23 (CSEL 25².938–39,
941); *Contra Faustum* XIV.1 (CSEL 25¹.401–4).
 251. *Contra Faustum* XV.7 (CSEL 25¹.429–30).
 252. *De moribus Manichaeorum* 65(18) (PL 32.1373).
 253. *Contra Faustum* XXII.84 (CSEL 25¹.687); also later in *De adulterinis conjugiis*
II.12.12 (CSEL 41.396).

through the "stirring up" of the evil part of his soul he was led away into sexual intercourse, they merely seek to excuse their own indulgence in sexual acts not motivated by the desire for reproduction.[254]

Moreover, Augustine precisely pinpoints the myth of the archons as the sanction for Manichean sexual perversity. Making fun of the Manichean belief that the sun is a ship which sails through the heavens, Augustine continues:

> This really is tolerable, however it may make us laugh or weep. But what is intolerable is your wicked notion about beautiful young women and men coming forth from the ship, whose great beauty of form inflames the rulers of darkness, the males for the women and the females for the men, so that the members of your god are released from this loathsome and nasty shackling in their members by means of burning lust and eager concupiscence.[255]

The myth to which Augustine here alludes is mentioned at least seven times in his writings—six times in his anti-Manichean works and once in *De haeresibus*.[256] Brief references or allusions to the story are made in other places as well.[257] The fullest version of the myth is found in *De natura boni* 44. Augustine there speaks of the Manichean belief that God's nature has gotten mixed into all bodies and seeds and is fettered to them.

254. *De moribus Manichaeorum* 73(19) (*PL* 32.1375–76).

255. *Contra Faustum* XX.6 (CSEL 25¹.540).

256. *Contra Felicem* II.7; 22 (CSEL 25².834–35, 852); *Contra Faustum* VI.8; XX.6; XXII.98 (CSEL 25¹.296–97, 540, 704); *De natura boni* 44 (CSEL 25².881–84); *De haeresibus* 46.7–8, 14 (CCL 46.314–17). The myth of the seduction of the archons, its variations and precedents have been well explicated by F. Cumont, *Recherches sur le manichéisme, La cosmogonie manichéene d'après Théodore bar Khôni*, "Appendice I: La seduction des archontes," 54–68. Cumont shows that several variations developed from the central myth as explicated in Mani's *Thesaurus* which had either semen or rain fall from the heavens. Mani was vague as to the substance, but Christian writers filled in the details. Probably the Manichean myth was derived from the older Persian myth of the primordial battle between the Primal Man and the bull. For background to the myth in Persian religion, see R. C. Zaehner, *Zurvan: A Zoroastrian Dilemma*, 183–92. Among Christian authors who cite the myth are Augustine's friend Evodius *De fide contra Manichaeos* 14–16 (CSEL 25.956–57); Hegemonius *Acta Archelai* 9 (GCS 16, 13, 15) where the substance is identified as rain and compared with the sweat a man sheds when he works; Epiphanius, who says he derives his version from "Archelaus" (*Haer.* II.2.66.32 [*PG* 42.80–81]); a remnant in Theodoret *Compendium haereticorum fabularum* V.10 (*PG* 83.487), where the substance is again identified as rain; and fully in Theodore bar Konai, *Liber scholiarum* XI (ed. Addai Scher), 316–18; German trans. in A. Adam, *Texte zum Manichäismus*, 20–21). One wonders if recalling the myth motivated Augustine to note that in the Bible, angels always manifest themselves *clothed* (*Opus imperfectum* IV.63 [*PL* 45.1376]).

257. E.g., in *De moribus Manichaeorum* 61(19); 73(19); 49–50(16) (*PL* 32.1371, 1375–76, 1365).

For they say that the powers of light are transformed into beautiful males
and are set opposite the females of the race of darkness, and that the same
powers of light are again transformed into beautiful females and are set
opposite the males of the race of darkness. And they say that through their
beauty they might inflame the filthiest *libido* in the princes of darkness. In
this way, vital substance (*vitalis substantia*), i.e., the nature of God which
they say is bound in their bodies, is loosed from their members relaxed
through concupiscence; it flies away and it is freed after it has been taken
up and purged.

Augustine continues, citing from book 7 of Mani's *Thesaurus:*

By this handsome sight of theirs, ardor and *concupiscentia* increase. Thus
the chain of their very worst thoughts is loosened and the living soul which
was held by their members is relaxed by this occasion, escapes, and is
mixed with its own most pure air. When the souls are cleansed through and
through, they ascend to the shining ships which have been readied for their
sailing and for transporting them to their own country. But indeed, that
which still bears the stains of the adverse race descends bit by bit through
heat and fires, and is mixed with trees and other plants and with all seeds,
and is tinged with diverse colors.

The figures of the beautiful males and females also appear to the "fiery"
and the "cold and moist" heavenly powers, who likewise release their
"life."[258]

When Faustus, Augustine's Manichean opponent, complains about
the patriarchs' sexual practices, Augustine rejoins: could *anything* the
patriarchs did be as bad as the Manichean teaching which affirms that
God's substance, confined in our bodies, is there subjected to the violent
motion of sexual acts and is released in ejaculation—that very God who
gave up his members to the libido of the male and female powers of the
race of darkness?[259]

Augustine repeats the story in his *Contra Felicem*,[260] and the anathema
that the defeated Felix signs is concerned almost exclusively with this
aspect of the Manichean myth:

I, Felix, used to believe in Mani, but now I anathematize him, his doctrine,
and the seducing spirit that was in him. He said that God had mixed a
portion of himself with the race of darkness, and that to free it in so
immoral a way, he transformed his virtues into women over against the
men, and again into men over against the female demons, so that afterward

258. *De natura boni* 44 (CSEL 25².881–84).
259. *Contra Faustum* XXII.98 (CSEL 25¹.704–5).
260. *Contra Felicem* II.7 (CSEL 25².834–35).

he fixed in a globe of darkness the rest of these parts of himself. All these things and other blasphemies of Mani, I anathematize.[261]

Augustine gives the following additions to the Manichean myth in the *Contra Faustum:*

> In that battle, when their Primal Man ensnared the race of darkness by deceitful substances, princes of both sexes of that source were captured and from them the world was constructed. And among those used in the formation of the heavens were some pregnant females. When the sky began to revolve, they were not able to stand the rotation, and these females cast off aborted fetuses, both male and female, which fell from the heavens to the earth. Here they lived, and grew; they had sexual relations and produced offspring. This they say was the origin of all flesh which is in the earth, the water, and the air.[262]

It is striking that Augustine, who mocks the myth frequently in his anti-Manichean writings, never once elaborates it in his lengthy books against Julian, despite Julian's constant charge that Augustine is still a Manichean, and Augustine's just-as-constant denial of the charge. Both he and Julian frequently mention the Manichean myth of the mixing of God's nature with evil, Julian complaining that the theory of original sin "mixed" evil with the nature of the good and hence is Manichean.[263] Since Julian had pinpointed with some specificity the biological problem in Augustine's theory—the vitiated seeds—he could have put the Manichean myth of the archons' seduction to good use had he known it: he could have claimed that it provided the precise Manichean background of and correlate to Augustine's theory. I suggest that Augustine neither could nor wished to answer Julian's question of how sin came to be mixed with seeds. Having decisively rejected his Manichean past, why should he bring to Julian's attention that other foundation myth to which, forty years earlier, he had subscribed?[264] It was enough to have

261. *Contra Felicem* II.22 (CSEL 25².852).
262. *Contra Faustum* VI.8 (CSEL 25¹.296).
263. *Opus imperfectum* I.49, 120; VI.25 (CSEL 85¹.41; PL 45.1559), and many other passages; also see *De continentia* 14(5) (CSEL 41.157–58) and *Contra Faustum* II.6 (CSEL 25.261).
264. I remained unconvinced by the intriguing argument of Pier Franco Beatrice (*Tradux peccati: alle fonti della dottrina agostiniana del peccato originale,* 222–59) that Augustine's theory of original sin stemmed from the Encratites, especially from Julius Cassianus (cited in Clement of Alexandria *Stromateis* III), perhaps by way of fourth-century Messalian teaching. Although there are indeed similarities between encratite and Augustinian theory, Beatrice provides no convincing historical road map of how Augustine would have known these earlier views. Beatrice cites in support of his theory a pseudo-Cyprianic sermon, "De centesima, sexagesima, tricesima" (PL Suppl. 1.53–67), which asserts that baptism cleanses us from the "delictum primae nativitatis" (col. 54, ll. 5–7; wrongly cited as col. 64 in Beatrice), but such generalized views of the matter were

built a Catholic sexual ethic that condemned lust without reproductive intent, an ethic that countered by inversion the very meaning of the Manichean myth. His Manichean past haunted him enough in Julian's charges without adding fuel to his opponent's fire.

6.

Social historians have recently suggested that periodization in history would look far different if it were based on changes that have primarily affected *women* rather than men. Thus Joan Kelly writes:

> What feminist historiography has done is to unsettle such accepted evaluations of historical periods. It has disabused us of the notion that the history of women is the same as the history of men, and that significant turning points in history have the same impact for one sex as for the other. Indeed, some historians now go so far as to maintain that, because of women's particular connection with the function of reproduction, history could, and should, be rewritten and periodized from this point of view, according to major changes affecting childbirth, sexuality, family structure, and so forth.[265]

If we accept the challenge here presented (although Kelly herself expresses reservations on the project this narrowly construed),[266] we could assert that the half century from 380 to 430 C.E. was of world-historical importance not only because of the battle of the Frigidus or the sack of Rome but also because in those years were firmed up the doctrines that for twelve centuries and more would ensure an ambiguous theological evaluation of reproduction, the "career" followed by the vast majority of women. Peter Brown has recently observed that Augustine, in contrast to his predecessors who championed an "ascetic paradigm,"[267] was more accepting of our bodily nature—but to Julian, and to

also common in Ambrose, a sure influence on Augustine. Moreover, the phrase does not pinpoint the problem to the seeds, as Augustine does. Second, it remains unclear how Augustine, with his limited ability in Greek, would have known much about the Messalians, an Eastern movement originating in the mid-fourth century. (The only early Latin source mentioning the Messalians, the prologue to Jerome's *Dialogue Against the Pelagians*, which was written in Palestine, is almost contemporary with the treatises in which Augustine begins to discuss vitiated seeds but postdates by about two decades Augustine's interest in Adam's sin, as described in Romans 5.) The sources on the Messalians are collected in *Patrologia Syriaca* I.3 (Paris, 1926), clxx–ccxcii. In sum, although Augustine's general theory of human sinfulness since birth is found in "orthodox" as well as sectarian and heretical authors, the motif of seeds becoming mixed with evil can most likely be linked to his Manichean past.

265. J. Kelly, *Women, History and Theory: The Essays of Joan Kelly*, 3–4.
266. Kelly, *Women*, 4.
267. Brown, *Augustine and Sexuality*, 6–11; also see M. R. Miles, *Augustine on the Body*.

many of our contemporaries, there were remnants in Augustine's work that still breathed his Manichean past.[268]

268. My emphasis thus differs somewhat from K. E. Børresen's (*Subordination and Equivalence: The Nature and Role of Woman in Augustine and Thomas Aquinas* [trans. C. H. Talbot]), who states that the biological arguments in the debate between Julian and Augustine are only "illustrative"; the essential argument is theological (p. 64). I agree that the essential argument *is* theological, but suggest that the "biological" substructure of the debate is more important than Børresen indicates. Of course, part of Julian's tactics was to "caricature" Augustine so that he looked Manichean (Brown, *Augustine of Hippo*, 393), but by raising the "biological" argument to a more important position in the debate as I have done, Julian's accusation, even if not ultimately convincing, gains a force it is too often denied. It is not for nothing that Augustine calls Julian *religiosus physicus* (*Opus imperfectum* IV.134 [*PL* 45.1429]) and Julian returns the jibe to Augustine: *physicus iste novus* (*Opus imperfectum* V.11 [*PL* 45.1440]).

Response to "Vitiated Seeds and Holy Vessels: Augustine's Manichean Past" by Elizabeth A. Clark

I speak for the entire conference when I thank Professor Clark for her learned and absorbing essay on late Latin Christianity's debate on the "genetics of original sin." She credits Julian of Eclanum with the discovery of Augustine's major weakness, the unscientific assumptions upon which his theology of original sin necessarily rested. We must credit her for analyzing the implications of this weakness more thoroughly than did Julian and for identifying the Manichean myth of the "Seduction of the Archons" as a source (albeit repudiated) for Augustine's ideas on "vitiated seeds." For it was this myth, according to Professor Clark, that "gave Augustine his first explanation of how seeds became corrupted."[1]

I would like to suggest that this statement is both true and not true. As Professor Clark has shown, Augustine knew the myth and, in the course of his debate with Julian, scrupulously avoided bringing it up. There was no reason to give the enemy more ammunition. But even if Julian had traced "vitiated seeds" back to a Manichean source, Augustine would have been impervious to his criticism. The complexity and novelty of Augustine's anthropology, I shall argue, protected him from any charge of Manicheism. In fact, alone of all these contestants—Manicheans, pagan philosophers, Pelagians, other Catholics, and even Paul himself—Augustine is least "guilty" of the charge of dualism. And so novel and nondualistic was his thought, I shall argue, that ultimately it drove him

1. E. A. Clark, "Vitiated Seeds and Holy Vessels," p. 391, above.

to anticipate a future Catholic doctrine of unimpeachable gnostic ortho-
doxy. Allow me to present these points one at a time.

1. How vitiated are the vitiated seeds of the Manichean archontic
myth? Not very. This Fall story accounts only for the fallenness of the
flesh. The spiritual side of the "seed" is uncompromised: Pure light
remains pure light. In this story, flesh and spirit, or darkness and light,
remain side by side, juxtaposed but fundamentally unmixed. The two
components are in suspension, not in solution. This principle of juxta-
position in turn accounts for the appeal that docetic Christology exer-
cised for the Manicheans: had Christ only appeared in the likeness of
sinful flesh, "juxtaposed" to flesh rather than actually joined in true
union with it, he could remain pure light, uncompromised by "fleshly"
darkness.[2]

But Augustine sees not man's body, but man's *nature*, as vitiated after
the Fall. And this nature in turn, he argues, must be understood as a true
union of both soul and body together.[3] The postlapsarian Augustinian
soul is, correspondingly, much more complicated than that of the Mani-
cheans and even, *mutatis mutandis*, of the Pelagians. For Augustine held
not only that the soul, not the flesh, was the seat of sin but also that, after
the Fall, the soul was divided against itself. The fault line caused by
Adam's sin not only violated man's nature, sundering the fundamental
unity of body and soul; it also ran right *through* the soul, separating
intention and affect, dividing man's will from man's loves, the loves that
escape his conscious control.

Accordingly, the nature of *both* body *and* soul, of flesh *and* spirit, was
vitiated by the Fall, Augustine held, because it is one nature, human
nature. Hence, whereas for the Manicheans "flesh" and "spirit" are
cosmic principles, and for the Pelagians they are ontological and exis-
tential realities, for Augustine they are primarily *moral categories*. After
the Fall, both the body and the soul are "carnal," because human loves
are oriented away from God and toward the self. With the resurrection
of the flesh, the reintegration of body and soul, will come the reinte-

2. Clark, "Vitiated Seeds and Holy Vessels," p. 392ff., above.
3. "The entire nature of man is certainly spirit, soul, and body. Therefore whoever
would alienate the body from man's nature is unwise" (*De anima et ejus origine* IV.2.3).
This emphasis on human nature as a psychosomatic unity, and on the terms "spiritual"
and "carnal" as moral categories, was the fruit of Augustine's intensive work on Paul
against the Manicheans in the five years immediately preceding the appearance of his
two stunningly original works on the divided will, the *Ad simplicianum* and its
autobiographical companion piece, the *Confessions*. See esp., e.g., *Propositiones ex
epistola ad Romanos* 13–18.10; 46.7; and *De diversis quaestionibus* 66.6, where he carefully
distinguishes between *caro* and *qualitas carnalis*.

gration of human love and will, their reorientation toward God. Thus, at the end, will both body and soul be made "spiritual" (1 Cor. 15:44).

According to this anthropology, then, Christ need not have had a human body to be "carnal": a labile human soul marked by Adam's sin would have sufficed. And since, Augustine concludes, Christ did indeed have both a human body and a human soul—since, in other words, Christ was truly human—his nature could not have been as man's is now. Rather, Christ enjoyed a union of love and will unknown to humankind since the Fall. Born of a virgin, and thus conceived without concupiscence, Christ had avoided the enervating effects of Adam's penalty. Free of original sin, he could both love and act not *carnaliter* but *spiritualiter*.

In brief, Augustine presupposes the true union of these two components of human nature, body and soul. Together they form a solution, not a suspension. *Both*, accordingly, were in and by Adam vitiated. Whether Augustine here is "nondualistic" or "doubly dualistic," he nonetheless sees the *semen generationis* after Adam bearing a deeper damage than the bicameral seeds of the archontic myth can express.

2. Scientifically, Julian was absolutely right and Augustine wrong. Contemporary medical theory would have regarded Augustine's *concupiscentia carnalis* as a nonsensical theologizing of the *calor genitalis*, that heating through *voluptas* required for orgasm, the sine qua non of human conception. Blood had to be brought to the boiling point in order to discharge seed and "cook" a human embryo. Augustine, viewing orgasm whether male or female as a symptom of loss of control, a religious fact underscoring the will's lack of freedom, continued to insist that human reproduction as now constituted expressed a major religious problem. But he did so in defiance of the basic scientific thinking of his day.[4]

But this does not seem to have mattered one bit, either to Augustine or to his audience. This fact raises the interesting issue of the function of science in religious polemic. Augustine in the *Confessions* had made much of the rational reasons for his disenchantment with the Manichees. Scientific astronomy, he claims, had undermined the credibility

4. See P. Brown, "Sexuality and Society in the Fifth Century A.D.: Augustine and Julian of Eclanum," in *Tria Corda: Scritti in onore di Arnaldo Momigliano* (ed. E. Grabba), 55–60, 63f. Medical tradition held that both male and female partners had to experience orgasm for conception to occur (e.g., Galen *De locis affectis* VI), but Augustine is the only patristic theologian to my knowledge who grants equal consideration to female orgasm as a religious problem (*De nuptiis et concupiscentia* II.13.26).

for him of their cosmology.[5] If this were so—and I see no reason to doubt Augustine here—then we cannot but conclude that such scientific "disson,nce" was neither necessary nor sufficient to occasion his religious change of heart. Then (in those prescientific days of late antiquity) as now, the rhetoric of science seems to have been a useful ally: both Augustine and Julian make claims to it. But apparently, again then as now, it rendered no decisive advantage and accordingly could be ignored with impunity when more fundamental ideology was at stake.

3. Augustine should not have "won," but he did.[6] Science did not matter; neither did the creationism of earlier Catholic tradition;[7] nor the church's traditional presumption, inherited from high philosophy and made explicit during the long centuries of its debate with Gnostics and Manicheans, that the will was free. In this regard certainly, Julian was the traditionalist, Augustine the innovator. Unbaptized babies going to hell, people condemned for a sin they themselves had not committed—

5. *Confessions* III.6.10 on the appeal of Manichean claims to rationality (so also, e.g., *De utilitate credendi* I.2); on his disappointment, V.11.21.

6. I intend "won" in a purely technical and limited sense. Augustine politically outmaneuvered the Pelagians, ensuring that their clergy were exiled and their teachings anathematized. But the assumptions of both the Western Church and Western culture on such issues as sexuality, marital relations, and free will continued in their "semi-Pelagian" ways for centuries. The Germanic invasions in part gave Julian his posthumous victory. The old Roman-cum-episcopal aristocracy had stepped into the void in civic administration created by the invasions; and the "glue" of traditional political relations—the aristocratic Mediterranean family—proved as impervious to the assaults of Frankish tribes as it had to the social implications of Augustine's theology. Gregory of Tours, e.g., admires supererogatory celibacy (as indeed would the Pelagians; *Historia Francorum* I.47), but appreciates the practical benefits of episcopal family relations (V.49 and passim), and certainly sees nothing inherently culpable in marital procreation, whether on the part of the clergy or the laity. Thus Brown: "[W]e should be careful not to exaggerate the immediate consequences for the Latin church of the triumph of Augustine's opinions. The moral texture of late Roman Christianity did not change dramatically. . . . It would take centuries more of steady drizzle for many of Augustine's ideas to work their way deep into the soil of Latin Christianity, in order to produce, in Augustine's name but in a social and moral climate totally different from that of Late Antiquity, the marital and sexual ethics of high medieval Catholicism" (Brown, "Sexuality and Society," 69–70; cf. Pagels, "Adam and Eve and the Serpent in Genesis 1—3," pp. 412–23 below, esp. p. 421, who grants Augustine an immediate as well as an eventual victory).

7. E.g., Tertullian *De anima* 28.5–6; and Cyprian *Ep.* 64.5. Cf. Augustine's use of this African tradition, specifically on the topic of the soul's origin and the moral status of infants, in *De baptismo*; and cf. *De genesi ad litteram* X, on the problem of the origin of the soul, esp. 3 and 4, where, speculating that Eve's soul derived from Adam's, Augustine concludes, "una anima primi hominis facta, de cuius propagine omnes hominum animae crearentur." On the ways that the Origenist controversy effected this debate, see E. TeSelle, "Rufinus the Syrian, Caelestius, Pelagius: Explorations in the Prehistory of the Pelagian Controversy," *Augustinian Studies* 3 (1972) 61–96; and H. Chadwick, *Early Christian Thought and the Classical Tradition*, 144ff.

this was the work of a good and just God? Who had ever heard of such a thing?

Considered purely from the point of view of erudite Catholic tradition, Augustine's victory is inexplicable. But we must keep in mind its social nexus as well. On a popular and *ad hominem* level, Augustine was able to make Julian seem like the innovator. It takes more than theologians to make a church, or even a church's policy—a fact the old bishop both appreciated and exploited. For most Catholics encountered their tradition, and thus the shape of the Christian past, first of all through the liturgy and sacraments of the church. That church baptized infants. This practice cohered best with the assumption that infants inherited sin. Otherwise, why baptize them?

Also, Augustine would argue, Adam was the father of humanity, and after his sin he had been condemned. All subsequent humanity sprang from Adam. Should the child be better than its father? Of course not! Julian might argue that punishment for the sin of another is unfair in principle. But look who this "other" is, Augustine could counter: the father of the whole family! His late Roman audience would appreciate such sound and reasonable social thinking. The family of man, as interpreted from the Bible within the culture of late antiquity, was after all specifically and foremost a *Mediterranean* family.[8]

By focusing on the practice of infant baptism, furthermore, Augustine could reap the theological benefits of traducianism without either overtly embracing it or directly addressing its philosophical incoherencies.[9] By reasoning not so much forward, from Adam's sin to universal damnation, as backward, from the universal and absolute necessity of salvation in Christ, Augustine urged that baptism is *re*birth, an event that effects the roots of man's being. Consequently, he concluded, Adam's sin must be equally deeply rooted in the individual, at birth.

8. Subsequent humanity suffers justly the penalty of Adam's transgression not only because of Adam's position as *pater* but also because, "seminally" speaking, all subsequent humanity was "in Adam" when he sinned—Augustine's interpretation of Rom. 5:12, based on the notorious misreading of Paul's ἐφ᾽ ᾧ as "in quo, id est, in Adam." The Pelagians criticized this mistranslation, but to little effect: Augustine's idea of the *massa damnata* and the solidarity of the race in Adam was independent of any single Pauline verse by the 420s C.E. Cf. *De nuptiis et concupiscentia* II.8.20, where Augustine argues that this understanding of Rom. 5:12 is required to make sense of Eph. 2:3, "we were by nature children of wrath"; cf. *Contra duas epistolas Pelagianorum* IV.4.7 and *De nuptiis et concupiscentia* II.5.15, where Augustine defends this reading on the basis of Latin tradition, namely, "Hilary" (actually Ambrosiaster) and Ambrose—"Do you dare call him a Manichean?"

9. Augustine was aware of the pneumatic materialism implied by the traducianist outlook (*De genesi ad litteram* X.24.40—26.44).

Christ through baptism infuses grace; therefore Adam, through human propagation, infused concupiscence, that element necessarily present in every act of conception. And if those not born again through baptism—*even infants*—are condemned, then the only source of their sin is their birth in Adam.[10]

> If Christ is the one in whom all men are justified . . . then also Adam is the only one in whom all have sinned. It is not merely following Adam's example [the Pelagian argument] that makes all men sinners, but the penalty which generates through the flesh. (*De peccatorum meritis* I.15.19)

Thus, Augustine continued,

> Concerning the soul, the question arises whether it, too, is propagated in the same way [as the body] . . . for we cannot say that it is only the flesh of the infant, and not his soul also, which requires the help of the Savior. (II.36.59)

In other words, Augustine argued, human nature is unitary, both soul and body together. Both need the grace of Christ in baptism, and therefore both were previously damaged through and in the sin of Adam. *Something* is wrong with humanity as now constituted, that something stems ultimately from Adam, and therefore that something must be inherited—not just by *bodies* but by *humans*. What weight had medical science or philosophical convention when opposed to an issue of Christian truth?

4. So finally, despite the harsher contrasts of his world, Augustine really does go beyond the dualism of his opponents, whether pagan or Christian. He held that sin resides neither in the flesh per se nor in the soul per se but in both together as a unit. The flesh, now subject to demeaning appetites and to death, and the soul, which cannot control its own divided will, are both carnal. Both will be made spiritual, for both must be redeemed.

In explaining how and why this should be so, Augustine came to formulate the human side of the problem of evil in a way that makes him surprisingly modern. His theological efforts generated a definition of what it meant to be human that went well beyond the ancient view of a soul occupying a body. Not that the conclusions he teased from this view are especially congenial. But his ruthless critique of carnal concu-

10. "Non videmus quid aliud possit intelligi nisi unumquemque parvulum non esse nisi Adam et corpore et anima, et ideo illi Christi gratiam necessariam" (*De genesi ad litteram* X.11.19); see also Clark, "Vitiated Seeds and Holy Vessels," p. 381, above; Brown, *Augustine of Hippo*, 344, 385.

piscence, for the modern reader, has the curious effect of elevating human sexuality from the realm of the purely biological to the emotionally conflicted, compulsive, and indeed uniquely human world of the psychological. Sex to Julian is reproductive biology; sex to Augustine is eroticism. This is a more complex (not to mention more interesting) phenomenon. And for Augustine it is the measure of a theological problem more complex, and a human situation more desperate, than the Pelagians with all their healthy-minded talk of scientific medicine and philosophical freedom could or would acknowledge.

But Augustine's solution is also, at the same time, uncompromisingly mythological. The ultimate cause of the soul's dark compulsions so familiar to our post-Freudian *regard* is the feud between God and Adam. Why had God condemned humankind to such torments? Turning to Genesis, Augustine infers from the narrative of the garden the key to this answer: Adam's defiance had provoked God's righteous wrath.[11]

This "myth of the Fall"—the explanatory narrative of Adam's defiance in the garden, and how it called forth "the bitter sea of the human race with the depths of its curiosity, the storms of its pride, and the restless tossing of its instability" (*Confessions* XIII.20.28)—provides the backdrop for Augustine's seemingly modern "psychologizing" and for his view of the salvation in Christ wrought by the incarnation. And here, as Professor Clark points out, lurks a delicious irony.[12] For Augustine's analysis of concupiscence and heritable sin greatly complicated the theology of the virgin birth. Julian put his finger right on it: there was a problem of infinite regress. If human nature as represented by the flesh were sinful, then Mary's flesh was sinful, and Jesus should have contracted this sinfulness from her. But if only sexual intercourse, that is, male involvement, occasioned the transmission of original sin, so that the human fruit of a nonsexual conception—Jesus, born of a virgin—was utterly sinless, then Augustine in essence made original sin a problem peculiar to males.

Thus Julian inadvertently contributed to the doctrine of the immaculate conception: the logic of Augustine's sexual theology required it. Had Valentinus been looking down on this cosmos from his place in the pleroma on December 8, 1854, then, he must not have been able to resist a bemused smile. For on that day Pius IX decreed, in bull *Ineffabilis Deus*, that Mary by a special act of grace had been made utterly sinless from

11. Brown, *Augustine of Hippo*, 395ff., on Augustine's invoking God's anger as an explanation for the human predicament.
12. Clark, "Vitiated Seeds and Holy Vessels," p. 392, above.

the moment of her conception. Thus even the *psychikoi* of the Roman Church had finally come to acknowledge what Valentinus had known all along: that salvation could come into this fallen world only through a perfect Virgin Mother who without intercourse conceived the Savior and without loss of virginity gave him birth. A torturous road to Sophia! Still, better gnosis late than gnosis never.

PART TWO

PLENARY ADDRESS

Adam and Eve and the Serpent
in Genesis 1—3

Several years ago when I was traveling in Khartoum, I visited an American anthropologist and her husband, then the foreign minister of the Sudan. He was a Dinka tribesman who had published a book of Dinka myths. One evening, as I was thinking about our conversation—how the Dinka story of creation relates to the whole social, political, and religious structure of Dinka culture—I returned to the hotel. There I found two successive issues of *Time* magazine. The first was an issue on bisexuality in America. But what fascinated me were the letters to the editor in the following issue. To my surprise, four out of six of them mentioned the story of Adam and Eve; how God had created man and woman "in the beginning"; and what, consequently, was "natural" and "right." This suggested to me that many people, including those who do not literally "believe it," still go back to that ancient story as a frame of reference when they encounter issues that challenge traditional values.

As I thought about it, I realized that this is no wonder: like the creation stories of other cultures, the story of Adam and Eve addresses such enormous and simple questions as: What is our purpose on earth? How do men and women differ from one another, and from animals? Why do we suffer, and why do we die?

Further, the juxtaposition of this story with the account in Genesis 1 adds complexity and depth to Jewish and Christian tradition. Many have claimed to find in Genesis 1 a great range of human possibilities suggested by our creation "in God's image." Yet the following story of Adam, Eve, and the serpent deals starkly with the roots of work, sexual desire, destructiveness, and violence.

Fascinated by the relationship between the story and its interpreters, I decided to take up the history of hermeneutics of Genesis 1—3 in the early Christian centuries. Taking the story as a kind of Rorschach test, I wanted to see how various projections upon that familiar story relate to specific historical circumstances and perspectives. What I'd like to share with you is a quick sketch of three variations on that theme: how the paradise story was read, first, by gnostic Christians; second, by their orthodox opponents; and third, by that most influential of all interpreters, Augustine.

My own research on this theme began with the Gnostics. Many scholars of Gnosticism now recognize how often the wild profusion of gnostic myths can be traced to a single scriptural source: Genesis 1—3. It is an oversimplification—but not much—to look at the whole controversy between orthodox and gnostic Christians as a battle over the disputed territory of the first three chapters of Genesis.

Yet gnostic and orthodox Christians read the same passages in radically different, even opposite, ways. To borrow the words of that nineteenth-century gnostic, William Blake, "Both read the Bible day and night; but you read black where I read white." Orthodox Christians—especially such antignostic writers as Irenaeus, Tertullian, and Clement—all approach Genesis 1—3 essentially as *history with a moral.* They treat Adam and Eve as actual and specific historical persons, the venerable ancestors of our species. From the story of their disobedience, shame, and punishment, each of the orthodox teachers derives specific moral consequences. They use the story to warn against disobedience, to encourage chastity, and to interpret the hardships of human life, from death to male domination, as the just consequences of our first parents' sin. You may recall the words Tertullian addresses to his "sisters in Christ" whom he regards, nevertheless, as Eve's co-conspirators:

> You are the devil's gateway. . . . You are she who persuaded him whom the devil did not dare attack. . . . Do you not know that you are each an Eve? The sentence of God on your sex lives on in this age; the guilt, necessarily, lives on too.

Gnostic Christians, on the contrary, read the Adam and Eve story as *myth with a meaning.* Such exegesis tends to dissociate the figures of Adam and Eve from their literal one to one of correspondence with actual men and women, past or present. Instead, such exegetes take Adam and Eve as representing two distinct elements within our nature. As the Gnostics define them, these two elements are, first, the *psyche,* or

soul—that is, the center of our emotional and mental life, in effect our
"ordinary consciousness"—and, second, the *spirit*, that is, the capacity
for spiritual consciousness, or the "higher self." As the Gnostic read it,
the story of Adam and Eve reveals symbolically the interaction of soul
and spirit within us. Such exegesis varies considerably. The gnostic
author of the *Exegesis on the Soul*, for example, takes Adam as the higher,
spiritual self and Eve as the soul. Yet many other gnostic texts reverse
the valences. Such major texts as the *Apocryphon of John*, the *Hypostasis
of the Archons*, and the Valentinian sources see Adam not as the higher
but as the lower element of our nature, and Eve as the higher one.
According to this group of texts, Adam tends to represent the psyche,
the soul, and Eve the spirit, or divine intelligence. As you recall, Genesis
2 tells how Adam at first appeared to be alone. Then, while he was
sleeping, Eve emerged from within him, and as one Gnostic tells it, she
said:

> "Arise, Adam." And when he saw her, he said, "It is you who have given me
> life; you will be called 'Mother of the Living.' For it is she who is my
> mother. It is she who is the Physician, and the Woman, and She Who Has
> Given Birth."

Gnostic exegetes interpret the story of Adam's sleep as showing how
the spirit originally is hidden within the soul as a latent potential. The
Apocryphon of John concludes as Eve, personifying the "perfect pronoia,"
calls out to Adam—to the *psyche* (in effect to you and me, the readers of
the text)—to wake up, recognize her, and so receive spiritual illumina-
tion.

> I entered into the middle of their prison which is the prison of the body.
> And I said, "He who hears, let him get up from the deep sleep." And he
> wept and shed tears. Bitter tears he wiped from himself and he said, "Who
> is it that calls my name, and from where has this hope come to me, while I
> am in the chains of the prison?" And I said, "I am the Pronoia of the pure
> light; I am the thinking of the virginal Spirit. . . . Arise and remember . . .
> and follow your root, which is I . . . and beware of the deep sleep.

Above all, what interests gnostic exegetes is psychodynamics (or
maybe we should say "pneumato-psychodynamics"). They take as their
primary theme the religious conviction that the capacity for spiritual
insight is hidden, ordinarily unseen, within psychic and bodily expe-
rience. For gnostic interpreters, the story of Eve often becomes the story
of that spiritual intelligence. Such interpreters love to tell, with many
variations, how she emerges and separates from the psyche; how she

encounters resistance, is attacked, and mistaken for what she is not. Finally, when she attains proper recognition from the psyche, she unites with him and becomes spiritually powerful and fruitful. (The antignostic bishop Irenaeus says scornfully that the Gnostics have nothing on which to base their outlandish interpretations except their own subjective feelings. Their own claim is that they base them on individual religious experience.)

While regarding this story as *myth with a meaning,* gnostic Christians go on to derive from it practical consequences. The *Apocryphon of John* shows that to recognize the true Eve—one's spiritual self—one must repudiate any relationship with the "other woman" who embodies the passions. The *Exegesis on the Soul,* using reverse imagery, declares that Eve, here representing the soul, must repudiate her involvement with "the adulterers," the "other men" who symbolize the soul's entanglement with sense experience, in order to receive her "true bridegroom."

Because of this tendency to dissociate Adam and Eve from identification with actual men and women, few of us today would simply assume that positive feminine imagery in the texts means positive evaluation of women, or vice versa. It may, and often it does; but these gnostic authors read Genesis 1—3 primarily as an allegory that they believe reveals the deep truth about the structure of our common human nature. If we have to generalize about practice, the truest generalization would be that many Gnostics see sexual relationships as impediments to spiritual recognition—of one's self as well as of others. Exceptional are the Valentinians, who regard marriage as the most appropriate symbol of spiritual union. Yet scholars are still debating whether the Valentinians actually practiced such relationships or merely treated them as religious metaphor.

The very ambiguity of their texts suggests to me that gnostic Christians were far less concerned than we are with questions of practice. For when we ask what they actually did, we find that they tell us frustratingly little. At the Claremont conference, we scholars, being earnest heirs of orthodox tradition, kept sifting through the texts for even the meagerest clues about social practice. The hints we did find most often came from the orthodox fathers, who concerned themselves with such questions (the Gnostics might have said that the orthodox were obsessed with such questions!).

Orthodox Christians, for their part, see in Genesis virtually no trace of the dimension the Gnostics represent as the spiritual Eve. They deny, indeed, the gnostic premise that this potential for spiritual consciousness

is innate in human nature. Rejecting *myth with a meaning,* they read the story of Eden instead as the history of the first human couple engaged in a fateful act of moral choice. In their hands, the story becomes a paradigm for the development of moral accountability.

The argument over Genesis 1—3 turns, then, on major theological disagreement. The orthodox insist that it turns on the issue of human freedom. Orthodox Christians unanimously denounce gnostic exegetes for denying that freedom. They denounce the gnostic myths of the spirit (or soul) inextricably caught against her will in psychic and material bonds. Such myths, they say, deny what the orthodox consider our essential God-given attribute—free will. Denouncing the Gnostics, Irenaeus declares instead that the story of Adam and Eve proclaims "the ancient law of human liberty." Nor was that liberty ever lost. Irenaeus says that "God has always preserved freedom and the power of self government in humankind." Tertullian agrees: the whole point of the story of Adam and Eve is that God gave us free will. Clement of Alexandria declares that this freedom is our glory. That we are "made in God's image" speaks of our capacity for *autexousia,* often translated "free will," but more accurately, "the power to constitute one's own being."

The more I went on to reread second- and third-century patristic literature, the more I began to see how generations of orthodox Christians took the story of creation as virtually synonymous with the proclamation of human freedom. What does this mean in practical terms? "Everything," Justin Martyr might reply. Above all, this freedom expresses itself in transformed lives. Christians are people who have radically changed their behavior in matters of sex, money, and racial relations. As Justin says,

> We, who once delighted in immorality, now embrace chastity alone; we, who valued acquiring wealth and property above everything else, now bring what we have into a common stock, and share with those in need; we, who hated and destroyed one another, refusing to live with people of a different race, now live intimately with them.

Justin celebrates the Christians' freedom from internal domination by passion and from external domination by the state. Clement praises their freedom from the oppressive weight of custom. Methodius depicts the whole of human history, ever since Eden, as a progressive evolution of human freedom which finally culminates in the life of greatest freedom—the life of voluntary virginity. Gregory of Nyssa speaks for the whole tradition when he says, "The soul directly reveals its regal and

excellent quality in that . . . it is governed, ruled autonomously by its own will."

This conviction concerning human freedom compels the orthodox to concern themselves primarily with the choices that Christians make—choices that prove their moral superiority to their pagan neighbors. Most Christian converts of the first four centuries regard the proclamation of moral freedom, grounded in Genesis 1—3, as effectively synonymous with "the gospel."

You may imagine, then, the culture shock involved when I returned to reread Augustine. For with Augustine, this message changed. His teaching, radically breaking with his predecessors, effectively trans-formed the preaching of the Christian faith. Where others see in Genesis the proclamation of human freedom, Augustine reads a story of human bondage. What the apologists praise as God's greatest gift to human-kind—free will, liberty, and autonomy, self-government—Augustine regards with ambivalence, if not outright hostility. As Augustine tells it, Adam's desire for autonomy became the very root of sin. Far from expressing the true nature of rational beings, the desire to exercise control over one's own will became, instead, the great and fatal tempta-tion. It became, in fact, the forbidden fruit itself. In Augustine's words, "the fruit of the tree of the knowledge of good and evil is personal control over one's own will." Augustine insists that Adam's original sin involved nothing else but his prideful attempt to claim his own freedom. Astonishingly, Augustine's radical views prevailed, eclipsing, for future generations of Christians, the consensus of the first three centuries of Christian tradition.

As he matured, Augustine did, of course, repudiate the Manichean version of Christianity which categorically denied human freedom. He tells us how hard he struggled to understand the Catholic doctrine of freedom of the will. But as he groped for ways to come to terms with his own tumultuous experience, Augustine concluded that the conditions of creation no longer apply to our present life. Once blessed with the freedom of the will, humanity actually enjoyed it only for those brief moments in paradise. Since the Fall, for all practical purposes, it is entirely lost.

Given the intense inner conflicts that he reveals in his *Confessions*, Augustine's decision to abandon the emphasis on free will need not surprise us. What I find much more surprising is the result. Why, I have been asking myself, did the majority of Christians—instead of repu-diating Augustine's views as idiosyncratic or rejecting them as heretical

—embrace them instead? For what reasons did his teaching on original sin move into the center of Western Christian tradition? How could such radical teaching displace those orthodox views on human freedom so hard won against the Gnostics?

I now suspect that to answer these questions we need to recall how totally the situation of Christians had changed by Augustine's time. So long as Christians remained members of a brutally persecuted sect, contending against the "evil empire" of the Roman state, they saw themselves as a tiny group of free men and women contending against the demon-enslaved emperors and their henchmen. These embattled sectarians saw their church as an island of purity surrounded by an ocean of corruption. Yet by, let us say, 350 C.E., the situation had reversed. Once, becoming a bishop had marked a man as a likely target for arrest, torture, and execution. Now episcopal office offered tax exemptions, opportunities for wealth and power, and even influence at court. Now that emperors had repudiated Rome's traditional gods, they sometimes used military force to stamp out paganism! No wonder that many fifth-century Christians found that the old, defiant slogans about human freedom no longer fit their status as the emperors' "sisters and brothers in Christ." But Augustine's theory could speak to their condition, interpreting the new constellation of state, church, and believer in ways that made religious sense of these astounding new realities.

Consider, then, how Augustine reads, in Genesis 1—3, the politics of paradise. As Augustine tells this "history with a moral," what happened in Eden is this: In the beginning, when there was only one man in the world, Adam discovered within himself the first government—the rule of the rational mind over the body. Both Adam and Eve "received the body as a servant." At first they enjoyed stable government. As Augustine says, before sin the mind ruled the body "without resistance."

Yet the primal couple soon experienced within themselves not only the first government on earth but also the first revolution. Augustine believes that Adam's assertion of his own freedom was tantamount to rebellion against God. And Augustine appreciates the aptness with which the punishment fits the crime: "The punishment for disobedience was nothing other than disobedience. For human misery consists in nothing other than our own disobedience to ourselves." The result of such rebellion is, then, "rebellion in the flesh"—that is, everything we experience against our will, including pain, suffering, fear, aging, and death. What epitomizes this rebellion is the spontaneous uprising, so to speak, in what Augustine calls our "disobedient members":

After Adam and Eve disobeyed . . . they felt, for the first time, a movement of disobedience in their flesh, as punishment in kind for their own disobedience to God.

Specifically, Augustine continues,

The sexual desire of our disobedient members arose in those first human beings as a result of the sin of disobedience, and because an indecent movement *(impudens motus)* resisted the rule of their will, they covered their shameful members.

Once, as God had created Adam and Eve, they enjoyed mental mastery over the procreative process. Like the other parts of the body, the sexual members once enacted the work of procreation by a deliberate act of will, "like a handshake." Augustine tells us that ever since Eden spontaneous sexual desire is the clearest evidence of the effect of original sin. He admits that "the trouble with the hypothesis of a passionless procreation, controlled by will, as I am here suggesting it, is that it has never been verified in experience." Yet he believes that each of us can verify from experience the spontaneity of sexual passion, its quality of acting quite independently of the will's command.

By defining spontaneous sexual desire as the proof and penalty of original sin, Augustine believes that he has implicated the whole human race except, of course, for Christ. He explains that Christ alone was born without libido, being born without the intervention of semen which, he believes, transmits libido. But the rest of humankind issues from a procreative process that, ever since Adam, has sprung wildly out of control, marring the whole of human nature.

Collectively implicated in Adam's sin, we remain, apart from grace, in a hopeless state of internal civil war. What, then, can remedy human misery? How can anyone achieve internal balance, much less establish social and political harmony between man and woman, man and man? Augustine's whole theology depends on his claim that no human power can achieve such restoration. Part of our nature stands in permanent revolt against the "law of the mind." From this Augustine concludes that humanity has totally lost its original capacity for self government.

What, then, are the practical consequences? Augustine draws so drastic a picture of the effects of Adam's sin that he embraces human government, even when tyrannical, as the indispensable defense against the forces that sin has unleashed in human nature. Where internal government has broken down, external government now must take control. Augustine agrees that three forms of oppression are evils—male

domination of women, coercive government, and slavery. Yet he insists that all three are utterly *necessary* evils—because of original sin.

Of course, Augustine was not the first Christian to find human government to be essential for preserving social order. Some two hundred years earlier, Bishop Irenaeus, who himself had suffered the terrors of persecution, declared nevertheless that external government is necessary because of human sin, "lest people devour one another like fishes." Like many of his contemporaries, Irenaeus had learned from experience —the experience of mob violence against Christians and Jews—to appreciate the government's role in restraining the savage fury of pagans and unbelievers.

Yet Irenaeus and his colleagues took it for granted that such restraint was utterly unnecessary for Christians themselves. The apologists sharply contrast the tyranny of external government with the liberty that Christians enjoy within the church. As Bishop John Chrysostom says, "*There*, everything is done through force and compulsion; *here*, through free choice and liberty!" What makes Augustine's view so different—and so radical—is his claim that the baptized Christian, no less than the pagan, needs external government; that even the Christian, like the unbeliever, may struggle in vain against the internal domination of sin; and that even the saint often manifests the effect of our universal—and, in this life, ineradicable—sinfulness. And I suggest that Augustine's theory, far more effectively than the traditional sectarian one, enabled his contemporaries to come to terms with the paradoxical facts they faced—the Christian empire and the imperial church.

For if the fifth-century state no longer looked so evil, the church, in turn, no longer looked so holy. Such Christians as John Chrysostom, who maintained the sectarian theory, deplored what had happened to the churches. They complained that since imperial favor shone upon Christians, masses of nominal converts had flooded the churches. Then, even worse, a shower of imperial privilege had changed the dynamics— and raised the stakes—of church politics. But what sectarian theory could only denounce, Augustine's theory could interpret. Challenging the traditional model of the church and the assumption upon which it rested—free will—Augustine's theory of original sin could accomplish two contrary functions at once. First, it could make religious sense of the observation that both state and church are as imperfect as those who administer them. Simultaneously it could explain why, in spite of that, Christians must accept and obey both, for the sake of their very survival, here and hereafter.

Augustine himself clearly grasped the correlation between theology and politics. When he found his authority as bishop of Hippo challenged by the rival church of Donatists, Augustine came increasingly to appreciate—and masterfully to manipulate—his alliance with imperial power. Abandoning the policy of toleration practiced by the previous bishop of Carthage, Augustine took up the attack. Beginning from polemics and propaganda, he turned to an escalating use of force. First came laws denying civil rights to non-Catholic Christians; then penalties, fines, and eviction from public office; and finally denial of free discussion, exile, and physical coercion. Many criticized him for practicing persecution—not even of pagans and Jews, but of his fellow Christians. But Augustine replied to such criticism by writing what Peter Brown calls "the only full justification, in the history of the early church, of the right of the state to suppress non-Catholics."

Later, contending against the monk Pelagius and the bishops who supported him, Augustine offered to the bishop of Rome and to his imperial patrons a clear demonstration of the political efficacy of his doctrine of the Fall. By insisting that humanity, ravaged by sin, now lies helplessly in need of outside intervention, Augustine's theory not only could validate the means and ends of secular power but could justify as well the imposition of church authority—even by force, if necessary—as essential for human salvation.

Far beyond his lifetime, for a millennium and a half, Augustine's influence has far surpassed that of the church fathers. Certainly there are many reasons for this. Yet I suggest, as primary among them, the following: It is Augustine's doctrine of "original sin" that made the uneasily forged alliance between the Catholic church and imperial power palatable—not only justifiable, but necessary—for the majority of Catholic Christians. This does not mean, however, that we need to attribute these events to Machiavellian motives. Augustine's doctrine went far beyond mere expedience. Serious believers concerned primarily with political advantage could find in Augustine's theological legacy ways of making sense out of a situation in which church and state had become inextricably interdependent.

Certainly we are not surprised that Augustine, reading Genesis 1—3 as *history with a moral*, finds there no trace of the "spiritual Eve"—no trace, that is, of the spiritual potential that Gnostics claimed to find in human nature. But Augustine also rejects the orthodox alternative. In Adam's progeny he finds no effective trace of the moral freedom that orthodox theologians had seen as the central theme of that story. Augus-

tine even accused those who proclaimed human freedom of being
"heretics." He actually succeeded in joining the forces of church and
state to condemn them!

If Augustine rejected both interpretations, in another sense, he man-
aged to have it both ways. First, while claiming to accept the orthodox
teaching on free will, he projected it back onto a primordial paradise
lost. Second, he reclaimed the territory once ceded to the Gnostics—the
psychological description of the experience of powerlessness, grace, and
redemption. As a result, Augustine reads into the story of Adam and Eve
an analysis of human motivation that has proven to be more complex,
and many believe more profound, than either of its predecessors.

Yet Augustine's exegesis is not the last word, any more than were
those of second-century orthodox or gnostic Christians. Every gener-
ation of Christians has contended with the story of creation. Even now
the interpretation of Genesis 1—3 continues to provoke, irritate, and
inspire Christians to invent new variations on that theme. Clearly we
have no lack of controversial issues—beginning with the questions
concerning sexuality that aroused the readers of *Time* magazine. Con-
sider, for example, how those few New Testament sayings on creation
attributed to Jesus and Paul have touched off controversies concerning
sexual practice, ranging from marriage, divorce, and celibacy to gender
and homosexuality—controversies that have lasted for centuries (or for
millennia, depending on how you count).

Second, consider how radically different views of Adam's sin—and so
of human nature—have divided Jews from Christians, from Paul's time
to our own (one can see this most simply by comparing Paul Tillich's
view of human nature with Martin Buber's).

Third, consider the political implications. I mention only the most
obvious example: how American revolutionaries appealed to the crea-
tion stories as support for "truths" they held "to be self-evident, that all
men are created equal . . .".

Finally, we recall how black theologians and women theologians have
challenged the inequities perpetrated both by that very declaration and
by the culture that produced the Genesis stories in the first place. Those
who oppose the very institutions that Augustine claimed were necessary
—male domination, coercive government, and slavery—might do well
to consider whether—or in what ways—they still accept traditional
teaching on original sin. Yet, such Christians often go back to Genesis
reading new dimensions of meaning into those same archaic passages.
For example, the nineteenth-century black activist Anna Cooper inter-

preted Gen. 1:26 like this—in a way that would have dumbfounded the priestly author of Genesis 1:

> We take our stand upon the solidarity of humanity, the oneness of life, and the unnaturalness and injustice of all special favoritism, whether of sex, race, country, or condition. . . . The colored woman feels that woman's cause is one and universal; and that not till the image of God, whether in parian or ebony, is inviolable; . . . not till then is woman's cause won—not the white woman's, nor the black woman's, nor the red woman's but the cause of every man and every woman who has writhed silently under a mighty wrong.

So long as Genesis 1—3 remains a basic text for Jews, Christians, and Moslems—and a living, symbolic language for many others—we can expect (and some of us will hope) to see such transformations of the text continue.

Works Cited

Aalders, G. J. D. "L'Epître à Menoch, attribuée à Mani." *VC* 14 (1960) 245–49.

Abramowski, Luise. "Ein gnostischer Logostheologe: Umfang und Redaktor des gnostischen Sonderguts in Hippolyts Widerlegung aller Häresien." In *Drei christologische Untersuchungen*, 18–62. BZNW 45. Berlin and New York: Walter de Gruyter, 1981.

Adam, Alfred. "Das Fortwirken des Manichäismus bei Augustin." *ZKG* 69 (1958) 1–25.

———. "Der manichäische Ursprung der Lehre von den zwei Reichen bei Augustin." *TLZ* 77 (1952) 385–90.

Allberry, C. R. C., ed. *A Manichaean Psalm-Book, Part II*. Manichean Manuscripts in the Chester Beatty Collection II. Stuttgart: W. Kohlhammer, 1938.

Allo, E. B. *Saint Paul: Première épître aux Corinthiens*. 2d ed. Paris: Librairie Lecoffre, 1956.

Anderson, G. *Ancient Fiction: The Novel in the Greco-Roman World*. Totowa, N.J.: Barnes & Noble, 1984.

Appel, Andrea. "The Image of Mary Magdalene in Some Christian-Gnostic Texts and Her Significance in Respect to the Position of Women in Gnostic Communities." Unpublished.

Arai, Sasagu. "Zur Christologie des Apokryphons des Johannes." *NTS* 15 (1968–69) 302–18.

Armstrong, A. H. *The Architecture of the Intelligible Universe in the Philosophy of Plotinus*. 1940; reprint, London: Cambridge University Press, 1967.

———. "Dualism: Platonic, Gnostic and Christian." In *Plotinus Amid Gnostics and Christians*, edited by David T. Runia, 29–52. Amsterdam: Free University Press, 1984.

———. "Emanation in Plotinus." *Mind* 46 (1937) 61–66.

———, ed. *The Cambridge History of Later Greek and Early Medieval Philosophy*. London: Cambridge University Press, 1970.

Arthur, Rose Horman. *The Wisdom Goddess: Feminine Motifs in Eight Nag Ham-*

425

madi Documents. Lanham, Md., and London: University Press of America, 1984.

Attridge, Harold W., ed. *Nag Hammadi Codex I (The Jung Codex)*. 2 vols. NHS 22–23. Leiden: E. J. Brill, 1985.

Bachmann, Philipp. *Der erste Brief des Paulus an die Korinther*. Kommentar zum Neuen Testament. Leipzig: A. Deichert (George Böhme), 1905.

Baer, R. A. *Philo's Use of the Categories Male and Female*. Leiden: E. J. Brill, 1970.

Bangerter, Otto. *Frauen im Aufbruch: Die Geschichte einer Frauenbewegung in der Alten Kirche: Ein Beitrag zur Frauenfrage*. Neukirchen-Vluyn: Neukirchener Verlag, 1971.

Barb, A. A. "Diva Matrix: A Faked Gnostic Intaglio in the Possession of P. P. Rubens and the Iconology of a Symbol." *Journal of the Warburg and Courtauld Institutes* 16 (1953) 193–238.

Barc, Bernard. *L'Hypostase des Archontes (NH II,4): Traité gnostique sur l'origine de l'homme, du monde, et des archontes*. Bibliothèque copte de Nag Hammadi, Section "Textes," 5. Quebec: Les Presses de l'Université Laval, 1980.

———. "Les noms de la triade dans l'Evangile selon Philippe." In *Gnosticisme et monde hellénistique: Actes du Colloque de Louvain-la-Neuve, 11–14 mars 1980*, edited by J. Ries, 361–76. Publications de l'Institute Orientaliste de Louvain 27. Louvain-la-Neuve: Institut Orientaliste, 1982.

bar Konai, Theodore. *Liber scholiarum XI*. Edited by Addai Scher. CSCO, Script. Syri 26. Louvain: Secrétariat du CorpusSCO, 1960 (Réimpression anastatique). German translation in Alfred Adam, *Texte zum Manichäismus*. Kleine Texte für Vorlesung und Übungen 175. 2d ed. Berlin: Walter de Gruyter, 1969.

Barrett, C. K. *The First Epistle of St. Paul to the Corinthians*. New York: Harper & Row, 1968.

Bauer, Walter; William F. Arndt; and F. Wilbur Gingrich. *A Greek-English Lexicon of the New Testament and Other Early Christian Literature*. 4th ed. Chicago: University of Chicago Press; Cambridge: Cambridge University Press, 1952.

Baumann, Hermann. *Das doppelte Geschlecht: Ethnologische Studien zur Bisexualität in Ritus und Mythos*. 2d ed. Berlin: Dietrich Reimer, 1980.

Bavel, Tarsicius J. van. *Recherches sur la christologie de saint Augustin: L'humain et le divin dans le Christ d'après saint Augustin*. Paradosis 10. Fribourg: Editions Universitaires, 1954.

Beadle, J. H. *Life in Utah; or, the Mysteries and Crimes of Mormonism*. Philadelphia: National Publishing Co., 1870.

Beatrice, Pier Franco. *Tradux peccati: alle fonti della dottrina agostiniana del peccato originale*. Studia Mediolanensia 8. Milan: Vita e Pensiero Università Cattolica del Sacro Cuore, 1978.

Bechtel, F. *Die historischen Personennamen des griechischen bis zur Kaiserzeit*. Hildesheim: Georg Olms, 1964.

Bekker, I. *Anecdota Graeca*. 3 vols. Berlin, 1814–21; reprint, Graz, 1965.

Benko, Stephen. "The Libertine Gnostic Sect of the Phibionites According to Epiphanius." *VC* 21 (1967) 103–19.

———. "Pagan Criticism of Christianity During the First Two Centuries A.D." *ANRW* 23.2 (1980) 1081–89.

Bieber, M. *The History of the Greek and Roman Theater*. Princeton: Princeton University Press, 1961.

Blackstone, W. J. "A Short Note on the Apocryphon of John." *VC* 19 (1965) 163.

Blanchard, A. *Essai sur la composition des comédies de Ménandre.* Collection d'études anciennes. Paris: Les Belles Lettres, 1983.

Bleeker, C. J. "Isis and Hathor: Two Ancient Egyptian Goddesses." In *The Book of the Goddess, Past and Present: An Introduction to Her Religion,* edited by Carl Olson, 29–48. New York: Crossroad, 1983.

Bochartus, *Heirozoicon, sive Historia Animalium S. Scripturae.* 2 vols. Leiden, 1663.

Böhlig, A., and P. Labib. *Die koptisch-gnostische Schrift ohne Titel aus Codex II von Nag Hammadi.* Deutsche Akademie der Wissenschaften zu Berlin, Institute für Orientforschung 58. Berlin: Akademie-Verlag, 1962.

―――, and Frederik Wisse. *Nag Hammadi Codices III,2 and IV,2: The Gospel of the Egyptians (The Holy Book of the Great Invisible Spirit).* NHS 4. Leiden: E. J. Brill, 1975.

Bonner, G. I. "*Libido* and *Concupiscentia* in St. Augustine." In *Studia Patristica* 6, 303–14. TU 81. Berlin: Akademie-Verlag, 1962.

Bornhäuser, D. "'Um der Engel willen' 1 Kor. 11,10." *NKZ* 41 (1930) 475–88.

Børresen, Kari E. *Subordination and Equivalence: The Nature and Role of Women in Augustine and Thomas Aquinas.* Translated by C. H. Talbot. Washington, D.C.: University Press of America, 1981.

Bothe, F. H. *Poetarum comicorum Graecorum fragmenta.* Post A. Meineke. Paris: Firmin Didot, 1894.

Botte, Bernard. *La tradition apostolique de saint Hippolyte: Essai de reconstruction.* Liturgiewissenschaftliche Quellen und Forschungen 39. Münster: Aschendorff, 1963.

Bousset, Wilhelm. *Hauptprobleme der Gnosis.* Göttingen: Vandenhoeck & Ruprecht, 1907; reprint, 1973.

Broek, R. van den. "Autogenes and Adamas: The Mythological Structure of the Apocryphon of John." In *Gnosis and Gnosticism,* edited by Martin Krause, 16–25. NHC 17. Leiden: E. J. Brill, 1981.

―――. "The Creation of Adam's Psychic Body in the Apocryphon of John." In *Studies in Gnosticism and Hellenistic Religions: Festschrift for Gilles Quispel,* edited by R. van den Broek and M. J. Vermaseren, 38–57. Leiden: E. J. Brill, 1981.

―――. "The Present State of Gnostic Research." *VC* 37 (1983) 41–71.

―――. "The Shape of Edem According to Justin the Gnostic." *VC* 27 (1973) 35–45.

―――, and W. J. Vermaseren. *Studies in Gnosticism and Hellenistic Religions.* Etudes preliminaires aux religions orientales dans l'empire romain 91. Leiden: E. J. Brill, 1981.

Brooten, Bernadette J. "Paul's Views on the Nature of Women and Female Homoeroticism." In *Immaculate and Powerful: The Female in Sacred Image and Social Reality,* edited by Clarissa Atkinson, Constance Buchanan, and Margaret R. Miles, 61–87. Boston: Beacon Press, 1985.

Brown, Peter. *Augustine and Sexuality.* Colloquy 46. Berkeley: Center for Hermeneutical Studies in Hellenistic and Modern Culture, 1983.

―――. *Augustine of Hippo: A Biography.* Berkeley and Los Angeles: University of California Press, 1967.

_____. "The Patrons of Pelagius: The Roman Aristocracy Between East and West." *JTS* n.s. 21 (1970) 56–72. Reprinted in *Religion and Society in the Age of Saint Augustine*, 208–26. New York: Harper & Row, 1972.

_____. "Sexuality and Society in the Fifth Century A.D.: Augustine and Julian of Eclanum." In *Tria Corda: Scritti in onore di Arnaldo Momigliano*, edited by E. Grabba, 49–70. Como: Edizioni New Press, 1983.

Bruckner, Albert. *Die vier Bücher Julians von Aeclanum an Turbantius: Ein Beitrag zur Charakteristik Julians und Augustins*. Neue Studien zur Geschichte der Theologie und der Kirche 8. Berlin: Trowitzsch & Sohn, 1910.

_____. *Julian von Eclanum: Sein Leben und seine Lehre: Ein Beitrag zur Geschichte des Pelagianismus*. TU 15. Leipzig: J. C. Hinrichs, 1897.

Brun, Lyder. "'Um der Engel willen' 1 Kor. 11,10." *ZNW* 14 (1913) 298–308.

Buckley, Jorunn Jacobsen. "A Cult-Mystery in the *Gospel of Philip*." *JBL* 99 (1980) 569–81.

_____. "An Interpretation of Logion 114 in *The Gospel of Thomas*." *NovT* 27 (1985) 245–72.

_____. *Female Fault and Fulfilment in Gnosticism*. Chapel Hill and London: University of North Carolina Press, 1986.

_____. "The Mandaean Šitil as an Example of 'the Image Above and Below.'" *Numen* 26 (1979) 185–91.

_____. "A Rehabilitation of Spirit Ruha in Mandaean Religion." *HR* 22 (1982) 60–84.

_____. "Transcendence and Sexuality in *The Book Baruch*." *HR* 24 (1984/85) 328–44.

_____. "Two Female Gnostic Revealers." *HR* 19 (1980) 259–69.

Budge, E. A. Wallis. *Amulets and Talismans*. New York: University Books, 1961.

Bullard, R. A. *The Hypostasis of the Archons*. Berlin: Walter de Gruyter, 1970.

Burchard, Christoph. *Joseph und Aseneth*. Judische Schriften aus hellenistiche-römischer Zeit. Gutersloh, 1983.

_____. *Untersuchungen zu Joseph und Aseneth: Überlieferung, Ortsbestimmung*. Wissenschaftliche Untersuchungen zum Neuen Testament 8. Tübingen: J. C. B. Mohr (Paul Siebeck), 1965.

Burkert, W. *Structure and History in Greek Mythology and Ritual*. Berkeley and Los Angeles: University of California Press, 1979.

Burrus, Virginia. *Chastity as Autonomy: Women in the Stories of the Apocryphal Acts*. Studies in Women and Religion 23. Lewiston: Edward Mellen Press, 1987.

Bynum, Caroline W.; Stevan Harrell; and Paula Richman, eds. *Gender and Religion: On the Complexity of Symbols*. Boston: Beacon Press, 1986.

Cameron, Ron. *The Other Gospels*. Philadelphia: Westminster Press, 1982.

Carden, Maren Lockwood. *Oneida: Utopian Community to Modern Corporation*. Baltimore: Johns Hopkins Press, 1969.

Casey, R. P., ed. and trans. *The Excerpta ex Theodoto of Clement of Alexandria*. Studies and Documents 1. London: Christopher, 1934.

Castelli, Elizabeth Anne. "Virginity and Its Meaning for Women's Sexuality in Early Christianity." *Journal of Feminist Studies in Religion* 2 (1986) 61–88.

Černý, J. *Coptic Etymological Dictionary*. Cambridge: Cambridge University Press, 1976.

Chadwick, Henry. *Early Christian Thought and the Classical Tradition*. Oxford: Clarendon Press, 1966.

———. *Priscillian of Avila: The Occult and the Charismatic in the Early Church*. Oxford: Clarendon Press, 1976.

Chantraine, P. *Dictionnaire étymologique de la langue grecque*. Paris: C. Klincksieck, 1968.

Charles, R. H. *The Apocrypha and Pseudepigrapha of the Old Testament*. 2 vols. 2d ed. Oxford: Clarendon Press, 1960.

Charlesworth, J. H. *The Old Testament Pseudepigrapha*. 2 vols. Garden City, N.Y.: Doubleday & Co., 1985.

———. *The Greek Version of the Testaments of the Twelve Patriarchs*. 2d ed. Oxford: Oxford University Press, 1960.

Clark, Elizabeth A. "Ascetic Renunciation and Feminine Advancement: A Paradox of Late Ancient Christianity." *ATR* 63 (1981) 240–57.

———. *The Life of Melania the Younger: Introduction, Translation and Commentary*. Studies in Women and Religion 14. New York and Toronto: Edwin Mellen Press, 1984.

Collins, Adela Yarbro. *Crisis and Catharsis: The Power of the Apocalypse*. Philadelphia: Westminster Press, 1984.

———, ed. *Feminist Perspectives on Biblical Scholarship*. Chico, Calif.: Scholars Press, 1985.

Collins, John J. *The Apocalyptic Imagination: An Introduction to the Jewish Matrix of Christianity*. New York: Crossroad, 1984.

Colpe, Carsten. "Manichäismus." *RGG*[3] (1960), 4:714–22.

Colson, F. H. *Philo*. 10 vols. LCL. Cambridge: Harvard University Press, 1967.

Conzelmann, Hans. *1 Corinthians: A Commentary on the First Epistle to the Corinthians*. Philadelphia: Fortress Press, 1975.

Courcelle, Pierre. *Recherches sur les Confessions de saint Augustin*. 2d ed. Paris: Editions E. de Boccard, 1968.

Coxe, A. Cleveland, ed. *The Ante-Nicene Fathers*, vol. 5: *Hippolytus*. Grand Rapids: Wm. B. Eerdmans, 1978.

Craig, C. T. "The First Epistle to the Corinthians." In *The Interpreter's Bible*, vol. 10. New York and Nashville: Abingdon Press, 1953.

Cramer, J. A. *Anecdota Graeca. e codd. Mss. Bibl. Oxon.* 4 vols. Oxford, 1835–37.

———. *Anecdota Graeca. e codd. Mss. Bibl. Reg. Parisiensis*. 4 vols. Oxford, 1839–41. Reprint, Hildesheim: Georg Olms, 1967.

Crawley, Ernest. *Dress, Drinks, and Drums: Further Studies of Savages and Sex*. London: Methuen, 1931.

Crook, J. A. *Law and Life of Rome, 90 B.C.–A.D. 212*. Ithaca, N.Y.: Cornell University Press, 1967.

Crum, W. *A Coptic Dictionary*. Oxford: Clarendon Press, 1939. Reprint 1972.

Cumont, Franz. "Appendice I: La séduction des archontes." In *Recherches sur le manichéisme*, vol. 1: *La cosmogonie manichéenne d'après Théodore bar Khôni*, 54–68. Brussels: H. Lambertin, 1908.

Dahl, Nils A. "The Arrogant Archon and the Lewd Sophia: Jewish Traditions in Gnostic Revolt." In *The Rediscovery of Gnosticism*, edited by Bentley Layton, 2:659–712. Leiden: E. J. Brill, 1981.

Danby, Herbert. *The Mishna*. 12th ed. Oxford: Clarendon Press, 1977.

Davies, D. W. *Paul and Rabbinic Judaism: Some Rabbinic Elements in Pauline Theology*. 2d ed. rev. London: SPCK, 1955.

Davies, Steve. "The Canaanite-Hebrew Goddess." In *The Book of the Goddess, Past and Present*, edited by Carl Olson, 68–79. New York: Crossroad, 1983.

de Beauvoir, Simone. *The Second Sex*. Translated by H. M. Parshley. New York: Vintage Books, 1974.

Decret, François. *Aspects du manichéisme dans l'Afrique romaine: Les controverses de Fortunatus, Faustus et Felix avec saint Augustin*. Paris: Etudes Augustiniennes, 1970.

———. *L'Afrique manichéenne IVe–Ve siècles): Etudes historiques et doctrinales*. Paris: Etudes Augustiniennes, 1978.

de Faye, Eugène. *Gnostiques et gnosticisme*. Paris: Paul Geuthner, 1925.

Delling, Gerhard. *Paulus' Stellung zu Frau und Ehe*. Beiträge zur Wissenschaft vom Alten und Neuen Testament 56. Stuttgart: W. Kohlhammer, 1931.

DeMaria, Richard. *Communal Love at Oneida: A Perfectionist Vision of Authority, Property, and Sexual Order*. Texts and Studies in Religion 2. Lewiston, New York: Edwin Mellen Press, 1978.

de Montcheuil, Yves. "La polémique de saint Augustin contre Julien d'Eclane d'après l'*Opus Imperfectum*." *RSR* 44 (1956) 193–218.

Derrett, J. Duncan M. "Religious Hair." In *Studies in the New Testament*, vol. 1: *Glimpses of the Legal and Social Presuppositions of the Authors*. Leiden: E. J. Brill, 1977.

de Vaux, Roland. "Sur le voile des femmes dans l'orient ancien." *RB* 44 (1936) 411–12.

Devereux, G. *Femme et mythe*. Paris: Flammarion, 1982.

Dibelius, Martin. *Die Geisterwelt in Glauben des Paulus*. Göttingen: Vandenhoeck & Ruprecht, 1909.

Diels, H. *Fragmente der Vorsokratiker*. 3 vols. Berlin and Charlottenburg: Weidmannsche Verlagsbuchhandlung, 1956.

Dodds, E. R. *Pagan and Christian in an Age of Anxiety*. New York: W. W. Norton, 1965; reprint, 1970.

Dörrie, H. *Platonica Minora*. Studia et Testimonia Antiqua 8. Munich: Wilhelm Fink, 1976.

———. "Was ist spätantiker Platonismus?" *Theologische Rundschau* 36 (1971) 285–302. Reprint in *Platonica Minora*, 508–23.

Downing, C. R. "The Mother Goddess Among the Greeks." In *The Book of the Goddess, Past and Present*, edited by Carl Olson, 49–59. New York: Crossroad, 1983.

Drower, E. S. *The Canonical Prayerbook of the Mandaeans*. Leiden: E. J. Brill, 1959.

———, ed. *The Thousand and Twelve Questions (Alf Trisar Suialia)*. Berlin: Akademie-Verlag, 1960.

———, and R. Macuch. *A Mandaic Dictionary*. Oxford: Oxford University Press, 1963.

Dübner, Fr. *Scholia Graeca in Aristophanem*. Hildesheim: Georg Olms, 1969.

Dummer, Jürgen. "Die Angaben über die gnostische Literatur bei Epiphanius, Pan. Haer. 26." In *Koptologische Studien in der DDR zusammengestellt und herausgegeben vom Institut für Byzantinistik der Martin-Luther-Universität*

Halle-Wittenberg, 205–8. Halle-Wittenberg: Wissenschaftliche Zeitschrift, 1965.

Edmonds, J. M. *The Fragments of Attic Comedy.* After A. Meineke, T. Bergk, and T. Kock. 3 vols. Leiden: E. J. Brill, 1957–1961.

Eijk, A. H. C. van. "The Gospel of Philip and Clement of Alexandria: Gnostic and Ecclesiastical Theology on the Resurrection and the Eucharist." *VC* 25 (1971) 94–120.

Elanskaja, A. I. "'Kvalitativ vtoroj' v koptskom jazyke." In Akademija nauk SSSR, Institut vostokovedenija, Lenigradskoe otdelenie: *Pis'mennya pamjatniki i problemy istorii kul'tury narodov Vostoka* II, Moskva, "Nauka" 1975, 44–47.

Eliade, Mircea. *Mephistopheles and the Androgyne: Studies in Religious Myth and Symbol.* Translated by J. M. Cohen. New York: Sheed & Ward, 1965.

Emmel, Stephen, ed. *Nag Hammadi Codex III,5, The Dialogue of the Savior.* NHS 26. Leiden: E. J. Brill, 1984.

Esbroeck, M. van. "Col. 2,11: 'Dans la circoncision du Christ.'" In *Gnosticisme et monde hellénistique: Actes du Colloque de Louvain-la-Neuve, 11–14 mars 1980,* edited by Julien Ries, Yvonne Janssens, and Jean-Marie Sevrin, 229–35. Publications de l'Institut Orientaliste de Louvain 27. Louvain-la-Neuve: Institut Orientaliste, 1982.

Evans, Ernest. *The Epistles of the Apostle Paul to the Corinthians.* Clarendon Bible. Oxford: Oxford University Press, 1930.

———. *Tertullian, Adversus Praxean Liber.* London: SPCK, 1948.

Evans, Mary. *Woman in the Bible.* Exeter, England: Paternoster Press, 1983.

Fallon, Francis T. *The Enthronement of Sabaoth: Jewish Elements in Gnostic Creation Myths.* NHS 10. Leiden: E. J. Brill, 1978.

Fendt, Leonhard. "Borborianer." *RAC,* 2:511.

———. *Gnostische Mysterien: Ein Beitrag zur Geschichte des christlichen Gottesdienstes.* Munich: Chr. Kaiser Verlag, 1922.

Festugière, A. J. *La révélation d'Hermès Trismégiste.* 4 vols. Collection d'études anciennes. Paris: Les Belles Lettres, 1983.

Foerster, Werner, ed. *Gnosis: A Selection of Gnostic Texts.* Translated and edited by R. McL. Wilson. 2 vols. Oxford: Clarendon Press, 1972 and 1974.

Fredriksen, Paula. "Hysteria and the Gnostic Myths of Creation." *VC* 33 (1979) 287–90.

Freedman, R. David. "Woman, A Power Equal to Man." *Biblical Archaeology Review* 9/1 (1983) 56–58.

Frend, William. "The Gnostic-Manichaean Tradition in Roman North Africa." *JEH* 4 (1953) 13–26.

———. "Manichaeaism in the Struggle Between Saint Augustine and Petilian of Constantine." In *Augustinus Magister: Congrès International Augustinien, Paris, 21–24 Septembre 1954,* 2:859–65. Paris: Etudes Augustiniennes, 1954.

Frévin, Henri. *Le mariage de saint Joseph et de la sainte Vierge: Etude de théologie positive de saint Irénée à saint Thomas.* Cahiers de Josèphologie 15, 2. Montreal: Centre de Recherche et de Documentation Oratoire Saint-Joseph, 1967.

Frickel, J. *Hellenistische Erlösung in christlicher Deutung. Die gnostische Naassenerschrift: Quellenkritische Studien–Strukturanalyse–Schichtenscheidung– Rekonstruktion der Anthropos-Lehrschrift.* NHS 19. Leiden: E. J. Brill, 1984.

————. "Unerkannte gnostische Schriften." In *Gnosis and Gnosticism*, 119–37. NHS 8. Leiden: E. J. Brill, 1977.

Friedrich, P. *The Meaning of Aphrodite*. Chicago: University of Chicago Press, 1978.

Fuller, R. H. *The Foundations of New Testament Christology*. New York: Charles Scribner's Sons, 1965.

Gaffron, Hans-Georg. *Studien zum koptischen Philippusevangelium unter besonderer Berücksichtigung der Sakramente*. Ph.D. diss. Bonn: Rheinische Friedrich Wilhelms-Universität, 1969.

Gardiner, Alan. *Egyptian Grammar*. 3d ed. Oxford: Griffith Institute, 1957.

Gasparro, Giulia Sfameni. "Aspetti encratiti nel 'Vangelo secondo Filippo.'" In *Gnosticisme et monde hellénistique: Actes du Colloque de Louvain-la-Neuve, 11–14 mars 1980*, edited by Julien Ries, Yvonne Janssens, and Jean-Marie Sevrin, 394–423. Publications de l'Institut Orientaliste de Louvain 27. Louvain-la-Neuve: Institut Orientaliste, 1982.

————. "Il personaggio di Sophia nel Vangelo secondo Filippo." *VC* 31 (1977) 244–81.

Geerlings, W. "Zur Frage des Nachwirkens des Manichäismus in der Theologie Augustins." *ZKT* 93 (1971) 45–60.

Gero, Stephen. "With Walter Bauer on the Tigris: Encratite Orthodoxy and Libertine Heresy in Syro-Mesopotamian Christianity." In *Nag Hammadi, Gnosticism, and Early Christianity*, edited by Charles W. Hedrick and Robert Hodgson, Jr., 287–307. Peabody, Mass.: Hendrickson Publishers, 1986.

Gilhus, Ingvild Saelid. "Gnosticism—A Study in Liminal Symbolism," *Numen* 31 (1984) 106–28.

————. "Male and Female Symbolism in the Gnostic Apocryphon of John." *Temenos* 19 (1983) 33–43.

Giversen, S. *Apocryphon Johannis*. Acta Theologica Danica 5. Copenhagen: Munksgaard, 1963.

————. *Filipsevangeliet*. Copenhagen: Gads Forlag, 1966.

Goehring, James E. "A Classical Influence on the Gnostic Sophia Myth." *VC* 35 (1981) 16–23.

Goergemanns, H., and H. Karpp, eds. *Origen. Vier Bücher von den Prinzipien*. Darmstadt: Wissenschaftliche Buchgesellschaft, 1976.

Goldsmith, L., ed. *Der Babylonische Talmud*. 12 vols. Berlin, 1930–36.

Grant, R. M. *Gnosticism and Early Christianity*. New York: Columbia University Press, 1959.

————. "The Mystery of Marriage in the Gospel of Philip." *VC* 15 (1961) 129–40.

Grimal, P. *Romans grecs et latins*. Paris: Editions Gallimard, 1958.

Grosheide, F. W. *Commentary on the First Epistle to the Corinthians*. New International Commentary on the New Testament. Grand Rapids: Wm. B. Eerdmans, 1953.

Haenchen, Ernst. "The Book *Baruch*." In *Gnosis: A Selection of Gnostic Texts*, edited by Werner Foerster; translated and edited by R. McL. Wilson, 1:48–52. Oxford: Clarendon Press, 1972.

————. "Das Buch Baruch." In *Die Gnosis*, vol. 1: *Zeugnisse der Kirchenväter*, edited by Werner Foerster, 65–79. Zurich and Stuttgart: Artemis Verlag, 1969.

————. "Das Buch Baruch: Ein Beitrag zum Problem der christlichen Gnosis." *Zeitschrift für Theologie und Kirche* 50 (1953) 123–58. Reprint in *Gott und Mensch: Gesammelte Aufsätze*, 299–334. Tübingen: J. C. B. Mohr (Paul Siebeck), 1965.

Hagg, T. *The Novel in Antiquity*. Berkeley and Los Angeles: University of California Press, 1983.

Hansen, Jørgen Verner, "Den Sethianske Gnosis i Lyset af Nag Hammadi-Teksterne." M.A. thesis. University of Copenhagen, 1981.

Harder, R. "Ein neue Schrift Plotins." *Hermes* 71 (1936) 1–10.

Harl, M. "Les 'mythes' valentiniens de la création et de l'eschatologie dans le langage d'Origène: le mot hypothesis." In *The Rediscovery of Gnosticism*, edited by Bentley Layton, 1:417–25. Leiden: E. J. Brill, 1980.

Harvey, W. W., ed. *Sancti Irenaei, Episcopi Lugdunensis, Libros quinque adversus haereses*. Cambridge: Typis Academicis, 1857. Reprint, 2 vols. Ridgewood, N.J.: Gregg Press, 1965.

Hawley, J. S. "Images of Gender in the Poetry of Krishna." In *Gender and Religion: On the Complexity of Symbols*, edited by Caroline Walker Bynum, Stevan Harrell and Paula Richman, 231–56. Boston: Beacon Press, 1986.

Hennecke, E., and W. Schneemelcher, eds. *New Testament Apocrypha*. 2 vols. Philadelphia: Westminster Press, 1964.

Henrichs, Albert. "Changing Dionysiac Identities." In *Jewish and Christian Self-Definition*, vol. 3: *Self-Definition in the Greco-Roman World*, edited by Ben F. Meyer and E. P. Sanders, 137–60. Philadelphia: Fortress Press, 1982.

Henry, P., and H.-R. Schwyzer, eds. *Plotini Opera*. 2 vols. Oxford: Oxford University Press, 1964 and 1977.

Hercher, R. *Erotici Scriptores*. 2 vols. Leipzig, 1858–59.

Héring, Jean. *The First Epistle of St. Paul to the Corinthians*. Translated by A. W. Heathcote and P. J. Allcock from the 2d ed. London: Epworth Press, 1962.

Heussi, Karl. *Der Ursprung des Mönchtums*. Tübingen: J. C. B. Mohr (Paul Siebeck), 1936.

Heyob, Sharon Kelly. *The Cult of Isis Among Women in the Graeco-Roman World*. Leiden: E. J. Brill, 1975.

Hick, Ludwig. *Stellung des hl. Paulus zur Frau im Rahmen seiner Zeit*. Kirche und Volk 5. Cologne: Amerikanisch-Ungarischer Verlag, 1957.

Hirsch, E. D. *Validity in Interpretation*. New Haven and London: Yale University Press, 1967.

Hirschig, G. A. *Erotici scriptores*. Paris: Firmin Didot, 1856.

Hock, Ronald F. "The Will of God and Sexual Morality: I Thessalonians 4.3–8 in Its Social and Intellectual Context." Unpublished.

Horowitz, Maryanne Cline. "Aristotle and Woman." *Journal of the History of Biology* 9 (1976) 183–213.

Horsley, G. *The Coptic Version of the New Testament*. Oxford: Clarendon Press. Boharic, 1898–1905; Sahidic, 1911–24.

Horsley, G. H. R. *New Testament Documents Illustrating Earliest Christianity: A Review of the Greek Inscriptions and Papyri Published in 1977*. Vols. 2 and 3. North Ryde, New South Wales: Ancient History Documentary Research Centre, Macquarie University, 1982 and 1983.

Hude, K., ed. *Aretaeus. On the Causes and Symptoms of Acute Diseases.* CMG 2. Leipzig, 1923.

Huhn, Joseph. "Ein Vergleich der Mariologie des hl. Augustinus mit der des hl. Ambrosius in ihrer Abhängigkeit, Ähnlichkeit, in ihrem Unterschied." In *Augustinus Magister: Congrès International Augustinien, Paris, 21–24 Septembre 1954,* 1:221–39. Paris: Etudes Augustiniennes, 1954.

Hurd, John C., Jr. *The Origin of I Corinthians.* London: SPCK; New York: Seabury Press, 1965.

Hurley, James B. "Did Paul Require Veils or the Silence of Women? A Consideration of I Cor 11,2–16 and I Cor 14,33b–36." *WTJ* 35 (1973) 190–220.

_____. *Man and Woman in Biblical Perspective: A Study in Role Relationships and Authority.* London: Inter-Varsity Press, 1981.

Hurst, D., and M. Adriaen, eds. *Sancti Ieronimi Commentariorum in Matheum.* CCSL 77. Turnhout, Belgium: Brepols, 1969.

Ibscher, Hugo. *Manichäische Handschriften der Staatlichen Museen Berlin I.* Stuttgart: W. Kohlhammer, 1940.

Ilbert, Johannes. *Soranus.* CMG 4. Berlin: Teubner, 1927.

Isenberg, W. W., ed. and trans. "The Gospel of Philip." In *The Nag Hammadi Library in English,* edited by J. M. Robinson, 131–51. San Francisco: Harper & Row, 1977.

Jacobi, J. L. "Gnosis." *Realencyklopädie für protestantische Theologie und Kirche.* 2d ed., 5:246–47.

Janssens, Yvonne. "L'Apocryphon de Jean." *Le Muséon* 83 (1970) 157–65; and 84 (1971) 43–64, 403–32.

_____. "L'Evangile selon Philippe." *Le Muséon* 81 (1968) 71–113.

Jaubert, Annie. "Le voile des femmes (I Cor XI.2–16)." *NTS* 18 (1972) 419–30.

Jenkins, Claude. "Origen on I Corinthians." *JTS* 9 (1908) 231–47, 353–72, 500–514; *JTS* 10 (1909) 29–51.

Jervell, Jacob. *Imago Dei: Gen 1:26f im Spätjudentum, in der Gnosis und in den paulinischen Briefen.* FRLANT 58. Göttingen: Vandenhoeck & Ruprecht, 1960.

Jewett, Robert. "The Sexual Liberation of the Apostle Paul." *JAAR* 47 Supplement B (1979) 55–87.

Joly, R. *Hippocrate.* Collection des Universités de France. Paris: Les Belles Lettres, 1970.

Jonas, Hans. "*Evangelium Veritatis* and the Valentinian Speculation." In *Studia Patristica,* 96–111. TU 81. Berlin: Akademie-Verlag, 1962.

_____. *Gnosis und spätantiker Geist.* Göttingen: Vandenhoeck & Ruprecht, 1964.

_____. *The Gnostic Religion: The Message of the Alien God and the Beginnings of Christianity.* 2d ed. rev. Boston: Beacon Press, 1963.

Junod, Eric, and J. D. Kaestli. *Acta Iohannis.* Turnhout, Belgium: Brepols, 1983.

Kähler, Else. *Die Frau in den paulinischen Briefen: Unter besondere Berücksichtigung des Begriffes des Unterordnung.* Zurich: Gotthelf-Verlag, 1960.

Kelly, Joan. *Women, History and Theory: The Essays of Joan Kelly.* Chicago and London: University of Chicago Press, 1984.

Kerenyi, K. *Die griechisch-orientalische Romanliteratur.* 2d ed. Darmstadt: Wissenschaftliche Buchgesellschaft, 1962.

Keuls, Eva C. *The Reign of the Phallus: Sexual Politics in Ancient Athens.* New York: Harper & Row, 1985.

Kippenberg, Hans G. "Gnostiker zweiten Ranges: Zur Institutionalisierung gnostischer Ideen als Anthropolatrie." *Numen* 30 (1983) 146–73.

Kittel, Gerhard. "Angelos, etc." *Theological Dictionary of the New Testament.* Edited by Gerhard Kittel; translated by Geoffrey W. Bromiley, 1:74–87. Grand Rapids: Wm. B. Eerdmans, 1964.

Klijn, A. F. J. *The Acts of Thomas: Introduction—Text—Commentary.* Leiden: E. J. Brill, 1962.

Knight, George W. *The New Testament Teaching on the Role Relationship of Men and Women.* Grand Rapids: Baker Book House, 1977.

Knox, A. D. *Herodas, the Mimes and Fragments.* With notes by W. Headlam. Cambridge: Cambridge University Press, 1966.

Koch, Hugo. *Virgo Eva–Virgo Maria: Neue Untersuchungen über die Lehre von der Jungfrauschaft und der Ehe Mariens in der ältesten Kirche.* Arbeiten zur Kirchengeschichte 25. Berlin and Leipzig: Walter de Gruyter, 1937.

Koester, Helmut. *Introduction to the New Testament.* 2 vols. Philadelphia: Fortress Press, 1982.

Koschorke, K. "Die 'Namen' im Philippusevangelium." *ZNW* 64 (1973) 305–22.

———. *Die Polemik der Gnostiker gegen das kirchliche Christentum.* NHS 12. Leiden: E. J. Brill, 1978.

Kraemer, Ross. "The Conversion of Women to Ascetic Forms of Christianity." *Signs* 6 (1980/81) 298–307.

———. "Ecstatics and Ascetics: Studies in the Functions of Religious Activity for Women in the Greco-Roman World." Ph.D. diss. Princeton University, 1976.

———. *Maenads, Martyrs, Matrons, Monastics: A Sourcebook on Women's Religions in the Greco-Roman World.* Philadelphia: Fortress Press, 1988.

Kraft, H. "Gnostische Gemeinschaftleben: Untersuchungen zu den Gemeinschafts- und Lebensformen häretischer christlicher Gnosis des zweiten Jahrhunderts." Thd.D. diss. Ruperto Carola Universität, 1950.

Krause, Martin. "Das Evangelium nach Philippos." *ZKG* 75 (1964) 168–82.

———. "Das Philippus evangelium." In *Die Gnosis*, vol. 1. Edited by Werner Foerster. ET in *Gnosis.* Translated and edited by R. McL. Wilson, 2:76–101. Oxford: Clarendon Press, 1974.

———, and Pahor Labib, eds. *Die drei Versionen des Apokryphon des Johannes im koptischen Museum zu Alt-Kairo.* Abhandlungen des Deutschen Archäologischen Instituts. Cairo and Wiesbaden: Otto Harrassowitz, 1962.

Kroeger, Richard, and Catherine Clark Kroeger. "An Inquiry Into Evidence of Maenadism in the Corinthian Congregation." In *Society of Biblical Literature 1978 Seminar Papers*, edited by Paul J. Achtemeier, 2:331–46. Missoula, Mont.: Scholars Press, 1978.

———. "St. Paul's Treatment of Misogyny, Gynephobia, and Sex Segregation in First Corinthians 11:2–6 [sic]." In *Society of Biblical Literature Seminar Papers*, edited by Paul J. Achtemeier, 214–21. 2 vols. Missoula, Mont.: Scholars Press, 1979.

Kuhn, C. G. *Claudii Galeni opera omnia.* Leipzig, 1882. Reprint, Hildesheim: Georg Olms, 1964.

Kuhn, K. H. "The Gospel of Philip." In *Gnosis: A Selection of Gnostic Texts*, edited by Werner Foerster; translated and edited by R. McL. Wilson, 2:76–101. Oxford: Clarendon Press, 1974.

Kürzinger, Joseph. *Die Briefe des Apostels Paulus: Die Briefe an die Korinther und Galater.* Echter-Bible, Das Neue Testament 6. Würzburg: Echter-Verlag, 1959.

Ladurie, Emmanuel Le Roy. *Montaillou: The Promised Land of Error.* New York: George Braziller, 1978.

Laeuchli, S. *The Language of Faith.* New York and Nashville: Abingdon Press, 1962.

Lagrand, J. "How Was the Virgin Mary 'Like a Man' (ܟ̄ܝܟ ܡ̄ܢܪ)? A Note on Mt. i 18b and Related Syriac Christian Texts." *NovT* 22 (1980) 97–107.

Lambert, M. D. *Medieval Heresy: Popular Movements from Bogomil to Hus.* London: Edward Arnold, 1977.

Lampe, G. W. H., ed. *A Patristic Greek Lexicon.* Oxford: Clarendon Press, 1961–68.

Layton, Bentley. "The Hypostasis of the Archons or The Reality of the Rulers." *HTR* 67 (1974) 351–425.

———. "The Hypostasis of the Archons, Part II." *HTR* 69 (1976) 31–101.

———, ed. *The Rediscovery of Gnosticism.* 2 vols. Leiden: E. J. Brill, 1981.

Leenhardt, Franz J. "La place de la femme dans l'église d'après le Nouveau Testament." *ETR* 23 (1948) 3–50.

Lefkowitz, Mary R. *Heroines and Hysterics.* New York: St. Martin's Press, 1981.

———, and Maureen B. Fant, eds. *Women's Life in Greece and Rome: A Source Book in Translation.* Baltimore: Johns Hopkins University Press, 1982.

Leipoldt, Johannes. *Die Frau in der antiken Welt und im Urchristentum.* 2d ed. Leipzig: Koehler & Amelang, 1954.

———, and H.-M. Schenke. *Koptisch-gnostische Schriften aus den Papyrus Codices von Nag Hammadi.* Theologische Forschung 20. Hamburg: Herbert & Reich, 1960.

Leisegang, Hans. *Die Gnosis.* 4th ed. Stuttgart: Kröner Verlag, 1955.

Lentz, A. *Grammatici Graeci.* 4 pars. Hildesheim: Georg Olms, 1965.

Lerner, Robert E. *The Heresy of the Free Spirit in the Later Middle Ages.* Berkeley and Los Angeles: University of California Press, 1972.

Lesky, Erna. *Die Zeugungs- und Vererbungslehren der Antike und ihr Nachwirken.* Wiesbaden: Akademie der Wissenschaften und der Literatur, 1950.

Lewy, H. *Chaldaean Oracles and Theurgy.* 1st ed. Le Caire, 1956; reprint, Paris: Etudes Augustiniennes, 1978.

Liddell, Henry George, and Robert Scott. *A Greek-English Lexicon.* 9th ed. Oxford: Oxford University Press, 1968.

Lietzmann, Hans. *An die Korinther I–II.* 4th ed. Tübingen: J. C. B. Mohr (Paul Siebeck), 1949.

Littré, E. *Oeuvres complètes d'Hippocrate.* Paris, 1851. Reprint, Amsterdam: Adolf M. Hakkert, 1962.

Lloyd, G. E. R. *Science, Folklore and Ideology: Studies in the Life Sciences in Ancient Greece.* Cambridge: Cambridge University Press, 1983.

Lodovici, Emanuele Samek. "Sessualità matrimonio e concupiscenza in sant' Agostino." In *Etica sessuale e matrimonio nel cristianesimo delle origini,* edited by Raniero Cantalamessa, 212–72. Studia Patristica Mediolanensia 5. Milan: Università Cattolica del Sacro Cuore, 1976.

Longenecker, Richard N. *New Testament Social Ethics for Today.* Grand Rapids: Wm. B. Eerdmans, 1984.

Lösch, Stefan. "Christliche Frauen in Corinth (I Cor 11,2–16): Ein neuer Lösungs-versuch." *ThQ* 127 (1947) 216–61.

Lubac, Henri de. *Origen. On First Principles*. Gloucester, Mass.: Peter Smith, 1973.

MacDonald, Dennis Ronald. *The Legend and the Apostle: The Battle for Paul in Story and Canon*. Philadelphia: Westminster Press, 1983.

————. *There Is No Male and Female: The Fate of a Dominical Saying in Paul and Gnosticism*. Philadelphia: Fortress Press, 1987.

MacKenna, S. *The Enneads*. 3d ed. rev. by B. S. Page. London: Faber & Faber, 1962.

MacMullen, Ramsay. *Christianizing the Roman Empire: A.D. 100–400*. New Haven: Yale University Press, 1984.

McNeil, B. "New Light on Gospel of Philip 17." *JTS* 29 (1978) 143–46.

MacRae, G. W. "The Jewish Background of the Gnostic Sophia Myth." *NovT* 12 (1970) 86–101.

————. "Seth in Gnostic Texts and Traditions." In *Society of Biblical Litrature Seminar Papers*, 17–24. Missoula, Mont.: Scholars Press, 1977.

————. "The Thunder, Perfect Mind." In *Nag Hammadi Codices V,2–5 and VI*, edited by D. Parrott, 231–55. NHS XI. Leiden: E. J. Brill, 1979.

Mahé, J. P. "Le sens des symboles sexuels dans quelques textes hermétiques et gnostiques." In *Les textes de Nag Hammadi*, edited by J.-E. Ménard, 123–45. Leiden: E. J. Brill, 1975.

Mansfeld, J. "Bad World and Demiurge: A 'Gnostic' Motif from Parmenides and Empedocles to Lucretius and Philo." In *Studies in Gnosticism and Hellenistic Religions*, 278–90. Etudes préliminaires aux religions orientales dans l'Empire romain 91. Leiden: E. J. Brill, 1981.

May, G. *Schöpfung aus dem Nichts: Die Entstehung der Lehre von der Creatio ex Nihilo*. Berlin and New York: Walter de Gruyter, 1978.

Meeks, Wayne. "The Image of the Androgyne: Some Uses of a Symbol in Earliest Christianity." *HR* 13 (1974) 165–208.

————. *The Writings of St. Paul*. Norton Critical Edition. New York: W. W. Norton, 1972.

Meier, John P. "On the Veiling of Hermeneutics (I Cor. 11:2–16)." *CBQ* 40 (1978) 212–26.

Ménard, J.-E. *L'Evangile selon Philippe*. Strasbourg: Université de Strasbourg, 1967.

————. "L'*Evangile selon Philippe* et l'*Exégèse de l'Ame*." In *Les textes de Nag Hammadi*, edited by J.-E. Ménard, 56–67. Leiden: E. J. Brill, 1975.

————. "Le milieu syriaque de l'*Evangile selon Thomas* et de l'*Evangile selon Philippe*." *RevScRel* 42 (1968) 261–66.

Menoud, Philippe-H. "Saint Paul et la femme." *Revue de Théologie et de Philo-sophie*, 3d series, 19 (1969) 318–30.

Mercadante, Linda. *From Hierarchy to Equality: A Comparison of Past and Present Interpretations of 1 Cor 11:2–16 in Relation to the Changing Status of Women in Society*. Vancouver: G-M-H Books, 1978.

Merkelbach, R. *Roman und Mysterium in der Antike*. Munich: C. H. Beck, 1962.

Meslin, Michel. "Sainteté et mariage au cours de la seconde querelle pélagienne."

In *Mystique et continence: Travaux scientifiques du VIIe Congrès International d'Avon*, 293–307. Les Etudes Carmélitaines. Paris: Desclée de Brouwer, 1952.

Metzger, B. *The Early Versions of the New Testament*. Oxford: Clarendon Press, 1977.

Meyer, Marvin W. "The *Apocryphon of John* and Greek Mythology." Paper presented at the Society of Biblical Literature Annual Meeting, Chicago, Ill., December 1984.

———. *The Letter of Peter to Philip*. Society of Biblical Literature Dissertation Series 53. Chico, Calif.: Scholars Press, 1981.

———. "Making Mary Male: The Categories of 'Male' and 'Female' in the Gospel of Thomas." *NTS* 31 (1985) 554–70.

———, trans. *The Secret Teachings of Jesus: Four Gnostic Gospels*. New York: Random House, 1984.

Miles, Margaret R. *Augustine on the Body*. American Academy of Religion Dissertation Series 31. Missoula, Mont.: Scholars Press, 1979.

Milik, J. T. *The Books of Enoch: Aramaic Fragments from Qumran Cave 4*. Oxford: Clarendon Press, 1976.

Monceaux, Paul. *Le manichéen Faustus de Milev: Restitution de ses Capitula*. Extrait des mémoires de l'Academie des Inscriptions et Belles-Lettres 43. Paris: Imprimerie, 1924.

Montcheuil, Y. de. "La polémique de saint Augustin contre Julien d'Eclane d'après l'*Opus imperfectum*." *RSR* 44 (1956) 193–218.

Morard, Françoise-E. "Encore quelques réflexions sur monachos." *VC* 34 (1980) 395–401.

———. "Monachos, moine: Histoire du terme grec jusqu'au 4e siècle; Influences bibliques et gnostiques." *Freiburger Zeitschrift für Philosophie und Theologie* 20 (1973) 329–425.

Morris, Leon. *The First Epistle of Paul to the Corinthians*. Tyndale New Testament Commentaries. London: Tyndale Press, 1958.

Mortley, Raoul. *Womanhood: The Feminine in Ancient Hellenism, Gnosticism, Christianity, and Islam*. Sydney: Delacroix, 1981.

Müller, Michael. *Die Lehre des hl. Augustinus von der Paradiesesehe und ihre Auswirkung in der Sexualethik des 12. und 13. Jahrhunderts bis Thomas von Aquin*. Regensburg: Verlag Friedrich Pustet, 1954.

Murphy-O'Connor, Jerome. "Sex and Logic in 1 Corinthians 11:2–16." *CBQ* 42 (1980) 482–500.

Murray, Robert. *Symbols of Church and Kingdom: A Study in Early Syriac Tradition*. Cambridge: Cambridge University Press, 1975.

Mussies, Gerrard. "Catalogues of Sins and Virtues Personified (NHC II,5)." In *Studies in Gnosticism and Hellenistic Religions: Festschrift for Gilles Quispel*, edited by R. van den Broek and M. J. Vermaseren, 315–35. Etudes preliminaires aux religions orientales dans l'Empire romain 91. Leiden: E. J. Brill, 1981.

Naber, S. A. *Photii Patriarchae Lexicon*. Amsterdam: Adolf M. Hakkert, 1965.

Needham, Joseph. *A History of Embryology*. Cambridge: Cambridge University Press, 1934.

Nestle-Aland. *Novum Testamentum Graece*. 26th ed. Stuttgart: Deutsche Bibelstiftung, 1979.

Nilsson, M. P. *Opuscula Selecta*. Lund: CWK Gleerup, 1960.

Noonan, John. *Contraception: A History of Its Treatment by the Catholic Theologians and Canonists*. Cambridge: Harvard University Press, 1965.

Obolensky, Dmitri. *The Bogomils: A Study in Balkan Neo-Manichaeism*. Cambridge: Cambridge University Press, 1948; reprint, New York: AMS Press, 1978.

Ochshorn, Judith. "Ishtar and Her Cult." In *The Book of the Goddess, Past and Present*, edited by Carl Olson, 16–28. New York: Crossroad, 1983.

O'Flaherty, Wendy. *Women, Androgynes, and Other Mythical Beasts*. Chicago: University of Chicago Press, 1980.

Olender, M. "Eléments pour une analyse de Priape chez Justin le gnostique." In *Hommages à Maarten J. Vermaseren*, 2:874–97. Leiden: E. J. Brill, 1978.

———. "Le système gnostique de Justin." *Tel Quel* 82 (1979) 71–88.

Olsen, Carl, ed. *The Book of the Goddess Past and Present*. New York: Crossroad, 1986.

O'Meara, John J. *The Young Augustine: An Introduction to the Confessions of St. Augustine*. London and New York: Longmans, Green & Co., 1954.

Ong, Walter J. *Fighting for Life: Contest, Sexuality, and Consciousness*. Ithaca, N.Y.: Cornell University Press, 1981.

Orbe, A. "'Sophia Soror': Apuntes para la teología del Espíritu Santo." In *Mélanges d'histoire des religions offerts à Henri-Charles Puech*, 355–63. Paris: Presses Universitaires de France, 1974.

Ort, L. J. R. *Mani: A Religio-Historical Description of His Personality*. Supplement to *Numen;* Altera Series 1. Leiden: E. J. Brill, 1967.

Pagels, Elaine. *Adam, Eve, and the Serpent*. New York: Random House, 1988.

———. "Adam and Eve, Christ and the Church: A Survey of Second Century Controversies Concerning Marriage." In *The New Testament and Gnosis: Essays in Honour of Robert McL. Wilson*, edited by A. H. B. Logan and A. J. M. Wedderburn, 146–75. Edinburgh: T. & T. Clark, 1983.

———. "Exegesis and Exposition of the Genesis Creation Accounts in Selected Texts from Nag Hammadi." In *Nag Hammadi, Gnosticism, and Early Christianity*, edited by Charles W. Hedrick and Robert Hodgson, Jr., 257–85. Peabody, Mass.: Hendrickson Publishers, 1986.

———. *The Gnostic Gospels*. New York: Vintage Books, 1981.

———. "What Became of God the Mother? Conflicting Images of God in Early Christianity." *Signs* 2 (1976) 293–303.

Painchaud, L. *Le Deuxième Traité du Grand Seth*. Quebec and Laval: Les Presses de l'Université Laval, 1982.

Parrott, Douglas M., ed. and trans. *Nag Hammadi Codices III,3–4 and V,1 with Papyrus Berolinensis 8502,3 and Oxyrhynchus Papyrus 1081: Eugnostos and Sophia of Jesus Christ*. Leiden: E. J. Brill, forthcoming.

———, ed. *Nag Hammadi Codices V,2–5 and VI with Papyrus Berolinensis 8502,1 and 4*. NHS XI. Leiden: E. J. Brill, 1979.

Parvey, Constance F. "The Theology and Leadership of Women in the New Testament." In *Religion and Sexism: Images of Women in the Jewish and Christian Traditions*, edited by Rosemary Radford Ruether, 117–49. New York: Simon & Schuster, 1974.

Pasquier, Anne, ed. and trans. *L'Evangile selon Marie*. Quebec: Les Presses de l'Université Laval, 1983.

Pearson, Birger A. "Egyptian Seth and Gnostic Seth." In *Society of Biblical Literature Seminar Papers*, 25–43. Missoula, Mont.: Scholars Press, 1977.

———. "The Figure of Norea in Gnostic Literature." In *Proceedings of the International Colloquium on Gnosticism, Stockholm, August 20–25, 1973*, edited by Geo Widengren, 143–52. Kungl. Vitterhets Historie ock Antikvitëts Akademiens Handlingar, Filologisk-filosofiska serien 17. Stockholm: Almqvist & Wiksell; Leiden: E. J. Brill, 1977.

———. "The Figure of Seth in Gnostic Literature." In *The Rediscovery of Gnosticism*, edited by Bentley Layton, 2:472–504. Leiden: E. J. Brill, 1981.

———. "Jewish Haggadic Traditions in the *Testimony of Truth* from Nag Hammadi (CG IX,3)." In *Ex Orbe Religionum: Studia Geo Widengren*, edited by J. Bergman, K. Drynjeff, and H. Ringgren, 1:457–70. Supplement to *Numen*. Leiden: E. J. Brill, 1972.

———. "Jewish Sources in Gnostic Literature." In *Jewish Writings of the Second Temple Period*, edited by Michael Stone, 443–81. Assen: Van Gorcum; Philadelphia: Fortress Press, 1984.

———. "Philo and Gnosticism." *ANRW* II 21:1, edited by W. Hasse, 295–342. Hellenistisches Jüdentum in römischer Zeit: Philon und Josephus. Berlin: Walter de Gruyter, 1984.

———. *The Pneumatikos-Psychikos Terminology in 1 Corinthians*. Society of Biblical Literature Dissertation Series 12. Missoula, Mont.: Scholars Press, 1973.

———. "'She Became a Tree'—A Note to CG II, 4:89,25–26." *HTR* 69 (1976) 413–15.

———, ed. *Nag Hammadi Codices IX and X*. NHS 15. Leiden: E. J. Brill, 1981.

Peel, M. L., and J. Zandee. "The Teachings of Silvanus." In *The Nag Hammadi Library in English*, edited by J. M. Robinson, 346–61. San Francisco: Harper & Row, 1977.

Perdelwitz, Richard. "Die exousia auf dem Haupt der Frau." *Theologische Studien und Kritiken* 86 (1913) 611–13.

Perkins, Pheme. "On the Origin of the World (CG II,5): A Gnostic Physics." *VC* 34 (1980) 36–46.

———. "Pronouncement Stories in the Gospel of Thomas." *Semeia* 20 (1981) 121–32.

Pétrement, Simone. *Le Dieu séparé: Les origines du gnosticisme*. Paris: Les Editions du Cerf, 1984.

Philonenko, Marc. *Joseph et Aséneth: Introduction, texte critique, traduction et notes*. Leiden: E. J. Brill, 1968.

Pincherle, A. *La formazione teologica de Sant' Agostino*. Rome, 1947.

Placher, William. "Paul Ricoeur and Postliberal Theology: A Conflict of Interpretations?" Unpublished.

Polotsky, H. J. "Manichäismus." PW Supplement, vol. 6 (1935) 240–71.

Pomeroy, S. *Goddesses, Whores, Wives and Slaves: Women in Classical Antiquity*. New York: Charles Scribner's Sons, 1975.

———. *Women in Hellenistic Egypt: From Alexander to Cleopatra*. New York: Schocken Books, 1984.

Preus, Anthony. "Galen's Criticism of Aristotle's Conception Theory." *Journal of the History of Biology* 10 (1977) 65–85.

Puech, Henri-Charles. *Le manichéisme: Son fondateur, sa doctrine.* Musée Guimet, Bibliothèque de Diffusion 56. Paris: Civilisations du Sud, 1949.

———et al., eds. *Tractatus Tripartitus.* 2 vols. Bern: Francke Verlag, 1973 and 1975.

Quecke, Hans. *Die Briefe Pachoms.* Textus patristici et liturgici 11. Regensburg: Verlag Friedrich Pustet, 1975.

———. *Das Markus-evangelium Saïdisch.* Barcelona: Garriga Impresores, 1972.

Quispel, Gilles. "From Mythos to Logos." In *Gnostic Studies,* 1:158–69. Istanbul: Nederlands Historisch-Archaeologisch Instituut in het Nabije Oosten, 1974. Reprint from *Eranos Jahrbuch* 39 (1970) 323–40.

———. "Genius and Spirit." In *Essays on Nag Hammadi Texts in Honour of Pahor Labib,* edited by Martin Krause. NHS 6. Leiden: E. J. Brill, 1975, 155–69.

———, ed. *Lettre à Flora.* 2d ed. Sources Chrétiennes 24. Paris: Les Editions du Cerf, 1966.

Rabbinowitz, J. *The Midrash Rabbah, Deuteronomy.* London: Lehmann, 1939.

Rattenbury, R. M.; T. W. Lumb; and J. Maillon, eds. *Heliodorus, Les Ethiopiques.* 3 vols. Paris: Société d'édition Les Belles Lettres, 1935–43.

Refoulé, François. "Julien d'Eclane, théologien et philosophe." *RSR* 52 (1964) 42–84, 233–47.

Rensberger, D. K. "As the Apostle Teaches: The Development of the Use of Paul's Letters in Second Century Christianity." Ph.D. diss. Yale University, 1981.

Ricci, James V. *The Genealogy of Gynaecology.* Philadelphia: Blakiston, 1943.

Richardson, Alan. *An Introduction to the Theology of the New Testament.* New York: Harper & Bros., 1958.

Ricoeur, Paul. *Hermeneutics and the Human Sciences.* Translated by J. B. Thompson. Cambridge: Cambridge University Press, 1981.

———. *Interpretation Theory: Discourse and the Surplus of Meaning.* Fort Worth: Texas Christian University Press, 1976.

———. "Naming God." *USQR* 34 (1979) 215–27.

———. *The Symbolism of Evil.* Translated by E. Buchanan. Boston: Beacon Press, 1967.

Roberge, Michel. *Noréa (NH IX,2).* Bibliothèque copte de Nag Hammadi, Section "Textes," 5. Quebec: Les Presses de l'Université Laval, 1980.

Robertson, Archibald, and Alfred Plummer. *A Critical and Exegetical Commentary on the First Epistle of St. Paul to the Corinthians.* 2d ed. Edinburgh: T. & T. Clark, 1914.

Robertson, Donald S., ed. *Apuleius, Les Métamorphoses.* 4 vols. Paris: Société d'édition Les Belles Lettres, 1940–46.

Robinson, James. M. "Basic Shifts in German Theology." *Interpretation* 16 (1962) 76–97.

———. "On the *Gattung* of Mark (and John)." In *Jesus and Man's Hope,* edited by David G. Buttrick and John M. Bald, 99–129. Pittsburgh: Pittsburgh Theological Seminary, 1970. Reprinted in *The Problem of History in Mark and Other Marcan Essays,* 11–39. Philadelphia: Fortress Press, 1982.

_____. "Die Hodajot-Formel in Gebet und Hymnus des Frühchristentums." In *Apophoreta: Festschrift für Ernst Haenchen*, 194–235. BZNW 30. Berlin: Alfred Töpelmann, 1964.

_____. "Jesus as Sophos and Sophia: Wisdom Traditions and the Gospels." In *Aspects of Wisdom in Judaism and Early Christianity*, edited by Robert L. Wilken, 1–16. University of Notre Dame Center for the Study of Judaism and Christianity in Antiquity 1. Notre Dame and London: University of Notre Dame Press, 1975.

_____. "LOGOI SOPHON: On the Gattung of Q." In *Trajectories Through Early Christianity*, 71–113. Philadelphia: Fortress Press, 1971.

_____, ed. *The Nag Hammadi Library in English*. San Francisco: Harper & Row, 1977.

Roloff, D. *Plotin: Die Gross-Schrift III,8; V,8; V,5; II,9*. Berlin: Walter de Gruyter, 1970.

Rose, Eugen. *Die manichäische Christologie*. Studies in Oriental Religions 5. Wiesbaden: Otto Harrassowitz, 1979.

Rousseau, A. H., and L. Doutreleau. *Irénée de Lyon, Contre les Hérésies, livre 1*. Paris: Les Editions du Cerf, 1979.

Rousselle, Aline. "Observation féminine et idéologie masculine." *Annales: Economies/Sociétés/Civilisations* 35 (1980) 1089–1113.

Rudolph, Kurt. *Gnosis: The Nature and History of Gnosticism*. San Francisco: Harper & Row, 1983.

Ruef, J. *Paul's First Letter to Corinth*. Westminster Pelican Commentaries. Philadelphia: Westminster Press; London: SCM Press, 1977.

Ruether, Rosemary Radford. "Mothers of the Church: Ascetic Women in the Late Patristic Age." In *Women of Spirit: Female Leaders in the Jewish and Christian Traditions*, edited by Rosemary R. Ruether and Eleanor McLaughlin, 71–98. New York: Simon & Schuster, 1979.

_____. *New Women, New Earth: Sexist Ideologies and Human Liberation*. New York: Seabury Press, 1975.

Runia, David, ed. *Plotinus Amid Gnostics and Christians*. Amsterdam: Free University Press, 1984.

Sage, Athanase. "Le péché originel dans la pensée de saint Augustin, de 412 à 430." *Revue des Etudes Augustiniennes* 15 (1969) 75–112.

Sagnard, F. *Clément d'Alexandrie: Extraits de Théodote*. Paris: Le Cerf, 1948.

Schenke, Hans-Martin. "Das Evangelium nach Philippus." In *Koptisch-gnostische Schriften aus den Papyrus-Codices von Nag Hamadi*, edited by J. Leipoldt and H.-M. Schenke. Hamburg-Bergstedt: Reich Evangelischer Verlag TF 20 (1960) 33–65; TLZ 84 (1950) 1–26.

_____. *Der Gott "Mensch" in der Gnosis: Ein religionsgeschichtlicher Beitrag zur Diskussion über die paulinische Anschauung von der Kirche als Leib Christi*. Göttingen: Vandenhoeck & Ruprecht, 1962.

_____. "Nag-Hammadi Studien I: Das literarische Problem des Apokryphon Johannis." ZRGG 14 (1962) 57–63.

_____. "Nag-Hammadi Studien III: Die Spitze des dem Apokryphon Johannis und der Sophia Jesu Christi zugrundeliegenden gnostischen Systems." ZRGG 14 (1962) 352–61.

_____. "The Phenomenon and Significance of Gnostic Sethianism." In *The Rediscovery of Gnosticism*, edited by Bentley Layton, 2:588–616. Leiden: E. J. Brill, 1981.

_____. "Das sethianische System nach Nag-Hammadi Handschriften." In *Studia Coptica*, edited by Peter Nagel, 165–72. Berlin: Akademie-Verlag, 1974.

Schlatter, A. *Die Korinthische Theologie. Beiträge zur Förderung christlicher Theologie*. Gütersloh: C. Bertelsmann, 1914.

Schmidt, Carl. *Gnostische Schriften aus koptischer Sprache*. TU 8. Berlin: Akademie-Verlag, 1892.

_____, ed., and Violet MacDermot, trans. and notes. *Pistis Sophia*. NHS 9. Leiden: E. J. Brill, 1978.

Schmidt, M. *Hesychii Alexandrini Lexicon*. 5 vols. Amsterdam: Adolf M. Hakkert, 1965.

Schmithals, Walther. *Gnosticism in Corinth*. Translated by John E. Steely. Nashville and New York: Abingdon Press, 1971.

Schmitt, Emile. *Le mariage chrétien dans l'oeuvre de saint Augustin: Une théologie baptismale de la vie conjugale*. Paris: Etudes Augustiniennes, 1983.

Schoeps, Hans Joachim. *Aus frühchristlicher Zeit: Religionsgeschichtliche Untersuchungen*. Tübingen: J. C. B. Mohr (Paul Siebeck), 1950.

Scholer, David. *Nag Hammadi Bibliography 1948–1969*. NHS 1. Leiden: E. J. Brill, 1971. Supplements in *NovT*.

Schüssler-Fiorenza, Elisabeth. *Bread Not Stone*. Boston: Beacon Press, 1984.

_____. *In Memory of Her: A Feminist Theological Reconstruction of Christian Origins*. New York: Crossroad, 1983.

_____. "Word, Spirit and Power: Women in Early Christian Communities." In *Women of Spirit: Female Leaders in the Jewish and Christian Traditions*, edited by Rosemary R. Ruether and Eleanor McLaughlin, 29–70. New York: Simon & Schuster, 1979.

Scopello, M. *L'Exégèse de l'Ame: Introduction, traduction, commentaire*. NHS 25. Leiden: E. J. Brill, 1985.

_____. "Youel et Barbélo dans le traité de l'Allogène." In *Colloque international sur les textes de Nag Hammadi, Québec, 22–25 août 1978*, edited by B. Barc, 374–82. Bibliothèque copte de Nag Hammadi, Etudes 1. Quebec: Université Laval; Louvain: Peeters, 1981.

Segal, Alan F. *Two Powers in Heaven: Early Rabbinic Reports About Christianity and Gnosticism*. Studies in Judaism in Antiquity 25. Leiden: E. J. Brill, 1977.

Segelberg, E. "The Coptic-Gnostic Gospel According to Philip and Its Sacramental System." *Numen* 7 (1960) 189–200.

Senft, Christoph. *La première épître de saint-Paul aux Corinthiens*. Commentaire du Nouveau Testament; second series 7. Neuchâtel: Delachaux & Niestlé, 1979.

Sevrin, Jean-Marie. *Le dossier baptismal Sethien: Etudes sur la sacramentaire gnostique*. Louvain: Peeters, 1986.

_____. *L'Exégèse de l'Ame (CG II,6)*. Bibliothèque copte de Nag Hammadi, Section "Textes," 9. Laval: Les Presses de l'Université Laval, 1983.

_____. "Les noces spirituelles dans l'Evangile selon Philippe." *Le Muséon* 87 (1974) 143–93.

Shinn, Larry. "The Goddess: Theological Sign or Religious Symbol." *Numen* 31 (1984) 175–98.

Showalter, Elaine, ed. *The New Feminist Criticism: Essays on Women, Literature, and Theory.* New York: Pantheon Books, 1985.

Sieber, John H. "The Barbelo Aeon as Sophia in *Zostrianos* and Related Tractates." In *The Rediscovery of Gnosticism,* edited by Bentley Layton, 2:788–95. Leiden: E. J. Brill, 1981.

———. "An Introduction to the Tractate *Zostrianos* from Nag Hammadi." *NovT* 15 (1973) 233–40.

Smith, Morton. *Clement of Alexandria and a Secret Gospel of Mark.* Cambridge: Harvard University Press, 1973.

Sparks, Hedley F. D., ed. *The Apocryphal Old Testament.* Oxford: Clarendon Press, 1984.

Speyer, Wolfgang. "Zu den Vorwürfen der Heiden gegen die Christen." *Jahrbuch für Antike und Christentum* 6 (1963) 129–35.

Spicq, C. "Encore 'la puissance sur la tête,' (I Cor XI,10)." *RB* 48 (1939) 557–62.

Spittler, Russell P. *The Corinthian Correspondence.* Springfield, Mo.: Gospel Publishing House, 1976.

Stählin, Otto. *Clemens Alexandrinus.* 2 vols. Berlin: Akademie-Verlag, 1972.

Stanley, J. P. "Gender Marking in American English: Usage and Reference." In *Sexism and Language,* edited by A. P. Nilsen et al., 43–76. Urbana, Ill.: National Council for Teachers of English, 1977.

Stead, G. C. "The Valentinian Myth of Sophia." *JTS* 20 (1969) 75–104.

Stein, R. M. "Liberating the Feminine." In *Male and Female,* edited by R. Tiffany Barnhouse and U. T. Holmes, 76–86. New York: Seabury Press, 1976.

Stone, Michael, and John Strugnell. *The Books of Elijah: Parts 1—2.* Society of Biblical Literature Texts and Translations 18. Missoula, Mont.: Scholars Press, 1979.

Strack, Hermann L., and Paul Billerbeck. *Kommentar zum Neuen Testament aus Talmud und Midrasch.* 4 vols. Munich: Beck, 1922–28.

Stroumsa, G. A. G. *Another Seed: Studies in Gnostic Mythology.* NHS 24. Leiden: E. J. Brill, 1984.

Tardieu, M. *Ecrits gnostiques: Codex de Berlin.* Sources Gnostiques et Manichéennes. Paris: Editions du Cerf, 1984.

———. "Epiphane contre les gnostiques." *Tel Quel* 88 (1981) 64–91.

———. *Trois mythes gnostiques: Adam, Eros et les animaux d'Egypte dans un écrit de Nag Hammadi (II,5).* Paris: Etudes Augustiniennes, 1974.

Temkin, Owsei. *Soranus' Gynecology.* Baltimore: Johns Hopkins University Press, 1956.

TeSelle, E. "Rufinus the Syrian, Caelestius, Pelagius: Explorations in the Prehistory of the Pelagian Controversy." *Augustinian Studies* 3 (1972) 61–96.

Thomassen, E. "The Structure of the Transcendent World in the Tripartite Tractate." *VC* 34 (1980) 358–75.

———. *The Tripartite Tractate from Nag Hammadi.* Quebec: Les Presses de l'Université Laval. Forthcoming.

Thonnard, François-Joseph. "La notion de concupiscence en philosophie augustinienne." *Recherches Augustiniennes* 3 (1965) 59–105.

_____. "L'aristotélisme de Julien d'Eclane et saint Augustin." *Revue des Etudes Augustiniennes* 11 (1965) 295–304.

Thraede, Klaus. "Frau." *Reallexikon für Antike und Christentum*, 8:197–269. Stuttgart, 1973.

_____. "*Freunde in Christus werden* . . ." *Die Beziehung von Mann und Frau als Frage an Theologie und Kirche*, with Gerta Scharfenorth. Kennzeichen 1. Gelnhausen: Burckhardthaus-Verlag; Stein: Laetare-Verlag, 1977.

Thyen, Hartwig, and Frank Crüssemann, eds. *Als Mann und Frau geschaffen: Exegetische Studien zur Rolle der Frau.* Gelnhausen: Burckhardthaus-Verlag, 1978.

Till, W. *Das Evangelium nach Philippos.* Berlin: Walter de Gruyter, 1963.

_____. "The Gnostic Apocryphon of John." *JEH* 3 (1952) 14–22.

_____, and Hans-Martin Schenke, eds. *Die gnostischen Schriften des koptischen Papyrus Berolinensis 8502.* TU 60; Berlin: Akademie-Verlag, 1972.

Tischendorf, C. von, ed. *Evangelia apocrypha.* 2d ed. Leipzig: Mendelssohn, 1876.

Tischleder, P. *Wesen und Stellung der Frau nach der Lehre des heiligen Paulus.* Neutestamentliche Abhandlungen 10, 3–4. Münster: Aschendorff, 1923.

Tran tam Tinh, V. "Serapis and Isis." In *Jewish and Christian Self-Definition*, vol. 3: *Self-Definition in the Greco-Roman World*, edited by Ben F. Meyer and E. P. Sanders, 101–17. Philadelphia: Fortress Press, 1982.

Trible, Phyllis. *Texts of Terror.* Philadelphia: Fortress Press, 1984.

Tripp, D. H. "The 'Sacramental System' of the Gospel of Philip." In *Studia Patristica XVII*, edited by Elizabeth A. Livingstone, 1:251–60. 3 vols. Oxford and New York: Pergamon Press, 1982.

Turner, John D. *The Book of Thomas the Contender.* Society of Biblical Literature Dissertation Series 23. Missoula, Mont.: Scholars Press, 1975.

_____. "The Gnostic Threefold Path to Enlightenment: The Ascent of Mind and the Descent of Wisdom." *NovT* 22 (1980) 324–51.

_____. "Sethian Gnosticism: A Literary History." In *Nag Hammadi, Gnosticism and Early Christianity*, edited by Charles W. Hedrick and Robert Hodgson, Jr., 55–86. Peabody, Mass.: Hendrickson Publishers, 1986.

Unnik, W. C. van. "Les chevaux défaits des femmes baptisées: Un rite de baptême dans l'ordre ecclésiastique d'Hippolyte." *VC* 1 (1947) 77–100.

Valk, M. van der. *Eustathii, Commentarii ad Homeri Iliadem pertinentes.* 3 vols. Leiden: E. J. Brill, 1971–79.

Vetterling-Braggin, Mary, ed. *Femininity, Masculinity, and Androgyny: A Modern Philosophical Discussion.* Totowa, N.J.: Rowman & Littlefield, 1982.

Waldschmidt, Ernst, and Wolfgang Lentz. "Die Stellung Jesu im Manichäismus." In *Abhandlungen der Preussischen Akademie der Wissenschaften, philosophische-historische Klasse* 4 (1926–27), 1–131.

Wallis, R. T. *Neoplatonism.* New York: Charles Scribner's Sons, 1972.

Waltke, Bruce K. "I Corinthians 11,2–16: An Interpretation." *Bibliotheca Sacra* 135 (1978) 46–57.

Waszink, J. H. *De Anima: Edited with Introduction and Commentary.* Amsterdam: J. M. Meulenhoff, 1947.

Webster, T. B. L. *Studies in Later Greek Comedy.* Westport, Conn.: Greenwood Press, 1981.

Weeks, Noel. "Of Silence and Head Covering." *WTJ* 35 (1972) 21–27.

Weinel, Heinrich. *Paulus: Der Mensch und sein Werk: Die Anfänge des Christentums, der Kirche und des Dogmas.* Lebensfragen 3. 2d ed. Tübingen: J. C. B. Mohr (Paul Siebeck), 1915.

Weiss, Johannes. *Der erste Korintherbrief.* 9th ed. Göttingen: Vandenhoeck & Ruprecht, 1910.

Wendland, Paul. *Refutatio omnium haeresium.* GCS 26. Leipzig: J. C. Hinrichs Verlag, 1916. Reprint reduced in size, Hildesheim and New York: Georg Olms, 1977.

Wesendonk, O. G. von. "Jesus und der Manichäismus." *OLZ* 30 (1927) 221–27.

Widengren, Geo. *Mani and Manichaeism.* New York: Holt, Rinehart & Winston, 1963.

Wilken, Robert L. *The Christians as the Romans Saw Them.* New Haven: Yale University Press, 1984.

Williams, F. E. "Were There 'Immoral' Forms of Gnosticism?" Unpublished.

Williams, Michael A. "Uses of Gender Imagery in Ancient Gnostic Texts." In *Gender and Religion: On the Complexity of Symbols,* edited by Caroline Walker Bynum, Stevan Harrell, and Paula Richman, 196–227. Boston: Beacon Press, 1986.

Wilson, R. McL. *The Gospel of Philip.* London: Murray, 1962.

Wisse, F. "Gnosticism and Early Monasticism in Egypt." In *Gnosis: Festschrift für Hans Jonas,* edited by B. Aland, 433–40. Göttingen: Vandenhoeck & Ruprecht, 1978.

———. "The Nag Hammadi Library and the Heresiologists." *VC* 25 (1971) 205–23.

———. "The 'Opponents' in the New Testament in Light of the Nag Hammadi Writings." In *Colloque international sur les textes de Nag Hammadi,* edited by B. Barc, 99–120. Bibliothèque copte de Nag Hammadi, Etudes 1. Quebec and Louvain: Les Presses de l'Université Laval, 1981.

———. "Prolegomena to the Study of the New Testament and Gnosis." In *The New Testament and Gnosis: Essays in Honour of Robert McL. Wilson,* edited by A. H. B. Logan and A. J. M. Wedderburn, 138–45. Edinburgh: T. & T. Clark, 1983.

———. "Stalking Those Elusive Sethians." In *The Rediscovery of Gnosticism,* edited by Bentley Layton, 2:563–76. Leiden: E. J. Brill, 1981.

———. "The Use of Early Christian Literature as Evidence for Inner Diversity and Conflict." In *Nag Hammadi, Gnosticism, and Early Christianity,* edited by Charles W. Hedrick and Robert Hodgson, Jr., 177–90. Peabody, Mass.: Hendrickson Publishers, 1986.

Witt, R. E. *Isis in the Graeco-Roman World.* Ithaca, N.Y.: Cornell University Press, 1971.

Yarbrough, Anne. "Christianization in the Fourth Century: The Example of Roman Women." *CH* 45 (1976) 149–65.

Zaehner, R. C. *Zurvan: A Zoroastrian Dilemma.* Oxford: Clarendon Press, 1955.

Zeller, Eduard. *Die Philosophie der Griechen in ihrer geschichtlichen Entwicklung.* 3d ed. Leipzig: Fues's Verlag, 1880.

Zirkle, Conway. "Animals Impregnated by the Wind." *Isis* 25 (1936) 95–130.

Zscharnack, Leopold. *Der Dienst der Frau in den ersten Jahrhunderten der christlichen Kirche.* Göttingen: Vandenhoeck & Ruprecht, 1902.

Index

447

perversity, 397; as pollution (*see also*
Original sin), 109, 303, 318, 320, 391
n. 204; same-sex love, 295–96, 340, 422;
sexual deviance, 331–33, 355, 363–65;
social norms of, 331–33, 416
Shame, 281, 287, 288, 312, 318, 370, 372,
382–83, 419
Shem, 100 n. 21, 265
Sibyl, 279
Sige. *See* Silence
Silas, 316
Silence ,33, 64, 182 n. 2
Simon (Magician), 63, 89–90
Simon Peter (*see also* Peter), 19, 303
Simonian Gnosticism, 47, 62, 63, 69, 70 n. 6
Snake. *See* Serpent
Social setting, 297, 299, 306–7
Sodomites, 375
Solomon, 99
Son, 31–32, 35, 37–38, 57, 66, 105–6, 113,
115–16, 118–21, 125–26, 130–33, 135, 137,
140–41, 150, 161–63, 166–67, 175, 179–80,
181, 182, 184, 205, 226, 230, 233, 236, 243,
256, 287, 357
Sophia (*see also* Wisdom), 5, 8, 17, 46, 54
n. 32, 54–62, 67–70, 71, 76–77, 94, 96–112,
114, 119–20, 122, 126, 129, 133–35, 148–
51, 158, 163–66, 168, 168 n. 17, 170–71,
174, 180–81, 183–85, 190, 192, 198, 202,
211–13, 218, 221–22, 228, 232–33, 238,
255, 256, 267–68, 269, 270, 274, 298 n. 2,
319–20, 322, 349–52, 354, 357, 358–60,
366, 409; fall of, 46, 55–60, 77, 94, 105–8,
171, 302, 349; without male consort, 12,
17, 58, 149, 163, 254, 303, 349–50
Soranus, 348, 351, 353, 355, 378, 386 n. 167,
395 n. 240
Soter. *See* Savior
Soul (*see also* Psyche), 9, 13, 14, 16, 18, 20,
27, 29, 37, 39, 56 n. 35, 61, 70 n. 6, 72–78,
79 n. 55, 80 n. 56, 81–82, 91–94, 102 n. 29,
106, 109, 120, 137, 144, 156, 162, 186, 190,
194–95, 199, 200, 201, 205, 219, 234, 244,
255, 274, 283, 284, 288, 291, 298 n. 2, 300,
319, 321, 342, 346, 352, 354, 356, 357, 358,
359, 366, 369, 380, 383–84, 390–91, 397,
398, 403–4, 405 n. 7, 407–8, 413–15, 417
Speech, 184, 246
Spirit, 9, 10, 13, 20, 38, 43, 46, 56, 58, 61, 66,
103, 115, 116, 117–19, 126, 128–31, 140,
144–48, 154–57, 161, 162, 163, 164–65,
169, 174, 180, 190, 191, 192, 194–96, 197,
198–99, 200, 203, 205, 219–21, 224, 226–
27, 231–34, 244–45, 248, 249 nn. 42, 43, 45;
253, 254–55, 256, 270, 285, 288, 303, 305,
313, 315–16, 351, 352, 355, 357, 359, 374,
386, 403, 414, 416

Spirit, Holy, 37, 54, 55, 55 n. 34, 117–18, 125,
150–51, 181, 197, 201, 202–3, 211–15, 217–
18, 220, 222–24, 226–27, 228, 233–34, 241,
246, 255, 315, 371, 387
Spirits, 18, 99, 116, 126, 224, 227, 238, 242,
283, 287, 288, 290, 316, 398
Spiritual Principle, 10
Spiritual Woman, 10, 55, 245–46, 251–52,
414
Status, social and/or cultic (*see also* Roles),
110, 172–73, 178, 183, 309, 325–26, 327,
334–35, 338, 343, 344; of women (*see also*
Veiling), 16, 89–90, 178–79, 185, 281–82,
291–92, 383, 395 n. 243, 423
Stobaeus, 54
Stoicism, 37, 377
Stratioci, 185
Strato of Sardes, 52, 69
Subordinationism, 116
Susanna, 86

Tabitha, 315
Tamar, 82–86, 92
Tatian, 307
Terence, 54 n. 29
Tertullian, 36–38, 207, 277, 281–82, 284, 287,
360, 384, 413, 416
Thecla, 291, 316–17, 323
Theodore bar Konai, 397 n. 256
Theodoret, 268, 397 n. 256
Theodotus, 14–15, 351, 356
Theophrastus, 52, 54 n. 29
Thought, 16, 33, 35, 60, 169, 181, 191
Tillich, Paul, 422
Torah, 7, 132
Traducianism, 384, 406
Transvestism, 146 n. 28, 288, 291, 295–96,
317
Triple-Powered One, 161
Truth, 5, 9, 32, 64, 148–50, 212, 214, 219,
227, 254, 255–56
Turbantius, 372, 375
Typhaon, 69

Unction. *See* Anointing
Union, 33, 65, 195, 199, 201, 204, 220, 224,
228, 234–35, 237, 336, 354, 381, 415; of
Adam and Eve, 61 n. 55, 64, 190, 201, 202;
of angel and its image, 223, 238; of Christ
and Church, 202; with the divine, 21, 28;
of Eve and demiurge, 108; of Father and
Holy Spirit, 201, 220; of Holy Spirit and
Light, 234; of husband and wife, 223; of
lover and beloved, 28, 80; of male and
female, 13–14, 64, 155–56, 212, 232, 236,
238, 283–84, 374; of soul and bridegroom,
82, 190, 202; of soul and its lovers, 77, 79,